The Age of the Avant-Garde

THE AGE OF THE

An Art Chronicle of 1956-

AVANT-GARDE
1972 by Hilton Kramer

Farrar, Straus and Giroux • *New York*

FIRST PRINTING, 1973

Library of Congress catalog card number: 72-89885
ISBN 0-374-10238-4
Printed in the United States of America
Published simultaneously in Canada by Doubleday Canada Ltd., Toronto
DESIGNED BY HERB JOHNSON

Acknowledgments

Grateful acknowledgment is made to the editors of the following publications, where many of the articles and reviews collected in this volume first appeared: *Artforum, Arts Magazine, Boston Museum Bulletin, Commentary, Encounter, The Lugano Review, Modern Occasions, The Nation, The New Leader, The New York Review of Books,* and *The Reporter.* I also wish to thank The Foundation for Modern Art, Inc. (now the New York Cultural Center in association with Fairleigh Dickinson University) and Terry Dintenfass, Inc., in whose catalogs two of the articles originally appeared.

I owe a special debt of gratitude for the generous support and encouragement I have received from my editors and colleagues at *The New York Times,* and I also wish to thank the editors of the publications mentioned above for their cordial hospitality and advice.

Special thanks to my wife Esta for her help and forbearance in preparing the manuscript of this book.

For Esta, with love

Preface

The essays and reviews gathered together in this volume, though they deal with a great many different subjects, are nonetheless concerned with a single theme. They all dwell, in one way or another, on the art—and on the critical conventions and social institutions that have developed around the art—of what I have called the Age of the Avant-Garde and its immediate aftermath.

Difficult as it may be to establish exact dates for such an age, no one seriously occupied with the vicissitudes of modern culture doubts that it once existed. (I would myself set the boundaries of the age as extending from the 1850's—for convenience, 1855, the year that Courbet mounted his own one-man show on the doorstep of the Exposition Universelle—to the 1950's, when Abstract Expressionism, the last of the "unpopular" art movements, began to enjoy a widespread prosperity and prestige.) The only question still under debate is whether the avant-garde persists into our own day as a vital artistic force or has given way to something else—an age in which the rhetoric and attitudes of the avant-garde continue to be upheld, but very largely as a cover for a mode of artistic production and consumption that differs from the Age of the Avant-Garde in its fundamental assumptions.

My own view of the matter, as will be apparent in the bulk of the pieces in this book, is that the Age of the Avant-Garde has definitely passed. What it has been succeeded by—and what light our own problematic period casts upon the actual development of the avant-garde in the heyday of its creative powers—I have tried to explore in my introductory essay. But the reader should bear in mind that the essays and reviews brought together in this volume, though they take as their principal theme this century of avant-garde art, do not themselves belong to the Age of the Avant-Garde. They belong to the period that has followed it—a period that has witnessed an extensive and far-reaching review of the preceding century.

This review has taken two forms. On one hand, there have been the new art movements which have often functioned as a creative and critical commentary on the avant-garde heritage, and, on the other, there has been a vast array of exhibitions, publications, and publicity coups designed as an effort to come to terms with the avant-garde achievement. It is to this review that the many separate and diverse pieces in *The Age of the Avant-Garde* address themselves.

They may thus be regarded as initiating a revisionist view of the avant-garde era—an attempt to see the classic accomplishments of the avant-garde through the lens of a post-avant-garde sensibility. They are by no means intended to repudiate those accomplishments, though I fully expect that many simpleminded partisans of the avant-garde, for whom the pieties of vanguard ideology have long been a convenient substitute for thought, will so regard them. My admiration for the greatest of those accomplishments—and, indeed, for many of the lesser ones as well—is attested to by many of the pieces in this book. But I do feel that the time has come—it is, in fact, long overdue—for us to separate the achievement itself from the vast superstructure of outmoded faith that history has attached to it, a faith that our institutions and our critical practice still tend to take for granted. My own belief is that we are no more likely to get at the truth about the Age of the Avant-Garde by piously reaffirming the tenets of that faith than we could expect to understand the aesthetics of Versailles by limiting ourselves to the assumptions that prevailed in the court of Louis XIV.

Any attempt to separate the avant-garde achievement from the sentimental myths that still surround it runs the risk, of course, of being stigmatized as simply one more episode in the long history of Philistine resistance to artistic vitality. But this is a risk that criticism is obliged to take, I think, if it is not to become yet another expression of the very myths that conceal the actualities of art from disinterested scrutiny.

Nothing in this volume is intended to be the last word on one of the greatest as well as one of the most complex periods in the history of the artistic imagination—a period that is all the more important to us because it forms the foundation of our own sensibilities. On the contrary, the essays and reviews gathered here were written—usually in haste, in response to particular occasions and for particular deadlines—in the conviction that a start in the arduous task of critical revaluation needed to be made, and not because a critical theory prescribed it but because our experience compelled it. For better or worse, we are now living in a period vastly different from that which nurtured the vision and the values of the avant-garde, and we are already late in recognizing where this difference has brought us.

H.K.

Westport, Connecticut
August 1972

Contents

The School of Paris

Illustrations

"*A sense of the waste of criticism, however, a sense
that is almost in itself consoling, descends upon the
fond critic after his vision has fixed the scene awhile
in this light of its lost accessibility to some informed
and benevolent despot, some power working in one
great way and so that the interest of beauty should
have been better saved. Is not criticism wasted, in
other words, just by the reason of the constant
remembrance, on New York soil, that one is almost
impudently cheated by any part of the show that pre-
tends to prolong its actuality or to rest on its present
basis? Since every part, however blazingly new, fails
to affect us as doing more than hold the ground for
something else, some conceit of the bigger dividend,
that is still to come, so we may bind up the aesthetic
wound, I think, quite as promptly as we feel it open.
The particular ugliness, or combinations of uglinesses,
is no more final than the particular felicity. . . . The
whole thing is the vividest of lectures on the subject of
individualism, and on the strange truth, no doubt, that
this principle may in the field of art . . . often conjure
away just that mystery of distinction which it some-
times so markedly promotes in the field of life.*"

—Henry James, in "*The American Scene*"

I. The Age of
 the Avant-Garde

The Age of the Avant-Garde

How strange a thing it was to understand
And how strange it ought to be again, this time
Without the distortions of the theatre,
Without the revolutions' ruin,
In the presence of the barefoot ghosts!
 —Wallace Stevens

In his *Histoire de la littérature française de 1789 à nos jours*, published in 1936, the French critic Albert Thibaudet speaks of the three "revolutions" that the Symbolist movement brought to the writing of poetry in France. The first was a revolution in literary technique—"the liberation of verse" that exempted poetry from rhyme and syllabic scansion and thus "created a rupture between 'normal' poets and 'free-verse' poets." The second was a revolution in the ultimate objective of poetic style—"the advent of pure poetry," the attempt, as Mallarmé put it, "to recapture the best in music" and thereby create a poetry in which "the words take the initiative." But it was the third of these revolutions that proved to be the most fateful—"the idea itself of revolution." Symbolism, Thibaudet writes,

> accustomed literature to the idea of indefinite revolution, an artistic Blanquism, a right and duty of youth to overturn the preceding generation, to run after an absolute. If the poets were divided into "normal," or "regular," and free-verse, literature was divided into normal literature and literature of the "avant-garde." The chronic avant-gardism of poetry, the "What's new?" of the "informed" public, the official part given to the young, the proliferation of schools and manifestos with which these young hastened to occupy that extreme point, to attain for an hour that crest of the wave in a tossing sea—all this was not only a new development in 1885 but a new climate in French literature. The Symbolist revolution, the last thus far,

might perhaps have been definitively the last, because it incorporated the theme of chronic revolution into the normal condition of literature.

The "new climate" of 1885 has indeed become the "normal condition" of a good deal more than literature. It has become the basis of our entire cultural life. Thibaudet's "What's new?" is no longer the exclusive possession of a tiny "informed" public. It is now the daily concern of vast bureaucratic enterprises whose prosperity depends on keeping the question supplied with a steady flow of compelling but perishable answers. The "right and duty of youth to overturn the preceding generation" is an established datum in the academic curriculum, and "that crest of the wave in a tossing sea" has long been turned into a public facility drawing record crowds.

For the "normal condition" of our culture has become one in which the ideology of the avant-garde wields a pervasive and often cynical authority over sizable portions of the very public it affects to despise. That it does so by means of a profitable alliance with the traditional antagonists of the avant-garde—the mass media, the universities, and the marketplace—only underscores the paradoxical nature of the situation in which we find ourselves. It is in the interest of this ideology to deny the scope of its present powers, of course. Its continuing effectiveness—its ability to come before the public not only as an arbiter of taste but as an example of moral heroism— is peculiarly dependent on the fiction of its extreme vulnerability. The myth of the underdog, of a struggle against impossible odds with little hope of just recognition, is an indispensable instrument in the consolidation of avant-garde influence.*

But this is only part of the myth that is fostered in the avant-

* A perfect example of this myth in action is to be found in the symposium called "Art, Culture and Conservatism," in the summer 1972 number of *Partisan Review*. Among its other contributions is an essay by Richard Gilman, entitled "The Idea of the Avant-Garde," in which the former literary editor of *The New Republic* and former drama critic for *Newsweek*, now a professor at Yale University and contributing editor to *Partisan Review*, defends the idea of "absolute art" ("Happenings . . . John Cage's music, Ad Reinhardt's Black paintings, Beckett's *How It Is*"), as if this has not been one of the principal prestige items of our culture for as many years as he has been observing the scene, and as if his own highly visible career as a critic has not been associated with its phenomenal success. The question never raised in this essay, or elsewhere in the symposium, is this: would Mr. Gilman have been invited to Yale, or to *Newsweek* or *Partisan Review*, if he had set himself in vocal opposition to such "absolute art"? This is a case where a little autobiography would have been far more instructive than a solemn display of "disinterested" critical analysis.

garde scenario. Central to its doctrine of embattled and threatened virtue is the notion of what Lionel Trilling has called the avant-garde's "adversary" relation to the larger (bourgeois) culture in which it functions. If the institutions that now serve as conduits of avant-garde claims are no longer shy about acknowledging this adversary role, it is because the role itself has acquired an unquestioned historical prestige. We have all been brought up on the legend of avant-garde martyrdom, with its celebrated episodes of tardy vindication. Nothing is more familiar to us than the literature of cautionary tales recounting middle-class resistance to and stupidity about "advanced" artistic innovation. The history of modern art abounds in such tales, which are often chronicles of genuine suffering when they are not mere comedies of cultural manners. As a result, the tendency of modern critical thought, whether sympathetic to avant-garde objectives or openly hostile to them, has been to accept without question an essential, perhaps even a metaphysical, antagonism separating high culture from the middle class—an antagonism readily confirmed in our guilty feelings over the crowded roster of abused and misunderstood genius.

But these feelings are more and more at odds with our current experience. At a time when avant-garde claims are enthusiastically embraced by virtually all the institutions ministering to middle-class taste, the old pieties about what Mr. Trilling calls "the adversary intention, the actually subversive intention" of modernist art are clearly out of date. An accommodation has obviously been reached —an accommodation that makes nonsense of established notions of cultural warfare. We have, in fact, been witnessing a startling reversal of roles. The appetite for innovation is now voracious on the part of the new public for art, but it is more and more a source of impotence and despair among artists who recognize that this volatile and often heartless taste for the "new" can be quite as destructive to any real attachment to the objects of the artistic imagination as the old Philistine resistance ever was. It is now the artists who represent "tradition," if only the paradoxical tradition of the avant-garde, and the "informed" public that is likely to be quickly bored with what is established and familiar. Under the circumstances, we have ample reason to wonder what it is exactly that modernist art intended to subvert—to wonder what the once-exacerbated relation of the avant-garde to the middle class has come to and, indeed, what it actually was in the epoch of its legendary conflicts.

I doubt if we can fully appreciate the fate that has overtaken the avant-garde in our own day without some drastic alteration in our understanding of the avant-garde as a historical phenomenon— without a clear understanding, first of all, that it *is* a historical phenomenon rather than an immutable fixture of cultural life. Contrary to the romance that encloses so much of its history for us, the avant-garde belongs ineluctably to the world of the middle class and is barely conceivable in isolation from it. The avant-garde has been, from the start, a vital coefficient of bourgeois culture. Beginning as an avowal of the life of feeling that the defensive and insecure institutions of the middle class could not bring themselves to acknowledge, lest its precarious hold on its own self-esteem be shattered, the avant-garde developed into the critical and increasingly combative conscience of bourgeois civilization. The cultural history of the bourgeoisie is the history of its gradual and painful adjustment to this conscience—an adjustment that made the bourgeoisie, despite its own worst inclinations, the moral and aesthetic beneficiary of the avant-garde's heroic labors.

It is not enough to see this fateful history, which is nothing less than the history of the effort to align the interests of high art with the realities of an industrial society governed by democratic principles, as a cartoon struggle between the enlightened and the unenlightened. The actual scenario is far more complicated than that. The bourgeoisie was, after all, the first truly "modern" class. Its headlong development of industrial technology into the dominant means of production, with everything this brought in the shift of power from the countryside to the cities, had a deeper and more permanent effect on the texture and the dynamics of modern life— on the "values" that impinge on experience—than art of any sort, whether avant-garde or *retardataire,* could possibly make claim to. Likewise its sponsorship of democratic institutions. In short, there is a "progressive" side to the bourgeois ethos—an impulse toward emancipation from outmoded social forms as well as from outmoded means of production—that is at least as significant as the "reactionary" side, though you would never dream of its existence from the caricature of bourgeois motives that emerges from the doctrinal literature of the avant-garde.

As for the avant-garde itself, its own history is anything but a singleminded tale of revolt against bourgeois values. Cocteau may have been exaggerating when he claimed that "The 'bourgeoisie' is

the bed-rock of France from which all our artists emerge. They may possibly get clear of it, but it allows them to build dangerously on substantial foundations." ("With us," he wrote in *Cock and Harlequin,* "there is a house, a lamp, a plate of soup, a fire, wine and pipes at the back of every important work of art."*) But he was only exaggerating an essential part of the truth. The history of the avant-garde actually harbors a complex agenda of internal conflict and debate, not only about aesthetic matters but about the social values that govern them. If the bourgeois ethos may be said to have both a "progressive" and a "reactionary" side, the avant-garde is similarly divided. At one extreme, there is indeed an intransigent radicalism that categorically refuses to acknowledge the contingent and rather fragile character of the cultural enterprise, a radicalism that cancels all debts to the past in the pursuit of a new vision, however limited and fragmentary and circumscribed, and thus feels at liberty—in fact, compelled—to sweep anything and everything in the path of its own immediate goals, whatever the consequences. It is from this radical extreme, of which Dada, I suppose, is the quintessential expression, that our romance of the avant-garde is largely derived. But the history of the avant-garde is by no means confined to these partisans of wholesale revolt. It also boasts its champions of harmony and tradition. It is actually among the latter that we are likely to find the most solid and enduring achievements of the modern era—among those tradition-haunted artists (Matisse and Picasso, Eliot and Yeats, Schoenberg and Stravinsky) who are mindful, above all, of the continuity of culture and thus committed to the creative renewal of its deepest impulses.

This division between art conceived as a form of guerrilla warfare and art conceived as the reaffirmation of a vital tradition is by no means absolute. Many important artists—even such self-avowed Dadaists as Arp and Schwitters—identified their interests with the one camp while quietly enjoying the advantages of the other. And such a division is certainly no guide to the aesthetic quality of individual works of art. But it does describe the essential dialectic that governed the sensibilities of the avant-garde in the era of its greatest endeavors. That the custodians of bourgeois taste failed so miserably and for so long to distinguish between their genuine adversaries and their rightful allies is part of the historical

* In *A Call to Order,* translated by Rollo H. Myers (New York: Henry Holt, 1923), page 7.

tragedy of bourgeois culture. It is also part of its comedy. But neither the tragedy nor the comedy should mislead us about the actual course of the avant-garde enterprise, which in the twentieth century—and even earlier—has been characterized by extreme dissensions in its own ranks.

These dissensions tended to increase, both in ferocity and effect, more or less in direct ratio to the turbulence of the political scene. The most celebrated avant-garde event of the relatively tranquil nineties—the raucous debut of Alfred Jarry's *Ubu Roi* at the Théâtre de l'Oeuvre in 1896—was at once a sensation and a prophecy, but it could scarcely be said to have stimulated a powerful new movement on the spot. Its consequences were delayed; the requisite political atmosphere had not yet ripened. What it prophesied—not only an assault on the audience, but an assault on art itself—was not to be fully realized until events outside the realm of art, namely the First World War and the political exacerbations that preceded it, removed certain inhibiting factors in its path. Until the advent of Futurism and Dada, in fact, Jarry's aesthetic nihilism remained buried in the subplot of the avant-garde scenario. The principal avant-garde action of the period—the main plot, if you will—was being prepared elsewhere, with no public attention to speak of, hence without scandal or violence, in the studios of Matisse and Picasso, who were working their way toward those fundamental revisions of established pictorial practice that proved to be the very basis of modernist painting in the twentieth century.

There is, indeed, a sense in which all nihilist aesthetic programs are condemned by their very nature to remain confined to the subplot of vanguard history. Their protagonists may conduct guerrilla raids on the main body of artistic endeavor, as the Futurists and the Dadaists did in such spectacular fashion, acting out dreams of revenge and vindication *in response* to what the votaries of the most vital traditions have created, but the insurgents are themselves powerless to produce an art of the first importance without aligning their aspirations with these same traditions—an alignment that necessarily modifies their own intransigence. Those radical breaks with the past which constitute a recurrent claim in the literature of each successive avant-garde group and which, so far as the public is concerned, may be said to embody the essence of what the avant-garde is understood to be doing—such breaks, it seems, are easier to formulate than to implement. In theory, the break may sound

complete (and it is usually theory that prominently assists in generating an avant-garde myth); in the studio, it rarely turns out that way.

The Futurists, for example, despite their cry of "Courage, audacity and revolt" and their confident assertion that "Poetry must be a violent assault on the forces of the unknown," were obliged to retrace the course of painting step by step from Post-Impressionism to Fauvism and Expressionism to Cubism in order to produce an art of their own—an art that, in the end, added only a marginal increment to the monumental achievements of the Cubists. Artistically, the Futurists lived off the practices—the traditions and piecemeal revisions—their ideology loudly condemned. (Apollinaire was the first to point out—in 1912—that "They declare themselves to be 'absolutely opposed' to the art of the avant-garde French schools, yet at this point, they are nothing but imitators of those schools.") This was the case even where Futurist pronouncements promised genuine innovations of great consequence. Boccioni's call, in his 1912 manifesto on sculpture, for the use of "transparent planes, glass, sheets of metal, wires, external and internal electric lights" and other new materials went unheeded by the artist himself. The first "Futurist Manifesto" of 1909 had proclaimed that "a roaring motor car . . . is more beautiful than the Victory of Samothrace," but three years later, when Boccioni approached the sculptural task of making a striding figure he called "Synthesis of Human Dynamism," "he seems to have in mind," one of his recent (and highly sympathetic) commentators tells us, "the example of the 'Victory of Samothrace' (of which there was a cast in the Brera), as well as Rodin's 'Balzac,' 'St. John the Baptist Preaching,' and Mestrovic's or Bourdelle's bulgingly-muscled males."* Even the greatest of Boccioni's sculptures—the figure called "Unique Forms of Continuity in Space" (1913)—reflects this classical inheritance and leaves the traditional notion of a unity of materials undisturbed. In the studio, Boccioni too was engaged in revising a tradition.

The genius of Futurism, as of many subsequent movements of aesthetic revolt, lay less in the realm of artistic innovation (which tended to remain in the hands of artists who were politically less *engagé*) than in the realm of ideology. The Futurists correctly perceived that only a profound social upheaval could produce condi-

* Marianne W. Martin, *Futurist Art and Theory, 1909–1915* (New York: Oxford, 1968), page 166.

tions favorable to their cherished dream of establishing a new civilization based on violence, heroism, technology, national pride, and, as Marinetti put it in 1923, "the coming to power of the young in opposition to the parliamentary, bureaucratic, academic and pessimistic spirit." Hence the glorification of war ("the only cure for the world," according to Marinetti) as the crucible in which the authority of the past could be decisively defeated. Hence, too, the incessant cry for novelty and speed, and for its inevitable corollary, the destruction of institutions—libraries, museums, academies, etc. —whose function it is to uphold the glories of the past.

That the ideology—though not necessarily the art—of the Futurists led directly to Fascism has long been recognized. (Art, after all, has a more equivocal influence.) "For anyone who has a sense of historical connections," wrote Croce in 1924, "the ideological origins of Fascism can be found in Futurism, in the determination to go down into the streets, to impose their own opinions, to stop the mouths of those who disagree, not to fear riots or fights, in this eagerness to break with all traditions, in this exaltation of youth which was characteristic of Futurism. . . ."* Yet Marinetti was telling the truth—part of the truth, anyway—when he declared that "Futurism is a movement that is strictly artistic and ideological. It intervenes in political struggles only in hours of grave danger for the nation." For what the Futurists failed to perceive was the contingent and suicidal nature of their own impulse—the impulse to politicize aesthetics and to make politics itself a realm of aesthetic gratification.

The fact is, it was first the war (which it heralded) and then the victory of Fascism (which it abetted) that destroyed Futurism as a movement. It belonged, after all, to the world it despised, the world of the bourgeoisie, and could survive in no other. With Italy at war or with the Fascists in power, any further *soirées futuristes*—the object of which was to provoke a riot in the audience—were unthinkable. Violence no longer belonged to the realm of aesthetics; it had passed into the hands of bureaucracy. The prerogatives of *Ubu* were now the possession of *il Duce*.

The line, then, from the première of Jarry's play to the *soirées futuristes* to the March on Rome is fairly clear—a line that traces "the adversary intention, the actually subversive intention" of the

* Quoted in James Joll's excellent essay, "F. T. Marinetti: Futurism and Fascism," *Intellectuals in Politics* (London: Weidenfeld & Nicolson, 1960), page 143.

avant-garde in its purest political form. But this line of nihilist intent, though undeniably fateful in its historical consequences, was only one term in the dialectic of the avant-garde endeavor, and artistically it was rarely, if ever, the stronger term. The more creative, countervailing impulse cleaved to quite different values, and foremost among them was a virtual obsession with the past— with the museum, which the Futurists wished to destroy, and the extension of certain traditions, which the Futurist painters and sculptors were obliged to observe despite their protestations to the contrary. The same year that witnessed *Ubu*'s debut saw the twenty-seven-year-old Henri Matisse painting *"La grotte,"* a painstaking rehearsal of one of Courbet's favorite themes. (Years later, when he could afford it, Matisse acquired one of Courbet's masterpieces on this theme, thus reaffirming an abiding affinity.) The next year, 1897, the sixteen-year-old Pablo Picasso, already a precocious bohemian, was writing to a friend about his admiration for El Greco, Van Dyck, Rubens, and Velázquez. The young artist promptly produced, in a painting called "Nana," an accomplished Post-Impressionist "reply" (as one critic has called it) to the powerful figure of the dwarf in Velázquez's *"Las Meninas,"* the seventeenth-century masterpiece that, decades later, was but one of several classic works Picasso was to paint an elaborate series of variations on. (Another was Courbet's *"Demoiselles de la Seine."*) Neither painter had yet produced the work that would, within the coming decade, establish him as a leader of the avant-garde; both were engaged in mastering a tradition—a tradition from which they were soon able to wrest their respective innovations and which they never really abandoned.* The point not to be mistaken is that these historic innovations, from which nearly everything we most value in the art of the twentieth century has been derived, represented in their own eyes no essential rupture with the classic works that had nourished them. Their most radical efforts were, indeed, the only way these new masters could keep faith with their classic inheritance. The past had to be absorbed before it could be seriously extended and added to. It had to be *felt* if any really new emotion were to be distinguished from it and given a new form. Writing

* "Mallarmé is an innovator in one way," wrote Paul Valéry. "Rimbaud in another. And the remainder in each is not new, but traditional." In *Leonardo Poe Mallarmé*, translated by Malcolm Cowley and James R. Lawler (Princeton, New Jersey: Princeton University Press, 1972), page 372.

about Matisse on another occasion, I suggested that he was intent in these early years on "testing the ground in every direction, copying the Old Masters . . . assaying Impressionist color and a Post-Impressionist facture, zigzagging his way from the pieties of tradition to the innovations of the avant-garde and back again. . . ."* It was precisely through such zigzag methods, audacity alternating with acts of *hommage,* that Matisse and Picasso created a body of work that changed the face of modern art—work bold enough to inspire and resourceful enough to nourish buccaneers like the Futurists and yet sufficiently strong and durable to withstand their wholesale borrowings and vulgarizations. Sufficiently resourceful, too, to support the innovations of Dada, Constructivism, and the entire history of abstraction from its earliest exponents to its latest epigoni.

Thus, the impulse to act as the creative conscience of a usable tradition was as much a part of the avant-garde scenario—it was indeed, as I have suggested, its main plot—as the impulse to wage war on the past, and the artists who aligned their ambition with this tradition-oriented function faced an infinitely subtler and more difficult task. For "tradition" already had its official guardians, who, armed with an elaborate system of sanctions, were determined to resist any change that required them to reconsider the precious inheritance in their charge. But a constant reconsideration and revaluation of the past is precisely what the master artists of the avant-garde were forcing upon the official guardians of taste, and doing so not out of any conscious determination to "subvert" tradition but, on the contrary, to rescue it from moribund conventions and redefine it in the most vital terms—terms that spoke directly to the sensibility of the age. That this effort to place tradition under the pressure of a constant revaluation had an unexpected effect, that it resulted, in the end, in the virtual dissolution of any really viable concept of tradition, is, of course, at the heart of the situation in which we find ourselves today. Without the bulwark of a fixed tradition, the avant-garde finds itself deprived of its historic antagonist. Much to its own embarrassment, it finds that it has itself become tradition. With its victory over the authority of the past complete, its own *raison d'être* has disappeared, and it has, in fact, ceased to exist except as an imaginary enterprise engaged in combat against imaginary adversaries.

* See "Matisse: The Paintings," p. 175.

The classic statement of the avant-garde view of tradition is to be found in T. S. Eliot's essay on "Tradition and the Individual Talent," published in 1919. It is worth turning again to the famous passages in which the author of "Prufrock," himself a leader of the literary avant-garde, sets out to defend the concept of tradition against the easy contempt of the avant-garde, as well as the sterile assumptions of the academy—to make it, in fact, a foundation of the highest artistic accomplishment. In what I take to be a reference to the critical practice of the avant-garde, Eliot notes a "tendency to insist, when we praise a poet, upon those aspects of his work in which he least resembles any one else." He goes on:

> In these aspects or parts of his work we pretend to find what is individual, what is the peculiar essence of the man. We dwell with satisfaction upon the poet's difference from his predecessors, especially his immediate predecessors; we endeavor to find something that can be isolated in order to be enjoyed.

But there is, Eliot insists, another and more comprehensive way of looking at the poet's work:

> . . . if we approach a poet without this prejudice we shall find that not only the best, but the most individual parts of his work may be those in which the dead poets, his ancestors, assert their immortality most vigorously. And I do not mean the impressionable period of adolescence, but the period of full maturity.

Eliot is at pains in this essay to distinguish this concept of tradition from the practice of "following the ways of the immediate generation before us in a blind or timid adherence to its successes"; "novelty," he agrees, "is better than repetition." But he firmly rejects this false choice, which, by 1919, in the heyday of Dada and Constructivism, had become the motto of every new vanguard movement. "Tradition," he writes,

> is a matter of much wider significance. It cannot be inherited, and if you want it you must obtain it by great labor. It involves, in the first place, the historical sense . . . and the historical sense involves a perception, not only of the pastness of the past, but of its presence; the historical sense compels a man to write not merely with his own generation in his bones, but with a feeling that the whole of the literature of Europe from Homer and within it the whole of the literature of his own country has

a simultaneous existence and composes a simultaneous order. This historical sense, which is a sense of the timeless as well as of the temporal and of the timeless and the temporal together, is what makes a writer traditional. And it is at the same time what makes a writer most acutely conscious of his place in time, of his own contemporaneity.

Eliot then goes on to assert a principle of the greatest importance to the art of the modern age. "No poet, no artist of any art," he declares,

> has his complete meaning alone. His significance, his apprecia-
> tion is the appreciation of his relation to the dead poets and
> artists. You cannot value him alone; you must set him, for
> contrast and comparison, among the dead. I mean this as a
> principle of esthetic, not merely historical, criticism . . .
> [for] what happens when a new work of art is created is some-
> thing that happens simultaneously to all the works of art which
> preceded it. The existing monuments form an ideal order
> among themselves, which is modified by the introduction of the
> new (the really new) work of art among them.

The aesthetic principle upheld in this essay thus placed tradi-
tion at the very center of artistic consciousness, in an intimate,
symbiotic relation to the innovative function in art. This is indeed
how tradition had come to be subsumed in the work of the greatest
avant-garde masters, and it was, too, the way it passed, unacknowl-
edged, into the work of the Futurists, the Dadaists, and other
doctrinaire exponents of the radical impulse. But Eliot's conception
of tradition—tradition as it was reconceived by the avant-garde—
was not the "tradition" of the official custodians of bourgeois culture.
Their tradition was something assumed to be fixed and immutable, a
barrier against novelty and change. (Or so they often claimed. In
actual fact, change was cautiously admitted so long as its pace could
be slowed to a barely visible trickle and its disruptive effect thereby
nullified.) In revealing this static notion of tradition to be a sham, a
tissue of pieties that no longer corresponded to anything real either
in the past or in the present, the avant-garde was bound to incur the
wrath of precisely that segment of society that had the most to fear
from disruptive changes of any sort. Its resistance to this more
volatile and uncontrollable conception of what tradition might be
was nothing less than an attempt to isolate the realm of culture from

the remorseless flux that had overtaken life in virtually every other respect—and, ironically, had done so as a direct consequence of the democratization and industrialization the bourgeoisie had itself pioneered. It was nothing less than an attempt to preserve culture in something like its former relation to power which, in aristocratic, monarchist, and theocratic societies, was a relation understood to be ornamental, functional, flattering, and morally supportive.

This legendary resistance, from which the myth of the avant-garde still draws so much energy, was often stupid. It was often cruel. It caused considerable suffering, and its basic assumption—that culture could somehow be held in a timeless reserve, quarantined from the pressures of new experience and new emotions—was completely illusory. It was, moreover, undeniably indifferent, indeed hostile, to the very standards of excellence it purported to uphold. But it cannot be denied that what was being resisted was something fundamental—a historic alteration in the relation of culture to power. Henceforth—so the avant-garde was, in effect, declaring—culture would no longer be answerable to power, it would no longer serve an ornamental function, it would no longer flatter and dissimulate in order to survive and prosper. It, too, would demand to be free—free to exercise the democratic option implicit in the bourgeois ethos and explicitly guaranteed in the bourgeois polity. The bourgeoisie thus became the first ruling class in history—I, at least, know of no precedent—to suffer the loss, the alienation, as we say, of its highest cultural constituency.

To what, we may ask, does it owe this catastrophic distinction? To its stupidity? Its cruelty? To its Philistine illusions and its well-known failures of sensibility? Not, in my opinion, primarily. In my reading of history, the bourgeoisie does not have a patent on these (or any other) moral or aesthetic deficiencies. The fact is, the middle class enforced even the worst of its own prejudices with a lighter and a more diffident hand than other classes in power. No, it owed this fateful distinction to its most conspicuous virtue—to its liberalism, to its commitment to the principle of freedom and dissent, to its refusal to tyrannize or terrorize its own opposition. However distasteful it may have found the expression of that dissent, however alarmed it became in the face of the cultural forces arrayed against it, however panic-stricken it occasionally was in responding to them, bourgeois society remained more or less loyal to its liberalism. And to that liberalism, which the avant-garde so often

mocked and despised, the avant-garde owed its very existence. Only where bourgeois liberalism itself was destroyed—not infrequently, with a little help from the avant-garde—did the avant-garde suffer a brutal and enforced demise.

Where bourgeois liberalism prospered, or at least survived, the avant-garde was free to pursue its headlong course of revision and revolt. To the *révoltés* there always accrued the greater share of publicity and a more immediate response. (Apollinaire noted, in 1912, that whereas the Futurists were "doing very nicely financially," the Cubists were "abandoned by all, ridiculed by practically every art critic, and living at best in semi-poverty, at worst in the most abject poverty."* The Surrealists were to enjoy a similar advantage, while Mondrian was being ignored.) An abrupt break with the past, real or imagined, was somehow more encompassable than a far-reaching revision or extension of it. But it was the artists engaged in the work of revision—in the work of transforming the artistic inheritance rather than obliterating it—who ultimately effected the profoundest changes, for it was they who altered irrevocably our sense of the past; it was they who liquidated its authority in the very process of harnessing its energies. The application of what Eliot called "the historical sense" to the immediate tasks of artistic innovation had the effect—unanticipated, for the most part, by the artists who pioneered the effort—of making the past permanently hostage to the pressures of the present. History was removed from its familiar hinges, and its myriad discrete episodes laid out, museum-fashion, in a way that left them neutralized and inert to anything but an aggressive principle of selection. For what was Eliot's notion of "an ideal order" of the "existing monuments" of art but a museum condemned to perpetual modification "by the introduction of the new (the really new) work of art among them"? The "simultaneous existence and . . . simultaneous order" that Eliot claimed for the whole of the literature of the past and present effectively cancelled whatever intrinsic authority the past might enjoy. All authority was now to be extrinsically invested in the imperatives of the moment. Everything now was subject to the tests of immediate creative utility, even as such tests were becoming increasingly arbitrary and irresponsible.

It is no accident, then, that the museum has emerged as the

* *Apollinaire on Art: Essays and Reviews 1902–1918*, edited by LeRoy C. Breunig (New York: Viking, 1972), page 256.

representative institution of the age of the avant-garde, succeeding the academy as the principal repository of whatever standards may be said to survive. For the museum, as it has evolved under the pressures of modernism, is founded on a principle of dynamism, a principle designed to keep the past under constant surveillance and revision, whereas the academy is based on a principle of stability. For the academy, history remains a hierarchy of fixed positions and "eternal" values against which the new can be measured and judged—and, if necessary, rejected. For the museum, history is fluid, without fixed boundaries, a medium of unremitting but fecund tension between past and present, subject only to what the "individual talent" deems most vital to its immediate interests. Admission of the new can be delayed, if only because claimants to the office are so manifold, but cannot be resisted on principle. In the academy, the new is admitted to a line of succession; it is accepted as a historical increment to an ongoing enterprise, which it is expected to enhance and strengthen but leave essentially unchanged; whereas in the museum the new is pitted against the inherited order in a test of strength, and strength is judged on the extent of the change it effects. In the academy, tradition can be transmitted; in the museum, it may be acquired, but only as one option among many.

Eliot's tradition, alas, is finally a little like Tolstoy's God—it is the name of his desire. It is certainly not the bastion against novelty and anarchy he envisioned. (Perhaps that is why, when he came to adumbrate his general theory of culture, he recoiled from the implications of what, in practice, could only be a highly solipsistic conception of tradition. The hierarchical structure of an imaginary "Christian society" had to be invoked as a control against free-thinking applications of the unruly "historical sense.") The "tradition" of the avant-garde turned out to be something not really transmissible *as* tradition, after all. What was transmissible was not a "tradition" but a principle of artistic coherence, gleaned from the work itself, that might be applied to any tradition, or to none, as the artist wished. For the roots of this "tradition," if we can still call it that, were no longer in the general culture but in the personal culture of the "individual talent," and this personal culture—precisely because it could only be acquired at "great labor"—could easily be by-passed in favor of those properties of "style" to which a later generation of artists swiftly reduced all artistic inheritances.

It was not the traditions subsumed in *Ulysses* and the *Cantos*

that were usable to the writers who placed themselves in the line of succession to Joyce and Pound, but something else—a compulsion toward the fragmentation and atomization of language that was felt (correctly, I think) to contain their stylistic essence. Similarly, it was not primarily the ways in which Picasso and Matisse "used," say, Courbet or Cézanne in their art that proved transmissible to the artists who followed them but, on the contrary, the force with which they showed this inheritance to be expendable. Picasso's Cubism may retain its blood ties to Cézanne, whereas a "ready-made" by Duchamp, although it takes its cue from Cubist construction, deliberately orphans itself from the tradition in which it has its genesis. Picasso's art may still cleave to the museum ambience, while Duchamp's deliberately repudiates it. But given the dynamics of modernism, where only consequences count, this difference proves to be nugatory. For Picasso prepares the way for Duchamp, and Duchamp's art has nowhere to go except to the museum, where its presence does indeed modify the "existing monuments" in a way Eliot had not foreseen. It deprives them—and us—of their essential seriousness. Duchamp's legendary assault on the work of art as traditionally conceived effectively demonstrates that there is no such thing as an object or a gesture that, within the magical museum context, cannot be experienced as art, and this demonstration has the effect of consigning both the idea of tradition and the museum itself to a limbo of arbitrary choices and gratuitous assertions. Which is exactly what our culture has now become.

If, then, the age of the avant-garde can definitely be said to have passed, as I believe it can, it is not because the will to innovation has abated its course—it has, if anything, accelerated its pace and grown more desperate—but because it no longer has any radical functions to perform. The avant-garde's historic antagonist, the bourgeoisie, has been dispossessed of all its traditions—dispossessed, above all, of its faith in the idea of tradition—and now lies supine and demoralized, awaiting the next scheduled rape of its sensibilities with that mixture of dread, curiosity, and bemused resignation befitting an organism no longer in control of its own habitat. And what of the forces that now claim to speak in the name of the avant-garde—what are we to call them? Only they are any longer in a position to invoke the pieties of a tradition. Only they can now be said to constitute something resembling an academy in the hurly-burly of the current scene. Only they are permitted to cite

precedents, establish prohibitions, lay down laws, and generally behave as if there were definite rules to be followed and prescribed aims to be achieved. The will to innovation has been triumphantly institutionalized, and the inherited order—part reality, part fiction, that it was—disestablished, sent spinning, Futurist-style, into fragments we shall be a long, long time recovering and reassembling into meaningful shapes. These shapes are no more likely to be exact replications of the past than such labors of reconstruction ever are. History will have had its way with them, as history always does. But recover them we must. For the new academy of innovation, which is what the museum culture of the avant-garde has come to be, is no more able than other academies to encompass the pressures of new experience; it can only satisfy an existing taste and minister to an empty prejudice. And the pressures of new experience—above all, the unremitting experience of the new—now point in another direction entirely, toward renegotiating our pact with the past and re-examining all those restrictive clauses that have so often rendered our commerce with "tradition" simply foolish and parochial. And this means, first of all, re-examining the great epoch of the avant-garde itself, for this is today the only part of the past that still enjoys an exemption from the critical exercise of the historical sense. The task of criticism today is, in large part, an archaeological task—the task of digging out a lost civilization from the debris that has swamped and buried it.

In the poem I have quoted at the opening of this essay, Wallace Stevens wrote:

> *One man opposing a society*
> *If properly misunderstood becomes a myth.*
> *I fear the understanding.*

So once did we all, but history—the history of the avant-garde—has now clearly demonstrated that we have more to fear from the myth than from the understanding.

II. The Nineteenth Century

1. The Turner Revival

How does it happen that a museum devoted to modern art, an institution celebrated for its attention to the latest and most radical artistic developments, should display the works of a nineteenth-century English painter who, besides being a loyal member of the Royal Academy, was a great success with a public not exactly famous for its advanced ideas?

The question will no doubt occur to many a spectator who sets out to see the exhibition called "Turner: Imagination and Reality" at the Museum of Modern Art. For Turner is an artist we know, or think we know, from pictures that hang in the Frick Collection and the Metropolitan Museum, and it must appear odd that this same artist—the darling of Ruskin and the scourge of all those critics who reacted against the accepted taste of the nineteenth century—should now, more than a century after his death, be presented to us as a prophet of the avant-garde.

To anyone who has closely followed the shifting terrain of contemporary aesthetics, however, the mounting of an ambitious Turner exhibition will be anything but a surprise. The event may even seem just a bit late in coming. For it constitutes the second act in the revisionist drama that began in the 1950's with the revaluation of Claude Monet.

Like Turner, Monet had long been regarded as an artist having little or no relevance to contemporary artistic concerns. Monet lived on until 1926, painting steadily at his retreat in Giverny, but to a public interested in Picasso and Matisse, he seemed an anachronism. He was a painter safely ensconced in history, a classic of Impressionism, the favorite artist of those millionaire collectors of our grandfathers' generation who found solace in his sunny landscape and flower paintings at a time when more menacing and revolutionary movements—Fauvism, Expressionism, and Cubism—loomed on the horizon.

But the Monet who was rediscovered in the fifties turned out to be a painter rather different from the one admired by our grandfathers. The artist once beloved for his gentle and virtuoso fidelity to nature was now being hailed as a tough-minded precursor of the most advanced forms of abstraction. The landscapes of the seventies and eighties, with their weather-perfect details of sky and sea and

countryside, were passed over in favor of the painter's late works—many of them so blurry and indistinct that earlier connoisseurs had confidently ascribed their "failure" to the artist's diminished eyesight in his old age.

This sort of revision in emphasis and judgment does not, of course, take place in a historical void. It is the direct reflection of contemporary experience. In the case of Monet, it reflected the enormous change in pictorial values effected by the Abstract Expressionist movement in New York. The late mural-size paintings of Monet's water garden at Giverny—vast orchestrations of feathery brushstrokes in which the precise specifications of nature are no longer visible—seemed an inexplicable indulgence to eyes trained in the more classical pictorial values of Cézanne and the Cubists. But to a generation that drew its inspiration from the mural-size paintings of Jackson Pollock—abstractions which dispensed with nature altogether and forsook classical form in favor of skeins of paint deployed in free-wheeling designs—Monet had the look of a contemporary.

Thus, when the Museum of Modern Art opened its great Monet exhibition exactly six years ago this month, the way had already been prepared. Scarcely five years earlier, the painter's late works—many of them rolled up in his studio for more than a quarter of a century and considered unsalable—had been ferreted out and sold, at exhibitions in Paris and New York, for prices that doubled and quadrupled by the time some of the same pictures came to adorn the walls of the museum. Critics were eloquent in their praise of these late paintings, and younger painters began imitating them shamelessly. Intellectually and commercially, Monet was vindicated.

The Turner revival owes its existence to a similar change in aesthetic perspective. And as with Monet, the Turner whose accomplishments are now so highly prized is not quite the same artist whom respectable collectors of the last century were pleased to spend their money on. Once again, it is the artist's late works which are felt to have a special relevance to current artistic concerns; once again, we are being ushered into the presence of some works of art never exhibited in the artist's lifetime (the Museum of Modern Art show includes works never before exhibited anywhere), but works which now seem to address us in a language we recognize as our own.

The qualities that confer this mark of contemporaneity on

Turner's late paintings—and most especially on his late water-colors—may be summed up in two words: *color* and *light*. For we see in the last decades of Turner's immensely productive career, particularly in the work executed between the 1830's and his death in 1851, the elevation of color to the most radical priority ever accorded it (until then) in the history of Western painting. It is precisely this priority of color upon which an increasing number of contemporary American painters have lately been concerned to build their entire pictorial vision. It is color liberated from the form-making authority of drawing—color conceived and executed as the sheer embodiment of light. Even the technical innovations adopted by these American painters—the habit of thinning color into a watery wash and then dyeing or spraying it into the canvas, rather than laying it on, stroke by stroke, with a brush—echo Turner's highly original use of watercolor technique and the watercolor effects he often sought to achieve in his oils.

Thus, Turner comes to us at the present moment as an inspired precursor of the attempt to create a pictorial style out of the materials of color alone. So far as we know, Turner himself always had in mind some specific subject matter for even the most radical of his pictures. Even the most "abstract" of his watercolor sketches represented—to his own eye, if not always to ours—an actual motif. Yet so free had Turner become in divorcing the notation of color from the dictates of drawing—in some of his later watercolors, the entire image consists of a few amorphous blots of transparent wash—that the motif seems to have lost all bearing on the final result. Even in the more elaborately finished oil paintings, where the ostensible subject (usually landscape or seascape) remains more apparent, the light-bearing properties of color swamp the particularities of the scene with an overwhelming luminosity.

The man who effected this radical transformation of painting into a pure statement of color disengaged from the confinements of drawing was, paradoxically, a master draftsman much admired in his lifetime for his feats of graphic delineation. Born in London in 1775, the son of a barber, Turner began drawing as a boy and was something of a prodigy. He was apprenticed early to Thomas Malton, who specialized in topographical watercolors of architectural subjects—a specialty the young Turner quickly made his own. At the age of fourteen, he became an art student at the Royal Academy Schools, and at fifteen began a lifelong career of showing

at the Royal Academy itself (his first exhibit being a watercolor rendering of the Archbishop's Palace, Lambeth).

At twenty-four, the earliest age at which the Academy admitted membership, Turner was selected an Associate, and in 1802 he achieved the rank of a full Academician. A country that boasts of having radical Tories may have no difficulty in accommodating the notion of a vanguard Academician, but to less paradoxical minds, Turner still seems an anomaly in the annals of modern art: a radical supported by an official academy against the attacks—often very violent attacks—of the conservative opinion of his day. And the paradox is compounded by the fact that Turner (like Monet in this respect) was a canny custodian of his own career and succeeded in making a handsome living out of a talent that was almost constantly embroiled in artistic controversy.

But then, Turner was the very archetype of the robust, extrovert artist, uncouth in manner, immensely energetic, tirelessly productive, jealous of his status, yet adamant in pursuing his highly individual goals.

His usual procedure was to adopt an accepted style and approved subjects, and then carry them to some personal extreme of invention and innovation. Coming of age in a period that favored picturesque views of remote landscapes and that looked to the past—to Poussin and Claude Lorrain—for the correct ways of rendering such views, Turner toured the countryside and the seashore, first in England itself and then on the Continent, constantly sketching and storing up memories of the exact effects he intended to achieve in his finished work, but still alert to the traditional ways in which such effects were realized in the paintings of the masters. He made himself a connoisseur of the traditions in which he worked: no innovator of modern times was a more attentive student of the masters than Turner, and he worked in conscious competition with the great painters of the past.

In 1802, he undertook his first journey to the Continent, and his close study of the masterworks lately garnered in the Louvre by Napoleon yielded him a body of insights and ideas that were to serve him well in the future. The English art historian Michael Kitson recently wrote of this visit to the Louvre: "In two or three weeks he filled a notebook with studies, some of them colored, of pictures he thought important. The latter were chiefly works in which landscape played a major, but not necessarily exclusive, part

in the composition. To judge from the number of studies devoted to their work in the notebook, the artists who most attracted Turner's attention in the Louvre were Titian, Poussin and Rembrandt."

By the first decade of the nineteenth century, Turner's basic repertory of pictorial themes, if not his final way of handling them, was well established. Picturesque landscape subjects, often highly theatrical in effect, occupied the central place. Architectural motifs, painstakingly rendered down to the finest details, played an important role. And there was also a strong literary element in Turner's painting, for many of his most grandiose landscape paintings were settings for Biblical and mythological anecdotes—a reflection of the belief, still widely held in Turner's time, that a truly heroic style required for its full realization a traditionally heroic subject.

There are significant traces of these themes in Turner's later work—the emphasis on landscape and seascape, at least as a starting point, remained central—but they do not account for the quality of that work. For between his early success and his later radical accomplishments, Turner underwent a fundamental change in his understanding of what a heroic modern style might consist of. We see in his development from, say, the turn of the century to the 1830's, one of those extraordinary leaps of the imagination that separate the assumptions of one period from those of another. At the end of that development it is no longer the particular motif or the specific literary subject that commands our attention, but the pure painterly dynamics—those masses and swirls of light-vibrating color—which dominate the final image.

It would be a mistake, however, to assume that Turner lost interest in nature when he undertook these forays into what now look to be exercises in pure painting. If anything, his devotion to the actual visual content of nature—but nature seen in the raw, so to speak, rather than through the ameliorating conventions of earlier painting styles—became more and more of an obsession. One of the most brilliant of the pictures he produced in the last decade of his life, "Snow Storm: Steamboat off a Harbor's Mouth" (1842), in the collection of the National Gallery, London, provides a vivid example, for it owes its existence to this obsession and shows the lengths to which Turner was prepared to go to accommodate it. He had first brooded about the theme and then actually contrived to experience it firsthand. "I got the sailors to lash me to the mast to observe [the storm]; I was lashed for four hours, and I did not

expect to escape," Turner later remarked, "but I felt bound to record it if I did." Turner was sixty-six at the time. Clearly, the visual sensations to be derived from nature had not lost their importance for him.

Yet to suggest that the painting is only, or even primarily, a record of his impressions of the storm at sea would scarcely do justice either to the work or to the complexity of the mind that conceived it. The dynamics of painting, the imagination of what the deployment of pure color was capable of expressing, came to hold equal sway over Turner's sensibilities. He became notorious for swamping his subjects (or so it seemed) under swirls of heavy pigment. A cartoonist of the forties, depicting Turner at work on a painting, shows him using a mop and a bucket instead of a brush and palette. Contemporaries referred to the way he "plastered" his pictures and were dumfounded at their apparent obscurity.

In subtitling their exhibition "Imagination and Reality," the organizers of the new Turner exhibition have, then, deliberately focused our attention on the dialectical drama that took place in the painter's sensibility during those last crucial decades. Turner's was a mind divided in its loyalty to two orders of visual reality—the reality of nature and the reality of the artistic process. In his case, imagination consisted not of choosing one over the other, but in mediating between the two. In his essay for the museum's catalogue—quite possibly the best single study ever written on Turner's aesthetic—Lawrence Gowing, Keeper of British Painting at the Tate Gallery and co-director (with Monroe Wheeler) of the Turner exhibition, observes: "Eventually no single touch of paint corresponded to any specific object; the equivalence was between the whole configuration and the total subject." In the end we are at a very far remove from those picturesque views that evoke memories of Claude Lorrain; we are made witness to an imagination absolutely vehement in its personal logic, in its determination to summarize all experience in the rhythmic and luminous flow of a swirl of pigment.

No wonder the public balked!

How are we to judge these late paintings? Mr. Gowing suggests that they are "still not altogether comprehensible today," that "in [Turner's] painting something singular and incomparable happened." Without questioning the singularity of Turner's late work,

it does nonetheless seem comparable in its general aesthetic logic to several of the most important *oeuvres* in the painting of the last hundred years.

Monet's late phase has already been cited. But in one important respect, Turner's development more closely resembles that of Monet's contemporary Cézanne. For Cézanne, too, began his career with fantasies of heroic subjects—in his case, baroque fantasies derived from Delacroix and Rubens—and only slowly, under the influence of Impressionism, conceived those formal and painterly revisions of style that elevated the pictorial means itself to the heroic role. The purity of Cézanne's late painting, though more classical in its formal rigor than Turner's, is based, like Turner's, on the dynamics of the pictorial process. The motif is the painting's support, but no longer its *raison d'être*.

And in the extremity of its stylistic resolution, Turner's final painterly avowal also calls to mind those ultimate works of Mondrian and Matisse—the one severe in geometric rigor, the other highly simplified in arrangements of pure color—that summarize and subsume their authors' long and arduous development in pictorial statements of the utmost concision. Turner's modernity anticipates theirs, and in retrospect seems inevitable rather than willful or eccentric.

In recovering the late paintings of Turner, are we also recovering a missing link in the chain of modern art history? The answer to this question continues to elude art historians, though we may be sure that it will now be pursued with renewed vigor. For French writers have consistently denied that Turner exercised any influence on the Impressionists—but the denial is hard to credit when one finds so many of Turner's attitudes toward light and color echoed in Monet, who had an opportunity to see the Englishman's works in London.

In any case, the possibility is too suggestive to ignore and, followed through to its logical outcome, would indeed cast Turner's shadow onto the present artistic scene with even more force than it now enjoys. For if Turner's link to Monet exists, then we know that Monet, in turn, was a decisive influence on Kandinsky's decision to separate the expressive element in painting from its representational function; that Kandinsky provided a precedent and inspiration for many of the innovations of the Abstract Expressionists—

Pollock especially—without whose example the color painters of the present moment would scarcely exist in their present form. Thus, the possibility exists that Turner is not only a precursor of our present artistic accomplishments and dilemmas but their actual progenitor. This vanguard academician may be, after all, the true father of modern painting.

March 20, 1966

2. The Radicalism of Courbet

The work of the nineteenth-century French painter Gustave Courbet marks a turning point in the influence of democratic ideology on styles of art. It also marks the beginning of certain key elements in the tradition of modernist painting. Courbet was a genuine innovator. Twenty years younger than Delacroix and twelve years older than Manet, he was a radical both in his choice of subjects and in the way he sometimes chose to paint them. Yet his achievement was ambiguous. His innovations often remained at odds with each other even in his own work, and they have remained separate impulses in the history of his influence down to our own day.

The irony which presides over the long and continuous history of Courbet's influence is that the whole school of social realism, which is officially supported by the Communist ideology that looks upon modern art as a symbol of bourgeois decadence, regards Courbet as a heroic ancestor, and does so in the face of the fact that his work clearly gave rise to the Impressionist movement and the subsequent development of avant-garde modernism. Less than ten years ago, the French Communist poet Louis Aragon wrote a major work on Courbet, and yet Matisse, who came as close to celebrating the values of bourgeois hedonism as any great painter of our time, had three of Courbet's finest works in his private collection. Indeed, there are performances by this extraordinary artist—feats of care-

fully structured landscape painting, such as "The Rocks of Mouthier," in the collection of the Phillips Gallery in Washington, D.C., or "The Source of the Loue," in the Albright Art Gallery in Buffalo—in which we can practically hear Cézanne shuffling in the wings, waiting to come on: Cézanne, whose late works form the basis of Cubism and the abstract art which developed out of it. And still, the partisans of social realism are right to claim Courbet as a precursor and a mentor. He himself often spoke (albeit confusedly) about the political implications of his style.

The brilliant exhibition of Courbet's work organized by the Philadelphia Museum of Art and the Museum of Fine Arts in Boston does a great deal to clarify the contradictions which have made this painter's art available to such opposing intellectual systems. The exhibition includes eighty-six works, covering the whole range of Courbet's career, from his first pictures, painted in 1840 when he first arrived in Paris at the age of twenty-one and decided to become an artist, to "The Lake of Geneva," painted in 1877, the year of his death as a political exile in Switzerland. The first thing to be said, I think, is that none of these doctrinal claims, neither the social realist's nor the modernist's, does violence to Courbet's art. He is not one of those artists whose work suffers from having conflicting demands made upon it. On the contrary, they underscore the deep divisions of his own sensibility which he was never able to overcome.

Courbet was an artist who gave voice to many new feelings and ideas; he was audacious in his grasp of what new tasks an artist in his time might perform. He insisted on choosing his subjects from life and on rendering them without romantic flourishes or classical niceties. He came from a farming family in the provinces and drew upon that milieu for his subject matter, which he reproduced with a clarity, affection, and good humor devoid of condescension or sentimentality. In an age of revolution, the political implications of this (at first) purely aesthetic decision were radical enough even without the inflammatory political statements with which Courbet subsequently burdened his work. As the result of his meeting the socialist philosopher Proudhon and of his own outraged feelings at the massacre of the radicals in 1848, Courbet grew more and more doctrinaire about the social meaning of his style, which, in truth, had had a more innocent origin than that which he was later fond of ascribing to it.

It is important to note that the style preceded the social doctrine, and that it was the product of a prodigiously gifted painter of provincial origins who, though he felt a deep emotional attachment to his surroundings, was without any notable intellectual or visionary endowments, and who therefore decided to trust his art entirely to his own immediate experience. Later on, when Courbet became famous and even notorious—the current exhibition includes an interesting collection of caricatures which hostile critics made of Courbet at the height of his fame—he was at no pains to distinguish between the personal origin of his style and the political meanings which events forced upon it. He fully accepted the social role which the revolution of 1848 imposed on his art. As the critic Castagnary wrote at the time, "It was the *coup d'état* [of 1851] that forced [Courbet's] realism into opposition. Prior to the *coup d'état* it had been merely an artistic doctrine, afterwards it became a social doctrine, the protest of republican art." Twenty years later, in 1871, Courbet joined the Commune, and shortly thereafter paid the price of his commitment by going first to prison and then into exile.

But Courbet was a man whose ideas were not always in perfect agreement with his sensibility and whose practice as a painter was not always consistent with his ideas. There was nothing in his political doctrine which accounts for those astonishing pictures of landscapes and seascapes from which nearly every major painter in the second half of the nineteenth century took his cue. The styles of Manet, Monet, Whistler, Renoir, Pissarro, and Cézanne are unthinkable without the particular kind of plastic construction which Courbet lavished on these subjects. As a painter Courbet was a "natural" if ever there was one, and not surprisingly, the pictures which fathered the tradition of modernist painting were not those which could lay claim to any social or political significance. Indeed, most of Courbet's paintings on social themes are characterized by the kind of plastic banality which has been all too evident in the work of his socially conscious successors. Courbet may thus be credited with having set into motion two of the main currents in the painting of the last hundred years. The profound division we see in the art of our own time, between plastic intensity on the one hand and social eloquence on the other, was a division bequeathed to us by Courbet himself.

March 17, 1960

3. Late Monet

Claude Monet has long been considered the principal votary of Impressionism, but lately there has been a new interest in Monet and it is of a kind which throws new light on his achievement, or at least a different light from that which an older generation had focused on it. His name has now replaced that of Cézanne on the lips of many painters—Cézanne, who holds such an immovable position as the father-figure of our painting; and while there is not likely to be anything permanent in this displacement, the process of reconstructing Monet into an avant-garde master of heroic dimensions is now in full swing and we may expect to hear a great many inflated claims while it is on.

This interest in Monet received some vigorous stimulation in New York last year when the Museum of Modern Art acquired one of the enormous paintings from the water-lily series, *"Les Nymphéas,"* for it is this series which forms the locus of interest in this new appraisal of an artist who has never been for long without considerable influence. The brilliant exhibition which Knoedler's has put on view of paintings from this *"Série de paysages d'eau,"* which occupied the last decade of the artist's life, has again confirmed the extraordinary quality of these paintings, and it has also underscored the reasons—if there was anyone left who was unaware of them—that painters today should derive so much pleasure in invoking the example of Monet for their problematical situation. He does indeed make an exquisite apologist.

Since the invocation of Monet in our time issues directly out of our interest in luminist or close-value abstraction, it is worth remembering that an earlier generation expressed a marked distaste for this phase of Monet's *oeuvre* on precisely opposite grounds. We need not choose the most boorish critics, either. Lionello Venturi has stated flatly that the water-lily series was Monet's "gravest artistic error," but it is in the writings of the venerable Roger Fry that one finds the criticism of Monet which is likely to astound us today, caught as we are in the full flush of what everybody agrees to call his "abstract impressionism." Of all things, Fry found these paintings too utterly abandoned to the representational impulse, so completely given over to naturalism as to be "scientific." He compared them, in fact, to—Zola's novels! I think it is worth quoting

him on Monet's method: "He cared only to reproduce on his canvas the actual sensation as far as that was possible. Perhaps if one had objected to him that this was equivalent to abandoning art, which has always been an interpretation of appearances in relation to certain human values, he would have been unmoved because he aimed almost exclusively at a scientific documentation of appearances." And on the water-lily paintings in the Orangerie: "We get the effect of an imagery with no boundaries, just as we do in an actual scene where we can turn in any direction. There is no attempt to organize the vision in any way, there is no pattern, no apparent rhythm. Such unity as there is depends on the uniform quality of the texture."

These are not the observations of an ignorant man; and while I believe they do not define Monet's purpose in his late period—though they come very close, as I shall try to make clear in a moment—they do serve to restore one term in the dialectic of Monet's imagination which tends to get overlooked at the moment, the term deeply rooted in the naturalistic foundations of Impressionism. What makes Monet's achievement so baffling is that he arrived ultimately at a style whose components we are used to regarding as separate, incompatible entities, as deriving from opposite cultural impulses. (Wilhelm Worringer, for example, has postulated a brilliant theory based on this separation of naturalism and abstraction.) There is nothing in our thinking about modern painting to prepare us for their convergence in this particular way, and since we have no way of thinking about it, we are inevitably caught in an error very much like Fry's—only in this generation it is the thing to speak of these paintings as if they had *no* naturalistic basis at all. For Monet, however, this naturalistic interest was scarcely negligible. The care which he lavished on the creation of his water garden at Giverny should remind us of that. It is the leitmotif in Clemenceau's *hommage* to the painter, as it must be in any account of Monet's last years. But above all, it is the leitmotif in the paintings themselves, even in these last years when Monet was so removed from the facile descriptiveness of his early work; even when, with his eyesight failing and his mind swarming with images which seemed to have no fixed properties, he painted a subject which no one before him had ever imagined.

The paintings in the Knoedler exhibition all date from the period after 1916 when Monet had a studio built adjacent to his

water garden at Giverny for the purpose of carrying out this last cycle of his career. Most of the paintings are from a group over-looked in Monet's studio until last year—an oversight all the more fantastic when one realizes that three of them are each the size of the one acquired by the Museum of Modern Art, something beyond fifteen feet long, and the "smaller" pictures are quite large, too. (They were exhibited in New York, together with a few works from private collections, after an initial showing in Paris.) They vary in their details, but they all partake of the same world: a world in which sky and clouds and mist and water lilies and river grass and willows and underwater flora all converge, unhampered and undi-vided by horizon lines or by spatial demarcations derived from fixed perspectives. All elements are consumed in their own reflection and counter-reflection on the pond's surface and by their proliferating refraction in the air above and the water below. As these conver-gences become more and more intricate, the surfaces of the pictures lose their details in large areas of marine, lavender, or roseate light in which the last particularities of the *mise en scène* give way to forms of an entirely new order.

To define this order we must go beyond these proliferations of light and shade, object and atmosphere, to the vaster subject which pervades these paintings, to the subject which Fry touched on when he emphasized Monet's preoccupation with sensation.

For it was nothing less than the fluidity of sensation itself which came ultimately to occupy the center of Monet's interest—sensation perceived as a continuous interweaving of the particles of experience, unfettered in its headlong course by any single, discrete moment of exact definition, but on the contrary, each moment of perception and the memory of perception impinging upon and submitting to the sweet flux of all sensation as it unfolds itself to the senses. And for this subject—if something so impossible, so devas-tating to accepted notions of pictorial ideas, can be called a "sub-ject"—for this Monet refined his habitual feathery brushstroke into an instrument incredibly sensitive and far-reaching; each one of these dazzling touches became itself a painterly equivalent of the sensation whose trajectory was woven into the swirling skeins of color and light which traced out an infinite course. Thus, as Fry noted, only the *textural* qualities of the surface could ultimately preserve the integrity of these paintings whose subject had moved them beyond the reach of received ideas of structure.

In these final paintings, then, Monet stands as the polar oppo-
site of Cézanne, and it was doubtless for this reason that Fry re-
jected them and that many will follow in Fry's example. While each
was heroic in his vision, the one submitted his art to the onrushing
course of sensation—in fact, to the outermost circumference of the
Impressionist ideal; the other defined his task in the very triumph
over this ideal, in a search for permanence beyond the flux, in forms
which might arrest the flow of sensation and make out of it an
immutable image.

November 1956

4. The Conscience of Impressionism

Among the painters who made up the original Impressionist group,
the oldest was Camille Pissarro. He was born in 1830 and died in
1903. John Rewald has called him "the dean of the Impressionist
painters," and he certainly occupies a special position in the history
of the movement. Yet his authority was not based on a gift for
daring innovations. He was anything but the typical firebrand of the
avant-garde. Indeed, despite his seniority, Pissarro was more often a
follower than a leader. He looked first to the examples of Corot and
Courbet. Then to Monet. Then to Seurat—Seurat, who was twenty-
nine years his junior!

Still, it was not false sentiment that prompted Cézanne, in
1906, to list himself as "Paul Cézanne, pupil of Pissarro." Nor was
Cézanne alone in owing a sizable debt to Pissarro. It was Pissarro
who introduced Van Gogh to the principles of Impressionist color. It
was Pissarro who guided Gauguin's early, uncertain development.
(Writing in 1902, Gauguin remarked, "He looked at everybody,
you say. Why not? Everyone looked at him, too, but denied him. He
was one of my masters and I do not deny him.") It was Pissarro,
too, who fastened the attention of Matisse on the quality of Cézanne.

Modesty, sympathy, sincerity—these were Pissarro's dominant characteristics as both a man and an artist. They were combined with a very sharp intelligence, a vivid social conscience—fundamentally an anarchist, Pissarro was the most political of the Impressionists—and a sensibility that was wonderfully alert to the nuances of nature as well as the problems of painting. Though he had a remarkable faculty for communicating the essence of an artistic idea to others, he took a very questioning attitude toward his own accomplishments. Braque says somewhere that, in art, every new acquisition involves an equivalent loss. As an artist, Pissarro seemed to weigh the merits of every loss and every gain in his very soul— and all the more so since he was so often drawn to radical practices.

He is, all in all, a most attractive and appealing figure. Yet in any large collection of Impressionist paintings, Pissarro's artistic profile is very slow in revealing itself. His art discloses its quality modestly and patiently, with a diffidence that reflects something of the artist's own moral stance. Monet, Renoir, Degas, Cézanne, Gauguin, Van Gogh—each makes an emphatic and unmistakable impression at the very first glance. Pissarro, like Sisley, does not. There is so little that is theatrical, doctrinaire, or voluptuous in his art; so little "personality." It could almost, at times, be mistaken for something plodding. The truth, of course, is that it is very pure. The more one looks at Pissarro, the more one learns to appreciate what Zola meant when he said that a painting by Pissarro was "the act of an honest man."

In the exhibition called "One Hundred Years of Impressionism," at Wildenstein & Co., there are thirteen paintings by Pissarro. They are all landscapes and cityscapes. Five of them, dating from the years 1871–4, are in that gentle, unemphatic, pastoral vein that was Pissarro's forte in this period. My favorite among them is *"La Barrière du Chemin de Fer"* (1873–4), a beautifully constructed picture with a delicate, soft light that still reminds us, despite the advent of Impressionism, of Pissarro's affinity for Corot. But each of these pictures is a very individual accomplishment. One is reminded of the answer Pissarro gave Matisse when the latter once asked him, "What is an Impressionist?" Pissarro replied, "An Impressionist is a painter who never paints the same picture, who always paints a new picture."

Looking at these landscapes of the 1870's, one can well understand the shock that many of Pissarro's admirers must have experi-

enced when, in 1885, the year in which he met first Signac and then Seurat, he took up the latter's theories and began painting pictures in the "divisionist" or Neo-Impressionist manner. There are no strictly orthodox pointillist paintings at Wildenstein's—a reminder of the fact that Pissarro's dealer, Durand Ruel, for whom the exhibition at Wildenstein's has been organized as a tribute, spurned these works as an aberration—but the lovely "Old Chelsea Bridge, London" (1890), painted the year Pissarro abandoned his commitment to the divisionist method, nonetheless reflects something of the rigor that attracted the painter to this audacious movement in the first place.

It was formerly the custom for critics to regard Pissarro's involvement with the Neo-Impressionist movement as a "mistake." Certainly it inhibited the artist's spontaneity, as Pissarro himself came to realize. In a letter of 1896, dissociating himself from the Neo-Impressionists as a group, Pissarro wrote:

> Having tried this theory for four years and having now abandoned it, not without painful and obstinate struggles to regain what I had lost and not to lose what I had learned, I can no longer consider myself one of the Neo-Impressionists who abandon movement and life for a diametrically opposed esthetic which, perhaps, is the right thing for the man with the right temperament but is not right for me. . . . Having found after many attempts (I speak for myself), having found that it was impossible to be true to my sensations and consequently to render life and movement, impossible to be faithful to the so random and so admirable effects of nature, impossible to give an individual character to my drawing, I had to give up.

To be true to my sensations. This was the conscience of Impressionism speaking, and Pissarro returned to the Impressionist faith, now somewhat modified to accommodate "what I had learned." How characteristic it was of Pissarro to give the divisionist theory, with its rigid application of the "dot," its due in the very act of repudiating it.

Yet was Pissarro's involvement with the Neo-Impressionists an unmitigated mistake? Nowadays we tend to take a somewhat larger view of the Neo-Impressionist movement. We see it as a part of a more general tendency to consolidate the gains of Impressionism in a style that would have all the solidity and power of classical art without being in any way reactionary or academic. There is hardly a

significant painter in Paris in the years between the late 1880's and the First World War who remained untouched by the ambitions of the Neo-Impressionist aesthetic.

Pissarro's involvement with divisionism reminds us, too, that even his enthusiastic response to Monet was tempered by a desire to confer on the Impressionist "sensation" a firmer and more classical structure than Monet himself desired. Wherever we touch Pissarro's art, we find the same quality of scrupulousness—the weighing of losses and gains, a fundamentally moral attitude toward every aesthetic value. Artistic conscience of this sort rarely generates a myth, but Pissarro was nonetheless, in his own way, one of the heroic figures of his time.

April 12, 1970

5. Degas as Expressionist

If familiarity does not always breed contempt, it does at times breed a damaging complacency. This has certainly been the case with the art of the Impressionists. No pictorial style of the modern era has proved to be more popular. None has seemed so readily available to our sensibilities, so well documented in our histories, or so well established in our institutions. And yet—despite the plethora of publications and exhibitions, the insane auction prices, and the status-conferring acquisition of some overcelebrated examples—we are still a long way from anything like a complete understanding of these extraordinary artists and their work.

More than ten years have passed since we discovered that Monet—perhaps the most popular of the Impressionists—had not been precisely the painter he had long been thought to be. The recovery of his late paintings in the 1950's prompted a new evaluation of the artist and his career—an evaluation now so firmly established that it is difficult to think back to the time when these late

works were openly despised where they were not totally disregarded. One need only compare the discussion of Monet in Clement Greenberg's *Art and Culture* with that to be found in the pages of Roger Fry's *Characteristics of French Art* to see the extent to which our understanding of an artist's *oeuvre* may be transformed by the rehabilitation of certain crucial works.

Now, apparently, we are in for a similar revaluation of Degas —or so I am moved to conclude after seeing the superb exhibition that Eugenia Parry Janis has organized at the Fogg Art Museum, Harvard University. This is the kind of exhibition—modest in scope, exact in scholarship, and immensely sophisticated in its grasp of aesthetic nuance—that compels us to alter our perspective on an achievement we have heretofore taken for granted. The Degas who emerges from this exhibition is, in some important respects, an astonishingly unfamiliar artist.

The focus is limited to Degas's monotypes, perhaps the most interesting and surely the most personal form of printmaking available to a painter—indeed, the form that most closely resembles the dynamics of painting itself. Mrs. Janis has brought together seventy-nine works in this medium, a good many of which have never before been exhibited in America, and in the comprehensive catalogue she has produced for the occasion—henceforth, an indispensable work of reference for anyone seriously interested in Degas—she annotates and reproduces 321 items. Four years of research have gone into the preparation of the exhibition and the catalogue, and the result is what many art historians aspire to but few achieve—a critical as well as a scholarly illumination.

Degas was, from the beginning, the most gifted of the followers of Ingres—an artist mad about drawing, devoted to the line, to the Ingresque contour, and to the classicism that such a devotion entailed. His talents in this direction were the talents of genius, and he had the temperament, the culture, the social position, and—above all—the spiritual disposition to become a magnificent reactionary in the academic mode.

But his sensibility was too pure, his vision too honest, his intelligence too unremitting, to abide such a subterfuge. He became, almost despite himself, first a realist and then something else, something wholly unexpected—a kind of Expressionist, at once savage and aloof, improvising a new canon of feeling out of his immersion

in an art he adored and a world he despised. With the condescension of an aristocrat deeply resentful of his moment and milieu and the compulsion of an artist with a sure instinct for distinguishing what was most vital in that milieu, he became a convert to the modernist adventure, a participant in a historical saga we are still learning to appreciate.

It was the late Lionello Venturi who, so far as I know, was the first to speak of Degas's "expressionism," pointing out two of the essential elements that contributed to it: his growing commitment to the "simplification of forms" and to a new "dramatic content," the latter derived from the direct observation of forms of life theretofore not considered proper subjects for high art. These elements were given their most original form in the artist's pastels—works depicting (for the most part) female figures in homely, unexpected, and often unlovely postures.

The pastel medium, which Degas raised to the level of a major expression, permitted him to carry his inspired draftsmanship into a realm of color and light in which the old classical contours were dissolved into forms at once more immediate and more "abstract" than he had achieved in his painting. What was never clear before now was the role that the monotype medium played in the development of Degas's Expressionism, and thus in the realization of his most profound work.

As its name suggests, the monotype differs from other forms of printmaking in that each impression is virtually unique. The artist draws directly on the metal plate in either printer's ink or liquid pigments, wiping away or adding by means of a brush, a rag, and even his finger. Degas apparently found this process a very congenial one, allowing him to achieve all at once the freedom of the quick sketch and the total pictorial structure of a painting, with all the subtle modulations of light and shade that such a structure—to his eye—required. He attained an amazing mastery of the medium, exploiting its resources and elevating them to extraordinary refinements.

Indeed, the range of feeling in these monotypes is truly stunning. At one extreme, there are the notorious brothel scenes—wicked, bitter, and hilarious, masterpieces of social observation and of misogyny. At the other, there are the landscapes of the nineties—blurry stains of color, with barely discernible details and muted

contours, works in which the medium is given a clear and trium-
phant priority over the subject. In these landscapes, the follower of
Ingres is gone forever, absorbed in a pictorial enterprise that makes
even Monet's last works rather conventional by comparison.

Many of these monotypes served Degas as the basis for pastels;
Mrs. Janis suggests that about a quarter of the artist's pastels were
executed in this manner. But whether they were combined or kept
separate, the monotype and the pastel clearly became the means to
Degas's most intimate and compelling art, the locus of his most
daring flights of originality and his most intense feelings. It was in
the monotypes and the pastels that he became an Expressionist, a
realist in his handling of his medium as well as in his depiction of
his themes.

We are a long way, then, from conventional notions of Impres-
sionism. There are really very few works in the Fogg exhibition that
conform to such notions. No doubt Impressionism made it possible
for the student of Ingres to produce the work that makes up this
exhibition, but the work itself suggests that we are only at the
beginning of a new understanding of both Degas and Impres-
sionism. To this understanding Mrs. Janis has made a notable
contribution.

May 26, 1968

6. Neo-Impressionism

I

The exhibition of "Neo-Impressionism" at the Solomon R. Guggen-
heim Museum is one of those rare artistic events that addresses our
minds and sensibilities at several levels at once, and thus succeeds in

illuminating a good deal more ground than its ostensible purposes seem, at first glance, to encompass or even aspire to. A crucial chapter in the history of modern painting is explored with an exemplary fidelity to its actual accomplishment and complexity, and the process of exploration sheds some unexpected light on the aesthetic imperatives of the present moment.

We are, then, first of all in the presence of a meticulous and comprehensive view of the whole Neo-Impressionist movement as it originated in the work of Georges Seurat (1859–91), developed in the work of his contemporaries in France and elsewhere, and established itself as a major avant-garde force in European painting in the early years of the twentieth century. At the same time, we are being offered a kind of case history of a pictorial style that, because of its extreme commitment to formal method and to a highly detached and analytical use of color, has a direct bearing on the art of the 1960's.

Neo-Impressionism was, in its essentials, a response to Impressionism—specifically, a response to the improvisatory and romantic-lyrical elements in Impressionism. Professor Robert L. Herbert of Yale University, who has organized the exhibition at the Guggenheim and written an extensive and indispensable catalogue for the occasion, states very well what it was in Impressionism that prompted Seurat and his followers to diverge from its example and establish a pictorial method that was in many respects its antithesis. "The most notable feature of Impressionism, its choppy brushwork and strong color," writes Professor Herbert, "had resulted from a wish to exploit the intensity of nature seen freshly, without reflection, a kind of instant realism of vision in which the sketch became the final picture. Forms were seen indistinctly and brushstrokes were impetuous and irregular because only that way could the artist record quickly his impressions, and leave in the movements of pigment the imprint of his emotions."

By the 1880's, however, a widespread reaction against this Impressionist bias had set in among the younger painters—and indeed, among some of the older ones as well—who, though appreciative of the Impressionist achievement, were seeking an art less precariously founded on the flux of perception and the vagaries of spontaneous feeling. This reaction took a variety of forms, but they all shared in a basic aspiration—to transform the Impressionist

renovation of painting, and especially its purification of color and light, into a new classicism.

Cézanne, Renoir, Gauguin each pursued this goal in his own way, but it was Seurat who pursued it with the greatest fanaticism and who achieved the most definitive results in the shortest time. It still comes as a shock to realize that Seurat died before his thirty-second birthday, that the masterpieces of his maturity were all completed in the seven years between 1884 and 1891. The style he perfected in the course of this short, brilliant career betrays none of the diffidence or uncertainty of a young artist venturing on untried terrain. On the contrary, it is astonishingly pure and complete. It is "finished" to the utmost degree—which is to say, to a degree that can only be attained by an artist of superior technical faculties working in total harmony with exalted emotions and a clearly envisioned intellectual objective.

The most conspicuous feature of this style was, of course, the atomization of color into minute dots or divisions applied to the canvas with a painstaking regularity of design. Pictorially, the effect of this method was highly ambiguous. On one hand, the absolute fixity of each tiny dot of color, designed not to "dissolve" or "mix" in an optical blur but to retain its identity as an irreducible form, seemed to arrest all sense of naturalistic movement in the painting and to empty it of its mimetic content in the interests of abstraction. On the other hand, the carefully calculated design of these myriad dots, which endowed every observable centimeter of the canvas with an active optical function, served—and served with an inspired efficiency—to articulate a mimetic conception of great complexity. It was upon these very ambiguities that Seurat's classicism rested, and his breathtaking resolution of them placed his art in a closer proximity to that of Poussin than to the art of a contemporary like Monet.

Seurat's great monumental works are not included in the Guggenheim show—no doubt it was impossible to secure the necessary loans. But the quality of his achievement is evident enough from the twenty-eight paintings and drawings that are included, and he still dominates the exhibition by the sheer force of genius. He dominates, let it be said, but he does not overwhelm it, for there are 175 works here by fifty-one artists.

In no other painter, to be sure, do we find the same concentration, absorption, and inspiration. Even Signac, an immensely gifted and likable artist who served as a publicist and theorist of the Neo-

Impressionist cause, emerges as an attractive satellite. (Even so, the artist who painted *"Le Petit Déjeuner,"* 1886–7, was no duffer.) The great names that are included—the elder Pissarro, Gauguin, Van Gogh, and Matisse, among others—sustain their identities even under the spell of Seurat's influence, but the real weight of the exhibition is to be found in the momentum of that influence, in the way Seurat's methods are transformed into a new and amazingly fecund convention and assimilated to a wide variety of experience.

Professor Herbert has ferreted out a great many unfamiliar artists and unfamiliar pictures. The painter Charles Angrand (1854–1926), represented by eleven works, is only one of many who are here established as distinct personalities for the first time. Henri-Edmond Cross (1856–1910), though more familiar, comes through as a far stronger painter than one had formerly believed possible. The pictures by the Belgian painter Henry van de Velde and the Dutch painter Jan Toorop—both better known in their later phases as votaries of Art Nouveau—are a revelation in their own right as well as an illuminating introduction to the fine small work by Mondrian, an artist who may be said to have done to Cubism in the twentieth century what Seurat did to Impressionism in the nineteenth.

The pleasures and revelations of this exhibition are, indeed, too numerous to mention. We are not here in the presence of a great many masterpieces, but we are in the presence of an immensely persuasive aesthetic idea and of the impact of that idea on a wide variety of sensibility and ambition. It is, moreover, an idea that answers to something immediate in our own aesthetic preoccupations, for the parallels between Neo-Impressionism, with its emphasis on impersonal method, and current modes of abstract art are real and afford an interesting perspective on our own values.

February 18, 1968

II

In his essay on Seurat, included in the volume called *Transformations,* the English critic Roger Fry wrote:

Nothing can be imagined more deliberate, more pre-ordained than this method, nothing less like that divine afflatus of inspira-

tion with which artists are often credited. . . . Who before Seurat ever conceived exactly the pictorial possibilities of empty space? Whoever before conceived that such vast areas of flat, unbroken surfaces as we see in his "Gravelines" could become the elements of a plastic design? And yet nothing less "empty," pictorially speaking, can be imagined.

Rereading these words on the occasion of the "Neo-Impressionism" exhibition at the Guggenheim Museum, one has a sense of reading an account of the present—or of something relevant to the present—as well as of the past. Not that we are any longer amazed at the idea of "such vast areas of flat, unbroken surfaces" being used as "the elements of a plastic design." Just the contrary, in fact. We are surrounded now by a great deal of painting in which far vaster areas of far flatter, unbroken surfaces are employed as virtually the only elements of pictorial design. And the surface of Seurat's lovely "Gravelines, Evening" (1890), if this was indeed the particular landscape Fry had in mind, is not likely to seem either so vast or so unbroken as his remarks suggest.

We are, clearly, in a position to imagine a good many pictorial methods "more deliberate, more pre-ordained" than Seurat's pointillism, for such methods abound wherever one looks today. The proliferation of such methods, which reduce—or appear to reduce—the physical execution of a work of art from an expressive activity to a merely technical one, induces a certain chill in the aesthetic atmosphere. The spectator is offered little or nothing to engage his imagination—which is to say, his emotions—in the picture-making process. He is presented with a result rather than a process, and the decisions entering into the result remain undisclosed, at least so far as the eye is concerned. (We hear a good deal about these decisions in the form of words, but the decisions themselves are not part of the visual evidence.) The picture appears to have been "developed," in the sense that a photographic print is developed in the dark room. The development process may be crucial to the quality of the work, but it cannot alter the conception, which is indeed "pre-ordained."

Seurat's most famous utterance—"They see poetry in what I have done. No, I apply my methods, and that is all there is to it"—has certainly been echoed (and unintentionally parodied) a good many times in recent artists' statements. At this distance in time, one cannot help responding to Seurat's utterance with a mixture of irony and assent—irony, because there is in his work such a

sublime and classical poetry; and assent, because the poetry is so totally invested in, and inseparable from, his methods. The chill that we feel in current painting all but rules out any comparable sense of irony. Method often does seem to be triumphant today in a way that excludes the very possibility of poetry. Painters who nowadays deny a poetic intention easily persuade us that they are correct.

For these painters work, aesthetically, in terms of a pictorial dialectic that permits fewer and fewer expressive options. Seurat and his Neo-Impressionist followers significantly enlarged the possibilities of painting by applying their finical methods to the Impressionist heritage. The optical painters and color-field abstractionists who stand in relation to Abstract Expressionism very much as the Neo-Impressionists stood in relation to Impressionism have had, perforce, to narrow the possibilities. Whereas Seurat could absorb the process of Impressionist picture-making into his system, preserving it even as he purified and transformed it, the new abstractionists have had to obliterate nearly all trace of Abstract Expressionist process in their own effort of purification. In the one case, the *donnée* was elaborated; in the other, it was disposed of.

How much was preserved in the methods of Neo-Impressionism is clearly evident in the early works of Matisse that are included in the Guggenheim show. These pictures draw freely—sometimes very freely—from Neo-Impressionist practice; yet they are far removed in feeling from the strict objectives of Seurat and his disciples. These Matisses are indeed closer to the lyric imperatives of Impressionism than to the classicizing aspiration of Neo-Impressionism. Compared to the classics of Neo-Impressionism, Matisse's *"Luxe, calme et volupté"* (1904–5) and "The Port of Abaill, Collioure" (1905) are wonderfully open and free, yet something of their openness and freedom derives from the strict analytical procedures of Seurat.

Will the new modes of abstraction, with their even more impersonal methods and antipoetic doctrines, yield again to the lyric impulse? Certainly a great many people who have been left aesthetically homeless in the chilly climate of the current art scene are yearning for such an eventuality. And there is, to be sure, a certain comfort for them in the history of "Neo-Impressionism" as it is displayed at the Guggenheim—the comfort of seeing a rigorously observed aesthetic dogma dissolved, finally, in the interests of feeling, sensibility, and a personal poetry.

But New York is not Paris, the 1960's are not the 1890's. The relation in which Matisse stood to Seurat is not the kind of creative relation that any abstract painter now working enjoys with any of his predecessors. Each artistic victory now seems to deplete painting of some of its resources rather than add to them. Ours is, alas, an age of depletion in the pictorial arts, and it is difficult to see how a reassertion of the lyric impulse could change it.

February 25, 1968

7. Odilon Redon: "The Medium of Mind"

At exactly what point does a work of visual art pass over into the terrain of the "literary"? Many celebrated artists, even in modern times, have based their work on literary materials, and yet a deep-seated fear and suspicion of the literary pervades modernist aesthetics. To risk making a painting or sculpture or drawing hostage to literary interpretation is, to orthodox modernists, to risk artistic disaster. It is by its own internal logic of form that a work must stand or fall, without recourse to literary props: this is the prevailing view.

When one considers the immense task of aesthetic hygiene once required to rescue the values of the sheerly visual from the literary excrescences that had long obscured them, it is impossible not to sympathize with this position. Nor is there much reason to suppose that the old literary view of the visual arts has completely died out among cultivated literary people. In a volume of essays published just the other day—George Steiner's *Language and Silence*—an informed critic does not hesitate to offer a wholesale condemnation of contemporary art specifically on the grounds of its distance from literary discourse. With such attitudes still circulating

in high literary places, the critical task of establishing the purely visual as a legitimate mode of discourse, with expressive conventions of its own, can hardly be considered obsolete.

Yet, granting the importance of this task, there remain certain artists whose work will forever lie beyond its reach. These artists do not lack a powerful sense of the visual, but they do not confine their purposes to purely visual ends. Something else enters in—some element of poetry or symbolism which, though given a memorable visual form, draws its meaning and spiritual sustenance from outside the visual arena. For such artists, the visual is emblematic rather than absolute, and the strategy of forms is a means rather than an end in itself.

Certainly this is the case with the art of Odilon Redon (1840–1916), an exhibition of whose work is currently at the Albert Loeb & Krugier Gallery. Though he belongs chronologically to the generation of the Impressionists, and even showed his work in the last of their group exhibitions (in 1886), Redon stands apart. This is true even of his delightful flower pictures, the work that stands in the closest stylistic proximity to that of the Impressionists. The bulk of his work belongs to another order of sensibility altogether.

This is particularly evident in the current exhibition, which contains only one flower picture—"Geranium," a pastel—and is mainly devoted to the artist's lithographs. There are a number of Redon's splendid and original charcoal drawings, a few other pastels, and some paintings, but the lithographs—whole series, jamming every available space—dominate the show and underscore the extent to which Redon was an artist deeply immersed in the literary culture of his day and deeply intent upon creating an art that would accommodate its peculiar mysteries and obsessions.

This is pre-eminently a task for the graphic artist rather than the painter, and it was as a graphic artist of genius that Redon fulfilled it. His paintings of imaginary and fantastic subjects have their admirers, to be sure, but I do not count myself among them. These paintings (as distinct from the flower pictures) have always seemed remarkably unpersuasive to me, especially when compared to the graphic work. There was something about color and the nature of the painterly process that acted as a brake on Redon's fantasy. While his lithographs have the immediacy of a dream, his paintings on similar subjects seem more like painstaking efforts to

reconstruct the half-remembered lineaments of a dream in the cold light of day.

Redon's was indeed a nocturnal imagination, and I do not think it too fanciful to suggest that the daylight world of color blighted his capacity to dream. In that world, he was a careful and accomplished observer, as his flower pictures amply testify, and he had a keen interest in botany. Redon himself insisted that the "logic" of his fantasy was, in fact, derived from his scrupulous observation of nature. "My whole originality consists . . . in making unbelievable things live in our human world according to the rules of the believable," he wrote. "This I accomplish by putting the logic of the visible world as far as I can at the service of the non-visible. . . ."

However much "the logic of the visible world" might contribute to the realization of the "non-visible," the latter inevitably took the form of a world of shadows, the forms of chiaroscuro, in which a velvet black darkness disclosed a purely interior realm of consciousness—a realm of mind. In Redon's case, it was a mind filled with literary images—or, rather, with images inspired by the literary and created less as illustrations of particular texts than as highly metaphorical meditations on the emotions harbored in these texts. Poe, Flaubert, even Bulwer-Lytton provided occasions for Redon's elaborate and ambitious flights into his own imaginary world of shadows. Wagner, Mallarmé, and the whole poetic and psychological ambience of the Symbolist movement determined the events—more suggestions than actualizations—to be found in that world. It was indeed a universe removed from the sun-drenched observation of the Impressionists.

For this reason, no doubt, Redon had to wait for the 1890's for a full recognition of his gifts. It was only then, when the Impressionist tide gave way to the imperatives of Symbolism, when the sun began to set on the observation of nature and the mysteries of the psyche began to loom as a compelling aesthetic phenomenon, that Redon was acknowledged a master.

Redon was aware that this affinity for a world of shadows, and its accompanying disposition in favor of the graphic, ran counter to the natural sympathies of French taste; that there was something "northern" in his preference for a "black" medium. And he offered an eloquent defense of his own practice.

In a lecture delivered in Holland—a favorable atmosphere for

such a declaration—Redon remarked: "Black, far more than all the resplendent colors of palette and prism, is the medium of mind. Good engravings will always be more appreciated in serious countries where man is forced by the harshness of the climate to shut himself up at home and cultivate his own thoughts. In the lands of northern Europe, for instance, as opposed to the Mediterranean regions, where the sun takes us out of ourselves and enchants us."

April 23, 1967

8. Medardo Rosso

The one hundredth anniversary of the birth of Medardo Rosso last year passed without notice in this country or, indeed, almost anywhere else. Yet Rosso is undeniably one of the great modern sculptors. In his own day he was second only to Rodin and, at times, Rodin's equal. He seems to have had a decisive influence on one of Rodin's greatest works, the "Balzac"; and it is said that dealers used to peddle Rosso's sculptures in this country as Rodins. If we are less likely to confuse their quite different sensibilities today, it is not because we have been overly familiar with Rosso's *oeuvre*. Until a year ago, no American museum owned a single work by him, and the exhibition which has now been organized by the Peridot Gallery, consisting of twelve works in wax, plaster, and bronze, is the first of its kind in this country.

It is a stunning exhibition, rare both in its exquisiteness and in sculptural vigor. It comes as something of a shock to be confronted with a sculpture in which so many qualities we have learned to respond to separately and in isolation are here found to live in a genial unity. Direct observation of life, a generous and robust plasticity, a lyrical delicacy combined with a clear-eyed, "realistic" view of the human image, a profound warmth unscarred by sentimentality—these are the qualities of the masters, and they are

Rosso's qualities, too. Yet, far from placing him among those artists whose regard for the past freezes them forever in a backward glance, Rosso's art looks to the future. Compared with Rosso, it is Rodin who looks like the latter-day master of the Renaissance. In their war against the art of the museums, it will be remembered that the Futurists looked to Rosso as their hero and mentor.

Rosso was born in Turin on May 12, 1858, and he died in Milan seventy years later. He stands at the beginning of Italian modernism, occupying that ambiguous position practically by himself, and he enters the history of French Impressionism at an angle, so to speak. In many ways his career developed along what we should now consider the classic lines of the avant-garde artist. Expelled from the Milan Academy, he worked in difficult circumstances before attaining a certain recognition in Paris and Rome. Ultimately, he earned the respect of the two generations whose disparate aesthetic ideologies amplify certain qualities of his art even if they do not exhaust it: the French Impressionists, with whom he exhibited in Paris, and the Italian Futurists (Boccioni, Carrà, and Soffici especially), who regarded his work as prophetic of the particular dynamism they aspired to in their own work.

Clemenceau and Zola were among the first to collect his work in France, where he showed in the salons, and from 1905 onward he was increasingly exhibited and praised in Italy. By this time he had almost completely ceased to work, and his production had never been prodigious. In his introduction to the catalogue of the Peridot exhibition, Professor Giorgio Nicodemi notes that "the number of known original sculptures is placed at thirty-nine, whereas the drawings probably number no more than a hundred." In 1929, the year after his death, the Salon d'Automne in Paris presented a retrospective exhibition of his work, and in the interval of three decades since that event, Rosso has to a very large degree simply passed out of the official history of modern art.

The present exhibition is certain to revive interest in Rosso in an artistic as well as a historical sense. His particular mode of Impressionism, notably in several waxes, cannot help striking the contemporary eye as being a prelude to Expressionism. Several works in the Peridot show do, in fact, impress one as realizing in a fragmentary but nonetheless perfect degree some of the ambitions of current sculpture. For one example: they cast Giacometti's portrait heads of his brother into a company which is more congenial

perhaps than any his own contemporaries have been able to provide. Sculptors who have been searching out the possibilities of a more expressive surface without wanting to abandon the monolithic image will find in Rosso a precursor of their aspiration. And in an utterly unforeseen way, his work injects itself into the current discussions of a figurative Expressionism, for Rosso holds an important place among those modernist artists who were the first to effect a subtle, powerful equation between their subject and their means. There are sculptures by Rosso in which the image seems just barely to emerge from its medium, in which the subject seems always in some danger of suddenly dissolving again into its materials. It never does, of course. The image persists, with ever so many delicate touches, and its complete dissolution was never part of Rosso's intention. Yet the fact that it often *seems* about to dissolve into a mere lump of matter will endear Rosso's work, one supposes, to a certain kind of contemporary sensibility.

On the other hand, Rosso's sculptural image has a marked purity about it. If some of these waxes did choose to "dissolve," they would become something very like an early Brancusi. Beneath the play of light and the delineation of an "impermanent" surface, one is made aware of something hard and immutable, a structure that cannot be further reduced to its essential character. And yet what is permanent, or *pure,* in this structure, though we are made to perceive it and respond to it, is not in the end especially favored over what is "impermanent" and subject to the cruel dissolutions of light and shadow. They exist, in fact, in a curious equality: the pure and the impure; the hard, archetypal essence and the continuously dissolving surface. And one perceives, after all, that it must have been precisely this exquisite balance of elements—the object dissolving into space and light, space itself "becoming" the object— which made Rosso a hero to the Futurists, for here was the Futurist problem posed at the most appealing level of intelligence and sympathy.

There is still another element in Rosso's art which cannot be left out of the account. To speak of it requires a certain tact, I suppose, so removed are we from what it must have meant to him. It is simply this: that Rosso drew his subjects from life and—how shall one put it?—he was not indifferent to them. There is a sociality in his subjects which is consciously preserved in the finished sculpture; they are not figments in a dream. From the social caricaturism of

Daumier to the purism of Brancusi might look to us like an enormous aesthetic distance, but nevertheless, Rosso somehow contains the elements of one as well as the other. To judge from the photographs of the early work he called "Impressions in an Omnibus"—unfortunately, the work was destroyed—social observation counted importantly for him from the beginning.

It is well to remember that Rosso was of the nineteenth century, whatever affinities he may have with the art of the twentieth, and in the nineteenth century the *choice* of a particular subject matter was still an aesthetic choice. Rosso was one of those artists—Courbet and Daumier were others—who looked to the immediate scene both out of a natural sympathy and as a means of breaking through the inherited pieties of an exalted and phony canon of beauty. His realism was thus motivated by a quest for purity, and the purist aspect of his work was abetted by a desire to render the truth. It is, altogether, an aesthetic dialectic composed of many terms which have in the interim been separated, fragmented, capsulated, and promoted as incompatible orthodoxies. For Rosso it was still possible to use this complex dialectic as an instrument of precision.

Still, there *is* something fragmentary in Rosso. He is among the first of the modern artists who give us a "sketch" as the finished work. Like every other Italian artist, he was haunted by the Renaissance tradition, and he was repelled by it. To present a sketch, drawn from life and imbued with a purity of feeling, at once humble, realistic, and unfinished, was the only means at hand by which this crushing inherited Classicism could be undermined and subdued. In what remains a very useful and exact discussion of Rosso's vision—the chapter which Julius Meier-Graefe accorded him in his book *Modern Art,* published in 1906—the German critic remarked that "Michelangelo seemed to him the representative of a decadence." "In all the church pictures of the Italians," Meier-Graefe wrote, "he was disturbed by the insistence of the figures, standing out from the surface. These saints sometimes concealed an exquisite landscape, in which alone the artist had revealed himself . . ." What liberated Rosso from Renaissance orthodoxy was the example of Velázquez and then of Manet. He found in the new freedom and integrity of their painting the inspiration for a new beginning in sculpture. The realism of their style, which admitted

the truth of their medium into an equality with their subjects, gave Rosso the clue to his own sculptural style. He was among the first of the modern sculptors who perceived that their art could only be revived under the guidance of painting, for there was, in fact, no living tradition in sculpture comparable to what Rembrandt, Veláz-quez, and Manet represented in painting.

December 1959

9. Simeon Solomon: Preview of a Revival

The exhibition of paintings and drawings by Simeon Solomon at Durlacher's is the sort of event that signals a change in taste. Precisely how significant or widespread this change may be remains to be seen, but the exhibition itself—the first ever devoted to this artist in America—is not an isolated development. It epitomizes one of those radical reversals of favor that separates one period from another.

Solomon, whose dates are 1840–1905, was a minor and late Pre-Raphaelite—an artist who, if known at all, was until recently more famous for his disreputable life than for the slender accomplishment of his art. He shared with his English confrères in the Pre-Raphaelite movement a disposition toward literary painting that has remained, for many connoisseurs of modern art, the hallmark of the most retrograde pictorial outlook.

At almost any time during the past sixty years, the thought of a Pre-Raphaelite revival would have been regarded as a preposterous joke among followers of the modern movement. Everything that Pre-Raphaelitism represented—its facile medievalism, its religious and poetic sentimentality, its ethical posturing at the expense of aesthetic realization, and the bogus realism of its elaborately cos-

tumed pictorial tableaux—seemed to have been permanently discredited by the far-reaching formal and expressive innovations of modern painting. For modernists, Pre-Raphaelitism was the very embodiment of the *ancien régime* that had been overthrown.

The first sign of a change in this attitude came with the revival of Art Nouveau in the late 1950's. Art Nouveau was mainly a movement in the graphic and decorative arts, and the favorable revaluation of its accomplishments outside the sphere of painting was a genuine act of aesthetic reclamation. But insofar as Art Nouveau derived from Pre-Raphaelitism, it represented a decorative refinement and distillation, the aesthetic quintessence of a vision that, in the hands of the original Pre-Raphaelite painters, was hopelessly confused with a good deal of frippery.

The vogue of Art Nouveau was not, to be sure, entirely free of this attachment to frippery, but at least something authentic was being salvaged in the process. The jocular irony and "camp"—the amused acceptance of bad or outrageous taste as an aesthetic joke—that attended this vogue could never take complete possession of it, and thus Art Nouveau may be said to have survived the ironic giggles of its most supercilious partisans.

Any revival of Pre-Raphaelitism must, perforce, proceed along the same ambiguous lines—half seriously, half ironically, at once a straightforward art historical inquiry and an indulgent spoof on the pieties of modernist aesthetics. An ambiguous attitude of this sort would have been unthinkable in approaching the work of Cézanne, say, or the Cubists, or even the Abstract Expressionists. But the reigning school of Pop art, itself the product and beneficiary of this half-straight, half-gag double talk, has sanctioned this attitude and made it intellectually chic. Hence, one is scarcely surprised to find that a gradute seminar on Victorian art—largely, one understands, devoted to the Pre-Raphaelites—is currently being conducted at Columbia University by Professor Robert Rosenblum, a serious art historian who happens to be one of the most enthusiastic champions of the Pop movement.

To exponents of a Pre-Raphaelite revival, present or future, academic or hip, Simeon Solomon offers ideal material. In the vicissitudes of his career as well as the development of his work, he marks a transition from the lofty Victorian pretensions of the movement to that amalgam of aestheticism, religiosity, and sexual inversion that became the prevailing ideology of the nineties. Even

the briefest account of Solomon's life reads like a parody of late nineteenth-century decadence conjured up by a hyperbolist of the Grove Press. Born into an Orthodox Jewish family, Solomon became both alcoholic and homosexual, a voluptuary who enjoyed the friendship of Swinburne and the admiration of Oscar Wilde, an acolyte of the Catholicism of the Oxford Movement as well as the doctrines of the Marquis de Sade.

The thirty works that comprise the current exhibition at Durlacher's are sufficient to demonstrate that Solomon had some very real gifts as an artist, but they show, too, that he lacked the resources for applying these gifts with any artistic consistency. Vulnerable (as he apparently was) to the heady milieux in which he moved, he seems constantly to have been revising and reversing his stylistic loyalties, neither completely comfortable within the limits of the styles he inherited nor capable of transcending them with any lasting conviction.

The early religious pictures—"Moses in His Mother's Arms" (1860) and "Isaac and Rebecca" (1863)—conform to the most meticulous mode of Pre-Raphaelite banality. On the other hand, a drawing of the same period—"The Anguish of Miriam"—must be counted a superb piece of draftsmanship. Much of the exhibition is sentimental illustration of a type that no amount of critical flimflam will ever succeed in redeeming from its own shallowness. Yet in one extraordinary work, a watercolor of a man's head entitled "Night" and thought to have been painted around 1895, Solomon anticipated those early, somber blue figures of the young Picasso, and thereby establishes his link to an authentic modern sensibility. There is nothing else quite like this watercolor in the present exhibition, and one would like to know more about it. Perhaps we shall when Lionel Lambourne, who contributes a brief text to the Durlacher catalogue, produces his forthcoming book on Solomon.

As Pre-Raphaelitism was itself much in vogue in Barcelona in the nineties, when Picasso was producing his first serious work, this picture poses some beguiling historical and aesthetic questions. But the revival of interest in an artist like Simeon Solomon will not, one feels sure, depend on such questions alone. The ironic preciosities that already color so much of the current artistic and intellectual scene will, in this case as in others, prove to be the decisive factor.

April 10, 1966

10. The Pre-Raphaelite Revival

"Every great and original writer," wrote Wordsworth, "in propor-
tion as he is great and original, must himself create the taste by
which he is to be relished." This is no doubt true of every great
artist; certainly it is true of the great modern artists. But in the case
of lesser artists, more mundane factors play a very large role in
creating the taste by which they are relished, and never more so than
at the present moment.

In this respect, the English art historian Francis Haskell,
writing last month in *The New York Review of Books*, offered some
observations on a phenomenon which everyone who follows the
contemporary art scene has lately noticed, either with a certain
pleasure or with acute pain, depending on the standards he applies.

> There is some fascination to be derived from watching a change
> in artistic taste, or at any rate an artistic revival, taking place
> —so to speak—under one's very eyes [Mr. Haskell wrote].
> Hidden qualities are discovered in pictures hitherto despised
> or ignored; commercial pressures are applied by the dealers,
> and speculative buying begins "as an investment"; a cult that
> was once "camp" soon seems to be merely eccentric and then
> rather dashing; scholarly articles are written because there is
> nothing new to be said about established favorites; color supple-
> ments spread the good news to a wider public. From some
> combination of these and other factors a new taste develops . . .

Mr. Haskell had especially in mind the "big machines" of the
nineteenth-century Salon painters in France—painters such as Meis-
sonier, Gérome, and Bouguereau. But his observation holds true
with equal justice for that vast wasteland of British painting that
stretches from the Victorian academicians to the Pre-Raphaelites
and beyond—in fact, to the preposterous pastiche of Victorian and
Pre-Raphaelite mannerisms that persisted (albeit feebly) up until
the very moment when Hitler's armies finally awakened even this
somnolent sector of the British art world to the fact of the twentieth
century.

For several years now, the sort of "revival" Mr. Haskell de-
scribes has been working to breathe new life into the decayed
corpses of Victorian and Pre-Raphaelite painting, and the results are

now beginning to show. Some very respectable scholars have lent their talents and their prestige to this essentially comic enterprise, and the market has responded with its usual sensitivity to any possibility of making a large profit. Thus, a month ago, one of the most laughable products of the British academic tradition—Sir William Russell Flint's "The Judgement of Paris," which William Randolph Hearst first purchased when it was exhibited at the Royal Academy in 1935—was auctioned at Christie's for the sum of 3,800 guineas (nearly $10,000). A new taste—or, to be precise, an old and discredited taste now adorned with a new set of intellectual pretensions—had indeed made itself visible. The transition from "camp" to something "rather dashing" was clearly in progress.

At that moment, too, a large exhibition entitled "The Earthly Paradise" could be seen in the galleries of the Fine Art Society, New Bond Street. Consisting of nearly two hundred works, this exhibition was devoted to twelve artists of the Birmingham Group of Painters and Craftsmen, which flourished—if that is the word—in the years preceding World War I and which did not pass into total obscurity until the end of the 1930's. While nothing in this exhibition was as totally meretricious as "The Judgement of Paris," the work itself, with its complete fidelity to the imagery and ideals of William Morris and Burne-Jones, Puvis de Chavannes and Walter Crane, was of a style that even ten years ago would have been regarded as only a benighted historical amusement. On this occasion, however, the show was an unmistakable success. The critics treated it as a perfectly serious enterprise, and on the day I visited the exhibition, more than three-quarters of the items had been sold.

How can one account for such a patent reversal of taste? In his observations on the dynamics of revivals of this sort, Mr. Haskell has, I believe, omitted a very significant element—perhaps, indeed, the most significant. He has left out the role played by contemporary styles in revising our outlook on the past. I think this role is fundamental to the whole phenomenon, and in the case of the current revival of both French Salon painting and the art of the Victorian and Pre-Raphaelite painters, it was the ethos as well as the aesthetics of Pop art that made all the difference.

For Pop, however great its reliance on the forms of modernist painting, broke the spell of modernist taste. It joined with the revival of Art Nouveau in mocking the purity and rigor of modernism, and under an umbrella of "camp" irony, succeeded in develop-

ing that combination of facetiousness, nostalgia, and relaxed sociability without the authority of which these current revivals would be unthinkable.

What is remarkable about this development is the ease with which this new taste has established itself and the sense of liberation with which its votaries have embraced it. And liberation of some sort has certainly taken place. There was always an element of moral authority, and therefore of moral prohibition and constraint, attached to the aesthetic authority of modernist art; there was always the voice that said, "Thou shalt not." It was this puritan side of modernism that Pop shattered so effectively, and in the process created a large and unconstricted space for the sensibility to roam, indulging whatever whims, whatever silliness and bad taste its heart desired.

There is an obvious parallel here between the changes that have overtaken "advanced" taste in the visual arts and those that have influenced the new codes of sexual behavior, though the exact connection, if any, between one and the other remains to be established. It is this very parallel that gives to the unreconstructed champions of modernist values an unfortunate air of puritan divines defending some sort of theological fiction. And yet, despite this unhappy posture of puritan outrage, these champions have a point. Can one really believe that these revivals of Bouguereau and the Pre-Raphaelites represent anything but—however one defines the term —a certain decadence?

August 17, 1969

11. Rediscovering Puvis de Chavannes

The disinterment of Symbolist painting continues on its merry, necrophiliac course and on this occasion seems to have turned up something resembling a warm body. For the principal exhibition in

London this summer is the "French Symbolist Painters" show at the Hayward Gallery, and one of the figures prominently featured in it is Pierre Puvis de Chavannes (1824–98).

Puvis, as he is called, was once a painter of formidable reputation and influence. A reproduction of his "Hope" (c. 1871) remained pinned to the wall of Gauguin's hut during his exile in Tahiti. "The Poor Fisherman" (1881) was much admired by Seurat, Signac, and Maillol, who made a copy of it. The Nabis venerated his style. In the revolt against Impressionism that won the allegiance of the younger generation in France in the last decades of the nineteenth century, Puvis was a hero and a model. Enlightened opinion at the turn of the century considered him one of the masters of modern painting.

Subsequently his reputation suffered a serious eclipse. Critics no longer felt obliged to have an opinion of his work, and few artists paid it any attention. His name dropped out of discussion—permanently, it seemed—and he looked more and more like another fatal casualty of the history of taste.

Yet here he is again, in 1972, the undoubted center of interest in a large and ambitious exhibition. True, the competition—if it is painting rather than the psychopathology of literary, religious, and erotic fantasy that interests us—is not great. What Puvis is up against in this exhibition of "French Symbolist Painters" is not painting of a high order but the iconography of a perverse dream world. Puvis, to be sure, has certain affinities with the purveyors of this epicene rubbish, but at the edges of his art rather than at its center. Unlike the general run of painters represented in this exhibition, he was in possession of an original and deeply felt pictorial sensibility. It is the expression of this sensibility rather than the specifications of his symbolism that is so impressive, not merely in comparison to what others in this show have to offer but intrinsically, as an artistic achievement in itself.

For Puvis's was a sensibility of extraordinary purity and conviction. The compulsion to record the raw optical data that impinges on the retina of the eye—the mania for exactitude that so absorbed the Impressionists—interested him not in the least. For him, the art of painting consisted in filtering out all chromatic contrasts to a point where every tone enjoyed an equal visual weight and the surface of the picture became a flat, continuous, unbroken plane bathed in an unearthly light. What Puvis sought was an inten-

sity—a spiritual intensity for which the subtlest visual equivalents had to be found—without vividness or verisimilitude. No other nineteenth-century painter of comparable ambition so deliberately resisted the temptation to exploit the sensuous appeal of pure color, or made so much of the dry, gray, neutral medium that remained once the more obvious resources of chromatic drama had been eschewed.

Puvis, too, had his favored iconography—a timeless, Arcadian world of nymphs without satyrs, a poetic evocation of classical Greece minus all conflict and all appetite and the tragedies these engender. The truth is, Puvis's imagery is as shorn of drama as his palette. It is not a narrative he aspired to give us but a spiritual atmosphere, which, though remarkably innocent and austere, is realized with such unfailing delicacy and such absolute conviction that in the end it triumphs over its own fragility. What may at first look soft and even a little inane in Puvis turns out to be a mysterious source of strength.

In addition to "Hope," and "The Poor Fisherman," the current exhibition also includes the very large "Summer" (1873) from the Musée des Beaux-Arts in Chartres—a painting that establishes both his debt to Chassériau and his own originality and power. There are also a great many smaller paintings and drawings as well as studies for the large decorative works that were Puvis's particular preoccupation. Where he is closest to the special malaise and the unendurable vulgarity of the Symbolist painters, as in the really awful "Beheading of St. John the Baptist" (1869), Puvis is always at his worst. But generally he had both a finer and a tougher mind than theirs, and his art ought now to be rescued from the Symbolist necropolis that so many jaded art historians have induced their graduate students into mistaking for a vital tradition.

July 16, 1972

12. Aubrey Beardsley:
The Erotic and the Exquisite

The English graphic artist Aubrey Beardsley died in 1898 at the age of twenty-five. In the space of a very few years—he had received his first commission, to illustrate *Le Morte d'Arthur,* in 1892—he had become one of the most admired, most imitated, and most notorious artists of his time. Denounced as an immoralist, and in fact the author of certain very genteel pornographic drawings and writings, he was in the heyday of his fame an acclaimed genius who wielded a wide influence on the tastes of the most respectable classes. He became a classic in his lifetime and has remained so.

The wonder is not that we should now be seeing a revival of interest in Beardsley, but that such a revival has not been sooner in coming. For Beardsley's work occupies a central position in the development of Art Nouveau. As the sympathetic revival—not to say exploitation—of Art Nouveau has been one of the salient features of the 1960's, it was inevitable that Beardsley would again be brought forward and revaluated before the current vogue of Art Nouveau had run its course.

Last summer such a revival was given exemplary form in the exhibition of Beardsley's work mounted at the Victoria and Albert Museum in London, an exhibition numbering 611 items. A somewhat smaller but nonetheless impressive survey of this legendary artist has now come to New York. The exhibition called "Aubrey Beardsley and His Era," at the Gallery of Modern Art, brings us a sizable portion of the materials that were assembled for the London show. Brian Reade, the Curator of Prints and Drawings at the Victoria and Albert, who organized both exhibitions, has been able to add some items from American collections—notably John Hay Whitney's—not included in the London show. The result is an exhibition that, if not quite equal to its superlative London counterpart, nonetheless offers us a generous array of Beardsley drawings as well as the artist's prints, illustrated books, manuscripts, posters, and other documents. Altogether there are approximately four hundred exhibits from the life and work of this astonishing figure.

For Beardsley does astonish us still. Where his original public was inclined to be appalled (but fascinated) by his art, we are apt to be delighted and amused (and no less fascinated). But these are

incidental details in the history of public taste. The essentials of Beardsley's art were grasped in his own time even if disapproved—he was anything but misunderstood—and his art now enjoys a widespread esteem once again precisely because these essentials are particularly prized at the present time.

It is true that fashion, with all its inane superficies and outright silliness, plays a role in the current revival of Beardsley, just as fashion attended his initial fame. But it would be a decided error to regard the art itself as the "mere" expression of a fashion, for this is an art that harbors—that indeed apotheosizes—an attitude to both art and life distinctly modern and distinctly relevant to the way we live and think and feel.

There is an important clue as to what, exactly, this attitude is in the essay Roger Fry devoted to Beardsley in 1904. Noting that Beardsley was "a confirmed eclectic, borrowing from all ages and all countries," Fry adds: "The only thing he could do nothing with was nature itself." Beardsley's genius lay not in the direct transmutation of observed experience but in the fabrication of a style that distilled other styles, that pressed style itself to a radical extreme of artifice. For an artist so inclined, it was an advantage rather than a limitation that he worked primarily as an illustrator of literary texts, for this further sealed his vision against the importunities of nature and ensured his art the right to dwell securely in the realm of imaginative artifice.

If we customarily regard art of this order as a form of aestheticism, as an example of art-for-art's-sake, we are nonetheless aware that something in the realm of experience is implicated in so single-minded a devotion to aesthetic distillation. Hence the designation "decadent" that has traditionally been assigned to such art. Hence, too, the paradox that an absorption in the realm of aesthetic artifice should signify so distinct an attitude toward life.

It is one of the merits of the Beardsley revival that it affords us an opportunity to explore this paradox in the work of an artist who remained consistently loyal to all of its inner contradictions. In all of Beardsley's drawings, from the slightest little decorative vignettes to the most elaborate figure compositions, there is that total concentration of design—a total absorption of the literary or thematic materials at hand into the logic of style—that is characteristic of all artists who place the realization of their own highly personal sense of form above every other consideration. With Beardsley, certainly,

we are always conscious of his form before we are fully conscious of anything else.

And yet—for this is the paradox his art does so much to illuminate—we are never in doubt as to what emotion that form signifies. Nowhere in the annals of modern art is there a body of work more thoroughly imbued with erotic feeling than Beardsley's. Every line, every shape, every gesture suggests an erotic ambience; the very dynamics of the style, with its extreme distortions and compulsive exaggerations, seem intent on perpetuating and savoring an erotic glow. And this is true, often most especially true, where there is nothing explicitly sexual in the given motif. In the world of Beardsley's imagination, no item of apparel, no common object, no botanical motif or architectural detail or cloud in the sky is innocent of erotic design.

It follows that Beardsley's figures, not only in their confrontations but in their very existence, are figments of this erotic dreamworld. And as figments of a dream, they are assigned quite definite roles: the females, generally aggressive, hearty, possessed of extravagant appetites; the males, generally passive, delicate, victims of lassitude and inertia. Sexual roles are not so much reversed as dissolved into an androgynous ideal.

Beardsley's obsession with the erotic is, as it turns out, the other side of his devotion to form, for both are celebrations of artifice in which the exquisite specifications of fantasy displace the dynamics of nature. The aesthete-designer and the erotic fantasist— Mr. Reade speaks of a "mental erethism embracing most forms of deviation"—collaborate to remake the world.

This alliance of the erotic and the exquisite has always been one of the attractions of Art Nouveau, whether openly acknowledged or not, and in Beardsley we confront it in its most brilliant graphic form.

February 19, 1967

13. The Erotic Style

The exhibition of Art Nouveau at the Museum of Modern Art has been a shock and a delight. It is assembled with remarkable intelligence and an unfailing taste. The quality of the objects and art works is uniformly high. It is not primarily a painting exhibition. Dr. Selz remarks in his essay for the catalogue: " 'Art Nouveau.' 'Jugendstil,' 'Secessionstil,' 'Stil floreale,'—whatever one calls the style, it belongs to the decorative arts. It was largely a way of *designing*, not of painting, sculpting, or building." There are fine paintings in the exhibition and some good sculpture, but they cannot compare with the truly remarkable graphic art, the glass, and the other decorative objects. Everything has the air of being precious and exquisite, and indeed, the prevailing exquisiteness barely misses at times being a little oppressive and smothering. One sees clearly enough why, for an earlier generation, the lovely and the beautiful became terms of contempt; one sees why, even though one may find many of the objects in this exhibition extremely beautiful without a qualm of conscience.

The nineties, we have been told, suffered from a sickly preoccupation with "aesthetic" emotions, from an obsession with art at the expense of life, and while this turns out not to be precisely the whole case, the evidence of sickly obsessions and a kind of crippling aestheticism is certainly at hand among the many and diverse elements which make up this exhibition. What complicates the matter and invests it with an ambiguity that will never be susceptible to easy definitions is that so much of the precious and esoteric side of this movement was directed not to private purposes but to public functions. A style that could claim some of the most comical refinements in the history of snobbery was yet a powerful influence in the making of subway entrances! Unless one is able to hold in one's mind simultaneously both the aesthetic side of this style and those subway entrances, one's understanding of this exhibition and the crucial chapter in modern culture it represents must go down in defeat.

There is a sense, then, in which this exhibition, for all its smothering aestheticism, is not primarily an artistic event. Can any assemblage of decorative objects, even on this level, ever be purely a matter of art? I doubt it. Too many promises of life, too many

fantasies about the improvement and transformation of the conditions in which we live, are invoked without being clearly resolved in relation to our experience. The claims they make on us seem urgent but somehow alien and untransmuted. As we weigh these claims, the differences between the designer and the artist are more apparent, and chief among them seems to be precisely this matter of the direction in which the whole effect is to be resolved. The designer must necessarily hand over what he has invoked to the hazards of contingency at the very moment the artist will want to transform it into a statement of meaning. Because the designer wishes to affect our lives more directly, he speaks *for* our experience only remotely, if at all.

In an exhibition such as "Art Nouveau," one is made to feel the pressure of an experience in a way that is quite the opposite of what one feels in the presence of a compelling artistic event. Here one responds to an invitation to become part of a world, a world other than one's own, a very special world in which only certain emotions will have a place and then only if they comport themselves with a very special etiquette. One responds to this invitation, which may either be accepted or rejected. It is precisely this option which we do not feel in a work of art, for the claim that art makes on us is the claim of truth and we are not permitted to reject it without rejecting something of ourselves at the same time. Art illuminates our experience without asking us to become something other than what we are. Sooner or later the designer must of necessity include *us* in his design, for the motive of all design is to change our lives. In this sense, art makes no designs on us. Design, even the most prosaic, always aspires to an ideal, whereas art addresses itself to actuality.

The idealism of Art Nouveau is not easy to define, for it was in the nature of this style to be euphemistic, to combine curious concealments with an at times misleading explicitness, and it often draws on visual materials in a way which changed their meaning completely. Consider what happens to the wealth of botanical motifs in Art Nouveau. Are there any flora in the history of art which seem less intended to represent, either in image or spirit, the actual botanical functions? For Art Nouveau the natural fecundity of the botanical world becomes a treasury of visual artifice and oblique symbolism. Nature seems more adored than admired; the intention is always to absorb its mysterious and atmospheric side into a

suggestive poetry without allowing any undue evidence of its bio-
logical vitality to corrupt the purity of image.

And as with botany, so with the emotion which, more than any
other, pervades this style from its innermost conceptions to its most
superficial details: I mean the peculiar eroticism that seems to color
everything and to account finally for the feeling evoked by the style
after all the historical and formalist explanations are in. The ideal-
ism of Art Nouveau is—though often, but not always, euphemistic
and oblique—an erotic idealism. The atmosphere it seeks to sustain
is the atmosphere of an erotic daydream in which a continuous, self-
absorbing languor is not to be interrupted by the least suggestion of
a climactic action. In its English version, this atmosphere is a
dreamworld carefully transmuted from Victorian taste by way of Pre-
Raphaelite sentiment. In France it became something more virile
and worldly, but this peculiar eroticism was all the same the prevail-
ing leitmotif of its psychology. In practically all its manifestations,
it was a vast decorative euphemism for the same erotic fantasy, a
vision which transformed a particular kind of eroticism into a
mystique and a spiritual atmosphere. It seized upon the erotic as,
curiously, a defense against life, sentimentalizing and rarefying it
beyond the reach of its vitalistic functions.

It may almost be claimed, in fact, that Art Nouveau was too
much interested in life and not enough in art; that its untiring
aestheticism was less an effort to perfect art than to alter the nature
of life itself in both its private and public forms. The old notions of
art-for-art's-sake cannot be applied here, for art is nowhere less pure,
nowhere less concerned to refer only to itself, than in the mainstream
of the Art Nouveau movement. Everything in Art Nouveau was
directed toward changing not only the décor and the environment
but, above all, the emotions. Now the ambition to make life conform
more closely to an aesthetic object, to make of one's own experience
something more or less resembling a work of art, is quite the reverse
of the artistic attitude. It expresses not a devotion to art but a lack
of faith in its ability to be meaningful on its own terms. There is a
sense in which Art Nouveau was really contemptuous and hostile to
art, just as it was at heart indifferent to, if not actually afraid of, a
robust sexuality. What happened to the erotic in this style was pre-
cisely what happened to art: not the thing itself, but its appearance
and atmosphere were what was wanted; not the essence, but its
superficial delicacies and delights. This is the principal reason why,

for all its aesthetic snobberies and refinements, Art Nouveau succeeds brilliantly as design and only very occasionally as art. It was a style of life, not a style of art, and it always needed the pressure of a given practical situation to give it the formal and expressive resolution which an authentic artistic statement provides for itself.

One hastens to add that such a distinction is intended not to denigrate the achievements of Art Nouveau, which are evident to anyone seeing this exhibition, but to clarify a more fundamental matter that is so often confused and that is now bound to be even more muddled in the wave of neo-Art-Nouveau design that is sure to follow from an exhibition of this kind. We have never been more ready for a revival of Art Nouveau than at the present time. The pervasive sickly chic which has spread over everything in our cultural life and which has taken such a heavy toll in the vitality of recent painting would seem to call for such a revival as a natural consequence. It seems, too, to connect with the cult of sartorial preciosity that has already transformed certain of our neighborhoods in the evening hours into mock *fin de siècle* tableaux. Was it Harold Nicolson who remarked that nowadays the heirs to the great dandies of the past are all to be seen wearing tight-fitting blue jeans?

The point is that Art Nouveau, in its original expression, was at best an exquisite, brilliant, but essentially moribund style which sacrificed a great measure of human and artistic vitality in order to perfect its very circumscribed vision. One admires it for particular achievements, especially in the graphic arts, but scarcely for its psychology or general view of life. Above all, it holds a unique fascination for us because of its crucial historical position. It was, after all, nothing less than the crucible in which the taste of the nineteenth century underwent its final metamorphosis into the new values of the twentieth. The real achievements of our century did not take place until Art Nouveau had either been totally rejected or completely assimilated into something very different. If Kandinsky, Bonnard, Villon, Boccioni, Gauguin, Toulouse-Lautrec, Maillol, and some of the other celebrated names here had confined their gifts exclusively to this vision, our judgment of them would be radically altered, to say the least. Yet the style and spirit of Art Nouveau affected them all, and the museum's exhibition illuminates this influence unmistakably.

Art Nouveau left its mark, but it was rejected for very good

reasons—for reasons going to the heart of its deficiencies as an image of life and a philosophy of art—and the attempts to revive it, the symptoms on every side which make a revival plausible and imminent, leave one feeling vaguely distressed about the faithlessness and modishness of current taste. Art Nouveau, even at its dazzling best, represents the end of an era; the next chapter, *our* chapter, didn't begin until its fallacies were clearly understood and repudiated and its ideas recast for other purposes. The kind of aesthetic swampiness that such a revival would bring—I mean among living artists, not in the antique shops where it is already doing handsomely—oppresses the spirit and leaves one feeling a little cynical about the possibilities of any authenticity in the whirlpool of our contradictory and adventitious culture.

September 1960

14. Whistler: Choosing London over Paris

The career of James McNeill Whistler (1834–1903) embraces a rich and extraordinary period, and Whistler himself was one of the most extraordinary people in it. Born in Lowell, Massachusetts, he spent his boyhood in Russia, where his father was in charge of building a railway line from St. Petersburg to Moscow for Czar Nicholas I. Whistler's first art classes—at the age of eleven—were in the Imperial Academy of St. Petersburg. He spent the summers of 1847 and 1848 in England, the country destined to be the scene of his later tragicomic adventures. In 1849, when Whistler was not yet fifteen, his father died, and the family returned to America.

Incredible as it now seems, he attended West Point, and, inevitable as it now seems, he was kicked out. By the end of 1855, the year after his dismissal from West Point and the same year that Courbet mounted his historic one-man show in a private pavilion

outside the Exposition Universelle and issued his manifesto on realism—in that fateful year Whistler established himself as an artist in Paris. Whistler was not to meet Courbet for another three years, but his career as a potential recruit to one of the great ages of French painting had begun.

All his life Whistler remained, in a sense, a brilliant fellow-traveler of advanced French painting, but he never committed himself to full membership in the Paris avant-garde. England proved to be a powerful lure. No doubt the illusion persisted that he was in a position to have the best of both worlds.

The illusion was not without some foundation in fact. To a degree that was most unusual among the American artists and writers of his time, Whistler enjoyed the esteem of both the Paris and the London art worlds. He was acquainted—often closely—with a great many people who counted in those worlds, and he came to have a significant influence on them. His work was remarked upon from the very start, on both sides of the Channel. He was, moreover, in possession of a vivid personality. He was intensely sociable, his gifts as a wit and a phrasemaker were highly developed, and he was not a man to shrink from scandal. He became a myth in his own lifetime.

The myth has now faded, and some of the celebrated episodes that gave rise to it—such as Whistler's ill-conceived law suit against Ruskin—have passed into the folklore of Victorian culture. His life still yields abundant anecdote, and his *mots* remain highly quotable. Whistler will undoubtedly continue to be a subject of popular biography for years to come. Yet the more one looks into his life, the more difficult it is to resist the belief that he somehow failed—as an artist—to live up to his opportunities. His achievement is not a small one; his gifts as both a painter and a graphic artist were large. But as soon as one places his name beside those of his contemporaries with whom he was acquainted, it is not among names of the first class to which he seems to belong. It is not with Courbet or Degas or Baudelaire or Mallarmé that one is inclined to place him, but rather among Fantin-Latour and Rossetti and Swinburne and Wilde.

This, in any event, is the conclusion I draw from the large Whistler exhibition that Frederick A. Sweet, the Curator of American Painting and Sculpture, has mounted at the Art Institute of Chicago. The exhibition is, in many respects, a fine one. Fifty-one paintings are included as well as, besides a lively anthology of

pastels, watercolors, and drawings, virtually the entire corpus of Whistler's graphic art—eighty-five etchings and forty-two lithographs. There are, to be sure, some outstanding omissions—not only the portraits of Whistler's mother (in the Louvre) and of Thomas Carlyle (in the City Art Gallery and Museum, Glasgow) but other major works now sequestered in collections with legal restrictions against lending. There is, for example, nothing here from the great Whistler collection at the Freer Gallery in Washington. There are, happily, some impressive loans from that other great repository of Whistler's *oeuvre*—the University of Glasgow. In particular, there is a large preliminary cartoon for the Freer's Peacock Room—a spectacular gouache drawing measuring six feet three inches by thirteen feet—which has never before been exhibited, even in Glasgow.

If the present occasion cannot, then, be said to be a definitive survey of Whistler's work, it is nonetheless the closest we shall now be able to come to such a survey. It is certainly sufficient to define for us the peculiar strengths and weaknesses of the artist, and it has been installed with an affectionate regard for Whistler's own terribly refined standards of taste. Even the catalogue is an affectionate evocation of Whistler's elegant taste in the art of book design.

To a far greater extent than one might have expected, the exhibition generates a distinct period atmosphere. The period is interesting and complex, especially as Whistler sought to embody in his work so many of its diverse elements, and yet the work itself rarely succeeds in transcending its period qualities. The realism of Courbet, the Pre-Raphaelitism of Rossetti and others, the cosmopolitanism of Baudelaire, the aestheticism of Mallarmé, the dandyism of the nineties, the vogue of Japanese design—these and other elements of the period are broached, elaborated, explored for a time, yet never given a really profound expression. Throughout the many vicissitudes of Whistler's development, there is a high quotient of charm. He was a superb decorator, not only as an interior designer but in his painting too. Though he did not, to put it mildly, always succeed in pleasing the public of his time, one is struck by the extent to which his painting is designed to please. Rarely in the history of art has a reputation for troublemaking had so little reflection in aesthetic fact.

Whistler was at his best, I believe, precisely in those pictures—mainly portraits—where all his considerable charm, his sociability,

and his mastery of observation and craft could meet in a happy harmony. "The Little White Girl: Symphony in White, No. 2" (1864) and "Harmony in Gray and Green: Miss Cicely Alexander" (1872–4), both from the Tate Gallery, London; "The White Girl: Symphony in White, No. 1" (1862), from the National Gallery in Washington—these and a few other similar pictures have a strength which his more obviously radical seascapes and "Nocturnes" quite lack.

There are many prophecies to be discerned in Whistler's *oeuvre*. The Glasgow cartoon anticipates, in taste and design, almost the whole of the Art Nouveau aesthetic. His graphic work looks forward to the Intimists; his close-valued seascapes suggest a vein of abstraction only much later developed. Yet these prophecies remained somehow peripheral. Whistler seemed to lack roots deep enough to make them into something major and central. Perhaps his intuitions served him well, after all, when he chose London over Paris.

January 21, 1968

15. Whistler in the Seminar Room

At Wildenstein & Co. there is a large exhibition called "From Realism to Symbolism: Whistler and His World," which has been organized by the Department of Art History and Archaeology at Columbia University in cooperation with the Philadelphia Museum of Art. "The idea for this exhibition," according to the preface of the substantial catalogue accompanying the show, "grew out of a seminar given at Columbia in the autumn of 1969 in which the students looked at Whistler's relations with his contemporaries as a means of examining the complexity of the various progressive developments in the art of the later nineteenth century. The exhibi-

tion is intended neither as a conventional one-man exhibition nor as a survey of the period. Its purpose is to explore international cross-currents, using Whistler's friendships and connections as a focus."

It is important, I think, to keep the notion of "progressive developments" firmly in mind in attempting to come to terms with what is, to my eye at least, a quite bizarre event. Applied to such works as Whistler's "The White Girl" (1862) or the "Portrait of Théodore Duret" (c. 1883), to Manet's "Woman with a Parrot" (1866) or Medardo Rosso's *"Ecce Puer"* (1906–7)—all of which are in the current exhibition—one knows, more or less, what the concept of "progressive developments" might signify. But what can it possibly mean when applied to Albert Moore's "A Musician" (c. 1867) or Thomas Armstrong's "Hay-Time" (c. 1869) or Frederic Leighton's *"Lachrymae"* (c. 1895), all of which, I regret to report, are also in this exhibition. Such pictures may still be good for a laugh, but they are devoid of the least trace of aesthetic interest. As works of art, they are completely, irrevocably dead, and only a mind totally immune to aesthetic quality could suppose otherwise.

How are we to explain, then, the aberrant character of this exhibition, with its sometimes hilarious and more often appalling juxtaposition of the sublime and the ridiculous? Are the historical lessons to be learned from exploring Whistler's relation to some of the worst painters of his day so great that we must suspend critical judgment in order to attain some higher wisdom about the vicissitudes of the artistic enterprise?

It's no use looking at pictures for the answers to these questions. One must look to the catalogue, where (one might suppose) the explanations are to be found. But what do we actually find? The entry on Albert Moore establishes a friendship with Whistler. But what else? Moore's early work followed the Pre-Raphaelite style of William Holman Hunt. Later he turned to a kind of feeble pastiche of neo-classicism. According to the catalogue, "Moore's classicizing qualities appealed to Whistler," but no evidence is adduced. The clincher seems to be that Moore "was the only artist to testify for Whistler at the Whistler–Ruskin trial"—a touching detail in the artist's biography, to be sure, but not one that tells us *anything* about the relation of Whistler's style to Moore's.

Turn to the entry on Thomas Armstrong, one of the English painters Whistler first met in Paris in the 1850's. "Armstrong seems to have been a good, if never intimate, friend of Whistler from their

earliest time together, when they were in Paris in 1856. They continued to see each other irregularly in England during the late sixties." To which one can only say: so what?

And Frederic Leighton, who became president of the Royal Academy in 1878? "Although Leighton was a fixture in the titled, official art scene and Whistler generally was not," we read, "the two artists seem to have maintained good, if distant, relations. . . . Examples of Leighton's appreciation for Whistler are irregular and reserved." One doesn't have to have an exalted notion of what an academic seminar should be to feel that "research" of this sort verges on the ridiculous. Hasn't anyone actually *looked* at the preposterous picture by Leighton in this exhibition?

The unhappy truth is, this exhibition is an almost laboratory demonstration of academic folly—a demonstration of what happens when "research" is divorced from aesthetic intuition and the tests of sensibility. One had heard that the younger generation of art historians was desperate for fresh subjects of scholarly investigation, but the full horror of this desperation had never been really clear to me before the experience of this exhibition.

Whistler was a legend in his own lifetime, and he has been something of an enigma ever since. Why did this American painter —the most celebrated expatriate of his generation—abandon the tremendously vital Paris art scene in 1859 for the pallid aesthetic atmosphere of London? How could the early admirer of Courbet and later friend of Degas and Mallarmé have found the pretensions of the Pre-Raphaelites and the academic classicists that followed them anything but contemptible—not to say laughable?

Whatever the answers to these questions may be, the fact remains that something went wrong with Whistler when he moved outside the orbit of French painting, something that inhibited the fullest realization of his very large gifts. In London, to be sure, Whistler found ample space in which to indulge his taste for art-world politics—it was in London that the Whistler legend was really launched—but the whole English side of his career only underscored certain defects in his character without adding anything essential to his aesthetic development.

A career as complex as Whistler's, traversing the French, British, and American art worlds, with an influence extending to virtually every part of Europe, is not a wise subject for an exhibition based on the artist's "friendships and connections." There are

simply too many friendships and too many connections—and thus too many temptations to seek out tenth-rate works of art simply because the course of research has uncovered them. The result is a historical miscellany that ends in illuminating very little.

The real pleasures in the Wildenstein exhibition are to be found, for the most part, where we would expect to find them—in the works of Whistler himself, in those of the great French artists of the nineteenth century (Courbet, Manet, Degas, Redon, *et al.*), in a few of the other Europeans (Klimt, Rosso), and in certain American painters (Chase, Sargent, Dewing). In the very large representation of British painting in this show, only the work of Sickert is in anything close to the same class, but the organizers of the show seem not to have noticed.

March 14, 1971

16. Mary Cassatt: An American in Paris

The career of Mary Cassatt is one of the most remarkable in the history of American art. So remarkable, indeed, that only Henry James, whom she apparently disliked and disapproved of, might have done justice to both her personal story and the artistic achievement that is its principal ornament. What a pity that he never interested himself in this subject, which in the eyes of posterity has assumed so many of the features of a Jamesian fiction.

There was, first of all, the indelible mark of her European upbringing. Born in 1844 in Allegheny City, now part of Pittsburgh, she was taken as a child to live in Paris, Heidelberg, and Darmstadt. Her parents were amateurs of French culture, her father a businessman who could never really get interested in making a fortune. They lived for a time in Germany to provide their son Alexander—Mary's

older brother—with the technological education his gifts seemed best suited to, and thus launched him on a career that led to his becoming president of the Pennsylvania Railroad.

In 1858 the Cassatt family returned to the United States, settling in Philadelphia, and by 1860 Mary Cassatt—at the age of sixteen—was already determined to be an artist. There is a reference that year in one of Alexander's letters about plans for her to study in Rome. These plans never quite materialized, but the next year she entered the Pennsylvania Academy.

The kind of academic art instruction available to an ambitious student in Philadelphia in the 1860's proved unequal to her ambitions, and by 1866 she had persuaded her father to allow her to study abroad. She went first to Paris, however, rather than to Rome, probably because the Cassatt family's social connections in the French capital assured her of a style of life consistent with their strict bourgeois standards of respectability.

For the next few years—in France, Italy, Spain, Belgium, and the Netherlands—she steeped herself in the Old Masters, having found the academic instruction available in Paris no more to her taste than what she had found in Philadelphia. Her true masters, she later said, were Manet, Courbet, and Degas, and when at last her pictures were given a place beside theirs, her fondest dreams were realized. "I began to live," she told her French biographer in 1913, sounding more than ever like the quintessential Jamesian heroine. But Mary Cassatt gave the Jamesian fable a special twist. To the artistic vocation, usually reserved in James's fiction for his male characters, she brought all the independence and determination, all the courage and ambition, of the Jamesian heroine in search of romance. For art was indeed the great romance of her life, there being no evidence of any other.

She began submitting her pictures to the official Salon in Paris, and one of these—a small portrait of a woman—happened to be noticed by Degas in the Salon of 1874. He pronounced it "genuine"—high praise from an artist known to be a misogynist and never renowned for lavishing extravagant compliments on the work of his contemporaries. Three years later he sought her out—she was, by then, permanently settled in Paris—and invited her to join the "Independent" group of painters already known as Impressionists. In this, too, there is an irony worthy of a Jamesian scenario, for

Mary Cassatt thus passed into the history of modern art under the banner of a style that ill-describes either her interests or her achievements.

"I will not admit that a woman can draw so well"—Degas's famous back-handed tribute to Cassatt's draftsmanship remains an important key to an understanding of her work. She had little of the Impressionists' interest in outdoor effects of light. She was not really a distinguished colorist. She produced few landscapes, and these are never her strongest or most personal pictures. She was primarily interested in the figure—in portraiture, in fact—and in that radical revision of pictorial space for which the Impressionist generation found inspired precedents in the Japanese print. Degas, who repudiated the Impressionist label, was the great exemplar of the style she aspired to, and he became the guiding spirit of her work.

In the biography of Mary Cassatt that Frederick A. Sweet published in 1966, he wrote that she "was not a very inventive painter and could prosper only when she was surrounded by strong influences." The question raised in this harsh judgment is certainly the one that haunts the visitor to the large retrospective exhibition of her work at the National Gallery of Art. This is the largest exhibition of her work we have ever had—one hundred paintings, pastels, and graphic works. The career they trace is so interesting, the artistic intelligence embodied in the finest examples so forceful, and the incidental charm of her work so engaging, that one is reluctant to admit, even to oneself, a certain dissatisfaction with the exhibition as a whole. But the admission must be made. There is simply not the pressure here to sustain an exhibition on this scale.

This dissatisfaction fades, of course, in the presence of her undoubted masterpieces. The greatest of these, in my opinion, is the portrait of her mother, "Reading *Le Figaro*" (1883). This marvelous painting, all whites and grays, is a triumph of pictorial realization. The design, with its mirror-image locking the figure into a space that is totally felt, achieves a perfection rare for this painter. The figure, moreover, is beautifully integrated into this space— unlike so many of Cassatt's figures, which seem to exist in a physical realm almost separate from the space they occupy. Then, too, there is the iron grasp of character, a psychological dimension that raises the painting to a height all its own. Seeing this picture, one can well understand why Gauguin, comparing Cassatt to Berthe Morisot,

declared, "Miss Cassatt has as much charm, but she has more power."

The power could not be sustained, however. The truth seems to be that few subjects moved Mary Cassatt as deeply as her mother, and she was the kind of painter who needed a subject that moved her—moved her beyond the boundaries of "pictorial problems" into a more personal realm of inspired expression. She was repeatedly drawn to the subject of children, and with certain exceptions—the best, I think, is the "Child in a Straw Hat" (1886)—these repeatedly failed her. Degas characterized one of these pictures as "little Jesus with his English governess," and his remark sums up a great deal of what still troubles us about this aspect of Cassatt's work.

The exhibition is certainly welcome, nonetheless. What remains so impressive about Mary Cassatt as an artist, even beyond her isolated masterpieces, is the absolute seriousness of her work. She aspired to the highest standards of her day, and she knew what they were. She felt nothing but contempt for compromises with fashionable or official taste. She was, in the best sense, an Independent—James's "passionate pilgrim," unwilling to settle for innocence, provincialism, or a fate determined by moribund custom.

October 4, 1970

17. The Stratagems of Realism

Every work of art is a fiction—a fantasy endowed with the power not only to coexist with the real objects of this world but to modify in some degree the very manner in which we perceive these objects. The modern movement in painting has brought this fictive element in art to a high degree of self-consciousness and has done so, paradoxically, by declaring the unequivocal reality of its own arti-

fice. Nothing is more characteristic of modernist art than its radical insistence on shedding all disguises.

One of the unforeseen consequences of this development has been the extent to which *all* pictorial styles—not only those which explicitly proclaim their own fictive stratagems—have now been altered for us by our awareness of this fundamental *donnée* in the aesthetic transaction. In a famous statement in 1890, Maurice Denis wrote: "It is well to remember that a picture—before being a battle horse, a nude woman, or some anecdote—is essentially a plane surface covered with colors assembled in a certain order." Eighty years later this observation is likely to strike us as a commonplace precisely because its essential point has entered so deeply into our assumptions about all art.

No style or group of styles has been more drastically altered for us by this change in our outlook on what is "real" in a work of art than those which came into existence under the banner of realism. For realism makes a double claim on our attention, appealing at once to our sense of recognition of the world beyond the boundaries of art and our capacity to respond to a wholly imaginary conception of that world. It is in the nature of the realist aesthetic to deceive the spectator, if only temporarily; to trap him into mistaking a fiction for a report on reality; to lure him into suspending his disbelief in the artifice of art long enough to fasten his attention on forms that give every appearance of transcending artifice in the interest of bringing him a glimpse of reality itself.

Yet realism *is* an aesthetic conception. It is as dependent on conventions and stratagems, on devices artfully employed, on the whole fictive process of art, as any other style. And to the modern eye, so radically disabused of its innocence in regard to this process, it is the conventionality of realism—the degree to which it too must, perforce, abide by the "artificial" imperatives of style—that is most remarkable. Modernism has not, I think, diminished our natural capacity to respond to the feat of representation which is essential to realist art, but it has totally altered the character of our response. We now see such feats of representation as simply another species of pictorial fiction—as one more option in the battery of possibilities open to the pictorial imagination. Despite its name, realism is no longer assumed to enjoy special privileges vis-à-vis the "reality" it claims to represent.

Inevitably, then, our response to a historical exhibition like

"The Reality of Appearance" at the National Gallery of Art in Washington is bound to be very much at odds with the kind of innocent, amused response that the artists themselves had reason to expect in their own lifetime. Subtitled "The *Trompe l'Oeil* Tradition in American Painting," this exhibition is a survey of those native artists of the nineteenth century, from Raphael Peale (1774–1825) to John Haberle (1856–1933), who specialized in ultrarealist still-life pictures.

Although twenty-eight painters are represented in this exhibition of more than one hundred works, the major figure here is William M. Harnett (1848–92), to whom approximately one third of the show is devoted. The second largest section is devoted to John Frederick Peto (1854–1907), who is represented by fifteen pictures. The exhibition was chosen by Alfred V. Frankenstein, the art critic of the San Francisco *Chronicle,* who is the leading authority on American *trompe l'oeil* painting, and is being circulated by the University Art Museum, Berkeley, California, where Mr. Frankenstein also serves as Curator of American Art.

What the pictures in this exhibition have in common is an extremely meticulous representation of (mostly small) objects arranged in a very confined, shallow space. The objects vary, of course. Harnett favored old pipes, crocks, books, newspapers, candlesticks, tankards, musical instruments, sheet music, and old letters. But money, labels, guns, old photographs, lengths of string, and all manner of small hardware also figured in these "fool-the-eye" compositions.

Although the compositions themselves always affect a slightly miscellaneous look, neither the choice of objects nor their arrangement is in any sense random or improvised. Quite the contrary. The objects are carefully chosen for their age and association—for their power to evoke a sense of nostalgia. Peto called one of his pictures "Old Souvenirs," and Haberle one of his "The Changes of Time"; both titles could easily serve for most of the pictures in the show. Even in their own day, these paintings were remembrances of things past.

Allied to this appeal to nostalgia is the suggestion of anecdote which is more or less implicit in each work. The spectator is supplied with the vividly rendered props of a narrative he is free to devise for himself. The dreamlike verisimilitude of the objects induces daydreams of imaginary episodes. And not only anecdote

but social history, too, is strongly implied in the choice of objects and the manner of their realization.

Thus, the realism to be found in these *trompe l'oeil* paintings was, at the very outset, placed at the service of a purely fictional impulse. Visual fact, for all its uncanny specificity, was made to function as a mode of fantasy. But to the modern eye, it is not only the element of fantasy in these paintings that reminds us of their fictional intention. Even stronger is the element of abstraction—a sense of pictorial design so totally conceptualized, so overwhelmingly formalized, that no object is ever allowed to violate it.

The paintings of the *trompe l'oeil* tradition have not, I think, lost their power to charm us, but they charm us now in a very different way. We are no longer taken in by their realism. What appeals now is the elaborate artifice and the sense of paradox which this "fool-the-eye" strategy signifies for an eye educated in the belief that "a picture . . . is essentially a plane surface covered with colors assembled in a certain order." It is indeed our sense of the *unreality* of these paintings which now elicits our interest in them.

March 29, 1970

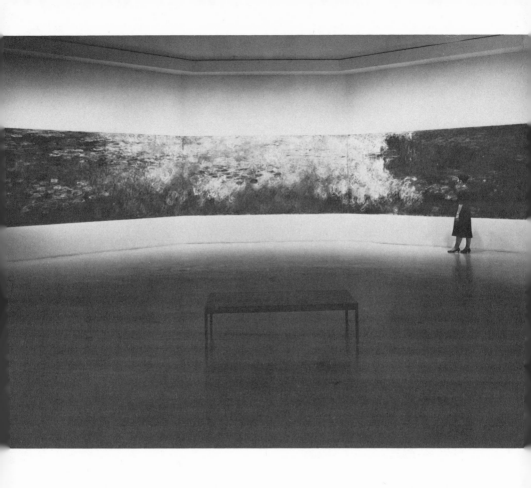

CLAUDE MONET: *"Water Lilies"* (*c. 1920*)
Oil on canvas, triptych, each section 6′ 6″ × 14′
COLLECTION, THE MUSEUM OF MODERN ART, NEW YORK. MRS. SIMON
GUGGENHEIM FUND

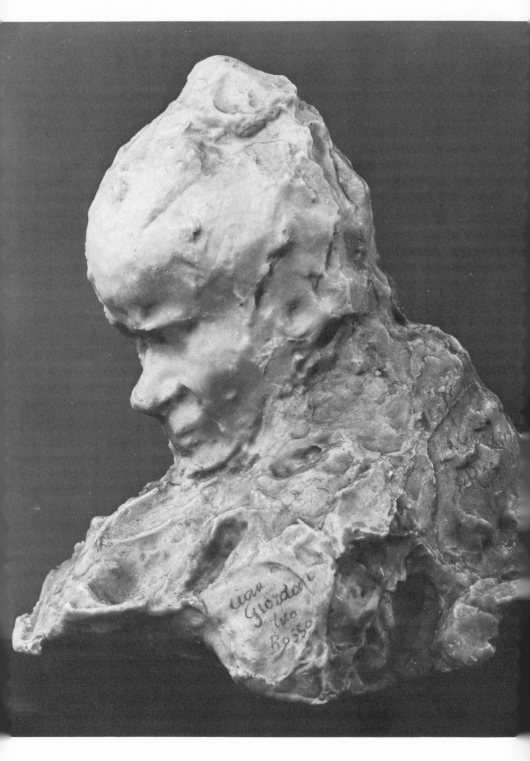

MEDARDO ROSSO: *"The Concierge"* (La Portiaia) (*1883*)
Wax over plaster, 14½ × 12⅝"
COLLECTION, THE MUSEUM OF MODERN ART, NEW YORK. MRS. WENDELL T.
BUSH FUND

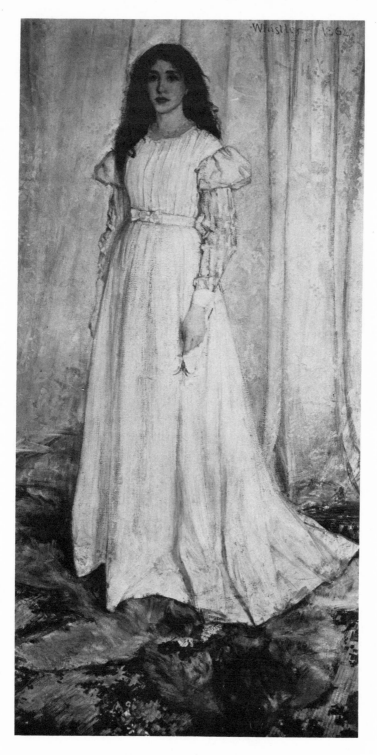

JAMES McNEILL WHISTLER: *"The White Girl: Symphony in
White No. 1"* (1862)

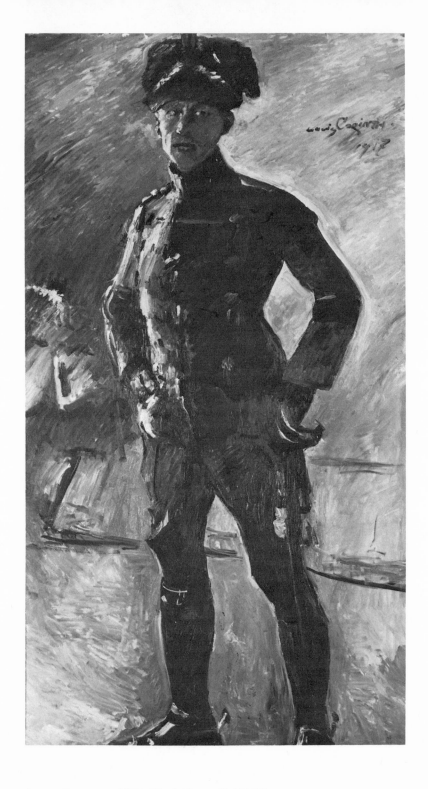

LOVIS CORINTH: *"The Black Hussar"* (*1917*)
Oil
COURTESY ALLAN FRUMKIN GALLERY, NEW YORK

III. The Twentieth Century: Germans and Other Northerners

1. Lovis Corinth

Why is it that an artist who is one of the towering figures of modern German painting, a master in his own right, and a seminal force among his immediate successors, should remain—at least until now —relatively unknown to the broad public which in recent years has become so familiar with the principal artistic accomplishments of this century and the last?

Though the answer to this question is not to be found in the realm of aesthetics alone, it is nonetheless an odd aesthetic fact that for some decades now modern German painting has been, with few exceptions, more of an enigma than an easy cultural acquisition outside its immediate sphere of influence in Northern and Central Europe. Not only in the United States and England but even more emphatically in France and the Mediterranean countries, the peculiar genius of German-speaking modernists (and here one includes Austria and Switzerland as well as Germany itself) has only rarely penetrated either public taste or the individual artistic conscience. It has sparked very few of those wholesale waves of imitation and emulation which for more than a century have followed upon each successive innovation from the School of Paris. A private artistic interest for some, an object of historical curiosity or sociological import for others, German painting of the modern period may still be said to constitute a virtually unknown territory for the vast numbers of people who today feel quite at home with Picasso and Matisse, with Impressionists and Surrealists and abstractionists of every persuasion.

We tend to forget, I think, how recent a development this curious isolation of German modernism really is. We forget, too—if, indeed, we ever knew—how an essentially political phenomenon was slowly allowed to be transmuted into an aesthetic *fait accompli*. The unjustness of this cultural transmutation can scarcely be overstated, for it resulted in banishing from the consciousness of the free sophisticated intelligence precisely those artists whose works were the principal spiritual—and all too often, even the physical—victims of a political repression we had every reason to abhor. The modern movement in Germany thus lost the sympathetic attention of the rest of Europe—and of America—at the very moment it was suffering its

severest blows from Nazi charges of *Kulturbolschewismus*. Its artists have been a long time regaining that attention.

Modern painting has been, from its beginnings, an international phenomenon, but its history—or what might be called its "publicity"—has been largely written out of nationalist commitments. Bounded at one geographical extreme in Moscow (in the period just before and after the Russian Revolution) and at the other in New York, the most significant modern art centered in Paris, Berlin, and Munich, and a great deal of importance took place in Vienna, Zurich, London, Brussels, Barcelona, Milan, Dessau, and Oslo. The internationalist character of the modern movement was still an article of faith among the cognoscenti of the 1920's. In the pages of the American *Dial*, for example, works by Northern and Central European artists were reproduced together with those of the School of Paris, exactly as the writings of Thomas Mann and Hermann Hesse were published alongside those of Jean Cocteau and Paul Valéry. But the war and the Versailles Treaty had already begun to undermine a clear view of this history in less sophisticated circles, and the successive campaigns waged against modernism by Stalin, Hitler, and Mussolini finally isolated the modern movement in Paris.

By the 1930's Paris alone was both politically free and aesthetically hospitable. Foreign artistic circles (such as those in London and New York) that looked to Paris for their aesthetic intelligence had, perforce, to narrow their focus. Modern art came to consist largely of what was reproduced in the annual volumes of the *Cahier d'Art* and other French publications. When Paris fell to Hitler in 1940 and the leading personalities of the School of Paris moved to New York to sit out the war, the focus shifted again and New York emerged as an influential center. After the war, the writing of twentieth-century art history was chiefly concerned with this Paris–New York axis, and there was an understandable tendency to make the past conform to the interests of the present.

Individual artists who, like Paul Klee, enjoyed widespread fame and influence outside their native milieux, owed more than a little of their success to the way they grafted Parisian ideas—in the case of Klee, the ideas of Cubism—onto the mainstream of the German imagination. But that imagination itself, in its purer and more characteristic modern forms, tended to be lost from view. When encountered in recent years, it has often proved to be too raw,

psychologically, and too abrasive, spiritually—too utterly vehement in feeling and inelegant in method—for tastes nurtured on the intellectual refinements of Parisian aesthetics.

The work of Lovis Corinth, though it belongs to an earlier period than that of the artists who endured at firsthand this wave of political repression and historical revisionism, has suffered nevertheless from its critical effects. And indeed, the fact that an artist of Corinth's stature is not now a familiar classic throughout the West is a measure of how deep these effects have been. For Corinth is unquestionably a painter and draftsman on the old, heroic scale. His brilliant and copious *oeuvre*, far from being in any sense an aesthetic byway or a sport of history, takes its place with ease and authority in the mainstream of Western painting. It constitutes one of the crucial chapters in the rich and often tortuous development of European painting as it passed from the immense but problematical spectrum of possibilities in the nineteenth century to the permanent and almost too fecund crises of the twentieth. It joins one of the great movements of the last century—the realism initiated by Gustave Courbet in France and practiced with great distinction by Wilhelm Leibl in Germany and Thomas Eakins in America—to one of the central and essential styles of our own era—Expressionism.

Corinth was not himself an Expressionist, but Expressionism—the most important movement in modern German art—forms the aesthetic link that binds us to his achievement. So long as that link remains misunderstood and in critical doubt, the contours of Corinth's genius are not fully graspable, nor the difficult beauty of his greatest works easily accessible. For this was an artist steeped in the conventions of tradition—the tradition of Rembrandt, Hals, and Rubens; of Velázquez, Courbet, and Manet—and one who broke with those conventions, to the limited extent that he did, under the pressure of severe and deeply felt emotions, and even then, in order to extend conventions rather than to shatter them. His large body of work thus loses something of its true shape and size when considered outside the history in which it played so pivotal a role. In Corinth's case, the role was that of an innovator *malgré lui*. What for him began as a profound personal necessity—the recasting of the realist tradition by one of its most gifted practitioners into a distinctly modern language of feeling—turned out to be, for the Expressionist generation that succeeded him, a collective artistic imperative.

Moreover, the very qualities Corinth brought to his innovative

role may today, in some quarters anyway, act as a barrier to a just appreciation of his art. Nowadays we tend to lose sight of the creative reciprocity that obtains between convention and innovation. The whole drift of our culture—a drift against which the modern movement was once inclined to protest, but to which it now mainly conforms—militates against a conscious awareness of this reciprocity. The artists on the current scene who make the biggest splash usually represent, quite apart from their individual merits, a repudiation of precisely that sense of the past which, for Corinth and the artists of his time, was still a living reality and a source of creative vitality. An art that derives from so intimate and confident an emulation of the great tradition may therefore come as a discomforting revelation. Hopefully, it may at the same time be an exhilarating rediscovery of a lost world.

What Corinth's achievement dramatizes anew, then, is just what the idea of "tradition" means in the hands of genius.

Corinth's lifetime coincided with the last period in which the official art academies of the great European capitals still had reason to regard themselves, even if mistakenly, as the sanctioned custodians of tradition. And indeed, the quintessence of modernism may be said to have first announced itself in those artists of the nineteenth century whose re-examination of the Old Masters showed them to have qualities that were radically at variance with the values then being upheld by the academicians who were the ostensible guardians of tradition. Modern art, before it became a campaign for "the future," was thus first of all an effort to recapture and build on the most vital links with the past.

This effort developed at a slower rate of speed in Germany than in France, and in the service of a different mode of feeling. Germany could claim no Delacroix or Corot or Daumier. Its own master of the Romantic period, Caspar David Friedrich, was an artist who combined to an extraordinary degree a vivid, detailed, illustrational style with otherworldly, dreamlike subjects, but neither his remarkable powers as a draftsman nor his gift for evoking exalted visions of unreal worlds was particularly useful as a means of "connecting" with the Dutch, Flemish, and Venetian masters whose works held the key to the revitalization of painting. *Their* special strength lay precisely in having transcended the disjunction between drawing and painting, between illustration on the one hand

and pure painterly color on the other, that had long been the bane of the German school in general and of Friedrich in particular.

In order to appropriate this painterly tradition for their own uses, the Germans had to look elsewhere—to Constable in England, to Delacroix, Corot, and especially Courbet in France, and to the past itself. Even so, their pursuit of a style that was freely and intrinsically of the brush, rather than an echo or a restatement of the draftsman's pen, was fragmentary and ill-sustained. It was Leibl (1844–1900) who created the firmest foundation for this painterly tradition in the generation preceding Corinth's own. As the German critic Meier-Graefe wrote: "In Leibl there was a remarkable union of pure painting and pure draftsmanship, two things which in most of the great Germans are incompatible . . . [he] is the most brilliant representative of our art in the nineteenth century because at moments he brought the two into complete harmony." Leibl was able to effect this synthesis of the painterly and the graphic by reverting to the methods of the Dutch masters, and in this respect, as in others, Corinth was Leibl's heir.

He was also something more, of course. And there is, I think, no better way to gauge Corinth's particular achievement in the course of his career than to look at it in the light of Meier-Graefe's interesting comparison of Leibl and Manet. Of Leibl's "Cocotte" (1869), Meier-Graefe wrote: "It is our 'Olympia.'" And he continued:

It is significant, I might almost say it is essential, for the understanding of the difference between [German] art and the French to note how the two greatest representatives of either race arranged their respective masterpieces. . . . The one gave his cocotte naked, showing his greatness in the nude; the other left her clothed, revealing himself no less significantly by this means. The one when he painted his most important group planted naked women among clothed men in the open air; the other [in "Peasant Women in Church" (1878–81)] dressed his women in all the clothes they could carry, set them in a church and put prayer books in their hands. We see different habits of life, opposed systems of morals, races fundamentally diverse, each of which keeps to that which is suited to its own needs. The "Olympia" is the re-awakening of Titian who painted the most womanly of nudities, the Queen of the Tri-

buna. The "Cocotte" is the relative femininity of the race that created Holbein's men. The difference is the difference in age of the two cultures; it is all to the advantage of the Latin who is old enough to have had a glimpse of the Gods of Greece and it is our misfortune that we were Christians when we first appeared in history.

Meier-Graefe then added a further note on Leibl that places Corinth in a useful perspective: ". . . in most of his other works," he wrote, "[Leibl] was obliged to regard painting in the French sense merely as a stage to be passed through."

Now anyone who knows the breathtaking painterly freedom of Corinth's middle and late styles—the pictures which immediately preceded his illness of 1911, and the even more astonishing pictures which followed on that illness and continued until the artist's death in 1925—will see how far he had traveled from Leibl's example, and how far, too, he carried German painting with him. *Pace* Meier-Graefe, a good deal of Corinth's later development may be said to consist of bringing the aesthetic spirit of Manet and the "Olympia" home to the Germans—and, in another sense, literally home, for the pictures in which Corinth upheld this spirit most spectacularly, at the same time that he gave it a very personal inflection, were highly domestic. They were celebrations of his marriage to Charlotte Berend and of their family life: paintings in which erotic passion, domestic felicity, and expressive fervor unite to create a genre almost unique in the modern canon—a kind of *Olympia en famille.*

To be sure, Corinth's art could never exactly be called "painting in the French sense." (That designation would better describe, I think, certain pictures by his very gifted compatriot, Max Liebermann—another artist who, even more perhaps than Corinth, remains a victim of our general ignorance of the German school.) Corinth's whole manner was too completely suffused with his personal psychology, his artistic passions too inextricably bound up with his sense of himself as a man, ever to succumb totally to the temptations of French aestheticism. Yet Corinth's art came, all the same, to embody in remarkably large measure the kind of pictorial freedom, painterly finesse, and existential release which Meier-Graefe had in mind when he spoke of "painting in the French sense." For Corinth, probably more than for any other German artist, painting of this persuasion was decidedly not "a stage to be passed through," but a part of its expressive and metaphysical crux.

But the freedom and realization of Corinth's later work was always firmly based on his academic training, both in Munich and in Paris, and on his early adherence to the innovations of Courbet and Leibl. The emancipation of the twentieth-century modernist who prepared the way for Expressionism was clearly born of the nineteenth-century realist who had mastered all the finical pictorial "science" that custom as well as conviction called for.

Thus, Corinth's earlier pictures closely conform to the Leiblesque spirit. The portraits, still lifes, and pastoral landscapes of the 1880's reflect a similarly austere fidelity to their subjects. They show Corinth, even at that early stage in his development, to be an artist of immense natural endowment and accomplished craft. The emphasis is everywhere on observation and felicitous rendering; conventional conceptions are brought to life by sudden flashes of brilliance and personal conviction. The pictures of this period are therefore at once a measure of Corinth's rigorous training and of an expressive energy that could not for long be contained within the received conventions of that training. By the close of the eighties, in a picture like "Kitchen Still Life, Shellfish and Beef" (1889), he had revealed a more restless and independent hand—and a markedly more restless temperament—than could be easily fitted into the constricted "Protestant" assumptions of the style by which he came of age as an artist.

It was in the nineties that the full implication of this restlessness made itself felt. It was then that the realist component in Corinth's art—a component never, even in the most manic and emancipated works of his last years, totally abandoned—first joined with other pressures and other ideas to produce something quite different.

Corinth might, at first glance, seem a typical figure of the nineties. In some respects he was. Literary, mythological, and religious themes abound in his work, and they are precisely the themes favored by the votaries of Art Nouveau and the literary *décadence:* Salome, Leda, Samson and Delilah, Adam and Eve, the Temptation of Saint Anthony. Yet these figures of poetry and legend do not enjoy in Corinth's art quite the same status that the poets, painters, and composers of the *fin de siècle* customarily bestowed on them.

The principal tendency of the nineties was to make something decorative, jewel-like, and exquisite of these poetic materials. The preferred emotion was a kind of languor in which the erotic was

transformed into a mode of feeling in which the religious was not easily distinguishable from the aesthetic, and the aesthetic was all a matter of design, decoration, and surface effects. Concrete experience, specific observation, individual psychology were shunned in favor of generalized, impersonal emotions—sensations almost more than feelings—which could be entered into as easily as putting on a costume or decorating a room. In the process, the devices by which the observed facts of experience might be given a place of importance in the conception of a work of art were quietly jettisoned. Art, for the aesthetic acolytes of the *fin de siècle*, was systematically dematerialized; the observable world gave way to "spiritual"—that is, decorative—equivalents.

By virtue of his temperament, perhaps, as much as for reasons of aesthetic doctrine or artistic training, Corinth stood aloof from this tendency. His earthy personality, his fundamental masculinity and robust nature, separated him—and his art—completely from the "exquisite" side of the nineties. Far from being dematerialized, *his* gods and goddesses, saints and sinners remained very much creatures of this world. And their materiality, their very fleshiness and earthiness, called into play a plasticity, a vigor and concreteness in painterly representation, which stands in dramatic opposition to the "flat" style then in the ascendency throughout the aesthetic purlieus of the European capitals.

Corinth's position might be likened to that of Richard Strauss, who similarly enjoyed the kind of earthy temperament and masculine taste that permitted him to partake of the aesthetic vogue of the nineties without succumbing to its facile and bloodless "spirituality." And just as Strauss invoked the example of Mozart against the aestheticizing tendencies of the Wagnerian heritage in composing for the operatic stage, so Corinth invoked the example of his beloved Dutch masters—Hals and Rembrandt—in addressing his art to the concrete and the particular.

This is not to say, however, that Corinth was completely untouched by the spirit of the nineties or unaffected by the historical and intellectual currents that produced it. As Peter Selz points out in his study *German Expressionist Painting*, Corinth "lived in Munich in close association with the Secessionists and the Jugendstil [*i.e.*, Art Nouveau] artists Eckmann, Obrist, and Behrens until 1900." (It was his move to Berlin at the close of the nineties, and his subsequent marriage to Charlotte Berend in the German capital,

which marked his final break with what the nineties represented.)
But the element in Corinth's art that was strengthened and vivified
by his involvement with the prevailing tastes and ideas of that
decade was not, strictly speaking, a pictorial element. It was, rather,
the emphasis which the *fin de siècle* laid on the mystical and, above
all, on the demonic.

For many of the facile aesthetes of the nineties, the demonic
was, at best, a kind of cultural charade in which little more than the
proper costume was at stake, spiritually or otherwise. Even for more
serious artists, the elevation of artifice to the rank of an artistically
and psychologically exalted goal robbed the demonic of its real
content and transformed it into a kind of décor. Yet for certain
artists, among whom Corinth was surely one of the greatest, the
demonic assumed the status of a force of nature; it emerged as a
threat and a brake to their vitalistic impulses, and their art became a
battleground on which the forces of life confronted the forces of
darkness and death.

From the nineties onward, but particularly after his move to
Berlin, Corinth's *oeuvre* reflects a deep division of this sort. On one
side of this spiritual and psychological abyss, all is lyrical, pastoral,
and full of passionate delight. The daylight world—closely observed
and faithfully rendered—is given a familiar and affectionate em-
brace. An almost innocent ardor is conferred on every motif that
comes to hand: domestic scenes in which homely details and erotic
intensities mingle in an easy union; landscapes which celebrate the
natural scene and the painter's response to it with a direct and
untroubled élan; flower paintings, city scenes, portraits of children
and friends, vignettes of the breakfast table and the outdoor café, all
conjured up with what seems an effortless exercise of sensibility and
craft. To this side of Corinth's achievement belong some of his most
felicitous and accessible pictures—works such as "Oyster Dinner"
(1902), "Lake in the Woods" (1904), "The New Pond in the Berlin
Zoo" (1908), "Kaiser Day in Hamburg" (1911), "Mother and
Child" (1911), "At the Dressing Table" (1911), "Breakfast Still
Life" (1913), and some of the amazing nudes of 1910–11, among
many others.

It was this lyrical, hedonist part of Corinth's production which
formed the basis of his reputation as an "Impressionist"—a desig-
nation that is accurate enough if taken to imply an empathetic,
descriptive account of the natural world and a style attuned to the

quick, sketchlike transcription of immediate visual impressions, but utterly misleading if taken to suggest an effort on Corinth's part to incorporate the specific chromatic methods of the French Impressionists into his own work. Corinth's "Impressionism" has a far closer affinity with those dazzling flicks of the brush one sees in the luminous ruffs of Hals's solid Dutch burghers than with the intricate orchestrations of color touches in the landscapes of Monet and his friends. There is, perhaps, a more tenable resemblance to be found in the nudes of Renoir, but even there, more in the way both painters took hold of their subjects—boldly, with great emphasis on the sensuousness and physicality of the flesh—than in their respective painterly methods, and even this resemblance, such as it is, probably owes more to their common interest in Rubens and the Venetian masters than to direct influence. The work of Corinth stands, in any case, at some distance from Renoir in its overall spirit, and underscores the degree to which the German painter, even in his sunniest and most lyrical mode, remained firmly within the "Northern" orbit. For Renoir, we feel, the hedonist outlook was a natural concomitant of experience that required no special effort of the will, no existential leap, to be given full expression. Far from placing a strain on his psychology or effecting a personal liberation, the artistic form of that expression gives every indication of being the inevitable fulfillment of a way of life; whereas for Corinth—even in his freest moments of release—this daylight world of delight seems a prize dearly won, a liberation arduously pursued and triumphantly achieved, but only after grappling with formidable obstacles.

The nature of those obstacles and the intensity of the grappling are everywhere to be seen in the harrowing pictures of Corinth's last years, but it is worth noting, too, that they are already evident even in some of the more placid pictures of the nineties. One in particular that takes on an almost prophetic meaning in the light of the artist's later obsessions is the "Self-Portrait with Skeleton" (1896). Corinth portrays himself in this painting in a mood practically benign; none of the anguish and self-laceration that are so compelling in the late self-portraits is to be seen here. Yet the macabre symbol of death that occupies a place nearly equal in importance to his own visage in the picture clearly portends the theme that will more and more occupy his mental and artistic life in later years and with more dramatic effect.

This abiding concern with death and decay is also to be found in the pictures Corinth devoted to slaughterhouses and carcasses. The subject matter itself was undoubtedly derived from his interest in Rembrandt, who had given it memorable expression, but Corinth gave it a more psychological inflection and made it a disturbing fact of his own mental universe. No less than the dramatis personae of the Bible and the old mythologies, he made these bloody carcasses part of his own earthly existence.

I have already remarked that Corinth's religious and mythological pictures, though they reflect the prevailing period interest in such themes, always portray their subjects as distinctly worldly creatures. In this respect they comprise—and increasingly so after the turn of the century—not a flight from reality but only another arena in which he confronted his death-haunted obsession with the flesh. There are, for example, certain pictures which cannot by any stretch of the imagination be placed with what I have called the "daylight" side of his art, but which have as their ostensible theme the celebration of life over death. I mean those manic portrayals of Bacchus in which the stout protagonist always more or less resembles the figure of Corinth himself, even when not explicitly identified as a self-portrait. Indeed, the theme of the Bacchanalia in Corinth is, in some ways, more ominous than the direct encounter with darkness and death, for it underscores more poignantly the profound inquietude that underlay his commitment to life. Behind the healthy bluster of such pictures one senses a death-dealing doubt that is already very deep.

When one turns to the side of the abyss in which darkness is the pervasive medium of all feeling and decay the fate embracing all existence, the full intensity of this inquietude shows itself with a shattering force. This is particularly true of the paintings—and the no less remarkable drawings and watercolors—which Corinth produced in an almost demonic and unabated copiousness in the years following the stroke he suffered in the winter of 1911. One sees in the work of these last fourteen years of his life not only the drama of a great artist transforming his style under the pressure of the most exacerbating experience but also of a man confronting his fate— affirming life in the shadow of death. Art was, for Corinth, a medium of affirmation—inseparable from the *élan vital*.

The characteristics of Corinth's celebrated late style—the controlled frenzy of its brushwork, the intensity of its depictions, the

unabashed emotionality of its entire mode of address—are "new" only in the sense that they reflect a greater concision and a greater depth of feeling. They result from the artist's having submitted the conventions practiced with such ease in his early development to the grueling necessities of his own later experience. The concentrated pictorial effects of these late paintings trace the course of a personal drama even as they lay bare the triumph of a revitalized art.

Every motif to which Corinth addressed himself in his last years is invested with the momentum of that drama. Had he produced nothing else in these years but his Walchensee landscapes— lyric evocations of a world which seems to pass into the realm of hallucination, and back again, before our very eyes—he would still be a figure of sizable interest. One of the very last cityscapes that came from his hand—"Garden in Berlin, West End" (1925)— remains one of the prophetic masterpieces of the twenties, even if it has not yet been widely recognized as such. And still lifes and flower pieces of rare power abound in the late period.

But it is, above all else, in his portraits and self-portraits that Corinth produced in the end his finest achievement. These portraits include an astonishing repertory of types and moods and a no less astonishing arsenal of painterly means for capturing on canvas the exact visual equivalent of the emotion the artist wished to convey. Corinth's wife and two children loom large among the subjects of these late portraits; painters, poets, and professional men of the period, together with some other family connections, make up a good deal of the rest. And year after year, there are those searing images of self-regard in which Corinth, confronting his own mirror, made his deepest artistic avowal.

Some of the best of these pictures—the "Study of Professor Edouard Meyer" (1911), "Wilhelmine with Ball" (1915), "Portrait of Frau Hedwig Berend" (1916), "Thomas and Wilhelmine" (1916), "Portrait of Mr. Beyer" (1917), "The Black Hussar" (1917), "Portrait of Admiral von Tirpitz" (1917), "Portrait of the Painter Artur Degner" (1925), and numerous of the self-portraits, among which I find it difficult to make choices—pictures on this order brought Corinth's art to the boundaries of the Expressionist era. And just as his earlier work could best be distinguished by comparing it to his predecessors in the nineteenth century, this late work can perhaps be most profitably discussed in relation to his contemporaries and successors in the twentieth.

By the time Corinth came to paint many of these pictures, the Expressionist movement had, of course, already seen its first flowering—though its greatest representative, Max Beckmann, was not to produce his strongest work until the decades following Corinth's death. The Corinth who contributed something essential to the birth of Expressionism was the Corinth of the turn of the century: the painter—and, of perhaps equal importance, the draftsman and graphic artist—who brought the spiritual and demonic obsessions of the nineties into a meaningful dialogue with the innovations of Courbet and Manet. His own late work developed concurrently with that of artists such as Kirchner and Nolde, and, even in retrospect, I believe, gives permanent definition to an area of feeling that is markedly different from, though sharing many affinities with, the Expressionist mode as such.

What, in fact, marks Corinth as a precursor of Expressionism, rather than a participant, is the extent to which his art still inhabits the closed world of European civilization. That this world was smothering his spirit and oppressing his sensibility can, I think, be clearly seen in the tortuous vicissitudes that I have briefly recounted here. But an artist of Corinth's temperament and training could turn nowhere but to his own aggravated mental state, to his own hallucinations and obsessions, to find a way out. For him, there was no exit from the culture he inhabited and the values he upheld as a representative of that culture. And turning inward was, after all, the path prescribed by the tradition of German Romanticism. In this sense Corinth remained a votary of the nineteenth century even in the most radical painting of his later years. Or, to put it another way, the art of these later years gives us a vivid glimpse of the modern temper, struggling with the force of distinctly modern emotions, as it attempted to fulfill itself entirely within the limits of its European heritage.

The Expressionists broke with this strictly European orientation, or at least dealt it a shattering blow. That was their modernism and their optimism. In turning to primitivism, they forged a weapon against the wreck of European culture; the primitive became a standard by which the whole life of feeling was to be judged, and with that standard they judged it differently from Corinth. The Expressionists dreamed of a liberation of the senses, of a renewal of life in a more direct and unfettered concourse with nature. Whitman and Strindberg were their gods; bohemianism was their mode of

life; the image of naked men and women bathing together in the life-giving sun and sea their characteristic fantasy.

Between Corinth and the Expressionists, then, there is a cleavage of the spirit as well as of the generations. Against the unclothed bodies of the Expressionists—representing more of a hope, perhaps, than a realization—we have Corinth's peculiar and symbolic habit of painting himself in a medieval suit of armor. The physical constriction, the solitary and unnatural confinement that this old dream of glory imposed on the body and the spirit, is both a measure of Corinth's distance from the Expressionists and something more: a clue, if you will, to the kind of interest he brought to his portrait subjects.

For the personalities who appear in these pictures—whether Corinth himself, in his various moods, or the many others—are enclosed in something like the same kind of solitary confinement of the spirit. Their armor is their experience, which marks their faces like scars and gives them each an irreparable identity. Corinth triumphed in these late portraits when he was forced to "read" these scars and bring them into a meaningful, expressive relation with all that he knew about the art of painting. He was most poetic—often, indeed, unbearably tragic—where "life" forced the script. Loose and freewheeling as these portraits sometimes are, verging in some cases on a vein of feeling utterly wild and vehement, they belong nonetheless to the great tradition of the Northern masters rather than to the Expressionist mode. The existential imperative that produced them tells us a great deal about the necessity for Expressionism that was so profoundly felt in the generation that followed Corinth, but his own art retains its ineluctable link with the old culture and the old values.

Corinth thus occupies, in the history of German art, a place comparable to that of Cézanne and Rodin in French art. His *oeuvre* belongs at once to the past and to the present. It is the great hinge on which a rich inheritance undergoes a profound metamorphosis into the peculiar stringencies of the modern era. The line of achievement that stems from Cézanne may now be said to have been comfortably—perhaps even too comfortably—assimilated into contemporary culture. Rodin's more ambiguous legacy is at last being given its due. However the achievement of Lovis Corinth may differ in scope from that of his illustrious counterparts in France, it is now

the hour for his great work to enter into its rightful position in our histories, in our museums, and, above all, in that part of our lives where art—rather than the vagaries of artistic fashion—really counts.

October 1964

2. Edvard Munch

The name of Edvard Munch is not one that shines very bright in the contemporary pantheon. Once the doyen of the Expressionist movement, a familiar of the avant-garde in Paris and Berlin and its principal representative in his native Norway, he seems to have passed into modern art history and remained there, secure but marooned within his immediate sphere of influence. In its time, that influence was immense, on a level with his compatriot Ibsen's in the theater. And just as Ibsen's importance is no longer taken for granted in the theater of Brecht, Beckett, and Genet, so Munch's position too has been diminished by the tide of aesthetic innovation.

As a graphic artist Munch's place is more or less assured— even in this country, where the size of his other achievements is but dimly recognized. As a painter, however, he is in the unenviable position of an artist whose characteristic style everyone "knows," whose quality everyone thinks he has correctly gauged, but whose actual work is rarely experienced firsthand. Munch cannot be considered unknown—indeed, his chances of making a deeper impression on us would probably be enhanced if he were—yet how many really know him by his true accomplishments? The 1963 centenary, which might have been expected to focus fresh attention on his work (and which in Northern and Central Europe was taken, properly enough, as a major event), passed virtually unnoticed in this country. I doubt if the book which two of the artist's countrymen,

Johan H. Langaard and Reidar Revold, have now produced on Munch* will do much, either, to alter the atmosphere of benign indifference—so much more damaging to an artist's standing than outright hostility—which continues to surround his work.

This volume is the latest in an interesting series of Munch publications that have been coming out of Norway in recent years**—all of them useful to the interested student but none sufficiently compelling to ignite new interest among the uninitiated. Messrs. Langaard and Revold undoubtedly know more about Munch's life and art than anyone else now writing, and their new book, though compromised somewhat by their reluctance to make the necessary critical discriminations within the artist's vast output of paintings and prints, still has much to tell us about his artistic development and the intellectual milieu that nourished it. In tracing Munch's progress through the bohemian capitals of France, Germany, and Norway in the period from the nineties to the First World War, the authors correctly locate his art at the very crossroads of the Parisian, Berliner, and Scandinavian avant-garde worlds then in the ascendancy. This was the period of Munch's friendships with Ibsen and Strindberg, with Lugné-Poë and Mallarmé and Richard Dehmel and Meier-Graefe, when he was the favorite of both *Pan* and *La Revue Blanche* and worked as a designer for the Théâtre de l'Oeuvre and Max Reinhardt. These were the halcyon years of Art Nouveau, when the aesthetics of Symbolism and Naturalism existed in an intense and fecund relation to each other—years in which Munch created his personal dialectic out of these conflicting currents and produced a style in which the formal innovations of French painting, the radicalism of Nietzschean ethics, and the pathological strain of his own experience were all brought to bear on the visual materials of his native Norway.

There are plenty of artistic reasons why Munch's personal synthesis of French aesthetics, German philosophy, and Scandinavian *Angst* should now be so difficult to come to terms with. Certainly the most important is the fact that there is little in the art

* Johan H. Langaard and Reidar Revold, *Edvard Munch* (New York: McGraw-Hill, 1964).
** See especially Johan H. Langaard and Reidar Revold, *A Year by Year Record of Edvard Munch's Life* (Oslo: Aschehoug, 1961), text in both English and Norwegian; *Edvard Munch: The University Murals* (Oslo: Forlaget Norsk Kunstreproduksjon, 1960), English-language edition; and *The Drawings of Edvard Munch* (Oslo: Kunsten Idag, 1958), English-language edition.

of the present moment that effects a comparable conjunction of elements so wide-ranging in intellectual curiosity. Art, in the interim, has become more single-minded, more cautious of venturing into extravisual modes of thought and expression and appropriating them for pictorial purposes. We thus lack an equivalent idiom into which Munch's particular kind of artistic ambition can be "translated" and made viable again. But preceding even so central an artistic reason for our current distance from Munch is the sheer geographical problem his work represents. The paintings housed in the National Gallery in Oslo and in the newly constructed Munch Museum at Töyen, outside Oslo, constitute the bulk of the artist's *oeuvre*. Together with the murals in the Assembly Hall at the University of Oslo, these paintings represent the central course of Munch's development. No one can hope to judge—or, alas, even to *see*—what that development consisted of, what heights of poetry and vision it reached, and the particular ways in which it passed into decline, without access to this dazzling cache of the artist's major pictures. The illusion that Munch is really "known" as a painter is a technical illusion fostered by the modern habit of judging art on the basis of mechanical reproduction. Only as a printmaker have most of us actually *seen* Munch with our own eyes. His painting has remained, for the most part, an undiscovered—or at least, an unvisited—country.

Munch was as pathological about parting with his pictures as he was about every other aspect of his inner life—all the more so, as art was for him the very crux of the inner life. He allowed the National Gallery of his native city to acquire a sizable number of his works during his lifetime, and then left his own huge collection of paintings, drawings, prints, letters, and documents to the city of Oslo upon his death. It is to house the latter that the Munch Museum has now been built. And it is as an introduction to some of the outstanding works in the museum collection that Messrs. Langaard and Revold have brought out their new book. "From 1914 onward," they point out, "Edvard Munch became increasingly reluctant to part with his works. He sold almost nothing except those pictures that were bought by museums or had been executed on commission. In earlier years he had also been averse to letting his works go but then he had been forced to sell in order to live. Even then, however, there were two groups of pictures which he kept in his possession as long as he could: those works which were linked most closely with

his emotional life, and everything that formed part of the cycle of pictures which he called The Frieze of Life." One can, of course, see individual pictures of great quality in the European museums and, less frequently, in this country too, but Munch's is clearly a case of an artist whom we have to confront in his own habitat if we are to confront him at all.

It was in the hope of seeing at least a part of this *oeuvre*, which has been isolated—and indeed, virtually apotheosized—in the artist's homeland, that the present writer journeyed to Europe by way of Oslo three years ago. As it happened, the pictures belonging to the Munch Museum, which was then in construction, could not be seen. One's impression was that the presence in Oslo of a foreign critic, who might report on the physical condition of Munch's later work prior to its "restoration," sent a tremor of anxiety through the lower echelons of the municipal bureaucracy. (Munch's practice, in his later years, of using an outdoor studio, and his penchant for leaving his pictures standing in the snow, hanging from trees, and otherwise exposed to the rigors of the long Norwegian winter, has left the conservators of the museum an admittedly large problem.) But the galleries devoted to Munch in the National Gallery could be seen, as could the university murals, and it is upon the glimpse of Munch's genius such work affords that I have based my own understanding of his art.

What strengthened that understanding, too, was the unexpected visual drama of Norway itself. The psychological *frisson* that the visitor to Oslo experiences on his first encounter with the December sunset, which comes just as he has finished eating lunch and leaves him adrift in the darkest night conceivable until midmorning the next day, when the sun, a blood-orange disk in a gray-lavender sky, rises again for its short, symphonic tour of the horizon—this experience tells one more about the existential foundations of Munch's art than any critical or historical material could possibly impart. Three days before reaching Oslo, my ship had docked for an afternoon in Bergen, and there, too—in the view of the low, rocky islands that are one's first sight of land after the black North Sea, in the sudden, steep mountains on which clumps of pines rise in jagged stitches on the frozen snow while the sun appears a faint yellow-silver glow in the murky blue-silver sky that might, for all one knows, be snow-covered too—there I felt for the first time that I was in the landscape of Expressionism. There the imagery of

Munch and Nolde was no longer an invention but the brute retinal data of all waking life.

Yet astonishingly, when I came to examine the work of Munch's predecessors in the rooms devoted to nineteenth-century Norwegian painting in the National Gallery, almost no trace of the landscape that had impinged on the eye so powerfully at Bergen, and even in the park a few steps away from the museum, could be seen. Landscapes abounded, of course, but all of them visual echoes of Leibl and Courbet, of the Munich school and Millet. The landscape of Expressionism turned out to be something like an invention after all. And the key to the invention was, alas, the sun-drenched imagery of the French Impressionists—a school of painting utterly removed from the spiritual inquietude of Munch and his Expressionist progeny, but nonetheless crucial to their artistic fulfillment.

Certain of Munch's pictures in the National Gallery reveal that debt to Impressionism very explicitly: the interior "Night" (1890), the cityscape of Paris, "Rue Lafayette" (1891), and the stunning portrait of Meier-Graefe, also from this period, which is a pure distillation of Degas and Toulouse-Lautrec. Such pictures mark Munch's entry into the world of Parisian painting—the Meier-Graefe portrait invokes an elegant stylization, for example, wholly removed from the portrait of Hans Jaeger (1889), also in the National Gallery, which is closer to the portraits then being produced by Lovis Corinth. Munch came to Impressionism, however, at the very moment when the principal Post-Impressionist impulses—the Symbolism of Gauguin and the decorative devices of Art Nouveau—were displacing it in the Parisian avant-garde. Before the broken color and exalted luminosity of Impressionism could take root in his art, they became absorbed into the more openly decorative manner of Gauguin and his school. Thus the "flat" style of Gauguin, with its Symbolist bias and overall exoticism, passed into Munch's painting as a permanent feature, at times totally eclipsing its Impressionist details, but frequently—especially in later years—existing in an uneasy alliance with them.

It was this Impressionist–Gauguinesque component in his art that allowed Munch to incorporate into his painting those expressive visual features of the Norwegian landscape which had eluded his countrymen earlier in the nineteenth century. As Ibsen discovered "his" Norway in Italy, so Munch created his in the crucible of French aesthetics—or, to be more precise, found in that crucible one

of his principal means. For Munch's is not an art in which the purely formal can ever account for everything. The formal innovations of French painting provided Munch with a way of dealing with his experience, but they did not significantly alter his relation to that experience. What did alter that relation—and profoundly—was his involvement in the German avant-garde of Berlin in the nineties. What, indeed, sets Munch apart from other artists of the Art Nouveau persuasion, and what made him a kind of patron saint of the German Expressionists, was the way in which he brought about a *rapprochement* between the surface features of French painting and the social, literary, and philosophical themes then at issue in the Berliner vanguard. Standing outside the conventions of both French and German circles, and yet burdened with a personal history and native temperament that could be effectively transmuted into art only by submitting to the radical ideas of these alien milieux, Munch created a style and a world that transcends the disparate specialization found in each.

If Gauguin represents the French side of Munch's art, it is Nietzsche who represents the German. Quite apart from his personal involvement—he was a friend of Nietzsche's notorious sister and painted a portrait of the philosopher (unhappily, a notably poor picture)—Munch found in *Thus Spake Zarathustra*, a work published in the nineties, an answer to his own inner turmoil. Coming from a family that boasted a lineage of important clerics but himself a rather sardonic anarchist; a sexual romantic who could never reconcile himself to the mysteries of the female mind; a man of strong family and national ties who began his life as a bohemian rebel and ended it, isolated and alone, as a kind of cultural monument; bitter, quarrelsome, plagued by thoughts of death, insanity, and imaginary betrayal, and all the while aspiring to an art that would redeem the spiritual torment of his life—Munch recognized in the Nietzschean philosophy all the contradictions of his own existence.

Munch's art undoubtedly reached its heights in those years— the nineties and the first years of the 1900's—when he was shuttling between the French and German capitals, supported by sympathetic circles of friends in each, and making his most intensive effort to come to terms with his native background by means of these new aesthetic and spiritual discoveries. It is in such works as "The Dance of Life" (1899–1900), "The Death Chamber" (1896) and

"White Night" (1901)—even more, I think, than in the better-known "Cry" and "Anxiety"—that one finds the quintessential Munch of this period. And the period itself comes to something like an end in Munch's nervous breakdown of 1908. Thereafter, though he returns again and again to his basic repertory of themes—and, indeed, attempts both in the university murals of 1910 and in "The Frieze of Life," pictures that occupy him for the remainder of his life, to summarize and elevate these themes to epic proportions; though he remains copious as a producer and rarely falls below a very accomplished standard—still, the Munch of the last three decades or so is an artist struggling to make whole again what once existed in a sublime unity.

One can see a terrifying fragmentation taking place in the university murals, in which painting of exalted elegance and lyricism exists side by side with a rather grim bathos. And the split that is writ large in the murals—a split between the "French" side of Munch's style and its Nietzschean imperatives—continues, with greater or lesser effect, to plague his painting to the end of his life. (He died in 1944.) Its origins are clearly evident in the "Self-Portrait in a Blue Suit" (1909), painted while Munch was under treatment in a mental institution and the first of his many subsequent attempts to paint in a lighter, more "optimistic" mode—to paint, that is, in the French manner, with the Nietzschean component removed. Wherever Munch does succeed in his later work (see, for example, the stark self-portrait called "Spanish Influenza," 1919), one feels very clearly the effort being made to restore the old equation between aesthetic and spiritual elements as a working principle.

Nowadays the very existence of such an equation as a basis of style would be highly suspect; we expect our artists to be altogether neater and more discreet in the disposition of their interests and energies. Yet in Munch's case, the ability to effect that significant connection between the aestheticism of the French school and the spiritual radicalism of the German produced both a great body of work and a major change in the course of modern art in the form of the German Expressionist movement. When one compares Munch's pictures from the turn of the century with those of his French contemporaries—a comparison easier to make in the Swiss and German museums than in ours—his own sometimes seem overly endowed with "psychology" and anguish. But then, compared to his

German and Scandinavian contemporaries, he is the compleat aesthete. No one else, really, managed to sustain that double vision with quite the same power, and it is for that that we shall honor Munch when, if ever, we catch up with his true achievement.

November 1964

3. The Rebellion of Oskar Kokoschka

It is one of the ironies of art history to honor the rebel together with the art against which he rebels. The legacy we garner from the past embraces both sides of the artistic barricades. About the art of our own time we may at times be ferociously sectarian, selecting and rejecting with categorical imperatives, but about the past we display an amiable neutralism. Sooner or later, we want all of it.

The Austrian painter and draftsman Oskar Kokoschka was once the very archetype of the artist-rebel. Into the repressed and ornamental atmosphere of Vienna in the last days of the Austro-Hungarian imperium his searing and intense art came like a scourge, violating not only accepted taste but the hypocritical moral compact that lay behind it. To a public that loved every form of decorative dissimulation Kokoschka offered a vision that insisted on honesty and pain, on the raw nerves of life as it was actually lived, rather than on its comfortable transmutation into one or another version of exquisite fantasy. Naturally, the public preferred the fantasy to this outspoken advocacy of something so rude and powerful and sent up a howl of protest when confronted with the real thing.

In the large exhibition of Kokoschka's work at the Marlborough-Gerson Gallery, there is a good selection of the pictures that earned this artist his reputation as a firebrand in the decade before the First World War. These pictures are primarily portraits, for portraiture was the most effective instrument the artist had at his

disposal for penetrating the smug façade of Viennese respectability. The best of these portraits—those of Peter Altenberg, Ludwig Ritter von Janikowsky, Professor Hans Tietze and Mrs. Erika Tietze-Conrat, Paul Scheerbat, and Count Verona (all from 1909–10)— have a graphic power, a depth of characterization, and a sensitivity to the visual and psychological reality of their subjects that few other painters of this century have been able to match.

They are the kind of pictures that only a young artist working within the confines of a morally and aesthetically suffocating situation could produce. Kokoschka himself, recently turned eighty, has of course continued to paint a good many portraits over the years, but none are like these early examples. Beginning in the 1920's, something more benign entered into the aesthetic equation. The later pictures have quality, but they are not of a kind that strikes the depths.

It is the custom to speak of these early portraits, with their tormented visages and exacerbated emotions, as "distorted," but this is probably a mistake. It is, in fact, a way of undermining and softening their power, which is inseparable from the truth they convey. I am reminded, in this connection, of Santayana's remark about Dickens: that Dickens struck him as a caricaturist until he (Santayana) went to live in England, whereupon he realized that the novelist was in fact a realist. To think otherwise of Kokoschka in this early phase is simply to refuse the artist's vision.

Yet there is no denying the fact that the irony I spoke of earlier has now overtaken Kokoschka's great early work very much as it has overtaken the work of other rebels of the modern period. No one any longer feels constrained to choose between these pictures and, say, the ornamental and voluptuous portraits of Gustav Klimt, Kokoschka's immensely gifted and immensely successful senior contemporary in the Viennese school. Klimt was the court painter, so to speak, to the wealthy Austrian middle class. He had the extraordinary ability to flatter and exalt his subjects, while at the same time, but ever so subtly, exposing their pretensions. His exquisite style, with its flat, decorative patterning, attaining at times a kind of abstract intensity and richness, satisfied his clients' sense of fantasy at the same time that it exposed their vulnerability for all that was most unreal.

Klimt is now regarded as a classic of Art Nouveau, and Kokoschka—at the least the Kokoschka of these early portraits—a

classic of Expressionism. But where once these styles seemed locked in a life-or-death struggle, adversaries in a contest that would determine the probity of art for generations to come, they both now strike us as unique, valuable, and necessary. The struggle, so far as it enters into our experience of these pictures at this distance in time, has been reduced to a historical charade.

This is an odd fate to have overtaken an art conceived with such vehemence and executed with such polemical thrust, but it is a fate no doubt inevitable. What is odder is that Kokoschka should himself have become, in the long run, a far more traditional painter than the eminently respectable Klimt. The current exhibition at the Marlborough-Gerson Gallery includes sixty-eight paintings, fifty-seven watercolors and drawings, and a selection of recent graphics, and ranges in time from 1907 to August 1966. It contains many glories, and these are by no means confined to the earlier works. But it is the nature of these glories to echo the masters, to seek out a personal—and personal is what Kokoschka's work always is—inflection of an established mode. Over the long course of a distinguished career, the rebel has turned into a guardian of the great tradition. By comparison, Klimt seems the more daring and surprising artist, if also the more eccentric.

But it is the virtue of Kokoschka's achievement, early and late, to remind us of what this great tradition—the tradition of the Dutch and Flemish masters mainly—can still yield a rich sensibility intent upon applying its lessons to the materials of modern experience. The results, in recent pictures like "Sunflowers and Mask" (1964) and "Still Life with Cat" (1965), are not of a sort that can be assimilated to any historic struggles or daring departures, but they have a lyric power only a painter of long experience and superior gifts could command. And yet there is a certain sadness in noting their distance from the moral intensity of the artist's earlier days.

October 23, 1966

4. Egon Schiele

The life and work of the Austrian painter Egon Schiele form a chapter in the history of modern art which, though brief, is unforgettable in its combination of irrepressible talent, tortured vision, and personal agony. Schiele was the very embodiment of the artist *maudit*, and the course traced by his short, electric career in the Vienna of the turn of the century has an almost allegorical quality in its unequal mingling of suffering and accomplishment. That the accomplishment was possible in the face of so much suffering is a testimony to Schiele's profound commitment to his artistic vocation, yet this commitment cannot disguise the fact that the accomplishment itself bears the scars of the artist's suffering at every turn. For Schiele's *oeuvre* is one in which we feel the presence of the artist's agony first as a stimulus and finally as a limiting and nearly disabling affliction.

Recent exhibitions of Schiele's paintings and drawings—particularly the double exhibition of "Gustav Klimt and Egon Schiele" directed by Thomas M. Messer at the Guggenheim Museum in 1965—have afforded some tantalizing glimpses of what, exactly, Schiele achieved. Now our understanding of the artist's total work has been much enhanced by the publication of *Egon Schiele* (Crown Publishers), an *oeuvre* catalogue of the paintings compiled by Dr. Otto Kallir, the director of the Galerie St. Etienne in New York and Schiele's most persistent champion.

This is not a book for anyone with a casual interest in the artist's work. A stout volume of over five hundred pages, handsomely printed, with texts in English and German, the book contains a reproduction (mainly black and white) of every known surviving painting by Schiele, complete with details of provenance, plus an additional list of paintings known to have existed but now lost. There is also a selection of documentary photographs. The texts—by Dr. Kallir, the late Otto Benesch, and Mr. Messer—are too brief, but they are useful as far as they go. The book does not bring us Schiele's total work, of course, for it is not designed to include his large and brilliant production of watercolors and drawings—in some respects, a production even more important than the paintings—but the volume is nonetheless indispensable for a true comprehension of

the artist's character and achievement, and thus for a comprehension of the art of Central Europe at a crucial historical juncture.

Less than half a century separates us from Schiele's death in 1918 at the age of twenty-eight, yet the circumstances of his life already read like some fable of a dark and remote age. It was a life entirely enclosed within the claustral and hypocritical atmosphere of the Austro-Hungarian imperium in the last stages of its decadence. A preposterous and provincial public morality existed side-by-side with an extraordinary flowering of intellectual and artistic genius. A narrow and suffocating world contained within it a virtual renaissance of talents whose creative fulfillment was inseparable from the task of laying bare the values that prevailed as a cover for a foolish and bankrupt style of life. We know this world from the work of Klimt and Kokoschka, from Mahler and Schoenberg and Adolf Loos, and from the writings of Schnitzler—a world whose motives formed the materials of Freud's first researches and whose pretensions are forever apotheosized in the operatic art of Richard Strauss.

Schiele proved to be at once the victim and the beneficiary of all the contradictions of this amazing era. His entire development, from a precocious boyhood to an early grave, was dominated by the narrow, life-denying restrictions of this period; the insensitive guardian who opposed the youth's artistic aspirations gave way to the even more ignorant Philistine public that condemned the young artist's vehement creations. And in Schiele's case, it is no idle metaphor to speak of condemnation, for he was once jailed for twenty-four days for having executed "immoral" drawings.

Yet Schiele enjoyed the encouragement of a succession of teachers, artists, and sympathetic spirits, and from the time he entered the Vienna Academy of Art at the age of sixteen, he lived the free, if desperately poverty-stricken, life of an artist. Nor can one attribute the suffering that marks his work entirely to outrageous circumstance, for there was clearly an element of neurasthenic compulsion in Schiele's sensibility which circumstance abetted and inflamed, but which it could not of itself have created. Schiele's rebellion was in the end a rebellion against life itself and not only against the life of his time.

The visual form which this rebellion took was first the imitation and then the subversion of the style of Schiele's great—and greatly admired—senior contemporary in Vienna, Gustav Klimt.

What one sees in Schiele's most powerful work is the highly decorative and ornamental vision of Klimt, who managed both to flatter and ever so gently to expose the pretensions of his bourgeois patrons, invested with a more adamant and uncompromising concern for psychological truth. The eroticism that in Klimt is always enveloped in a hedonist's dream of pleasure is, in Schiele, turned into an unyielding exposure of anguish and pain. Even Klimt's glorious and luminous color is turned dark, muddy, and grim in Schiele's more lacerating version of the same thematic materials. In a sense, Schiele's entire work was bounded by the attempt to do Klimt over again from his own afflicted nature.

True, in Schiele's final pictures one detects an element of benign feeling that pointed to a more felicitous accommodation to things as they are. But it was too late. In the last days of the First World War, after enjoying his first public success in the annual exhibition of the Vienna Secession, both Schiele and his wife were overcome by the flu epidemic that swept over Europe, and his death on October 31, 1918, followed hers by only three days. Fortune ensured that the tortured countenance of his outraged sensibilities would remain his indelible legacy.

January 8, 1967

5. Nolde: An Aggrieved Solitary

In the exhibition of graphic art by Emil Nolde at the Allan Frumkin Gallery, there is a self-portrait etching (No. 32 in the catalogue), dated 1908. The face that meets our glance in this etching is neither young nor particularly pleasant. The mouth, set in a grim, determined expression, is a little cruel. The eyes, slightly askew in their uneven shadows, stare with an intensity that suggests the possibility of madness. Certainly there is no trace of sociability or human

felicity in this self-image. It is an image of a man possessed by emotions that carry beyond the reach of workaday cares and the values that govern them.

We have seen this haunted look before—in the self-portraits of Van Gogh, Munch, and Lovis Corinth, and in the works of Rembrandt's old age. It is the look of a man isolated in his own spiritual turmoil—an aggrieved solitary bending art to purposes which art alone can probably never fulfill. In Nolde's case, the isolation is all the more intense because of the peasant solitude and primitive religiosity which he carried with him, untouched by the light of reason or the ameliorations of urbanity, even in the period of his immersion in the advanced cosmopolitan culture of his day.

Nolde is one of those fierce, troubling figures who doesn't fit easily into any of the categories we devise for understanding the meaning of modern art. He was, to be sure, an Expressionist—in some respects, the very archetype of the Expressionist personality. Like the artists of *Die Brücke* group, with whom he formed a temporary alliance in 1906, he was in open revolt against the bourgeois mercantile ethos of modern industrial culture. He, too, yearned for some transcendent union of nature and spirit that would vanquish forever the entrenched materialism and elaborate social artifice of the modern world, and found in art a mystical refuge—at once a solace and a revenge—from all that he most detested in his own epoch.

Yet Nolde was anything but a representative votary of the avant-garde. The powerful libertarian impulse of *Die Brücke* was repugnant to his narrow and suspicious outlook. The freedom of spirit that was an article of faith for the younger Expressionists was alien to his temperament. The bohemian manners of the Expressionists, their sexual emancipation and complex intellectual culture—all this was distant and distasteful to Nolde. Whereas the main thrust of the Expressionist movement was on the side of life, Nolde seemed never really at home in human society. Even his religious fervor seemed to separate him from normal social intercourse. As one of his German commentators remarked: "His was the brooding, highly vulnerable religion of a solitary reader of the Bible, a religion that easily becomes eccentric and is characteristic of the Protestant north."

For an artist so rigidly disposed, nature was the only consolation—the harsh and dramatic landscape of Nolde's native province

on the North Sea, with its vast sky and spectacular light hovering over endless vistas of solitary flatlands. In the presence of this landscape, the atavistic dream of a mystical union of blood, soil, and spirit was once again a compelling reality. Human society was, by contrast, a realm of the grotesque.

All of this, needless to say, had distinct consequences for Nolde's work as an artist. It meant, first of all, that all of his reserves of tenderness and empathy were lavished on nature—on landscapes and flowers, the subjects that elicited his freest energies and most poetical vision—rather than on the human comedy itself. The exceptions to this rule are confined mainly to the portraits of his beloved wife, Ada, and to the self-portraits. Human society beyond the boundaries of the domestic hearth inspired only a ferocious gift for "gothic" exaggeration and pitiless satire. Human intercourse, as Nolde depicts it, is mainly an arena of cruelty and doom.

This is even true, oddly enough, of the religious pictures, for in Nolde's imagination, the world of the Bible is only a more primitive, more ornamental, and less inhibited version of the wretched human society he observes here on earth. And whether the subject is Biblical or earthly, the artist exhibits the same fascination—a revulsion so intense as to be indistinguishable from attraction—with the sins of the flesh. Only his native soil—and the household he established there—were exempted from these devouring maledictions.

The exhibition now at Frumkin's, though limited to woodcuts, lithographs, and etchings, brings us an amazingly full account of Nolde's development from 1906—the year of his involvement with *Die Brücke* group—to the 1920's. Like many artists of the German school, Nolde was as great a graphic artist as a painter—possibly even greater as a graphic artist. I, for one, find the aesthetic quality of the graphic art far more consistent than that of the paintings, which are sometimes strident in ways which dissipate their own intensity. There was, apparently, something in the technical processes of the graphic media which acted as a brake on Nolde's more incontinent emotions. And Nolde lavished considerable attention and patience on his graphic art, often making of each print in a series (and none of the series runs to large editions) a unique work. There are several examples which have not been seen here.

The work on view represents, of course, only a fraction of Nolde's career as a whole. He was already forty-one when he joined *Die Brücke,* and he lived until 1953. But the two decades repre-

sented in this exhibition were, from the aesthetic point of view, the most important. His later years were compromised by the obscene tragicomedy of his involvement in Nazi politics—a movement he approved and enthusiastically joined in the earliest stages, but which treated him nonetheless as just another "degenerate" modernist.

March 15, 1970

6. Kirchner and Expressionism

The Expressionist movement forms the central chapter in the history of modern art in Germany. It is the crucible from which all other developments derive. Even the Bauhaus, which, with its rationalist principles and its commitment to industrialization, may seem to embody all that the Expressionists most abominated, was in actuality an attempt to reconstruct the social idealism of Expressionism on terms more congenial to machine civilization. Dada, too, was an outgrowth of this idealism—the "negative," anarchic counterpart to the socially more optimistic ambitions of the Bauhaus. Behind these and other developments—including, paradoxically, even some of the despised tenets of Nazi ideology—lay the Expressionist impulse, with its romantic yearnings, its highly critical outlook on art and society, and its contradictory attitudes toward modern life.

There are, moreover, some striking parallels between the ideals that animated the Expressionist movement and the values which have come to dominate the most extreme exponents of our own dissident culture. The profound recoil against the mechanization of life, the wholesale attack on bourgeois morals, the emphasis on nudity and sexual license, the affinity for anarchist tactics, the search for exotic states of mind and exotic forms of dress, the yearning for pastoral freedom, communal living, and generational solidarity, above all, perhaps, the cult of the irrational as a means of

combating the life-denying conformities of middle-class social life—
all of these features of the revolt we are now witnessing were crucial
to the Expressionist program. The vogue that has suddenly made the
novels of Hermann Hesse a valuable literary property once again is
only the most direct of the many links that bind us to the Expres-
sionist era. It was indeed an awareness of these links that recently
prompted the English poet Roy Fuller, in the course of his first
lecture as Professor of Poetry at Oxford, to ask: "Is the whole of the
West in a Weimar period?"

Yet, despite its immense relevance, the art of the German
Expressionists nowadays receives little serious attention. Our best
critical minds pay it little or no heed. You can read the art journals
for years on end without encountering a single challenging insight
into the Expressionist enterprise. No doubt one reason for this is the
general paucity of serious social criticism of the visual arts. Our
critics and art historians seem unequipped—temperamentally, if not
intellectually—to deal with a pictorial style whose implications take
us beyond the edges of the picture itself. Perhaps this, too, will
change under the pressures that are now changing so much in our
colleges and universities, but at the moment there is no sign of it.

There is certainly no sign of it in the text which Professor
Donald E. Gordon has written for the catalogue of the E. L.
Kirchner exhibition currently installed at the Museum of Fine Arts
in Boston. If anything, Professor Gordon seems slightly embar-
rassed at finding himself with an artist whose work may be sus-
pected of not sufficiently asserting "the absolute primacy of the
picture plane." He is certainly aware of the differences that separate
Kirchner and his fellow Expressionists of *Die Brücke* group from
their contemporaries in Paris, observing that whereas " 'decoration'
and 'expression' were essentially synonymous for Matisse and other
French fauve artists . . . Kirchner and his Dresden friends came
ultimately to value self-expression in the creative process more
highly and for its own sake—seeing the work of art as bridge
between self and world." But this useful insight into the psychology
of Expressionism is less an explanation than an apology. Professor
Gordon is so anxious to legitimize Kirchner in formal pictorial terms
that he manages to overlook the real strengths of this interesting
artist—strengths that have little to do with disquisitions on "the
absolute primacy of the picture plane."

Kirchner is not, I think, a great artist. The masters of Expres-

sionism were Edvard Munch, Oskar Kokoschka, and Max Beck-mann, and Kirchner is not quite of their company. But he was, at his best, a very intense artist who endowed his work with an emotion and a point of view that have lost none of their critical edge. His work is imbued with a sense of alienation that still speaks directly to our experience. If it does not speak directly to the art of the moment —not the pictorial art, anyway—well, that, too, tells us something about the art of the moment that we need to be aware of.

The point that makes Kirchner's art so difficult for a con-temporary sensibility to grasp is that it uses the conventions of modernist pictorial form as a means rather than as an end in itself. The decorative innovations of Matisse and Gauguin were indis-pensable to Kirchner's pictorial vision, but there is also in this vision a large element of Dostoevsky and Whitman. His interest in the primitive sculpture of Africa did not inspire—as it did in Paris—any radical departures in pictorial syntax, but rather another way of defining his own existential aspirations. Art, for Kirchner, was conceived as a criticism of life, and life itself conceived as an enterprise that would not permit art either an easy or an autonomous role.

Kirchner himself could not sustain so difficult an artistic task for the whole of his career. Indeed, very few of the Expressionists could. The momentum of modern history, which they at once feared and were deeply fascinated by, broke their spirit. The break, in Kirchner's case, came in the First World War, from which, in some sense, he never really recovered. His sharpest utterances derive from the years immediately preceding the war, when it was still possible for his deepest anxieties to be tempered and complicated by the kind of spiritual optimism that made Whitman so congenial to his whole sense of vocation. The nudes and portraits of these prewar years, together with the landscapes and street scenes—street scenes that became the very symbols of the Expressionist malaise—are ex-tremely exacerbated images in which marked distortions are com-bined with exalted hopes. To miss the exuberance of this prewar work is to mistake one of its essential features, but it is a grim and rather desperate exuberance, a lyricism already prepared to accept the worst.

Actually, if it is well-made pictures that you want, you are better off with the later Kirchners, especially the landscapes of the twenties and thirties. A kind of innocence pervades these pictures,

but it is the innocence of an exile no longer willing or able to come to terms with the terror of modern existence. The Expressionists always accorded an important place in their culture to elements of the primitive and the folkloric, but whereas Kirchner's earlier work makes something critical and unsettling out of these elements, his later work makes of them a kind of refuge from the real world. The Expressionist nightmare has been displaced by pastoral dreams.

Compare, say, Max Beckmann's work of the twenties and thirties with Kirchner's and you see the difference between an artist who was able to make something solid out of his confrontation with history and an artist who ended by being cruelly victimized by history. But whatever judgment we may pass on Kirchner's achievement as a whole, he remains a sympathetic—if not a great—figure, and the Boston exhibition brings him to us in force.

April 6, 1969

7. Feininger: A Visionary Cubist

The strength of the German artistic tradition has always been its graphic rigor. For pure painterly values, for pictorial conceptions that allow finer shades of feeling than the graphic alone can ever fully accommodate, German artists have had to look elsewhere—to Italy or Spain or France or, more recently, the United States. The work that has resulted from this confrontation of graphic genius with alien pictorial traditions has sometimes been magnificent, and not at all a mere rehearsal of received style; the *oeuvres* of Lovis Corinth, Paul Klee, and Max Beckmann, among others, are ample testimony to the fact. Yet the free play of painterly sensibility has never taken hold. Every generation of German artists has had to begin again from the beginning, suffering the *frisson* of the painterly tradition as a fresh shock and acquiring its resources only through painful personal growth.

This confrontation was particularly crucial for the artists who came of age in the decade preceding the First World War, the decade in which the School of Paris was at the height of its powers. In a purely formal sense, modern German art can be divided between those artists who found in Fauvism—and in the gods the Fauvists especially favored: Gauguin and Van Gogh—the necessary impetus to a style of their own, and those who, eschewing the emotional freedom of Fauvism, adopted Cubism as a more viable and universal grammar of form. The one resulted in Expressionism, which, for all its mysticism and otherworldly aspiration, was a style addressed to the things of this world. The other produced a kind of metaphysical Cubism which used the formal devices of this most Parisian style as a scaffolding for exploring an imaginative empyrean in which there was no clear demarcation between the world of spirit and the world of matter.

The principal exponent of this metaphysical Cubism was Paul Klee, whose observation "In my work, man is not a species but a cosmic point" can be taken as its motto. Lyonel Feininger's remark (in a letter to Mark Tobey), that "What I want to do is capture some of the cosmic wonders," places him unmistakably in this line. Yet Feininger's gifts, like Klee's, were formed in the German graphic mold, whose procedures and assumptions place it at a pole far removed from the Cartesian refinements of Cubist aesthetics. Feininger's development from a talented cartoonist and illustrator into a painter fully cognizant of the most momentous revolutions in modern form thus constitutes for the critic a peculiarly interesting case of an artist who reformed his entire outlook on art while remaining completely loyal to his own sensibility. There are some dramatic turns in Feininger's development, but none of those dispiriting tergiversations by means of which certain of his contemporaries felt at liberty to reinvent their personalities at the onset of every shift in aesthetic fashion.

Feininger has been fortunate in his expositors. A few years ago Dr. Hans Hess produced a lengthy and comprehensive monograph on the artist which is a model of its kind. Now Professor Scheyer has written a book* far smaller in compass, more specialized, but nonetheless important. It concentrates on Feininger's early life in America, his career as a successful cartoonist and illustrator in

* Ernst Scheyer, *Lyonel Feininger: Caricature & Fantasy* (Detroit: Wayne State, 1965).

Germany, France, and the United States, and his transformation into a serious painter under the impact of the School of Paris. Its special value lies in the documents Professor Scheyer has assembled to illuminate these early, crucial chapters of Feininger's long career —mainly the artist's correspondence with two close friends, H. Francis Kortheuer and Alfred Vance Churchill, and reproductions of the comic strips, cartoons, and caricatures which provided him with his first livelihood and reputation. All in all, the book is a valuable pendant to Dr. Hess's more exhaustive study, and in itself affords an intimate and delightful glimpse into the art history of the turn of the century. (The material on the artist's later years—Feininger died in 1956 at the age of eighty-five—is of more perfunctory interest.)

Feininger was born in New York in 1871 and, except for his periodic visits to Paris, lived in Germany from 1887 to 1937. He always retained his American citizenship, and it is now customary to include him in surveys of American art, but this is more an act of social courtesy, I think, than of considered aesthetic judgment. His work clearly belongs to modern German art in the development of which it played a distinct, if minor, role. Even his childhood and youth in America were overshadowed by the German outlook of his parents, who—like Klee's—were musicians and wanted their son to follow a musical career.

Professor Scheyer lays great emphasis—rightly, I believe—on the abiding influence which Feininger's early interests and environment exercised over his later development, particularly his romantic preoccupation with the wonders of technology and engineering, his musical education, and his lyrical feeling for nature. These interests, already highly developed during his American years and intensified in Germany, predisposed Feininger to adopt a view of the world and of his own experience that was more notable for its fantasy and innocence than for its firm grasp of the direction in which modern life was actually moving. One reason, perhaps, that Feininger was able to enter so freely and successfully into a career as a humorous illustrator, especially as an illustrator for children, was this predisposition toward innocent and high-minded ideals.

The other reason for his success was, of course, his remarkable gifts as a draftsman. Feininger began earning his living as a cartoonist for the Berlin papers at the age of nineteen, and his career in that field was an immediate and astonishing triumph. Between 1890

and 1906 he contributed an immense variety of cartoons, carica-
tures, illustrations, and comic strips to journals in Germany, France,
and the United States, even working for a time as a liberal political
cartoonist on *Ulk*, the Sunday supplement to the *Berliner Tageblatt*.
Toward the end, in Paris, he worked for the journal *Le Témoin* at
the same time as Juan Gris, and he brought his career to a close in
1906 with two comic strips, "The Kin-der-Kids" and "Wee Willie
Winkie's World," which flourished briefly in the pages of the
Chicago Tribune.

By that time, however, Feininger was determined to devote
himself to serious art. His sojourn in Paris had brought him into
contact with the modern movement for the first time. He discovered
Cézanne, Van Gogh, and Matisse, and struck up a friendship with
Pascin (who also earned his living as an illustrator). It was not until
1906, in fact, that Feininger—at the age of thirty-five—first painted
in oils. He turned down an invitation to join the *Tribune* staff, a job
that would have brought him back to the United States, and instead
dispatched his cartoon strips from Paris until he decided to abandon
that lucrative career altogether.

It was Feininger's encounter with Cubism in 1911 that decided
the course his art would take thenceforth. But his was from the start
a Cubism markedly different from the style practiced by his Parisian
contemporaries. Feininger himself described it as "visionary" Cub-
ism, and behind that precise designation lay not only his enthusiasm
for Turner and Whistler—and thus for light as a primary subject—
but also something of his graphic gifts as well. Feininger's early
critics spoke of the prismatic or "crystalline" quality of his pictures,
and the characteristic works of his maturity were, in fact, a kind of
Cubist transmutation of this romantic preoccupation with light and
atmosphere. Never a strong colorist, Feininger was nonetheless able
to bring his graphic powers to bear on the construction of monu-
mental prisms of light—symbols, in his own imagination, of a
simpler and more spiritual world than any to be seen with the naked
eye.

These symbols all retained a recognizable relation to the
observable world, however. Feininger was not, in the sense that
other Cubists were, an abstract artist. Both landscape and urban
motifs abounded in his work, and the artifacts of modern technology
existed side by side with figments of the Biedermeier revival, but
they all tended more and more to represent a pure country of the

mind. In Feininger's vision, the impedimenta of modern experience were exquisitely dissolved in an unearthly light and refracted into a form of visual pastoral that harked back to the innocent, mystical emotions of his youth. One of the virtues of Professor Scheyer's study is the way it shows us this transition from the fantasies of the cartoonist to the visionary imagery of the painter. In the course of this transition, as often happens in German art, painting was not so much mastered or enlarged as simply enlisted as an instrument, but it yielded Feininger exactly what he needed to transcend the limits of his graphic talent and address his art to the "cosmic wonders."

May 6, 1965

8. George Grosz: A Moral Recoil

It is now exactly ten years since George Grosz died in his native Germany at the age of sixty-six. From 1933 until shortly before his death, he had made his home in the United States. He taught for many of these years at the Art Students League in New York. He became, technically at least, an "American" artist and did not lack admirers for the work he produced during his American years. The Whitney Museum devoted a large exhibition to it in 1954, and no less a figure than Edmund Wilson went on record, in 1963, with the opinion that the anti-Hitler satires which Grosz produced in the United States were "as powerful as anything he had done in his youth." Mr. Wilson also declared that the non-satirical works he produced here—"the sand dunes, the nude figures, the portraits of friends"—were "all as solidly constructed as Dürer," which could only mean, I suppose, that Mr. Wilson considered them masterpieces.

I do not myself agree with this judgment. Grosz seems to me at his most powerful in the drawings and paintings he produced in Germany under the painful pressures of the First World War, the German revolution, and the Weimar Republic. This, as Mr. Wilson

remarked, six years ago, is the "stock thing to say about him," but the stock thing has, in this case, I believe, the merit of being correct.

At least I have never seen an exhibition that persuaded me otherwise, and I have seen more than a few that confirmed the "stock view" without difficulty. Yet I must admit that the small exhibition which William S. Lieberman has now organized at the Museum of Modern Art lends a certain plausibility to Mr. Wilson's view of the matter.

This exhibition consists of forty-five drawings and watercolors and a single small painting ("Explosion," 1917), mostly from the artist's estate—some are being shown for the first time—and from the museum's own superb collection. It is an uncommonly well-selected exhibition. It is certainly not concerned to diminish the impression of strength, anguish, and ferocious comedy in the early work, but at the same time it succeeds—as few Grosz exhibitions do—in conveying the entire profile of the artist's career without descending, in the later work, to the vulgarity, sentimentality, and sheer desperation which so often disfigured Grosz's art in his American period.

The German period remains, to be sure, the locus of the artist's fundamental accomplishment, but at least in this account of the later years, Grosz emerges as an artist of some dignity, restraint, and tenderness. (Mr. Lieberman was wise in limiting the exhibition to drawings and watercolors. Grosz's "American" paintings tell quite another story.) Yet one cannot help feeling that the work of the later years was, after all, a kind of holding action for Grosz. Despite the enormous attraction that life in America held for Grosz, the art of his American period is an art of exile. Technically proficient—for Grosz was magnificently endowed as a draftsman—and sometimes even inventive in a small way, it is an art that lacks resonance and commitment. Emotionally it has no center, and stylistically it lacks the kind of imperative which was absolutely essential for an artist of Grosz's temperament. It is an art permeated with the pathos of the refugee.

Until we are given a full biographical account of Grosz's American period, we can only guess at the reasons for this, but the artist's decision to return to Germany so late in life tells us a great deal, I believe. He was not the kind of artist whose vision is detached from historical circumstance. If we compare his work to that of two other German exiles—Hans Hofmann and Josef Albers—it is

easy enough to see why they should have succeeded where Grosz so conspicuously failed.

Different as they are from each other, Hofmann and Albers are alike in turning the artistic enterprise into a pedagogical and aesthetic system. They distill from the morphology of modernist painting an aesthetic essence that is no longer contingent upon a response to immediate history for its artistic realization and development. Their "roots" are purely aesthetic and conceptual, and their removal to America, far from constituting an obstacle to their growth as artists, liberated their special gifts. It was a distinct advantage, in their case, not to be concerned in their art with the kind of social observation, political emotion, and historical vision which, for an artist of Grosz's persuasion, are inseparable from the idea of art itself.

They were fortunate, too, in coming to America at a moment when American art was itself ready to make an overwhelming commitment to the modernist aesthetic—a commitment they helped to shape and from which they derived an energy and strength not to be found in their European work. Grosz was in a very different position. He was, fundamentally, a graphic artist, an illustrator and satirist whose gifts needed for their complete fulfillment a visible, familiar antagonist capable of generating a profound moral recoil.

Grosz needed an enemy—an enemy whose values, manners, and emotions he knew inside out, an enemy whose culture he shared and whose mind he could see reflected in his own—and Germany, in the terrible years of war, revolution, and republican turmoil, provided him with that enemy as nothing in America ever could. He was too grateful to America, too vulnerable to the immigrant's innocent dream to permit himself a glimpse of its seamier side. The satires he produced here were all directed against the distant Nazis —an antagonist he no longer knew firsthand.

Like every satirist perhaps, he had always dreamed of going "straight," and America provided him with the opportunity. He could now produce an art for the museums—an art no longer stained with the blood of history. But it was too late. He had the talents, certainly, but they had been bent for too long to other purposes. He lacked a clear conception of what a truly disinterested style might be. For too long he had been out of touch with the currents that might have nourished such a style. He could occasionally produce a drawing in a fine Old Master mode—as, indeed, he had often done

in Germany: there are several excellent examples in the current show—but he could not find a viable basis for a really new departure.

The great satirical works of his German period, however, have lost none of their lacerating power. This exhibition does not give us as copious a view of this period as the one which closed a month ago at the Kunstverein in Stuttgart and which I saw during the summer. That exhibition consisted of some ninety works devoted almost entirely to the German years. But the current show has the virtue of showing us certain aspects of Grosz's early development that are not as familiar as they should be. There is, for example, the astonishing watercolor-drawing, "Republican Automatons" (1920), with its echo of de Chirico resounding in a very different nightmare. And indeed, all the satirical works of these early years remind us of how open Grosz then was to all the modernist currents—to the inventions of Cubism and Futurism as well as Expressionism—and with what intense emotion and polemical drive he was then able to turn them to his own artistic purposes.

October 12, 1969

9. Poet and Pedagogue: Paul Klee

My work probably lacks a passionate kind of humanity.
I do not love animals and other creatures with an earthly
heartiness . . . The idea of the cosmos displaces that of
earthliness . . . In my work, man is not a species, but a
cosmic point.
 —*Paul Klee, 1918*

The German imagination moves easily over frontiers,
especially those between reality and unreality . . .
 —*V. S. Pritchett*

Few artists have been as self-aware as Paul Klee. Yet his work stands
at a certain distance from his own personality, and it does so by
intention. Only his humor and literary *jeux d'esprit* seem to retain a
direct link with the vicissitudes of private sensibility. Everything
else in his art shows a yearning for "objectivity" and pretty well
succeeds in achieving it. Among painters of the Romantic school
who looked upon their art as a way of exploring an essentially
interior existence, Klee is outstanding for the success he achieved in
creating a visual grammar by which this exploration could be
carried out as if it were the excavation of a realm utterly removed
from the personal. He thus transcended the psychological vanity of
Romanticism while remaining loyal to its essential quest.

Klee made of modern self-consciousness (the universal trait of
modernism) both a poetic method and a pedagogical system. The
second followed upon the first and represented the socialization of a
poetics that had been born of the need to establish a more objective
and concrete basis for what remained a subjective interest. His
pedagogy was therefore the natural consequence of his aims as an
artist, and it was regarded as such by both his juniors—the students
who were attracted to his work even before he began teaching—and
his senior colleagues at the Bauhaus. In a sense, Klee was drafted
into teaching by his contemporaries, who saw the direction in which
his art was moving and recognized that its principles were suscep-
tible to a more widespread application. They recognized that there was

a professor in Klee waiting to be liberated from the Romantic poet.

The recognition was by no means universal, however. When Oskar Schlemmer, while still a student at the Stuttgart Academy of Art, was leading a movement (in 1919) to have Klee appointed to a professorship, he reported that "one of the chief criticisms which we are constantly having to contend with is that so dreamy and remote an artist as you [Klee] 'presumably' are would hardly make a teacher equipped to lead the cause of modernity in a city like Stuttgart as forcefully as necessary." Klee's adversaries in Stuttgart regarded him as too "playful" and "feminine" an artist, a passive wit whose art lacked the strength and conviction of a new vision. He was not appointed, his rejection being made explicitly on the grounds that his art was deficient in "the powerful impetus toward structure and composition that the new movement rightly demands."

His opponents were only half wrong, I think. There *was* something scattered and feminine, as it were, in the romantic side of Klee's sensibility, and if in the end it had prevailed over his pedagogical impulse, Klee would surely have been a less consequential artist than he did in fact become. As a poet Klee was no revolutionary but an addict of Romantic conventions, with their literary trappings and metaphysical fancy. He could easily have become another Alfred Kubin, a rare and fantastic illustrator of the macabre but an artist who finally lacked the power to transform his immense graphic gift into a style that could stand free of its own literary occasions. Klee was, in fact, very close to Kubin, both personally and artistically, and in departing Kubin's realm—a departure signalized by his joining the Weimar Bauhaus in 1921—he turned his back on depicting the subjective and took up the task, far more explicitly than he or anyone else had hitherto attempted, of formulating a rigorous visual "science" by which the subjective could be rendered into an objective and transmissible plastic convention.

In a new volume of documents* on his father's career, Felix Klee quotes Will Grohmann on the meaning of this move to the Bauhaus so far as it affected Klee's theoretical turn of mind: "Various quotations from his letters and journal have already demonstrated that Klee always thought about the why and wherefore of his art. But at the Bauhaus he had to formulate a theory—con-

* Felix Klee, *Paul Klee*, translated by Richard and Clara Winston (New York: George Braziller, 1962).

sistent, communicable, and intelligible—concerning the use of pictorial elements for those who 'wanted to get their bearings on the formal plane.' " What in the past had been improvised and *ad hoc* had now to be clearly articulated and systematized; what had heretofore been an instrument and a process had now itself to be made into a subject and a doctrine. For in the teaching of art it is not vision but procedure that can be universally communicated—though, hopefully, the right procedure can perhaps liberate the capacity for vision—and in allying himself with the Bauhaus, Klee was forced to eschew the poetical side of his sensibility and become an abstract artist in a more literal sense than almost any other painter who has gone by the name. Klee made no attempt to keep his art separate from his teaching methods once he was launched on his pedagogical career. The principles of the Bauhaus would scarcely have permitted him to do so, in any case, even if he had wanted to. His art, which had begun as a depiction of mysteries, was thus ineluctably drawn into an arena in which it became a series of inspired demonstrations.

The intellectual fervor and completeness with which Klee plunged into his pedagogical duties—which is to say, into this new development in his own art—have long been known, of course, but the recent publication of *The Thinking Eye,** the most complete collection of his theoretical writings and diagrams now available, makes clear once again the depth of the task and the incredible imaginative detail which he was able to bring to it. It makes clear something else, too: that Klee never ceased to be, in some sense, an illustrator. Whereas in his earlier Kubinesque work, the means by which he achieved artistic results were visual metaphors drawn from the iconography of Romantic illustration and tempered with sardonic humor and graphic distortion, Klee now turned increasingly to the equations of pure design to illustrate the "lesson" which each work became. In exchanging the mysterious for the demonstrative, he thus shifted his theater of operation. Art became more of a laboratory and less a private creative realm contingent upon the symbols of experience and individual culture. But Klee retained to the end a point of view which saw art as something transitive, instrumental, and illustrational.

The Thinking Eye is enormously rich and instructive for

* *Paul Klee: The Thinking Eye*, edited by Jürg Spiller, translated by Ralph Manheim, with assistance from Dr. Charlotte Weidler and Joyce Wittenborn (Documents of Modern Art, No. 15, New York: George Wittenborn, Inc., 1962).

anyone willing to approach it on its own terms: as a pedagogical guide to the visual science of design. Page by page, lesson by lesson, it reads like a work of natural history, and Klee was indeed a kind of naturalist in the optical and plastic properties of visual forms and techniques. Yet one does not have to penetrate very far into these voluminous notes and demonstrations to sense that there is more going on in them than meets the eye. As a writer on design—and as a designer himself—Klee is remarkably precise, but his precision has its limits; it falls short of the imaginative energy Klee himself brings to it. It seems somehow unequal to his meta-visual obsessions, which constantly spill over into a world of spirit one recognizes straightaway as having the same metaphysical qualities as the Romantic idealism that supported his earlier and more literary style. The fact is that Klee made a virtual mythology out of the elements of design. He conferred on every line and color and form, on every graphic, chromatic, and plastic possibility, a destiny and complexity that make the gods of the old mythologies seem like simple spirits indeed. The combinations and permutations that are conceived, analyzed, and endlessly proliferated in *The Thinking Eye* are endowed with a fate that so far exceeds their visual presence on the page that only the most transcendent metaphysical drama could contain all they are intended to represent. And it is precisely a drama on this order that does provide the medium in which Klee's ideas are conceived: the drama of German idealist metaphysics, in which universal mind—pure spirit—constitutes the principal reality and in which the details of earthly life, while wholly necessary and meaningful, are of a secondary and transitive character.

Klee's metaphysical loyalties in no way curtailed the task he set himself in his pedagogical studies. On the contrary, they provided him with a mode of thought which naturally conceived of all phenomena (including, of course, visual phenomena) in terms of internal hierarchies and which sought, above all, to establish logical and immutable connections between the whole and its parts. (Idealist metaphysicians never shrank from plunging into the most detailed analyses of the material universe.) Klee pursued his visual interests with the most exacting attention to physical and material detail, and yet at every turn in *The Thinking Eye* one hears the echo of transcendent realms. His finical exploration of the visual becomes a kind of cartographer's dream for a world that, in fact, can never be

wholly seen or fully imagined—a world in which art becomes a clue, but not a key, to reality.

As a document of the imagination, quite apart from its pedagogical uses, *The Thinking Eye* stands to painting very much as *The White Goddess* and *A Vision* stand to poetry. Universal in aim, it is nonetheless obsessive and eccentric in character. On the one hand a pedagogue's metaphor, on the other it is the instruction manual of a visionary for whom the visual was an all-absorbing but insufficient mental universe.

One needs always to bear in mind this obsessive metaphysical interest if one is to grasp what Klee really meant when he said that, in his work, "man is not a species, but a cosmic point." (One reason that German commentators on Klee tend to be so unsatisfactory—often, indeed, far more baffling and obscurantist than Klee himself—is that they share, for the most part, this philosophic habit of mind which shuttles back and forth in the world of spirit and matter without making any hard and fast discriminations along the way; in psychology they tend to be Jungians.) Nor can Klee's role in the Bauhaus be fully understood apart from his meta-visual yearnings, for the Bauhaus may be said to occupy in relation to Klee's ideas a place similar to that of Marxism in relation to German idealism: it represents the materialization of a spiritual dialectic. To the Bauhaus, man was indeed "a species," and his material destiny was its overriding concern.

Reading *The Thinking Eye* along with Felix Klee's felicitous (but incomplete) account of Klee as a man, one sees how fully his style, in both his thought and his art, corresponded to his temperament, his culture, to the very events of his life: there is throughout the attempt to deal with everything in the most impersonal, "universal" terms, an attempt that is more successful in art, perhaps, than in life. The man who became the most celebrated visual dialectician of the Bauhaus could write about his own marriage: "Decision to marry . . . Once the inner self had achieved maturity, the outer life must seek corresponding form; not to do so would be to suffer shipwreck." He admired certain scenes in Molière because they seemed to be "constructed in a wholly abstract manner." Music meant everything to him, films almost nothing. Felix Klee's collection is more an anthology than a memoir, and provides these and other glimpses into Klee's development, but as a book it is

distressingly scattered, patchy, and undefinitive. What we really need is a volume of Klee's personal documents on the scale that *The Thinking Eye* achieves with his pedagogical writings, and the artist's son may not be the best qualified editor for that important task.

December 1962

10. Max Beckmann: "The Quality of Pulsating Life"

The German painter Max Beckmann came to the United States in 1947. He was then sixty-three years old. He died in New York three years later. So far as one can tell, his experience in America was too brief to have any discernible influence on his art. His powerful style—in my opinion, one of the most powerful in the history of modern painting—had long been formed. But he continued to work during these American years, and the paintings he produced in this short period are as fine as anything he ever painted. There is an excellent selection of them at the Catherine Viviano Gallery.

Beckmann had a long and eventful career. In fact, he had several careers. In the period before the First World War, he worked at a distinct distance from the modern movement. He was absorbed in the Old Masters and dreamed of emulating their epic scale and tragic grandeur. He undertook elaborate figure compositions on heroic themes, both contemporary and mythological, and in general gave the impression of remaining immune to the doubts and anxieties as well as the radical aspirations that were elsewhere prompting his contemporaries to reject the established rhetoric of the Old Masters and reconsider the whole question of pictorial form.

In this period he even took up a critical position against the German avant-garde. Replying to some articles by Franz Marc in the magazine *Pan*, in 1912, Beckmann denounced the fantasy-abstrac-

tions of the Blue Rider group as "Siberian-Bavarian shrine posters." He had a horror of painting degenerating into two-dimensional decoration, and saw—not entirely incorrectly, as it turned out—that the new tendency to abstraction would ultimately tempt painting to become more and more superficial.

It was not, then, by means of an aesthetic conversion that Beckmann became a modern painter, but through his experience in the war. Beckmann belonged to the generation of European artists and intellectuals for whom the slaughter of the First World War was the central and overwhelming experience of their lives, shattering their confidence in the moral assumptions of European culture and throwing into question the entire nature of the human enterprise. His own term of duty in the war was relatively short. He volunteered as a medical orderly when the war began, and the next year—1915—was seriously wounded. While recuperating in a Frankfurt hospital, he resumed his work as an artist, but was now to be an artist of a very different sort.

It was in this period that Beckmann's work began to acquire the compression and intensity—that sense of emotion barely able to contain itself within the strategies of pictorial discourse—which were to become the dominant characteristics of his mature style. He adopted a tighter and more concentrated form, based in part on German Gothic painting, and as a social observer became increasingly mordant in his account of the pretensions and hypocrisies of the world around him. Though less political than George Grosz, Beckmann was equally merciless—and a good deal subtler—in his sardonic depiction of the grim human comedy that war and revolution brought to Weimar Germany.

Even in the twenties, moreover, his art had a largeness of vision that Grosz's lacked, suggesting that modern experience, if it lent itself to an epic dimension at all, did so because of the dreams, myths, and fantasies, the reservoirs of unappeased anger, appetite, and aspiration—the whole oceanic realm of the unconscious—which remained the unacknowledged scenario of human intercourse.

It was not until the late twenties and early thirties, however, that this largeness of vision was given a form equal to its expressive ambition. Beckmann's approach to the radical innovations of modern paintings was cautious, skeptical, and deeply critical. He was, I suppose, the most conservative of the great modern painters—the most concerned to keep alive, without resorting to irony, parody, or

an extreme formal reductivism, a sense of continuity with the pictorial resources of the masters. He remained firm in his devotion to what he once called "the full, the round, the quality of pulsating life . . . full plastic form," and he found first in Cézanne and then in Matisse a way to align this ambition with those revisions of structure and color which these two great artists bequeathed to the vocabulary of modern painting.

Yet the pressure that one feels in the later Beckmann cannot be explained entirely in aesthetic terms. From the thirties onward—and gaining momentum from his experience as an exile, first within Germany and then in Holland, where he spent the war years—there is a response to history and a meditation on the spiritual role of the artist in the dark labyrinth of the historical process which is unequaled in the work of any other modern painter.

Even Picasso—Beckmann's only serious rival in this particular sphere—is no match for the extraordinary vision that Beckmann brings to the masterworks of his later years. Compare "Guernica" to the great triptychs and allegorical paintings of Beckmann's later years and you see the difference between an artist registering his intense moral indignation over an obscene political atrocity and an artist confronting the complex role of the artist himself in the crisis of modern history. When it came to a political subject, Picasso refused to implicate the artist as a historical actor; he saved all that for his erotic subjects. In Beckmann, the artist is not exempt from the tragedy he depicts.

Included among the fifteen paintings in the current exhibition is the last of Beckmann's great triptychs—"The Argonauts," which dates from the year of his death. The picture is at once extremely moving and extremely mysterious. Beckmann's symbols do not yield up their meanings at a glance, and he himself always refused to amplify in words what he had committed with so much emotion to the canvas. But our appreciation of the scope of his imagination does not depend on our having a literal meaning to assign to each of the images that crowd this magnificent painting. No doubt we shall sooner or later have a firmer grasp of these meanings. But painting of this persuasion gains access to our imagination, or fails to, long before our curiosity feels the need of explication, and will always transcend it.

It is difficult to know what kind of audience such a painting might nowadays enjoy—or indeed, whether there is any audience at all for it. The visual arts today are so devoid of moral intelligence,

so totally sealed off from any problem, idea, or emotion that reaches beyond the dialogue that art conducts with itself, that a mind like Beckmann's seems more and more like a visitor from another civilization.

November 23, 1969

11. Kandinsky: Theosophy and Abstraction

The exact relation of an artist's ideas, or beliefs, to the character and quality of his art remains one of the most vexing problems in the study of modern art. For a work of art cannot be judged—or indeed, even experienced—on the basis of an artist's beliefs, yet it is doubtful if it can be fully understood in complete isolation from those beliefs. Clearly, we need to know something beyond the concrete visual "facts" that a work of art offers to the retina of the eye. The question is, what?

This problem is less of a problem, of course, for those who confine their interest to the morphology of forms, and on grounds of what might be called aesthetic hygiene there is much to be said for that position. A view of the artistic enterprise that systematically excludes all consideration of the extra-artistic impulses that may inhabit a work of art can be accused of being incomplete, but it is wonderfully efficient in focusing our attention on problems that are susceptible to visual verification. The problem of belief in art offers no such tidy field of inquiry. It promises instead a kind of jungle where it is not uncommon for the unwary to encounter an occasional mirage.

Still, it is a problem that needs to be pursued, and we are now beginning to see some interesting work being done on one of its crucial aspects—the relation that obtained between art and ideas in the creation of abstract art in the years preceding World War I. The

principal figures under examination are Mondrian and Kandinsky, and it is particularly of the latter that I shall speak here.

The most specialized of the new Kandinsky studies—Sixten Ringbom's *The Sounding Cosmos*—comes to us from Finland. (Published by the Abo Akademi in 1970, it is fortunately written in English and only occasionally lapses into the kind of awkward usage we associate with such monographs.) Another recent publication of considerable interest is a long article called "Kandinsky and Abstraction: The Role of the Hidden Image," by Rose-Carol Washton Long, in the June number of *Artforum*—an excerpt from the author's forthcoming book on Kandinsky, to be published by Oxford. These should be read in conjunction with two other books— Hans K. Roethel's *The Blue Rider* (Praeger), already out, and *The Blaue Reiter Almanac* (Viking), soon to be published in the Documents of 20th Century Art series. Also of interest is Donald B. Kuspit's article, "Utopian Protest in Early Abstract Art," in the spring 1970 number of *Art Journal*.

It is Mr. Ringbom's monograph that is most directly addressed to the problem of belief—the problem, that is to say, of the way beliefs, whatever their intrinsic merit, nourish the development of pictorial styles and determine, however distantly, their visual form. As beliefs go, it is quite a kettle of fish that Mr. Ringbom has to serve us. His work is subtitled "A Study in the Spiritualism of Kandinsky and the Genesis of Abstract Painting," and it plunges us straightaway into the murky shallows of theosophy where reason bows to the irrational and there is literally nothing too farfetched to be entertained as a revelation of eternal truth.

It has long been known, of course, that Kandinsky was a devoted follower of theosophical doctrines during the very years (1909–14) when he was fervently absorbed, in both his painting and in his theoretical writings, with the creation of abstract art. But the tendency of most writers, until recently at least, has been to treat this conjunction of interests as an interesting but unimportant aberration. It had to be acknowledged, if only to be denied any real significance, but it certainly did not have to be explored. Rationalist art historians, working out their neat tables of stylistic progressions, were clearly embarrassed about having to deal with so woolly an episode in the life of an admired master, and they therefore tended to avoid it.

Mr. Ringbom shows no such reluctance to face up to intellec-

tual absurdities, which indeed he anatomizes with remarkable patience and skill. He does not write, however, as a partisan of theosophical doctrine. He writes as an art historian, firm in his conviction of Kandinsky's artistic importance and yet convinced, too, that the artist's beliefs have somehow to be accounted for in any final assessment of his achievement. He knows very well that, in the realm of art at least, a silly idea may sometimes form the basis of a serious accomplishment, and he therefore undertakes to give us a detailed profile of Kandinsky's theosophical beliefs as these are reflected in the art that was intended to be their supreme expression and in the writings designed to be their theoretical justification.

Central to these beliefs was the assumption, derived from the writings of Madame Blavatsky, Rudolf Steiner, Annie Besant, and others, that the spiritual sins of mankind could be attributed to its overzealous attachment to the material universe—an attachment all the more to be resisted because matter itself was, according to the theosophical view of the latest discoveries in atomic physics, drifting toward an imminent dissolution. Thus, as Mr. Ringbom observes, "since matter was disappearing anyway, time had become ripe for pure composition and abstraction."

This involved a good deal more than the search for a mere style that might prove apposite to a new historical period. It meant nothing less than elevating art itself to the status of a spiritual instrument capable of preparing mankind for the world to come—a world in which all forms of material history would be transcended. For Kandinsky, then, "the polemic against materialism serves as a prelude to his description of a new era, the 'Epoch of the Great Spiritual,'" This "dawning era," as Mr. Ringbom calls it, thus "serves as the fundamental justification of the movement towards abstraction and away from material appearances."

But it was not only a theoretical justification for abstract art that Kandinsky found in this utopian vision of the "Epoch of the Great Spiritual." He also found some concrete artistic ideas, for the literature of theosophy abounded in descriptions and even illustrations of particular colors and shapes and the spiritualist value that attached to each. Kandinsky was thus prompted by theosophical doctrine to reconsider the forms as well as the content and the function of pictorial art.

What he found, indeed, was what the Germans call a *Weltanschauung*, a comprehensive view of existence. The terms of this

Weltanschauung were such that they tempted Kandinsky to consider (albeit briefly) the possibility of abandoning painting altogether. Since, according to theosophical doctrine, the material universe was heading toward an imminent dissolution, the painter began to wonder, as Sixten Ringbom observes in *The Sounding Cosmos*, "whether art could not even dispense with its material media."

He thus hit upon "the idea," Mr. Ringbom tells us, "of a purely immaterial medium of artistic expression." Like a great many other spiritualist ideas, Kandinsky's notion of "a purely immaterial medium" was not quite as immaterial as it seemed. It derived, according to Mr. Ringbom, from a "keen interest in psychical research, thought-transference and so-called 'transcendental photography.'" It was this latter enterprise—"the art of recording spiritualist phenomena on photographic plates"—that particularly appealed to Kandinsky, prompting a short-lived belief in a "telepathic art of the future."

Why a photographic plate—in Kandinsky's day a weightier object than in our own—should have been deemed more "immaterial" than a painted canvas is a question I am happy to leave to those who may be in possession of the proper instruments for measuring such phenomena. I mention it here only as an index to the kind of overriding philosophical compulsion that occupied the artist at the very moment that he was absorbed in creating the earliest abstract paintings.

When it came to adumbrating the forms that might prove appropriate or viable to such painting, the literature of theosophy was also a rich resource for the artist. One of the theosophical classics in which Kandinsky maintained a continued interest—he is known to have consulted it well into the twenties, while he was teaching at the Bauhaus, and it remained an abiding interest for the rest of his life—is a copiously illustrated work called *Thought-Forms*, by Annie Besant and C. W. Leadbeater. This slender volume is easily available, for it remains in print to this day (now in paperback), complete with the color chart and color plates of abstract forms that served Kandinsky as an inspiration in his quest for a nonobjective art which would embody a high spiritual content.

The abstract illustrations to be found in *Thought-Forms* may not look very remarkable to our jaded vision today, and the meanings assigned to them may be almost touching in their naïve assumptions. (A blue cone-shape, pointing upward against a black

background, is said to signify an "upward rush of devotion"; a pink bolt of lightning descending from a brownish cloudlike blob is said to be the symbol of "murderous rage," and so on.) Yet such naïve and facile materials had a profound effect on the course of painting, and Kandinsky was not alone in succumbing to their influence. It is worth recalling that Mondrian, working in another country in complete isolation from Kandinsky and his friends, was in this same period a member of the Theosophical Society (which Kandinsky, incidentally, never was).

Kandinsky never adopted any of the shapes or "meanings" to be found in *Thought-Forms* literally. He remained a painter, after all, faithful to his own sensibility, arduously developing his own pictorial vision, and always alert to what other painters were up to. It was not actually until he returned to Russia, during World War I, and discovered the new vocabulary of the Constructivists that he could make explicit use of the kind of tight, closed shapes he found in *Thought-Forms*. Until then, he remained an Expressionist.

And it was as an Expressionist, eager to confer a cosmic significance on the improvised shapes and colors of his landscape-like "Compositions," that he created his first abstractions. It requires a certain leap of the imagination on our part to understand how difficult this transition to abstraction was for the artists who pioneered it. The great merit of the article by Mrs. Long in *Art-forum* is the way it retraces this transition in painstaking detail. Mrs. Long fastens our attention on the stratagems Kandinsky employed in order to hold fast to certain representational symbols while in the very process of disguising them as abstract form. She thus discloses the "hidden image" that underlies a good many of the early abstractions.

It is extremely doubtful if the historic leap into abstraction could have been effected without the sanction of a *Weltanschauung* on the general order of theosophy, which supplied a systematic cosmology to which the new abstract art could readily attach itself. For the pioneers of abstraction were as eager to have their art "represent" something—even, in some special sense, to have it represent "nature"—as the most academic realist, and theosophy gave them a meaningful world beyond the reach of appearances to "represent" in a new way. Thus, abstraction can be said to have made its historic debut as an esoteric form of representational art.

This effort to keep art somehow attached to a significant "con-

tent" even after it had abandoned the world of appearance was fueled, too, by a dread of the decorative. Kandinsky in particular harbored a profound anxiety on this score. Without a specific and profound spiritual content, he felt, abstract painting would simply decline into decorative trivialities, and it may be for this reason that he never abandoned his commitment to an occult ideology. To the end of his life he claimed that the pictorial forms he employed in his paintings were "the echoes of the music of the spheres, and hence establish the cosmic significance of the abstract work," to quote Mr. Ringbom once more. For Kandinsky, pure aestheticism—art for its own sake—was of little interest. It was not to effect the autonomy of art that he turned to abstraction but to integrate art more deeply into the functioning universe. The fictions required to sustain this noble purpose constitute one of the most interesting chapters in the intellectual history of modern art.

July 23 and 30, 1972

12. Kandinsky: The Last Decade

We tend to forget the extent to which the careers of certain modern artists have been affected by the violent vicissitudes of modern politics. Consider the case of Kandinsky. There is little in his work of any period to suggest that it was created in anything but the most placid external circumstances. The early landscapes have a positively idyllic quality. The early "Compositions" and "Improvisations" are likewise lyric in mood, though more and more metaphysical in their fundamental concerns. Thereafter, the "events" reflected in his painting are all of an intellectual and mystical order. Attention is paid to certain changes taking place in the evolution of pictorial form, but there are few signs that history or even the normal tribulations of the individual psyche have made the slightest impression on the artist's aesthetic faculties.

Yet in actual fact, Kandinsky lived through some of the stormiest moments in modern history. Twice in a lifetime he was obliged to uproot himself from Germany—the scene of his greatest artistic triumphs and, for all practical purposes, his permanent home. The outbreak of the First World War forced him to return to his native Russia on the eve of the Revolution. Though the exact degree of his commitment to the Bolshevik program has always remained obscure, he became a leader in the historic, short-lived alliance between the Russian avant-garde and the Revolutionary government. He functioned as both a bureaucrat and a teacher, establishing new museums, serving on committees, and even taking an academic post at the University of Moscow.

He returned to Germany in December 1921 and was very shortly appointed to the faculty of the Bauhaus in Weimar. Kandinsky was thus a major figure in the two most ambitious attempts to align the aesthetics of abstract art with the political goals of radical socialism. He remained at the Bauhaus until it was closed by the Nazis in 1933, and in the fall of that year he moved to Paris.

Kandinsky was then sixty-six years old. He died at Neuilly eleven years later. This so-called Parisian period was perhaps the most difficult of his entire career, and few writers have paid it close attention. Yet Kandinsky remained extremely productive in these last years. According to Will Grohmann, he painted 144 pictures and over two hundred watercolors and gouaches in this final decade of his life. To judge by the fifty-odd examples at M. Knoedler & Company, they are works which stand somewhat apart from anything Kandinsky had produced earlier.

The manner of execution in these late paintings still follows very closely the "tight" style of the Bauhaus years. Every image is very precisely delineated. Every element in the design is clearly legible. Every form is given an emphatic contour, which color—generally applied in a dry, flat manner—is not permitted to violate. There is a general disposition toward geometricity.

Yet what impresses one most about these paintings is not the qualities they share with the work of the Bauhaus period, but an element that had long been suppressed in Kandinsky's art—the element of poetic fantasy. Kandinsky now appears to draw closer to two artists—Arp and Miró—whose early work he had himself influenced. Indeed, a comparison with Miró is scarcely avoidable, for in painting after painting in these years, Kandinsky seems all but obsessed with

the kind of freewheeling poetry that Miró—working under the fecund pressures of the Surrealist movement—had turned to such inventive pictorial effect. Certain pictures of this period—"Delicate Accent" (1935), "Center with Accompaniment" (1937), "Elan" (1939), "One Figure among Others" (1939), "Sky Blue" (1940), and others—are scarcely imaginable without Miró.

What is interesting here is not the influence of one artist on another—such influence is, after all, a commonplace—but the particular use to which this influence was put. No one, so far as I know, has described the effect of Surrealism on Kandinsky's later work, but I would judge the effect to have been a powerful one. There are reasons, of course, why French critics would shy away from the problem. In Paris in the thirties—and indeed, until just the other day—the intellectual enmity separating the partisans of Surrealism from the partisans of geometrical abstraction was intense and unforgiving, and Kandinsky was presumed, not incorrectly, to belong to the camp of the geometrical painters. Apparently Kandinsky himself had cordial personal relations with a number of Surrealists, including Miró and Breton, but critically he was located elsewhere.

And what we see in Kandinsky's later work is not a conversion to Surrealism, but a struggle to move into the orbit of Surrealist freedom—at least as that freedom was exemplified in the work of Miró and Arp—while retaining the same rigor of design, the same logical procedures, the same philosophical outlook that were, by this time, the very substance of his vision. There is a constriction in Kandinsky's later work—and a yearning to be free of it—that has nothing to do with talent but everything to do with the artist's emotions and ideas. Comparing these late Kandinskys with Miró's paintings of the thirties, one can see what a radical advantage it was for Miró to have immersed himself in the poetry of eroticism and to have committed his art to the whole prolonged assault on the unconscious that Surrealism took as its special province.

In lieu of this immersion in the erotic, Kandinsky had only his devotion to the "spiritual," his commitment to a mode of expression "outside space and time." In this last decade of his career, geometric form gives way to biomorphic form, but his use of biomorphic form—again, in contrast to its use in Arp and Miró—seems singularly devoid of any existential correlative. The impulse to poetic fantasy is strongly and repeatedly expressed, but it seems to lack any real roots in the artist's experience. In the end, Kandinsky's

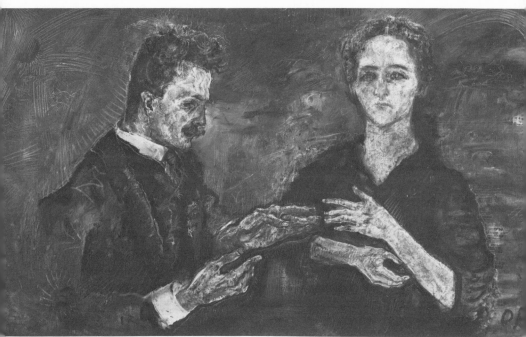

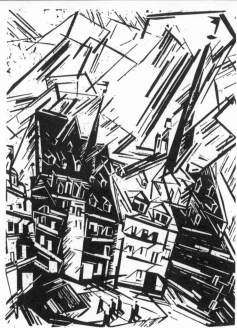

OSKAR KOKOSCHKA: *"Hans Tietze and Erica Tietze-Conrat"* (*1909*)
Oil on canvas, 30⅛ × 53⅝"
COLLECTION, THE MUSEUM OF MODERN ART, NEW YORK. ABBY ALDRICH
 ROCKEFELLER FUND

LYONEL FEININGER: *"Buildings"* (*1919*)
Woodcut, 23⅞ × 19"
COLLECTION, THE MUSEUM OF MODERN ART, NEW YORK. GIFT OF
 MRS. LYONEL FEININGER

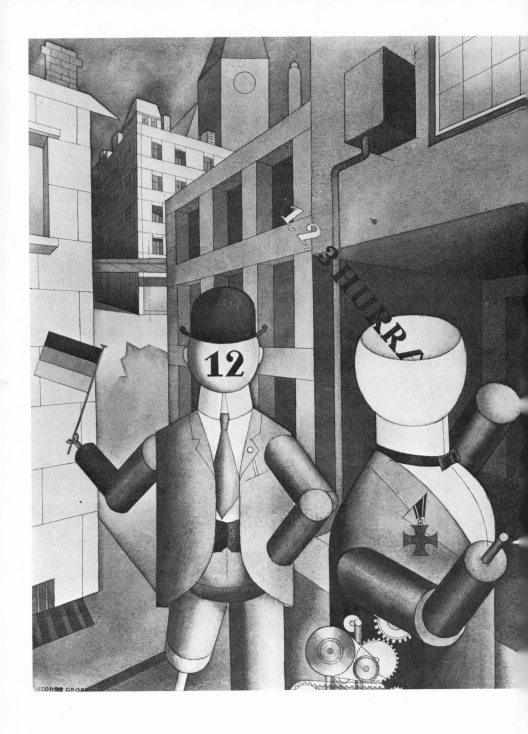

GEORGE GROSZ: *"Republican Automatons"* (*1920*)
Watercolor, 23⅝ × 18⅝″
COLLECTION, THE MUSEUM OF MODERN ART, NEW YORK. ADVISORY
 COMMITTEE FUND

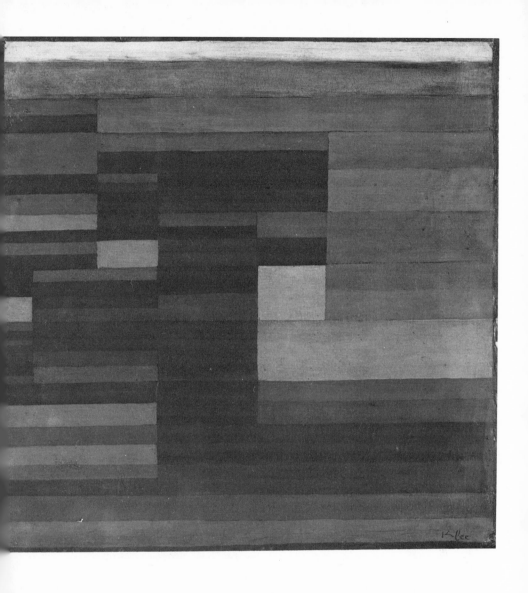

PAUL KLEE: *"Fire Eveningtime"* (Feuer abends) (*1929*)
Oil on cardboard, 13⅜ × 13¼″
COLLECTION, THE MUSEUM OF MODERN ART, NEW YORK. MR. AND MRS.
 JOACHIM JEAN ABERBACH FUND

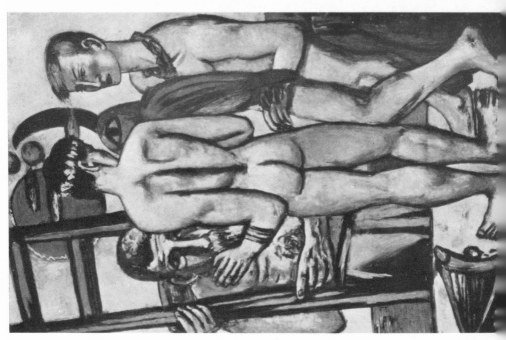

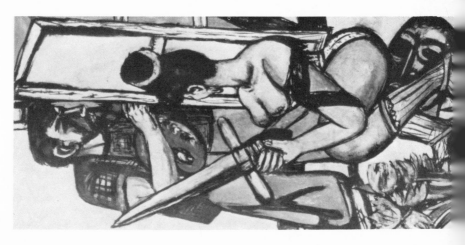

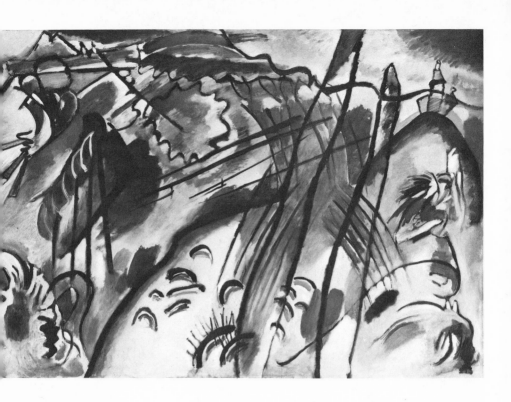

(*opposite*)
MAX BECKMANN: *"The Argonauts"* (*1950*)
Oil
COURTESY MRS. MATHILDE Q. BECKMANN

(*above*)
VASILY KANDINSKY: *"No. 160b (Improvisation 28)"* (*1912*)
Oil on canvas, 44 × 63¾″
THE SOLOMON R. GUGGENHEIM MUSEUM, NEW YORK

PIET MONDRIAN: *"Broadway Boogie Woogie"* (*1942–3*)
Oil on canvas, 50 × 50″
COLLECTION, THE MUSEUM OF MODERN ART, NEW YORK

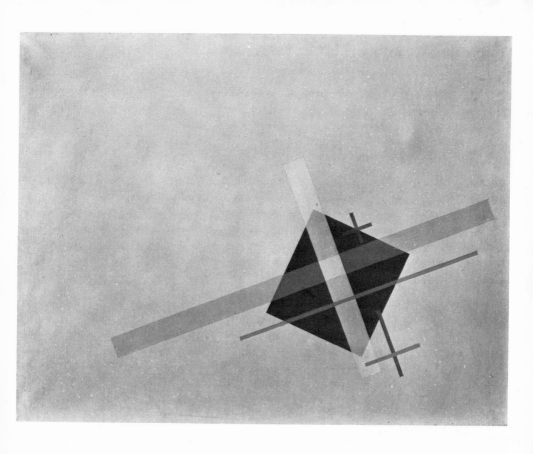

L. MOHOLY-NAGY: *"K-I"* (*1922*)

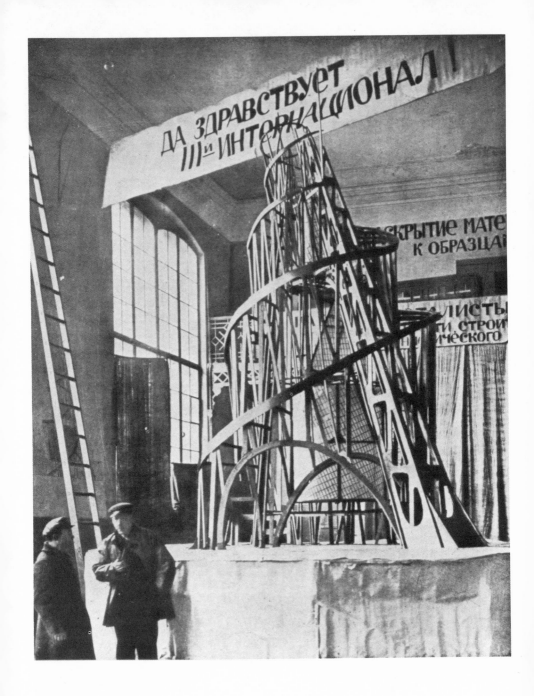

Vladimir Tatlin: *"Monument for the Third International"* (1919–20)

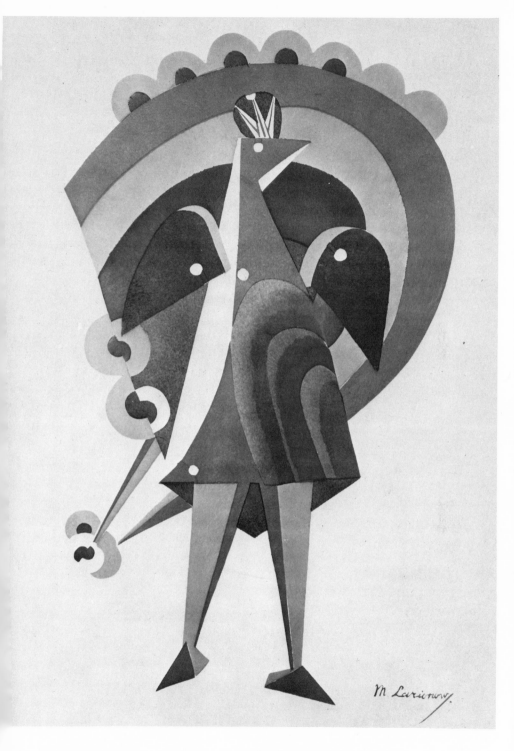

MIKHAIL LARIONOV: "Le Paon" (*The Peacock-Mechanical Costume*)
(*1915*)
19⅝ × 12⅞"
COURTESY HUTTON-HUTSCHNECKER GALLERY, INC., NEW YORK

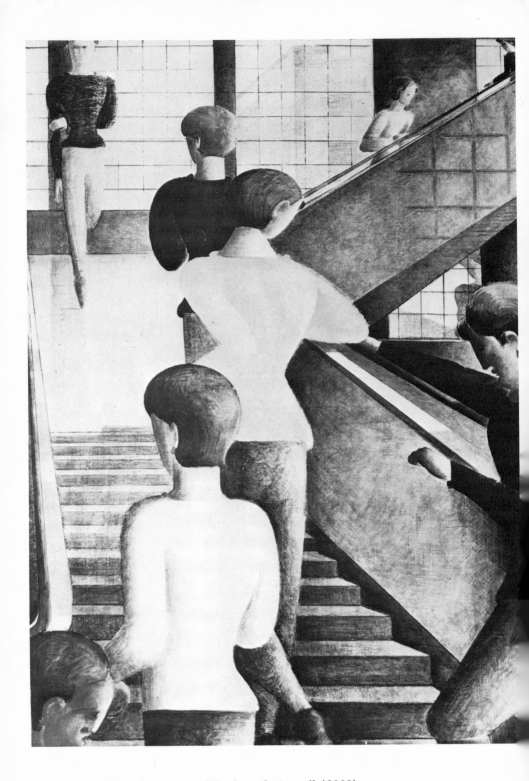

OSKAR SCHLEMMER: *"Bauhaus Stairway"* (1932)
Oil on canvas, 63⅞ × 45″
COLLECTION, THE MUSUEM OF MODERN ART, NEW YORK. GIFT OF
PHILIP JOHNSON

WALTER RICHARD SICKERT: "La Gaieté Montparnasse" (*c. 1905*)
Oil on canvas, 24⅛ × 20″
COLLECTION, THE MUSEUM OF MODERN ART, NEW YORK. MR. AND MRS. ALLAN
D. EMIL FUND

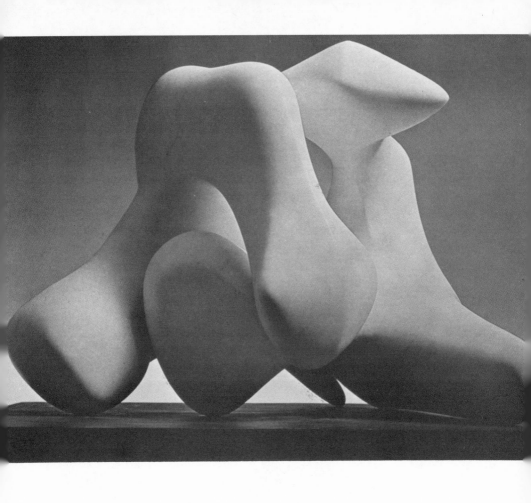

HENRY MOORE: *"Two-Piece Carving, Interlocking"* (1965)
White marble
COLLECTION, MISS MARY MOORE. PHOTOGRAPH, COURTESY M. KNOEDLER &
CO., INC., NEW YORK

concept of the "spiritual" was too bloodless perhaps, too metaphysical and otherworldly, to permit him to become the kind of pictorial poet he saw triumphantly at work in Miró. We are given the design of an imaginary universe, but not the thing itself.

However one judges these late works, though, they constitute a very moving and interesting chapter in an extraordinary career. They also tell us something important about Parisian art in the thirties, which Kandinsky came to as an exile and a refugee. And they remind us, too, that we have not yet had a really comprehensive biography of this painter who, in the face of the most momentous historical turmoil, continued to produce works of art of amazing detachment.

November 9, 1969

13. Mondrian's Freedom

The leap into abstraction that occurred in European painting around the year 1913—the exact date and the little matter of who was first are still in dispute—was an event of enormous artistic consequence. Whether the immediate point of departure was Expressionism, as in the case of Kandinsky, or Cubism, as in the case of Mondrian, the established pictorial means was suddenly relieved of the obligation to make any explicit reference to an immediately recognizable subject matter. Implicit references persisted, to be sure, but the whole notion of what a painting "represented" underwent a radical change. Thenceforth, the so-called "content" of painting could no longer be determined solely on the basis of what the artist put down on the surface of his picture.

Of the painters who were among the first to bring this leap into abstraction to a successful artistic realization, Piet Mondrian was certainly the greatest. In the logic and consistency of its development, his *oeuvre* is virtually a work of art in itself. In his extraordi-

nary clarity and tenacity of purpose, Mondrian set a standard of moral probity in art that few of his successors have equaled, and none has exceeded. There is, moreover, an intellectual dynamism in Mondrian's work—a conscious and constant pressure of mind at the service of aesthetic emotion—that significantly modifies our experience of painting as an art. In shutting out the whole realm of representational imagery as it was traditionally conceived, Mondrian transformed painting into a form of dialectic.

It was an amazing creative feat, and the passage of time has served only to increase our sense of both its audacity and its fertility. It was the kind of feat that could only be accomplished by an artist willing to forgo a good many of the gratifications traditionally associated with painting—and, indeed, a good many of the gratifications of life itself. Mondrian's career poses the question of the artist's sublimation in a particularly acute form. His appetite for life was evident enough to everyone who knew him, but so was his studied suppression of it. His sensitivity to nature was clearly stated in his early landscapes and flower paintings, but equally clear is the profound revulsion that nature came to inspire in him. The extreme asceticism of Mondrian's art had its counterpart—and, I believe, its spiritual source—in the extreme asceticism of his life.

It was not that he lacked feeling—far from it. All the old bromides about Mondrian having no emotions simply do not sustain critical scrutiny. It was, rather, that he was in spiritual flight not only from the vagaries of common feeling but from all the workaday disharmonies of the quotidian world. In Mondrian, a philosophical idealism combined with a remorseless puritan sensibility to produce an art that, in the eyes of its creator at least, existed well beyond the reach of earthly vulnerability.

The large Mondrian exhibition at the Solomon R. Guggenheim Museum brings us this art in all its astonishing complexity. This is a magnificent exhibition that traces, step by step, the arduous course by which this artist, so conservative and correct in his earliest efforts, so painstaking in avoiding anything false or fashionable or facile, first submitted himself to the fateful innovations of the modern movement and then drew his own logical conclusions from them—conclusions that outdistanced anything his own masters had conceived of, and led in the end to an art that has been widely imitated, widely acclaimed, but little understood.

Here, then, are the early academic landscapes and still lifes—

some dating from the 1890's, when Mondrian was still in his twenties—together with the Expressionist and Divisionist landscapes that succeeded them. Here, too, are the paintings that are said to represent his early theosophical beliefs, the most notable of these being the gruesome triptych called "Evolution," painted around 1911, which happens not to be a very good painting. And then, beginning in the years 1911–12, the wonderful pictures registering the first impact of Cubism. There are a number of beautiful paintings in the early sections of this exhibition, and some that are frankly commonplace, but we do not feel the real authority of Mondrian's special gifts until they come into fruitful contact with the Cubist vocabulary.

What is so impressive about Mondrian's response to Cubism is, first, his swift mastery of its basic syntax and then, the speed with which he essentializes that syntax into a pictorial form that is unanticipated in his original sources. The "Compositions" of 1913–14 take their place easily enough beside certain Cubist paintings of Picasso and Braque, but the "Composition in Black and White" (1916–17) already occupies an intermediate aesthetic territory of its own. Then, the "Compositions with Color Planes" of 1917, the "Diamond Shape" and "Checkerboard" pictures of 1919, until, in 1920, Mondrian arrived at the black grid format that, with many subtle variations, he retains almost to the end of his work.

Mondrian's famous grid style, with its reduction of pictorial form to right angles and primary colors, is usually described as "geometrical." This is accurate enough if we use the term to describe only his forms and not his method of composition. For there is nothing mathematical in his methods of composing a picture, which remained to the end as improvisational—as visually determined—as Monet's or Matisse's. If there is a Mondrian secret—an open secret that somehow eludes common understanding—it is simply that within the limits of the strict formal discipline he imposed on his choice of forms, he was nonetheless a painter working by visual trial and error, continually adjusting and revising the elements of his compositions until they conformed to the specifications of his feelings. He created a highly circumscribed vocabulary, but he created no system by means of which pictures could be mechanically produced.

It was this openness to the uncertainties of visual decision within the picture-making process—perhaps the only realm of un-

certainty Mondrian was entirely at peace with—that permitted him to abandon the black grids in creating his great last pictures. The freer, more syncopated use of pure color we find in "Broadway Boogie Woogie" (1942–3) and "Victory Boogie Woogie" (1943–4) is a remarkable testimony to the immense expressive freedom Mondrian had won for himself within the strict confines of his life and his ideas. If we fail to appreciate that freedom, if we see Mondrian's *oeuvre* only under the aspect of the disciplines he imposed on his art and on his life, then we fail to see his true importance as an artist.

October 17, 1971

14. Moholy-Nagy

Lászlo Moholy-Nagy, whose work is currently the subject of a large retrospective exhibition at the Museum of Contemporary Art in Chicago, is an artist who still somehow resists the normal categories of criticism almost a quarter of a century after his death. One of the reasons, of course, is his extraordinary versatility. Moholy was a painter, sculptor, designer, photographer, filmmaker, teacher, and theoretician. He achieved distinction in all of these fields and showed an unmistakable genius in several of them. This alone would make a conventional evaluation of his work difficult to come by, but versatility is only the beginning of the problem. The real obstacle to coming to terms with Moholy lies elsewhere. In attempting to deal with his artistic achievements, one is inevitably drawn into the orbit of his purely theoretical disquisitions, and these have the effect of placing works of art—not only Moholy's, but all such works—almost beyond the reach of criticism.

Thus, in the exhibition which Jan van der Marck has brought to Chicago, the largest section is devoted to Moholy's paintings—

sixty-nine works, dating from 1919 to 1946, the year of the artist's death. Certain of these paintings, particularly those of the early twenties, must be counted among Moholy's finest accomplishments. The influence, first of the Cubists, the Futurists, and the Dadaists and then of Malevich and Lissitzky, is certainly patent, but Moholy displays a breathtaking authority in assimilating these influences and a perfect understanding of their significance. Indeed, in the genre of pure geometrical abstraction, I would place Moholy's paintings of the early twenties above those of Kandinsky.

Yet Moholy clearly regarded such easel painting as a marginal activity, perhaps even an obsolete activity, which unfortunate circumstances still required him to pursue. The dream he harbored was for a kind of art that could not be contained by the easel, the studio, or the museum. Nowadays, I suppose, we would call it environmental art, though Moholy's dream cannot really be understood in purely aesthetic terms. What he envisioned was a grandiose form of social reconstruction—a benevolent revolution in which the resources of industrial technology would be used to liberate and elevate the sensibility of the masses. The role of the artistic impulse in such a revolution would not be to produce precious objects (such as easel paintings), but to redesign every object—indeed, every visual sensation—in the environment. Art would cease to be an end in itself and become a method—the primary method, in fact—for transforming society into a happier and more harmonious community.

Viewed from the vantage point of the urban debris in which we are all, perforce, picking our way these days, Moholy's aspiration is very moving in its unbridled utopianism and rather tragic in its misplaced optimism. History has made a mockery of dreams of this sort and has left Moholy himself, who yearned for a "totality" of vision, a fragmented figure. For it is a fragment of Moholy's career that we see in this fine exhibition, the fragment that lends itself to museum display, and it could not be otherwise. Insofar as this fragment shows him at his best, it transforms his career into an ironic comment on itself.

Museum exhibitions, by their very nature, turn works of art into precisely the kind of objects that Moholy wished to transcend, if not actually to obliterate entirely, and so the effect of this exhibition is, willy-nilly, to throw Moholy and his work back into the arena he

so much wished to escape—the arena of pure disinterested aesthetic contemplation where the values are primarily aesthetic and society need have no worry about any disturbing practical consequences.

Where Moholy did effect practical consequences, some of them disturbing indeed—in his teaching and his theories of art education, first at the Weimar Bauhaus and then at his own School of Design in Chicago, and in his great work as a designer—there, too, his career has had its ironic aftermath. A great deal that Moholy first proposed our schools have long since disposed as their standard fare. As Sibyl Moholy-Nagy observes in her essay for the catalogue of this exhibition: "The ubiquitous Basic Design courses of today have totally absorbed Froebel's *Gifts,* Van Doesburg's didactic transformation of a cow, and the Bauhaus *Grundlehre.*" And, one must ask, to what effect? The civilized world has become a notably uglier place since these theories were installed as gospel—not, of course, because of them, but in spite of them.

Here, too, history has reduced Moholy's great work to a fragment in a void. And this, in turn, ought to remind us of what the Basic Design philosophers always choose to forget—that art itself, no matter how extended our definition of it, is an insufficient vehicle for transforming the world. The world is changed, alas, only by political action, and philosophers of design who refuse to face this harsh truth consign themselves to a permanent state of self-deception.

Moholy's work—both the works of art and his theoretical writings—derived, of course, from an atmosphere of failed political revolution, first in his native Hungary and then in Germany. He was deeply influenced by the social idealism that animated the Russian avant-garde in the early years of the Bolshevik Revolution, and the Socialist values of the Bauhaus colored his entire outlook on the social mission of art in the modern world. Yet in the end he brought his ideas and his hopes to bear on an entirely different context—the world of capitalist commerce and product design, which, when all the theoretical niceties are swept aside, reduces the artist to a cog in the machinery of the advertising industry. The distance from Weimar to Chicago was even vaster in spirit than it was in miles.

And so we are left, after all, with a museum exhibition—a brilliant exhibition, too—and we must look at Moholy as a muse artist, something rather less than he wished to be. Looking at exhibition, it is interesting to observe that his purest painting was

done in the early twenties when his political idealism was strongest. The correlation is almost palpable, if still somewhat mysterious. Later on, despite the use of unorthodox materials and an unflagging capacity for visual invention, the paintings grow fussy and old-fashioned. Color is at times almost Post-Impressionist in its effects. One feels more and more the pressure of ideas, the will to experiment, the logic of this or that "solution," but less and less certainty about the goals to be attained.

What is true of the late paintings does not apply to Moholy's photographs, however. These are among the purest and most eloquent of his later works, and my only criticism of this exhibition is that it shows us too few of them. In this medium Moholy exercised a control over both the machine and his visual materials that fate denied him in the world at large, and he triumphed.

June 8, 1969

15. Rodchenko: Art in the Service of Revolution

"With the victory of the proletariat will come the victory of Constructivism." What a world of hope, illusion, tragedy, and genius is summed up in this statement, written in 1923 by the Russian critic Osip Brik about the Constructivist sculptor, painter, and designer Alexander Rodchenko. Yet such hopes and such illusions once had, or seemed to have, ample historical justification. Here was an authentic avant-garde, not only allied to a radical political program but actually functioning (at least in its own eyes) as an essential part of a momentous revolution. The very name of the journal in which Brik's statement appeared—LEF (Left Front of Art), founded by Mayakovsky—signified the hope of the perfect world to come in which the aesthetic impulse, now at last fully realized, would be indistinguishable from the practical tasks of social recon-

struction. Art and life would, finally, be united in a single, organic effort.

Those first years of the Russian Revolution, when artists of the stature of Kandinsky, Malevich, Gabo, Tatlin, Popova, and Rodchenko were all actively engaged in creating what was thought to be a new revolutionary culture, and doing so with the firm support of the new Soviet regime, which granted the artists large bureaucratic powers over all those institutions (academies, museums, workshops, etc.) in a position to affect the visual arts and their social function—those first critical years of the Revolution constitute a tender historical moment for anyone with an interest in forging a creative alliance between avant-garde aesthetics and radical politics. The hope expressed in Brik's statement, like the hope embodied in Rodchenko's Constructivist work—proved, as we know, to be short-lived. By the end of the 1920's, it was illegal in the Soviet Union to teach Constructivist doctrine. By the 1930's, abstract art was considered a crime against the State. In the end, neither Constructivism nor the proletariat could claim many permanent victories.

Despite the tragic aftermath of Constructivism's brief hour of glory in the Soviet political sun, interest in the movement—both as a subject of art historical study and as a possible model for an alliance between avant-garde art and radical politics—has enjoyed a significant growth in recent years, and at the present moment this interest is at something like a new peak. Later this month the Arts Council of Great Britain will mount a large exhibition called "Art in Revolution" at the Hayward Gallery in London. (The show has been organized by Camilla Gray, the British art historian who is married to Oleg Prokofiev, the composer's son, and whose book *The Great Experiment: Russian Art 1863–1923*, published in 1962, remains the best single guide to the subject.) Another survey of the movement, organized by the Technische Hochschule of Delft, was recently on view at Harvard University's Carpenter Center in Cambridge. And now the Museum of Modern Art in New York has opened a small but important exhibition devoted to Rodchenko. This is said to be the first Rodchenko exhibition ever organized outside the Soviet Union.

Both in its achievements and its repudiations, in its versatility and its fragmentation, Rodchenko's career tells us much about the whole Constructivist phenomenon—about its inspired aesthetic innovations as well as its doctrinaire political motives. He was born in

St. Petersburg in 1891 and attended art school in that city before moving to Moscow in 1914. He quickly joined forces with the reigning avant-garde, then dominated by Tatlin and Malevich, and a year later was invited by Tatlin to show his work in an exhibition.

At this time, Rodchenko's work was already geometrical and abstract, its imagery derived from the use of the compass and the ruler. He created his first three-dimensional construction in 1917, and in the years 1919–20 he produced an incredibly audacious series of geometrical constructions in metal and wood, which, if the surviving photographs are to be believed (unfortunately, the actual works have been lost), anticipate much that we have recently come to identify as the aesthetic characteristics of Minimal sculpture. The documentary photographs of Rodchenko's lost sculptures—most of them constructed of rough materials assembled in the most simple manner—are, in some respects, the most moving part of this exhibition.

The Revolution brought Rodchenko an important administrative post—he became Director of the Museum Bureau. He turned his attention to the theater, to film, and to architecture, working as a designer. And then, in 1922, he repudiated the "fine arts" altogether. In an essay written on the occasion of this exhibition for a forthcoming number of *Art News*, Jennifer Licht—the Associate Curator of Painting and Sculpture at the museum who organized the show—writes that Rodchenko "considered himself the first to discard [painting] as an anachronistic activity, but his position reflects the ferment of the time. Alexei Gan's manifesto, written in 1920, declared 'the first slogan of Constructivism is "Down with speculative activity in artistic work! We declare unconditional war on art." . . . The artist must be a Marxist educated man who has once and for all outlived art and really advanced on industrial material.' "

Thereafter, Rodchenko worked as a photographer and designer. He designed the journal LEF, among other things, creating a very original form of photomontage as an illustrational device. And just as his early geometrical paintings and drawings and his constructed sculpture exhibited remarkable gifts and a no less remarkable courage, his photographs and graphic designs are work of a high quality and individual vision.

The exhibition at the Museum of Modern Art is small in size: some thirty-odd items are included. But it brings us a sense of the full range of Rodchenko's achievements. All of the work is drawn

from the museum's own permanent collection. Most of this material we owe to the pioneering interest of Alfred H. Barr, Jr., the museum's first director, who visited Rodchenko in the Soviet Union in 1928, a year before the museum was founded, and began collecting his work at that time. Mr. Barr's article on "The 'LEF' and Soviet Art," published in *Transition* in 1928, is still an illuminating, sympathetic account of this extraordinary movement.

The exhibition itself, consisting of paintings, drawings, photographs, and graphic art, is an important contribution to our understanding of Rodchenko, Constructivism, and the Revolution—one might say, the lost Revolution. It is also, in some respects, unbearably sad. For what survives in Rodchenko's work is not the ideological fervor, not the dream of a new society, not the blood-spattered debris of terrorist politics, not even the aspiration of a new culture, but precisely what he and his fellow Constructivists thought they had repudiated—"speculative activity in artistic work." Rodchenko survives by virtue of his strength as an artist, and very largely because those who did not share his political convictions nonetheless honored his artistic integrity. The irony is harrowing to contemplate, and one cannot help wondering if Rodchenko, who lived until 1956 (still working, we are told, as a photographer and designer, but we do not know in what manner or style), gave the matter much thought.

February 14, 1971

16. Thinking about Tatlin

There are certain works of art—even certain artistic conceptions—which assume a historical importance far in excess of their workaday merits. Such works become imbued with an aura of myth. We need not even have seen them firsthand to feel the sense of excite-

ment, challenge, and prophecy which is forever after associated with them. A few photographs, a few documents, and a vivid legend are enough. Not only a great moment but a great aspiration is permanently memorialized. The meaning of art is never quite the same again.

For myself, as for many others, one of these works is Vladimir Tatlin's Monument for the Third International (1920). More than any other single work, it symbolizes the ideals of the Russian avant-garde in the early years of the Bolshevik Revolution. It represents a high point in that exhilarating union of radical aesthetics and revolutionary politics which dominated Russian cultural life in the first five years (1917–22) of the Bolshevik regime.

The monument itself was never built, of course. Even the original model, which stood about fifteen feet high, was destroyed. But photographs of the model have survived, and the work has acquired a legendary status. Now a new version of the model, built during the past year in Stockholm, has come to the Museum of Modern Art as part of its exhibition of "The Machine."

Contemporary museology refuses to be daunted by the tragedies of history. What fate has consigned to oblivion the curators are now in a position to order restored—or at least reproduced. Last year, in Buffalo, we were given a huge replica of Liubov Popova's Constructivist stage set for the 1922 production of *The Magnanimous Cuckold*. This year it is Tatlin's Monument. Soon, I suppose, we shall have the entire history of Russian Constructivism available in a handy kit. I don't know which I find more repellent: the solemnity of this enterprise or its frivolity. Perhaps it is only another case of talent revenging itself on genius.

One thing is certain. Far from confirming the importance of Tatlin's work, this replica of the original model seems more than anything else irrelevant to it. The new model stands in the museum's sculpture garden, and the effect of its presence there is—on me at least—to make Tatlin seem even more remote from us than he has been hitherto. (I couldn't help wondering, among other dark thoughts, when the table-model replicas would go on sale at Brentano's.) The whole thrust of Tatlin's ambition was to remove Constructivism from the realm of pure aesthetics. What he sought was a grand synthesis of sculpture, architecture, and engineering—a utilitarian art that would transform the structure of the physical

environment as radically as the Communist Party was transforming the structure of the social environment. Think what you will of this aspiration, it does not lack a certain grandeur. I cannot see that this new mania for making replicas does anything but trivialize a great idea.

Considering what Tatlin suffered in his lifetime, this latest episode is only a footnote of course. The cruelest blows were dealt him by Lenin, the leader who, during those few halcyon years of the Revolution, promised to make Tatlin's vision an integral part of the State, and then, in introducing his New Economic Policy, brought the dictatorship of the avant-garde to an end. That, too, is part of Tatlin's legend and part of his importance. His commitment to the Revolution was too complete for his art to survive the perfidies of a regime which, by the thirties, was stamping out all traces of the generation which made the Revolution. In Moscow last year, I saw some of the evidence of what this meant for Tatlin himself—a few pathetic and inept figure paintings, produced in the thirties, in the hope perhaps of conforming to the new dictates of the government. A grim dénouement to a heroic adventure.

Tatlin would have a claim on our attention even without the Monument for the Third International. He was, it seems, the first to create a nonobjective sculpture. He had visited Paris in 1913 for the express purpose of seeing the constructions Picasso was then working on—sculptural adaptations of Cubist collages that still retained an allegiance to representational motifs. Upon his return to Moscow that same year, Tatlin produced a startling series of abstract constructions, often employing common objects and a variety of materials. The basic tenets of Constructivist sculpture were stated—probably the most revolutionary revision of sculpture aesthetics in modern times.

Tatlin was, then, both a leader of the modernist movement and a renegade from its purist objectives. He was the classic example of the modernist who found "mere" art insufficient for his goals. All of life had to be assimilated to his grand design, and the combined force of modern technology and modern politics promised, for a time, to make this impossible ideal a workable reality.

It was, as I have said, an ideal with a certain grandeur, but its grandeur was inseparable from a chilling—and ultimately, a highly destructive—willingness to liquidate the past. In the catalogue of the current exhibition, his pupil Annenkov is quoted as having written:

Tatlin used to say that a modern factory at work is the culminating manifestation of our times, surpassing the opera or ballet; that a book by Albert Einstein is certainly more enthralling than any of Dostoevski's novels; and that is why art today should be the standard-bearer, the vanguard, and the incentive for the advance of human culture; to serve this role, it must be useful and *constructive.*

In art, as in politics, we have learned to be skeptical of such utopian visions. We are too well placed in history to measure their cost. But on the stage of history where the utopian claims of art and politics meet, the tragedy of Tatlin remains a legend and a legacy.

December 8, 1968

17. "The World of Art" in Exile

In the history of the visual arts in Russia in the years preceding the Revolution of 1917, we give first place to those modernist movements—Constructivism and Suprematism especially—which have had the greatest artistic consequences. These movements can also claim the additional interest of having been regarded by a number of their principal participants as constituting, in some degree, the aesthetic counterpart to the Revolution itself. This alliance of avant-garde art and revolutionary politics proved, alas, to be short-lived. But in the few years in which it flourished, it seemed the very model of what an enlightened, purposive aesthetics in harmony with a radical political outlook might be.

There is, however, another significant chapter in the Russian art of this period which traces a very different history and harbors values of a very different sort. This is the chapter that embraces the painters who were closely associated with Diaghilev and the Ballets Russes. And it is in their work that we confront the paradox of which I speak.

For the artists of the Diaghilev circle, deriving from the aestheticism of the nineties, set themselves against the revolutionary currents that finally overtook the Russian state in 1917. They constituted an avant-garde completely at odds with enlightened social causes. "None of us were in the least democratic," the painter Alexander Benois writes in his *Reminiscences of the Russian Ballet;* "We all felt, quite consciously, an absolute indifference to politics and every shade of it; yet, at the same time, we had a certain reverence for whatever appeared to us to be a 'living emblem of history,' and to that category belonged Monarchy and the Sovereign himself, his court and the nobility represented in it."

Benois was, with Bakst, Larionov, and Gontcharova, the most important of the Russian painters who joined with Diaghilev in his fateful artistic adventure, which began with the founding of an art journal, *Mir Iskusstva (The World of Art)* in St. Petersburg in 1898 and ended only with the death of Diaghilev in Venice in 1929. All owed their principal fame to the work they produced for the Ballets Russes, though Larionov is still remembered in his own right as the founder of Rayonism, one of the earliest nonobjective pictorial styles. Last summer the Council of Europe mounted a superb, comprehensive exhibition in Strasbourg to mark the fortieth anniversary of Diaghilev's death. One can only hope that some day an American museum will organize an exhibition of comparable scope, for the Ballets Russes represents a high achievement in the history of art as well as the history of dance. At the moment, however, we shall have to settle for the more modest and rather motley exhibition of "Ballet and Theatre Designs" at the Hutton-Hutschnecker Gallery. The emphasis here is mainly (but not exclusively) on Russian ballet design, and we are at least afforded a glimpse of what its special quality consisted of.

The visual world of the Russian ballet is an inspired amalgam of the primitive and the romantic, of folklore and fairy tale exquisitely transmuted into their aesthetic quintessence. The folk elements—folk art, folk music, folk legend—are an essential component of this vision, providing it with ample motifs and all sorts of stylistic ideas, providing indeed an indispensable vitality, but the vision itself is the very opposite of a folk vision. It is a vision of extreme aesthetic refinement and complication—the vision of a privileged, art-intoxicated intelligentsia whose only real attachment

to folk culture is in the materials it supplies for aesthetic delectation. What Diaghilev effected was, in a sense, the elevation of a certain *raffiné* St. Petersburg aestheticism, with all its vague yearnings and unfocused energy, into a viable artistic principle.

The sparks were all struck in this small circle of St. Petersburg aesthetes who conducted the editorial affairs of *The World of Art* around the tea table in Diaghilev's elegant apartment, but it required a larger, freer world than that of St. Petersburg—specifically, the world that looked to Paris for its artistic leadership and for its artistic standards—before these sparks could burst into full flame. And it required the ballet for its vehicle. Although painting, music, and literature were all of passionate interest to the Diaghilev circle, the ballet proved to be the perfect medium for the realization of their aesthetic dreams. For the ballet was the least burdened with that sense of moral and social duty which (with just cause) lay so heavily on the shoulders of Russian culture. Only the ballet was fully emancipated—if that is the word—from this burden of moral didacticism and thus fully open to the purification of its aesthetic essence.

It is no accident (as the Marxists say) that the Ballets Russes became an art of exiles and expatriates. Even before leaving St. Petersburg and long before the Revolution, the group that founded *The World of Art* had already exiled itself from the suppurating problems of Russian society and taken refuge, precisely, in the world of art whose closest earthly approximation was the capital of France. Only in Paris, where Diaghilev eventually enlisted many of the greatest talents of the century, could this very special Russian dream fulfill itself.

Historically, there is something immensely tragic in this recoil of art from its social matrix, but as an artistic achievement it remains one of the sublime ornaments of modern culture. Nor have the values and the essential vision that inspired this achievement entirely spent their force even now. The accomplishments of at least two living artists who are widely regarded as among the greatest of their time—George Balanchine and Vladimir Nabokov—and traceable, despite the changes of venue and language and outlook, to the aesthetic dream that nourished Diaghilev and the artists he gathered around him in St. Petersburg in the nineties. This is, I suppose, what Mary McCarthy meant when she characterized *Pale Fire* as "a

Fabergé gem." Thus, the cultural paradox which the artists of the Ballets Russes represent in such extreme, exquisite form is one that haunts us yet.

May 3, 1970

18. Oskar Schlemmer's Abstract Universe

Oskar Schlemmer, who died in 1943 at the age of fifty-four, is probably the least known of the "masters" who dominated the Bauhaus in its most creative period. The reasons for his relative obscurity—relative, that is, to the great fame and influence of Klee and Kandinsky and even to the somewhat lesser fame that came to Feininger and Albers—are no doubt many and varied, but chief among them, certainly, is the very special visual obsession that absorbed Schlemmer's imagination. Almost alone among the leading artists of the Bauhaus group, Schlemmer was haunted by a particular notion of what the ideal representation of the figure should be. Conceptions of the figure—in painting or sculpture or other media—were not (shall we say?) the principal interest of Bauhaus aesthetics, and Schlemmer has, therefore, always seemed, even to those few who have been more or less aware of his accomplishment, a somewhat marginal figure.

I am not sure that the large exhibition at Spender A. Samuels & Company is going to alter Schlemmer's status in this country to any great degree. There are some remarkable works of art in this exhibition, which numbers over one hundred separate items, yet the show as a whole is anything but definitive. The real problem, in this case, lies beyond the fragmentary nature of the present exhibition; it lies in the peculiar nature of Schlemmer's own imagination.

Among his immediate contemporaries, Schlemmer was closest perhaps to Feininger. Both men were profoundly influenced by Cubism, and their entire mature *oeuvres* derive from a very personal development of Cubist pictorial syntax. Like Feininger, too, Schlem-

mer favored a kind of crystalline light—earthbound in its origins, but essentially a medium of metaphysical yearning. What separated Schlemmer even from Feininger, however, was this obsessive interest in the human figure as the central motif and symbol of his art—indeed, as the central motif and symbol of reality itself.

Now what is very special about Schlemmer's interest in the figure is the radical degree to which this interest is removed from any of the traditional humanist concerns. Schlemmer wished to convert the figure into an element—the most important element—of a transcendent geometrical vision. For such a vision, the human body was no longer the imperfect psychological resident of the normal workaday world; it was a sublime mechanism functioning according to the metaphysical laws of an ideal geometry. In a very specific way, Schlemmer dehumanized the figure in the interests of a higher philosophical credo.

Whether one can any longer take Schlemmer's philosophical ideas very seriously remains, I suppose, a matter of intellectual taste. Like many another Bauhaus master, he seems to have carried into the classroom and into his own creative work some eccentric and rather exhausted remnants of German idealist philosophy. Thus, when Schlemmer refers to "man," as he repeatedly does in both his theoretical reflections and in his paintings, drawings, sculptures, and designs, he is referring to an abstract idea from which the accidents of experience, history, and personality have been stripped bare.

The real interest of the current exhibition, with its many small works and sketches, is in the way it traces the effect of this deeply felt philosophical position on the development of Schlemmer's visual ideas. The intellectual atmosphere of the Bauhaus certainly encouraged the tendency toward abstraction; yet we can see that Schlemmer worked out the visual logic of his designs in a very personal and painstaking manner. Sometimes the results were romantic, lyrical, and even fantastic in a way that his theoretical aims have literally nothing to do with. At such times, one is tempted to believe that the artist's emotions were a good deal more interesting than his ideas and that his sensibility might have found a more congenial task in an earlier period of art history when the outright illustration of romantic philosophical poetry was still considered an honorable artistic pursuit.

It is a question, in any case, whether painting and sculpture, at least as they were conceived by Schlemmer and his contemporaries,

were the proper vehicles for his imagination. Schlemmer himself was very conscious of this question and looked to a certain kind of abstract dance theater as the ideal realization of his visual ideas. He took an intense interest in the ballet, and "man as dancer" (*Tanzermensch*) assumed for him an enormous philosophical significance. He himself designed a mechanical ballet, in which the figures were all animated geometrical mannequins. I saw an exhibition of these mannequins—reconstructed, I believe, from Schlemmer's designs—some years ago in Rome, and they were extremely beautiful. They were clearly the work of a man who had a real and original gift for theater of a very radical kind—a theater in which the macabre, the abstract, and the purely mechanical were joined in a very compelling visual fantasy.

His paintings, however, suggest quite a different realm of feeling—something almost classical in its distance from the emotions of the workaday world. Indeed, there is something almost neoclassical about the way Schlemmer conceives of his impersonal figures in relation to their architectural settings. And yet, like so many products of the German imagination yearning for classical solutions, these pictures carry a strong suggestion of romantic association. And I believe there is, at the heart of all Schlemmer's art, a metaphysical romance he was not altogether conscious of serving. He was always seeking refuge from that side of his sensibility in diagrammatic form and abstract construction.

November 2, 1969

19. Walter Sickert and the Malaise of English Painting

Everybody knows that something happened to English painting after the death of Turner, but nobody knows exactly what. From that day until this, English painting has been in an invalid, or semi-

invalid, state. At times it has risen from its sick bed and put on a marvelous show of health, but usually by simulating the appearance of health in others. For a long time, the French provided the requisite look, only to be succeeded, sometime in the 1950's, by the Americans. Often something very engaging emerged from these repeated attempts to appear as if vitality had been restored, and there was always something touching in the effort. Yet, when one looked back, the infirmities were plain to see. The patient was being brave or optimistic or self-indulgent, but the mysterious disease persisted.

As one scans the annals of English painting over the past hundred years or so, looking for exceptions to this general rule of decline, one of the names that offers itself is that of Walter Sickert (1860–1942). It is not a name familiar to the American scene. The records are bare of Sickert exhibitions in New York; the last anywhere in the United States took place in Pittsburgh and Chicago nearly thirty years ago. And I do not recall that the Sickert pictures in the Museum of Modern Art's "Masters of British Painting 1800–1950" exhibition of 1956 excited any particular interest. On that occasion, it was (as usual) the Turners and Constables that arrested our attention.

Yet Sickert has had his partisans, in England if not here, though their partisanship has usually been cautiously equivocal. Clive Bell considered him "the greatest British painter since Constable," and then added: "But I do not think he had genius." Patrick Heron spoke of him as "a born painter," but then compared him unfavorably with Bonnard. Sickert is indeed the kind of artist whose work prompts one to qualify and amend whatever claims one is tempted to make for it on first acquaintance. The claims are usually based on something real, but the art somehow proves vulnerable to doubts.

The Sickert exhibition at the Hirschl & Adler Galleries will do nothing to change this equivocal response. The quality of certain pictures is undeniable, but these pictures are distinctly in a minority. The exhibition as a whole runs to second-rate examples. Yet there is enough here to remind us that Sickert is worth showing. Flawed and limited though his work may be, he certainly was "a born painter" with a marked sensibility of his own.

It was a sensibility that found its happiest expression in the gloomiest light. Many of Sickert's best pictures seem designed, at

first glance, to resist being seen. The palette is predominantly, often oppressively, limited to murky browns and grays. There is an insistence on—and, one gradually discovers, a beautiful control of—close values. Sickert's darkness turns out to be a highly personal realm of the imagination, and he inhabits it with authority.

For this darkness was, of course, a form of light, and a form in some respects more difficult to articulate than the open-air, sun-drenched light favored by the Impressionists and their followers. It was made more difficult and risky in Sickert's case because his own loyalties as a painter were firmly based on the French example. Beginning as a disciple of Whistler and then transferring his allegiance to Degas, Sickert was never in any danger of becoming a wholehearted open-air Impressionist of the Monet persuasion, but more than most English painters of the period, he painted out of a comprehensive firsthand knowledge and understanding of what Impressionism meant. In a sense, he took Impressionism indoors, into the gloomy half-light of his own sensibility, where he found a narrower margin of pictorial nuance to explore. Even Sickert's landscapes often have the look of ill-lit interiors, for it was really in the visual terrain of an interior just barely rescued from an impenetrable obscurity that his painterly gifts became most deeply engaged.

The best example in the Hirschl & Adler exhibition is probably *"La Gaité Montparnasse* (Self-Portrait)," about 1905, from the collection of the Museum of Modern Art, one of the many theater subjects for which Sickert had a particular affinity. (He had begun his career as an actor.) In this, as in many other pictures, he followed Degas's example of using unexpected, photographic angles as the basis of his design, and the design, abetted by his close-valued palette and an extraordinary fastidiousness of observation in a subject that seemed scarcely observable at all, yielded a very rich pictorial structure.

It would be a mistake to discount the element of realism in Sickert. Indeed, a facile realism often led him astray. But at his best, Sickert was an exponent of what might be called a retinal realism—a realism scrupulous in reporting the exact tones discernible even in the densest shadows—and the very individual shallow-spaced structure that emerges from this scrupulous attention to observed tonal value owes little of its glory to the conventions of more commonplace varieties of realism. It is this retinal integrity that aligns his

work with the Impressionist mode, even though he eschews the Impressionist taste for high color.

Another unmistakable element in Sickert's sensibility is the strain of melancholy that pervades all his work. No doubt this was a factor in drawing him to Degas, the most pessimistic and aloof of the Impressionist group and the least Impressionist in style. The series of low-life interiors with figures entitled "Ennui"— there is one example in the current show—is, in this respect, emblematic of the dour attitude to life that lay beneath the poseur's stance that Sickert commonly affected. This tendency to melancholy enters into his portraits, too, and imbues them with a quality of character that is in perfect harmony with—that is, in a sense, the psychological equivalent of—Sickert's retinal precision and chromatic sobriety. "Sir Thomas Beecham Conducting" (1930), also in the collection of the Museum of Modern Art, is probably the best and certainly the most famous of these portraits, but the current exhibition includes other notable examples, too.

Still, even Sickert's singular achievements seem fragmentary, and the sense of equivocation and doubt shown by earlier critics of his work is not likely to be contested—certainly not on the basis of the current exhibition. There are, to be sure, some fine examples I have not mentioned: a beautiful little still life, "The Making of an Omelette" (1919), from the Phillips Collection in Washington—a picture which, though painted in Sickert's usual palette, is surprisingly light and bright; an interior, "Venetian Woman Seated on a Sofa" (1903), which reminds one that Vuillard might prove a more viable comparison than Bonnard; and others, too.

Yet the impression persists of an artist who failed to sustain his art at a level that would make comparison with the greatest of his French contemporaries something more than a critics' game. Even as one takes note of Sickert's excellence, he seems to fall back into the ranks of the English invalids, and his very excellence reminds us that talent, as such, was not the issue. The malaise of which Sickert was a distinguished casualty went deeper. It had its roots in the very sources of modern English culture, and remains to this day an enigma.

April 16, 1967

20. Epstein in London

Nothing serves a gifted, ambitious artist working within the received conventions of his time quite so well as a reputation for being scandalous and "advanced." The reputation brings in the intelligentsia, and the conventional quality of the work brings in the money. Since an artist under attack from the Philistines can usually count on a certain exemption from serious criticism, his patrons may satisfy their otherwise unremarkable taste, while enjoying the added cachet of sponsoring, usually at reduced prices, something daring and "new." Thus, the aesthetic heroism of the vanguard artist, which everyone now recognizes as the central plot of modern art history, generates its own comic subplot, in which the rhetoric of aesthetic heroism is employed to describe quite another order of accomplishment.

It is the English who, in lieu of an authentic *avant-garde* of their own, have made a specialty of these mock-heroic figures. For reasons that remain obscure—at least to me—the figures themselves have often been Americans. The most famous was Whistler, and the most recent is a young American expatriate painter by the name of R. B. Kitaj, whose London debut a year or so ago was hailed in the *New Statesman* as an event comparable to the publication of *The Waste Land*. Between Whistler and Kitaj, the principal beneficiary of this confusion of publicity with workaday artistic practice was the late Sir Jacob Epstein, of whom it can correctly be said, I think, that he was knighted precisely for having failed to be the kind of artist his admirers always assumed he was.

The scandal that launched Epstein's career as an English sculptor—the episode of the "Strand Statues"—was one of those mildly humorous curiosities of Edwardian culture that are almost wholly devoid of intrinsic artistic interest. In 1907 the British Medical Association commissioned Epstein, who had settled in London only two years earlier at the age of twenty-four, to execute eighteen stone carvings for the façade of its new building in the Strand. These larger-than-life-size figures, a benign and not very interesting pastiche of Epstein's gleanings in the sculpture collections of the Louvre and the British Museum, caused a sensation when they were unveiled the following year. The substance of the ensuing controversy may be seen in the newspaper article which

solemnly warned that Epstein's carvings were "a form of statuary which no careful father would wish his daughter or no discriminating young man his fiancée, to see. . . ." It was the nudity of Epstein's figures that caused the commotion and created the myth of his artistic audacity.

This preposterous event virtually determined the conditions under which Epstein's entire subsequent development took place. It turned him overnight into a public figure, into an "issue" on which artists and writers, churchmen and newspaper editors, and parliamentarians were obliged to take sides. But the experience had a baleful effect on Epstein's sense of himself as an artist, however useful it was in establishing his reputation. It seems to have deprived him of whatever powers he had—they seem, from the outset, to have been small—for introspection and disinterested aesthetic analysis. It narrowed the range of his interests and further diminished his already feeble grasp of the new art he had briefly glimpsed in Paris a few years earlier. It set him on the course of a completely public career at a time when public response, whether stupidly hostile or lavishly approving (and Epstein had it both ways in different phases of his career), was utterly without reference to aesthetic merit, or even to aesthetic questions. Thereafter he was dependent, to an extent almost unparalleled among the artists of his time, on the accidents of patronage for those rare occasions in which his genius could really flower.

And yet, despite this fundamental dislocation of his energies, it is not out of order to speak of Epstein's genius. That it survived so many wearisome and inglorious encounters with the Philistines— for the Strand affair was only the first of Epstein's many fruitless controversies—is something of a miracle. But its survival is also a measure of his true gifts, which were not at all for those monumental projects he repeatedly essayed throughout a long career. Epstein's forte, on the contrary, was a mode of psychological portraiture that permitted him an emotional and expressive amplitude utterly removed from the archaic allusions and constrictions of feeling that are so deadening in his monumental works. Confronted with a particular personality that really excited him, Epstein showed a great talent for dramatic characterization and for a virtuosity in the modeling of clay that this mode of sculptural representation requires to an extraordinary degree. The only real artistic purpose that Epstein's notoriety served was in placing him in the position to do the

portraits of so many famous people. Epstein was the kind of artist who needed exceptional subjects. He lacked those powers of conception and invention that allow certain artists to make something memorable, and all their own, out of whatever material or experience comes to hand. This is only another way of saying, perhaps, that he was fundamentally not a modernist at all. In taking hold of one of the least radical aspects of the art of Rodin—his portrait style—and endowing it with a quasi-Expressionist inflection of his own, Epstein produced his most enduring work. At his best—the portrait of Joseph Conrad is, in my opinion, the outstanding example—he did indeed raise this portrait genre to the level of genius.

Artists like Epstein, the bulk of whose *oeuvre* explores so few aesthetic questions and is so unvarying in the solutions it seeks, pose enormous difficulties for the author of the kind of lengthy monograph which Richard Buckle has here undertaken.* The temptation is always to dwell on scandal and anecdote, on potted cultural history and extravagant claims, in order to escape the endless repetitions to which an art at once so copious in examples and so small in intellectual compass lends itself. Mr. Buckle has not, to say the least, resisted this temptation. His monograph suffers from the further handicap of having been undertaken at the request of the artist's widow, and thus occupies a place beside those pious and petrified writings—in the historiography of modern art, they constitute a virtual genre in themselves—whose principal function is to convey the impression that their subjects, and they alone, comprise the center of the art-historical stage. It is understandable, and perhaps even commendable, for Lady Epstein to entertain this view of her late husband's achievement. For Mr. Buckle to write an entire book on this assumption is simply absurd. With a nonchalance that would be breathtaking if it were not so patently farcical, he refers to Epstein—and without feeling any need to argue the point—as "the greatest sculptor of modern times." The rather conventional illustrations of Jewish life on the Lower East Side that Epstein contributed to Hutchins Hapgood's *The Spirit of the Ghetto*—the money for which allowed him to quit America in 1902—prefigure, for Mr. Buckle, the "violence and pathos which we associate with the German Expressionists of the next two decades. . . ." From a writer so egregiously insensible to artistic discriminations one might

* *Jacob Epstein, Sculptor* (New York: World, 1964).

at least expect some useful scholarly apparatus, but Mr. Buckle provides none whatever. There is no bibliography, and what he grandly entitles a *"catalogue raisonné"* of Epstein's *oeuvre* is nothing but an undocumented list of titles. The 665 plates constitute the only really useful feature of this expensive book, and even they are not of the highest quality.

In the history of modern sculpture Epstein occupies a marginal but not an uninteresting position. On several occasions—when he got involved with Ezra Pound, T. E. Hulme, and Vorticism, and then again when he met Brancusi—he produced work that signaled an alliance with the modern movement that he very shortly abandoned. These brief forays into modernist form provide a clue not only to the limits of his art but to the qualities of his best work. If one compares his portrait heads to Rodin's, for instance, one can see the extent to which a kind of passionate sculptural caricature has been made to do the work of what, in Rodin, is a feat of sculptural construction. This element of caricature is powerful in Epstein, but it placed the artist at a sculptural disadvantage wherever he had to deal with more than a face, and it is for this reason that Epstein's heads are invariably more successful than his figures. This purely sculptural limitation is also, I think, indicative of a larger failing. In choosing to become an English rather than a French artist—and it was, for him, a very conscious choice—he opted for the kind of career that would not oblige him to be judged, or to judge himself, by the highest achievements of his time. A serious study of Epstein's accomplishment, far from skimping this crucial point, would have to take it as its major premise.

May 1964

21. Barbara Hepworth: From the Avant-Garde to the Establishment

The history of the English avant-garde in this century is not a subject that makes one's pulse beat faster at its mere mention. There is the phenomenon of Henry Moore, of course, but the tendency is to regard him as the exception to a general rule of dullness. There was the Vorticist movement, but its principal figure—Wyndham Lewis —is far more imposing as a writer than as a painter. The current English art scene seems lively indeed, with sculpture once again predominant, but the very character of its liveliness—its emphasis on what is new and "far out" and young—tends to diminish interest in the past.

Yet there is a part of that past that ought not to be lost sight of. Writing recently in the journal *Art and Literature* (Number 7), Mrs. Myfanwy Piper reminded us of the particular atmosphere and ambition that prevailed in a certain segment of the London art world in the early 1930's. This was the period when the cognoscenti had been won over to the aesthetics of Picasso and Matisse and Derain, largely through the writings of Roger Fry and Clive Bell, but showed little inclination to welcome the more difficult nonobjective vision then emerging in the work of Moore, Ben Nicholson, and Barbara Hepworth, among others. The latter stood for something rather more severe and stringent in form, for styles less visibly attached to observed experience and less vulnerable to the specifications of the sensual world.

Not the hedonism of Matisse, but the conceptual refinements and visual austerities of Brancusi and Mondrian defined their universe of discourse. For these artists, there were thus, according to Mrs. Piper, "two sets of enemies . . . those who hated all art since Manet and those who blindly idolized the École de Paris."

A classic case, then, of an avant-garde struggling not only against the Philistines but against the entrenched opinion of an earlier vanguard generation. Mrs. Piper was herself an active participant in that struggle as the editor of the group's magazine, *Axis,* which functioned for a few years as the English counterpart to *Abstraction-Création,* the organ of those artists—led by Herbin and Vantongerloo—who were defending the nonobjective ideology in

Paris. (We tend to forget the hostility that nonobjective art encountered in Paris in the period between the wars.)

We would do well to remind ourselves of that period of struggle in confronting the Barbara Hepworth exhibition at the Marlborough-Gerson Galleries. Miss Hepworth is now not only an established figure, but an Establishment figure. The catalogue of her exhibition carries the inevitable preface by Sir Herbert Read. She was herself made a Dame Commander of the Order of the British Empire last year. She has been the beneficiary of important commissions, including the Dag Hammarskjold Memorial at the United Nations, and her work is represented in museums the world over.

Miss Hepworth's position, moreover, is not irrelevant to the character of the work she is now showing. The large bronzes, many of them cast from original wood carvings and reproduced in "editions" of six, seven, and nine copies, are sculptures of a kind that only an artist enjoying the prosperity of a world market could afford to have made. The sculptural quality of some of these bronzes is very high. Through a canny use of varied patinas, the visual simulacra of the carver's contrasting interior-exterior surfaces are very deftly imitated. But one finds oneself admiring, in these bronzes, the craftsmanship of the foundry rather than the vision of an artist. They are, in a sense, the sculptural equivalent of poetry translated into a foreign language: the basic conception remains intact, but all that one responds to in the way of nuance and suggestion, all that was most personal in the poet's "voice," has been lost or drastically attenuated.

Exactly how much has been lost in these technically impressive—and, occasionally, even handsome—bronzes is clear when one examines the few original wood carvings that are also included in the current exhibition. The finest of these carvings are the "Large and Small Form" (1945) and the "Oval Sculpture (Delos)" (1955)—sculptures in which the purity of form has a direct and meaningful relation to the means and the medium by which it is achieved. Works of this kind do indeed carry one's mind back to the period of *Axis* and *Abstraction-Création*, when pure abstraction was—for its gifted votaries in London and Paris—not only a style but a destiny, a metaphysical quest that required, for its physical fulfillment in art, the most scrupulous and painstaking and personal probity of craft.

In his preface to the catalogue of the Hepworth show, Sir Herbert himself reveals a certain nostalgia for this forgotten sculptural probity, even though he hastens to endorse the practices that now subvert it. But this endorsement, too, is only a measure of the distance—a spiritual as well as an aesthetic distance—that the avant-garde of thirty years ago has traveled since the days of its most arduous and exemplary battles against received opinions.

The point is worth making because Barbara Hepworth is a sculptor who matters. She is not, I think, the equal of either Moore or Brancusi, the two artists closest to her in feeling and accomplishment, but it is a mark of her distinction that she requires us to judge her work by their standard—which is to say, the highest standard.

If, as I believe, her work fails to meet it, it may be because it encountered fewer obstacles of sensibility in its search for a purity of utterance. In Brancusi, one feels that the ultimate concision of form has been reached through a triumphant struggle with passions that are suppressed, but nonetheless implied, in the final image. In Moore, too, one senses a more complicated dialectic of feeling.

In Miss Hepworth, the struggle for a sculpturally pure statement seems more a matter of culture and craft than of interior drama. Yet that sense of culture and craft has sustained a very beautiful, if not always a very complicated, vision. One misses the immediacy of that vision in these prosperous-looking bronzes, even as one honors it again in the loveliest of her carvings.

March 13, 1966

22. Henry Moore: A Very English Romantic

In nature, every form is the realization of an organic imperative. In a work of art, however, every form is the realization—or an attempt at the realization—of an aesthetic imperative. This holds true even for those works of art that simulate the organic forms which nature produces in such prodigal abundance. An artist may feel a special

affinity for the organic forms of nature, but he can only act upon the demands of that affinity through a series of aesthetic decisions.

Certain styles, certain sensibilities, certain epochs favor this affinity for organic form. Others hold it in furious contempt. The pendulum of taste is always on the move between the one and the other of these extremes of favor which, at a given moment, may suddenly acquire the status of an absolute and then just as suddenly stand revealed as arbitrary, pious, and conventional. The absolute turns out, in other words, to be a fiction. Yet the quality of an artist's work and the very character of his vision seem to depend on the conviction—as we say, the absolute conviction—with which this fiction is upheld.

In the sculpture of Henry Moore we are given a world of forms in which this affinity for the organic is asserted and reasserted with total belief in its aesthetic efficacy. True of his *oeuvre* as a whole, it is especially true of his work of the last decade which is now on view in a large double exhibition at the Knoedler and Marlborough galleries. Indeed, in the carvings and bronzes of the 1960's Moore seems more intent than ever before in calling our attention to this organic element in his work. He has carried the metamorphosis of his favorite heroic motif—the reclining female figure—to a point where it has evolved into the contours of a natural landscape. The earth mother has been transformed into mother earth.

The same tendency—a tendency to combine the anthropomorphic and the topographic in a single image—can be observed even in those sculptures which are not explicitly based on the reclining-figure motif. You can see it in the so-called "Vertebrae" sculptures—one of Moore's happiest conceptions—such as the bronze "Three Piece Sculpture No. 3" (1968) at Marlborough or the white marble "Two Piece Carving: Interlocking" (1968) at Knoedler. There is a suggestion here of the erotic and the pastoral. One thinks first of Arp, and then of Wordsworth. The feeling is at once gentle, sensuous, and powerful. Elements of human anatomy are generalized into an imaginary landscape. A delicate lyricism lives on easy terms with the monumental.

The most ambitious of Moore's recent sculptures—the great divided figures of the sixties and the huge "Reclining Figure" (1969–70) that occupies a gallery of its own at Marlborough—are both a summary and an extension of the imagery he has garnered from his long-standing romance with organic form. They are, I

think, a great achievement. But they also serve to remind us of why, for many people (including many artists) at this particular moment, Moore's sculpture is no longer an object of great interest. Indeed, why it represents everything they wish to reject in the art of our time.

For an imagery of this sort, highly metaphorical as well as metamorphic, discloses its mysteries and its pleasures slowly. For one thing, there are mysteries here, and they cannot be taken in at a single glance. One is obliged to "read" Moore's sculpture the way one reads certain modern poems, and there remains something elusive about his forms even when one is satisfied that the symbols he employs are more or less understood. He is, first and last, a carver. Even his most ambitious bronzes are, conceptually, the work of a carver who has resorted to other means. But Moore is a carver of a special kind—a carver who has penetrated the sculptural monolith in order to claim the "open-form" interior space of the mass as part of his expressive domain. This in itself confers an aura of mystery on his sculptural imagery—precisely the sort of mystery that is an anathema to the positivist mind, with its sectarian taste for the literal.

Whereas the syntax of Constructivism, say, employs the interior space of an open-form sculpture as a neutral material, susceptible to whatever metaphorical or non-metaphorical uses the individual artist wishes to make of it, the same is not true for the carver. Carving has a syntax of its own, and it sets a limit on what we can know about the interior of the mass.

Thus, the interior space of the monolith retains something of its primitive power to puzzle our curiosity. It can never wholly satisfy that curiosity. The open space of Constructivism is a daylight space, open to the intelligence; it harbors no secrets. The open space of the carver is never fully disclosed; it remains nocturnal and at least partly unknowable. It changes its character with every view— indeed, with every shadow. The proper analogue for the interior space of Constructivism would be a room designed by an architect— a space that can be measured. But the proper analogues for the interior space of the carver would be the womb, the cave, the unknowable byways of nature—images that refuse to separate themselves from our dreams and our myths.

Moore has long been drawn to this realm of visual ambiguity. His taste for the kind of poetry it yields him sets his work apart even

from the tradition of carving that first nourished him. As a carver, Moore belongs to the modern tradition established by Brancusi. But he now stands almost as distant from the Brancusian aesthetic as he does from that of the Constructivists. In his fine study of Brancusi's sculpture, Sidney Geist observes: "The primary experience on seeing a sculpture by Brancusi is that of knowing it at once. Prolonged attention or the accumulation of a series of views from a series of angles of vision adds nothing or little to the initial knowledge. Time only confirms what the first instant revealed; time continues to reproduce the first sensation." Now in Moore's work, especially the sculpture of the last decade, the very opposite is true. His sculptures always make a powerful first impression, but there is no question of "knowing it at once."

Mr. Geist quotes Brancusi as having said: "I have eliminated holes which. cause shadows." And Mr. Geist himself remarks: "Brancusian form is freed from reliance on nature with its painting of light and dark. It is form seen by the light of human intelligence." The forms favored by Moore owe their very existence to this "reliance on nature with its painting of light and dark." The famous "holes" in Moore's sculpture are designed to capture every fleeting shadow nature may offer. (It is important to remember that Moore's sculptures are conceived, for the most part, for natural light. The full range of their visual energy can never be fully appreciated in the artificial light of a gallery or museum.) If Brancusi's is a "form seen by the light of human intelligence," Moore's is a form observed through a chiaroscuro in which intelligence yields to the lights and darks of memory and association.

Moore is, then, a Romantic—and a very English Romantic at that. He is the true heir to the great nineteenth-century landscape painters. Despite the virtuosity which he brings to the invention of sculptural form—form that would be inconceivable without a keen appreciation of the most radical modern departures—in the end he withholds his assent from the "advanced" aesthetics of modernism. Modernist form is, for Moore, a means rather than an end in itself—a means of revitalizing something of the English pastoral tradition. This is at once his strength, his attraction, and the basis of the strong current that now runs against his large and powerful accomplishment.

April 26, 1970

The Twentieth Century:
The School of Paris

1. Matisse: The Paintings

*Un artiste ne doit jamais être prisonnier de lui-même,
prisonnier d'une manière, prisonnier d'une réputation,
prisonnier d'un succès. . . . Les Goncourts n'ont-ils
pas écrit que les artistes japonais de la grande époque
changeaient de nom plusieurs fois dans leur vie. J'aime
ça: ils voulaient sauvegarder leurs libertés. . . .*
 —Matisse, "Jazz"

In the visual arts, two forces above all others determine the charac-
ter of our response and the quality of our judgments: our experience
of the masterworks that carry a particular style or vision or idea to
its most complete realization, and our sense of the aesthetic history
in which these masterworks take their central, transfiguring place.
Especially in our encounters with works of modernist art, this sense
of history is often the primary intermediary, indeed the very
medium of our aesthetic experience, for modernism is itself the
offspring of an acute historical self-consciousness. Aesthetic emo-
tion, which offers its pleasures in the guise of a spontaneous and
transcendent response to an unanticipated revelation, is, more often
than we generally care to admit, in thrall to a theory—some general-
ized notion of the terrain on which such revelations will take place,
and even perhaps of the form they may be expected to assume.

But what if this sense of history, with its elaborate scenarios of
victories and defeats and its disposition to favor some revelations
over others, turns out to be something of a myth—a synthetic con-
struction based on imperfect knowledge and the need to believe that
the aesthetic imperative follows a logic and enjoys an ontology all its
own? The process of putting art in a museum, itself a coefficient of
the modernist movement, reinforces this myth by imposing—on our
consciousness no less than on the walls of the museum—a series of
masterworks in which all trace of the problematical, all those failed
alternatives and rejected misadventures which occupy so large a

place in any serious artistic career, have been subsumed in the final process of consummation. Yet it is doubtful if a theory of art based on a scenario of such perfect consummations is any more faithful to the actual vicissitudes of art history than a theory of love based on nothing but the realization of an ideal communion would be to the vicissitudes of life. In art, as in love, or indeed in any form of contingent human experience, what has misfired, what has been refused, and what has actually failed are frequently the key to a real understanding of what has been achieved.

The great virtue of the large and astonishing Matisse exhibition which Pierre Schneider organized at the Grand Palais* in Paris this summer lies precisely in the extent to which it disturbs the established museological view of the artist's accomplishments and, even if only temporarily, places the myths of art history at a certain distance from our immediate apprehension of the artist's true quality. Masterpieces—well-known, little known, and unknown—certainly abound in this exhibition. But in assembling a more detailed and comprehensive account of Matisse's *oeuvre,* especially in the early decades of his career, than any we have ever had before, Mr. Schneider has restored these masterpieces to their proper context—the arduous, workaday, seesawing progress of an artist who was often profoundly unsure of his course, who frequently recoiled from his own audacity, and for whom no "breakthrough" was ever mistaken for a fixed solution to the problems that haunted his imagination. Rarely has an exhibition of an artist so familiar and so firmly established in his greatness modified so decisively not only our appreciation of his greatness but our understanding of all the timidities, hesitations and anxieties—all the false starts and temporary obstacles—that have contributed to it. There is ample reason indeed for Mr. Schneider's claim to have brought us in this exhibition "*un artiste peu connu, voire méconnu.*"

He has accomplished this feat, first of all, by crowding the early sections of the exhibition with a great many small pictures from the nineties and the first two or three years of the century—the first decade of Matisse's production. Here is Matisse, already well into his twenties—compared to Picasso, a latecomer to his profession—testing the ground in every direction, copying the Old Masters, rehearsing with painstaking care the realist conventions of

* *Henri Matisse: Exposition du Centenaire.*

Chardin and Courbet, assaying Impressionist color and a Post-Impressionist facture, zigzagging his way from the pieties of tradition to the innovations of the avant-garde and back again; uncertain, intense, ambitious, intelligent, immensely talented, and absolutely serious.

From the dark and rather clumsy Courbetesque structure of *"La grotte"* (1896)—years later Matisse acquired one of Courbet's masterpieces on this theme—to the brilliant impastoed sun of Van Gogh in *"Coucher de soleil en Corse"* (1898); from the bleak, near-monochrome austerity of *"Grande marine grise"* (1898) to the Cézannean color and architecture of the *"Homme nu"* (1900); from the prescribed rendering of tones and half-tones to the frontiers of that promised land—the naked use of pure color—in which Matisse achieved his most celebrated victories and which ultimately became in his eyes a kind of paradise of feeling: these are but a few of the many courses traced in this first decade of his work.

In certain pictures of this period the artist's search for a definitive statement—either in the form of a summary of what he has already mastered or as an intimation of new ground to be explored—yields him a stunning success. But even the best of these pictures are far too various to permit us to generalize about any concrete "direction" they may prophesy. Some, like the famous *"La desserte"* (1897), simply close the door on a path never again attempted, while others—I think especially of the *"Pont Saint-Michel"* (c. 1901) in the Wright Ludington collection, with its stunning clarity of color and design—seem to arrive too soon at solutions too radical or too disconcerting for Matisse to act upon. Certain paintings of the Pont Saint-Michel motif—and of other motifs, too—are executed with an almost Expressionist *pâte*, yet a picture such as *"Madame Matisse en Japonaise"* (1901), with its grayish light and its nervous, sketchy texture, looks like nothing so much as one of Giacometti's portraits of the 1950's. In this first decade of Matisse's life as an artist, we are still a long way from the mythic scenarios of art history. Everything is open, unsettled, and problematical. At thirty, an age when an artist might nowadays be planning his first retrospective, Matisse had not yet found the ground on which his sensibility could flower.

He made his first tentative exploration of that ground in the summer of 1904 when he submitted to what he afterward called *"la tyrannie du divisionnisme,"* adopting Signac's somewhat freer

modification of Seurat's pointillist method—a method that called for the juxtaposition of small touches of color as the sole means of pictorial construction. Matisse was never an orthodox divisionist; his temperament was singularly devoid of that appetite for doctrinaire solutions that such orthodoxy answered to. But the very narrowness of the divisionist method signaled the release of something essential in his own sensibility. The "tyranny" of this highly restrictive and exceedingly laborious method gave him the first inkling of the expressive freedom he was seeking—the freedom to construct a painting of pure color, unfettered in its application by anything but the dictates of the artist's own emotions.

The Baudelairean title Matisse chose for his first foray into this terrain—*"Luxe, calme et volupté"*—is, in some respects, as significant as the style in which the painting is executed. It alerts us to the kind of imaginary paradise that now begins to beckon from Matisse's *oeuvre*. In his long and interesting essay for the catalogue of the Grand Palais exhibition, Mr. Schneider is at some pains to separate his own interpretation of the artist's sensibility from the popular image of Matisse (*"Un nom qui rime avec Nice"*) as the *"peintre du plaisir, sultan de Riviera, hédoniste raffiné."* But such a separation, as Mr. Schneider himself certainly recognizes, is hardly possible. The most eloquent pages of his essay celebrate Matisse as a poet and connoisseur of pleasure, a specialist in satisfying his own very personal and distinctly *raffiné* standards of well-being. The popular image of a sensibility on a permanent and ideal holiday only trivializes what is essentially the truth. Mr. Schneider's catalogue is crammed with an anthology of marvelous quotations from Matisse himself, many of them never before published, in which the artist insists over and over again upon the primary criterion that governed the work of his maturity: sheer delectation. What Matisse was, in effect, repeating—and many times—was the answer once given by Debussy when he was asked what his method of composition was: *"mon plaisir."*

What the popular image of the *"sultan de Riviera"* can never accommodate and therefore discounts is not only the fact that even a *peintre du plaisir* requires, after all, a method of composition and a mastery of his métier in order to realize his goals but, equally important, the exact quality of the emotion that governs his search for this elusive Cythera. It discounts the extraordinary artistic conscience that is invested in this search, and the flights of inspiration that are encompassed in its course. It makes banal what is actually sublime.

Historically, the most famous of Matisse's achievements are, of course, the Fauvist paintings of 1905–6 and the greatly simplified, color-drenched paintings that follow from them, almost in unbroken succession, until the beginning of the First World War. Here, too, in the period of the artist's best-known works no less than in the preparatory paintings of the nineties, Mr. Schneider has significantly enlarged our understanding of the scope of Matisse's *oeuvre*. By reuniting the paintings from the great Russian collections—some of them now seen in the West for the first time since the Revolution—with the more accessible paintings from Western collections, the exhibition allows us to follow the workings of Matisse's unflagging invention with a closeness formerly reserved for a few specialists. (Not that the Russian pictures are the only, or even the most important, of the revelations which this exhibition offers us. The large number of paintings from the Matisse family, many being shown for the first time, constitute the single most important addition to our knowledge of Matisse's work.)

Fauvism—of all the curious names to have attached themselves to a pictorial style, this is surely the silliest—was indeed the crucial breakthrough. In Matisse's Fauvist paintings, the firm pictorial architecture of the Post-Impressionist picture is significantly modified in favor of a structure composed of pure color—color applied with a broader freedom, color released from its fixed contours and answering more and more to the lyric improvisations of the artist's emotion. Improvisations: this is what Kandinsky called his first Abstract Expressionist pictures a few years hence—pictures that owed a great deal to Matisse's separation of color from its accustomed place in the picture-making process. Yet the Fauvist style, daring as it certainly was, retained a firm hold on the modeling of objects and the carving out of a three-dimensional image. The modeling was looser, the illusionist space shallower, the solidity of every object more precarious as it showed signs of dissolving in a blaze of light, but tradition was nonetheless upheld, however minimally, in those vestiges of a boxlike conception of space.

It is in the immediate post-Fauvist paintings—in the great *"La desserte rouge"* (1908), in the two mural-size versions of *"La danse"* (1909 and 1910), and in those two masterpieces in which Matisse summarized his entire aesthetic up to that time, *"L'atelier rose"* and *"L'atelier rouge"* (both 1911)—that he revised this received conception of pictorial space with such radical effect.

Drawing upon the precedents of Islamic art and Japanese prints, of Gauguin and the decorative strategies of Art Nouveau, Matisse launched his first frontal attack on the syntax of three-dimensional illusionism—which is to say, on the pictorial tradition which had nurtured him and which he had displayed such extraordinary gifts in mastering.

Flatter patterning, drawing simplified to the contours of a silhouette, larger areas and heavier saturations of unbroken color, the pictorial image more and more reduced to a single plane—these are the salient elements of the new pictorial syntax which he was here proposing as an alternative to the established procedures of Post-Impressionist painting. The authority Matisse brought to this bold innovation is still breathtaking. The sheer grandeur of these paintings is overwhelming. Without going farther in this exhibition, one is already certain that one is in the presence of the greatest painter in modern times.

But even in this, the most joyous and *exalté* period of Matisse's accomplishment, he was constantly drawing back, reconsidering his ground, casting a covetous eye on the conventions he was so effectively dissolving, and repairing his links with a tradition he had already seriously, if not irrevocably, undermined. Among the most daring of these post-Fauvist pictures are others—the *"Nature morte à la danse"* (1909), from the Hermitage, for example, or *"Les poissons rouges"* (1911), from the Pushkin Museum—which play inspired games back and forth across the shifting boundary lines that at once divided and bound together his newly realized vision and the traditions from which he had wrested it.

Not only in the *L'atelier* pictures but in many others, Matisse was constantly anthologizing his own work, remeasuring the distance he had so swiftly traversed, re-exploring the nuances and possibilities that might still lie undeveloped there. So fertile was the ground he cultivated in this period that he found himself in the rare and enviable position of being able to produce something extraordinary whether he pushed forward or looked back to where he had already been.

What closed the door on the glories of this period, as it did on so many other glories of those years, was the coming of the First World War. We shall have to await the biography of Matisse on which Mr. Schneider is now at work before we know the full story of the war years, but it is already clear that Matisse experienced a

profound disruption in his artistic thinking at this time. For anyone who had invested so great a part of his sensibility in his own sense of *bien-être*, it was perhaps inevitable that such a disruption would occur under the pressure of so fateful a catastrophe But the artistic course which this change of feeling assumed has been very little discussed, and criticism will be a long time in coming to terms with the work Matisse produced under the shadows of the war.

For here, in the emotional isolation of these years, he turned his attention for the first time to a confrontation of the single most important development that had occurred in painting concurrently with his own prewar achievements: the creation of Cubism. Some of the key pictures of this period are still relatively new to us: *"Une vue de Notre-Dame"* and *"Porte-fenêtre à Collioure"* (both 1914), pictures that would still have looked incredibly daring had they been painted in New York in the late forties, were exhibited for the first time at U.C.L.A. in 1966.

Alfred H. Barr, Jr., in the monumental study of Matisse he published in 1951, had already suggested that it was the artist's sudden friendship with Juan Gris at the start of the war that turned him toward a consideration of the formal challenges posed by Cubism—challenges from which he had, until then, carefully averted his glance. But the subject was left unexplored. Here again, the exhibition organized by Mr. Schneider greatly enlarges our understanding of Matisse's development at this time. But it must be said that Mr. Schneider's own discussion of Cubism and its effect on Matisse's painting in his essay for the catalogue—a discussion that invokes a mythical "geometry" and lumps Cubism together with the Neo-Plasticism of Mondrian and his followers as a foil for Matisse's superior sensibility—obscures far more than it clarifies. For what Matisse seems to have attempted in his Cubist and near-Cubist paintings was precisely the kind of pictorial synthesis that came to occupy the New York painters of the forties—a synthesis of those broad saturations of color which he had himself pioneered and the superior intellectual rigor of Cubist syntax. With the pictures that Matisse himself never exhibited now becoming more familiar to us, some of the well-known masterpieces of these years—*"Les Morocains"* and *"La leçon de piano"* (both 1916)—acquire a deeper significance. I predict that this phase of Matisse's *oeuvre*—with its many magnificent pictures and many unanswered questions—will be a fecund field for scholars and critics for years to come.

Whatever he achieved in the war years and whatever the reasons for his hesitations about showing the most radical pictures he produced at that time, Matisse turned his back on such bold adventures once the war was over. Without precisely calling it that, Mr. Schneider pretty much accepts the standard view of the "decline" that occurred in Matisse's work in the twenties and thirties—the period of the "odalisques"—and the sections of the exhibition devoted to these decades are, though not without some fine pictures, a shade perfunctory. For an appreciation of those years, one was almost better off at the splendid exhibition of Matisse's graphic *oeuvre* which was mounted at the Bibliothèque Nationale as a companion event.

But the exhibition at the Grand Palais closes—as did Matisse's long career—on a note of high excitement. There are hints of what is to come in the decorative murals called *"La danse"* (1931–2) and in other works of the thirties—one reason why it would have been worth examining this period more closely—but the momentum accelerates again during the early forties, another wartime period that seems to have affected Matisse deeply, and comes to flower in the great decorative projects of his last years. Still again, in this last section of the exhibition, Mr. Schneider brings us a great many unfamiliar works, some of them enormous in size, and without necessarily concurring in his judgment that Matisse's final *gouaches découpées* represent the artist's "supreme accomplishment," one cannot help finding this last powerful avowal of the artist's vision tremendously moving.

Georges Duthuit once spoke of these works as carvings of light. Matisse himself said that the *papier découpé* allowed him for the first time to draw in color. In this medium, the last fetters of the traditional easel picture are swept away, and the artist finds himself in a realm in which there are no longer any clear distinctions between painting, sculpture, and drawing—a realm in which, as Mr. Schneider puts it, there is *"rien que l'émotion dans tout l'espace."* Matisse had, in a sense, fulfilled his dream in this medium, transcending what he called "the eternal conflict between drawing and color," and thus bringing the art of painting as we had understood it theretofore to a close. This, certainly, is the accepted current view. But it is not the only view one can take of this work. The question that is raised in Matisse's last works acquires a more immediate artistic urgency when one recognizes that it is precisely the question

that has dominated abstract painting in this country for the past decade—the question whether this unfettered and highly decorative conception of color is sufficient for the artistic tasks that are now assigned to it.

For myself, I do not find Matisse's last works, marvelous as they are in so many ways, his supreme accomplishment. They remind me, in fact, of how fortunate he was that the "eternal conflict between drawing and color" remained so long unresolved, so long a source of creative tension in his imagination, and thus the fulcrum of so many of the emotions we treasure in his work. Indeed, painting itself seems to require such "eternal conflicts" if it is to encompass modes of feeling that are not utterly simplistic. The emotional impoverishment of so-called "color-field" painting is eloquent testimony to the fate of an art that has liberated itself from every trace of the tensions that were once the crux of the artistic vocation itself, an art that reduces the conflicts of painting to a series of ingenious technicalities.

It may have been in the very nature of modernist painting to seek ways in which it might transcend its own limits, but Matisse's *oeuvre*, detached from the teleological scenarios of art history, is not to be valued for its final success in this task. Matisse stands supreme in the painting of this century for the quality of feeling that he invested in his struggle with the traditional problems of his medium. How odd that this figure—so bourgeois, so distant from the well-publicized gyrations of the bohemian avant-garde, so fundamentally conservative in everything but his sensibility—should have triumphed so decisively in a realm in which history itself seemed to demand a quite different posture. But Matisse warned us, in the text he wrote for *Jazz*, against making the artist a prisoner of history, and this glorious exhibition answers that warning with a triumphant affirmation of his great singularity.

October 8, 1970

2. Matisse: The Sculpture

About Matisse's greatness as a painter, one entertains no doubts. Here, clearly, is a master. Here is a pictorial *oeuvre* that offers us a total sensibility, an *oeuvre* in which a vital tradition is submitted to one of its most sublime and far-reaching transformations, but a transformation that exalts and extends—and thus, in a sense, ratifies—the materials of the tradition it leaves permanently altered. The same claims cannot be made for the artist's sculpture. The same vitality of tradition is not present, and the transformations are less far-reaching. We are given the outline of an achievement rather than the achievement itself. Magnificent as the outline is in some of its particular accomplishments, it would be a mistake, I think, to allow the almost overpowering light emanating from Matisse's pictorial achievement to blind us to the more modest scale of his sculptural attainments. Matisse the sculptor is an extraordinary minor artist, but a minor one all the same.

No doubt this discrepancy in the scale of his pictorial and sculptural *oeuvres* is traceable to something essential in Matisse's sensibility. For it is not only that sculpture occupies a lesser place in Matisse's total work, but that the expressive potentialities of sculpture appear to have engaged his imagination only intermittently. Nor were they ever allowed to have any profound effects on his painting. There are, of course, abundant examples of sculptures figuring as motifs in Matisse's painting, but they usually have no more status than any other observed visual fact. They are simply part of the given *mise en scène*. There are even instances in which a painting clearly owes its conception to an actual sculpture—the "Blue Nude" of 1907, based on the "Reclining Nude I" of the same year, is perhaps the outstanding case. But it is nonetheless true that this involvement with sculpture remained marginal to Matisse's main concerns, which were pictorial. If we search his painting for some clue to his fundamental attitude toward the sculptural as a mode of visual realization, we find this mode utilized mostly as a foil. Rarely is it employed as the coefficient of a primary emotion.

In this respect, Matisse differs sharply from Picasso, in whose painting the sculptural element is charged with crucial responsibilities and in some periods assumes a central expressive role. Is it possible, then, to discern in this attitude toward the sculptural some

basic disposition in Matisse? I believe so. Matisse was an artist with a highly developed sense of his historical moment. He was keenly conscious of the exact place where his own efforts joined those of his artistic inheritance, and he was a shrewd judge of the resources of that inheritance. There was in his artistic make-up something of the good bourgeois' resistance to gambling and chancy speculation; he preferred to invest his energies where the conditions were favorable and the auguries reasonably auspicious. For an artist—especially, it seems, a French artist—given to his peculiar combination of caution and ambition, the art of sculpture at the turn of the century was indeed, from the aesthetic point of view, a gamble against unfamiliar odds.

In any estimate of Matisse's sculptural accomplishments, it is worth bearing in mind that insofar as this gamble was undertaken by artists of his generation—and even those of the succeeding generation—it was not for the most part undertaken by native Frenchmen but by artists coming to French art from other and quite different spiritual climates. After Rodin, and with the possible exception of Maillol (an exception to be discussed), France did not produce another sculptor of major rank. Lachaise was a special case in having been trained in France but actually producing all his mature work in America and in response to his American experience. The revolution in modern sculpture was the work of foreigners—Picasso, Brancusi, and Lipchitz; Arp, Gonzalez, and Gabo —either working in Paris or drawing their inspiration from it, but in a position (as, apparently, native French artists were not) to bring some fecundating force to bear on Parisian aesthetics from outside the boundaries of French sensibility. That sensibility remained first and foremost pictorial.

Thus, as a painter, Matisse joins a glorious, ongoing line of development. His work of the nineties, in particular, being in its essentials a critical rehearsal and personal testing of the painting that preceded him, shows us with what pains he undertook the mastery of his native tradition. But where his painting represents a summary and purification—and, ultimately, a radical distillation— of this tradition, his sculpture reflects the more tentative and provisional victories which that fallen and only partially redeemed art had won over the long decades of infertility it suffered in the nineteenth century. Neither Barye, upon whose "Jaguar Devouring a Hare" he based his own first effort (1899–1901), nor even Rodin,

who opened up so many possibilities only to consume most of them himself, could provide Matisse with anything like the rich potentialities he found proffered in Delacroix and Cézanne, in Gauguin and Seurat and Signac, and the dazzling tutelage of Pissarro. Nor does there seem to be much reason for regarding Rodin, as some writers have suggested, as the sculptural counterpart to Cézanne in his influence on Matisse: the work itself, excepting the very exceptional "The Slave" of 1900–3, does not support such a suggestion. To artists of Matisse's generation, Rodin offered the choice of becoming either a satellite or a rebel, and Matisse himself did not favor either of these roles. In painting he was able to realize his ambitions without becoming one or the other.

It is not, in fact, among the "official" sculptors like Barye and Rodin that Matisse belongs, but to the camp of the painter-sculptors. In this line of "unofficial" sculptors, it was Degas who was Matisse's real predecessor, and the characteristics we discern in Degas's sculpture are to be found in Matisse's as well. The heroic is eschewed in favor of the informal. The "sketch" replaces the monument. Rather than a display of power, the work becomes a display of sensibility. There is no pretense of recovering the scale and grandeur of the ancients; there is, if anything, a distinct aversion to them. A severe contraction in the scope of the sculptor's ambition is accepted without regret, for his goals are strictly limited. His efforts are concentrated on the realization of something small and specific—a certain gesture, a certain rhythm—which he attempts to render with complete fidelity, not only to direct observation but to the emotion governing the observation. This emotion presides over the whole sculptural process—indeed, the limits placed on the size of the work are designed to conserve and sustain the emotion, to articulate it more directly—and confers on the very act of modeling (the painter-sculptor being pre-eminently a modeler, not a carver) an interest as great as the subject itself. The gesture or rhythm embodied in the finished work will bear the marks of this encounter between observation and process, between an attitude toward the subject and the expressive metamorphosis which this attitude undergoes in the course of its physical realization.

With its scope (both in theme and size) drastically delimited, and a sense of the medium given an added expressive value, such sculpture effects a radical alteration in the very rhetoric of the medium, clearly separating itself from the heroic mode of Rodin and

his school. Only in "The Slave," a work that owes its whole stance and gesture to Rodin, does Matisse show any affinity for this mode. But even there he modifies it with a highly dramatic inflection of the medium. The vigorous modeling of the surface conveys an emotion that at times almost supersedes the overall rhythm of the figure it is meant to enhance. "The Slave" gives us virtually the only hint we have of what Matisse would have made of the Rodin inheritance if he had chosen to exploit it: we have a glimpse in that work of the heroic posture undermined by a virtuoso handling of the surface, of the means threatening a disruptive modification of the ends.

Where the sculptural rhythm was more congenial to Matisse's sensibility, and the form thus more susceptible to the control of his own characteristic emotion, as it was in "Madeleine I" (1901), the modeling is far more discreet. The breach between means and ends is significantly healed. It is from this rather modest work, with its concise concentration of the female figure into a serpentine mass of some elegance, that Matisse's real beginnings as a sculptor date. He takes over from Art Nouveau its ubiquitous S-curve visual rhythm, and restores it to a world of feeling and gesture akin to that of the modeled-wax ballet dancers of Degas; which is to say, he removes it from the realm of the ideal and places it in closer proximity to the real. If there is still a suggestion of the "statuesque" in this figure, of a received attitude toward sculpture rather than a fresh attempt to begin anew, it nonetheless points in the direction of the more independently conceived figures that occupy Matisse in his first protracted burst of sculptural activity in the years 1905–9.

These are the years when Matisse produces a number of small heads and figures, which, though not uniformly remarkable, establish his working ambience as a sculptor. The most notable works of this period are the figures—the "Reclining Nude I" already mentioned (1907), the "Decorative Figure" (1908), and the "Two Negresses" (1908). What is particularly striking in the handling of the figures in "Reclining Nude I" and "Two Negresses" is the way their limbs and heads are thickened and enlarged into weighty masses. The sculptural rhythm is carried by the arrangement of these masses, which have the look of being exaggerated, while the torso is assigned a distinctly minor, underemphasized place in the overall conception. (Quite the reverse emphases obtain in both "The Slave" and "Madeleine I.") A deliberate ungainliness—the "ugliness" about which Matisse's early critics were so incensed—is

invoked in order, it seems, to enlist the added expressive power that could be derived from resolving such overstated masses in a new harmony. This harmony has an earthbound, forthright quality that is distinctly Matisse's own and suggests that he was on his way to exploring and reinterpreting the syntax of the monolithic sculptural image with some of the same independence and spirit he brought to the design of his paintings in these years. Even the "Decorative Figure," though more elegant and spare than the "Reclining Nude I" or the "Two Negresses," is, with its exaggerated thighs and massive head, enclosed in the same earthbound ambience, though in this case the slender torso and long neck endow the figure with a certain lyric transcendence.

One has only to compare a work like "Reclining Nude I" to Maillol's "Mediterranean" (c. 1901), to see how truly personal Matisse's sculptural imagery had become in the years of his Fauvist endeavors and at what a distance in feeling from the best of his contemporaries among the "official" sculptors his sculptural treatment of the female nude had placed him. Beside the classical serenity of Maillol's nude, Matisse's seems the work of an Expressionist. For Maillol, if the classical ideal needed to be in any way modified, it was only in the direction of Renoir's sun-drenched realism of the healthy female body—itself a plebeian version of the ideal. But for Matisse, the ideal has dissolved and given way to the dictates of feeling and experience. Whereas Maillol's classicism permits him to remain on easy terms with the monumental, Matisse's loyalty to the primacy of his emotion precludes the possibility of such terms. For Matisse, the intervention of the ideal would only falsify the entire enterprise.

With "The Serpentine" (1909), Matisse permits himself more freedom in distortion and invention. In this figure, the parts are each given an unexpected weight—the torso as slender as any to be found in a later Giacometti, the head conceived like a flower too large for its stem, the calves almost too absurdly thick for the lean thighs—yet the whole is resolved in a harmony that belies the distortion of the parts. This sculpture seems to me one of the most interesting Matisse ever produced. It opens up the modeled figure to some possibilities that one only sees realized in work produced much later by Lipchitz, Moore, and Giacometti, and it is one of the deep disappointments of Matisse's performance as a sculptor that he never really followed through on the implications of the piece.

Thereafter, Matisse produced several outstanding individual pieces: the "Large Seated Nude" of 1922–5, the "Venus in a Shell" of 1930, and the very beautiful "Tiari (with Necklace)," also of 1930. But in any estimate of Matisse's sculptural *oeuvre*, it is the two series—the five "Heads of Jeannette" and the four major "Bas Reliefs," or "Backs"—that constitute the principal interest. It is in these series that one sees Matisse's sculptural energies given their fullest realization, and it is there, too, that one is able to gauge the boundaries of his accomplishments in this medium.

Both these series follow a similar course, beginning with more or less faithfully rendered observed detail and progressing toward a more freewheeling invention. But as the "Jeannette" series consists of variations on a portrait head and the "Bas Reliefs" take as their motif the more expressively neutral theme of the back view of the model, the nature of the invention varies considerably. In the development of the former, the tendency is toward broader and more explicit feeling, toward forms that underscore and exaggerate and elaborate the given visual facts, whereas in the latter the development is toward a tough-minded simplification and generalization that grows increasingly detached from the original point of departure.

The "Jeannette" series was produced in the years 1910–13. "Head of Jeannette I" is a fairly conventional portrait study, modeled with care and tact but no unusual distinction. "Jeannette II" betrays a certain vacillation: the roll of the hair is given a broader articulation, the nose a discernible twist, the eyes a shade more concentration, and the mouth a slightly pinched quality, but the effort to retain verisimilitude acts as a brake on these distortions and deprives them of their force. With the "Head of Jeannette III," however, the entire conception is altered, and it is the last three sculptures in the series that give it its great quality.

"Jeannette I" is a head resting on a full neck; "II" is a head alone, rather abruptly severed. But "III," "IV," and "V" are more elaborately formed works in which there are three principal divisions: the head, the upper part of the chest (with the connecting neck very strongly stated), and a carefully modeled pedestal. The chest and pedestal are in each case a strong abstract form, a forthright sculptural mass that has a presence and character quite apart from the support they render the head, and the sculpture as a whole is, in essence, a powerful arrangement of three heavy masses. The

relation of the head to the arrangement as a whole, moreover, reminds one—at this distance in time—of later works by Brancusi and Giacometti in which the carving and/or modeling of the head is given a dramatic heightening by being made to occupy only a part of the sculptural whole.

The modeling of the heads in "III," "IV," and "V" contains some of Matisse's best work, not only in sculpture but in his art as a whole. Every element is freshly conceived; no feature, structure, or relation—of the nose to the eyes, of the eyes to each other, of the head's cavities to its enveloping skin—is taken for granted: everything is reconstituted and transmuted under the pressure of intense feeling. The results are magnificent and, in the heads of "Jeannette IV" and "V," particularly, sheer masterpieces of a kind rarely attained by Matisse in his sculpture.

The "Bas Reliefs," and especially the final version, are at another pole of feeling altogether. They were produced over a long period, the first dating from 1909, the second from 1913, the third from 1916–17, and the fourth version from 1930, and thus follow the course of Matisse's changing view of his art. In discussing these reliefs in his book, *Matisse: His Art and His Public,* Alfred H. Barr, Jr., speaks of the figure in the first version as "Cézannesque," and there is indeed something of Cézanne in the way the figure is synthesized with the rectangular format of the relief throughout the series. In the first version, the figure is rendered with a certain sensuousness, and the background is relatively neutral—a physical atmosphere from which the figure can be sculpturally distinguished. But as the series progresses, the figure and background are more closely joined; sensuousness gives way to analysis. The body is bisected into irregular vertical panels as it is gradually divested of its organic identity and associations. In the final version, it is nearly abstract—abstract in the way Cézanne's late landscapes are, with their topographical details dissolving into the pictorial design.

The "Bas Reliefs" are certainly Matisse's most ambitious sculptural effort, the only sculptures in which he seems to postulate his own notion of what monumental sculpture might be in our time. Like Brancusi and Arp, though not to the same degree, Matisse moves toward a radical simplification, yet remains enough of the painter-sculptor to resist the ultimate logic of the course he has taken. Matisse is almost as close here as he ever got—the "Tiari (with Necklace)" is, perhaps, a step closer—to the extreme purity

of form that, in modern sculpture at least, is the domain of carving and construction rather than of modeling. One is reminded that Matisse has probably had a greater influence on this purity of form than has customarily been acknowledged, but it is the influence of the painter rather than the sculptor. And only in the final "Bas Relief" and the "Tiari" did Matisse's own painting influence his sculpture decisively.

He remained, to the end, at some distance from official sculpture as it continued to develop—a painter-sculptor haunted by the equivocations that the professionals had bequeathed to the art in his youth. If one compares the modeling of the figures in the "Bas Reliefs" with, say, the handling of similar motifs in Lachaise—I think particularly of the backs of his "Torsos" of 1927, 1930, and 1934—the latter have a confidence and conviction, a display of sheer sculptural power, that are not to be found in Matisse. Lachaise was probably himself influenced by Matisse's art, but he had in abundance the sort of imperious sense of his own mission as a sculptor that one finds in Rodin and Maillol, but not in the sculpture of Degas or Matisse. It is the realization of that sense that ultimately separates the major from the minor practitioner of an art, and by that standard Matisse was a minor sculptor.

I cannot myself leave the subject of Matisse as a sculptor without casting a glance in the direction of his last works—I mean the *gouaches découpées,* which, though not sculpture as such, suggest such rich possibilities for sculpture. In writing about these last works, Georges Duthuit spoke of Matisse as "the carver of light," and it was in this capacity that the artist made perhaps his most fateful contribution to sculptural aesthetics. Cutting his colored shapes with scissors and "constructing" his compositions by improvised juxtaposition, Matisse was able to bring all the strengths and experience of his painting to bear on a medium that somehow approximated the sculptural ambience. Here the painter-sculptor was in major form. If, from the vantage point of the 1960's, Matisse's bronzes do not address us with the immediacy of an aesthetic imperative, these *gouaches découpées* do, reminding us that the current proliferation of constructed color-sculpture owes him something essential and has not yet exhausted the possibilities to be gleaned in his last magnificent works.

1966

3. Bourdelle: The Age of Innocence

The sculpture of Antoine Bourdelle—what could be more remote from the aesthetic imperatives of the present moment? The work of this sculptor, who actually died less than half a century ago (his dates are 1861–1929), but whose spirit seems at times to hark back to a more obscure, mythological age, is replete with a kind of rhetoric we have long grown used to distrusting. Bourdelle's is a mind filled with the epic dreams of ancient and medieval cultures, his forms are at once an echo and an embrace of anonymous masterworks, his vision sublimely immune to that sense of irony and skepticism that for a century or more has been the standard modern response to heroic postures and unbridled eloquence.

He is said to have made some sixty studies for his monument to Beethoven, whose music he venerated, and Victor Hugo is known to have been one of his favorite poets. His own work was pursued on a scale similar to theirs and similarly encompassed large emotions, exalted themes, and monumental structures. Nowhere in the sculpture of the last hundred years—not even in Rodin—do we find a display of confidence in the artist's powers so complete, so distant from the nagging modern doubt about the efficacy of the whole aesthetic enterprise. Nowadays, especially, we rather like that suggestion of doubt—it gives us an immediate point of entry into the imaginative world of the work itself—but Bourdelle's *oeuvre* has no commerce with this modern psychology. It has all the swagger, conviction, and pride that we associate with the great Romantic rhetoricians.

Yet Bourdelle belongs, undeniably, to modern sculpture. The self-conscious archaism of his most ambitious works is not to be mistaken for any *retardataire* retreat into safe conventions. It is, on the contrary, part of the modern search for the recovery of emotions more "primitive" and fundamental than those afforded us in the classical sculptural forms of Periclean Greece or Renaissance Italy. In turning to archaic Greek sculpture and to the stone carvers of the medieval cathedrals, Bourdelle was in the vanguard of those artists who looked to "early" art—art that still spoke with the innocence and energy of an anonymous folk culture—for their inspiration.

What separates Bourdelle from his successors in the search for "primitive" roots is the European-bound limits of his imagination.

Bourdelle belongs to the last generation of European artists for whom the unity, vitality, and priority of European culture could be taken as an unquestioned, untroubled, and indeed unconscious article of faith. His work is, in this respect, a poem that upholds and celebrates this faith. As it turned out, the poem proved to be an elegy rather than the epic its author had in mind, but that, too, is an irony that seems never to have touched Bourdelle's consciousness. His confidence in his role as an actor in the drama of European civilization remained undimmed, oblivious to Gauguin's subversions and the even vaster fragmentations to come.

For anyone with an interest in either the aesthetic vicissitudes or the historical ironies of this emblematic episode in the development of modern culture, the large show of Bourdelle's sculpture at the Hirschl & Adler Galleries will be an event of considerable interest. Bourdelle was a sculptor of formidable talents, with a total command of his craft, an almost unlimited capacity for hard work, and a mind that moved easily—perhaps too easily—among grandiose conceptions and heroic themes. He was altogether equal to the tasks he set for himself.

He was one of the real masters of the sculptural monolith, wresting for the "block," as it used to be called, a virtuosic variety of image and emotion. His sculptures are also full of hints and prophecies of things to come—prophecies unintended by Bourdelle himself, but significant nonetheless. The "Study for Head of the Suffering" (1894–1900) is already far advanced in the direction of Expressionist feeling. And almost everywhere in Bourdelle one has a sense of a conflict between the pressure of large emotions and their resolution in a sculptural structure rigorous enough and ample enough to contain them. In much of the work, the resolution of this conflict is, perhaps, too complete, the design a little too foreordained—again, we miss the hint of a doubt in the outcome. Yet there is hardly a form here that is merely routine. Nothing has been abandoned to a formula for the grandiose.

Still, it looks distant and "late." Bourdelle's search for a "primitive" resource in "early" art aligns his sculpture with the central modern quest, but his assumption that this quest could be realized without some radical modification of Western sensibility keeps his art from entering the mainstream of the modern movement. Modernist art is predicated on an assumption of crisis, on a critical re-examination of its own premises—a state of mind alien to

Bourdelle's supreme confidence in both himself and in the culture that nourished him.

It is interesting—almost, indeed, diagrammatic—to note that Giacometti worked with Bourdelle in the early 1920's, for in Giacometti all trace of that once imperious confidence is gone. Doubt, anxiety, crisis become the very medium in which the sculptor works. Art has become the orphan of history, seeking confirmation of its necessity in the labyrinth of the isolated self. Bourdelle belongs, as I say, to modern sculpture, but he belongs to its age of innocence, to the period when men of a certain talent, a certain will, and a certain blindness to the drift of their own destiny could still believe that the history of European culture would have a happy ending. We all know better now, and modernist art has been one of our teachers.

November 29, 1970

4. Vuillard

The career of Édouard Vuillard (1868–1940) evokes for us today a world almost as remote from the tensions and pressures of contemporary life as the world of Fragonard. It is a world in which the cultivated bourgeoisie is still secure in its privileges and in its taste—a world in which art, money, comfort, talent, and new ideas exist in an untroubled harmony, a world insulated from catastrophe.

It is not, to be sure, a world devoid of conflict. Far from it. Even if there were not ample evidence in Vuillard's own work of a certain (albeit muffled) malaise, his close association with the first Paris productions of Ibsen would be enough to remind us of what the real life of the middle class was in this period of surface placidity. But it is a world to which Proust and Gide are better guides than either Marx or Freud. It is, above all, a world in which art remains supremely confident of its value and its destiny.

In this world Vuillard himself cuts an attractive figure—a man

lucky in his friendships, loyal in his family attachments, secure in his talent, and altogether benign in his personal and social relations. Those who knew him invariably wrote about him with affection and respect. No artist of the modern era stands at a greater distance from the legendary suffering of the *peintre maudit*.

Yet there was, after all, something not quite right—something definitely wrong, in fact—in what happened to his art. His master-pieces came early and, for the most part, remained small. Their power is undiminished, and their complexity, perhaps, is now more apparent than ever—the sheer compression of Vuillard's paintings of the nineties has the effect of a new revelation to eyes that have become habituated to pictures that are nothing more than vast expanses of uninflected color. Vuillard's paintings are, in every respect but one, a virtual catalogue of what we no longer expect painting to be. Small though they are, they are nonetheless abun-dant in visual incident. They are at once exquisite and tough-minded in their minuscule accretions of observation—observation acutely transmuted into its chromatic constituents. They also boast an extraordinary charm—an almost literary charm, rich in the atmosphere of familiar life observed firsthand, rich in the humor of common experience, yet everywhere touched with a gravity that is never solemn. They are indeed a remarkable combination of pic-torial probity and autobiographical evocation.

The one respect in which Vuillard's small paintings of the nineties are linked to what painting—abstract painting, anyway—has now become is in their radical reduction of every form to a "flat" field of color that articulates a continuous decorative surface. In Vuillard's painting of this period—indeed, in the best of his painting of any period—we are still made to feel the tension that inheres in this synthesis of affectionate observation and a strong decorative impulse. The peculiar power of Vuillard's art is, I should say, to be found precisely in this tension, which confers on subjects of an almost humdrum modesty—domestic interiors, relaxed por-traits of family and friends, café and theater scenes, etc.—an eloquence out of all proportion to their intrinsic interest or to the actual size of the pictures themselves.

The complaint about the small size of Vuillard's pictures—in effect, a complaint about the small size of his ambition—came early, and unfortunately, Vuillard himself shared in it. What he most wished to produce were large decorative panels for architectural

settings—and, alas, he succeeded, over and over again. He was well connected, first with private patrons and then with the agencies that presided over public commissions. A good deal of Vuillard's professional life was given over to these decorative tasks in which, curiously enough, he gradually abandoned the strengths of his early "flat" style in favor of a more conventional depiction of objects and figures in space. It was left to his friend Bonnard—and even more, to Matisse—to produce the kind of aesthetically effective large-scale decorative work that one had reason to expect of Vuillard on the basis of his early painting.

If one looks for reasons for this evident decline, they will be found, I think, in Vuillard's steadfast attachment to the world that first nourished him—that world of cultivated bourgeois taste which reached a kind of crescendo in the aestheticism of the *belle époque* and which was never afterward to regain its confidence or its élan. Lacking the large emotional resources that sustained Bonnard and Matisse, Vuillard's sensibility remained totally enclosed within the ethos of that world, which, in the last decades of his career, had become a world of bloodless phantoms.

The Vuillard exhibition that Mario Amaya has now organized at the Art Gallery of Ontario in Toronto has the great virtue of concentrating on the artist's small easel paintings—which is to say, on Vuillard at his best. There are some later, larger works among the ninety paintings, but they are, with few exceptions, of distinctly secondary interest. The big decorative panels that survive could not be removed from their architectural settings, and so our view of Vuillard the painter is certainly not complete in this exhibition, but not everyone will regard this as a misfortune.

Included also are fifty-seven lithographs (Vuillard's complete output in this medium), nineteen drawings, and—a welcome surprise—twenty-three of the artist's own photographs. At least one of the latter—Vuillard's photograph of Thadée Natanson and his wife, Misia, taken at their home in the rue St. Florentin, Paris, around 1898, can certainly claim an aesthetic interest equal to the marvelous paintings he was producing at the time.

The Toronto show has been selected by John Russell, who also wrote the valuable text for the catalogue and has, in addition, placed us all in his debt by including in this publication an extensive selection of commentaries on Vuillard written by his contemporaries. Mr. Russell's own essay gives us a vivid account of Vuillard's career and

is especially good on the *Revue Blanche* milieu and on the artist's connections with the avant-garde theater in the nineties. Mr. Russell seems to be of two minds about Vuillard's decorative commissions, but in general he is a most reliable and delightful guide to the vicissitudes of the artist's life and work.

He has also ferreted out some unfamiliar masterpieces. The landscape called "The Saltings" (c. 1910) is surely one of the greatest of Vuillard's paintings, a miracle of chromatic subtlety. But the exhibition abounds in excellent pictures both familiar and unfamiliar—the wonderful domestic scenes and family portraits of the nineties especially, in which Vuillard seemed (as an artist as well as a man) most completely at home.

September 26, 1971

5. Bonnard's Drawings

In the work of Pierre Bonnard we encounter a pictorial world so enchanting in its delicacy of observation, so pleasurable in its careful evocation of time, place, atmosphere, and the feelings they engender, that we are sometimes in danger of overlooking one of the essential constituents of his art—its extraordinary rigor. Visual felicities abound in such profusion, gratifying the eye's appetite with such a surfeit of retinal delectation, that we hardly feel called upon to search out the source of our pleasure. There is a temptation to succumb to the paradise of sensation that is so abundant in Bonnard without ever bothering to consider what it is that makes his art at once so appealing and so strong.

For it is, after all, an amazingly tough-minded art that Bonnard has left us. Out of what once seemed to be the least promising remnants of the Impressionist tradition, Bonnard fashioned a pictorial style that looks more original and more daring now than it did in his lifetime. (He died in 1947 at the age of seventy-nine.) Picasso

was not alone in his harsh judgment of Bonnard's work. "Don't talk to me about Bonnard," Françoise Gilot reports Picasso as saying. "That's not painting, what he does." And indeed, for many tastes less distinguished than Picasso's, Bonnard did not measure up to what a "big" painter was expected to be doing.

Picasso's mistaken judgment is worth pursuing, however, because it contains—not surprisingly—some real clues to Bonnard's genius. "He never goes beyond his own sensibility," Picasso declared. "He doesn't know how to choose." The result, Picasso insisted, was "a potpourri of indecision."

"Painting," according to Picasso, "isn't a question of sensibility; it's a matter of seizing the power, taking over from nature, not expecting her to supply you with information and good advice." Bonnard is condemned as "just another neo-Impressionist, a decadent; the end of an old idea, not the beginning of a new one." And then, in summing up his aversion to everything Bonnard represents, Picasso isolates very precisely the special strength and originality to be found in this artist. "Another thing I hold against Bonnard," the quotation in *Life with Picasso* continues, "is the way he fills up the whole picture surface, to form a continuous field, with a kind of imperceptible quivering, touch by touch, centimeter by centimeter, but with a total absence of contrast. There's never a juxtaposition of black and white, of square and circle, sharp point and curve. It's an extremely orchestrated surface developed like an organic whole, but you never once get the big clash of the cymbals which that kind of strong contrast provides."

All in all, not a bad account of what makes Bonnard's art, in addition to being so pleasurable to the eye, such a rich source of pictorial ideas. Picasso was wrong, of course, about the artist not knowing how to choose. Bonnard was flawless in his control of the selection as well as the accretion of detail in his work. He was a master at placing not only those beguiling touches of color Picasso so abominated but also the forms that contain them—forms that were completely his own, a pictorial invention of a high order, derived with great subtlety from the very wish to create a picture surface that would form "a continuous field." And this "extremely orchestrated surface developed like an organic whole" turned out to be the very opposite of "the end of an old idea." It turned out, indeed, to be "the beginning of a new one," as the enormous quantity of color-field painting is there to attest.

That this accomplishment was not merely a matter of slavishly looking to nature for "information and good advice" is evident enough in the paintings, I should think, but if we needed any further evidence of Bonnard's inventive genius—of his exceptional gift for turning every observation into an arresting pictorial idea—we now have it in the superlative exhibition of his drawings organized by the American Federation of Arts and currently on view at the Finch College Museum of Art.

This is a wonderful show, and all the more welcome because Bonnard's drawings are so rarely exhibited. Here we have 114 works from the collection of Mrs. Kyra Gerard and Alfred Ayrton. They cover the entire range of his career from 1893 to 1946. They are all very modest in size, and yet extremely rich in the way they trace the vicissitudes of Bonnard's pictorial development. Many of the tiny pencil drawings, particularly of landscape subjects, are, in effect, large pictorial statements in miniature. It is breathtaking to see how many tones, how many kinds of marks and touches, how many nuances of light and space Bonnard was able again and again to create in a few square inches of the paper surface with his inspired pencil. Here, too, only without recourse to color, we find the artist creating those incredibly sensuous "continuous fields" of pictorial invention out of an affectionate observation of familiar landscapes and interiors.

The method employed in most of these drawings is extremely informal, relaxed, and low-keyed. Nothing is highly polished, nothing "finished" in the grand manner. They are filled with the squiggles and scrawls of an artist who is more interested in setting down an immediate impression than in working up an elaborate account of what he sees. And yet they are in the end often very elaborate indeed—elaborate in the completeness with which so many subtle details are depicted and organized without being literally rendered. These are, after all, the drawings of a great colorist determined to make us feel the visual effect of color in all its delicate nuances through another medium. They certainly give the lie to any notion of "indecision" in Bonnard. They are, if anything, extremely single-minded, ruthlessly omitting everything that does not contribute something essential to the idea—the pictorial idea—they are intended to serve.

And yet, with no loss of that rigor that was an essential part of Bonnard's seriousness, with what good humor these drawings were

done! There is a good deal of comedy in them, and much affection—as indeed there are in the paintings. If there is no "big clash of the cymbals," there is something more appealing and more durable—the chamber music of the French aesthetic sensibility at its finest. In Bonnard, as in much of the greatest French art, the hedonist lives on easy terms with the analytical intelligence. It is a synthesis of mind and emotion no other art has yet equaled—or displaced.

October 1, 1972

6. Picasso's Radical Inventions

At a moment when sculpture is all the rage, filling public spaces and functioning as the overnight darling of the mass media, the exhibition of sculpture by Picasso at the Museum of Modern Art is almost shocking in its quality and power. Here is a major sculptural *oeuvre*, much of it unfamiliar, that recalls us to the great age of modern sculpture. Beside the masterworks that adorn this *oeuvre*, much that is acclaimed on the current sculpture scene looks gauche, blatant, and woefully unprepared for the attention that is being lavished on it. With Picasso, we are back on the hard rock of fundamental accomplishment. We are reminded that the most devastating and most illuminating criticism of art comes not from what critics write but from what artists—great artists—do.

The Picasso exhibition spans a period of sixty-five years. At least twice in those years—first in 1912–16 and then again in the late 1920's and early thirties—Picasso effected the kind of change in sculptural thinking that leaves the medium permanently altered. In each case it was a change that that could only have been executed by a painter willing to carry out a daring attack on the pieties of accepted sculptural practice. In each case, too, Picasso was the painter supremely qualified to execute the attack, for it involved the

radical application of Cubist pictorial aesthetics, which Picasso himself had formulated in collaboration with Braque, to the three-dimensional medium.

The first of these changes was the more fundamental. The method of Cubist collage, in which pieces of paper and other materials were actually joined to the picture surface, was elaborated into a new syntactical principle. Where sculpture had theretofore been carved or modeled, Picasso opened the possibility of creating sculpture by means of joinery—by putting together disparate materials, either nailed or glued or otherwise fastened, to form a single coherent image. In the "Guitar" of 1912, the materials were sheet metal and wire; in the "Violin" of 1913–14, they were cardboard and string; in the "Still Life" of 1914, painted wood and upholstery fringe. The imagery of these works adhered closely to the imagery of Cubist painting, but their physical and expressive realization brought something new to the sculptural medium. A profound pictorial imagination had crossed the boundary into a new mode of sculpture.

The consequence of this invention proved to be of enormous import. We know that at some point in this period, the Russian sculptor Tatlin glimpsed these works in Picasso's Paris studio and, on his return to Russia, embarked upon the work that launched the history of Constructivism. Interestingly, it was the Russian Constructivists who carried Picasso's invention into the realm of completely nonobjective imagery, but it was Picasso who provided the basic grammar of style that made Constructivism possible, and it was Picasso who produced the first masterpieces of the new mode.

These were, for the most part, reliefs. A more capacious and radical technique was required to carry the new sculptural aesthetics into free-standing works in the round, and for this technique Picasso turned, in the late twenties, to the Spanish sculptor Julio Gonzalez, who had been trained from boyhood in the methods of metalcraft. Together Picasso and Gonzalez perfected the style of welded-metal open-form sculpture—itself a further extension of the collage principle—that has figured so importantly in the art of the last thirty-five years.

Whereas the relief-constructions of 1912–16 began as a form of three-dimensional painting, the later open-form welded constructions culminate in a kind of drawing-in-space. Flat and slender masses are joined with a marvelous calligraphic ease and exactitude,

the very air—so-called "empty" space—functioning to contain their lyrical arabesques.

Picasso's masterpieces in the open-form genre have long been familiar in reproduction. Indeed, it was their reproduction in the French magazine *Cahier d'Art,* in the 1930's, that inspired the greatest of American sculptors—the late David Smith—to follow a similar direction. But we are now seeing these masterpieces for the first time—works such as the "Construction in Wire" (1928–9), "Woman in the Garden" (1929–30), "Woman" (1930–2), "Head of a Woman" (1931), and "Head" (1931)—and they are superlative indeed.

In the Picasso exhibition at the Museum of Modern Art there are some 290 works. The sculptures I have cited are not those that have contributed to Picasso's great popularity with the public. Indeed, they could not be, for the public has not been permitted to see them before this year—Picasso has jealously guarded them in his own private collection—but they are, I believe, the works that form the central core of his sculptural achievement. They are the works that have provided succeeding generations of sculptors with new intelligence about the possibilities of their medium while at the same time implementing these possibilities with a standard of performance that has sometimes been equaled but never exceeded.

The works that have captured popular esteem are of another sort entirely. These are mainly monolithic bronzes of traditional bearing and familiar themes—figures and animals—which, though eloquent in their wit and pathos and archetypal symbolism, do nothing to disturb conventional expectations about the nature of the sculptural medium. Highly accomplished they most certainly are—I refer to such works as the "Man with Sheep" (1944), "Pregnant Woman" (1950)— and "Baboon and Young" (1951)—but they are sculptures that confirm our feelings, fitting neatly into a practiced response, rather than define new ranges of feeling.

Still, these more conservative works cannot be regarded as inessential to an understanding of Picasso's genius. For one thing, this conservative tendency at times produced work of breathtaking beauty—e.g., the monumental heads of women from 1931–2. For another, the sculpture of this persuasion reminds us of the essential rhythm, or dialectic, of Picasso's sensibility as an artist. To a degree unequaled by his few peers in this century, he has always been an artist who felt called upon to emulate as well as to challenge the past,

to reconstruct tradition, even as his radical inventions dissolved it. No matter which term of this dialectic we may value more, for Picasso it has been the dialectic itself, with all its contradictions and antiphonies, that has been essential.

October 22, 1967

7. Picasso's "Guitar"

Picasso's "Guitar," now bearing the slightly revised date of 1911–12, is currently on exhibition in a small show of new acquisitions at the Museum of Modern Art. This is the work—a construction of sheet metal and wire, 30½ inches in height, now believed to have initiated the entire tradition of modern constructed sculpture—which Picasso unexpectedly presented to the museum as a gift last month. It was exhibited in this country for the first time in the museum's large survey of Picasso sculpture in 1967. It is the first example of the artist's constructed sculpture to enter a museum collection anywhere in the world, for Picasso has always—until now—jealously held on to these historic sculptures for his own private delectation.

Indeed, until the 1967 exhibition, Picasso's constructions—both those of the 1912–14 period and the quite different constructed works that date from his collaboration with Gonzalez in the late twenties and early thirties—were known mainly through photographs reproduced in art journals and monographs. Even so, they exerted a powerful influence, altering the entire course of sculpture in this century. The best-known case of this influence in this country, I suppose, is to be found in the career of David Smith, the beginning of whose *oeuvre* virtually dates from his first acquaintance with reproductions of Picasso's constructions in the pages of *Cahier d'Art* in the early thirties.

So now, at last, we have an example of the thing itself—in fact,

the example, the work which (according to Picasso himself) was his very first effort at constructed sculpture. It was preceded, to be sure, by a cardboard maquette (still in Picasso's possession), but this was apparently regarded as a "sketch." The sheet-metal version was the first complete realization of the Constructivist idea.

It has long been supposed that the idea itself—that is, the idea of making a sculpture by pasting, nailing, welding, or otherwise joining together discrete masses and open spaces—derived from Cubist collage. The assumption has been that the two-dimensional collage led to the three-dimensional construction in a smooth, perhaps inevitable progression. But Picasso now says this is not the way it happened at all. According to William S. Rubin, chief curator of the Modern's Painting and Sculpture Collection, who talked with Picasso at length last month when the artist presented his gift to the museum, the "Guitar" preceded "by many months" the "Still Life with Chair Caning," which is believed to be the first Cubist collage and which is usually dated 1912. Thus, Mr. Rubin informs us, the "Guitar" was executed "no later than early 1912, and very possibly in 1911."

Actually, one of the standard reference works on the artist—*Picasso: Fifty Years of His Art*, by Alfred H. Barr, Jr., Mr. Rubin's predecessor at the museum—dates the "Still Life with Chair Caning" as 1911–12, and describes it as follows: "Owned by the artist who suggests that this may be dated 1911 and is his first collage." If the "Guitar" preceded the first collage "by many months," then it would have to be placed firmly in the year 1911. I suspect we have not yet heard the last about the dating of these seminal works.

Whether construction preceded collage, or the other way around, however, there can be no question about the sheer artistic audacity of this momentous innovation in both the conception and the technology of sculpture. Nothing in Picasso's earlier sculpture, not even the Cubistic "Woman's Head" of 1909–10, prepares us for the radical features of the "Guitar." Whereas the "Head" is a solid bronze monolith whose surface has been modeled into faceted planes reflecting the play of light and shadow in a more or less traditional manner, the "Guitar" offers the eye a sculptural object of an entirely different sort.

Instead of sculpture in the round, we have a shallow, three-dimensional "picture" on the wall. Instead of the romantic and "painterly" play of light and shadow, suggesting a kind of sculp-

tural chiaroscuro, we have flat masses enclosing "open" spaces in an almost diagrammatic arrangement of pictorial planes. The "Head" still belongs to the realm of sculptural illusionism, whereas the "Guitar" ushers in a new universe of sculptural discourse in which syntax—the relation of the materials to the way they are utilized and articulated—takes precedence in our experience of the work over our response to the depicted image. Henceforth, sculpture enjoys—or perhaps one should say, is condemned to—a new literalism and a new immediacy.

With Picasso's "Guitar," we enter upon what might be called the era of sculptural scaffolding—of sculpture as scaffolding. The armature is dislodged from its traditional function as an invisible support in order to become physically coextensive with the sculptural object itself. The expressive burden shifts from the flesh, so to speak, to the skeleton. This change entails a radical alteration in our relation to the technical history of the sculptural object. We are now obliged to be privy to every step of that history; virtually every step is made apparent, to the mind if not to the eye, in the final realization. The notion of the sculptor covering his tracks—a notion carried to its logical extreme in certain forms of bronze-casting, where nothing of the artist's hand or tool remains visible or even imaginable in the object itself—is decisively repudiated. What was formerly concealed is now enthusiastically revealed as part of the expressive value.

A shift of this magnitude, which jettisons some of the cherished fictions of the artistic process in order to display and exalt its own inner workings as a new syntactical principle, was bound to incite a certain opposition and alarm. The late Sir Herbert Read, for example, could never reconcile himself to the idea that sculpture was really sculpture if it was not sculpture in the round. The notion of sculpture as a form of drawing-in-space, which was what Picasso (and others) eventually made of it, was deeply repugnant to him, and his writings on the subject are filled with a good deal of futile argument against a mode of expression he had simply not begun to grasp.

Nor is the opposition to this development even now at an end. In his text for *The Cubist Epoch*, the book-length catalogue of the large Cubist exhibition coming to the Metropolitan Museum next month, the English art historian Douglas Cooper pretty much dismisses Picasso's constructions as "objects existing in paintings

transposed for study in three dimensions." Clearly, these "objects" still have no sculptural validity for Mr. Cooper, and he firmly excludes them from the exhibition.

The judgment of artists has been otherwise, however. From Tatlin to David Smith, from the Bauhaus of the twenties to the Minimalists of the last decade, we have seen the importance of Picasso's audacious innovation continuously reaffirmed. "There is no doubt, to my mind," wrote the young English sculptor William Tucker last year, "that the most totally revolutionary of all modern sculptures in concept, material and execution, are Picasso's Cubist constructions." The sculptural history still unfolding before us at the present moment begins with this rather modest and in some ways rather crude and simple "Guitar."

March 21, 1971

8. Were These Braque's "Great Years"?

The exhibition of paintings by Georges Braque that Douglas Cooper has organized at the Art Institute of Chicago is subtitled "The Great Years," and the subtitle is evidently intended to be something of a provocation. For most of us, as Mr. Cooper knows very well, tend to assume that Braque's "great years" belong to the period of classical Cubism—roughly, the years 1907–14—when, in his celebrated collaboration with Picasso, he helped to create the central pictorial style of the twentieth century. This, however, is very far from being Mr. Cooper's view of Braque's achievement. For him, Braque is "the most consummate pure painter of the School of Paris," and the "great years" commence in 1918. The Chicago exhibition concentrates its attention on the later years when, despite Braque's increasing detachment from the artistic ferment that was still taking place in Paris, he remained in Mr. Cooper's words, "an artist of monumental stature."

We are thus given thirty-eight paintings from the years 1918–56. These paintings cannot, of course, be easily detached from Braque's earlier achievement as one of the creators of Cubism, for there is not one among them that does not derive its essential syntax from Cubist form. Braque remained a Cubist (of some sort) for the remainder of his artistic career. Yet it is true that in his later years he aspired to something rather different from the ideals that are implicit in the paintings of the pre-World War I period. He clearly recoiled from the self-conscious missionary zeal—the legendary zeal of the vanguard artist—that had once required him to forgo so many of the traditional gratifications of painting in order to articulate a daring new vision in its purest form. That vision remained, for Braque, the fulcrum of all his subsequent endeavors, but it was continuously modified in the later years by an arduous effort to reintroduce the traditional "content" of painting and make it viable once again in the most compelling pictorial terms.

That he did not consistently succeed in this ambition even Mr. Cooper willingly concedes. He speaks of Braque's having "lost his sense of direction" in the years 1930–6, and there are only three pictures in the exhibition from that period. And the pictures that precede them, while never entirely without interest, are certainly insufficient to support any claim of greatness. The claim, in this selection of Braque's work, rests on the paintings produced between 1936 and 1956. These are, almost entirely, still lifes and studio interiors, themes that reinforce our sense of an artist who has withdrawn from the clamor of experience in order to effect some final resolution of the problems that haunt him.

In working out the terms of that resolution, Braque turned more and more to the resource that had sustained some of his most inspired innovations in the early Cubist period—his exceptional skill and experience as a pictorial artisan. Braque's father had been a professional painter-decorator, and the artist himself had been trained as a youth in all the technical refinements of his father's trade. This training left him with both a love and a knowledge of the materials of his craft that, in his maturity, were inseparable from his intuitive sense of the visual weight that every element of a painting should ideally attain in the spectator's eye. And in the end, his mastery of painterly craft served to safeguard the pictorial integrity of all those visual complexities—above all, the depiction of a space filled with the nuances not only of particular objects but of the

relations obtaining between them—that he was determined to restore to his art.

The task Braque set himself, simply put, was to find a means by which the pictorial surface—the flat plane on which the painting is created—retains its expressive force and priority, while at the same time accommodating itself to an illusionistic space in which objects and their relations can be vividly and convincingly depicted. What he sought, in other words, was a pictorial style in which the "fiction" of his imagery and the "nonfiction" of his medium could each be given its due.

It was in the interest of preserving the immediacy and integrity of the surface medium that he began introducing sand into his pigments, thereby conferring on his paintings a tactile physicality sufficient to withstand any amount of illusionistic imagery without any loss of surface vitality. His habit of priming his canvas in black or dark gray had a similar function, leaving him free to "hollow out" a pictorial space that would embellish and revise but never violate the surface integrity of the painting.

This preoccupation with surface is one of the two dominant concerns of Braque's late work. But the other—the impulse to fill up the imaginary space of the picture with a dense orchestration of visual incident—is no less compelling. And it was in the attempt to carry out the latter task, crowding his canvases with such myriad details of observation and analysis, that Braque ran his greatest risks—the risk, especially, of producing only an academic pastiche of Cubist mannerisms. It was also where he achieved his most notable results.

And the result, in a picture such as "The Studio VI" (1949–52), is, in my view, undeniably great painting. The way in which Braque achieved this result is, however, unfamiliar to us even in the work of his great French contemporaries, and for this reason alone his late work has proved hard to "read" and properly appreciate. Compared to a late Bonnard, in which the entire picture surface is filled up touch by touch, with a minimum of contrast and a complete absence of contour, every detail in Braque's painting stands free, a discrete visual entity, separately legible to the eye. Yet compare this legibility to a late Matisse, in which a very few forms somehow fill and overflow a space much greater—to the eye, at least—than the literal space they occupy, and Braque's thickly woven tapestry of forms looks overcrowded, overly dense, lacking in that airiness and

openness on which we have come to place an aesthetic premium. The fact is, we can nowadays "read" a complex field of color or a radically simplified design more easily than the particular kind of composition Braque offers us in this picture.

For it was Braque's genius, finally, to create a style in which every visual incident—every contour, every shape, every patch of color or change of tone—is given its exact place, the exact zone of its authority, and nothing overlaps or expands beyond it. The richness of the painting derives from the way every detail in the dense accretion of forms holds its place, without ambiguity or optical illusion, and yet at the same time serves very poetically, even illusionistically, the larger decorative scheme of which it is a part. What holds these complex structures together—and they are, at times, almost exhausting in their intricacy—is indeed the rigorous syntax Braque perfected in his great Cubist paintings and collages. Only in the later work this syntax is burdened with heavier duties and loftier emotions. What Braque aspired to, to borrow a phrase, was nothing less than to do Cézanne over again from Cubism, and the astonishing thing is not that he often failed but that he managed to succeed at all. If Mr. Cooper does not convince us that these were Braque's truly "great years," he has nonetheless succeeded in reminding us that they were at least the years in which a great artist painted some of his greatest pictures.

October 22, 1972

9. Juan Gris

*I never seem to be able to find any room in my pictures
for that sensitive, sensuous side which I feel ought
always to be there. Maybe I'm wrong to look for the
pictorial qualities of an earlier age in a new form of art.
At all events I find my pictures excessively cold. But
Ingres is cold too, and yet it is good, and so is Seurat;
yes, so is Seurat, whose meticulousness annoys me almost
as much as my own pictures. Oh, how I wish I had the
freedom and the charm of the unfinished! Well, it can't be
helped. One must after all paint as one is oneself.
My mind is too precise to go dirtying a blue or twisting a
straight line.*
　　　*—Juan Gris, in a letter to Daniel-Henry Kahnweiler
　　　December 14, 1915*

*If I am sometimes able to push a picture to a successful
conclusion, it is due more to my understanding of the
language of art than to my experience of actual painting.
This lack of experience means that, though my feelings and
my thoughts are well under control, the same is not always
true of the point of my brush.*
　　　—Gris to Kahnweiler, September 3, 1919

Juan Gris (*né* José Victoriano Gonzalez) came to Paris in 1906. He
was nineteen years old. He had been educated as an engineer in
Madrid, and had earned himself a small reputation in his native city
as a caricaturist in the prevailing style of Art Nouveau. He is said to
have found Madrid a sterile inspiration. His studies with a local
academician failed as a stimulation, and the most advanced artistic
taste outside the academy consisted of the secondhand mannerisms
of Art Nouveau, which, in Madrid, was a style disposed toward
satirical, journalistic ends and without any serious interest in the
search for new aesthetic forms. Kahnweiler, in his monograph on
Gris, says of Madrid in this period: "I remember that when I first
went there as a tourist, in 1906, it seemed to me like a town which
had been asleep for fifty years."

　　　In Paris, Gris found studio quarters in the broken-down
Bateau Lavoir, where Picasso also lived. He met his countryman
there, and soon came to know the entire circle of painters and
writers, which included Braque, Apollinaire, Max Jacob, Pierre
Reverdy, and other luminaries of the Parisian avant-garde. Gris still
earned a small living as a graphic artist, now contributing drawings

to the Parisian papers, but his artistic ambitions were beginning to take serious shape from his contacts with Picasso and Braque particularly. By 1911, five years after his arrival in the French capital, he was in the vanguard of the Cubist movement; that is the year he steps into the drama of modern painting, never quite occupying a position in the front rank and dropping out again in less than a decade. Ten years later he was turning out carefully calculated paintings which are little more than academic exercises in "modern art"; in 1927 he was dead at the age of forty.

The large exhibition of Gris's work at the Museum of Modern Art has afforded an unusual opportunity to review Gris's achievement and his place in the modern movement. Sixty-three paintings and twenty-seven gouaches, drawings, and prints, as well as the artist's single serious attempt at sculpture, the "Harlequin" of 1917, have been brought together by James Thrall Soby, with Sam Hunter as his associate. The exhibition thus makes as good a case for Gris's importance as one can imagine: most of the major works are included, and those which could not be secured for the exhibition are reproduced in the well-illustrated monograph which Mr. Soby has prepared for the occasion. Altogether, it is a show entirely suitable for an artist who, until now at least, has often been judged one of the major figures of modern painting.

Lately there have been some murmurings of critical dissent on this estimate of Gris as a major figure. Among his colleagues in the Cubist group, Picasso, Braque, and Léger, he does not impress one as an equal in either the range of his expression or the depth of his natural gift. And outside of Cubism itself, if we compare his *oeuvre* with that of Matisse, of Miró, of Klee, of Kandinsky or Soutine, his status no longer seems as unequivocally supportable as it once did. For myself, these hesitations about Gris are thoroughly confirmed in the museum's exhibition. It shows us an artist of a very definite but not a very far-reaching temperament: an artist who appropriated a style and made it his own, only to impose upon it the constricting and fatal limitations of his own sensibility.

Gris was, of course, no ordinary fellow-traveler of the avant-garde. He came to Cubism after its syntax had been created by Picasso and Braque, but he brought to it a serious intelligence and a gift for graphic expression which he was then arduously bending in the direction of a more painterly vision. Cubism was the workshop within which he passed from apprenticeship to maturity as a

painter. Unlike Picasso and Braque, he did not come to it from another "position"; six years their junior, he brought to Cubism none of the experience which conferred on their work a greater freedom of action and a more expansive vision. Thus, while Gris became an authentic contributor to the evolution of Cubism in a relatively short time, his contribution was always a special one. The Cubist style was his first and only faith as an artist. His commitment to it can only be likened to a religious conversion, and, like many converts', his orthodoxy tended to be humorless and solemn.

In the beginning, Gris's solemnity was tempered by his experience as a graphic artist. "The Man in the Café" (1912), in the Arensberg Collection, derives much of its strength from an element of caricature wedded to a Cubist format which elevates its wit without compromising its immediacy. The example of Cézanne, too, contributes a more direct emotion to some of Gris's early efforts. Like his colleagues, he was of the generation which regarded Cézanne's *oeuvre* as the fulcrum of modern painting, and he sought to emulate the master's constructive method. His "Still Life with Book" (1911), one of the most appealing pictures in the exhibition, is a small *hommage* to Cézanne's philosophy of composition as well as a tentative commitment to the Cubist style. Gris's most singular pictures of 1911–12 are the "Still Life" (in the museum's collection), "A Table at a Café" and the "Portrait of Picasso." They enlist the artist's graphic sensibility (say, in the extraordinary nuances of light and shade, which remind one of Seurat's charcoal drawings and might well have been influenced by them, and in the clarity of form) in the service of a Cézanne-esque modeling of the pigment. Gris's touch with the brush never improved upon these early pictures; he afterward turned it to other ends. Yet, the curiously "bleached" quality of these pictures, icy in tone and frigid in feeling, with all their subtleties confined to a glacial margin of emotion, keeps them at a certain distance from our affections—a distance at which we begin to observe some of the first instances of Gris's tendency to domesticate, even to academicize, some of the formal departures of Picasso. The face in the "Portrait of Picasso" is but the first of Gris's many attempts to restore the inventive distortions of his contemporaries to a more "classic" and readable level of pictorial discourse.

Nowhere is this tendency more in evidence than in Gris's

collages, but, paradoxically, his collages also embody his particular strength as an artist. Collage occupies a unique and crucial place in the main body of Gris's work. Mr. Soby joins other critics in pointing out that "Gris' collages are paintings, whereas those of Braque are primarily drawings . . ." and, one might add, those of Picasso are primarily drawings on their way to becoming constructions. Gris's collages not only refrain from the clowning and the exuberance, from the free pictorial witticisms of Picasso's, they are burdened with the full weight of his solemnity. Following the pictorial logic of his collage inventions, Picasso did not hesitate to disrupt the actual, physical integrity of the picture plane; he felt completely free to carry it into relief and sculpture if that was where the conception seemed to lead. Retracing the history of Picasso's collages, one feels that anything might be possible; it is a medium open to the future, open to any improvisation, to any metamorphosis or sport which a powerful personality might choose to impose upon it. Gris's role was literally that of a conservative: he wanted to conserve the collage technique for painting itself. As quickly as Picasso emptied collage of its painterly elements and endowed it with an independent plastic life of its own, Gris restored it to the use of the most carefully meditated picture-making. Whereas Picasso's personality often carried him forward into an untried idea, Gris submitted everything to his scrupulous and humorless intelligence. Perhaps this is what critics mean when they speak of Gris as the "conscience" of Cubism.

Kahnweiler points to another element in Gris's collages which attests to what I have called the artist's conservatism: their so-called "realism." "Even in the early days, in 1912, he used pages from books and pieces of mirror in his pictures; but whereas, with Picasso in particular, the newspaper was often used simply as a piece of material, with Gris the fragment of mirror represents a mirror, the printed book page is itself, and so is the piece of newspaper." The introduction of foreign materials into his paintings was for Gris an extension of his use of *trompe-l'oeil* effects to clarify his forms. Consequently, there are no aesthetic discrepancies between the tight-lipped style of his paintings and that of his collages. They form a continuous universe of plastic means in which the contours of solid objects together with the space and light which they inhabit are painstakingly fitted to each other in airtight designs, where every

impulse is accounted for and every superfluous feeling suppressed. The result is certainly the *stillest* art of still life in the history of the genre.

I have remarked that Gris's collages embody his particular strength as an artist. That strength was precisely his gift for the graphic; it was in that gift that his solemnity, his detachment, his aspiration for the classic could come together in pictorial designs unmodified by the hazards of an authentic painterly technique. Either by intention or by remaining unconsciously faithful to the natural shape of his talent, Gris moved his painting into the realm of collage in order to make of it a more graphic art. At its best—say, in "The Marble Console" of 1914—the result was much superior to the austere oil paintings of the same period: it shows a physical vigor and at least a simulacrum of the sensuous which are so much wanting in the artist's non-collage paintings. Only rarely could Gris raise his straight paintings to a level at which their physical actuality had vitality in itself and was not merely the instrument of an intelligent design. The "Package of Quaker Oats" (1915) is such a picture, but there are not many others. This picture, incidentally, is one of the few in which Gris uses color to any real expressive purpose. I am surprised to find Mr. Soby talking about Gris's "highly original color sense"; Gris was practically without any color sense at all. The strength of his paintings is all in the transitions of value and in the articulation and tightening of forms. The use of color as a pictorial instrument seems not to have entered his head—and that was where his paintings came from.

Gris's graphic talent also gave us some of the most beautiful drawings of the period. With pencil, charcoal, or crayon in hand, he still aspired to a classic form, but he was relieved of that compulsion for a tight and totally rationalized design which gets to be such a bore in his pictures. The museum exhibition has some very fine examples of these drawings. The way forms take their shape in the subtle encounter of light, space, and object, and the ways in which a sensitive eye and an agile hand can give themselves over to this subtle drama are wonderfully revealed. The rigor of Gris's analytic mind is often in evidence in these drawings, but it is held firmly to the task of the hand, and the drawings remain largely untouched by the curse of the artist's grinding solemnity.

May 1958

10. The Conversion of Julio Gonzalez

The Julio Gonzalez exhibition at the Museum of Modern Art is not a major exhibition. It consists of only four sculptures and some fifty works on paper—drawings, pastels, collages, and a single engraving—and was organized by the museum as a touring exhibition. It was shown initially at the Instituto de Cultura Puertorriqueña in San Juan, Puerto Rico, and after its showing in New York will travel elsewhere. But whatever the shortcomings of this exhibition may be—and it does contain one incontestable masterpiece—Gonzalez's art occupies so important a place in the history of the modern movement that even a minor exhibition of his work compels our attention.

Gonzalez's career was a very unusual one. He produced almost nothing of consequence until well after his fiftieth year, and then, through an unexpected collaboration with genius, he was suddenly responsible for helping to change the technique and the style of modern sculpture. He very shortly went on to prove himself a marvelously sensitive and original sculptor in his own right. The work he produced in the 1930's constitutes one of the major artistic achievements of that decade, and its influence on American sculpture, while no longer as central as it once was, has been a very fertile one.

Gonzalez was born in Barcelona in 1876, into a family of gifted artists and craftsmen. His father was well known as a goldsmith and sculptor. The two sons—Julio and his older brother Joan—were trained in metalcraft in their childhood, and even the Gonzalez daughters worked in their father's atelier, which produced decorative work in bronze and iron. The brothers were particularly close. They both studied painting at the Barcelona School of Fine Arts in the early nineties, and their metalwork was widely exhibited—among other places, in the Chicago World Exposition in 1893 when Gonzalez was seventeen and his brother twenty-four.

While Barcelona in this period was the scene of a very lively and progressive artistic bohemia—the milieu from which the precocious Picasso was then emerging—Gonzalez's life was apparently confined to the family circle. Even his move to Paris, in the late nineties, was a family affair. Soon after his father's death, the family

sold their business and all of them—the mother, daughters, and two sons—established their household in Paris.

It was there that Gonzalez met Picasso for the first time. The present exhibition includes a touching memento of this period— Picasso's watercolor portrait of Gonzalez dating from (it is believed) around 1901–2. Joan Gonzalez had met Picasso in Barcelona, and Picasso now introduced the Gonzalez brothers to his circle of artist-friends in Paris. Gonzalez himself was painting then in a delicate if unremarkable style, derived more or less from Degas and Puvis de Chavannes, and he and Joan showed their work in the Salon des Indépendants and the Salon d'Automne.

The great crisis of Gonzalez's life occurred in 1908, when his beloved brother died after a prolonged illness. Gonzalez was overcome with despair. He withdrew from the vanguard-bohemian milieu to which his brother had introduced him. He quarreled with Picasso, and, as his own daughter Roberta later put it in a moving memoir of her father: "It was then the long period of solitude began."

It was not until after the First World War that Gonzalez renewed his friendship with Picasso, apparently at the latter's prompting. We actually know very little about Gonzalez's life from the time of his brother's death until the day, roughly twenty years later, when Picasso invited him to collaborate on making some openform welded iron sculptures. All we know is that these were years of doubt, isolation, and misery. Only one workaday detail points to the achievement of his later years: during the war he worked in the Renault factory and added to his immense knowledge of metalcraft a mastery of the oxyacetylene torch—the instrument that proved so fateful, first in his collaboration with Picasso and then in his own sculpture of the thirties.

The collaboration with Picasso—the results of which we saw for the first time in the great Picasso sculpture exhibition of 1967 —had a transforming effect on Gonzalez as an artist. It liberated his sensibilities. It allowed him for the first time to apply his expert knowledge of metalwork to a major artistic task. The vein of sculptural expression which Picasso opened to him—sculpture conceived as a medium in which slender masses of metal were joined to form a kind of three-dimensional draftsmanship—proved to be the perfect vehicle for his considerable talents. While Picasso himself,

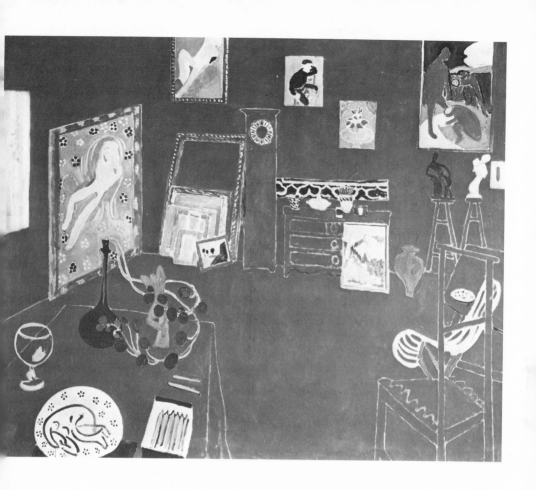

HENRI MATISSE: *"The Red Studio"* (*1911*)
Oil on canvas, 71¼ × 86¼"
COLLECTION, THE MUSEUM OF MODERN ART, NEW YORK. MRS. SIMON
GUGGENHEIM FUND

(*clockwise*)

HENRI MATISSE: "*Jeannette I*" (*Jeanne Vaderin, 1st state*) (*1910–13*)
Bronze, 13″ high
COLLECTION, THE MUSEUM OF MODERN ART, NEW YORK. ACQUIRED THROUGH
 THE LILLIE P. BLISS BEQUEST

HENRI MATISSE: "*Jeannette II*" (*Jeanne Vaderin, 2nd state*) (*1910–13*)
Bronze, 10⅜″ high
COLLECTION, THE MUSEUM OF MODERN ART, NEW YORK. GIFT OF
 SIDNEY JANIS

HENRI MATISSE: "*Jeannette III*" (*Jeanne Vaderin, 3rd state*)
 (*1910–13*)
Bronze, 23¾″ high
COLLECTION, THE MUSEUM OF MODERN ART, NEW YORK. ACQUIRED THROUGH
 THE LILLIE P. BLISS BEQUEST

HENRI MATISSE: "*Jeannette IV*" (*Jeanne Vaderin, 4th state*) (*1910–13*)
Bronze, 24⅛″ high
COLLECTION, THE MUSEUM OF MODERN ART, NEW YORK. ACQUIRED THROUGH
 THE LILLIE P. BLISS BEQUEST

HENRI MATISSE: "*Jeannette V*" (*Jeanne Vaderin, 5th state*) (*1910–13*)
Bronze, 22⅞″ high
COLLECTION, THE MUSEUM OF MODERN ART, NEW YORK. ACQUIRED THROUGH
 THE LILLIE P. BLISS BEQUEST

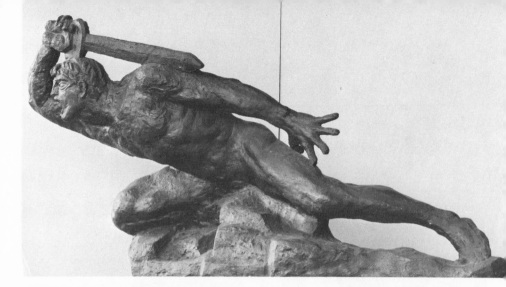

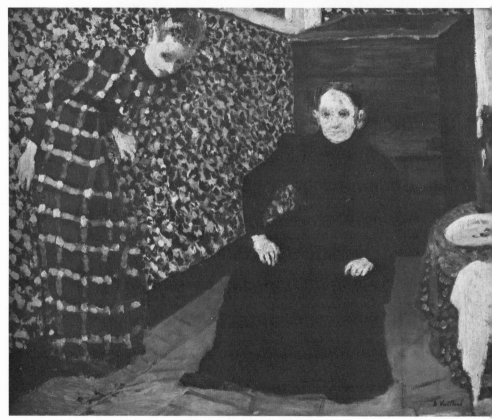

ANTOINE BOURDELLE: *"Naked Warrior with Sword"* (*c. 1898*)
Bronze
COURTESY HIRSCHL & ADLER GALLERIES, NEW YORK

ÉDOUARD VUILLARD: *"Mother and Sister of the Artist"* (*c. 1893*)
Oil on canvas, 18¼ × 22¼"
COLLECTION, THE MUSEUM OF MODERN ART, NEW YORK. GIFT OF
 MRS. SAIDIE A. MAY

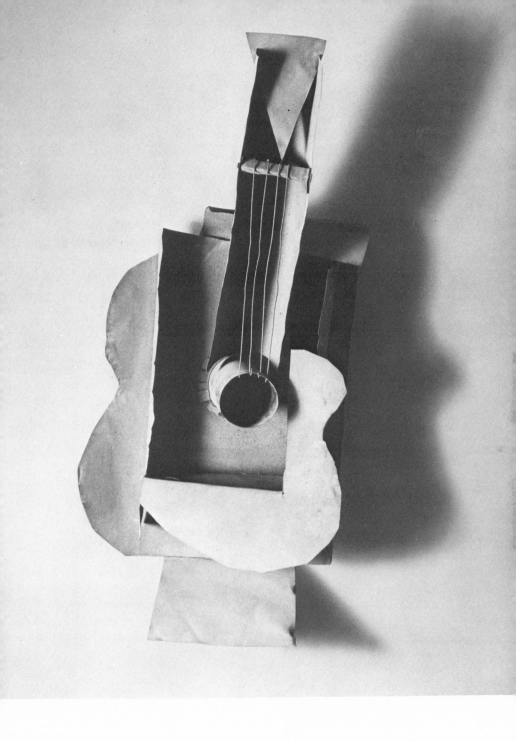

PABLO PICASSO: *"Guitar"* (*early 1912*)
Sheet metal and wire, 30½ × 13⅞ × 7⅝″
COLLECTION, THE MUSEUM OF MODERN ART, NEW YORK. GIFT OF THE ARTIST

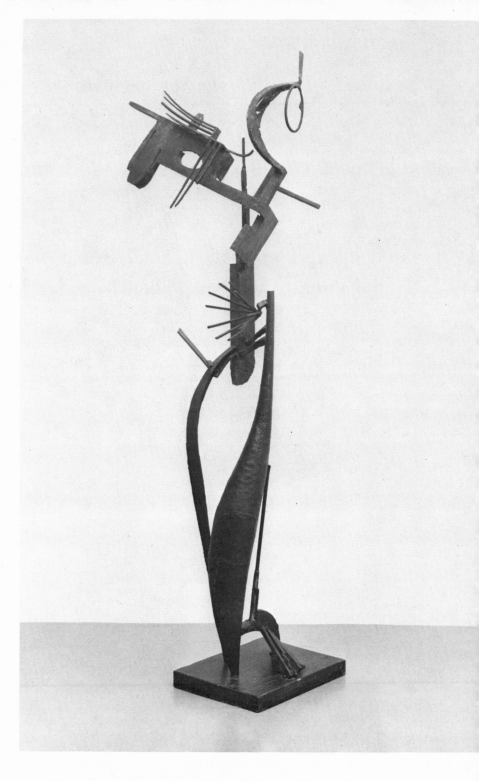

Julio Gonzalez: *"Woman with a Mirror"* (1936)
Iron
PRIVATE COLLECTION, PARIS

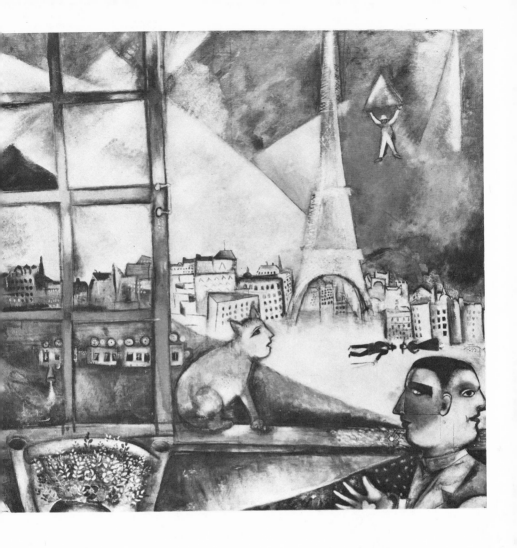

MARC CHAGALL: *"Paris through the Window"* (1913)
Oil

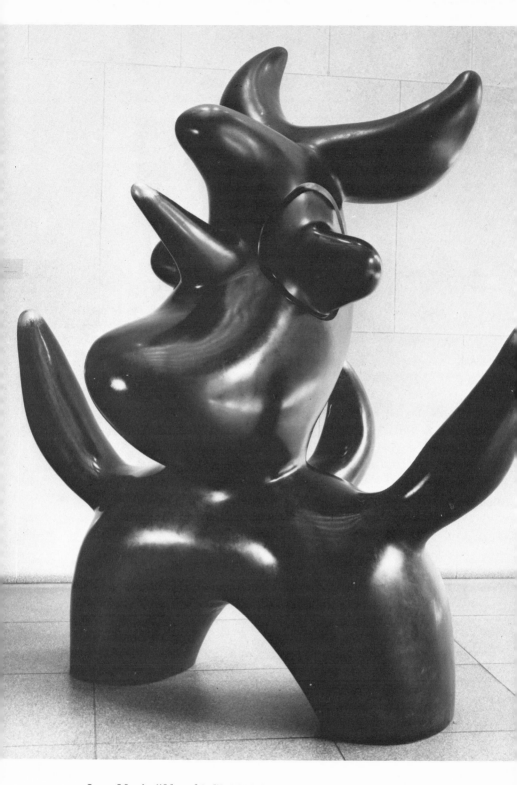

Joan Miró: *"Moonbird"* (1966)
Bronze, 7′ 8⅛″ × 6′ 9¼″ × 59⅛″
COLLECTION, THE MUSEUM OF MODERN ART, NEW YORK. ACQUIRED THROUGH
THE LILLIE P. BLISS BEQUEST

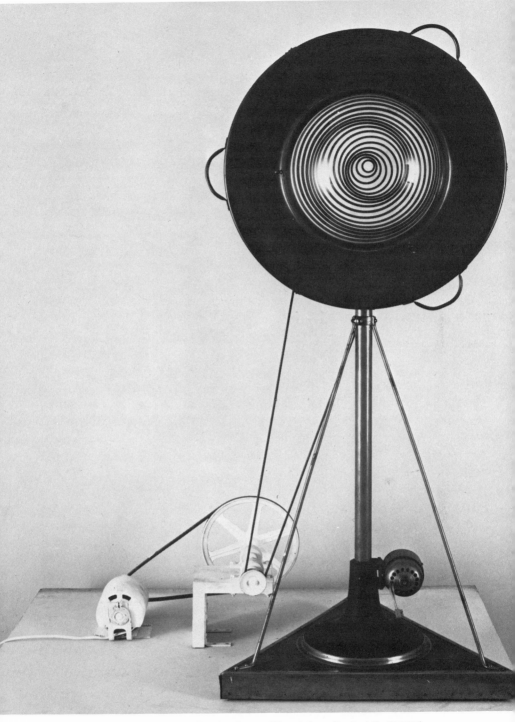

Marcel Duchamp: *"Rotary Demisphere (Precision Optics)"* (1925)
Construction of painted wood, velvet, metal, and plexiglas with motor
and pulley assembly; (a) construction, 58½ × 24¼ × 24″;
(b) pulley assembly, 11 × 13⅛″; (c) motor, 5⅛ × 5⅝ × 8¾″

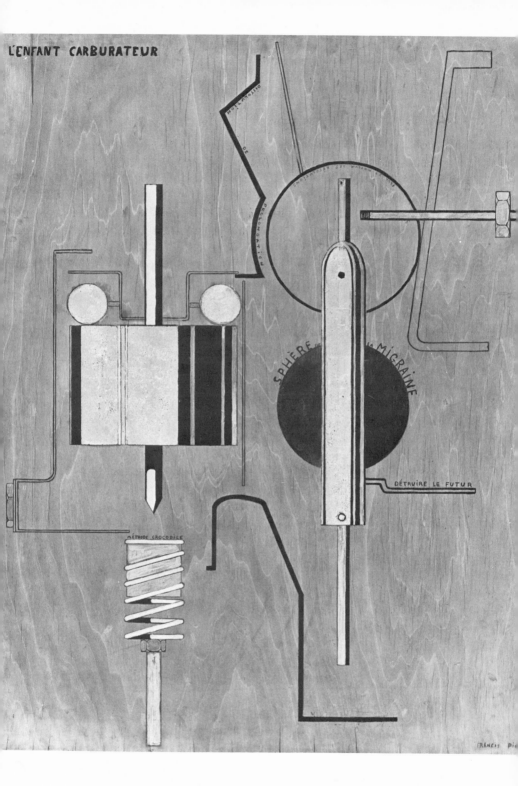

FRANCIS PICABIA: *"The Child Carburetor"* (1919)
Oil, gilt, pencil, and metallic paint on plywood

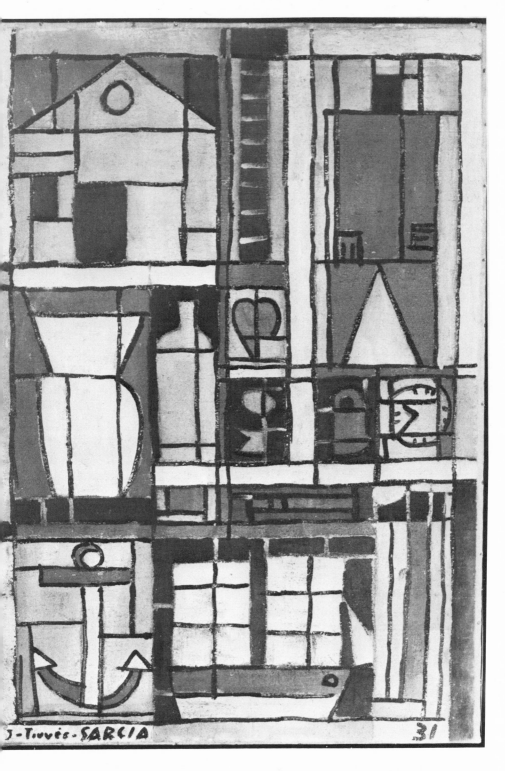

JOAQUIN TORRES-GARCIA: *"Construction in Red and Ocher"* (1931)
Oil on canvas, 34 × 23″
COURTESY ANDRÉ EMMERICH GALLERY, NEW YORK

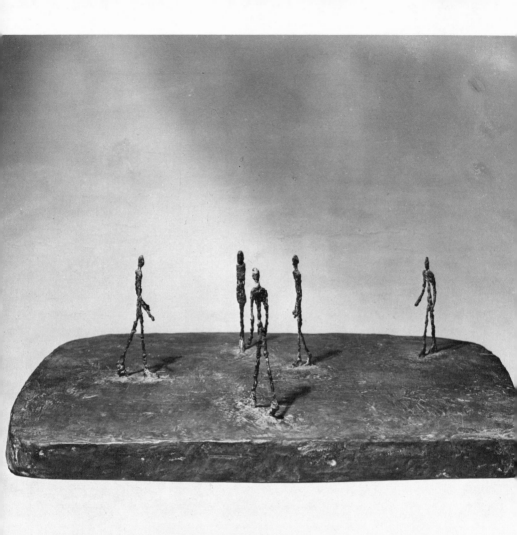

Alberto Giacometti: *"City Square"* (La Place) (*1948*)
Bronze, $8\frac{1}{2} \times 25\frac{3}{8} \times 17\frac{1}{4}''$
COLLECTION, THE MUSEUM OF MODERN ART, NEW YORK. PURCHASE

after producing several sublime masterworks in this genre, more or less abandoned it—or at least never again returned to it with the same conviction—Gonzalez made of this open-form medium a sculptural poetry all his own.

The "Woman with a Mirror" (1936) in the present exhibition is one of the masterpieces Gonzalez produced in the decade of his maturity. It is a work that transforms the syntax of Cubism into an open, airy, very delicate, and yet very decisive linear construction. The liberties it takes with its subject matter are liberties of concision and concentration. It is the gesture of the figure, the feeling that is traced in its posture and movement, that Gonzalez seeks to epitomize, and for this task the elegant sinuosities of this new medium, with their lyric touches but very precise forms, were exactly right. The former devotee of Degas was able to take his inherited motifs— dancers and figures in informal postures—and make something entirely new of them. In this medium in which welding made possible an inspired three-dimensional draftsmanship, Gonzalez was able to bring all the fragmented elements of his training, his talent, and his personal culture, and remake them into a cohesive and eloquent whole.

Apart from the "Woman with a Mirror," the main interest of the current show is to be found in those drawings of the thirties that are actually studies for sculptural constructions. In these studies we are given a very clear account of the way the artist conceived his forms, transmuting observed materials of a rather commonplace character into a vocabulary at once highly expressive and completely susceptible to technical realization.

The earlier drawings and pastels are, to say the least, a good deal less interesting—except in one respect. They show us how completely Gonzalez remained immune not only to Cubism but to virtually the whole avant-garde movement in the early years of the century. Gonzalez was indeed a late convert to the avant-garde tradition, and by the time he came to join it, it *was* a tradition. And yet he succeeded in modifying it to a profound degree, and in the process bequeathed to several generations of younger sculptors a formal idiom and a sculptural technology that now seems, in retrospect, the very essence of the modernist spirit.

February 2, 1969

11. Laurens: "The Ripening of Forms"

Despite the high esteem it has long enjoyed in his native France, the sculpture of Henri Laurens is not a familiar presence on this side of the Atlantic. For the younger generation of artists and collectors over here, he is hardly more than a name—a name certified by history because of Laurens's position as a member of the School of Paris in its heyday, but little more. Specialists in the history of modern sculpture tend to exhibit more interest in his early collage-like constructions than in the solid bronze figure sculptures that dominate his *oeuvre* as a whole. As for the aficionados of the "new," the extreme, and the far-out, who continue to wield an inordinate influence on the taste and values of the art world, they can find nothing in the main body of Laurens's work to confirm their own predilections. His career traces a course that contradicts their most cherished assumptions.

Laurens, who was born in 1885 and died in 1954, belongs to the generation of sculptors that orphaned itself first from the domination of Rodin in order to submit to the new discipline of Cubism, and then orphaned itself again—this time, from the protective cover of the avant-garde—in order to regain something of Rodin's grandeur. We are more familiar with this pattern of a revolt against tradition followed by a realignment with it in the careers of sculptors whose work has enjoyed a more continuous exposure here than Laurens's—in Lipchitz's and Henry Moore's especially, and even, to some degree, in Giacometti's. These are the hardest cases for critics of a certain intellectual disposition to come to terms with, for they violate the simpleminded faith of avant-garde aesthetics, which is nothing but the nineteenth-century idea of progress applied to a specialized field of discourse.

Laurens first encountered Cubism in 1911, the year he met Braque, and the earliest of his Cubist sculptures that have survived date from 1915. In the current show at the New York Cultural Center, there is a small polychrome construction in wood and metal of that year which gives us a fair measure of the mastery he brought to this (then) radical genre. The gallery has also borrowed Laurens's "Head" (1918) from the collection of the Museum of Modern Art— one of the greatest of his constructions, a work of sheer perfection. There is no doubt—in my mind, at least—that, had he wished to con-

tinue in the line of Constructivist sculpture, Laurens would have produced important work.

But his aspiration lay in another direction. Laurens himself once said: "We couldn't continue all our lives to make 'collages,'" reminding us that the origin of Constructivist sculpture was indeed the Cubist collage and, further, that the sculptor wishing once again to embrace the aesthetic of solid forms must sooner or later separate himself from the principle of joinery if the method by which he works is to have an organic relation to the image he hopes to realize.

There is a sense, of course, in which Laurens remained a Cubist to the end. The disposition of masses in his work, the fundamental architecture that determines the balance of weights in his figures, the very manner in which each segment of the mass is joined to the whole, tracing a topography of light and shadow—such fundamental elements of style echo and re-echo the Cubist matrix, no matter how distant from the orthodoxies of Cubism the work may appear to be. But it is precisely the collage side of Cubism, the play on disparate modes of visual reality that required the joining together of different materials and disjunctive effects, from which Laurens felt compelled to separate himself. What he retained of Cubism was its essential (but sometimes hidden) affinity with classical form. He had no use for the vast array of radical aesthetic consequences Cubism had set in motion.

The 1920's was, among other things, a period of classical revivals—in Cocteau's phrase, a "call to order"—and this proved to be a historical current completely congenial to Laurens's sensibility. It would not be out of order to speak of it as a liberation of his powers. It permitted him—slowly, painfully, but with a mounting confidence and conviction—to reclaim his true heritage, which was that of a Mediterranean voluptuary and lyricist. The figure—above all, the female figure—acquired a pre-eminent importance, for it proved to be the very embodiment of a vital principle, at once mythic and biological. "I strive for the ripening of forms," Laurens said. "I would like to make them so full of juice that they couldn't hold any more." In a fine monograph on Laurens's work published only a few months ago—*The Sculpture of Henri Laurens* (Abrams) —the Austrian critic Werner Hofmann names "Laurens's great mythic theme" as "fruitfulness."

Much of the interest in the current exhibition, which includes

more than sixty sculptures as well as some fifty works on paper (drawings, prints, and illustrated books), is to be found in the way we are able to follow, step by step, the artist's journey from an essentially detached, studied, and cerebral enactment of Cubist principles to the more emotionally charged imagery of his later years. It is a slow progress; we are not offered the spectacle of an existential "leap" into a fixed and deliberate style. Every move forward is carefully tested in the crucible of the artist's sensibility. There are awkwardnesses that a slicker and cannier artist would have had the presence of mind to avoid; there is, too, at times, a pressure of feeling for which the artist cannot quite find an exact form, and the result is a discrepancy between the high rhetoric of this sculpture and its formal realization. But there is, throughout, an honesty that is profoundly moving. Laurens is one of those artists whose work recalls us to the meaning of sincerity in art. Compared to some of the absurdities and trivialities that often pass for artistic expression nowadays, how innocent it all seems! How personal! How irreducibly authentic!

January 24, 1971

12. Lipchitz's Eloquence

Paul Valéry once spoke of Degas as an artist nourished on Racine and the old music, and in doing so, defined something important not only about Degas in particular but about sensibilities of a certain type. These are artists who, whatever the degree of innovation or invention they may boast, function out of some abiding sense of cultural tradition; artists who conceive their work as participating in a precious line of continuity. From such artists we do not expect rude assaults on our aesthetic assumptions. They stand at the very opposite pole from those determined vanguard spirits who, by

means of inspired guerrilla warfare, succeed in overturning established taste and positing new values.

Jacques Lipchitz, who will be seventy-five in August, has for some years now been an artist of this tradition-conscious persuasion. Since the 1930's, when his sculpture began assuming a more deliberately heroic, orotund form, searching for a monumentality that recalled, not the strict sculptural grammar of his Cubist beginnings but the more openly expressive rhetoric of Rodin and his school, Lipchitz has seemed to espouse this more traditional position. His sculpture has always retained, even in its most baroque flights of rhetoric, a basic Cubist syntax, but its expressive interests have shifted; his whole postwar *oeuvre* has been occupied with a kind of eloquence—at times, even grandiloquence—that the young Lipchitz and his Parisian confrères would have spurned.

Yet Lipchitz has not remained immune to the aesthetics of improvisation, to the use of found objects, or to the general climate of ideas as it developed during the postwar years. While his loyalties were clearly on the side of tradition and his principal tasks concerned with public sculptures of an almost epic bearing, the very rhetoric he aspired to seemed to require some less formalized, less constrained, and rationalized means for its full realization. Hence the apparent digressions that, beginning with the so-called "Semi-Automatics" of 1955–6, Lipchitz has allowed himself with increasing frequency over the past decade.

The Semi-Automatics were a series of small sculptures modeled in wax with a deliberate spontaneity and with no particular imagery envisioned as a goal. Not surprisingly, however, in their cast-bronze versions these sculptures turned out to be a somewhat freer, more lyrical rehearsal of the sculptor's usual themes—prophets, mythological beings, heroic gestures of various sorts. The improvisatory element, far from swamping Lipchitz's imagination, simply released an Expressionist energy that gave his repertory of motifs a new and attractive sculptural immediacy.

Lipchitz followed the Semi-Automatics a few years later with an exhibition called "The Limits of the Possible"—a rather grandiloquently titled survey of small works in which found objects were used very much as the modeled wax had been used in the first series, to stimulate invention and effect sculptural combinations of form not usually come by through his more orthodox working methods. In

their bronze castings, these sculptures, too, had the unmistakable Lipchitz refinement, the elevated language which is now his basic idiom. They were clearly the work of a master, but of a master who was all too conscious of—and just possibly a little nervous about—what the younger generations, for whom the found object was an accepted material, were up to. For them it was becoming more and more an antiformalist device, whereas for Lipchitz it was still another way of clarifying and elevating his form.

The new exhibition at the Marlborough-Gerson Gallery, entitled "Images of Italy" and consisting of twenty-five small bronzes, brings us the latest chapter of this "informal" side of Lipchitz's postwar development. Like the preceding works in this vein, the sculptures are not intended as studies for more elaborate public works. They affect a more private realm of feeling, and in technique call upon both the free modeling of the Semi-Automatics and the found-object construction of "The Limits of the Possible." Their title derives from Lipchitz's recent sojourns in Italy, where the sculptures were created and cast.

There are some lovely pieces here, and there are details in every one that only a sculptor of Lipchitz's experience and sensibility could have produced. But there is no use pretending that, so far as sculpture goes, Lipchitz really has any "private" feelings that remain undisclosed to us. His sensibility is now so saturated in the nuances of his own public language, his gifts are so completely attuned to high-flown public utterance, that even in these "informal" sculptural "Images" it is the public historical figure who addresses us with a resounding sculptural oratory. Lipchitz in a relaxed mood is very little different from Lipchitz the maker of monuments. His heroic stance seems to have deprived him of all small talk; however modest his intentions may be, even the most personal of these sculptures speak of an immodest public aspiration.

There is something exhilarating about Lipchitz's eloquence. It seems the natural mode for an artist steeped in the old culture, and few of Lipchitz's generation—or any succeeding generation—have been able to sustain it with such undiminished energy. But there is also something distant and historical about it, too. Its loyalties to a tradition of heroic utterance deprive it of immediacy, and give it a retrospective air. Among the plainer-spoken styles of the current scene, it seems a little fancy and oblique—less an elucidation of the present than a way of warding it off. Lipchitz has surely earned his

right to this elevated idiom, if anyone has; and he still employs it with amazing virtuosity. But it is not a language that we are going to see much used in the future.

April 24, 1966

13. Chagall

The School of Paris, which only yesterday loomed as the unrivaled citadel of modern art, has gradually slipped into history. Its former hegemony over the artistic consciousness of the West is shattered. Its senior living survivors—Picasso, Lipchitz, and Chagall—passed long ago into that peculiar historical limbo reserved for artists who, though honored as celebrities, lavished with commissions, and granted all the prerogatives which modern society can bestow upon its spiritual demigods, are no longer allowed to influence the course of artistic events. Its characteristic forms, which once provoked cries of aesthetic "bolshevism" from the official guardians of culture and tradition, are now firmly established in the *musée imaginaire* of sophisticated minds the world over. Its success has been complete— one might almost say, *too* complete, for the distinctive values and assumptions of the School of Paris now seem as distant, as enviable, and as historically determined as the style of life which produced them.

Foremost among these assumptions was a confident belief in the power of art to dominate, transfigure, and ultimately redeem the raw materials of experience. The conviction with which this belief was upheld by the generation that came of age, artistically, in the decade preceding Sarajevo gives to the art of those halcyon years an identity—incredibly optimistic and freewheeling in its intellectual ambition, formal inventiveness, and emotional poise—that stands in sharp contrast to the artistic impulses which derived from both the war and the Russian Revolution. These latter impulses—mainly

those of Dada and Surrealism, which, in altered and somewhat corrupted form, continue to dominate contemporary sensibility— were born of the sense of crisis that came into existence at Verdun and Petrograd and that, in a reversal of the historical atmosphere which had spawned the Fauvist and Cubist styles, undermined the very notion that art could significantly cope with, let alone master and redeem, the sheer ruthlessness of modern experience.

The career of an artist like Chagall, whose style and entire aesthetic stance were formed in those years before the First World War, but the bulk of whose life and work has been enclosed by the harsher historical climate which followed that war and another still worse in its spiritual devastation, is in some respects emblematic of the fate which the School of Paris has suffered from the period of its greatest artistic glories in 1904–14 to its subsequent decline into officialdom and senescence. Among the painters of his generation— the generation of Picasso and Matisse—Chagall cannot, of course, be said to occupy a position of the first rank. He is, rather, one of that remarkable group of Parisian "little masters" who made their way to the French capital from the provinces of Europe and who, by submitting their alien culture and diverse experience to the dialectic of French art, helped to make that art the richest and most influential fund of aesthetic ideas in the twentieth century.

In approaching Chagall's achievement, then, it is imperative that one bear in mind his status as an "outsider" who belonged to the School of Paris, but whose later work, unlike that of certain native French members of the school, underwent a marked and only occasionally abated diminution of expressive power once the personal and historical conditions of its initial thrust were eclipsed. For the crisis which overtook Parisian art in the aftermath of the First World War did not affect all its artists with equal, or equally lasting, force. Frenchmen like Matisse, Léger, Braque, and Bonnard were able, sooner or later, to recover their momentum and hence to sustain their genius to the end of their lives—even, in the case of Matisse, to produce some of their most magnificent work in their very last years—whereas "foreigners" like Picasso, Brancusi, and Chagall either stopped producing entirely—as in the case of Brancusi—or lapsed eventually into the unedifying visual logorrhea that has characterized the productions of both Picasso and Chagall for a period amounting now to decades.

Chagall's status as an "outsider" also sheds some light on one

of the most elusive aspects of his art: his use of Jewish themes, and thus his standing as a "Jewish artist." Much has been made of Chagall's Jewishness, as if all the questions raised by the Jewish element in his art came equipped with self-evident answers not susceptible of contradiction. It is therefore of great interest that in the mammoth study which Franz Meyer, the Swiss art critic and museum director who is also the artist's son-in-law, has now devoted to Chagall's life and work,* the use of Jewish materials and motifs has been confronted with unusual cogency and tact. Discussed, moreover, in the very detailed context of Chagall's family background, artistic education, personal associations, and overall development which Meyer's study provides, the Jewish themes and preoccupations that recur at irregular intervals throughout the artist's long and copious *oeuvre* are given—correctly, I think—a place of secondary importance without in any way being skimped or condescended to.

Meyer remarks at the outset of his voluminous monograph that "the spirit of Jewish mysticism [Hasidism] is one of the fundamental sources of Chagall's art," but at the same time he is careful to point out the painter's conscious abandonment of the Hasidic traditions of his parents, noting that "he lapsed from the movement in order to paint and only to paint, independent of any movement or any doctrine." Nearly six hundred pages later, in attempting to sum up the nature of Chagall's accomplishment, Meyer returns to the question, observes once again that the artist's "Hasidic heritage . . . made a quite decisive impact on his fundamental spiritual attitude and is therefore responsible for certain characteristics of his art," but is again careful to underscore the fact that "Chagall's art is not addressed in any special way to the Jews." Between his initial observation and his concluding remarks, Meyer recounts in detail the many occasions on which Chagall returned to Jewish themes: there is a particularly fine account of Chagall's work for the Kamerny State Jewish Theater in Moscow, in 1920–1, which involved not only his designs for the plays of Sholem Aleichem but some ambitious murals executed under the general title of *Introduction to the Jewish Theater*, and of his influence on the Habimah's original production of *The Dybbuk*. Meyer thus places the reader in a position to judge for himself the role that Chagall's Jewishness

* Franz Meyer, *Marc Chagall*, translated from the German by Robert Allen (New York: Harry N. Abrams, 1964).

played in the evolution of his art and, in the process, thoroughly vindicates his own reluctance to judge that role as being of the first importance.

In order to understand what happened to Chagall's Jewish preoccupations in the course of his artistic development, one needs, I think, to see that development as fundamentally Parisian in its loyalties and objectives. As a child of the *shtetl* of Vitebsk, educated in the local *cheder* and brought up on the customs of the Hasidim, Chagall was obviously saturated in a mode of experience that was, in its essential feeling if not in specific dogma, irreversible. But it was precisely in the nature of the Parisian aesthetics to which Chagall submitted his gifts that the specificities of that experience be made to give way, in the order of expressive priorities, to the means by which they could be artistically redeemed. For what ultimately distinguished the School of Paris from the various other European "schools" then in the ascendancy—Expressionism, Futurism, Constructivism, etc.—was the phenomenal degree of aesthetic "science" it brought to bear on any experience that came to hand. The triumph of Cubism was, exactly, the displacement of extrapictorial experience, no matter how compelling for the artist himself, with the expressive dynamics of the pictorial syntax by means of which it would ostensibly be rendered. Chagall, though he hesitated at going all the way to Cubist orthodoxy and found in the more sensuous and less intellectually exacting Fauvism a style more congenial to his temperament, was nonetheless thoroughly converted to Parisian aesthetics during the crucial years of 1910–14. Thenceforth, his Jewishness, his memories of the *shtetl*, his Hasidic preference for the mystical over the rational, together with his purely Russian heritage—his training under Bakst and the influence of the *Mir Iskusstva* (*The World of Art*) group in St. Petersburg—were all submitted to the transfiguring power of the School of Paris.

"The place counts, not the formal theory," Chagall has said, and the remark has a particular poignancy as one follows Meyer's account of the artist's enforced residence in Russia during the years of war and revolution that followed immediately upon his brilliant initiation into the Parisian art scene. In May 1914, Chagall traveled from Paris to Berlin to attend the exhibition of his works organized by Herwarth Walden at the Sturm Gallery—an event that marked the painter's debut as an artist of international standing. In June, he journeyed to Russia, intending a short visit. But the outbreak of

war, and then the Revolution, forced Chagall to remain in his home-
land for nearly a decade. The *place* did indeed account for a great
deal that followed. Severed from the avant-garde milieu he had
made his own, becalmed in the parochial atmosphere of his child-
hood, it was then that Chagall produced the most distinctly Jewish
of all his paintings. Moreover, his involvement in the Revolution,
which for a time promised to give him a new lease on his avant-
garde aspirations, ended in a shambles of bitterness and frustration
from which only his work in the Jewish Theater was exempt.

Chagall at first welcomed the Russian Revolution whole-
heartedly. For him, as Meyer writes, "it implied an unprecedented,
twofold emancipation. As a Jew it made him a full citizen; as an
avant-garde artist, a recognized spokesman of the new age." In
1918, he accepted the post of Commissar for Art in Vitebsk and
vigorously set about organizing schools, exhibitions, and a museum.
There was already evident at that early date an undercurrent of
party prejudice against the advanced artistic ideas which Chagall
avowed and in favor of more traditional, illustrational styles, but
ironically, it was not the party conservatives who succeeded in
frustrating his program but an avant-garde consisting of Malevich
and Lissitzky, who were far more radical in their aesthetic idealism
than Chagall ever dreamed of being. When Malevich contrived to
change the name of Chagall's school in Vitebsk from the "Free
Academy" to the "Suprematist Academy," to indicate its solidarity
with the nonobjective, geometrical style which Malevich and his
disciples deemed the only proper art compatible with revolutionary
culture, Chagall resigned his post and went to live in Moscow. It was
there that he did his work for the Jewish Theater. And it was from
Moscow, after suffering further humiliations at the hands of the
official avant-garde (by this time consisting of Kandinsky, Rod-
chenko, and the ubiquitous Malevich, who now presided on a
committee over the stipends allotted to artists by the State and
placed Chagall in the meagerly paid "third class"), that he left
Russia for Berlin and then Paris.

When Chagall returned to Paris in September 1923, he was
thirty-six years old. He was a veteran of two of the greatest events of
modern times: the prewar School of Paris and the Russian Revolu-
tion, and was thus in some respects unique among the artists of his
generation. He might have been expected to exert a powerful
influence on the younger generation for whom the double revolution

in politics and art was the pivotal experience of the century. At the least, his painting might have been expected to show an increased range and depth. As it turned out, it was his career rather than his art which prospered. For a brief moment it looked as if he would be adopted as an honorary progenitor of the one movement which promised to unite aesthetic innovation and revolutionary politics—Surrealism—but Chagall was repelled by the antics and ideas of the Surrealist camp and thereafter kept his distance from all groups, movements, and political alignments.

Upon his return to Paris, Chagall made one alliance that was to stand him in good stead throughout the remainder of his career. He accepted a commission from Ambroise Vollard to execute a series of illustrations for an edition of Gogol's *Dead Souls*. Thereafter, the etchings which Chagall produced—not only for the Gogol but for editions of La Fontaine, the Bible, and other works—became the principal repository of his genius. For four decades now, Chagall has remained a consummate graphic artist, and his illustrated books his most important work. Perhaps there is something about this particular visual genre, which explicitly bridges the culture of the past and the art of the present and, in its *modus operandi*, allows the artist a very personal statement while working at a highly sociable form of discourse, that especially appeals to Chagall's sense of his own position as an artist. Whatever the reason for his success in the graphic mode, he has not been able to extend it to the various decorative commissions which now come to him as a matter of course—nor, alas, to his painting, which, with its pastrylike surfaces and egregious sentimentality, has been generally deplorable for decades.

It is one of the virtues of Franz Meyer's monograph, which is certain to become the standard work on the artist, that it reminds us of how really glorious Chagall's painting was at its best, in those early Paris years when he was making a new aesthetic equation out of the conflicting demands of his own experience and the exalted ideas of his newly acquired confrères. The voice that speaks to us from the *"Hommage à Apollinaire,"* from "I and the Village" and "The Poet," is the voice of a lyricist who has learned to speak of his innermost experience in an idiom that is at once impossibly demanding and thoroughly liberating, an idiom whose very foreignness permits him to take possession of that experience for the first time.

It is a voice that is, at the same time, almost unbelievably innocent. Chagall's innocence, which in later years turned into something too saccharine to be borne, remains one of the most appealing qualities in his early pictures. But it is a quality that reminds one of his limitations. For Chagall's innocence often seems won at the expense of immediacy. Perhaps this is another way of saying that he was, after all, Parisian but not French. Place his work beside that of Renoir, Matisse, Bonnard, even Léger, and it looks exotic, "Eastern," dreamlike. It seems to have no commerce with its immediate visual environment; even the city of Paris, when depicted in Chagall's early pictures, looks like the daydream of an alien. Reading Meyer's moving account of both Chagall's life in Paris and his various exiles, one is reminded, too, of how vulnerable his art has been to the cruelties of history. In this respect, he is representative, and even his failures have an interest. For the course which Chagall's career traces from the *shtetl* of Vitebsk and the great days of the School of Paris to the era of Lenin, Stalin, and Hitler is a kind of allegory on the fate of aesthetic innocence in the modern world. The wonder is not that it has come through wounded and impaired but that it has survived at all.

July 1964

14. Soutine and the Problem of Expressionism

The life of Chaim Soutine is a harrowing fable of aspirations impossible to realize, emotions impossible to appease, appetites impossible to satisfy. It is all the more harrowing for being so familiar, not only in the particularities of the artist's own biography but in the archetype of the suffering Jew which that biography evokes with such intense drama and despair. No matter that this archetype has become a slightly shopworn fixture of our commercial culture.

Soutine recalls us to its essential shape and substance—to an adversity of spirit that is unalterable and unremitting even in the face of worldly acclaim and success.

At the same time, Soutine is—above all—a painter, an artist of a certain type, dreaming the dream of the museums, bending his will, his talent, the very marrow of his vitality, to the realization of an art which the dimensions of his own temperament and the desperation of his quest almost preclude him from carrying to its exalted conclusion. In Soutine, the suffering Jew and the *peintre maudit* conspire against the disinterested artist who would like nothing better than to be a classic, and in the process they turn him into a classic of another sort altogether—a classic of Expressionism, where the tradition of the Old Masters he venerates is not so much upheld as swamped by the pressures of extreme emotions.

Soutine is, indeed, a crucial example of the paradox of Expressionism. In the pantheon of modern styles, Expressionism is—after realism—the most conservative. It is the least adventurous in the pure inventions of mind, the most hesitant to tear asunder the basic constituents of traditional easel painting, the most eager to reform rather than to revolutionize what it inherits from the past. Yet it is the most fastidious in sustaining—even, it might be said, in celebrating—the momentum of raw emotion in the picture-making process. Thus, Expressionism aspires to a pictorial ethos to which Expressionist priorities of feeling inhibit easy access.

To this basic paradox Soutine added his own special imperatives. He seemed to go through life with all his nerve ends exposed, and certainly not least while he was painting. The visual equivalent of a kind of physical pain seems—at least in his most extreme paintings—an abiding constituent of his pictorial style. Yet his style was founded on the inventions and refinements of Post-Impressionism, in which—in varying degrees—feeling was carefully mediated by attentions to form, architecture, design. In the Expressionist painters of Northern and Central Europe, a similar debt to Post-Impressionist aesthetics was turned to quite different account. The best of these painters—Munch, Kokoschka, Beckmann—were intellectuals, connoisseurs of social crisis and sexual neurosis, acute observers whose profound comprehension of modern life turned them into tragic elegists. These men painted from the inside of the culture they inhabited, whereas Soutine remained an alien to that culture, unconcerned about anything beyond the difficult equations

he was able to effect between the art in which he had invested his entire human substance and the emotions which threatened that substance with imminent dissolution.

All in all, a problematic case. Soutine disrupts, unsettles, amazes. He puts us through something like his own intense dislocations. The physical pain he conveys has a way of turning into a form of ecstasy. Just as he often invests more emotion in a painting than its materials—the pigment, the motif, the frenzied process verging on hysteria and incoherence—can quite bear with total aesthetic equanimity, so does his work often compel our emotions to a response in excess of the intrinsic merits of the individual picture. He conducts a kind of artistic blackmail on the innocent spectator and exacts from him an involvement, an absorption, a submission beyond the ordinary, because Soutine's own absorption in the transaction is total.

In saying this, I realize that I am speaking primarily of the Céret landscapes. It is now several months since I have seen the great Soutine exhibition which Maurice Tuchman organized at the Los Angeles County Museum of Art. There were some ninety paintings in that exhibition—the largest Soutine exhibition we have had in this country. Certain portraits in that exhibition—or rather, certain faces in those portraits—I shall remember as long as any painting I have ever seen. I have no doubt at all that the "Beef" (c. 1925), from the collection of the Stedelijk Museum in Amsterdam, is a far greater painting than any single example from the Céret series. Yet it was the ten Céret landscapes that remained, for me, the crux of this exhibition, prompting a response more urgent—I will not say more enduring—than that elicited by exhibitions of artists (Matisse, say, or Bonnard) whom I hold in much higher esteem.

Is this a response to the painting or only to the man? "Soutine's art has, from first to last, a genuine as well as obvious capacity to move us. But, as I have hinted, this does not always accord with the art of painting." This observation, from Clement Greenberg's essay on Soutine—the best essay on the painter I know—is itself a virtual definition of the Expressionist aesthetic. Earlier, Greenberg noted of certain of Soutine's landscapes of the 1920's—it isn't clear whether he means the Céret paintings—that they "do not stay in place the way pictures should. They do not 'sit' decoratively." And still earlier in this same essay, Greenberg wrote:

Perhaps he asked too much of art, perhaps he set too high a value on the unimpeded expression of feeling. Certainly, he discounted to an excess the obligation to organize a picture decoratively; and even in the latter part of his life, when he became less high-handed in this respect and produced his most completely satisfying works, the decorative ordering of a picture remained something he submitted to rather than embraced.

Now I think there can be no doubt about the fact that Soutine *did* ask too much of art and that he *did* "set too high a value on the unimpeded expression of feeling." This "too much" and "too high" are what make the Céret landscapes—even now, half a century later—so difficult to accept as pure painting. There is an investment in them beyond the aesthetic. Yet, for myself, I know that when Soutine becomes "less high-handed," when his whole approach to picture-making becomes relatively tranquilized, he interests me far less. The drop in intensity has a sedative effect that is indistinguishable, at times, from ennui. The pressure is reduced; the painter is less emphatically *there;* there is only the painting. And in the dialectics of Expressionism, where only the painting is present, there is something essential left out.

It would be a mistake, though, to think that this view implies an involvement with the artist's biography at the expense of his art. In a sense, Soutine had no biography outside his art; one might even say that his art was a substitute for a biography. In this respect, the attempt made by Maurice Tuchman—in his essay for the catalogue of the Los Angeles exhibition—to portray Soutine as a *shtetl* personality fails utterly to illuminate the art of Soutine. The comparison of this art to the writing of Sholem Aleichem is simply vulgar. For the suffering Jew was not, in this case, a Yiddish artist. He was a homeless cosmopolite, and his very homelessness was one of the pressures that carried certain of his pictures—the Céret pictures above all others—to their extremes of inwardness.

15. Modigliani: Reconsidering a "Little Master"

The exhibition of paintings by Amadeo Modigliani (1884–1920), at the Acquavella Galleries, a benefit for the Museum of Modern Art, comes to us exactly twenty years after the museum's own large retrospective survey of the subject. So much has changed in those twenty years, so many reputations have risen and fallen, so many values have been challenged and overturned, our consciousness not only of the history of modern painting but of the nature of art itself has been treated to so many shocks, that one's first surprise now lies in finding that Modigliani is somehow still there. The truth is, he is not a painter who is much on our minds nowadays. There is nothing in his art that rattles our nerves, and nothing in it either that promises us nirvana. His art is earthly, elegant, and sociable, and nowadays that is hardly enough to lend it the requisite intellectual luster. For minds permanently bivouacked on the aesthetic barricades, he offers an embarrassing paucity of problems.

It is not only our artistic insurgents, moreover, who have passed this judgment on Modigliani—it is confirmed in the kind of dim-witted satisfaction that his art seems to offer all those people whose interest in modern art stops a very comfortable distance this side of anything likely to be the tiniest bit problematical to their minds or their emotions. Like many another fine painter, Modigliani has had the misfortune of becoming an object of sentimental association. Reproductions of his work were once almost as numerous as those of Van Gogh's "Sunflowers"—an ironical fate, to say the least, for an artist who sacrificed so much to the expression of authentic feeling, but a state all too familiar in the annals of modern culture.

Simply to see Modigliani, then, at this particular juncture in our history, we are obliged to clear away all the rubbishy associations that have accumulated around his name. I am not sure that the elegant quarters of the Acquavella Galleries offer the best circumstances for effecting this transaction. The stately rooms in which the show is installed, the expensive, ornamental frames that hang like an albatross around the neck of each painting, the strong smell of money that pervades the atmosphere—all this adds up to a sizable obstacle to appreciation. It leaves one yearning to see the paintings

out of their frames, far removed from that ambience of luxury and conspicuous consumption to which they have been too long condemned, so that they might somehow be restored, if only temporarily, to the humbler terrain of the artistic imagination from which they came.

There are fifty-two paintings in the current exhibition—the earliest dating from 1908, the latest from 1919. All but two are portraits or nudes, the exceptions being the single landscape of 1919 and the gouache "Caryatide Rose" from about 1914. The latter is the only explicit reminder here of Modigliani's ambitions as a sculptor. There are plenty of implicit reminders in the paintings themselves, but no sculpture has been included.

Modigliani came to Paris from his native Italy in 1906, the year of Cézanne's death. Cézanne was the reigning deity for the younger generation of painters in Paris—the legendary, international "school" that Modigliani very shortly joined—and Cézanne remained for him to the end a fixed point of admiration and inspiration. The "Portrait of Pedro" from 1908 is no doubt the most Cézannean of all the portraits in the exhibition, but the *"Paysage du Midi"* of 1919 is even more of a *"hommage"* to the master than the portraits.

Modigliani's relation to Cézanne is more than an idle fact about history; it signifies something essential about the quality of his art, and about its limitations. For his relation to Cézanne did not resemble Picasso's or Matisse's. Which is to say, he did not make of it one of those revisions of pictorial syntax that leaves the medium permanently altered. He made it a vessel of his own experience. In this respect Modigliani is closer to his friend Soutine than to the avant-garde leaders of the School of Paris. He brings the pressure of deeply felt experience to bear on the established pictorial means, and the established means is significantly—indeed beautifully—modified in the process. But the assumptions governing that means are largely unquestioned.

He was, then, one of the "little masters" of the School of Paris, not one of its leaders. If his art is less turbulent than Soutine's, if it lives on easier terms with physical pleasure—and, indeed, with the whole physical world; if it is so evidently more affectionate and erotic and hedonistic than Soutine's, and at the same time, so emphatically more "classical" in its harmony of design, this tells us something important about the quality of the experience these

painters brought to their vocation. Both were Jews, of course, but Modigliani's art nonetheless belongs to the realm of Mediterranean sensibility, with its openness to life and its dream of classical harmony, whereas Soutine's belongs to the closed emotional world of the Eastern European shtetl, with its legendary suffering and deprivation.

What touches us so directly in Modigliani's painting is precisely this openness of feeling, this empathy that could be at once so sympathetic, so amused, and so clear-eyed, and the almost matter-of-fact classical balance with which this ready emotional generosity is transmuted into a flawless pictorial structure. Certain pictures in the current show—the portrait of Jean Cocteau from 1916, *"Madame Hebuterne à la cloche"* from 1917, even the greatest of all his pictures, the great nude of 1919 from the Museum of Modern Art—are so perfectly constructed, so totally what the artist intended them to be, that they virtually consume all our curiosity about the artist who created them. They satisfy us in a way that greater paintings do not.

Still, we are only at the beginning of the era in which the "little masters" of the School of Paris are going to be looked at as individuals rather than as legendary—and thus larger-than-life— protagonists in the heroic saga of modern art. The whole tenor of the current show, with its insufferable air of snobbery and piety, militates against any serious revaluation of the artist, but a revaluation will come all the same. And when it does, I think we shall have a keener appreciation of Modigliani's true quality.

October 24, 1971

16. Miró: Enchanted Objects

Georges Vantongerloo once wrote: "A work of art unveils the state of the author's soul. Whether the motive of the creation is nature, a philosophical or poetic idea, it is the expression that counts. The subject never participates in the artistic value of a work." I believe this to be true. But is it the whole truth? Are there no significant forms of the artistic imagination that lie beyond—even the tiniest bit beyond—the reach of this truth? I sometimes wonder, and never more so than when looking at the art of Joan Miró.

Miró's is one of the great poetic minds of modern times. In his art "the motive of the creation" is, pre-eminently, the "poetic idea." And the poetic idea that governs Miró's art is distinctly modern. It trusts everything to the vitality and the efficacy of its imagery, and its imagery is sufficiently robust, capacious, and complex to accommodate a vast range of emotion and invention.

But to speak of Miró's imagery—that beguiling amalgam of the erotic, the fantastic, the magical, the folkloric, and what Baudelaire called nature's "mystic speech"—is not enough. For in Miró's art there is no distinction between the image and its form. The burden of expression in Miró is not so much on the assertion of an image as on its syntax. It is precisely this—the syntactical genius he brings to the articulation of the imagery that so totally possesses his sensibility—which separates Miró from the so-called "classical" Surrealists, who retain the spatial syntax of the Renaissance picture as a display case for their own often very original stock of poetic images.

The consequences, so far as painting is concerned, have long been familiar. From the mid-twenties until the present day, Miró has used the picture surface as a dreamscape. Flattening or deepening its space as the syntax of his fantasy required, he populated this imaginary terrain with his own symbolic cast of characters. Sometimes saturating the surface with large areas of color, sometimes making it a bazaar of spidery lines, biomorphic shapes, and other iconographic accretions, he has given us one of the truly seminal pictorial styles in the modern canon—a style which boasts a double appeal, enjoying as it does the economy and precision of a purely abstract conception, yet calling into play expressive energies which are always engaged in the realization of an intricate poetic scenario.

In the sense in which the term is commonly used nowadays, Miró is not really an *abstract* painter at all. There is always in his paintings an underlying symbolic narrative, generally of a comic and erotic character. We are in the presence of a Surrealist poet whose vision can never be wholly explained in formal "abstract" terms.

It is important to bear all this in mind when approaching Miró's sculpture, which may currently be seen in a dazzling exhibition at the Matisse Gallery. Miró comes to sculpture by way of his painting and that inspired by-product of his painting, the "poetic object." The latter is a collagelike construction of "real" but incongruous objects—a pictorial *donnée* suddenly given three-dimensional form, at once a joke, a sport, and a sublime flight of the imagination. Though the Surrealist poetic object has been much imitated in recent years, it has remained in a kind of limbo—its physical members too real to be pictorial, yet not quite real (or realized) enough to be truly sculptural, and always under sentence of a limited durability. Few artists of any seriousness have been willing to stake their entire *oeuvre* on a medium so vulnerable to both physical and aesthetic dissolution. Joseph Cornell is the only example that comes to mind, and Cornell has succeeded by fastening his work securely to the pictorial mode.

Miró found a sculptural answer to the problems of the poetic object in the ceramic medium—a medium that allowed him precisely the margin of improvisation and the freedom of pictorial embellishment his ebullient sensibility required. Suddenly the "figures" in his paintings were able to step forth into three-dimensional space, often with their chromatic characteristics intact, with no discernible loss in expressiveness, charm, or wit. And in the last three years, he has made the transition to bronze with a similar ease and success, jettisoning all reliance on decorative color, relying on the sheer sculptural mass to carry the entire expressive weight of his vision.

There are approximately fifty bronzes in the current show at Matisse's, and every one of these sculptures bears the stamp of a high-spirited comic virtuoso whose energies have been fully engaged by the challenge of a new medium. Conceptually, the work alternates between sculptures that are, in effect, a restatement of a poetic object in a more permanent form and those which show the clear traces of his pleasure in the ceramic process. There is nothing here that can be said to "advance" the medium of sculpture itself. Yet the

work carries the unmistakable authority of a master, for Miró brings to the sculptural medium the full force of his lyric imagination. He assimilates sculpture itself into his own highly personal dreamworld, and suddenly that world seems unfinished and incomplete without this unanticipated extension into the sculptural realm. The girls, the women, the birds, the heads, the suns and moons and "personages" and purely imaginary objects that we know so well from the myriad paintings are there to be touched, examined, interrogated, like some visitors from an imaginary planet we never quite expected to encounter on our own terrain.

"The subject never participates in the artistic value of a work," says Vantongerloo. Yet I continue to wonder. For in Miró's art one feels the pressure of an emotion that seems to transcend "expression"—marvelous as that is in this case—an emotion derived from the richness of the artist's experience. Or is this only another of the many poetic illusions that Miró has been able to persuade us to believe in? "The material of a poem," T. S. Eliot once observed, "is only *that* material after the poem has been made." Well, who could doubt it? Yet Miró is an outstanding example of an artist whose work leaves us with a heightened awareness of life itself. His new sculptures are enchanted objects, and they clearly draw their enchantment from a realm beyond the reach of aesthetic strategies, a realm beyond the vicissitudes of "expression." Or is it only that expression at this level is so rare that it seems somehow to leave behind the normal categories of artistic discourse? It is not the least of Miró's many virtues that his work recalls us to art's most serious functions and does so with an incomparable energy and wit.

May 24, 1970

17. Arp: Purity of Heart, Purity of Form

"I love nature, but not its substitutes," Jean Arp once observed. "I remember a discussion with Mondrian in which he distinguished between art and nature, saying that art is artificial and nature natural. I do not share his opinion. I believe that nature is not in opposition to art. Art is of natural origin and is sublimated and spiritualized through the sublimation of man." Arp published these remarks under the heading, "Art Is a Fruit."

He certainly abided by the faith expressed in these observations. In no other artist of the twentieth century, I think, do we feel the same gentle but persistent determination to produce an art at once so pure in the aesthetic sense and yet so eager to find a place in the impure order of nature. An exhibition of Arp sculptures is always a little like a garden, with forms reminiscent of natural growth and emotions redolent of a lyrical fecundity. But a garden is, of course, already at one remove from nature as such; it is nature modified by the intercession of aesthetics. And Arp, too, is anything but a naturalist. His style is, in truth, no less synthetic than any other style, but it enjoys the happy conviction of being a natural growth and is sustained by an act of faith that refuses to acknowledge, openly at least, the immense aesthetic tact invested in that conviction.

In art, every idea—even the idea that "Art is of natural origin"—is an aesthetic strategy, and has an aesthetic consequence. No doubt Arp was entirely sincere when he wrote, in his essay on "Concrete Art," that he "became more and more removed from aesthetics." In fact, this very attitude proved to be a useful device for establishing an aesthetic of his own. And, as is always the case where a genuine aesthetic is advanced, it involved something more than style. It embodied an entire view of experience.

For Arp's view of experience is exactly analogous to—is, indeed, an inseparable part of—his view of art. In neither sphere would he admit to the erosion of innocence. The purity he seeks in his art is a purity of heart as much as a purity of form. He yearns to re-create the world—especially the world of creation itself, with its manifold erotic processes and associations—in a state of innocence. In the service of this yearning he disavows his affiliations with culture, with "aesthetics," with the whole panoply of institutionalized

feeling and practiced response. He sets out to recover the emotions that civilization itself has repressed, and as with all such modern quests, he must therefore create the fiction that the quest itself is not what in fact it is: one of the most refined and exalted expressions of that civilization.

Unlike Mondrian, who looked forward to a utopia in which the human personality would, at last, be delivered from the conflicts of civilization, Arp looked back to a Garden of Eden where these conflicts do not arise, where man exists in a happy unison with nature, where a complete purity of feeling precludes the very necessity of "aesthetics." Mondrian regarded art as "artificial" and utopian because he regarded nature as the source of these conflicts—conflicts from which art alone, in its ultimate realization, would redeem us. This is what makes Mondrian's art, in the most fundamental sense, a tragic art, for it encompasses the violence that is endemic to the human enterprise and seeks to resolve it.

Arp is, by contrast, a comic artist—the artist of, if not the happy ending, at least the happy beginning. The violence of man, the separation of man and nature, the conflicts of civilization, what Wallace Stevens once called "The malady of the quotidian"—all this is swept aside, ignored, or transformed into a fiction of innocence. And so deeply felt is this fiction, and so deeply and clearly articulated, that it compels our assent—our aesthetic assent—even though experience itself fails to conform to its idealized emotions.

The visual vocabulary that Arp developed in his work—the proliferation of biomorphic forms, with their lyrical puns and gay metaphors—was the perfect instrument of this fiction. For Arp, as for so many artists who partook of his vision, there were no straight lines in the Garden of Eden. In the childhood of the race, in the privacies of the unconscious, in the very fabric of the uncorrupted sensibility, all was voluptuous and curvilinear, improvised and metamorphic. All was erotic—an eroticism without appetite, all very playful, delicate, and delightful, an eroticism indistinguishable from aesthetic sensation.

At this distance in time, we can see that this style did, after all, owe something to the culture—specifically, to the hated "aesthetics"—avowedly spurned. For in Arp's vocabulary of biomorphic form we can see the erotic languor of Art Nouveau stripped of its decorative excess and social inanity and transformed into something purer and less worldly. We can see, too, that this vocabulary of form

shares with that of Art Nouveau an overwhelming inclination to fantasy, to an idea of style that does not so much analyze experience as displace it.

March 17, 1968

18. The Two Archipenkos

Alexander Archipenko was born in Kiev, in the Ukraine, in 1887. He died in New York in 1964. His artistic career was long and distinguished. His production as a sculptor was copious and original—in some respects, historic. He belongs to that magic circle of courageous talents that changed the entire face of painting and sculpture in the first two decades of the present century. Had he passed from the scene in 1923, he would still be remembered as one of the most inventive and resourceful sculptors of the School of Paris in the halcyon days of Cubism and its immediate aftermath. Indeed, had Archipenko passed from the scene in 1923, his career would offer us a tidier and far less problematic subject than, in fact, it now does.

Archipenko went to Paris in 1908. Within two years of his arrival, he was at the very center of the Parisian avant-garde. He exhibited in the salons and with the "Section d'Or" group. He opened his own art school. He showed his work at the Sturm in Berlin and in the Armory Show in New York. By 1920, his work had been seen wherever there was an interest in modern art, and that year he had a large one-man show at the Venice Biennale. When he came to the United States in 1923, he was—at least for the small, avid public devoted to avant-garde art—an artist of international renown.

We are given an interesting—though incomplete—account of the artist's Paris period in the exhibition entitled "Archipenko: the Parisian Years," which is currently installed at the Museum of

Modern Art. This exhibition consists of twenty-six sculptures and seven works on paper, dating from 1909 to 1921. Unfortunately, the "Carrousel Pierrot" (1913), the very beautiful and important painted plaster now in the collection of the Guggenheim Museum, is said to be too fragile to travel even the thirty-five blocks that separate the Guggenheim from the Modern. But there is certainly a sufficient number of original pieces here to establish—or re-establish, as the case may be—Archipenko's place in the front rank of the first generation of Cubist sculptors.

The finest of these pieces, I think, is the painted wood relief of 1917 entitled "Figure"—what Archipenko himself called a "sculpto-painting." The work itself, together with the term Archipenko invented for it, clearly reveals the essential insight and commitment that lie at the heart of his work in this period. Archipenko was one of the first of the many modern sculptors to have found the "key" to their sculptural imagination in the formal syntax of Cubist painting and collage rather than in the established conventions of sculpture itself. He brought to Cubism a powerful sculptural sensibility. (The "Suzanne" of 1909–10, a small stone carving, is evidence enough of his natural gifts—large gifts attended by large emotions—for sculpture of a more traditional mode.) Cubism released his energies at the same time that it provided him with an essential intellectual discipline.

The transformation of the sculptural monolith into a structure of discrete planes, the opening of these planes to use their interior "negative" space as a positive sculptural form, and the use of disparate and unorthodox materials as well as color for the purpose of carrying these spatial ideas into new realms of sculptural expression—this was the nature of the artistic burden that Archipenko assumed in these exciting years.

It is in the painted reliefs and in the works on paper that we are given the most vivid glimpse of his accomplishments. Much of the work at the Museum of Modern Art consists of bronze casts that, for me at least, put the Archipenko of the Paris period at a certain distance from our ability to respond to his exact quality. Take the "Seated Figure" of 1913. The catalogue reads: "Polychromed bronze." But the piece on view is unmistakably a monochrome bronze. In the large monograph Archipenko published on his own work in 1960, the piece is reproduced in color and is, certainly, a polychromed bronze. What are we to make of this? There are other

sculptures here listed as "polychromed" but actually monochrome in the versions that are shown. Either the museum or the artist's estate owes the public some explanation of such patent discrepancies.

As an accompaniment to the show at the Museum of Modern Art, the Danenberg Galleries has mounted an exhibition devoted to "The American Years, 1923–1963." This is a rather sadder exhibition than the museum's, for it brings us face to face with the long years of Archipenko's isolation and decline. There are, to be sure, some powerful and accomplished works here—especially the great painted wood "Architectural Figure" (1937). But much of the sculpture of the American period is disfigured by a kind of Gothic-cum-Art Nouveau streamlining that is fundamentally at odds with the basic Cubist syntax that is invariably the source of strength in Archipenko's art. The exile from Kiev who found an intellectual home in the pre–World War I School of Paris was doubly homeless in America, and it shows. There is a decline into eccentric taste and cranky ideas, into a kind of fantasy that can find no compelling formal equivalent for its furious energies. One continues to feel the artist's power, but as shadow rather than substance.

We are still in need of a proper Archipenko retrospective—a show made up exclusively of the works Archipenko himself created, and with all the bronze "editions" that have apparently been made since his death categorically omitted. We are also in need of a proper biography of the artist. Both these exhibitions leave us with a quantity of unanswered questions—about both the work and the life—and it is a measure of Archipenko's achievement that we feel the need to have them answered.

August 2, 1970

19. Late Léger

We tend as a general rule to think of modern art as standing in a fixed posture of revolt against the ethos of modern life, and with good reason. "To be at odds with his times—there lies the *raison d'être* of the artist," wrote André Gide, and there is no shortage of evidence in the vast literature of modernism to support this assumption of an essential antagonism between modern art and the social environment that has harbored it. Certainly one of the salient characteristics of the modern movement has been its critical attitude toward established conventions of feeling, and at many crucial points in its history it has carried this criticism into an advocacy of alternative—even utopian—modes of existence.

Yet there is another side to the modern movement which, precisely because it does not conform to this familiar historical scenario, tends to be lost sight of—the side that actually celebrates modern life, taking an evident pleasure and satisfaction in its radically new promises and possibilities. For artists of this persuasion, the modern age is indeed a thing of beauty and the task of modern art is to expound the peculiar attributes of that beauty—to create, in fact, a heightened appreciation of its special strengths and imperatives. The mission of modernism, for such artists, is not critical resistance but a kind of yea-saying affirmation of the grandeur and vitality to be found in the new conditions that the modern age has brought us.

Among painters of the first rank, the outstanding representative of this point of view was undoubtedly Fernand Léger. This hearty French talent brought to modern painting an extraordinary spirit of optimism. His art lived on easy, affectionate terms with the material conditions of modern urban life, exulting in its characteristic syncopations and angularities, and deriving from its headlong, machine-oriented dynamism an uncommon energy and impetus. Untouched by that appetite for violence which so drastically compromised the Futurists—and unclouded, too, by dreams of revenging itself on the past—Léger's art is nonetheless firmly attached to the taste and momentum of the modern metropolis. It cheerfully embraces the culture of the street, and it is indeed precisely that culture which the artist takes into the studio and transforms into a pictorial style of enormous vigor.

The earlier results of this interesting enterprise are more familiar to us—and are generally more admired—than the later. Léger died in 1955 at the age of seventy-four, and he remained productive, ambitious, and utterly serious to the end. Yet we still tend to think of him as an artist of the pre-1914 avant-garde and the postwar twenties—two important periods of his work, to be sure, but by no means the only periods in which Léger produced work of great quality and high historic interest. The late work, especially, is rarely given its due.

It is this period that is the focus of the exhibition called "Léger: The Late Works," at the Pace Gallery. Approximately thirty paintings and drawings from the years 1948–55 are included. There is a directness in these works—a note of clarity and simplification— that is quite different from Léger's earlier painting. Clarity of design had long been Léger's forte, but in the late work it is carried to a new boldness of expression.

The strength of this clarity is to be found in two quite separate pictorial components. One is Léger's remarkable drawing. The other is his color. It is characteristic of the late work that, even where drawing and color are joined in a single picture, we are aware of them—and remain aware of them—as separate elements. Each is an expressive force that retains its own identity, and is clearly intended to.

"Drawing," however, is almost too feeble a term to apply to those bold black outlines that dominate Léger's late works—that, in some cases, are the works themselves (for occasionally he dispenses with color altogether). The only comparison that illuminates the visual strength—and something of the function—of this drawing is, I think, to be found in the black grids of Mondrian's paintings of the thirties. Léger's heavy black line traces a more earthly imagery and describes a happier relation to common experience, but it is nonetheless, like Mondrian's grid, essentially a mode of pictorial construction. The key to Léger's pictorial sensibility is, in fact, to be found in his bold use of an "organic" line for the purposes of construction.

His color, too, with its preference for primaries, resembles Mondrian's, but in the matter of color another comparison also suggests itself—that of the late Matisse. Were the discrete shapes of color that often mingle with the drawn figures in late Léger to be freed of their attachment to the black line, they would certainly

suggest something very close to the world of Matisse's late painted paper cutouts. In those late works Matisse himself was constructing entirely by means of color, and the double comparison I am suggesting—both Mondrian and Matisse—provides, I believe, a clue to Léger's fundamental (one might even say fundamentalist) intentions in these late pictures. For he was bringing together in these pictures two quite separate modes of pictorial construction, not with the idea of synthesizing them into a single expressive amalgam, but with the clear intention of keeping them separate and suspended in a dialectical embrace.

In Léger's art nothing is hidden, secret, or mysterious. There is no hidden scaffolding, no effort on the part of the painter to cover his tracks. Every step, every form, every strategy is made explicit. The spectator can see at a glance how the picture has been put together. There are no obscurities, no magic. All of this is wonderfully exhilarating—and Léger carries this boldness all the way to the point of keeping his drawing and his color radically differentiated. On that crucial point of joinery, too, where painting has traditionally lavished so much energy and invention on obscuring the means by which color and line are brought together to form an expressive whole, Léger has triumphantly persisted in playing an "open" hand.

We are used to pictorial strategies of this sort so long as they are confined to pure abstraction. Much of the abstract painting of the last ten years—and a good deal even earlier—is more or less constructed along those lines. But to have effectively combined this essentially abstract mode of pictorial construction with a representational imagery that sacrificed nothing of its happy commitment to the world of common experience—this is the real triumph of Léger's late work. In the end he was able to advance more deeply than ever into his own medium, while reaffirming his sense of joy in the very nature of modern life. His achievement was rarer than we commonly suppose.

February 20, 1972

20. Duchamp: Resplendent Triviality

The single most impressive thing about the large Marcel Duchamp exhibition at the Tate Gallery is the fact that it exists. Here are 185 items—paintings, drawings, sketches, collages, constructions, reconstructions, "ready-mades," replicas, and reproductions—plus a veritable bazaar of choice Duchampiana—manuscripts, letters, books, catalogues, indeed everything but the old man's laundry tickets. Well, not everything perhaps, for the organizers of the exhibition have been modest enough to call it only "The Almost Complete Works of Marcel Duchamp." Still, it is the most complete showing of Duchamp's *oeuvre*—if that is the word—to date.

The very idea of mounting an orthodox museum show to honor the work of a man whose fame rests so largely on thumbing his nose at all such historical and museological solemnities suggests a sizable contradiction, to say the least. One can only wonder if, in terms of the famous Duchamp irony and the mythology of Dada it is thought to embody, the occasion marks a triumph or—impious thought!—the ignominious failure of a career and an ideology?

Failure, indeed, is a notion that is rarely, if ever, associated with Duchamp. His admirers and his detractors alike have been content, for the most part, to take his work and his point of view at his own valuation—to judge them, that is, purely in terms of the ideological program Duchamp himself has never been shy about articulating. This program, which led first to the substitution of commonplace "ready-made" objects for works of art, and then in 1923 (or thereabouts) to the abandonment of even this minimal gesture for a role of ironic and supercilious (but by no means disinterested) detachment, has been cheerfully allowed to obscure Duchamp's actual accomplishment, and lack of accomplishment, by imposing the infinitely more glamorous myth of his dazzling and paradoxical intelligence.

How could anything so mundane as failure attach to a sensibility that seemed, by definition as it were, to exist beyond the reach of accepted standards of achievement? Other artists might suffer lapses of creative energy, might lose heart or nerve, or prove subject to extended periods of expressive impotence—but not, if one believes the legend, Marcel Duchamp. Thus, if he has chosen for over four decades to parody and repeat and reproduce and otherwise market

his old ideas, it is because (so we are invited to believe) only methods so far removed from the conventional channels of artistic expression could convey the complexities of his philosophical position.

The Tate exhibition, sponsored by the Arts Council and directed by Richard Hamilton with a reverence that itself borders on parody, is certainly not designed to question Duchamp's exalted position. He is presented to us here as one of the masters of the age—a master, moreover, who enjoys the enthusiastic esteem of his juniors. Mr. Hamilton is no doubt correct in declaring that "No living artist commands a higher regard among the younger generation than Marcel Duchamp," and such regard always lends a special force to an exhibition of this sort: it requires us to deal with the artist's work as a living issue rather than as a chapter of history.

Yet the effect of this solemn exhibition is not, perhaps, exactly what Mr. Hamilton intended. This observer has not been alone in noting a certain discrepancy between Duchamp's status as a legend of history and aesthetic theory and what actually meets the eye in this more than ample survey of his work. "In the conventionally arranged and well-lit exhibition at the Tate," writes Robert Melville in the *New Statesman*, "everything looks innocuous. Almost all the pictures he ever painted have been assembled, but they are shockingly disappointing. They are not bad; they are tasteful and, so to speak, well-informed."

Anyone who is familiar with the Duchamp pictures in the Arensberg Collection at the Philadelphia Museum of Art—those pallid rehearsals of turn-of-the-century styles executed by a pasticheur of refined taste but little force or originality—will know whereof Mr. Melville speaks.

To see some of these pictures yet again—the 1910 portrait of the artist's father, the "Chess Players" of the same year, and the Cubist paintings of 1911—and see them as part of a retrospective of a "master," is to be reminded that Duchamp's celebrated "abdication" a decade later did not, whatever other meanings it may or may not have had, deprive the world of a major painter. Mr. Hamilton's assertion that "the canvases of 1911 must be rated among the greatest products of a period that will be marked as one of the most distinguished in the history of French art" can only be taken as the pious utterance of a true believer.

But it is not, of course, as a painter that Duchamp's name has

assumed its present aura. It is, rather, as the archetypal antipainter that he now bestrides the artistic universe—the man who, instead of making works of art, chose instead to "nominate" workaday objects for aesthetic status and to do so under the cover of an ideology that affected to despise the whole aesthetic enterprise. And here they all are: the urinal dubbed the "Fountain," the Underwood typewriter cover, the bottle rack, the snow shovel called "In Advance of the Broken Arm." Or rather, since the "originals" have now been lost, here are the replicas that have now been commissioned and assembled for this surpassingly unfunny occasion.

Here, too, is Mr. Hamilton's own incredibly painstaking reconstruction of Duchamp's "The Bride Stripped Bare by Her Bachelors, Even," otherwise known as the "Large Glass," the original of which can be seen in the Philadelphia Museum. And along with this elaborate reproduction—surely the most pointless act of artistic *hommage* in modern times—are the many "editions" and "versions" of his own work that Duchamp has continued to produce over the years. The fact is, it seems, that the master did not really abdicate in 1923 after all; he went on providing the world with a variety of Duchamp objects and mementos, and they are handsomely installed at the Tate, in all their resplendent triviality, as if they were sacred objects.

As indeed, for many people, they are.

July 10, 1966

21. Dali

Certain forms of art are less important for what they *are* than for what they signify. Though they traffic in aesthetic goods, the place they occupy in our culture has little to do with aesthetic illumination. To the language of art, they contribute nothing but a parody of established conventions. To the definition of feeling, which is the

real glory and destiny of the artistic enterprise, they add only a corrupted simulacrum of familiar gestures. Their sole function is to perform a visual charade in which the public—a public terrified at experiencing any emotion it has never experienced before—will recognize its own most cherished yearnings.

Art of this kind does not appeal to our curiosity but to our prejudices. Its mission is not to question or to complicate our emotions but to confirm them. And such art can only succeed in its meretricious task if it effectively disguises its rehearsal of the familiar in the kind of technical display which, for minds of a certain disposition, is always a satisfactory substitute for real vision.

Two artists in our time have brought this charade to a kind of bogus perfection—the American Andrew Wyeth and the Spaniard Salvador Dali. Both have been duly rewarded with a surpassing popularity and success.

One offers us an image of American life—pastoral, innocent, and homespun—which bears about as much relation to reality as a Neiman-Marcus boutique bears to the life of the old frontier. The other offers us a fantasy of the psyche in which the real fissures of modern life are cosmetized in the very process of being evoked, and which thus exploits the anxieties of modernism while effectively subverting their critical and spiritual function. Together these two artists, with their respective daydreams of innocence and apocalypse, define—if indeed they do not exhaust—the artistic horizons of that vast, silent, uncritical majority which knows nothing about art but knows what it likes.

Of the two, Dali is unquestionably the more interesting and accomplished. He understands very well the modern appetite for violence and scandal, and has made a career of catering to this appetite, spicing each successive dish with sufficient outrage and surprise to keep the public a little baffled, a little angry, a little appalled, but always delighted, impressed, and—above all else— interested. He is a master showman who lavishes his real genius on the instruments of public relations. Only his talent goes into his art, which is less the focus of his deftly organized publicity campaigns than one of his means of achieving them. For Dali, painting is always an applied art—an art applied to advancing his own personality.

His latest exhibition—now on view at M. Knoedler & Co.—is devoted to paintings and drawings from the years 1965–70, and

contains a larger selection of new work than Dali has shown in many years. There are twenty-two items, several of them vast "machines" of the type that so delighted the knuckle-headed spectators in the official salons of the last century and that, to judge by the size and spirit of the crowds pouring into Knoedler's every day, have lost none of their power to impress a public content to live without intelligence or taste.

The famous technique has lost none of its luster. Only the power to shock has, perhaps, grown a little dimmer with the passage of time, but this is less a fault of Dali's than a reflection of the degree to which modern culture has now immunized itself against aesthetic shocks of any sort. Nowadays the real shocks come from life rather than from art, and Dali—*even* Dali, who has made such a specialty of shocking the public—is as helpless as anyone else in the face of this development. The time is past when his fantasies could disturb us. Now it is only his taste that disturbs, and even this is less a disturbance than a mild discomfort. For the first time, one almost feels a little sorry for Dali—all that effort invested in such a petty provocation.

As painting, of course, it is complete rubbish. The ostentatious display of "old master" ambition has degenerated into the purest kitsch. The puerile fantasy, with its aggressive self-importance and operatic rhetoric, is no longer even amusing. The feeble attempt at satire ends only in satirizing the satirist's own quite silly machinations. Everything about this work reminds us that we are dealing with a "case," a social phenomenon, an episode in the history of taste and reputations rather than an example of genuine artistic accomplishment.

"The two qualities that Dali unquestionably possesses," George Orwell once wrote, "are a gift for drawing and an atrocious egoism." Orwell defined Dali's sensibility as fundamentally that of an Edwardian illustrator. "Take away the skulls, ants, lobsters, telephones, and other paraphernalia, and every now and again you are back in the world of Barrie, Rackham, Dunsany, and *Where the Rainbow Ends*." The paraphernalia has changed since Orwell wrote his essay a quarter of a century ago, but everything in the current exhibition confirms this critical judgment. As for the celebrated "aberrations" that were once so shocking, Orwell remarked: "Perhaps they are a way of assuring himself that he is not commonplace." Dali's desperation in this respect is now greater than ever,

for the distance separating his facile, self-willed eccentricities and the commonplaces of our culture has been drastically reduced. The blatant "camp" that dominates the taste of his latest work is now the property of every two-bit filmmaker and commercial artist on the current scene.

None of this will dim Dali's popularity with the vast public that adores him—the public that still swoons over both his antics and his success—for Dali performs an essential service for this public. He provides a vision of the apocalypse that is at once exquisite and harmless—the apocalypse turned into a *parfumerie*. In performing that service, Dali brings the retrograde character of his art into perfect alignment with his decadent social ideology.

March 22, 1970

22. Picabia's Dada Holiday

In an interesting article entitled "Hello and Goodbye, Francis Picabia," in the September 1970 issue of *Art News*, Philip Pearlstein recounts the vicissitudes of his research into the work of this legendary figure some fifteen years ago and its effect on his own development as a painter. Mr. Pearlstein wrote a master's thesis on Picabia at New York University's Institute of Fine Arts—a work that has remained an important item in the Picabia literature. But his immersion in this subject—one of the key subjects in the history of modernist art—signaled his break with the very tradition Picabia represents.

"The effort to try to understand the recent past was so great," Mr. Pearlstein writes, "that at its conclusion I asked myself why need I, as a painter (I had my first one-man show about the time the thesis was completed), feel bound to continue the traditions of 'modern art.' I didn't, and with the rejection I felt liberated. But had

I been imprisoned before? Yes, and so had most of our art world. And one of our jailers was Francis Picabia."

Our feelings about the retrospective exhibition of Picabia's work at the Guggenheim Museum—the first such retrospective ever organized in this country—are likely to depend on the extent of our agreement with this harsh judgment. Those for whom every exploit of the modern movement has retained its status as a sacred occasion, inspiring reverence, emulation, and awe, will find in this exhibition yet another altar on which to immolate their critical faculties. For anyone inclined to re-examine the assumptions of the modernist faith, however, the Picabia exhibition poses questions galore—questions, above all, about the relation of aesthetic quality to the historical position of a work of art. On the basis of quality alone, Picabia's *oeuvre* simply does not merit a full retrospective review. It is our sense of history rather than our appetite for aesthetic quality that this retrospective really satisfies.

For a few years—scarcely more than a decade, to judge by the evidence of this exhibition—Picabia was indeed one of the most original and audacious painters of his generation, a generation still celebrated for the shocks and innovations it brought to the visual arts. He was one of the earliest abstractionists, and then one of the originators of the Dada movement—an artist in whose work the boundaries separating Futurism, Cubism, and Dadaism dissolve in a headlong rush of inspired improvisation. The works he produced in these years—roughly, from 1912 to the early twenties—have long been established as classics of the modern movement, and the Guggenheim exhibition confirms their distinction. But it reveals something else as well: the fundamental uncertainty of Picabia's talent. Working in an atmosphere of scandal, excitement, and high adventure, Picabia was able to impose on certain pictorial forms an uneasy alliance with ideas "beyond" painting. But when the ideas had run their course, when the excitement dissolved, when pictorial form unaided by heady scenarios was left to shift for itself, then Picabia's art collapsed into banality and pastiche. The last three decades of Picabia's production are among the saddest of modern times.

Picabia was born in 1879 and died in 1953. His early works were entirely conventional, retracing developments from the landscape art of the Barbizon painters to the Impressionism of Pissarro.

It was his encounter with Fauvism and then Cubism that kindled both his appetite and his talent for something more original, and Cubist form remained the matrix of nearly all his subsequent audacities. (Question: where would Dada have been without Cubism? Probable answer: nowhere.)

The best of Picabia's pictures fall into two groups: the abstract, near-abstract, or semi-abstract paintings of 1912–14, and the so-called "machine" paintings, which commence in 1915 and continue into the early twenties. The first group includes Picabia's most beautiful as well as his most ambitious paintings; the second some of his most interesting paintings. The progression here is from the sensuous to the intellectual; from pure evocations of feeling to an ironic commentary on feeling, perhaps even a denial of it, and certainly a mockery of it.

I agree with Mr. Pearlstein's view that the abstract watercolors Picabia produced in New York in 1913 for his one-man show at Alfred Stieglitz's "291" Gallery, represent his "highest accomplishment as a painter." Some of the oils are larger, more complex, and more ambitious, but they tend at times to look a little too much like old battle scenes in Cubist disguise. The watercolors have lost none of their lyrical élan. They are still deliciously fresh, luminous, and immediate.

There are jokes, puns, coded messages, and hidden narratives in these abstract paintings—enough of the "literary," indeed, to raise questions about whether these paintings are really abstract at all—but the paintings nonetheless address the eye as "liberated" Cubist compositions. The "anecdote" does not radically alter our experience of the picture itelf; it only adds another margin of interest to it. But this is not true of the "machine" pictures. Despite their sometimes hilarious erotic evocations and the elegance of their design, these pictures are intellectual anecdotes. They are designed to be read, to be decoded for their literary content, as well as to be looked at as a visual object. Their titles are an essential part of our experience of these works (as are the other words sometimes written on their surfaces), even in those cases where words are employed for the purpose of baffling the viewer's expectations.

It is interesting, I think, that despite Picabia's rhapsodic praise of skyscrapers, machinery, etc., and his repeated avowals of Futurist claptrap, he could use the machine itself only as a mode of irony. He could not really invoke the machine as a thing in itself, but only as a

way of mocking solemn pretensions about precious private experience. As an ideologue of the avant-garde, he upheld the machine civilization as the very essence of the "modern" experience, but as an artist he could only use the machine as a form of satire. His doctrine announced the dawn of a new culture, but his sensibility remained tied to the themes and strategies of the old culture.

This discrepancy between theory and practice may, perhaps, help explain Picabia's later collapse. Speaking of Picabia's work of the twenties, William A. Camfield—a Picabia specialist from Rice University who organized the show at the Guggenheim and wrote the excellent catalogue that accompanies it—writes that the artist "participated in a prominent trend of the 1920's toward conservative adaptations of modern art to more traditional forms." Once the Dada holiday was over, there was—at least for an artist of Picabia's sensibility—no place to go but home. But for Picabia it was too late. The journey proved to be too long, exhausting, and finally shattering.

September 27, 1970

23. Torres-Garcia: Scenario of Exile

In the history of modern art in South America the name that sounds with the greatest resonance—at least to European and North American ears—is that of Joaquin Torres-Garcia. No doubt one of the reasons for this distinction lies in the fact that Torres-Garcia's peculiar career belongs quite as much to the familiar art-historical terrain of Paris and New York as it does to the art history of South America. Indeed, the exact extent to which his art may be said to belong—aesthetically—to the culture of South America or to his native Uruguay is still unclear, at least to outsiders like myself, whereas his profound debt to the European avant-garde is only too obvious.

In singling out Torres-Garcia for attention, then, we should not be under any illusion that we are thereby penetrating the mysteries of South American art history. Torres-Garcia was born in Montevideo in 1874, and he died there in 1949; yet his life as an artist traces the most familiar of modern scenarios—the scenario of exile. He was a man of remarkable talent and energy, a man of large intellectual as well as artistic ambitions; yet there was something unrealized in his art and some fundamental division in the mind that produced it.

This was the impression that one took away from the retrospective exhibition that Daniel Robbins organized last year, and it is an impression that is reinforced in the smaller exhibition that has come to the Emmerich Gallery. This new exhibition is very well selected. It reminds us of the fact that certain artists—by no means the least interesting either—are simply diminished by the arduous tests of a full retrospective treatment. Fragmented careers are, perhaps, best treated to fragmentary exhibitions.

Fragmented Torres-Garcia's career certainly was. His life as an artist actually began in Spain, where his family went to live in 1891. It was in Barcelona in the 1890's that he received his academic training and made his first contacts with artists of his own generation. Among these was Julio Gonzalez, who was to achieve distinction as a sculptor about the same time and in the same place that Torres-Garcia began to make his mark as a painter—in Paris in the early 1930's. What released each of these artists from the protracted hesitations and equivocations of his earlier work was the intervention of another artist more powerful and original than himself. In Gonzalez's case, it was Picasso; in Torres-Garcia's, it was Mondrian.

Prior to his meeting Mondrian in 1929, Torres-Garcia seems to have followed an erratic and basically conservative course, working a good deal at murals and stained glass—early in the century, he worked with Gaudí on the Sagrada Familia—and keeping a safe distance both from Paris and from the radical pictorial ideas that were being tested there. In 1920 he came to New York, where he enjoyed the support of the Whitney Studio Club and attempted to launch a business manufacturing toys of his own design. Two years later he was back in Europe—this time in Italy. He then moved to the south of France and did not actually settle in Paris until 1926. He was fifty-two years old.

The earliest picture in the Emmerich show dates from 1923. Called "New York Harbor," its principal interest—apart from its period charm—lies in the way it assimilates a loose Cubist structure to the purposes of illustration. Everything about this picture suggests an amiable, unintellectual approach to painting—a cheerful indifference to the theoretical implications of its own structure. Yet the truth is that Torres-Garcia had a highly developed interest in aesthetic theory long before his encounter with Mondrian. He published his first article in 1901, his first book in 1913, and he continued to theorize on aesthetic questions throughout his career. What Paris in general and Mondrian in particular gave him was an opportunity to align both his own painting and his interest in theory with a significant historical development.

It was characteristic of Torres-Garcia that he seized this opportunity with tremendous energy and intelligence, yet he never brought to it an undivided intellectual allegiance. In 1929, the year he met Mondrian, he produced his first so-called "Constructivist" paintings—and the term had better be left in quotation marks to avoid confusion with the kind of Constructivist art that is firmly based on nonrepresentational form. In 1930 he founded the magazine *Cercle et Carré* with Mondrian's devoted disciple Michel Seuphor. This was the first organized attempt to establish nonobjective art on the Paris art scene, and it was launched as a counterthrust to the Surrealists, who were then dominating public attention. The irony, of course, is that Torres-Garcia was not himself a true nonobjective artist. To be sure, the structure he now brought to his painting owes much to Mondrian's rigid geometrical grid, but his own hermetic symbolism had a deeper affinity with the poetry of Surrealism than is generally admitted. And the touch as well as the palette of these "Constructivist" paintings derive not from Mondrian's radical paintings of the late twenties, with their strict right angles and primary colors, but from his earlier, more orthodox Synthetic Cubist paintings of 1914 and thereabouts. Even in the period of his most partisan avowals, Torres-Garcia could not entirely give up his basic equivocations.

It is, in any case, these "Constructivist" paintings, begun at the age of fifty-five, to which Torres-Garcia now owes his international reputation, and it is these, of course, that dominate the current exhibition. With their flat, compartmentalized design and their box-like divisions of a shallow space, these pictures certainly align

themselves with the kind of Mondrian-derived abstraction that began to make itself felt in Paris in the thirties. But the drawing that fills these boxlike divisions—highly simplified, childlike "signs" of fish, clocks, boats, buildings, keys, figures, and other less immediately decipherable symbols—speaks of something else, as does the "free" drawing that encloses them. There is a poetry in this iconography that is at once "primitive" and autobiographical. What these pictures attest to, in short, is an unashamed desire to smuggle personal experience into the "Constructivist" aesthetic. With a defender like Torres-Garcia, Mondrian needed no enemies.

It all adds up to an art that is affecting more by reason of its imagery than by way of its form. Its appeal resembles the appeal of certain Latin American poets—an appeal based on the lyrical intensity with which certain images have been wrested from experience, rather than on any compelling sense of the form that was required to express them. Yet, in Torres-Garcia's case, he clearly could not take full possession of that imagery until his encounter with Mondrian offered him a form appropriate to its expression.

From Paris he got what he needed, and in 1934 he returned to Montevideo. There he was acclaimed a great figure, and he immediately launched a campaign on behalf of "Constructivist" aesthetics, while his own art pursued an occasional turn to complete representationalism. Physically the exile had returned but aesthetically he was still in search of a style that might reconcile all his contradictory allegiances.

October 3, 1971

24. Giacometti

There is a passage in *The Prime of Life* in which Simone de Beauvoir writes as follows about her first encounter with Giacometti and his sculpture during the Occupation:

His sculptures took me somewhat aback . . . the first time I saw them; it was a fact that the biggest of them was scarcely the size of a pea. In the course of our numerous discussions he explained his ideas to me. He had formerly been connected with the Surrealists, and I remembered having seen his name and a reproduction of one of his works in *L'Amour fou*. At that time he was making "objects" of the sort which appealed to Breton and his cronies, and which had only a tenuous suggestion of reality about them. But for two or three years now he had been convinced this method was getting him absolutely nowhere; he wanted to return to what he regarded as contemporary sculpture's real problem—the re-creation of the human face. Breton had been shocked by this. "Everyone knows what a head is!" he exclaimed, a remark which Giacometti, in turn, repeated as something shocking. In his opinion no one had yet succeeded in modeling or portraying a valid representation of the human countenance: the whole thing had to be started again from scratch. A face, he told us, is an indivisible whole, a meaningful and expressive unity; but the inert material of the artist, whether marble, bronze, or clay is, on the contrary, capable of infinite subdivision—each little separate bit contradicts and destroys the over-all pattern by the fact of its isolation. Giacometti was trying to reduce matter to the furthest viable limits; this was how he had come to model these minuscule, almost nonexistent heads, which, he thought, conveyed the unity of the human face as it presents itself to the intelligent eye. Perhaps one day he would find some other way of counteracting the dizzyingly centrifugal effect of space; but for the time being this was all he could think up.

In the interval of twenty years since the Occupation, Giacometti has, of course, not only "thought up" but successfully realized, in both sculpture and painting, a plenitude of heads, faces, and figures a good deal larger than the size of a pea. Yet the moment that Mlle. de Beauvoir has isolated in this brief memoir provides, I think, the best vantage point from which to view the artist's achievement *as a whole*. The Giacometti who figures in our thinking nowadays is largely the Giacometti of the past twenty years, but these twenty years, though immensely important, represent only half of his career as an artist. For some time now there has been a tendency among European writers to deal with the first half of Giacometti's career—that is, with his work of the twenties and thirties—the way literary

critics deal with Gide's attachment to his mother or Valéry's discipleship to Mallarmé. They regard it as the prehistory of his serious accomplishments. They document it—and, one is glad to note, document it in some detail—not for its intrinsic artistic interest but as part of the case that can be made for his later work. This way of dealing with Giacometti's *oeuvre* seems to me a mistake. It results in a fundamental distortion of the artistic continuity that has characterized Giacometti's overall development, and serves a purpose other than to illuminate his specific achievement as a painter and sculptor.

This purpose may be defined as the attempt to turn Giacometti into an existential saint. It parallels in some respects a similar attempt to disguise Brancusi as a peasant sage, the homely communicant with the celestial archetypes who was somehow able to live in cosmopolitan Paris a spiritual life of a type that would not have taxed the most austere monk in a Zen monastery. In Giacometti's case, the first intimation of sainthood came with Jean-Paul Sartre's essay on the artist, *"La Recherche de l'Absolu,"* published in *Les Temps Modernes*, in 1948, and afterward reprinted in the author's *Situations III*. It was reinforced by Jean Genet's *"L'Atelier d'Alberto Giacometti,"* published in *Derrière le Miroir*, in 1957, and afterward reprinted with Genet's play, *Les Bonnes*. This notion of Giacometti as exemplar of the existentialist predicament, at once the victim of all the uncertainties that plague the modern mind and the hero who redeems them through a decisive action—in this case, an aesthetic action—has now formed the basis, more ideological than philosophic, of the two most ambitious monographs devoted to the artist's work.* In them, the elevation of Giacometti to existential sainthood has been completed.

M. Jacques Dupin and Signora Palma Bucarelli have both followed Sartre's lead in presenting their ampler studies of the artist. Each has assembled a large and useful selection of plates covering

* Jacques Dupin, *Alberto Giacometti*. Text in French. (Paris: Maeght Editeur, 1962.) Distributed in the U.S. by Wittenborn and Co.

Palma Bucarelli, *Giacometti*. Text in Italian, with complete translations into French and English. (Rome: Editalia, 1962.) Distributed in the U.S. by Wittenborn and Co.

Sartre's essay, *"La Recherche de l'Absolu,"* together with another essay on Giacometti's paintings, has been published in a volume called *Essays in Aesthetics*, selected and translated by Wade Baskin (New York: Philosophical Library). The catalogue of the Giacometti exhibition put on this summer at the Galerie Beyeler, in Basel, also contains a good selection of plates. Available through Wittenborn and Co. is a German translation, with plates, published by Verlag Ernst Scheidegger, Zurich, of Genet's essay on Giacometti. This essay has not yet been published in English.

the whole range of Giacometti's sculpture, paintings, and drawings—M. Dupin's is the more comprehensive of the two—yet each has provided this visual material with a commentary that simplifies and condenses the work as a whole and overdramatizes its later development in order to make it conform to the philosophic scenario that Sartre sketched so effectively in his short essay. The result is a kind of writing that American critics often envy, and at times try to emulate: writing in which the symphonic rhetoric of the most prestigious modern ideas soars into the empyrean of intellectual discourse while the works of art ostensibly under analysis remain comparatively earthbound, undislodged from their artistic quiddity and almost modest in their physical particularity. It is not that writing of this kind fails to illuminate something about the art under discussion; both M. Dupin and Signora Bucarelli have certain insights into the emotional dynamics of Giacometti's sensibility that are useful. It is only that their texts illuminate his *oeuvre* the way a display of fireworks lights up a landscape. Certain features are glimpsed, briefly but dramatically, in the flickering light, but one is never in any doubt that it is the display itself—not the landscape— upon which the principal energies have been lavished.

Despite its conspicuous consumption of philosophical ideas, this mode of criticism is primarily lyric in character and cannot be sustained at monograph length (particularly in the hands of M. Dupin and Signora Bucarelli, who are not themselves philosophers). A certain portion of these commentaries must be given over, then, to those workaday matters—chronology, motifs, artistic devices, formal morphology, even physical media—that cannot always be rendered in the lyric mode, and it is in these portions of their monographs that are the least lyrical and most banal that M. Dupin and Signora Bucarelli contribute the most to one's understanding of Giacometti. When they tell us what he did, when he did it, whom he saw, and what artists he admired, what media and models he used— when, in short, they return to the real world where Giacometti himself has lived and worked and are not competing with him to bestow exalted significance where none is required—they are at their best.

Reading these books, one has the feeling that Giacometti has not hesitated to be "dull" in a way these writers fear to be. In the work they particularly admire, the work of the last two decades, he has returned again and again to the same few problems, the same

models, the same means, reapplying himself with remarkable patience and force to an imagery already familiar and to artistic devices long established. It is neither the originality of his visual materials nor the radicalism of his formal devices that sustains our interest in Giacometti as an artist. He seems, in fact, to have turned his back on such distinctions in pursuing the goals of his later years. He holds our interest now by virtue of the extraordinary expressive strength he has been able to bring to that combination of visual innocence and intellectual sophistication that used to be a commonplace of French art.

The dissolution of that fecund equation is one of the facts of postwar art in France. There, as elsewhere, it gave way to an art in which the innocent eye—the ability to examine even the most familiar visual fact as if one were seeing it for the first time, with all its mysteries intact—was vanquished for the headier pleasures of a conceptual art in which the sophisticated mind could have unfettered reign, without reference to mundane visual experiences. But it was to this equation—which is to say, to the central tradition of French art—that Giacometti rededicated his art in the dark days of the Occupation. And it is important to see that it was a *re*dedication, a renewed assault on an earlier objective—but now undertaken with all the strength of mind and the depth of experience that had accrued to him through two decades of continuous artistic industry, the most recent years of which had been spent in the ranks of the Surrealists.

Giacometti once spoke of his Surrealist period as his "Babylonian captivity." At the very least, this remark suggests that his true artistic homeland is a country far removed from the world of André Breton and *Le Surréalisme au service de la Révolution.* A glance at the early paintings and drawings reproduced in M. Dupin's monograph reveals that this country was, in the beginning at least, none other than the country of Cézanne, the central landscape of modern art, and I think a disinterested artistic analysis of Giacometti's later work, relieved of its alleged existential imperatives, discloses a triumphant—if also much modified—return to his home base.

Giacometti's development, from the early twenties to the present day, has been rich, complicated, and various. His work of the twenties and thirties, in particular, reflects all the shocks and dislocations to which art in Paris was submitted in the period be-

tween the wars. Giacometti never stood aloof from the currents that surrounded him. Cézanne, Brancusi, Picasso, Arp, Miró, primitive art, Dada, Surrealism—these and other pressures have all had their effect on his work. It is complete nonsense for M. Dupin to write as follows about his career: "*Son attitude est en contradiction absolue avec toutes les tendances et toutes les recherches de l'époque et les théories qui les justifient. Il est seul dans son siècle et contre tous, cramponné à son idée fixe, malgré lui en travers du courant.*" On the contrary, Giacometti has absorbed "*toutes les tendances et toutes les recherches de l'époque*" and turned them to his own purposes. Even among postwar artists, Giacometti has not been alone in his effort to restore the viability of the French tradition.

There has, indeed, been too much talk about the differentness of Giacometti's art: too much, because such talk creates a barrier that prevents us from appreciating the many characteristics it shares in common with the other major styles of our time. A good deal, if not most, of the significant sculpture of our century is pictorial in orientation, as Giacometti's is. Between Giacometti's sculpture and his painting there has taken place a dialogue that follows in the tradition of such painter-sculptors as Degas, Renoir, and Matisse, and if there is any useful sense in which Giacometti himself may be said to be an artist in an extreme situation, it is above all because this tradition itself has fallen into so extreme a crisis.

If one wishes, then, to rescue Giacometti from the kind of existential sainthood into which recent commentators have cast him, it is in order to place his art in an aesthetic and historical context more directly related to its actual character. His career has in some ways resembled Picasso's; his father, too, was a painter, and he came of a family in which art was looked upon as an admired profession. When he came to Paris from his native Switzerland in the early twenties and took up his studies with Bourdelle, it was not to effect a revolt but to fulfill the demands of that profession. His paintings and drawings of the twenties are firmly Cézannean. His sculptures of that period are alternately Cubistic and Brancusian. Which is to say, the dialogue between his paintings, based on Cézanne, and his sculpture, deriving from Cubism and Fauvism, the two principal sculptural consequences of Cézannean aesthetics, was already joined at that early date. When, in the late twenties and early thirties, Giacometti fell in with the Surrealists, he began making those constructions—"*La Boule Suspendue*"(1930–1),

"Palais de Quatre Heures" (1932), and others—in which a cagelike
space is expressively inflected by means of sculptural shapes that are
still drawn from Cubist and Brancusian precedents now joined with
some ideas from Arp and Miró. The space that is articulated in these
constructions remains pictorial, even classical; only the forms that
occupy it have a specifically modernist sculptural character.

In addition to these constructions, three other modes of expres-
sion occupy Giacometti in the thirties. He had already shown an
interest in primitive art, and now, under its influence, made a
number of tall, slender mannequinlike figures on pedestals—e.g.,
"Nu" (1932–4), *"Femme qui Marche"* (1934–5). At the same time
he began making a series of heads, at first completely orthodox in
the Cubistic modeling of the mass, but gradually developing into a
freer, more realistic modeling of concrete features until, by 1938–9,
the Cubist armature dissolves in favor of a direct, portraitlike
rendering of a sculptural likeness. And he paints some still lifes—
M. Dupin reproduces *"La Pomme sur le Buffet"* of 1937—in which
the principal expressive concern appears to be the articulation of a
pedestal-like mass (in this case the *buffet*) and the space that it
creates, a space that in this instance is inflected by the single small
pomme whose minuscule size and emphatic isolation have the effect
of conferring on the entire image a scale far transcending its
modest subject.

Thus, without proceeding further than the late thirties, one
finds all the basic elements of Giacometti's later style already in
evidence, and already remarkably well developed. If one agrees that
the period of the Occupation was a crucial one for Giacometti's art,
it is not for the reason Mlle. de Beauvoir implies in her memoirs.
The architecture of Giacometti's later sculptures, with their massive
pedestals and vast, cagelike perspective, had already been postu-
lated. The occupants of that architecture—tall, slender figures and
tiny heads (or apples) isolated in an immense space—had already
made their initial appearance. The problem of scale that occupied
Giacometti so intensely during the war years, and that remains to a
large extent, even now, the nemesis of his art, was above all the
problem of reconciling the elements which were already his basic
vocabulary as an artist—elements which were fragments, lacking in
coherence and grandeur—with the tradition of classical French art
whose last great exemplar had been Cézanne.

When we remove Giacometti's postwar *oeuvre* from the rhet-

oric of existentialist dialectics and place it in the aesthetic context of the School of Paris, we are a good deal closer to its real achievement. Not Sartre, but Cézanne, provides us with the most useful help. Those slender figures almost lost on their huge pedestals are more akin to Cézanne's "Bathers" than to anything in the literature of existentialism. The only critic who has made this point, so far as I know, is Mr. David Sylvester, in the catalogue of the Arts Council exhibition he organized in London in 1955. He makes it in regard to Giacometti's painting, but I think it equally true of the sculpture— and indeed, I would say that it is in his sculpture, rather than in his painting, that Giacometti has truly succeeded in realizing the Cézannean grandeur. "The most striking thing about the paintings," Mr. Sylvester wrote, ". . . is the density of their space. The atmosphere is not transparent: it is as visible as the solid forms it surrounds, almost as tangible. Furthermore, it is uncertain where the solid form ends and the space begins. Between mass and space there is a kind of interpenetration." And he went on to say: "We see, then, that Giacometti is preoccupied with precisely those problems which so concerned Cézanne—the elusiveness of the contour which separates volume and space, and the distance of things from the eye."

In his sculpture Giacometti has created the equivalent of this density of space by means of those pedestal-masses that form a pictorial environment for the much slenderer masses—figures or heads—that occupy them. In doing so he has largely obliterated all traces of both Cubist syntax and Surrealist imagery, placing his art instead at the disposal of the tradition that preceded them. The affinity he has shown for this tradition has also, I think, been the source of his admiration for Derain, who, in his own way, passed through a similar "Babylonian captivity" before he turned to the commitments of his later years.

Signora Bucarelli says—correctly, I think—that "The most evident characteristic of [Giacometti's] nature, even as an artist, is uncertainty." One sees well enough what she means. Giacometti's compulsive willingness to address himself over and over again to the same themes and models, and his not so much finishing as abandoning every attempt to get right the elusive image he aspires to—all this, is, indeed, the mark of a very profound, but very fecund, uncertainty. But it is precisely the kind of uncertainty that is a precondition for that creative use of the innocent eye that had long been one of the principal terms in the dialectic of French art. Again, it is not

an existential drama that one is reminded of by this creative uncertainty—except insofar as every artist is, in some sense, the protagonist of such a drama—but of Cézanne in his later years, going out every day to scrutinize his "motif" and requiring Mme. Cézanne to sit through an eternity for each portrait. Only when we have come to terms with the Giacometti who is the principal living successor to the "uncertainties" of Cézanne shall we really be in touch with his achievements of the last two decades.

November 1963

The Twentieth Century:
Americans

1. Reflections on Lachaise

At first glance the art of Lachaise looks familiar. One places it in the felicitous realm of a sensual and robust physicality that, in sculpture, includes the work of Renoir, Rodin, Maillol, and Matisse. The sculptural development of Impressionism that held within its grasp both an Expressionist impulse and a classical yearning, resulting in a delicate and precarious balance of emotion and discipline, passed into the sculpture of Fauvism with a heightened consciousness of its own double nature. One sees the evidence of this consciousness—and its artistic consequence—not only in Maillol and Matisse but in Nadelman and the early Brancusi, too: a delicate balance that poses questions for itself and which, in the later work of Matisse, Nadelman, and Brancusi particularly, is given answers as diverse and powerful as any sculpture we have seen that enjoys a common source of style and idea.

Lachaise clearly belongs in this company. The sense of familiarity one feels on first seeing his work is recognition of his affinity with both the vitalist ideal of the Fauvist style and the purity and elegance of form that nearly always accompanied it, in part a caution and a discipline against its overflow of feeling, in part a means of fulfilling the implications of this feeling. The image of the mature female nude that occupies a central and animating position in Lachaise's *oeuvre* forms an obvious link in the chain of sensibility that leads from the audacious watercolor drawings of Rodin to Matisse's "Blue Nude" and the later odalisques. Himself a Frenchman, Lachaise seems to share in this realm of feeling and style as a natural element. Even at his most extreme moments of expressiveness in dealing with the female figure, Lachaise conveys a sense of complete and unstrained mastery in realizing his sensations. Subjects and feelings that would have shattered the aesthetic equilibrium of a lesser artist are embodied in a purity of gesture and density and sculptural diction that very few artists of our time have equaled without recourse to abstract conceptions of style.

From a purely historical view, then, Lachaise was a latter-day Fauvist. I would say his work stands to Fauvism very much as Bonnard's does to Impressionism—which is only another way of saying that a purely historical view accounts for very little of importance in either of these sublime artists. At first glance one *does* place

Lachaise's art very easily—too easily—into a familiar context of history and style, but it is a first glance only that can limit one's view of his *oeuvre* to the company of even so illustrious a group of artists as those I have named. The truth is that the art of Lachaise stands apart in a way it has sometimes embarrassed art criticism to speak of directly. If one compares it with the work of Matisse, for example, it is clear there is something more personal and obsessive in Lachaise's vision. In Matisse one sees an artist working from a model, who, no matter how crucial her visual presence may be to the realization of his creative goal, remains the anonymous *point d'appui* for a great analytic and sensual intelligence. In Brancusi one senses the memory of a model, perhaps memories even more personal and compelling that have been systematically and ruthlessly obliterated from sight until the finished form approaches an ideality that memory can no longer touch in any meaningful way. Brancusi's method often seems the result of a rigorous effort to place the whole of his art beyond the reach of his private experience. The vision that Lachaise aspired to preserve in his art is radically different. Far from obliterating his private obsession, far from regarding it as a mere scaffolding for his plastic intelligence, Lachaise places his experience at the center of his art, making something permanent, magnificent, and moving out of the very elements that other artists often took great pains to eliminate.

It was Baudelaire who remarked, in the *Salon of 1846*, that "All forms of beauty . . . contain something eternal and something transitory—something absolute and something particular." And he added: "The particular element in each form of beauty comes from the emotions and as we have our particular emotions, we have our own form of beauty." Lachaise is one of those artists who are especially concerned to keep the particular and the absolute in a close and easy commerce with each other. He is the opposite of those artists who labor to extract something immutable and universal from their experience; he remains aloof from the ambition to create a statement that no longer bears the marks of particular emotions. Baudelaire said of the search for an immutable expression that "Absolute, eternal beauty does not exist, or rather it is only an abstraction skimmed from the general surface of different forms of beauty." The art of Lachaise exists at an unbridgeable distance from the "abstraction skimmed from the general surface," which has sufficed as stylistic material for so many modern artists.

"At twenty, in Paris, I met a young American person who immediately became the primary inspiration which awakened my vision and the leading influence that had directed my forces. Throughout my career, as an artist, I refer to this person by the word 'Woman.' " So wrote Lachaise in 1928, when he was forty-six. This "young American person" was Isabel Nagle, the Bostonian lady whom Lachaise followed to America and who later became his wife. She was—to invoke Baudelaire again, in some ways the only artist who offers an appropriate comparison—both the Jeanne Duval and the Madame Sabatier of his creative life, at once the *"Vénus Noire"* and the *"Vénus Blanche"* in his existence as an artist and a man. His most powerful sculptural achievements are all traceable to the "particular emotions" which this woman brought into his life and which, as Baudelaire's observation suggests, provide artists like Lachaise with their "own form of beauty."

Lachaise was, of course, a sculptural craftsman and worker of the greatest versatility and skill, and he produced a large body of work which falls outside the realm of feeling that is primarily concerned with the "Woman" who first awakened his vision. His many decorative and architectural works and (of greater importance) his very fine portrait sculptures, especially of artists and writers, all show the ease and finesse of a master, even where the work itself may not be counted his best. Trained in France from the age of thirteen in the techniques of his art and himself the son of a prominent French cabinetmaker, Lachaise could turn his hand to any task that came his way with the skill and confidence of an old artisan. (Practical circumstances often required that he do just that.) This body of work has an honorable place in the history of Lachaise's own career. But if one speaks of Lachaise's artistic *vision* over and above the details of his professional career, then it is on the figure sculptures that one must dwell. American art is filled with artists who have had interesting careers, but there are very few whose works reveal a *vision* so deeply felt and so magnificently realized.

Most of us have had our experience of this vision confined to the few monumental works that are frequently seen at the Museum of Modern Art, the Whitney, and other museums. The "Standing Woman" of 1932 that stands seven feet tall in the garden of the Museum of Modern Art is a kind of *summa* of Lachaise's ideas and feelings on this subject, at least insofar as his ideas and feelings lent themselves to a public style of utterance. It is a great work, and

Lachaise's importance to modern sculpture would be assured by it alone. Yet our understanding of Lachaise's art and our pleasure in the vicissitudes of his sculptural vision can only begin—or end—with a conception so monumental in size and finish. To be admitted to the inner life of the sculptor's imagination, to the realm where his experience and his craft encounter each other with an equal and proliferating power, one must turn to the smaller figures, the "studies" and drawings. Here are some of the most extreme, most personal, most difficult, and at the same time (one does not hesitate to use the word) most *beautiful* works Lachaise ever achieved in his struggle with this theme—for him, the most important and overriding theme of all. Here one is witness to a confrontation of art and life on the heroic scale of the masters. No concessions to historical necessity, no conformity to narrow doctrines or evasions of feeling come between us and the artist's vision. One is caught up in the emotions of the man, the art, and the abiding, passionate image all at once, and in the end one returns to the public utterance of his museum works with a new and deeper conception of what it was he achieved in them. One thinks, again, of an artist on the level of Baudelaire, of the imagery of *"La Géante"* and the emotions of *"Les Bijoux"* and *"La Chevelure,"* of an art which quickens our sense of life as it enlarges our understanding of the aesthetic possibility.

Fall 1960

2. Prendergast

The career of the American painter Maurice Prendergast (1859–1924) offers a case of an artist who makes his historical debut under circumstances almost comically at odds with the real nature of his sensibilities. In 1908, when Prendergast was nearly fifty, he showed with "The Eight," a group that (whatever the differences that

divided them) were more or less united in espousing a realistic depiction of the American urban scene. Prendergast was not the only member of the group whose work stood at some distance from this aspiration—Arthur B. Davies was perhaps equally resistant to the "Ashcan" outlook—but Prendergast was already well advanced in a style that simply by-passed the concerns of his fellow exhibitors and lacked even a superficial resemblance to what they were doing.

Still, it was as a member of "The Eight" that Prendergast passed into history. Neither before nor after did his fortunes prosper. The discrepancy between the quality and consistency of his work and his lifelong lack of public success is still heartbreaking to contemplate, and all the more so because this unhappy fate left him at the mercy of the historical vagaries that accumulate around the name of a movement or group. For years "The Eight" was the peg on which Prendergast was left to hang in the history books.

It is only in recent years that the artist has begun to be lifted from that peg and be more seriously considered as the master he surely was—a minor master, perhaps, but a master nonetheless. The pivotal event in this revaluation was the full-scale retrospective mounted by the Museum of Fine Arts in Boston in 1960, and this memorable exhibition has now been followed by a smaller but still utterly delightful show at the Knoedler Galleries.

Fifty-nine paintings and watercolors, from the period 1892–1920, are included, and they give us a very exact profile of Prendergast's characteristic strengths and weaknesses. Foremost among these strengths was an abiding delicacy—a delicacy that transformed observed fact into intricate visual structures that maintained a wonderful air of effortless lyricism even at their most complex realization. Early on in Prendergast's work, he came under the influence of Winslow Homer's plain-spoken watercolor style; later, after immersing himself in the European art scene, he moved more and more into the orbit of Cézannean aesthetics, with its emphasis on a strict painterly architecture.

In the course of this change, his work deepened, becoming less descriptive and more thoughtfully involved in the expressive properties of pure painting. Though he never abandoned the anecdotal element in painting, that element grew progressively less important than the way he came to deal with it, rendering its carefully observed details in friezelike patterns of color touches. Prendergast's

subjects—luminous beach scenes, landscapes, and outdoor vignettes —always evoke a particular time, place, and ambience; the passage of time has, if anything, increased their power to overwhelm us with nostalgic feeling; but the strength of these pictures depicting such benevolent and pleasurable themes lies in an artistry that transcends anything facile or soft. In a painting like "A Day in the Country" (1913), the artist's delicacy, without losing any of its early élan, has gained a tough-minded edge that identifies it as belonging to the Cézannean camp. Lyric description has given way to the classic verities, or, to put it another way, American innocence has been displaced by a more universal formal idiom.

Yet Prendergast was never, even at his best, an artist of large range or really major powers. His special gift was for realizing to the fullest an emotion of small and circumspect scale. His pictures, early and late, have a beguiling unified rhythm where Prendergast undertook to orchestrate a canvas of myriad fragmented forms and touches. But where he addressed his brush to a large dominant form—in the "Portrait of Mrs. Oliver E. Williams" (1902) or the "Woman in Brown Coat" (1908)—pictorial structure tended to break down. Sheer charm was pressed into a service it could not fulfill.

Perhaps Prendergast's limitation as an artist is best understood by dwelling for a moment on his relation to Cézanne, for it was a peculiarly American relation. Prendergast responded to the radical changes the French master had effected in pictorial structure, and he assimilated them with a tact that preserved and strengthened his own delicate touch. That indeed is one of the glories of Prendergast's art—that he could draw from Cézanne's strength without sacrificing his own identity or experience. But what he could not do was enlarge upon what he gleaned in the lessons of the master. And it is that, finally, the ability not only to grasp but to build upon and extend a radical innovation, that separates a major artist from even an immensely gifted minor one.

But it is a measure of one's esteem for Prendergast's achievement that one is moved to discuss even his limitations in terms of the highest accomplishments of his time, to place him in a context wider than the American milieu that proved to be insufficient for his exceptional gifts. This is not what one feels moved to do in discussing the work of Prendergast's associates among "The Eight"; their particular qualities describe a much smaller arc of experience and

never quite ascend to the international level. It was Prendergast's peculiar fate to be mistaken for far too long as one of their number.

November 6, 1966

3. Marsden Hartley:
The Return of the Native

The career of Marsden Hartley is one of the most interesting in the history of modern painting in America, but the very reasons that make it interesting have also made it difficult at times to keep his accomplishments clearly in focus. Hartley moved around a great deal, and not only geographically. He was a writer as well as a painter and took a deep interest in the intellectual side of the artistic enterprise. He had a sharp critical intelligence and a wide-ranging curiosity. He was, like so many other American artists and writers of his time, a provincial in his origins and his loyalties, yet his outlook on art was distinctly cosmopolitan. His grasp of the European art scene in the heyday of the Paris and Munich avant-garde was profound. He registered his response to this avant-garde milieu in a sometimes bewildering succession of styles, and this has often led to charges of facile eclecticism and even frivolity. Yet there is a fundamental consistency and intelligence in the very shape of Hartley's artistic odyssey. Few careers in American art have traced so serious a course of self-realization.

He was born in Lewiston, Maine, in 1877, and Maine was to be the scene of his later triumphs when, after extensive travels in Europe and America, he returned to the isolation of his native ground in the last years of his life. He received his initial training in Cleveland, at the Cleveland School of Art, and then studied in New York, first in the studio of William Merritt Chase and then at the National School of Design. For much of the first decade of the century, he divided his time between Maine, whose mountain land-

scape supplied the principal motif of his pictures, and the bohemian art world of New York, which was just then awakening to the achievements of modernist art in Europe.

In 1909, Hartley had his first exhibition at Alfred Stieglitz's Photo–Secession Gallery. Three years later, with the backing of Stieglitz and Arthur B. Davies, he went abroad for the first time. Paris was, inevitably, the first stop. He made his first tentative explorations of Cubism, fell in with Gertrude Stein and her circle, and devoured the museums. But it was in Germany that Hartley became an active collaborator of the European avant-garde. He showed with Klee, Kandinsky, and Franz Marc in the Munich Blue Rider exhibition, and participated in the Berlin salon organized by the magazine *Der Sturm*.

Hartley had what might be called a "Northern" sensibility. He always showed a greater affinity for the bold forms and graphic orchestration of the German school than for the more classical modulations of French painting. This was true even when, in the late twenties, he renounced Expressionism as part of his conversion to Cézannean structure and what he called "the great logicians of color." Cézanne was indeed a turning point for Hartley. Without his immersion in the Cézannean aesthetic, Hartley would never have achieved the clarity and power of his late landscapes. But it was not to the Cézanne of the School of Paris that he had been converted. Cubism had become a distasteful concept to him. He saw Cézanne with a Northern vision, with the result that a landscape such as "The Old Bars, Dogtown" (1936), now in the collection of the Whitney Museum, is much closer in feeling and design to the landscapes of Max Beckmann, who also derived from Cézanne, than to the lambent subtleties of the French tradition.

This attachment to Cézanne was, in any case, the climax to Hartley's European experience. In 1926, after further visits to Paris and Berlin and a journey to Italy, he settled down in Aix-en-Provence for two years, living near Mont Ste. Victoire—the sacred Cézannean motif—and schooling himself in the vision of the master. The pictures that he painted in Provence are not among his best, but they have a special place in Hartley's development. In retracing the steps of Cézanne's return to home ground after his deep involvement with the art life of Paris, Hartley was preparing for his own homeward journey after the beguilements of the European capitals.

In the thirties, Hartley made one final trip to Germany, but by

that time the course of his development was clear. He painted for a while in New Hampshire, then Gloucester and Nova Scotia, was in and out of New York, and in 1937 he returned to Maine. He lived mainly in the tiny coastal community of Corea and died in the hospital at Ellsworth on September 2, 1943.

The exhibition of Hartley's paintings at the Danenberg Galleries, though billed as a "retrospective," is very far from being an ideal account of his achievement. The selection of paintings is not scrupulous enough to give us a clear-cut vision of his strengths, and it is not comprehensive enough to afford a detailed understanding of his complex history. The show is, alas, the usual dealer's patchwork, with some fine pictures borrowed from museum and private collections added to the gallery's own stock, which is (shall we say?) of a very mixed quality. Those who have remained unconvinced of Hartley's superior powers will find no lack of pictures here to support their mistaken judgment. Hartley's copious production certainly lends itself to this kind of mixed bag, and dealers can rarely be relied upon to show us only the best.

The New Mexican landscapes of the early twenties, of which there are several examples, were painted at a very problematic moment in Hartley's development. His experience in Europe had more or less alienated his talents from the kind of innocent and eager élan that informs his early Maine landscapes, and he had not yet submitted himself to the hard Cézannean discipline that would later enable him to make of such landscape materials a pure and evocative poetry. They, too, I think, must be counted among his failures. But there is a highly instructive Cézannean pastiche— "Mountain" (c. 1928), not a great picture but a very poignant reminder of what Hartley was endeavoring to master in these years—and several very strong flower still lifes from this same period.

But the real quality in this exhibition is to be found in a few pictures painted in Gloucester and in Maine in the 1930's. In the best of these—especially "The Old Bars, Dogtown," already mentioned, "Dogtown" (1934), and "Birds of the Bagaduce" (1939)—we have the mature Hartley. They are wonderfully realized paintings, and they persuade us that this was, after all, what Hartley had been seeking—a lyric image with a plain-spoken, tough-minded structure. They are also the most authentically "American" of Hartley's pictures. They have the kind of Yankee rigor Hartley so

much admired in Winslow Homer, but they have something else as well—that extra dimension of the imagination he had found in Courbet and in the beloved master of Aix.

The show is, despite its weaknesses, a very pleasurable event. There are several of the small early Maine landscapes of 1908–10 which indicate the scope of Hartley's talent—a lyricism already abetted by a natural gift for pictorial form—even before his European adventures. The "Abstraction—Still Life" of 1913, a misbegotten experiment with Cubism, is a failure, but there is a very interesting example of the symbolic abstractions Hartley painted in Germany in his first years there—"The Aero" (c. 1914).

September 21, 1969

4. The Loneliness of Arthur Dove

There is something at once glorious and poignant about the loneliness of the early American modernists. This first generation of painters who undertook, at the turn of the century, to cast their native experience in a radical pictorial mode of foreign origin suffered all the well-known afflictions of provincial aspirants to cosmopolitan achievement. Separated from the assurance of community acceptance—even when the community in question was a proud but unknowing New York art world—these artists could scarcely hope for a place in the front rank of the European avant-garde from which they drew their inspiration. As artists and as Americans, they were men suspended between worlds without a clear role to play in either. Indeed, their role (as it developed) proved to be that of creating a third stream of culture in which the modern movement of Europe, a far-reaching revolution in all realms of sensibility and expression, could somehow be reconciled to—and ultimately be made to illuminate—the very texture of American life.

One of the most attractive members of this generation was Arthur G. Dove (1880–1946), an artist whose career is a virtual allegory on the fate of enlightened American artistic aspiration in his time. Dove came out of a small town in upstate New York, was educated at Hobart and Cornell, and had a short, successful career as an illustrator in the years 1903–7, contributing to *Harper's, Judge, McClure's,* and other popular journals. This was the customary course for an artist playing it safe, but Dove refused, despite family complications and a general lack of encouragement, ever to play it safe. A career as an illustrator never really interested him. He simply used it to save enough money to go abroad—the inevitable ambition for an American who hoped to break out of the native rut and accomplish something comparable to the European standard.

Dove spent a year and a half in Paris. He immersed himself in the fateful innovations of Cézanne and his followers—innovations that were already transforming Western painting in new and unexpected directions. For the first time in his life, Dove was painting steadily in an atmosphere of total seriousness and commitment—an experience that set the mold for his entire subsequent career. He even showed for two successful years (1908 and 1909) in the Salon d'Automne.

Yet American he was, and to America he returned—an America that, far from emulating this atmosphere of total seriousness in the arts, was more than content to abide by the familiar genteel substitutes. Exceptions to the general blandness of American culture were few. Dove gravitated to the most exceptional artistic enclave New York offered at that time. The circle of Alfred Stieglitz, the photographer whose gallery was the principal oasis in this cultural desert, would for many years be Dove's haven. Indeed, it was Stieglitz and then Duncan Phillips who sustained Dove in the loneliness of his art, a loneliness that became an integral part of his art, a condition of its pastoral and marine imagery, and the emotion that gave it its human definition.

The place to see Dove's art at its best is still the Phillips Gallery in Washington, but there happen to be two shows of his work just now that are of unusual interest. One of these, a survey of his highly original collages from the 1920's, opened this week at the University of Maryland in College Park. The other is a collection numbering seventy-five works, most of them very small and some

quite tiny (3-by-4 inches), at the Downtown Gallery. The second of these shows consists mainly of watercolors only recently released by the Dove estate and publicly exhibited for the first time. To these watercolors, some of them barely sketches, the gallery has added a few pastels—notably, the Whitney Museum's superb "Plant Forms" of 1915.

It is a great pity that the Maryland exhibition will not be coming to New York, for Dove has never been given his due as a maker of collage. This was a genre in which the artist's humor, abetted by his extraordinary sense of design, realized itself in a series of marvelously deft and marvelously prophetic images. About one of these collages—the unforgettable "Goin' Fishin' " (bamboo rod, blue denim overalls, etc., enclosed in a box)—Duncan Phillips once wrote: "In Paris at the Jeu de Paume in 1938 that collage spoke of Mark Twain rather than of Braque, Gris, or Picasso." But of course, it was by way of Braque, Gris, and Picasso that Dove was able to find his way to Mark Twain, and we see this perhaps more explicitly in the collages than in the paintings—the arduous synthesis of native feeling and alien form that proved to be his special triumph.

As a painter, Dove enjoys an equivocal fame, and while there are many small delights to be found in the Downtown show, this is not the kind of exhibition that will redeem his standing from the equivocation that surrounds it. There are too few major examples, and too many minor (and less than minor) works, for that. There is, however, an ideal Dove exhibition to be done that would redeem his standing. It would not, I hasten to add, be based on his status as a pioneer abstractionist. Dove was, to be sure, one of the first abstract painters anywhere; his first abstractions apparently predate even Kandinsky's. But his abstract paintings have not fertilized the history of painting. They remain personal avowals—poems of nature, highly lyrical, almost private, removed from the programmatic, and utterly lonely in their attempt to reconcile the forms of art with the forms of the natural world.

When Dove returned to America from Paris, it was—paradoxically—only in his personal communion with nature that he found it possible to make the maximum use of the artistic resources he had perfected in the French capital. As a member of the School of Paris, his art might have entered into, and been tested by, that extraordinary dialogue of forms that is still the high point of artistic

invention in this century. As an isolated American, his art became instead a form of lyric meditation. This is the essence of Dove's remarkable accomplishment and of his limitation, too.

March 19, 1967

5. The Ordeal of Alfred Maurer

Among the many tragic lives which the history of art in this century contains, one of the most painful to contemplate—even at this distance in time—is that of the American painter Alfred H. Maurer. Born in New York in 1868, Maurer hanged himself in his father's house on West Forty-third Street on August 4, 1932. The date, as Maurer's biographer Elizabeth McCausland has pointed out, was a significant one for this tortured artist. It marked "the eighteenth anniversary of the outbreak of the war which drove him home from Paris in 1914."

More than half a century after the end of that war, we are still a long way from fully appreciating its effect on the generation of artists who came of age in the relatively tranquil decade preceding Sarajevo. In Maurer's case, the disruption of the war was doubly cruel. Not only was he forced to leave the beloved Parisian milieu where, after his early success as a Whistlerian realist, he had recast his talents—and indeed his life—in a more avant-garde direction, but his forced return to New York meant a resumption of the bitter family struggle in which Maurer and his father remained locked until the end of their lives.

It was a struggle on the order of one of those late plays by Eugene O'Neill in which the classic bonds of filial attachment—love and dependency, hatred and resentment, the desire for freedom and the impossibility of achieving it—are carried to every extreme of exacerbation and despair.

Most of the American artists who turned to modernism in the

early years of the century encountered harsh criticism and firm rejection. In the attitude of Maurer's tyrannical and overbearing father, himself a highly successful commercial artist and genre painter, the prevailing Philistinism of the period took the form of the most sweeping and unforgiving parental disapproval and condescension. What most of his contemporaries experienced as a general conflict of taste and allegiance—between the claims of tradition and respectability on the one hand and those of modernist art on the other—Maurer experienced as a profound family crisis.

There can be no doubt that this crisis broke his spirit. Certainly as a man he never recovered from it, nor had he the kind of strength required to release himself from the disapproving parental gaze. Maurer lived out his life, from 1914 onward, in his father's house, and when his father finally died in 1932, in his one hundredth year, Maurer followed him to the grave three weeks later.

In approaching Maurer's art, then, we are approaching the work of a man whose life was shattered in the service of an artistic ideal—the ideal first glimpsed in Paris when Fauvism and then Cubism gave a new and radical emphasis to the heritage of the Post-Impressionist masters. Maurer came to this radical pictorial idiom as a grown man and an experienced painter. In 1901 he had been awarded the first prize at the Carnegie Institute for his Whistlerian "Arrangement" by a jury consisting of, among others, Winslow Homer and Thomas Eakins. When he had his first show of Fauvist paintings at Stieglitz's Photo–Secession Gallery in 1909, he was over forty.

The exhibition of Maurer's paintings at the Bertha Schaefer Gallery is by no means a complete retrospective, but the thirty-eight works included in this survey are certainly sufficient to remind us both of the artist's undeniable quality and of his uncertain hold on that quality. The pictures range in date from 1903 to 1931. There are several excellent examples of Maurer's Fauvist manner—"Landscape with Red Tree" (c. 1907–8) and "Still Life with Bowl" (c. 1908), among others; the very bold and interesting "Abstraction" (c. 1919), which indicated a Cubist-derived turn toward nonobjective art; and a number of fine Cubist still lifes of a more representational character from the late twenties and early thirties.

It is pictures of this quality that show us Maurer at his best. They are very Parisian in character, displaying a real authority and understanding in the way their various elements are composed.

Fauvism, especially in the transcendent example of Matisse, certainly altered forever Maurer's understanding of color and showed him to have a direct and natural faculty for its expressive use. But I think it was Cubism that ultimately led to his most powerful pictures, for in the end he came to have a very strong hold on the kind of pictorial syntax that Cubism made possible. Indeed, in his finest paintings—in my view, these are the late still lifes—he was able to apply what he had learned of Fauvist color to the more rigorous syntax of Cubist construction.

The current exhibition also includes, inevitably, a selection of those "Heads"—some of them abstract or nearly so, some of women with unbearably sad eyes—which remain, for me at least, a closed book. Pictures of this sort are, to be sure, always touched with the kind of pictorial intelligence Maurer brought to everything he painted. But it is in these "Heads," I think, that we have some residue of Maurer's personal crisis that he was never able to transmute into a compelling artistic idea. They remind us, if we need reminding, that the man who painted them suffered some profound psychological wounds. Henry McBride once wrote of one of these late works: "There is something frantic in the arrangement of the items, as though they had been assembled by a highly nervous person in the midst of a cyclone," and of course, in one sense, this was indeed the case. The cyclone was Maurer's terrible life, and in such pictures we have the graphic evidence of his suffering. But they tell us more about his life than about his art.

We shall never have a complete grasp of what Maurer achieved in his Paris period, for most of the pictures he left behind in 1914 have been lost. From what we do have, the loss would seem to be a large one. It was typical of his luck. But then, we are only beginning to come to terms with the large body of his work that has survived both the vicissitudes of war and the terrors of his own life. The present show at Schaefer's reminds us that we have not always been attentive enough to his unusual achievement.

February 16, 1969

6. Introducing H. Lyman Saÿen

The history of the European and American avant-garde in the early years of this century is so familiar to us in the routine chronologies of museum collections, books, and college courses that we tend, mistakenly, to believe there are no more discoveries to be made. And then, out of the blue, we are obliged to confront a new name, a new career, and a new *oeuvre* of whose existence we had never had an inkling. Such experiences are admittedly rare, but we are now being offered one in the exhibition of paintings by Henry Lyman Saÿen at the National Collection of Fine Arts in Washington. It is the kind of exhibition that, on a certain modest scale, will require some revisions in the standard histories of modern American art.

Saÿen was born in Philadelphia in 1875. He first won distinction as an electrical engineer and inventor, and he won it early. At the age of eighteen, he was cited by the Columbian Exposition in Chicago for the design of a large induction coil. At twenty, he was designing precision instruments and electrical circuitry for the production of X-ray equipment, and two years later he patented his own X-ray tube. He became something of a specialist in medical radiography, and during the Spanish-American War was commissioned to construct the first military X-ray laboratory in the United States.

During the war he suffered a severe case of typhoid fever, and his artistic interests appear to date from the long convalescence that this illness imposed. In 1899, at the age of twenty-four, he enrolled at the Pennsylvania Academy and studied with Thomas Anshutz, the realist painter who forms a historic link between Thomas Eakins, who had been his teacher, and the painters of the Ashcan School who were his students. Saÿen proved at once to be enormously gifted at producing the kind of academic and commercial art then very much in vogue in this country. He promptly won a competition to paint four lunettes for a room in the Capitol building in Washington—they may still be seen in Room H-143, now used by the House Committee on Appropriations—and also worked as an illustrator and commercial designer. Meanwhile, he continued his scientific work, obtaining patents in a variety of fields. Before leaving Paris in 1914, he took out a French patent on a steel billiard ball.

He had gone to Paris in 1906 on a commission from the head

of Wanamaker's to design catalogues and posters for its New York and Philadelphia stores, and it was his experience in France that changed the course of his artistic career. "Saÿen went to Paris as an academician," writes Adelyn Breeskin, the Curator of Contemporary Art at the National Collection who organized the current exhibition, "and he returned a confirmed modernist." In Paris, he met Leo Stein, who introduced him to the work of Matisse. He joined Matisse's class during the 1907–8 season, and became a regular visitor to the salon of Leo and Gertrude Stein. (He even designed a lighting system for the Steins' collection.) While still in his early thirties, Saÿen was at the nerve center of the Parisian avant-garde.

All in all, a fascinating story. What elevates this story to something more than an interesting historical curiosity, however, is the quality of the paintings Saÿen produced in the last decade of his life. (He died in Philadelphia in 1918.) The earliest painting in the Washington show is "Notre Dame" (c. 1907), hardly a masterpiece but a work that shows at once an informed consciousness of the pictorial problems then very much at issue in the art of Matisse and his followers. Though the picture is unresolved—the foreground, consisting of a flat, almost geometrical pattern of color, tends to detach itself from the looser, more three-dimensional rendering of the cathedral and the space it occupies—it displays a remarkable grasp of Fauvist innovations.

We shall probably never know in detail the exact course of Saÿen's development during his years in Paris, for many of the pictures of this period have been lost. But the pictures at hand suggest that, in this endeavor no less than in others, Saÿen was not only quick to understand the essentials but gifted with the ability to bring that understanding to a rapid realization on the canvas. The paintings of the Paris years—Fauvist figures, still lifes, and cityscapes—culminate in the very beautiful "Trees" (1912–14), a picture certain to win a place in future museum surveys beside the work of Marin, Hartley, and Maurer.

The single most impressive series in the show, however, consists of the Fauvist landscapes Saÿen executed in the Pennsylvania countryside during the war years. It is in these paintings that color really comes to dominate his painting. The drawing is often very sketchy—a mere scaffolding for a structure of pure color. The artist seems at his freest in these paintings, and they boast a lyricism and élan that distinguish them from the rest of his *oeuvre*.

In the last two years of his life, Saÿen's work suddenly took a new turn, moving from an essentially Fauvist to an essentially Cubist orientation. It's odd, of course, that a man of Saÿen's sophistication should have held off so long from the attractions of Cubism, but now he set about repairing this delay with two remarkable conceptions, "Daughter in a Rocker" (1917–18) and the two versions of "The Thundershower" (1916–18). The small earlier version of the latter is executed in a combination of collage, tempera, and pencil; the larger version is painted in tempera on plywood. Both are extraordinary, and, like "Trees," certain to have a permanent place in our art history. The authority, invention, and wit that Saÿen brought to this new style suggest the presence of an artist who was only beginning to realize his true powers.

But alas, he was dead at the age of forty-three. It is painful to reflect on the loss that Saÿen's premature death represents to American art. He was clearly a figure from whom one might have expected almost anything.

October 11, 1970

7. Man Ray's Self-Portrait

The lives of some artists take on, in retrospect, a quality of myth, less because they dominate their environment than because they are dominated by it. Such artists tend not to be the strongest or most original personalities of their period, and their work is perhaps less an expression than a symptom of the experience on which it was formed, but they come nonetheless to represent something essential about a style and its period just because they were so responsive to its inner momentum and so little concerned to impose any decisive vision of their own on the direction it was taking. Their principal gift seems to consist of a cheerful ability to submit to new aesthetic currents without encountering the least resistance from their own

personal culture or beliefs, an ability perhaps to dispense with personal culture altogether and commit their energies without hesitation to the new ideas of the moment.

Among the first generation of modern artists in America—those who came of age at the time of the Armory Show and who thereafter, whether they managed to live there or not, looked to Paris as the art capital of the world—Man Ray is notable both for the speed and vigor with which he adopted the most radical stylistic innovations and for the nonetheless rather dim impression his long career has left on modern art as a whole. He was one of the few Americans who really entered into the spirit of the original Dada movement, and he afterward participated in the great Surrealist escapades of the 1920's and 1930's in Paris. Yet his work has remained more interesting for its historical and documentary character than for its intrinsic artistic distinction. And now, with the publication of his memoirs, his life, too, is stamped with this quality of period mythology without ever quite establishing itself as a credible reality.

Man Ray's career has indeed been amazing, and it is of a kind that many other artists (not only in America) must have yearned for and yet scarcely dared to realize—a career given over almost entirely to avant-garde ideas and bohemian pleasures. As set down in these memoirs, his life unfolds as a paradigm of what still passes in popular fantasy as the characteristic biography of the modern artist, a life well supplied with beautiful girls, bright celebrities, outrageous (but somehow successful) ideas, and delightful scandals. If at times it all seems too good to be true, it may be that the world—the art world no less than the humbler purlieus—has become a duller, grayer place in the interim. Or it may be that Man Ray shows a remarkable inability to recall anything but the most delightful and historic moments (the moments he, at least, regards as delightful and historic) out of his own past. Like many avowedly "frank" autobiographies, his *Self Portrait** remains oddly reticent behind its gay display of history, gossip, and self-revelation.

Born in Philadelphia in 1890, Man Ray grew up in Brooklyn, attended art school in Manhattan (Henri and Bellows were among his teachers), and drifted very early into the typical life of the young and aspiring artist in New York at the turn of the century, a life of dull jobs (mostly in commercial art), high ambition, and

* Boston: Atlantic Monthly Press, 1963.

narrow culture. His meetings with Stieglitz and then Marcel Duchamp marked the crucial turning points in his development. Both served to liberate him from his parochial background and training by opening up the world of modern European art for the first time. Stieglitz's importance was twofold; he was both the first to show the modern art of Europe in New York, even before the Armory Show, at his "291" gallery, and he was also a pioneer in promoting a far loftier view of photography as a fine art than was then common even in advanced artistic circles. His magazine, *Camera Work*, was a good deal more elegant than the art periodicals of that time (or of this). In both respects Stieglitz's influence had a lasting effect on the career of Man Ray, whose view of art has remained throughout his life that of a committed and narrow modernist—he notes in this book that he lived in Paris for years before venturing into the Louvre—and who has long divided his artistic interests between painting and photography.

His *Self Portrait* is, in fact, full of nervous references to this division of interests. Alternatively boastful and deprecating about his accomplishments in photography, uneasy that his readers might either underestimate his photographic work or, even worse, praise it at the expense of his painting, he seems never to have completely accepted the photographic medium in his own mind as an art really equal to painting. Yet he can be ludicrously adamant—as he is repeatedly in these memoirs—in attacking unnamed critics who have sensed this equivocation in his work. By his own account, he took up photography more as an economic than as an artistic activity. When his painting grew more unconventional under the influence of Dadaist ideas, and sales became fewer and fewer, he came to rely entirely on portrait photography for his living. Once involved, he experimented a good deal, making photographic abstractions and eventually producing some Dadaist movies, but as a photographer his fame derives almost entirely from his work as a portraitist of cultural celebrities.

If his encounter with Stieglitz bequeathed to Man Ray this double interest in modernist painting and photography, his encounter with Duchamp was undoubtedly the single most decisive event in his life as an artist. He met Duchamp in America shortly after the latter's "Nude Descending a Staircase" had caused a sensation at the Armory Show. By that time Duchamp had already turned his back on the Post-Impressionist and Cubist styles he had prac-

ticed in Paris. He was about to give up the practice of art altogether, but for the moment was deeply involved in his last artistic productions—machines and ready-made industrial objects, which, under the stimulus of Dadaist notions, were taken to have superior aesthetic value just because they had not been created as works of art.

For Man Ray—and for many later exponents of this anti-art position—the problem lay in how one could effect an artistic production while remaining loyal to a philosophy that seemed to preclude the whole idea of producing art. Man Ray's solution was the one that all artists of this persuasion have followed ever since. He adopted many of the formal ideas that had been worked out in more conventional painterly styles and executed them in unconventional materials, mainly the materials he had learned to use as a commercial artist. As an artistic innovation it was fundamentally superficial, a matter of surface effects rather than formal invention, but it caused a sensation at the time—and it still does.

When Man Ray arrived in Paris on Bastille Day, 1921, Duchamp met him at the station and immediately installed him in a hotel room just vacated by Tristan Tzara, the high priest of Dada. Thereafter, for two decades, he moved in the dazzling aura of the Dadaists and Surrealists and the wealthy bohemians and aristocrats who patronized their famous high jinks. He knew everyone and did everything, and yet it all somehow remains rather dim in his own account. Here is a man whose intimate friends for decades have been Picasso and Duchamp, a man whose artistic companions for years comprised some of the most brilliant and original French poets of modern times, and who yet writes his autobiography in a style more suitable to the memoirs of the retired president of some chamber of commerce. Though his heart belongs to Dada, his *Self Portrait* belongs to the conventional genre of self-important memoirs by celebrities who have "made it" historically. As a document, it is not without interest, but as with many of Man Ray's works, the interest is only historical—a symptom of the times they summarize rather than a genuine expression of them.

May 9, 1963

8. Arnold Friedman: "He Is Not a Pleasant Painter"

It is the fate of certain artists to remain difficult forever. The work they produce seems to resist easy appreciation no matter what changes take place in the aesthetic weather. It fits into no quickly apprehended historical slot. It carries no obvious label. Its quality cannot be instantly communicated to a public whose permanent characteristics are a short memory and a lack of discrimination. Such work tends to remain the special taste of a very few, keeping its distance from the kind of éclat that is indispensable to celebrity.

Consider the case of Arnold Friedman, an American painter who died in 1946 at the age of seventy-four. His pictures (though not a great many) are in the museums. Certain critics have paid him homage. From time to time he is represented in a period exhibition—as he was earlier this season in the Whitney Museum's survey of the thirties. But consult the latest text in which one might reasonably expect to find an account of his work—Barbara Rose's *American Art since 1900* (Praeger, 1967)—and what do you find? He is mentioned on page 94 in the following sentence: "By 1928, abstract color volumes were the formal basis of the work of Joseph Stella, Arnold Friedman, Alexander P. Couard, and Arthur B. Davies, although it should be emphasized none of these artists was officially a Synchromist." That's all.

Friedman himself had a comment for this sort of thing: "The file clerks who call themselves aesthetes are unhappy until they tag a work and file it away." He was used to having his work mishandled in this manner. The fact is, Friedman went on painting until the end of his life, and his later works are undoubtedly his most important. But there he is in Miss Rose's textbook, filed under "Synchromism, influence of."

The exhibition of Friedman's work at the Egan Gallery tells another story. This is not, I regret to say, the large retrospective exhibition that Friedman's achievement calls for. But the show gives us, at least, an opportunity to glimpse his quality once again. There are pictures in different styles, from different periods of his development. Some of them look as if they could use a cleaning, but with Friedman one cannot be sure—he often employed a gritty surface

that discouraged optical brilliance. In any case, his unmistakable quality is there to see for anyone who cares.

The principal source of his mature style was, as Friedman himself acknowledged, Impressionism, but he carried his work to a plateau of feeling far removed from the orthodoxies of that style. Certainly his own later pictures could never be confused with the productions of the Impressionists themselves. He was no pasticheur. He transformed the hedonism of Impressionism into something drier, harsher, more puritanical. He was a rigorous designer, and he was willing to sacrifice much in the way of superficial felicity and brilliant effects to achieve his goals. The whole side of Impressionism that suggests, to the modern eye, the sheer indulgence of the pleasure principle was completely alien to Friedman's vision.

What he derived from Impressionism was a certain pictorial logic—a gentle flattening of pictorial space, an evenness of texture, a reliance on subtle modulations of color instead of drawing. In a happier climate of feeling, he might have been another Bonnard. There is a similar tendency to convert observations of the commonplace into the logic of a flat design. There is a comparable attempt to carry Impressionism in the direction of abstraction while refusing, in the end, to go over into abstraction. What separates Friedman from Bonnard—and the whole milieu Bonnard represented—was the latter's sense of *volupté*. Everything about Friedman's life and work was exceedingly grim, and this grimness became an essential feature of his sensibility. His art suggests what his biography confirms: that Friedman could never permit himself any idle margin of pleasure. There is thus a dogged quality in his art, a patience and determination that would be merely poignant if the artistic results were not so strong, so emphatic, so plain-spoken.

But strong they are. The "Landscape in Green and Brown" especially, but also such pictures as "Bicycle Path" and "North Drive—Grand Central Highway"—these and other late works in the Egan exhibition make much of the painting by Friedman's more celebrated American contemporaries seem mere trifles of facility, fashion, and ineptitude. He was the real thing, and he knew it—despite the harrowing adversities that made his life as an artist one of the saddest chapters in our history.

For behind these dour masterpieces was a life characterized by unrelieved hardship and dedication. Friedman came to his vocation

very late; he did not begin to study art until he was thirty-two. When, at that age, he enrolled in Robert Henri's class at the Art Students League, he had been a clerk in the New York Post Office for fifteen years. He continued in that job until his retirement on a meager pension in the thirties. In his teens he had been the sole support of his mother and her three younger children; later he had a wife and four children of his own to support, having married at the age of thirty-seven. The exigencies of his existence gave rise to the fiction of his being some kind of "primitive" Sunday painter, a myth he endured with caustic irony. He was in his fifties before he had his first one-man show at the Bourgeois Galleries.

About his life Friedman once wrote: "The post office? It was one way, probably a lame way, of ducking the cadging, pettifogging, lick-spittling course exacted from the artists by the American collectors and dealers, with the few exceptions which are cheerfully granted." He knew, in any case, that he would never be popular. A reviewer of his very first exhibition had remarked (correctly, I think): "He is not a pleasant painter," and the judgment still has merit. But he was completely serious; he knew what the essential task was, and he had neither the leisure nor the temperament to avoid it.

March 23, 1969

9. Charles Sheeler: American Pastoral

The career of Charles Sheeler traces a complex course—more complex, in fact, than the art that resulted from it. In his life as an artist, Sheeler touched most of the major points on the compass. He was, first and last, a convert to Cubism. He was deeply responsive to the aesthetics of machine technology. Early on, he was in touch with Duchamp and Dada and the whole Arensberg circle. He had a keen appreciation of folk art, particularly folk architecture, and understood their relevance to modern art. He was an accomplished photographer—even more accomplished as a photographer than as a painter—and did not hesitate, from the beginning of his work in that medium, to make audacious use of photographic form for

purely pictorial ends. He moved a good deal in the worlds of com-
merce (including art commerce) and industry, and he was a very
successful illustrator. He had been quick to grasp the significance of
the Paris avant-garde, and he succeeded in making something very
American out of what he borrowed from the canon of Parisian
modernism. From these advanced interests and variegated skills, he
forged a style unmistakably his own.

Yet the art he produced was never as large as the vision which
animated it. No doubt this discrepancy—a familiar one in the
American art of his generation—owes much to the practical circum-
stances in which Sheeler worked. Disinclined to bohemianism, he
was never the sort of artist who sacrificed the material comforts of
life to the service of an impossible artistic ideal. He did what he had
to do—art dealing, photography, commercial art—to make a living.
There is a caution in Sheeler's work—a taste for the respectable—
that may be traceable precisely to the kind of living and to the style
of life he chose for himself. But the sources of the discrepancy lie
even deeper, I think. They lie in the very nature of his vision. There
was something about this vision—a fundamental innocence, a re-
fusal to be difficult—which inhibited some ultimate accommodation
of all the impulses and contradictions of which it was composed.

Sheeler was born in Philadelphia in 1883. He was trained first
in the School of Industrial Art (1900–3) and then in the classes of
William Merritt Chase at the Pennsylvania Academy of the Fine
Arts (1903–6). He was thus disposed, from the outset, to function
both as a commercial artist and as a fine artist. This was a common
situation for many American artists of the period. What was uncom-
mon, in Sheeler's case, was the degree to which this division of
aesthetic labor persisted. Indeed, it more than persisted—it pre-
sided. It determined much of the subject matter—no small issue for
Sheeler—to be found in his "serious" art. It determined his reliance
on illustration. In the end, it sealed his allegiance to a certain mode
of visual romance.

For Sheeler was a romantic in the American grain. Those
Bucks County barns were yet another up-to-date avowal of the
pastoral ideal. Cubism helped strip the subject of stale associations,
facile emotions, the old conventions. The romantic trappings of an
earlier generation—all those virtuoso painterly effects so patiently
mastered in the classes of William Merritt Chase—were displaced by
an immaculate geometry imported from Paris. But Sheeler's Cubism

is not a language of pictorial invention. It is an aid to illustration. The picturesque is not abandoned, it is only revitalized. It is adjusted to a new vocabulary. It is made palatable to the modern sensibility, but does not make any new demands on that sensibility. Sheeler was a master at domesticating the hard conceptual core of Cubist form to the specifications of a softer, more parochial vein of taste. The taste is folkloric. The appeal is to sentiments and standards of a simpler world than our own—in other words, to a myth. What is modern in Sheeler's art is made to serve the interests of what is traditional, homely, and cozy.

The folk architecture of Bucks County, with its simple lines and muted colors and its own very gentle geometry perfectly attuned to a very gentle landscape, was an ideal subject for a native son whose eyes had been instructed by the aesthetics of Cubism. These structures—particularly their interiors—were themselves a kind of folk Cubism. Sheeler seized the opportunity to synthesize these disparate but harmonious materials and made something memorable of them—though less for their high pictorial quality, perhaps, than for the quality of their feeling. An element of nostalgia was combined with an element of modernity. The past was discreetly, even poetically, evoked in the name of an aesthetic grammar that seemed, in Sheeler's hands, only an extension of the old verities. Cubism was made to serve an almost antiquarian function.

This may seem to us an ironical aspiration, but Sheeler's art is itself devoid of irony. The pastoral sensibility shuns the ironical—everything in Sheeler is "straight." He thus stands at the farthest possible remove from Dada. No doubt the very conception of a picture like "Staircase, Doylestown" (1925) owes a great deal to Duchamp's "Nude Descending a Staircase," but the borrowed structure answers to another order of fantasy. All the sentiments are changed. The nude would be as unthinkable as a joke, and jokes about nudes would be as shattering as an act of violence. Indeed, they would be an act of violence. We are on puritan terrain. There is a history to be written of the influence of the Protestant mind on Cubist aesthetics—on what happened to Cubism when it was removed from Paris to the colder climates—and Sheeler would have a place in that history.

For Sheeler, the city is as innocent as the countryside. Skyscrapers, too, are a version of pastoral. The machine is assimilated to the folkloric sensibility. Not even the massive impedimenta of

modern industry can break the precious thread of continuity with the emotions of the past, but the result is a decided increase in the fantasy quotient. Railway sidings, locomotives, factories are rendered with the fastidious tact and precision one had supposed were developed for the more intimate forms of early American houses and their artifacts. But for Sheeler the differences do not matter. The barn and the factory, the hearth rug and the skyscraper, the still life and the smokestack—they are all figments of the same dream. In the end, they are all still life. They are all immaculate and innocent. They are all acquitted of having any difficult or complex relation to experience. In fact, they are depicted as existing outside the realm of experience—untouched and inviolable.

The purity of it all nags after a while. It ceases to be a discipline and becomes a formula, an indulgence, a form of artifice. The paintings decline, so to speak, into design. The response to every subject is too well practiced, the fantasy too susceptible to sentimental solutions. Sheeler was very responsive to historical currents. In the beginning, when Cubism was a challenge, this responsiveness was a source of strength. The problem of adjusting modernist vocabularies to American subjects, the very newness of the enterprise and the seriousness with which the problem dominated every advanced quarter of the arts in this country—all this brought out the best in Sheeler. He was, fundamentally, an artist of the teens and the twenties—every accomplishment of his later years (he died in 1965) looked back to the period of the First World War and the decade that followed. The thirties weakened his art considerably. The outlook of the American Scene painters, the general air of nativism, the taste for regional evocations—these and other currents of the period tempted him into self-parody. He began then, and continued after, to underscore what was meretricious in his art. Only his photographs remained immune to the general decline. As a photographer, Sheeler kept faith with the values of the Stieglitz era. The quality of his photographs continued to be consistent—and consistently high—to the end. It is a paradox of Sheeler's career that photography freed him from the excesses of illustration. It vouchsafed the purity of his vocation. Generations hence, it will be the photographs, together with the early pictures, that will guarantee his reputation.

January 1969

10. The Return of John Storrs

John Storrs is one of the most interesting American artists of the twentieth century—certainly one of the most accomplished sculptors of his time. He was once recognized as such, too, receiving public commissions both in this country and in France (where he lived much of his adult life as an expatriate) as well as enthusiastic attention from the *Little Review* and other avant-garde publications.

When he showed his sculpture in New York in the twenties, first at the Folsom Galleries (1920) and then at the Société Anonyme (1923) and the Brummer Galleries (1928), the critics recognized that Storrs had already achieved something important— an audacious style in which the formal innovations of Cubism were combined with pure color to produce polychrome abstract sculpture of remarkable originality. Yet when Storrs died in France in 1956, he was virtually unknown to an art public busily congratulating itself on American achievements.

Storrs was born in Chicago in 1885. He studied art in Berlin and Paris in 1907–8, and then attended art schools in Chicago, Boston, and Philadelphia for two years before returning to Paris. After two years at the Académie Julian, he worked with Rodin for two years, 1912–14, and was said for a time to be the master's favorite pupil. When Rodin died, Storrs was chosen by the sculptor's family to do a drawing of the master on his deathbed.

We know little of the work Storrs created during this Rodin period, but he was certainly not one of those artists whose talents wither in the shadow of a master. As early as 1914, apparently, Storrs turned to Cubism for the matrix of his own sculptural style, and after the war he followed through with an amazing energy and conviction, moving in and out of abstraction and figuration, creating forms quite unlike anything else to be found in the sculpture of the twenties.

In the thirties, Storrs also painted a good deal—my impression is he turned to painting when he was away from his sculpture studio—and throughout his career he was prolific in the graphic media. His paintings—most of them abstractions of one sort or another—have the boldness and precision one sometimes finds in sculptors' paintings. They are at once illustrations of sculptural ideas and strong pictorial images in themselves. Together with

Storrs's marvelous drawings for sculpture, they constitute an essential part of his *oeuvre*—an *oeuvre* that future histories of American art in the period between the two world wars will now be obliged to make ample space for.

In 1965 and again in 1967, the Downtown Gallery mounted exhibitions of Storrs's work—the first was devoted to sculpture, the second to paintings—which, for some of us, were a dazzling revelation of an accomplishment we had never heard of. Now the Schoel-kopf Gallery has organized a large exhibition that includes selections of sculpture, paintings, drawings, and graphic art. There are nearly fifty items in all. The show is at once a great pleasure and a great frustration. The pleasure is in seeing so much of the work of an important artist rescued from the shadows; the frustration is in realizing how partial and fragmented our knowledge of this artist's work remains.

Storrs's work belongs, as I have suggested, to the aftermath of Cubism, but it carries the Cubist aesthetic into some interesting and unexplored terrain. There is, first of all, a strong attachment to the flat patterning of Art Nouveau design. At the time of the Folsom exhibition in 1920, Henry McBride noted the influence of the "Viennese Secessionists" on Storrs's sculpture, and it is true that the carved and painted planes of certain sculptures still carry the distant echo of Klimtian décor, but Storrs was also strongly drawn to the formal aesthetics of the machine, and there is thus a Futurist, or at least a Boccionian, element in his work. Art Nouveau plus machine art plus Cubism equals, according to some calculations, what is now called Art Deco, and sure enough, Storrs's work has already been taken up this season by the Art Deco fad. But his work should not really be confused with the Pop Cubism of what was essentially a bourgeois style of interior decoration. To mistake Storrs's art for a species of "camp," which is what the Art Deco revival comes down to, is to misunderstand him completely.

The function of Art Deco was to popularize the language of modernism (especially Cubism) for the general public and make it an easily assimilable and salable commodity. In both senses of the word, Art Deco was a "vulgarization" of modernism. Storrs, however, belonged to a generation of sculptors for whom the greatest challenge lay in re-creating the art of sculpture on modernist premises —in satisfying both the standards they derived from Rodin and the new vision they gleaned in Cubist form. Storrs, in one sense,

remained more faithful to Rodin than others of his generation, for he remains faithful to the sculptural monolith—unlike the Constructivists, who saw in Cubism the means of opening up sculpture and making it a structure of space itself. Perhaps the example of Brancusi supported him in this loyalty; it would be interesting to know what, if any, contact Storrs had with Brancusi.

But Storrs's vision was animated by a sense of dynamism different from Brancusi's, and it was this sense of dynamism, of movement from plane to plane, that his introduction of color into the sculptural process was designed to serve. Picasso, Laurens, and others had already experimented with the use of color in Cubist sculpture before Storrs, but not in the same way. There is no suggestion of collage or construction—none of the syntax of joinery—in Storrs's polychrome sculpture. In his work, color is the means by which the planes of the mass are articulated; color does not "dissolve" the volumetric nature of the mass, but on the contrary, expresses it and gives it a new sculptural definition.

The exhibition at Schoelkopf is short on this important aspect of Storrs's achievement, but the exhibition is an event in any case. We are only at the beginning of our rediscovery of this artist, and the current show adds significantly to our knowledge of his work. The pencil drawings and silverpoints give us a wonderful glimpse of the sculptor's imagination at work; Storrs was a superb draftsman. And the paintings, too, especially those that are explicitly given over to sculptural conceptions, are a revelation. What we need now is more research into the history of this neglected figure and, eventually, a large museum show that will give us a view of his accomplishment in its totality.

December 13, 1970

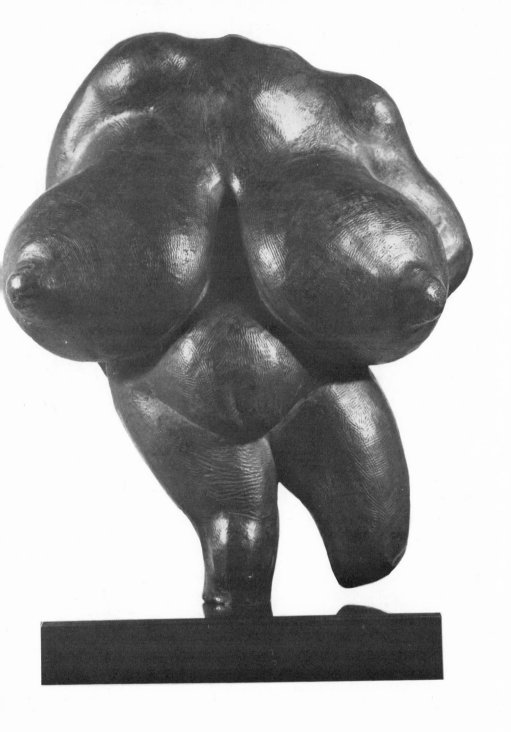

GASTON LACHAISE: *"Torso"* (*1928*)
Bronze, 9½″ high

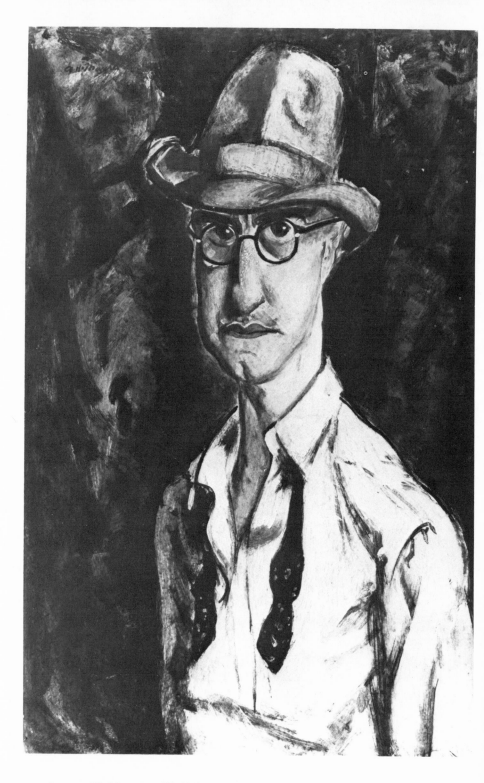

ALFRED H. MAURER: "*Self-Portrait*" (*c. 1927*)
Oil on board, 39 × 23⅞″
COLLECTION, WALKER ART CENTER, MINNEAPOLIS, MINNESOTA

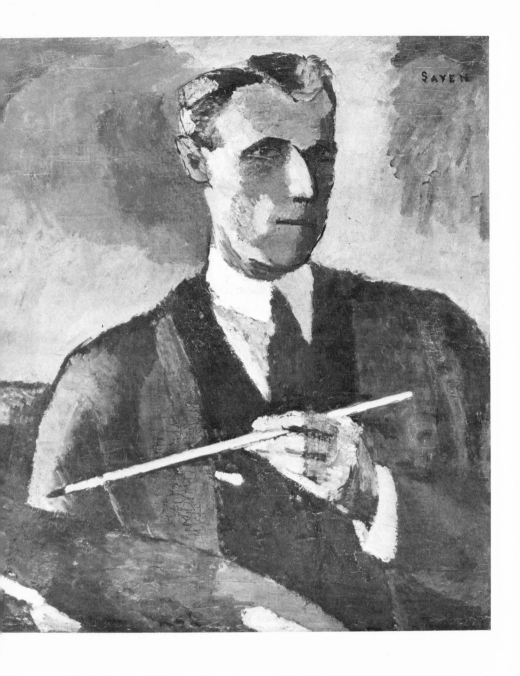

H. Lyman Saÿen: *"Self-Portrait"* (1910–13)
Encaustic on canvas, 27¾ × 24″

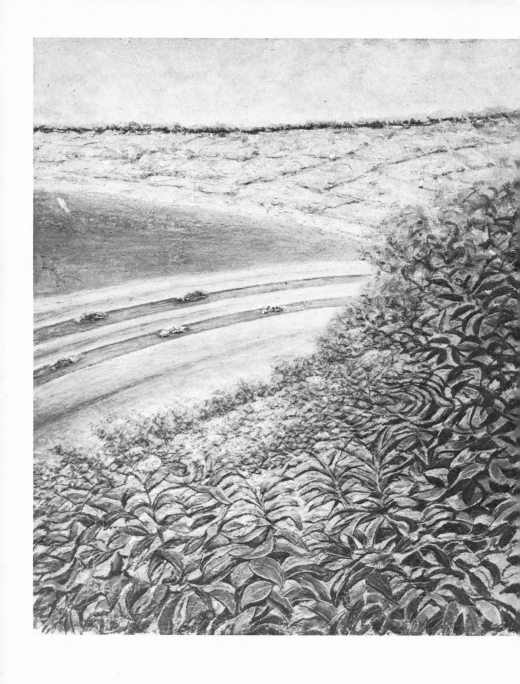

ARNOLD FRIEDMAN: "*North Drive—Grand Central Highway*" (*1940*)
Oil, 24 × 20″

PHOTOGRAPH BY O. E. NELSON, COURTESY EGAN GALLERY, NEW YORK

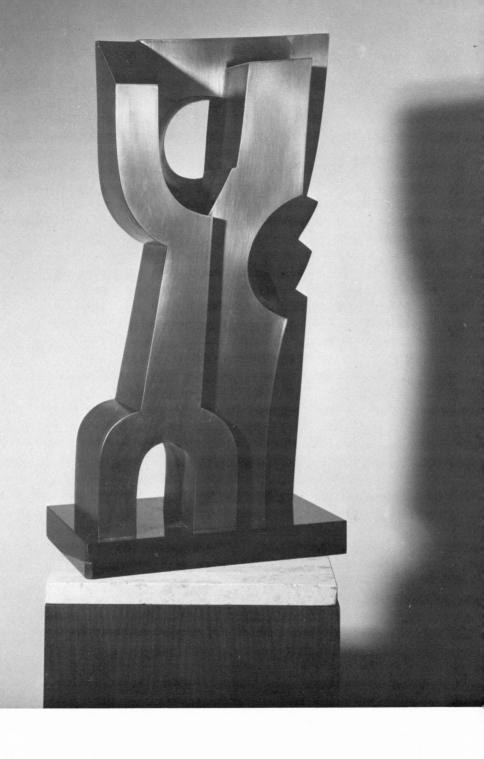

JOHN STORRS: *"Composition around Two Voids"* (*1932*)
Metals in combination, 21″ high
PHOTOGRAPH BY ARTHUR SIEGEL, COURTESY DOWNTOWN GALLERY, NEW YORK

JOHN GRAHAM: *"Self-Portrait"* (*undated*)
Oil drawing, 16¾ × 13¾″
COLLECTION, STEPHEN PAINE. PHOTOGRAPH BY ERIC POLLITZER, COURTESY
ANDRÉ EMMERICH GALLERY, NEW YORK

(*opposite above*)
ARSHILE GORKY: *"Summation"* (*1947*)
Oil, pastel, and pencil on paper, 6′ 7⅝″ × 8′ 5¾″
COLLECTION, THE MUSEUM OF MODERN ART, NEW YORK.
MR. AND MRS. GORDON BUNSHAFT FUND

(*opposite below*)
MILTON AVERY: *"Tangerine Moon and Wine Dark Sea"* (*1959*)
Oil, 60 × 72″
COLLECTION OF MR. AND MRS. DAVID LLOYD KREEGER. PHOTOGRAPH BY
CARL KOSKI, COURTESY ITHACA COLLEGE MUSEUM OF ART

SAUL BAIZERMAN: *"Enchantment"* (*c. 1936*)
Hammered copper
PHOTOGRAPH BY OLIVER BAKER, COURTESY ZABRISKIE GALLERY, NEW YORK

11. The Legendary John Graham

Of some artists it can truly be said that their legends act as an actual safeguard of their accomplishments, shielding them against the vagaries of taste and those bourselike fluctuations of value that characterize the utterances of critics no less than the enthusiasms of the public. Artists who enjoy legendary status, especially among the cognoscenti, remain exempt from the usual ravages of fickle opinion.

This has certainly been the case with John Graham (1881–1961), one of the oddest and most exotic figures in the art of our time. There is every reason why Graham's paintings and drawings—the two genres have almost equal status in his *oeuvre*—should have fallen into complete oblivion. For decades he pursued a pictorial iconography that defies definitive explication. Moreover, the two dominant motifs of this iconography—those lovely ladies with crossed eyes and Graham's own unforgettable self-portraiture—are rendered in a style markedly at odds with prevailing aesthetic dogma.

Graham adhered to a very classical draftsmanship which he often embellished with signs, symbols, and mysterious legends. There are elements of de Chirico and Picasso in Graham's style, and even at times a suggestion of the debased Romanticism of Eugene Berman, together with powerful evocations of Ingres and of Ingres's beloved master, Raphael. None of this exactly adds up to a formula of up-to-date taste, and didn't during the years Graham was working. Yet he made of this curious pastiche of outmoded styles and personal obsessions something very personal, haunting, and intense.

The exhibition of Graham's work at the Emmerich Gallery affords a generous glimpse of these paintings and drawings of women and his self-portraits, together with some pictures of Russian soldiers, harlequins, and other subjects executed in a plainer, less embellished, but more vividly designed manner. It is, all in all, an absorbing show that enlarges our understanding of the artist at the same time that it places his art in a more meaningful relation to his legend.

The legend itself derives mainly from two aspects of Graham's life: his origins in pre-revolutionary Russia, where, after taking a law degree, he was a cavalry officer in the czar's army and escaped to France after the Bolsheviks seized power; and his unusual role in

the American art world of the 1930's. Graham (whose real name was Dabrowsky) came to this country in the twenties, studied with John Sloan at the Art Students League and subsequently became for certain American artists—particularly Gorky, de Kooning, and David Smith—an important link with the Paris avant-garde, which Graham knew firsthand. (He once gave Smith a small sculpture by Gonzalez.) In 1937, he published a philosophic treatise, "System and Dialectics in Art," of interest now primarily because of its early recognition of de Kooning's and Smith's artistic stature.

Technically, Graham belongs to American art—he married an American girl and became an American citizen—but he remained an aristocratic exile and cosmopolite, and lived his last years in Paris. It is doubtful that anyone will ever be able to write the complete story of his life, so numerous (and so dubious) are the tales of his interests and exploits, and so few the reliable witnesses and documents.

The present exhibition does underscore, however, the principal paradox of Graham's career, the paradox in which his art and his legend are joined: the fact that his own aesthetic position drifted further and further away from the practices of the avant-garde about whose innovations he was both an evangelist and a connoisseur. The most important works in the Emmerich exhibition—*"Poussin m'instruit"* (1944), "Celia" (undated), and "Kali Yuga" (1950), among the paintings, and *"Venere Lucifera"* and the most complex of the self-portraits (No. 9 in the catalogue), among the drawings—place Graham in a special group of modern artists, a group that can only be designated as apostates of modernism. Thus, while his legend confers on Graham a pivotal position in the latter-day development of the modern movement in this country, his art shows us the depth of his own disenchantment.

Clearly, the direction that modernism was taking in the last decades of his life—a direction that precluded the kind of fantasy and symbolism that became Graham's obsession—could not accommodate the pressure of his own imagination. Graham opted out of the modernist adventure in order to pursue his private dream of an art that would make of his own private iconography something as classical and exalted as the style of Raphael.

It was too late, of course. The romance he carried on with the classical past yielded him an art only more eccentric and more per-

sonal but no less romantic than that of the modernists who pursued a steadier forward-looking course. The apostasy of a sensibility as deeply immersed in the strategies of modernism as Graham's could only produce a variation—in this instance, an immensely interesting variation—on the modernist dilemma.

In that sense, Graham's legend—with its extravagant mixture of a romantic past and a shrewd grasp of the present—represents his art more accurately than many of us had supposed.

May 29, 1966

12. Walkowitz

The exhibition of watercolors by the late Abraham Walkowitz at the Zabriskie Gallery is drawn entirely from the years 1900–20. It thus focuses on a pivotal period in American art—the years before and after the Armory Show of 1913 when the younger generation of advanced and ambitious artists was caught up in the romance and excitement of modern city life, especially the life of New York, and yet felt obliged to look to Europe for the most appropriate forms for dealing with its own experience.

American artists who came of age at the turn of the century faced a cruel dilemma. A new and quintessentially modern civilization—a civilization in which speed and mechanization were already effecting a radical change in sensibility—was rising in their midst. America seemed to be in the vanguard of this new style of life, at least so far as technology was concerned, but the official aesthetic arbiters of that period were adamant in refusing to allow the least evidence of this new civilization to enter the public arena of the arts. Like the poets and novelists who found it easier to tell the truth about American life if they not only adopted the aesthetic principles of their great European predecessors but actually did their work

abroad, American painters often found that their commitment to the new spirit of American life required them to become expatriates of one sort or another.

Walkowitz was one of these painters who committed themselves very early to the modernist spirit, and thus had to look abroad for the means by which to realize it in their own work. While still in his teens, in the 1890's, he worked in the elegant, romantic style of Whistler—the very archetype of the expatriate American modernist —producing oils and etchings in the mode of the master. But the first flowering of Walkowitz's talents came with his trip to Europe in 1906. In Paris he studied at the Académie Julian. He saw the great Cézanne exhibition of 1907—the Zabriskie exhibition includes a very beautiful watercolor of the village at Anticoli Corrado, near Rome, painted by Walkowitz in 1908 and clearly incorporating the lessons of Cézanne's radical watercolor style—and responded with enthusiasm to the revolution in pictorial form that had already overtaken French art and would shortly transform painting everywhere.

What makes this exhibition something of a revelation, however, are the paintings Walkowitz did in New York after his European sojourns. There are, first of all, five abstract watercolors from the years 1909–12—paintings that can take their place alongside the most radical early works of Kandinsky and Delaunay and Stanton MacDonald-Wright. Historians will no doubt have their hands full disputing and/or establishing the dates of these pictures, for they would seem to place Walkowitz among the pioneers of abstract art—a position that his general artistic temperament, which strikes one as that of a follower rather than a leader, prompts one to question.

All the work in the Zabriskie exhibition is taken from the immense early *oeuvre* Walkowitz left in his studio when he died last year, and the question of its exact chronology is further posed by the fact that his effects also included a well-worn copy of the first German edition of Kandinsky's treatise, *On the Spiritual in Art*, published in 1912. But whether these abstractions are eventually found to be correctly or incorrectly dated, the fact remains that Walkowitz was certainly among the earliest exponents of a lyric abstract style and—just as certainly—was, like so many of his American contemporaries, a fickle votary of the new aesthetics of abstraction. He very shortly gave it up for what looks, to American

eyes anyway, like a more self-conscious effort to apply the lessons of European modernism to the specifications of the American scene.

For the bulk of the Zabriskie exhibition consists of a group of city scenes, from the period 1912–18, in which the momentum of New York life is given a most poetic and persuasive form. The crowds and skyscrapers, the romance of the Brooklyn Bridge, and the peculiar light of New York at night—these and other visual aspects of the New York scene enabled Walkowitz to bring to bear all he had learned from the modern movement in Europe on a subject in which his emotions were already deeply engaged.

It was in these city scenes—a freer and more Expressionist version of material that most of us know from the watercolors of John Marin—that Walkowitz healed, for a time, the split between European aesthetics and American experience that every American artist of his generation was obliged to confront. Still, like the lyric abstractions that preceded them, they never became a firm base on which the artist could build his future work. In later years, Walkowitz could not bring the same pressure and excitement to his art. He became—even before blindness made the final years of his life a tragedy—another casualty of our aesthetic history.

May 8, 1966

13. Edward Hopper: An American Vision

Edward Hopper has long been a living classic of American art. This is not always the happiest fate for an American artist. Often it means only that a lucky formula was hit upon early in a career that was thereafter sustained by a ready audience. The history of American art is strewn with the corpses of artists whose success, won through the clever and persistent rehearsal of a single theme, masks

a terrible paucity of energy and ideas. Yet in the case of Hopper, whose work is certainly not lacking in formulas and repetitions, this classic status has been well earned and looks assured for the future. The current retrospective exhibition of his work at the Whitney Museum confirms him as an artist of unique, if narrow, vision—a vision that bequeaths little to the aesthetics of painting but which nonetheless penetrates American experience with a particularly incisive eye.

The Americanness of Hopper's art is by no means fortuitous. It is a quality the artist has consciously pursued. Those dazzling bravura flourishes that were once the standard export of French painting and that, in Hopper's youth, were still the distinguishing marks of high style among his ambitious coevals, are nowhere to be found in his own mature art. Hopper mastered this French manner very early, as the succulent surfaces of two pictures at the Whitney—*"Le Pavillon de Flore, Paris"* and *"Le Quai des Grands Augustins, Paris"* (both 1909)—make unmistakably clear. But from the twenties onward, he deliberately and painstakingly expunged this alien elegance in the interests of a native subject matter—and a native emotion—which the prevailing Gallic pastiche could hardly accommodate.

In the decade following World War I, Hopper settled on a vein of imagery that has been his special glory ever since. Recognizably American in its architectural and landscape subjects and in the character of its urban desolation, this imagery has established a repertory of scenes and motifs—the lonely, nocturnal glimpses of nearly deserted restaurants, theaters, and hotel rooms; the white clapboard houses and fantastic nineteenth-century mansions of New England, with their peculiar geometry of mansard roofs and dormer windows—which are now among the standard visual archetypes of our native imagination. Without investing it with false heroics or inappropriate rhetoric, Hopper raised this imagery to the level of poetry, where it stands free of both easy sentiment and facile historical encumbrances.

To effect so confident a transmutation of commonplace materials, Hopper developed a style remarkably dry, dispassionate, and plainspoken in its visual effects. At the center of this style is an obsession with light—the natural light of the sun as it defines the broad planes and geegaw oddities of old houses, and the cold,

artificial light of the modern city as it isolates moments of boredom, loneliness, and private ennui. Parker Tyler once spoke of Hopper's method as "alienation by light," and it is indeed this obsession—and his characteristic ways of accommodating it to the diversity of his subjects—that confers a vivid consistency on everything Hopper has produced in the last four decades.

He approaches the composition of a painting rather as a theatrical director might set the scene of a play. The specific *mise en scène* is selected—the lunch counter or filling station late at night, the hotel room early in the morning, the many-angled clapboard structure in the afternoon sun—and is then drawn in such a way that the crux of the pictorial drama consists almost entirely of the play of light and shadow in the scene depicted. Details are minimized and broad optical contrasts boldly emphasized in order to secure a maximum visual power from a relatively few pictorial elements.

It is Hopper's skill in shifting the center of expressive gravity away from the sheerly anecdotal and onto this more purely visual drama of light and shadow that keeps his art from falling into literary theatricalism. And it is this same luminist rigor, together with his gift for a stark pictorial geometry which never engulfs its themes but, on the contrary, delivers them to the eye with a beguiling and affecting modesty, that separates Hopper from the multitude of inferior artists who essayed similar American subjects in the twenties and thirties. By exerting an incomparably greater visual pressure on the materials of anecdote, Hopper's art transcends the limits of pictorial storytelling without repudiating the intrinsic human interest which such storytelling still holds, even for the sophisticated public.

Thus, while figures are not infrequent in Hopper's pictures, they are almost never "characters" or personalities. They are never portraits of specific individuals who might interest us, even visually, apart from their pictorial roles. Hopper's figures are mainly types rather than persons. Their pictorial function is to convey an emotion rather than a "biography," and this is a function that, given the unity of Hopper's style, they can discharge only by becoming fixtures in an environment they never dominate. Their presence sharpens but does not itself create the prevailing mood of Hopper's world, as one can see easily enough in those pictures—among them,

Hopper's best—in which the atmosphere of alienation and ennui dramatically persists, even though there are no figures at all to be seen.

The exhibition at the Whitney, covering the period 1906–63 and consisting of paintings, watercolors, prints, and drawings, brings us many of Hopper's most famous works, together with some—especially the prints and drawings—that are relatively unfamiliar even to Hopper enthusiasts. Among the former are "Gas" (1940) and "New York Movie" (1939), both owned by the Museum of Modern Art; "Nighthawks" (1942), from the Art Institute of Chicago; "Pennsylvania Coal Town" (1947), from the Butler Institute; and a dozen or more nearly perfect watercolors of New England houses. Among the latter are the rarely seen etchings Hopper produced in 1915–18 when he was doing very little painting. The exhibition—184 works in all—thus constitutes the strongest possible showing of an artist who has worked slowly but steadily for nearly sixty years, and is, incidentally, one of the most impressive events ever staged at the Whitney.

Certainly, Hopper's place in American art history looks secure. His art continues the line of Eakins and Homer, and does so under conditions, aesthetic and otherwise, that have not been conducive to so forthright a confrontation of American experience. The mode he practiced could very easily have degenerated, as it did with so many of his contemporaries, into something utterly parochial and provincial.

Not the least of Hopper's distinctions is the firm will with which he has sustained and purified his vision in the face of so many countervailing currents. At the Whitney, where his assembled life's work creates a complete world of its own, one might be tempted to take this exemplary steadiness for granted. But when one encounters his pictures elsewhere, particularly in those large surveys of contemporary American art—mixtures of fireworks and fire sales—which are among the minor afflictions of our cultural life, one has the exhilarating sensation of meeting an artist who knows his own mind, who sees the world with his own eye.

October 12, 1964

14. The Sculpture of Saul Baizerman

Saul Baizerman, who was born in Russia in 1889, came to this country in 1910, and died in New York in 1957, was one of the most gifted and powerful artists who ever graced the American art scene; yet a decade after his death he is still virtually unknown. You will not find his work in the Museum of Modern Art or in the Metropolitan. Surveys of modern sculpture pass him by, dwelling instead on large numbers of artists who haven't a fraction of his genius and would never dream of aspiring to the heights that were his natural universe of discourse. In the world where reputations are made and candidates are nominated for posterity, Baizerman has been all but forgotten.

The exhibition at the Zabriskie Gallery will therefore be, for many people, their introduction to this extraordinary artist rather than what it should be—a reacquaintance with an established classic. There are eight large works in this exhibition. All of them are executed in the exceptionally difficult and arduous medium Baizerman made his own—the hammered metal relief conceived on a monumental scale. His abiding theme was the heroic nude, and his achievement lay in elevating this theme to a high level of sculptural eloquence at a moment in the history of art when the rhetoric of heroic feeling had fallen into disrepute. The revolt against high style and exalted subjects, the preference for the ironic and the abstract, the whole historic shift against treading the path of the masters— none of this touched Baizerman's sensibilities. He pursued his goals as if the spirit of the age were entirely on his side, and—miraculously—he attained them.

In art, of course, the miraculous is only another name for mastery. Baizerman achieved his goals by means of an extraordinary control over his materials—a control that represented both a high order of technique and the exalted vision of experience that required such a technique for its full realization. Submitting the heroic nude to the rigors of the hammered metal relief, in which no process (such as casting) intervenes between the artist's touch and his completed image, Baizerman liberated this traditional theme from its academic associations and gave it an unexpected immediacy. The physical medium—those marvelous unbroken surfaces of copper modeled with such delicacy and such love—was rendered

with a vividness that answered to the modern emphasis on the expressive materiality of art; yet the medium remained the perfect instrument of the artist's poetic intuitions. Thus, though Baizerman's art derived from the ideals of Rodin and Bourdelle, it has nothing in common with the academic parodies committed in their name. It is an art freshly conceived and totally sustained by the artist's own imaginative powers.

The exhibition at the Zabriskie Gallery brings together a representative group of Baizerman's finest works. There are two handsome examples of what he called "sculptural symphonies"— large ensembles of nudes rendered in a friezelike pattern of evocative energy. There is an incredibly delicate depiction of lovers in "Enchanted" (1935–9), a recumbent larger-than-life-size "Aphrodite" (1940–6), and—at an opposite pole of feeling—the immense fragment of a male nude entitled "The Miner" (1939–45). In all these works, whether evocations of legend, celebrations of feeling, or observations of life, there is the same abiding tenderness—a tenderness that can break your heart—and an unashamed masculine force. Rarely have a sense of power and a sense of delicacy been joined with such affecting harmony.

As the dates of these works indicate, Baizerman often labored over each piece for years, perfecting its every nuance. In one of the most moving statements any artist has ever made about his own work, he once said, "How do I know when a piece is finished? When it has taken away from me everything I have to give. When it has become stronger than myself. I become the empty one, and it becomes the full one. When I am weak and it is strong, the work is finished." Clearly, we are a long way from the era when sculptors sketch out their ideas on a piece of graph paper and then order their work from some metal or plastics fabricator over the telephone.

The question is whether we are still equipped to respond to an art so distant from the aesthetic emotions—or anti-emotions—that have come to dominate the art of our own day. The world of feeling that is celebrated in Baizerman's sculpture cannot help striking us, in contrast to what now prevails, as a lost world. The erotic glow that permeates this sculpture, like the heroic ideals that animate it, looks back to a model of experience that seems almost prehistoric in its remoteness from the actualities of the life we lead today. The sonorities that echo in Baizerman's work were already perhaps an elegy in his own day and have become immeasurably more so in

ours. His power is undeniable, yet it makes such unusual demands on our sensibilities, it elicits so many emotions we are unused to expending on works of art, that one wonders if this power can still touch us with the depth the artist intended.

Baizerman is surely not the only figure out of the past whose accomplishment raises this question, but the question is always more acute where an artist does not yet have a fixed place in the canon of our appreciation. Many artists who have a settled position in our histories, in our museums, and in our own minds no longer make any real claim on our emotions. In a sense, they don't have to, because they have become part of those emotions. It was Baizerman's tragedy in his own lifetime not to be admitted to this official historical company—his tragedy, and our loss—and it may be that his posthumous fate will be no less tragic. For no one can restore an artist to history by an act of will—not permanently, anyway. Only the springs of feeling, uniting past to present out of a sense of emotional necessity, can do that, and it remains to be seen whether Baizerman's art can inspire this sense of necessity at the present time.

For myself, he remains an important and moving figure, and it grieves me to think that his large and beautiful *oeuvre* might remain sequestered in the limbo to which taste and the vagaries of the *zeitgeist* have consigned it. We have not had so many artists of his quality that we can afford to allow his work to slip permanently into oblivion.

November 26, 1967

15. Romaine Brooks

Imagine, if you can, a novel on which Henry James has collaborated with James Purdy, and you might begin to have the vaguest glimmer of the drama that was traced in the extraordinary life of

Romaine Brooks, the painter whose work is the subject of a small exhibition at the Whitney Museum of American Art. And it is important, in this case at least, to know something of the artist's life in approaching her work. Romaine Brooks was an American expatriate who was better known to the European *haut monde* than to the American art public. Indeed, she is now virtually unknown as an artist in this country. Although she died only a few months ago—on December 7, 1970, at the age of ninety-six—her career belongs to another era, and her paintings, of which a large number are portraits, are, in addition to being powerful pictorial statements in their own right, important visual documents in the cultural history of that era.

She was born in Rome in 1874, the daughter of a wealthy, eccentric, and perhaps even insane mother, Ella Waterman Goddard, from whose bizarre, peripatetic household her husband, Major Harry Goddard, had already fled at the time of Romaine's birth. Whatever the state of her mother's sanity may have been, Romaine's older brother, St. Mar, seven years her senior, was clearly mad—a condition that Mrs. Goddard was resolute in refusing to recognize. It fell to Romaine to become her brother's keeper, and she passed much of her childhood in the company of this brother, whose personality she herself described as "menacing and obscene," and of her mother, who was no less pathological in her autocratic cruelties. No wonder that Romaine Brooks entitled the memoirs of her early life, of which only a few extracts have been published, *No Pleasant Memories*.

Fortunately, there were also periods of separation from this mad household. She attended an Episcopalian church school in New Jersey, a convent school in northern Italy, and a stylish boarding school in Switzerland, and when she emerged from the last at the age of twenty-one, she first turned to music as a career and actually made a little money singing in operettas. But drawing had always been an absorbing interest of hers, and when her grandparents' lawyer finally succeeded in securing her an allowance of three hundred francs a month from the spendthrift Mrs. Goddard—at one period her mother simultaneously maintained three villas at Menton and six apartments in Nice—she went off to Rome to study painting in earnest.

Between 1898 and 1901, she studied both in Rome and in Paris, and lived part of the time in an old chapel in Capri. In 1901,

St. Mar died, and a year later, after some energetic and expensive attempts to contact St. Mar through the services of a spiritual medium, Mrs. Goddard also died. At the age of twenty-eight, Romaine Brooks suddenly found that she was free of her mad family and in possession of its large fortune.

She promptly married an Englishman, John Ellingham Brooks, who is described in Adelyn D. Breeskin's text for the catalogue of the exhibition as "a dilettante whom she took with her to London and then discarded, giving him an annuity as compensation." In Harold Acton's recently published *Memoirs of an Aesthete* (Viking Press), there is a more explicit account of this alliance; "For a while she settled in Capri and married a queer Englishman who encouraged her to dress as a boy. The marriage had been short-lived but she spoke of it with detached amusement." In England, according to Mrs. Breeskin, "she cut off her hair and dressed in male sport attire, a mode she preferred for the rest of her life."

Thereafter she lived her life as both an artist and a lesbian in the wealthy, highly cultivated, upper bohemian milieu of England and the Continent, and her friends included most of the celebrated names that emerged from this milieu in the epoch that came to an end with the rise of Hitler and the Second World War. Among the portrait subjects in the current show are Jean Cocteau, painted in 1914; Ida Rubinstein, painted in 1917; and Una, Lady Troubridge (1924), the lover of Radclyffe Hall, who gave an account of their life together in *The Well of Loneliness*. Romaine Brooks is said to figure as a minor character in this most famous of lesbian novels.

Unfortunately missing from the Whitney show, which is an abridged version of the exhibition organized by Mrs. Breeskin for the National Collection of Fine Arts in Washington earlier this season, are the portraits of the flamboyant Italian poet Gabriele D'Annunzio, who seems to have been the only important man in her life. On her relation to the poet Mr. Acton writes: "She had been an intimate friend of D'Annunzio, whom she understood better than most of the women he had dazzled, and thanks to a sense of humor which the poet unexpectedly happened to share. She helped him out of his difficulties when he fled to France from his creditors, and she painted several striking portraits of him, one of which is in the Luxembourg. In her relations with D'Annunzio she was probably the more masculine of the two."

This last point, far from being mere gossip, is actually an

important clue to the quality of her work. For there is in Romaine Brooks's painting a force, even a vehemence, that can only be described as masculine. There is also a coldness—a severity at once aesthetic and psychological—that strikes the viewer not as evidence of any lack of feeling but as a clear-eyed instrument for divining an essential truth. She can certainly not be accused of sounding but a single note in her work. The portrait of Cocteau is the portrait of an exquisite fop, at once very charming, very sympathetic, and very condescending. The portrait of Ida Rubinstein is a heroic idealization, the portrait of Lady Troubridge a devastating caricature. And the artist's own self-portrait, painted in 1923, is unmistakably the work of a woman who has been disabused of most of the illusions life had to offer.

The style Romaine Brooks perfected in the paintings of her maturity is at once both very decorative and very severe. Almost— but not quite—devoid of color, limited mainly to grays, blacks, and whites, these paintings are tightly, indeed immaculately, constructed. There is about them a slightly ghostly, unearthly quality, especially in the later work, and in the female nudes—particularly in the large and ambitious *"Azalées Blanches"* of 1910—an icy eroticism that places the picture in a realm where fantasy, memory, and a highly decorative aestheticism combine to evoke the figment of a dream.

Whistler—Whistler the decorator as much as the painter— seems to have been the last painter Romaine Brooks drew her inspiration from, and her style owes its strength to its special combination of Whistlerian aestheticism and a force—graphic as much as psychological—that was peculiarly her own. It is a style that keeps a safe distance from the vicissitudes of modernist painting in this century, but not, I think, out of any lack of courage. Her emotions belonged, in a sense, to the culture of the nineties, and although she made something tough-minded of them, she remained true to them in her art.

April 25, 1971

16. Arshile Gorky: Between Two Worlds

In the history of American painting over the last four decades, Arshile Gorky is one of the pivotal figures. His role in the conversion of European modernism into the art of the New York School was of great importance in the early history of that art. He brought to this role immense talent, an extraordinary sensibility, large ambitions, a total seriousness, and an appealing personality. Yet the exact nature of his role has been the subject of much debate. Is it true, as Clement Greenberg once suggested, that Gorky "finished rather than started something," or would it be more correct to regard this complex artist as "a typical hero of Abstract Expressionism," which is how Harold Rosenberg described him in the study of Gorky he published in 1962?

If there were not something to be said on both sides of this question, the question itself would no longer continue to haunt Gorky's art to the extent that it does. But the fact is that increased familiarity with Gorky's *oeuvre* only underscores the importance of the question, for the way we *see* his work depends—almost literally—on the way we answer this question. Gorky's art was a bridge between two worlds, joining the Cubism and Surrealism of the School of Paris to the new modes of abstraction of the New York School. It therefore lends itself to almost as many perspectives as the sources which nourished it and the goals it sought to realize. In every exhibition of Gorky's work, one cannot help being aware of its overwhelming quality, and yet one's awareness of this quality does little either to inhibit or to satisfy our curiosity about the exact nature of his artistic identity.

This is certainly true of the large, handsome, and very moving exhibition of Gorky's drawings at M. Knoedler & Company. This exhibition numbers 150 items. The earliest of the drawings dates from 1925–8; the latest, from 1947. (Gorky died in 1948.) As is often the case with drawings, especially when seen in large quantities, this exhibition gives us a wonderfully intimate view of Gorky's pictorial intelligence and of the emotions that animated it. Gorky was a superb and prolific draftsman, one of the greatest of his time, and there is almost nothing in his painting that was not first tested and elaborated in his drawings. The drawings thus constitute an eloquent and indispensable history in themselves, and in many

instances afford a more direct insight into the workings of the artist's sensibility than the finished paintings.

It was a sensibility in love with the great tradition—a sensibility that submitted itself, with a kind of ecstasy of surrender, to the artist's beloved masters. And it was, by and large, a very classical sensibility, partial to the purity of Ingres, Cézanne, and Picasso, and so intent upon emulating this purity that for much of the artist's career he was content to remain a devoted and inspired disciple of the styles he worshipped. This was especially—indeed, notoriously—true of his relation to Picasso, whose humble follower Gorky remained long after an artist of his gifts might normally have been expected to grow restive in so self-effacing a role.

It is impossible to appreciate what Gorky's profound response to Surrealism represented in the development of his art—the kind of threat, mystery, and opportunity that Surrealism posed for an artist of his temperament and culture—without an understanding of this fundamentally classical bias. For Gorky's response to Surrealism in the forties was very much like Henry Moore's in the thirties—a reluctant recognition that in this alien realism of romantic release there was something deeply congenial to the artist's hidden sources of feeling.

Surrealism, with its interest in automatism, psychoanalysis, and the erotic, broke the spell that Picasso's orthodox Cubism had for so long cast on Gorky's pictorial imagination, and opened up the possibility that a grand style—which is what Gorky had long aspired to—might be made of purely subjective materials. Surrealism released his prodigious gifts as a draftsman and allowed him to become truly *inventive* for the first time in his career. It gave him access to an iconography—the imagined iconography of the unconscious—consisting of intricate visual metaphors which symbolized, without literally representing, large constellations of feeling that were beyond the reach of the established classical vocabularies Gorky had formerly observed.

Even then, of course, Gorky was not free of the discipleship to which his art always remained attached, only now it was from Miró, Matta, and André Masson that he derived many of the constituent forms of his new language. Inspired by the possibilities of this new, freer, and more evocative language, Gorky created those imaginary erotic cosmologies that are the special glory of his later paintings and drawings. Still adhering to the classical, Ingresque line that,

however modified, defined the very nature of his talent, he now became a visionary lyricist of great power.

The current exhibition at Knoedler's traces this history with a wonderful fidelity to all its various shifts and searchings and painful avowals. There are beautiful examples of Gorky's purest classicism —among others, the "Self-Portrait" of 1935 and the drawing of "The Artist's Mother" (1929–36). There are copious examples of his many Picassoid imitations—acts of graphic ventriloquism which are dazzling in their refinement and mastery. And there is an abundance of those later drawings—indeed, they dominate the exhibition— given over to the heroic struggle he waged in making the Surrealist vocabulary serve his own ambitious objectives.

Not all the drawings from this later phase are exactly master-pieces. One has the impression that a good many of them are works that Gorky himself, had he lived, would probably have been content to consign to oblivion. But despite their large variations in quality— at times, even because of these variations—they are immensely interesting, immensely revealing of the way a mind like Gorky's seized the opportunity of a new vision and grappled with the intri-cacies of its realization.

His accomplishment was a large and important one, but he remained, I think, closer in every respect—in method as well as aspiration—to the European artists he derived from than to the votaries of the New York School who were his immediate friends and contemporaries. However much he may have contributed to the new art, he kept his distance from its more radical and sweeping rejections.

December 7, 1969

17. The Confidence of Milton Avery

The career of the American painter Milton Avery, who died on January 3, 1965, at the age of seventy-one, was one of the most astonishing in the art of his time. It was a career without interruptions, digressions, or climaxes. There was about it no suggestion of suffering, indecision, or the problematical. In place of these familiar constitutents of the modern painter's career there was instead a steady flow of observation, inspiration, and realization. Avery was one of the purest painters of the twentieth century, not only in America but anywhere, and his work remains even now a miracle of untroubled clarity and lyric grace.

A career of this sort, so distant from the historical and psychological traumas that have marked the work of Avery's contemporaries, is difficult to account for—indeed, it defies exact explanation. There are no dramatic changes in his work, no sudden shifts or abrupt revelations. Avery's career was long, unswerving, and totally serious. It was imbued with a classic calm and detachment—a detachment, above all, from ideological struggle and critical self-consciousness. Between the imperatives of the painter's exquisite sensibility and the clear, simple, luminous image on the canvas, no external interventions make themselves felt.

Yet Avery was a painter deeply attached to the things of this world, conscious of where his art stood in relation to the art of others, and possessed of a proud, affectionate regard for his own experience. His detachment was not the kind that is purchased at the price of some extravagant specialization. Throughout the long period of his maturity as an artist—from the mid-twenties to the early sixties—his painting was in the mainstream of the modern pictorial tradition. It was devoid of eccentricity. It followed, in many respects, a conventional course. It never relinquished its hold on traditional subjects—still life, homely anecdote, portraits of family and friends, cherished landscapes. There is nothing in his art to startle the modern observer except its amazing, unviolated calm and the extraordinary confidence that made it possible.

This confidence was, first and last, a confidence of vision. Avery had a special, highly sophisticated way of looking at the world—a habit of observation that sifted out everything that was inessential to the realization of his poetic vision. There are no

extraneous forms—no extraneous details, no extraneous touches or elaborations in his pictures. In Avery's art every object, every image, every contour, every optical sensation even, is stripped to its essential visual function. His vision is, indeed, very much a vision of contours and surfaces, each given its precise optical weight and poetic resonance.

The result was an economy of form that served his sensibility—particularly his sensibility for color—to perfection. A typical picture by Avery is rather like a very spare jigsaw puzzle in which a very few flat shapes are locked into a rigorously conceived design. Thus the structure of the image is at once very lean, very delicate, and yet very firm, with nothing tenuous or inexact siphoning off its energy. One sees the firmness of this structure more clearly perhaps in the artist's drawings and etchings, just as one can observe his spontaneous instinct for color more clearly in his watercolors. Avery was the kind of painter who based his large finished pictures on copious drawings and watercolors, and in the process of composition clarified both structure and color to their very essence. The wonderful immediacy and quickness in his pictures—the sense they convey of registering a very swift, spontaneous, total image—was actually the result of painstaking labor as well as a remarkable subtlety of perception.

What elevates these highly simplified pictorial structures to a level of sublime lyric eloquence is, of course, precisely this transcendent instinct for color. For Avery was a colorist of enormous virtuosity, originality, and range. His best pictures are marvels of chromatic delicacy and invention in which color is given a lightness, a luminousness, and transparency, an optical precision and material density that are, at the same time, both remarkably faithful to what the artist has observed and remarkably free to define the artist's own very special vein of feeling. In this respect, Avery's art belongs with the masters of Post-Impressionist color—with Gauguin and Seurat, Matisse and Bonnard—and if history were just and the historiography of American painting less parochial than it now is, his achievement would long ago have been placed in this company.

The retrospective exhibition of Avery's work organized by the National Collection of Fine Arts in Washington is both large, numbering 127 items, and beautiful, but it would have been even more beautiful and more definitive had it been even larger. The pictures range in date from "Sunday Riders" (1929) to "White Nude No.

2" (1963), and include examples of virtually every kind of picture Avery painted. Yet fine as this exhibition is, it does not give us a sufficiently comprehensive account of Avery's achievement. For that, we would have to have more of the large paintings of Avery's later years, particularly the late landscapes, every one of which is a highly individual conception and which, taken together, are an accomplishment equaled by very few painters in the last twenty years.

But at least there are good representative examples of these late landscapes—the marvelous "Morning Sea" (1955), "Hot Moon" (1958), "Sea and Dunes I" (1958), "Sea Grasses and Blue Sea" (1958), "Sand, Sea and Sky" (1959), "Tangerine Moon and Wine Dark Sea" (1959), "Beach Blankets" (1960), "Dunes and Sea II" (1960), and "Sea Birds on Sand Bar" (1960). And in addition, there are some less familiar aspects of Avery's *oeuvre*—the remarkable portraits of Eilshemius (1942) and Marsden Hartley (1943); the self-portraits, ranging from the very witty, lighthearted "Avery on 57th Street" (1943) to the stark, almost ghostly picture of 1961; and a handsome selection of the still lifes and figure paintings that occupied the artist at every point in his development. There are also drawings and watercolors, but not nearly enough.

We shall be a long time, I think, coming to terms with Avery's achievement. Earlier on, he seemed too close to the School of Paris for his own special quality to be fully appreciated. Lately, he has been unjustly overshadowed by some of the American painters he himself so profoundly influenced. But such misconceptions pass, and when they do, we shall recognize this amazing painter as a true master.

January 4, 1970

IV. Contemporaries

1. The Sculpture of David Smith

The sculpture of David Smith is one of the most significant achievements of American art, not only at the present moment but in its entire history. It is a major contribution to the international modern movement, and at the same time the most important body of sculpture this country has ever produced. Smith is the only American sculptor who brings an ample and fecund *oeuvre* covering three decades to the history of modern sculpture—the only one, that is, whose work has made a permanent change in sculpture itself. He is one of the very few artists anywhere today whose work upholds the promise and vision of the modern movement at the same level at which it was conceived. The singularity of his achievement has thus moved in the course of his career from an American to an international context. In its beginnings it was a rarity on the American scene, and in its full flower now, it remains singular on the world scene.

The atmosphere of American art in our time has been crowded with artists who lacked the force of talent, vision, or character—in the permanent crisis of modern art, these have tended to become identical—to pursue a clear path, artists who are always checking out, beginning again, inventing new personalities for themselves. Half the famous reputations of our time consist of twice-born and thrice-born "visionaries" who, sometimes very honestly and sometimes not, have struggled constantly to effect an artistic identity they could believe in or, failing that, a made-up face the art public might take for a miracle. David Smith's career is the noble exception. It has followed a path whose clarity, ambition, and singleness of purpose are all the more remarkable for the obstacles they have overcome. The characteristic rhythm and flow of his work have a Balzacian (as against, say, a Mallarméan) quality. He is in the line of artists who are copious, energetic, and unreservedly productive; artists who run the risk of vulgarity, repetition, and garrulousness in the interest of sustaining an unchecked flow of new images and ideas. He is the opposite of those artists who wish to make a very few things, each very small and hard and perfect. His masterpieces have an unworried purity, a perfection which is at once exalted, prodigal, and indifferent—a kind of rough precision which can only come from a hand which is completely knowledgeable but one which

is not going to pause in an endless fretting over final resolutions. The entire body of his work is marked by an astonishing confidence, at once a moral conviction in its rightness and a clear sense of its limits, promises, and inner necessity.

Smith is primarily a draftsman and a constructor, though he began as a painter. His sculptural method derives, as does all modern constructed sculpture, from the method of collage, and the whole body of his work retains, even at its farthest remove, a family resemblance to Cubism, whose analytic phase gave rise to collage as a genre and a technique. This relation to Cubism and collage must be kept firmly in mind for a full understanding of Smith's art, as must the more obvious relation of his early work to the iron constructions of Picasso and Gonzalez. Yet in themselves these relations bring us only to the threshold of Smith's own work. Once inside, they join in a complicated profusion of other ideas and necessities; they submit to a personal content and vision under the pressure of which the sculptural method itself is expanded and revised.

Smith's sculpture comes out of the factory; it draws on the methods of industry, technology, the mechanical arts of the machine shop. Its mode of work is hard, the material is heavy and obdurate, the work is dirty and, in a sense, hostile to the traditional refinements of sensibility. We should not make a romance of these facts— certainly Smith doesn't; he would gladly use an easier means, I am certain, if he could achieve the same results—but they need to be borne in mind in any attempt to grasp the significance of his work. This is true for two reasons especially. For one, it is a commonplace that modernist styles do not admit an easy separation of content and means; that what begins as a method for achieving a given result often undergoes a metamorphosis in which the means becomes an inseparable part of the result. (Inseparable, one should add, but *not* a substitute for the result.) Smith's work is wholly in this modernist tradition and thus completely subject to the temper of his working method. Yet the second and perhaps more important reason for bearing in mind the facts of his working method is that his themes are so often the opposite of what his workshop technology implies they might be. Smith's art is conceptual, but it is not theoretical. It does not move in the direction of machine-age or space-age physics, metaphorically or otherwise. His themes are very often landscape motifs, pastoral and lyrical, with a great warmth of feeling for natural forms. They are often figures, in anecdotal and erotic situa-

tions, and at various times (in the thirties and forties particularly) there has been a strong current of social comment and political symbolism in his sculpture. At the same time there is a hard core of formalism in Smith's work—not only in recent work but from the beginning, in the work of the thirties. This mingling of the anecdotal and the formalistic is something I shall return to; the point I wish to make here is that Smith's work, contrary to what we might believe if we turned his technology into a romance and made a mystique of his use of the blowtorch, actually contains a strong poetic element at its center. There is very little tendency in it to be "scientific." Notwithstanding his recent and very large geometrical constructions, I would say that the two modernist sculptors from whom he is the farthest removed in sensibility are Vantongerloo and Gabo. He is much closer to Léger, Picasso (the Picasso of Cubism, the iron sculpture, and "Guernica"), and Stuart Davis in the relation of his art to experience.

One sees this relation of his art to experience in a particularly clear way on a visit to his studio at Bolton Landing, New York. The Terminal Iron Works (as Smith calls his workshop) is a fully equipped welding shop, with industrial tools, factory lights, and a supply of raw materials (mostly stainless steel, cast-iron, and bronze components, and some silver), the atmosphere being that of a small-town factory in which some gadget is produced. This "factory" is set down, in the hills beyond Lake George, in the midst of one of the most beautiful, open, wide-ranging, and still isolated landscapes in America. Mountains, timberland, open meadows, and a view into the valley and the lake, a corner of which is the lowest point of elevation that meets the eye, make up the vista which reaches out from the artist's "studio." *A machine shop in a landscape:* this juxtaposition, with its disparate American ideals held together in an intense aesthetic equation, tells us something important about the moral and artistic character of the art which emerges from it. There are artists—one thinks of Giacometti in Paris and Henry Moore on his Herefordshire estate—who are as much the authors of their milieux as of their work; and Smith is one of these. To visit Giacometti in the tight, dark, dust-covered studio he occupies in a working-class quarter of Paris, entering from a narrow, constricted alleyway, stumbling over plaster dust and dried clay, the light murky and gray, the sculptor himself fretting over the fragility and impossibility of his art—this is not in itself an "aesthetic" experience, but its

peculiar qualities reveal something crucial about the psychic image and the sense of human possibility which will also be found in the art which is made there. Similarly, Moore's current style of life as a kind of benevolent country-squire humanist, a celebrity of his country's cultural establishment who sits on committees and contributes to the *Sunday Times*, meets its nemesis in the monument to international bureaucracy he designed for UNESCO in Paris. Smith's workshop in the mountains evokes an image radically different from either of these, for it brings together two old-fashioned ideals of American life: the proud individualism and keen workmanship of the man who lives by his skills, and the independent spirit of the man who lives on his own land. Both are ideals of freedom out of the American past, derived from the ethos of a harder but simpler life than most Americans find it possible to live now, and they are supported in Smith's case by an unsentimental grasp of the difficulty involved in sustaining such freedom in a social environment where success no less than failure can deprive one of its realization. One might say that everything about Smith's art is up to date but the style of life which makes it possible for him to create it.

Smith was born in Decatur, Indiana, in 1906. His father was a telephone engineer and part-time inventor, and his mother was a schoolteacher. He attended universities in the Midwest and Washington, D.C., but his education may be said to have begun when he moved to New York in 1926 and enrolled in the Art Students League. In 1927 he was a full-time painting student at the League, studying with John Sloan and—more crucial for Smith—with Jan Matulka, who introduced him to the modern movements of Europe. He continued to study with Matulka for several years, until 1930, and in 1929 he made his first painting trips to Bolton Landing, where he later acquired the land on which he built the house and workshop he still occupies there.

At the beginning of the thirties Smith was painting in an abstract Surrealist style. In 1930 he met Stuart Davis, John Graham, and Jean Xceron, who could be counted among the most important abstract painters in America at that time and were certainly the most sympathetic and informed about the abstract movement in Europe. To Matulka's teaching, based on a vivid respect for the work of Picasso, Kandinsky, and Mondrian, were thus added the conversation and personal example of three painters who knew advanced

European art firsthand and were endeavoring to practice their art at the same level of seriousness.

The teaching of Matulka and the association with Davis, Graham, Xceron, and others marked the beginning of Smith's life as an artist, but he was not in any sense of their generation. Davis had discovered modern art in the Armory Show of 1913; Smith was a student in the twenties, and as he once remarked, his mother is the same age as Picasso. Above all, he came of age as an artist in the thirties.

The history of American art in the thirties is not yet written. The spirit of the present moment is not conducive to a full understanding of the complex and frequently contradictory impulses which molded the art of that decade. We have too often marked it down as the era of social realism and left it at that, and the more recent tendency to convert the thirties into the first act in the drama of the New York School is equally false if left unamplified by a whole spectrum of related ideas and imperatives. We shall be much closer to the truth of the thirties if we try to hold all its contradictions in mind at the same time; that is, if we see that the social and political urgencies of the Depression and the rise of Fascism affected *all* the art of the period, that the abstract art of the thirties was no less aware of the historical crisis of the time than the politically committed realism that was reproduced in the left-wing journals. The thirties *was* a heyday for social realism, but it was not the period in which the most vital social realist painting in American art was done; the first quarter of the century could boast of a much keener pictorial commentary on American life and at a much higher artistic level. Realism was only one style among others in the thirties, and one which was losing its impetus; the thirties was a decade in which Cubism, Surrealism, Constructivism, Neo-Plasticism, and particularly the late figurative Cubism of Picasso and Gonzalez, along with the Abstract Expressionism of Kandinsky, were all in the running. Picasso, Matisse, Miró, Mondrian, Léger, Klee—the whole modernist pantheon was making itself felt and making the narrow culture of native American art look increasingly paltry and inadequate at precisely the same moment that the economic and political structure of the country was caving in. It was also the age of the Mexicans, with their ruthless amalgams of art and revolution. Directly or obliquely, the political crisis of the thirties touched every artistic style of the time. The idealism of the geometrical purists and

the compulsive irrationalism of the Surrealists (to name only two developments among many) lived under the same historical cloud as the ideology of the realists and the propagandists.

Smith's work of the thirties needs to be seen in this context before it can be seen in any other, for as an artist he came into the inheritance of all the modernist impulses of European art simultaneously and without having to commit himself exclusively to one over another. Moreover, he came to this inheritance under the pressure of an extreme historical moment, when the structure of society seemed as much in question as the conventional forms of native American art. There is an analogue in Smith's refusal to choose one branch of modernism over another—to become purely a Cubist *or* a Surrealist *or* a Constructivist—with the anarchism of his social views. He chose to use whatever was useful to him.

One must add that such a freedom of choice was possible because European modernism itself had become fragmented and split into isolated impulses by the early thirties. Henceforth, each artist was on his own in making whatever connections he could between the shattered fragments of the modern movement and projecting out of them a new aesthetic possibility. The period when artists worked together for common radical ideals—the Cubist period of Picasso and Braque, the period of the Expressionist and the Blue Rider groups in Germany, of the Constructivist manifesto and the Dadaists' revolt—was over. The two major movements of the twenties, the Bauhaus and Surrealism, were practically the last in which artists joined together—and *worked* together—for common stylistic ends, and even they were more concerned with social and literary ends that with the creation of new visual vocabularies. The man who represents the next phase of the modern movement is Miró, who brought his native Catalan sensibility first to Fauvism, then Cubism, then Dada and Surrealism, and in very short order fashioned a style in which he could freely choose among them. The personal synthesis of Cubism and Surrealism which Miró created in the twenties anticipates and contributes to the kind of synthesis, involving still other elements and devolving upon a different order of experience, which characterizes Smith's work of the thirties.

This is the context in which Smith's relation to the iron constructions of Picasso and Gonzalez has a more precise meaning. The example of these iron constructions provided Smith with two things: (1) the serious use of iron, a material he knew firsthand from jobs

of manual labor, and (2) the beginnings of a sculptural method—the technology, as it were—which enabled him to move from collage to free-standing sculpture. In 1931, Smith had already begun attaching objects to the surface of his canvas; the next year he also made some interesting "abstract" photographs, pictures of objects arranged in abstract and symbolic juxtapositions which were, in effect, photographs of sculptures which didn't yet exist except in the camera eye. The idea of iron construction and welded-metal images freed him from the built-up canvas and the camera, and thereafter Smith was on his own.

There are echoes of Picasso and Gonzalez in Smith's work for a long time to come, but sooner or later they dissolve in the unique synthesis of his own art. Moreover, in his work of the thirties, Smith sometimes used the iron and steel construction for purely nonobjective purposes. He did not do this exclusively or all at once; he continued to dwell (and still occasionally does) on figurative themes together with purely abstract conceptions. Nor was he the first, of course, to construct nonobjective images in iron; the Russian Constructivists had done this during the First World War. Yet in bringing the figurative iron construction of Picasso and Gonzalez—for even at their most abstract, the iron constructions of Picasso and Gonzalez were still figurative art; Gonzalez in particular never made an iron construction that wasn't a figure or a head—in bringing them into the same universe of discourse with the nonobjective art of the Russians and with nonobjective painting, Smith generalized and enlarged the genre. In effect, he restored the Constructivist idea to the Cubist tradition, which had spawned it in the first place, and then threw in the Surrealism of his own generation for good measure. Once this synthesis was achieved, Smith moved freely in and out of figurative and nonfigurative modes: heads, figures, landscapes, animal images, mythical and Surrealist fantasies, the symbolic anecdote and the purely formalistic conception were all available to his medium. There was, to be sure, an element of pastiche in some of these works, but unlike Gorky, say, or the later Nakian, Smith is fundamentally not a pasticheur but an original imagist who uses his own experience as a brake against the inclinations to exalted poetry which have made both Gorky and Nakian the victims of their own ambition.

If one dwells at some length on this background of the impulses and sources of Smith's work in the thirties, it is because the mold of

his personality as an artist was set then, in the crucible of that misjudged decade, and also because he produced his first master-pieces at that time. Among these I would include the two "Heads" of 1933; the "Reclining Figure" of 1936; four works from 1937: two abstractions, "Unity of Three Forms" and "Structure," the "Vertical Figure" in the collection of Clement Greenberg and the "Drummer" in the Baltimore Museum; the superlative "Leda" of 1938; and the "Structure of Arches" (like "Leda," in the collection of Douglas Crockwell), "Vertical Structure" and "Ad Mare" of 1939. These sculptures are small in scale compared to the dimensions in which Smith has been able to work since; "Drummer" is fifteen inches high, "Leda" eighteen and a half inches, and so on. (A number of Smith's recent steel constructions are eight and nine feet tall.) Yet they set forth the range of his interests, the inclination to the baroque at one extreme and to the geometrical at the other, and they also disclose in clear terms the nature, if not yet the full scale, of his style.

We have gotten in the habit of calling this style drawing-in-space, a useful epithet in some respects but one which leaves out the constructive element. A clumsier definition such as "the art of drawing an image in open space by means of constructing slender masses" might be more accurate, if less elegant. This is, after all, an art different from drawing and painting on a flat sur-face, and it is again different from the carving or modeling of a monolithic image. Nor does the other common designation of "open-space sculpture" represent more than the beginning of a definition of its radical difference. What is special about this par-ticular genre is that, unlike a painting or a drawing or a monolithic sculpture, it is not something we see around, but *through*. It does not focus our attention by obstructing a view of what is beyond it, but on the contrary, it draws strength from the fact that it absorbs what is beyond or behind into itself, that it becomes a locus of visual concentration and generates its symbolic emotion *in the midst* of its surroundings and not in spite of them. It is rather more genial and sociable—closer to life, if you will—than most observers have led us to believe. It is for this reason, too, that even Smith's greatest works always look a little wounded when seen only in museums and gal-leries, which tend to be barren of anything that could properly be called life. The kind of open-space sculpture which looks best in the emotional vacuum of a contemporary museum is the sort which

actually involves the "carving," as it were, of an imaginary mono-lith—constructions in which linear masses form the outline of an image which the eye is expected to *fill in* for itself. We see a lot of this in museums and galleries today; it is the work of academic minds disguising themselves as advance-guard. Smith's work is the opposite of this. His constructions are more literal and syntactical. Open space is not the grammar but the rhetoric of his style, and where this rhetoric is reduced to the stylish hush of a clean, white, empty room, his work tends to have a silence which is quite different from the sociable eloquence it commands in a less pious atmosphere.

The implications of Smith's sculptural grammar were devel-oped in a fuller and more complicated way in his work of the forties; his style blossomed in the period 1945–9, when he had already established his house and workshop at Bolton Landing, and the two years 1950–1, when he was freed of teaching and other jobs by a Guggenheim grant, represent a creative plateau comparable to the greatest periods in modern sculpture. Before going on to this work of the forties and fifties, however, it is important to take note of a completely different series of works Smith created in the late thirties: the "Medals for Dishonor," 1937–40, exhibited at the Willard Gallery in the fall of 1940.

In 1935–6 Smith traveled in England, France, Greece, and Russia. The art of the past he saw in Greece, on the island of Crete and in the British Museum—Greek, Egyptian, and Sumerian—as well as his experiences in Paris and Moscow, was decisive in affect-ing the work he did on his return. This was also the period of the Spanish Civil War, and of "Guernica." It was a moment when Smith fully acknowledged his identity as a sculptor; painting thereafter became an adjunct to sculptural conceptions. In a sense, the intri-cate amalgam of aesthetic and political ideology which he formu-lated for himself in those years—the curious blend of Cubism, Surrealism, and Constructivism with Leftist and pacifist loyalties—has continued to be the principal motive of his outlook as an artist and a man, but in the "Medals for Dishonor" Smith addressed himself to this ideology in a more concentrated and didactic fashion than he had ever done before or has ever done since.

The medals are small bronze plaques—fifteen in all—on which a kaleidoscopic narrative, political and pacifist in substance and Surrealist in style, is carved with an intense, finical care both for realistic details and the angry, symbolic message. Their titles—

"Death by Gas," "War-Exempt Sons of the Rich," "Sinking Hospital and Refugee Ships," etc.—remove any ambiguity about their meaning; and in any case, Smith wrote a detailed commentary on the imagery of each medal for the catalogue of the 1940 exhibition. These plaques were the work which gained Smith a reputation for a while as a social Surrealist, and it is worth noting, I think, that the Surrealist element endowed them, even in the grip of social outrage, with a poetry of human impulses which preserves their interest for us today. Surrealism was a medium—at least Smith's version of it was—in which irrational political violence could be related both to the hypocrisy of the social order and the primitivism of the private ego. Pacifism and eroticism combined to evoke a unified archetypal imagery which indicted current history at the same time that it projected a terrible and universal poetry.

The "Medals for Dishonor" are monolithic reliefs and therefore technically removed from the open-space constructions Smith made in the thirties, but their motifs prepare us for that repertory of images—specters, laments, races for survival, sinister birds, and preying insects—which was to dominate Smith's constructions during the war and just after. These constructions look forward, stylistically, to the great open-form compositions which have dominated Smith's production from the late forties to the present moment, but their iconography looks back on the political concerns of the thirties and the war. It should be remarked that it was through this iconography that his sculpture passed on its way to a more ambitious formality: as often (or always?) happens with an intensely conceived formalism, an explicit subject lies buried in its innermost core.

Out of the war years, too, and in the period after the war of Smith's settling into regular work at Bolton Landing, come the more lyrical and homely themes which gradually replace the terrible imagery of the "Medals" and the "specters"—themes of domestic life and landscape images, personal and unexalted subjects drawn from life and used for a grander and more equable style. There was also a satiric side to this change, represented by "Pillar of Sunday" and "Home of the Welder" (both 1945), which show a sarcasm gentler than that of the political works. And there was something different, too, in the workmanship of the sculptures Smith made just after the war, a scrupulous attention to details and small forms, an exactitude and perfection of parts, a sacrifice of spontaneity in the

interest of having every element in a work function in the most rational and intentional order. It was a period in which a tighter, more formalized tendency was replacing the iconographic wildness of the preceding works, when the anecdotal subject was more swiftly and more definitely sacrificed to the urge to abstraction. Put another way, with the end of the forties came the end of explicit Surrealist elements in Smith's style. There has remained, I think, an implicit Surrealist touch in everything Smith has done in the last decade, from the "automatism" of his numerous drawings to the large geometrical constructions, which suddenly at times take on the look of mysterious, symbolic personages—but it remains now an implicit, unconscious, fully assimilated element and completely at the mercy of stronger and more effective ideas.

Writing in *The Nation* in January 1946, Mr. Clement Greenberg remarked about Smith's style that its "point of departure was usually anecdotal but the result highly abstract. A unity of style was achieved that did not inhibit extravagance but inevitably controlled it—generally toward 'geometricity,' precision, clarity." In this comment, which describes very exactly the direction in which Smith's art was moving, Mr. Greenberg anticipated the great works of the early fifties—works such as "Australia," "Hudson River Landscape," "The Banquet," "The Agricola" constructions, "The Fish," "Blackburn—Song of an Irish Blacksmith," the early "Tank Totems," and many others (Smith's production really began to be enormous at this time) which have a clarity of syntax and image, a fullness of statement with an economy of conception which mark them as one of the singular achievements of modern sculpture as a whole. Mr. Eric Bentley once commented—he was speaking of Eugene O'Neill—that "What Europeans call the 'American' style—i.e., the 'tough' style—operates chiefly as an ironical mask for sensitivity." Something like this has always been true of Smith's tough-minded work, and it has not always worked to his advantage; one feels at times that a certain revenge is being taken on his own sense of delicacy in the name, perhaps, of energy or power or manliness. I think Smith's sculpture of the early fifties derives some of its extraordinary character from the degree to which it represents a perfect equation between his sensitivity and toughness without recourse to irony or sarcasm or violence as a catalyst. It has a classical temper which speaks for a confidence and certainty about its aims. There is

nothing tentative or merely assertive here, nothing faked or weak-willed. A kind of metaphysical calm hovers over this work, different in its quality from what precedes and what has followed.

Nor did this classical temper impose any uniformity of image or idea; on the contrary, it is as if every motif and expressive idea Smith had ever had in embryo came to maturity in these fertile years. There is a range and diversity of forms in Smith's work of the early fifties which is not equaled by the art of any other sculptor of the same period, either here or abroad. The iconographic division-ism of "The Banquet," the baroque and exalted lyricism of "Aus-tralia," the pastoral vigor of "Hudson River Landscape," the subtle economy and wit of the "Agricola" pieces, the monumentality of the early "Tank Totems," and, throughout, that phenomenal precision and clarity of which Mr. Greenberg spoke confer on each statement the kind of inspired finality we associate with a great statement.

It should be remarked that this "finality" is probably of more interest to us than it is to Smith, who has always been reluctant to make any hard and fast distinctions between his successes and his failures. His fecundity often precludes the necessity of having to choose between better and lesser works from his own production, and his very copiousness has frequently turned a failure into a success before the eye (his *or* ours) has had the chance to judge it. Yet I think it is true now that as a rule—if one can ever postulate such rules—Smith's work succeeds where it is most free of sarcastic encumbrances, where its own inner calm takes it by the shortest conceptual route to a realization of nothing but itself. This was not always true of his work in the thirties and middle forties, but it seems to be true now. Part of this change is to be explained by the distance his work has traveled from an involvement with Surrealist ideas, which had a way of turning even commonplace jokes into interesting metaphysical paradoxes. In place of this comic duplicity out of Surrealism, a certain crackpot element has crept into some of Smith's humor, so that it has less of a tendency to refer to anything but its own private concerns—always a compromising fate for humor of any kind. But the major reason for this change is that Smith's hold on his own syntax is now so firm and hard and unyield-ing that his fantasy has almost no functions to perform. It has been reduced to pulling his leg (and ours) once in a while, when the grip of his clenched-fist seriousness relaxes; and it has less and less to

contribute to his conceptual thinking. This means, I think, that there has been a loss in geniality and a gain in rigor.

Indeed, I suspect that Smith's new work will be thought far too rigorous even by the large audience which considers him our leading sculptor. The geometricity which Mr. Greenberg mentioned somewhat in a manner of speaking, using the word in quotation marks, in 1946, has taken over a good part of Smith's new production in the most uncompromising terms. And one might add that where his new work is not explicitly geometrical, it is put together as if it were. The margin of willfulness and extravagance has been locked into the tight logic of a style which disallows anything like the baroque flourishes which used to be an engaging, if not altogether a necessary, aspect of his style. The relation of Smith's new work to the iron constructions of Picasso and Gonzalez from which he first took inspiration is not unlike that of Mondrian's late works to orthodox Cubist painting. The blood ties are there, but the artist is speaking a different language.

It will put Smith's new work, as well as his past development, into perspective if we return for a moment to the comparison I touched on earlier, namely, with Giacometti and Moore. Moore was born in 1898, Giacometti in 1901, and Smith in 1906. Among sculptors their own age on the international scene, they are the three most important now living. For all three, the experience of Surrealism was in some way crucial but not sufficient.

For Moore, the Surrealist influence rescued him from a total absorption in primitive and archaic forms, which his work of the twenties reproduces brilliantly, and conferred on his work of the thirties a new way of realizing, rather than merely asserting, the emotions which most interested him. Moore came to primitive and archaic art by way of Roger Fry, and it was not until Surrealism unlocked his own urge to confront irrational feelings that he was able to animate the formal rigor he learned from the art which Fry's writings laid before him. Surrealism represented everything Fry most detested: the confusion of life with art, the injection of non-aesthetic emotions into aesthetic conceptions. It was in the tension posed by this contradiction of loyalties that Moore created his truly original work of the thirties. For Giacometti, Surrealism functioned in a similar way. His father had been an Impressionist painter, he

himself studied with Bourdelle and was much influenced by Brancusi. Surrealism—and, it should be added, Paris—gave him a weapon to use against this inheritance, and with it he arrived at those fantastic constructions which are among the most brilliant sculptures anywhere in the thirties.

Whether it was the violence of the war, which exhausted so many of the feelings that Surrealism had claimed for exalted ethical functions, or for other reasons, neither Moore nor Giacometti—nor Smith—was ever again quite so committed to the Surrealist impulse as he had been in the thirties. Moore turned his attention to a kind of monumentalism of the figure, and Giacometti became more and more absorbed in a smaller and smaller aspect of experience. I think Giacometti comes off better than Moore in the last decade, because he has been able to endow his personal malaise with an urgency which speaks to us directly, which seems our own as well as his. If his art is wounded and fragmentary, if it seems to ache and suffer frequent crises, it corresponds to our own condition.

By comparison with that of his English and Parisian contemporaries, Smith's art boasts an extraordinary optimism. The conceptual vehicle for this optimism has been his affinity and loyalty to Cubism. The Cubist tradition in modern art is the optimists' tradition. It does not harbor anxiety, it is the enemy of metaphysical disquiet. It asserts its hegemony over experience. When Smith abandoned the Surrealist side of his temperament, the Cubist-Constructivist side took over in force and has carried him through the achievements of the last decade. Those ideals of freedom I spoke of earlier in connection with Smith's style of living at Bolton Landing represent the existential aspect of this optimism, and the Cubist ideology of his art represents its aesthetic aspect. In bringing them together in an ambitious and copious *oeuvre*, Smith is certainly unique in the art of our time.

February 1960

2. The Jackson Pollock Myth

I

The Jackson Pollock exhibition at the Museum of Modern Art has presented us with a double spectacle: a moment of history and at the same time a selection of works from the career of an artist who died last summer at the age of forty-four. It is a matter of some importance that a distinction between the two be maintained, even (or especially) in the face of the prevailing tone of art criticism with its tendency to dissolve all discrete objects and events in a headlong historical continuum, which, by purely rhetorical transformations, is itself made the new fulcrum of artistic meaning. This tendency has nowhere been so quintessentially embodied in overwrought rhetorical sophistries as in Mr. Hunter's brief monograph* on Pollock for the exhibition which he has organized. It is a monograph which claims for Pollock the heroism of history to a degree which is absolute and unequivocal, and which then goes on to claim for this historical heroism an artistic sovereignty equally unqualified and immeasurable. It is a neat trick, and it does not lack for brilliance or verbal audacity. It lacks only the clarity and intellectual candor which should be the first principles of criticism.

Let me quote two examples—by no means the most flagrant—to underscore the point: "The dynamics of the development of Pollock's abstract painting style which was germinating in the thirties would seem to have sprung from a strong tension of renunciation, as if in the role of the revolutionary he had constantly to remind himself of his spiritual chains in order to spur his progress towards freedom"; and "[Pollock's] first exhibited work looked somewhat like a battlefield after a heated engagement, strewn in this case with the corpses of Picasso, the Surrealists, Miró, Kandinsky perhaps, and fragments of American Indian art." There is nothing to be said about the first sentence except that it is pretentious, but of the second, one must insist that there be a simpler way of saying that a painting is a pastiche—no small matter with Pollock, but not in any event a matter of dishonor or embarrassment in an artist's first

* Sam Hunter, *Jackson Pollock* (New York: The Museum of Modern Art, 1956). For a more expansive view of the author's rhetoric, see also "Jackson Pollock: The Maze and the Minotaur" in *New World Writing IX*, 1956.

exhibited work. In Mr. Hunter's commentary every phase of Pollock's career is invoked with the same hyperbolic claims and treated to the same historical dramatization. Even in the artist's "mature" period, it is the *role* of the picture and not its intrinsic, artistic factuality which commands the writer's high-flown periods.

The logic of this approach is all too clear: when the artist has been recast as a hero of history, his real achievements have equal weight with his most horrendous blunders as episodes in the unfolding spectacle. The singular interest of a particular work is utterly irrelevant. By such means is art thus sold out to history whose contingencies it seeks at its highest moments to modify and transcend.

The issue is a serious one and not irrelevant to the exhibition at hand. Pollock *was* involved in history to an extreme degree, a history which is still ours and from which we shall not easily disengage ourselves. But out of *his* involvement came specific pictures which have, presumably, an interest beyond the sheer fact that he made them. If they have nothing to say to us beyond that, then they are of less than no interest and all the rhetorical resources of the language will not make them otherwise.

The critical problem, then, is not to rehash the drama of history but to ascertain what sort of artistic *oeuvre* Pollock has left us. My own impression of that *oeuvre* is that it is dominated by an anarchic sensibility whose characteristic modes of expression were a vehement and sometimes nullifying pastiche and, for a short period, a decorative style in which the most intractable problems of his paintings were given over to design for their solution.

The anarchic and the decorative: these are the primary impulses which make themselves felt in Pollock's work, and whatever pictorial tensions they may claim derive from their confrontation, juxtaposition, or displacement in one degree or another. They form, in fact, Pollock's special dialectic—and, incidentally, help to explain why his imitators have generally produced either unspeakable messes or shallow interior decoration, depending on which term of the dialectic they have seized upon. In the early forties, in such works as "Guardians of the Secret," "The She-Wolf," and "Totem I," this anarchic impulse vented itself on the stylistic pastiche which Pollock was simultaneously creating and nullifying—creating out of the milieu which Mr. Hunter describes: a milieu in which Picasso, Miró, Mexican painting, Kandinsky, Surrealism, but above all

Picasso, were available for emulation and as counter-elements to the tepid American abstraction of the thirties; and nullifying by means of surfaces, structures, and a progressive derangement of *matière* which disavowed the felicities which Pollock obviously felt were expendable in the art of painting. Yet even in some of these pictures the decorative side of his talent performs important functions in lieu of a more far-reaching structural principle; thus in "Guardian of the Secret" the rectangular forms whose planes denote the picture's shallow spaces give the effect of a house of cards whose walls are furiously stitched together by the desperate "calligraphy" which everywhere attempts to draw these planes into a pictorial coherence. It fails to do so, I believe, and in its place substitutes the action of the stitching itself as the picture's dominant expressive means. The rectangular planes remain inert and lifeless. (If one wants to count corpses in Pollock's painting, that is a good place to start.) Where the decorative impulse is held in abeyance—as in "Totem I," for example—Pollock's proclivities as a pasticheur have full control and in this case produce a small anthology of Picassoisms, albeit somewhat ravaged and played off against other elements.

It is in "Shimmering Substance" (1946) that we have a suggestion of that plateau in Pollock's career—roughly, from 1947 to 1950—during which he temporarily purged this tendency for wild anthologizing and transmuted the anarchic impulse into the decorative style which has become his best-known signature. I find "Shimmering Substance" superior to any of the "drip" paintings which follow it: it remains a painting rather than a decorative simulacrum of painting, and it really does bring us a fresh imagery in its swirling, shimmering light. A decade after its execution it still looks very fresh, vigorous, and—surprisingly—even-tempered, and one can't say that about many of Pollock's works. And yet . . . all one can feel in its presence is a suggestion of the pleasure the artist must have felt in the physical act of painting, and even that is of short duration and, at best, a vicarious satisfaction, really a second-hand emotion for the spectator. One's initial delight in the picture turns out to be one's whole experience of it. Soon the small arcs and swirls, which are its basic formal motif, begin to reveal a cloying consistency; they do not have the variety of feeling they promise at first sight. Instead of an infinitude of sensation, there is ultimately only a closed world of tedium.

At that, however, the strokes by which the work is composed

have a felicity which separates them from the continuous, linear skeins of duco, oil, and aluminum paint which characterize the work of 1947–50. In "Shimmering Substance" Pollock's art was poised precariously between the vehemence of his anarchic energy and his penchant for the decorative. It was clearly a painting which "promised" something. (I think it promises something still: an overall, *painted* imagery which, independently of Cubism—though possibly not of Impressionism—may yet restore a kind of subtlety, variety, and nuance which our painting now lacks.) In the face of this promise he chose simply to enlarge the tedium which was already explicit in "Shimmering Substance," projecting it onto larger and larger canvases until his painting became a kind of architecture for the creation of which he invented a new technique—the famous "drip"—which finally disavowed all connection with the measured unit of feeling which is, after all, the brushstroke's decisive contribution to easel painting.

This "architecture," with its interweaving networks of linear arabesques, is not at all the Dionysian orgy of paint-splattering which people make it out to be. If anything, pictures like "Number 2" (1949) and "Lavender Mist" (1950) are overelegant and precious in the regularity of their effects. But in the "drip" technique Pollock found his perfect instrument: a means which, in execution, would give expression to the athleticism of his sensibility, but which in final result would provide that athleticism with a semblance of taste which it lacked as a native gift. In the "drip" paintings the anarchic was, temporarily, domesticated by the decorative.

I have spoken of this period as a plateau in Pollock's career. What followed was an abyss from which he retrieved, in my opinion, only one work of abiding interest: "Easter and the Totem" (1953), a surprising confrontation of the Matissean style which momentarily disarmed the appalling taste which dominates the pictures painted in the last four years of his life. Since Mr. Hunter makes much of Pollock's "lyricism," I am surprised to find that he doesn't mention this picture at all. But then, in claiming that this lyricism is "epic in its sweep"—a remark in which Mr. Hunter reaches, semantically, something comparable to that total freedom he attributes to Pollock's art—he confirms that lyricism is now a term invoked to bridge disparities between an artist's feeling and his achievement. By and large, the last gallery in the Pollock exhibition was a dismaying experience, revealing an artist driven by aspirations which cruelly

outdistanced his talents. But under the aegis of history, I suppose such judgments are unwelcome and dispensable, and it is in the name of history that the official rhetoricians have now claimed him.

February 1957

II

No one experiences art in a void, yet there are times when our relation to raw artistic fact becomes almost irretrievably lost in the morass of discussion and counterdiscussion surrounding it. Today, as never before, we confront works of art in a heavy crossfire of critical assertion and historical debate. Theoretical disquisitions multiply like angels dancing on the head of every *oeuvre* attaining a modicum of acclaim, while more earthbound scholarly minds are busily at work methodically arranging documents scarcely more ancient than the Xerox apparatus used to preserve them. Even an observer with a well-developed appetite for critical nuance may find himself inhabiting two quite separate realms of discourse—one consisting of the art in question, the other overcrowded with ingenious and sometimes brilliant reflection—without finding any clear way to relate the virtuosity of the latter to the actualities of the former.

This is more or less the position in which I find myself in approaching the Jackson Pollock exhibition that opened this week at the Museum of Modern Art. From my first acquaintance with Pollock's work some seventeen years ago, he has seemed to me an artist enormously overrated by his admirers—and, incidentally, woefully ill-described by his many detractors. Before seeing Pollock's work the first time, I had read the criticism published by Clement Greenberg in *Partisan Review, The Nation,* and the old *Horizon.* The criticism was marvelously persuasive. It had a quality I particularly prized—and still prize—in writing on art: a quality of intellectual conviction combined with a clear response of sensibility. And in Mr. Greenberg's criticism there was something else, too—a sense of history on the march.

But there began my difficulty. The artist described in the criticism was hard to locate on the walls. In his place was an energetic provincial struggling to compete with the luminaries of the

School of Paris. The criticism outlined large possibilities as if they were actual accomplishments; the art fell short by a wide, wide margin.

If I mention this personal history, it is not because I regard my judgment of nearly two decades ago as infallible. I have changed my mind about many things since—in both art and life. But in this matter, the discrepancy noted in my first encounter with Pollock has persisted. The discrepancy has, in fact, become so enlarged as to constitute—in its general implications as well as in the specific case—a cultural phenomenon of some importance.

There is just now being published in *Artforum*, for example, a long critical monograph on Pollock by Professor William Rubin of Hunter College. The current number carries the third voluminous installment; the entire work will be brought out eventually by Harry Abrams. Also due later this year, under the imprint of the Museum of Modern Art, is a volume of painstaking documentation on Pollock's life and work by Professor Francis V. O'Connor of the University of Maryland. I have read a good deal of the latter in manuscript and found it fascinating; parts of it are like Dos Passos's *U.S.A.* brought up to date. Between the biographical drama of Professor O'Connor's documentary chronology and the closely argued points of Professor Rubin's dazzling monograph, one feels in touch with an artist of heroic gifts and immense accomplishments.

It is only one's knowledge of Pollock's work that acts as a brake on the expectations aroused by this amazing literature. For in the presence of the work, the fine discriminations of Pollock's expositors read like a libretto for an opera that has remained largely unwritten. Enough fragments are discernible for us to grasp what it is about Pollock's work that prompts such optimistic flights of reflection and scholarship, but fragments they remain.

The display of ambition in Pollock's art, the naked attempt of an artist to invest his entire being in a style that might compete with the greatest achievements of Europe—and to do so in a quintessentially American manner—answers to something deep in the American intellectual community. We have seen the same thing happen more recently in the case of Allen Ginsberg, who has become an international legend while remaining a minor poet of small, fragmentary accomplishment. And indeed, Pollock stands to Picasso as Ginsberg stands to Whitman and Pound: provincials aspiring to a status which their intrinsic gifts deny them. But the exact quality of

their gifts does not matter; the whole momentum of our culture shares in this unearned aspiration and rewards its exemplars with the trappings of authenticity.

Seeing Pollock as I do, there seems little point in rehearsing once again the parabola of his development. The Museum of Modern Art has, if anything, overfulfilled its obligation to show us this development in quantity. While the museum's first Pollock show of 1956—the year of the artist's death—consisted of forty-four works, the present one numbers 172 items. What will be new to most visitors to the exhibition are Pollock's apprentice works of the 1930's— for the most part, works of dismal mediocrity. But every stage of his career is more than amply represented.

Buried in this vast assemblage is the authentic but imperfect work of an artist with a gift for the graphic. But the pressure of ambition in Pollock turned even this gift into something inflated, so that even his one undeniable claim to originality—the method of the "drip" paintings of the late forties and early fifties—appears as an overextended device that has since been put to more cogent use by later artists. Much of the time we are simply in the presence of drawings writ too large for their substance and thus availing themselves of decorative props to sustain their visual power.

Such is one observer's melancholy view of the Pollock phenomenon. There is always something depressing about dealing with a household god and finding him something less than godlike in his bearing, and Pollock is indeed one of the gods today. But the substance of his art, as distinct from the literary shadow that has all but displaced it, compels this unhappy judgment.

April 9, 1967

3. Robert Motherwell

I

The art of collage is one of the great visual inventions of the twentieth century. Deriving from the aesthetics of Cubism in the years immediately preceding World War I, collage has enjoyed a remarkable growth and development as generation after generation of artists have found this medium of pasted papers and other materials so essential to the realization of their goals.

Indeed, certain movements in the visual arts have been so dependent on the resources of collage that they are all but unthinkable in any other terms. Dada and Surrealism, for example, were peculiarly indebted to the syntax of outrageous juxtaposition which collage afforded with an immediacy and impact not to be found—in this early period at least—in the more traditional painting and sculpture media. And at a pole of aesthetic commitment far removed from the poetical-polemical climate of Dada and Surrealism, the whole modern tradition of Constructivist sculpture is likewise a direct offspring of collage principles. Nor are painting and sculpture the only arts to reflect the profound influence of collage: in music, in the films, in the dance, in poetry and the novel this influence continues to grow.

Seen against the background of this rich and complex history, the new collages of Robert Motherwell at the Whitney Museum of American Art do not make any dramatic or unusual claims on our attention. Clearly, the interest here is not in pressing the collage medium to any extreme of iconographic invention. The temptation to turn collage into a species of Surrealist poetry is firmly resisted. The whole impulse of Mr. Motherwell's art—on this occasion at least—seems to be directed to precisely the opposite course: to restoring collage to its original position as the medium of a purely pictorial imagination.

The most obvious resource of collage—its incomparable ability to place ready-made images and materials in striking juxtapositions—has an almost irresistible tendency to visual comedy. It is this tendency that the Dadaists and Surrealists and their numerous Neo-Dada and Pop progeny have exploited with such energy and en-

thusiasm, and the result has been to make collage the medium par excellence for the production of visual incongruity.

But time seems to be running out on this particular development. What was once a source of stunning, quick-witted poetry and hilarious revelations of the absurd has degenerated for the most part into well-rehearsed evocations of the familiar. This once vital impulse seems to have found a comfortable home in the television commercial where, a thousand times a week, you can see the ghosts of old ideas employed in spectacular campaigns to sell detergents.

But there is another use of collage—what we might call collage's classical tradition. We find it not only in the great early collages of Picasso and Braque, in their Synthetic Cubist period, but also in the early torn-paper collages of Arp and in the late color cutouts of Matisse. Certain minor artists—I think particularly of the late Anne Ryan—have based their entire *oeuvre* on a loyalty to this tradition and on a sensibility perfectly attuned to it. To artists of this persuasion, it is not what remains "raw" and ready-made in a collage that determines its aesthetic quality but what pictorial transmutations the artist effects in his use of the materials at hand. Such artists are more concerned with purifying their materials—with erasing, as it were, easy associations and comic effects—and thus placing the results firmly in the realm of disinterested pictorial discourse.

Mr. Motherwell's collages are very much in this line. Although he occasionally employs papers that convey a certain atmosphere and association—in the current show, the Gauloise cigarette wrapper is much in evidence—such materials are not really exploited for iconographic purposes. If there is an attempt at explicating the incongruous here, the incongruities in question are those that obtain between mundane materials of this sort and the solemn aesthetic functions they are made to serve. In any case, I think the most accomplished works in the current show are not those that employ these ready-made papers but, on the contrary, those that bear no association or form other than that created by the artist on the page.

In particular, there is a series of collages in this exhibition—works that are all more or less limited to beige and white forms and usually employing both pasted ready-made papers and some painted papers—which seem to me among the finest pictures Mr. Motherwell

has produced in some years. They are close in spirit to both Arp and Matisse. There is a kind of mandarin simplicity in them, an elegance that is at once highly deliberated and very suave. There is a suggestion of lyrical purpose abetted by intellectual decision. They achieve a kind of concision that only a very experienced artist could bring off without seeming slight or frivolous.

Where strong color is used, the results are, I think, less distinctive. In a work such as "In Beige, Ultramarine and Green" (1968), the shadow of Matisse clouds one's vision—as, indeed, it seems to have clouded the artist's—and elsewhere, too, color seems merely disruptive, a visual noise disturbing an otherwise calm and sustained meditation. Occasionally, too, there is a foray into quasi-geometric form, and this also seems foreign to the artist's sensibility. Only where the forms are relatively free in their irregularities and free of bright color and sharp contours does Mr. Motherwell seem able to sustain a high level of pictorial discourse.

All of this places the best of these works at a certain distance from the abstract art we are used to regarding as characteristic of the present moment—and certainly at a great distance from what collage has generally been concerned with in recent years. They recall us to purer purposes and a more personal expression.

October 13, 1968

II

Some years ago, in a statement entitled "What Abstract Art Means to Me," Robert Motherwell spoke of abstract art as "an art stripped bare." "How many rejections on the part of her artists!" he observed. "Whole worlds—the world of objects, the world of power and propaganda, the world of anecdotes, the world of fetishes and ancestor worship . . ."

So far as rejections go, Mr. Motherwell had then—the year was 1951—scarcely seen the beginning. Compared to the present moment, the early 1950's seem—in retrospect—a period of almost unbridled acceptances. Indeed, few decades rival the sixties in witnessing the rejection of so many conventions formerly deemed essential to the artistic enterprise. In principle, many of these rejec-

tions may have been broached—and many even acted on—long before the present decade, but the sixties have seen them realized on a vaster scale than ever before. Abstract painting has become, in a great many hands, an art barer than bare—an art almost, if not quite, anonymous; an art that has made an expressive principle out of its own radical barrenness.

At first glance, I think, Mr. Motherwell's new paintings—currently on view at the Marlborough-Gerson Gallery—appear to have succumbed to this principle. Their visual rhetoric is certainly leaner and more parsimonious than any he has offered us in the past. Their imagery is likewise drastically reduced, at times approaching the ultimate austerities of the Minimalists.

And there can be little doubt—in my mind, anyway—that the pressures of the Minimalist sensibility, so pervasive in the art of the sixties, have made themselves felt in the very conception of these new paintings, which date from 1967–9. For the effect of Minimalist art has been to make almost every other visual style appear—if only temporarily—overstocked with forms, methods, emotions, and ideas that cannot always justify their existence by performing some essential task within the work itself. Minimalist art, quite apart from how one judges its own specific accomplishments, has made a great many other styles seem parlous, noisy, and incontinent. Like all radical styles, it has functioned as a criticism of the art which preceded it, and in this case its critical function may turn out to be the most important thing about it.

It is in this sense, then, that I believe the Minimalist idea has played a critical role in Mr. Motherwell's new work. But it is very far from being the only idea, or even the dominant idea. Mr. Motherwell remains what he has always been: both a very intelligent and a very intellectual painter, an artist highly conscious of the expressive morphology of modern art and of the relation in which his own art stands to that morphology. His new work does not differ, in this respect, from his work of the past. It, too, mediates between the present and the past, cultivating an aura of tradition at the same time that it penetrates into something new and still problematical.

The past, in this instance, belongs to certain works of Matisse and Miró—the Matisse of "The Blue Window" (1911) and "View of Notre Dame" (1914), the Miró of "The Birth of the World" (1925) and "Spanish Dancer" (1928), pictures in which these painters have all but dissolved the specification of their respective

iconographies in the interest of a surface and a structure that is radically simplified, radically reduced to an articulation of the color and shape of the canvas itself.

As a painter, Mr. Motherwell has always kept the lines of communication open to the Parisian past, and I think these lines are no less evident in this new "Open" series—as it is called—than in his other work. The imagery may be the barest he has ever attempted, but its handling is in many respects "traditional." A squarish or broad-bottomed "U" is drawn in charcoal or painted onto an expanse of color, sometimes floating, sometimes anchored to the upper edges of the surface; sometimes accompanied by a horizontal line that divides the picture space, sometimes repeated as a series of inverted arches. Certain of the larger pictures encompass more complicated variations on these motifs, and yield a more complex composition, but the impulse remains uniform throughout: an impulse that presses both drawing and color to the very margin of their viability and yet seeks to sustain them in something very like their traditional relationship. There is no attempt to disguise the artist's "hand." There is nothing even approaching the kind of "anonymous" surface one finds, say, in Ellsworth Kelly's recent work. The loyalty to a certain kind of Parisian elegance persists— not an elegance of finish but the elegance inherent in a certain kind of intellectual attitude toward painting.

Needless to say, all of this places Mr. Motherwell very far from the orthodoxies of the Minimalists, but I doubt if his new work coud have assumed its present form without the radical pressures they have exerted on traditional conceptions of picture-making. What is remarkable, however, is the degree to which he has absorbed these pressures and turned them to his own account. As a colorist, he still works very much in a romantic, elegiac vein, evoking dreams of Matisse's blue light and of the ocher, umber, and gray structures of the classical Cubists. One of the pictures in this series—No. 22, in black and white, in some respects the most daring—is a kind of outsize extrapolation of a Matisse drawing, and brings to mind Matisse's observation that a painter's true understanding of color would be abundantly evident even in a black and white drawing.

Clearly, Mr. Motherwell's rejections have by no means been as complete or as far-reaching as those of the generation that has succeeded him. Indeed, in his attachment to the verities of Parisian

painting, he may even seem at times to be indulging in a bit of ancestor worship himself—though not exactly in the sense he had in mind in the statement quoted above. Still, however one defines it, there is in this work a sense of the past that has almost passed out of the art of painting in recent years—a sense of the continuity and community of sensibility among artists which was once a source of great strength to painters themselves. This sense of continuity is, perhaps, the easiest thing to overlook in these new works, but I think it is fundamental to their conception.

I can think of few exhibitions, in any case, that reaffirm the strengths of abstract painting to quite the same degree. To keep itself vital, abstract painting has traditionally had to narrow its vision, to ally its momentum to the velocity of history. And this, in turn, has often meant a kind of fear of and contempt for the past. But here the memory of the past is still vivid and is no longer a liability.

May 25, 1969

4. Willem de Kooning

I

The exhibition of new paintings and drawings by Willem de Kooning, currently adorning the brown plush walls of M. Knoedler & Company, is an event guaranteed to make everyone feel a little older. Twenty years ago Mr. de Kooning was painting some of the best pictures of his generation, and he had not yet had—at the age of forty-three—his first one-man show. Ten years later, though his painting had seriously declined, he was at the height of his influence. The fabrication of synthetic de Koonings had become a Tenth Street industry, and one of the games people played in those days was to see how many times Mr. de Kooning's name would turn up in

each month's issue of *Art News*. The cult of personality seemed to increase in exact ratio to the decline of the artist's work.

Autres temps, autres moeurs. The issue of Mr. de Kooning's influence is now a dead issue. No doubt it has already served as the subject of numerous academic theses, but it has long ceased to have any relevance to living artistic problems. His many imitators—not all of them young—have either repaired to other positions or passed from the scene altogether. New modes of sensibility, not necessarily superior to the old but certainly vastly different, have vanquished every trace of the once ubiquitous de Kooning school, together with the ill-conceived and overphrased theory of "Action painting" that gave it such promiscuous rhetorical support. The juggernaut of fashion has moved on, leaving Mr. de Kooning himself to stand isolated and alone as the sole survivor as well as the principal source of a curious episode in the history of taste.

If one is moved on this occasion to speak first of the artist's influence rather than of his intrinsic quality as a painter, it is because Mr. de Kooning has emerged in these circumstances as his own most distinguished imitator. The atmosphere of self-parody is almost palpable in this new exhibition, and what is being parodied is precisely the vein of Expressionism, the tendency to pictorial self-dramatization and unbridled painterly display, that has often been the weakness rather than the strength of his considerable talents.

This Expressionist tendency has been evident as one term in the dialectic of Mr. de Kooning's style at least since the 1940's, but in his best work it was never the dominant term. A stripped and battered Cubism, shorn of its rigidities and pressed to an extreme margin of flexibility and release, provided the basic pictorial syntax. This highly modified Cubist syntax owed a great deal to Mr. de Kooning's virtuosity as a draftsman. Indeed, in his great work of the forties, everything depended on the artist's virile and elegant line. Painting became more and more a form of drawing. Color proved to be extraneous and expendable, and in the black-and-white paintings of the late forties—still the high point, I believe, of Mr. de Kooning's development—was dispensed with altogether. Out of a flattened Cubism, raised to unexpected eloquence by the inspired improvisations of his draftsmanship, he had distilled a new classicism.

To this distillation, the Expressionist component contributed a necessary spontaneity and immediacy. It also had the effect of partly

dissolving and partly filling the contours traced by the artist's airy and energetic linear invention, endowing it with a weightiness and solidity that draftsmanship alone could not furnish. If Cubist draftsmanship, tempered by memories of Ingres and owing much to Picasso and Gorky, was the main "plot" of this pictorial style, Expressionism was its essential subplot.

In the "Women" series that, since the early fifties, has come to dominate the artist's production—and, apparently, his whole consciousness—Expressionism was released from its subordinate role and given much freer reign. Color was thus restored to a position of high priority in the picture-making process—the same hot pinks as appeared in Mr. de Kooning's earlier work, only now given a more rhetorical Rubensesque accent, evoking a universe of palpitating female flesh. Yet in the beginning of this series the basic image was still graphic, still dependent on the artist's command of line, and for this reason the finest works in the series have remained the early small pictures on paper—dating from just before and after 1950— which are essentially tinted drawings. Thereafter, the Expressionist element swamped the artist's style, bringing him by a long and tortuous route to his current impasse.

For the new paintings—most of them of women, or women in a landscape, or landscapes with memories of women—carry this Expressionist debacle still further. This is indeed the triumph of rhetoric over syntax. Paint is applied with an evident fury, but whether as an attempt to evoke the artist's ostensible theme or out of despair at forcing upon sheer painterliness functions it is helpless to discharge, it would be difficult to say. The cruel postures, the visceral emotions, the sexual obloquies, and the attempt to combine these with a sunny, almost pastoral landscape imagery—all this is clearly the stuff of which great art ought to be made. But here it is the ambition for greatness that one feels rather than its realization. The grand style that, for years now, has been Mr. de Kooning's aspiration—and indeed his obsession—has failed to materialize, and the pursuit of this aspiration has only succeeded in alienating the artist from his own deepest resources.

There are some forty-five paintings in this exhibition, and fifty drawings, and it is in the drawings that one can see the extent of this alienation even more vividly than in the paintings. They are surely the worst drawings that any artist with pretensions to a major accomplishment has exhibited here for years. The draftsman who

once emulated the eloquence of Ingres and Picasso has been reduced to mumbling a kind of Expressionist patois.

None of this will prevent this exhibition from being hailed as the work of a master, or Mr. de Kooning from being regarded as the artist uniquely endowed to uphold the glories of easel painting at a time when the historical tide is running against it. Though he is no longer an influence, he is now an established classic. But the claims that are now being made on his behalf are empty claims. His new paintings do not so much embody the crisis that has shattered the tradition in which he works—that would indeed be an accomplishment one could respect—as look back on an earlier crisis with nostalgia. By implication, they justify the wholesale revolt against Expressionism that has been so apparent in the art of the sixties. For after all the brave talk of "Action" and Existentialism, after all the brave references to Rimbaud and Melville, we have before us only another, more gifted, more energetic, and more desperate example of *pompier* Expressionism from the last surviving member of the de Kooning school.

November 19, 1967

II

No other exhibition I have ever seen has done more to justify the great claims made for American painting in the 1940's than the large Willem de Kooning show that has now come to the Museum of Modern Art. Nor has any other exhibition in my experience done more to confirm Mr. de Kooning's pre-eminent position in that difficult decade when the New York School emerged from the ashes of Europe to take up the international leadership of advanced art. The sheer quality of so many pictures from the forties is more than sufficient to explain why Mr. de Kooning was a legend among artists and other cognoscenti in New York long before the New York School became a certified historical phenomenon for the public at large. At its best, this is painting of tremendous eloquence, sensitivity, and power.

The exhibition itself, organized by Thomas B. Hess, the editor of *Art News*, and consisting of 147 works, is by no means an

unmixed triumph, however. If there were still any doubts about the artistic debacle of the painter's later years, the scale of this exhibition, with its merciless record of consistent decline over the last seventeen years or more, lays them to rest with a depressing finality. Needless to say, this is not Mr. Hess's view of the matter, and it must be admitted that his text for the comprehensive catalogue accompanying the show is the best explication of these later pictures anyone has yet made. Mr. Hess has, happily, abandoned some of the literary eccentricities that formerly disfigured his critical style and has produced for this occasion a text that will be indispensable to serious students of the period.

Mr. de Kooning is, I think, a far more unusual figure on the American art scene—and certainly a more unusual figure in his own generation of New York painters—than has generally been supposed. He is, after all, a European not only by birth but by virtue of his training and sensibility. (He was born in Rotterdam in 1904, educated in the Academy of that city, and he came to America in 1926.) Nourished on the traditions of the European masters, his art has always had a more inward and resonant relation to the values of those traditions than that of any other painter of the New York School. Only his friend Arshile Gorky, perhaps, approached him in this respect—it was, no doubt, one of the bonds of their friendship—but whereas Gorky sought by conscious emulation and even pastiche to assimilate his art to the great tradition, Mr. de Kooning had this tradition at his fingertips.

Entering the first gallery of the exhibition, with its brilliant array of "pink" figures from the early forties, I was reminded of another painter of similar disposition and circumstance: the Picasso of the "rose" period. The two artists are comparable in many ways and not least in their adroit use of traditional drawing and their essentially classical bias even in the face of their own innovations. Taking the forties as a whole, Mr. de Kooning's art traces—perhaps one should say retraces—a course already traversed in Picasso's transition from the "rose" figures to the inventions of Cubism. Mr. de Kooning's inventions in his great black and white abstractions of the late forties are not, I believe, to be equated with the creation of Cubism, if only because they are themselves so deeply indebted— however far removed and transmuted the debt may be—to the pictorial syntax of Cubism. But there is nonetheless a great similarity in these two painters, bearers of tradition and yet authors of

innovation, aliens in the capitals whose values they helped to transform, radicals with the culture of the museums informing their every breach with custom.

Though each of these artists has deeply influenced the forms of abstract art in his own time, neither has really ever been an abstractionist in the purest sense. Mr. Hess makes a point of emphasizing Mr. de Kooning's use of figurative fragments even in the most abstract of the black and white pictures, and it is certainly true that these pictures—which I believe to be the artist's best—now have the look of very subtle and intricate orchestrations of observed motifs. Whether one can find in them what Mr. Hess also claims—an erotic and even an orgiastic motif—is a good deal more questionable. Certain erotic symbols may be observable in the drawing, but the work itself, both in its internal modulations and in its general pictorial demeanor, is very far from suggesting any Dionysian revels. Pictures such as "Dark Pond" (1948) or "Attic" (1949) are, if anything, closer to the classicism of Cézanne (albeit a Cézanne that has gone to school to Picasso) than to the fictions of "Action painting."

What the retrospective character of the current exhibition makes clearer than ever before, at least to me, is that the abstract paintings of the forties (to the extent that they are abstract) represent the exception rather than the rule in Mr. de Kooning's career—a career that has been consecrated to the figure. There are, to be sure, certain abstract pictures in the thirties. (The best of them is the lovely "Pink Landscape.") And there are the lamentable, oversize abstractions of the fifties and early sixties—perhaps the only real "Action paintings" Mr. de Kooning or anyone else ever produced, and the less said about them the better. It is the figure, and mainly of course the female figure, that has elicited from Mr. de Kooning his subtlest uses of color and his most intensely wrought draftsmanship. It is his confrontation of the figure that has raised the aesthetic temperature of his work (if not always its aesthetic quality), and sometimes raised it to fever pitch.

But even in this realm, I think, Mr. de Kooning remains above all a painter of the forties, working under the pressure of the Picasso inheritance and giving it some marvelously personal turns, but working essentially as an heir to a tradition, with all that that implies about a certain modesty of scale and refinement of taste. In other words, the best of Mr. de Kooning's "Women" are small in

scale, either drawings or pastels or oils on paper, and they conclude at just the point when he was finishing his first "major" attempt to project this obsessive image onto a monumental pictorial scale. It is one of the ironies of history that the artist came into his first great fame with this attempt—"Woman I" (1950–2)—which, as I see his work, signaled his descent first into an agitated but increasingly empty rhetoric and then into the fulsome, if sometimes poignant, flaccidity of the more recent "Women" series.

What we have, in effect, is not one but two exhibitions here: the first, a résumé of the "unknown de Kooning," working in relative obscurity as one of the most deeply serious artists of our time; the second, a celebrity more and more alienated from his true qualities. It is this division that makes this exhibition at once one of the finest and one of the saddest shows I know.

March 9, 1969

5. Ad Reinhardt

The untimely death of Ad Reinhardt at the age of fifty-three is an event that prompts some reflection on the nature of his accomplishment as an artist. Reinhardt was not, surely, a major painter, but his ideas and example had come to signify something important for a generation of artists younger than himself. Though he had been an abstract painter since the 1930's and had come of age, artistically, in the era of Abstract Expressionism, it was the work of his later years—the notorious "black paintings"—that brought him his greatest measure of fame and influence. The fame was equivocal— the fame of an intransigent suspected of being a crank. The influence was limited. But there is no question that Reinhardt lived to see his own extreme and once isolated position relocated, as it were, by the vicissitudes of history into the mainstream of a movement. What had seemed, even five years ago, something singular and aloof from

the art of his time had become, by the mid-sixties, an almost over-colonized aesthetic territory.

Like many of the inhabitants of this new territory, he was an active ideologue as well as a painter. His gifts as a polemicist and pamphleteer—both as writer and cartoonist—were justly celebrated. He was highly conscious of what he was against, and it was in certain of his negative judgments that even his antagonists (among whom the present writer counted himself) could find a kind of comfort. For underlying the specific—and, as I believe, wrong-headed—principles which Reinhardt enunciated with untiring zeal was an appalled sensitivity to the vulgarity and disingenuousness that had overtaken art in the prosperous years of the fifties and sixties.

I doubt if the "rightness and purity" Reinhardt pursued in his art can really be understood apart from this critical attitude toward the culture in which he functioned. And by "culture" one means, in this case, not only culture in the general sense but the specific culture of the New York art world. "Any combining, mixing, adding, diluting, exploiting, vulgarizing or popularizing abstract art deprives art of its essence and depraves the artist's artistic consciousness," he wrote in 1962. The "essence," offered in the form of an extreme pictorial distillation, was Reinhardt's abiding obsession as an artist. But an extraordinary portion of his energies was devoted to combating the threat that art itself—characterized by Reinhardt as "false art" or "servile art" or simply "non-art" to the degree that it departed from his own ideal—constantly posed to the realization of this "essence." His performance in this respect often reminded one of a fundamentalist preacher denouncing sin. One wondered at times if the "sin" in question did not exercise a peculiar fascination for him. Certainly the "salvation" of his own pictorial practice was unthinkable without the existence of this sin.

In her essay for the catalogue of the big Reinhardt show at the Jewish Museum last fall, Lucy R. Lippard described this practice as located "in the area of recent geometric abstraction that can be called rejective art." For Miss Lippard, "Rejection does not . . . suggest attrition, but rather a strengthening process by which excess and redundancy are shed and essence retained," whereas for me the term "rejective art" merely confirms what I have always taken to be the essentially polemical character of Reinhardt's painting.

In art there is no necessary conflict, of course, between a

polemical intention and a result of high quality. If one doubted the quality of Reinhardt's case, it was not because of his involvement with polemic but because the quality, such as it was, appeared to be so completely at the mercy of the polemic. The black paintings that dominated his retrospective exhibition at the Jewish Museum, just as they had dominated the last years of his life, were, despite a good many jokes to the contrary, quite possible to see. The symmetrical geometric forms, rendered in dense black and near-black pigments, disclosed their internal relations easily enough if the spectator was a little patient. It was simply a matter of getting used to the dark. But once one was used to it, the relations were not only repetitious—after all, many good painters repeat themselves—but exceedingly banal. Patience was not, in this case, rewarded. Once one had "got" these paintings, one was thrown back on what they "meant"; what they *were* was simply not enough.

The meaning of Reinhardt's work brings us back to his ideas, however, not to his paintings. Reinhardt was an extreme case of an artist whose works signify a position but shrink in importance once divorced from that position. And it was the position *illustrated* in the work that, I believe, won Reinhardt his late following among certain younger artists, for they, too, had arrived at a point where art had become a form of art-historical combat. In such combat the actual physical and visual quiddity of the work, its specific tenor of feeling (if any), is far less important than the degree to which the work can score against accepted ways of looking at art and of making art. In such combat, the artist is enclosed in a world in which nothing exists but other works of art, most of which he finds decadent, dishonest, and opportunistic. The mission of his combat is, indeed, to restore health and purity where he finds only disease and impurity.

This combat was the essence of Reinhardt's quest as an artist and as a polemicist. It was the kind of quest that had sometimes yielded other artists some extraordinary achievements—Mondrian, I suppose, is the finest example. But the very nature of the cultural milieu in which Reinhardt functioned, coupled with his own disabilities as a functioning painter, made it all but impossible for him to make of this quest anything but a negative gesture. His work was, finally, too deeply implicated in the very vulgarities against which he protested. No artist of our time was more hostile to the spirit of Dada, which, in its more dilute and fashionable forms, accounts for

so many of those vulgarities, and yet his work became for many of the people who admired it—as well as for those who did not—simply another manifestation of the Dada program. The black paintings became what Reinhardt certainly did not intend them to be—amusing.

In this respect, the younger generation that looks to Reinhardt with admiration has a more realistic sense of the culture in which it works. It understands, as perhaps no artist of Reinhardt's generation could, the extent to which art—art of every persuasion and ideology—now functions in an open arena in which the artist himself cannot control the fate of his own intentions. Nothing dates Reinhardt more than the assumption that he could carry on his program in public and not be touched by the disease he set out to cure. It seems unlikely that the artists of the future will be able to function with that particular kind of innocence.

September 10, 1967

6. Jean Dubuffet: Playing the Primitive

Amid the general decline that has marked French painting since the end of the Second World War, the work of Jean Dubuffet has occupied a special place. It came to public view for the first time after the war when the artist himself was in his forties, and it was interpreted then as having very little connection with the refinements and ambitions of prewar French painting. It was an art that seemed to repudiate all those elements of logic, analysis, and order that the French, more than any other nation, had especially prized in painting. Dubuffet was widely regarded—and appeared to regard himself—as a man who had thrown into question all the pieties of French tradition. He was taken to be an artist-revolutionary, a man who would effect a wholesale revision of French values and taste. The effect that Dubuffet's art produced, at once alarming and excit-

ing, may be gauged by the outcome of his second exhibition in 1946: although widely denounced as a scandal, the show sold out.

In many ways Dubuffet's style was exactly suited to the anticultural role that was eagerly assigned to it. It could boast of irrational sources, imperfect materials, and irreverent subjects. Its crude drawing deliberately aped the untutored scribbling of children, savages, and psychopaths. Its attitude toward color was a calculated affront to one of the glories of French painting. There was something mildly obscene in some of Dubuffet's subjects, and an element of childlike caricature was clearly intended to amuse and entertain in a completely unpainterly manner. The pigment itself tended to be corrupted with "inartistic" materials so that the surfaces of Dubuffet's pictures came more and more to resemble, physically, the cracked sidewalks and crumbling walls whose graffiti yielded the artist some of his original motifs. Where its surfaces were conventional, the color was harsh and garish. This was surely not painting as the French had formerly envisioned it—or so one was told.

As it turned out, there were ample precedents in the art of the 1920's and 1930's for most of Dubuffet's "innovations." The interest in naïve drawing came straight from Paul Klee, and the use of incongruous materials from the old Dadaists. The Surrealists, and especially Miró, had already exploited the expressive possibilities of irrational subjects; they had also created something of a vogue for naïve and automatic drawing, particularly for the kind that reveals "unexpected" erotic themes. The truth is that the radicalism of Dubuffet's style has always been exaggerated by his admirers, but there can be no doubt that the style itself, whatever its debts and limitations, exactly suited the temper of postwar art circles in Europe and the United States.

It was Dubuffet's achievement to bring together these separate elements from movements that had flourished between the wars and give them a raw and forthright expression at the very moment when the artistic community had lost confidence in a more complex, more rational and analytic view of art. Dubuffet's was the case of a man connecting with the right historical moment. The whole nature of his success has been a remarkable example of an artist riding in on a wave of feeling that his own work exploits and enlarges upon but does not itself either create or in any way alter. Twice before, first in 1918 and again in the 1930's, Dubuffet had embarked on an artistic

career but had given up both times. He turned to other interests—music and poetry, masks and marionettes—and meanwhile became a successful wine merchant. It was only with his third attempt, in the 1940's, that he scored—and then with an acclaim that few of his contemporaries have equaled.

The retrospective exhibition of Dubuffet's work that Dr. Peter Selz has assembled at the Museum of Modern Art gives one a very clear view of the artist's development over the last two decades. Nearly two hundred works are included, and all the major themes and materials that have occupied Dubuffet's attention are represented. Like most figurative painters, Dubuffet has focused his interest on a very few subjects: landscape, figures, and still life. He has painted a great many nudes and some striking portraits of his friends. As many artists have done in the past, he frequently paints pictures in series: the *"Corps de Dames"* group of nudes, the *"Sols et Terrains"* series of landscapes, and so on. His final compositions are frequently based on drawings from nature.

If one feels inclined, on seeing this exhibition, to underscore the conventional side of Dubuffet's achievement, it is because he emerges from this copious survey as anything but a revolutionary personality. Critics, including some very intelligent ones, have for the most part taken Dubuffet at his word and have praised or condemned him according to their taste for radical aesthetics. And it must be said that Dubuffet's word is highly persuasive. His own writings are bright and elegant, and he has been a tireless explicator of his every intention and ambition. There is only one thing wrong with the essays Dubuffet has written on his own work: their dazzling intellectual finesse makes nonsense of his claim to a free and untutored primitivism. They show us a mandarin literary personality, full of chic phrases and up-to-date ideas, that is quite the opposite of the naïve visionary. In the polished prose of a Parisian dandy, Dubuffet is constantly proclaiming his special affinity with the irrational; in prominent journals, in the publications of the most prosperous galleries and museums in the world, he is forever representing himself as the partisan of "scorned values." It has been a long time since one could regard this sort of thing as anything but a pose. Whatever the virtues of spontaneous, unconscious creation may be, Dubuffet has never known them. His language is the language of the *lycée* and the cafés, just as his art is an art of the studio.

Dr. Selz, in the monograph he has prepared for the exhibition, shows no interest in confronting this discrepancy between Dubuffet's alleged intentions and the actual character of his sensibility and style. (The book is valuable nonetheless for its plates and the small anthology of Dubuffet's essays.) Dr. Selz tells us that Dubuffet "was always fascinated by the strange world on the frontier of reason" and then continues: "Convinced that ideas and intellectuals are enemies of art, he began a systematic search for 'true art,' untouched by artistic culture and unspoiled by contact with the western classic tradition." As if this search for a "true art" transcending the values of the classic tradition hadn't been one of the central conventions of Western art for more than sixty years!

Dubuffet actually takes his place in the line of mandarin intellectuals who yearn to play the primitive. He differs from them only to the extent that his conceit prevents him from acknowledging the futility of the enterprise. Whereas the great figures of this tradition have always realized that an unbridgeable distance—a distance of culture, sensibility, and feeling—finally separated them from the kinds of primitive experience they were most drawn to, and then went on to make something meaningful of the contradictions involved, Dubuffet acts as if that alien world were completely accessible to him.

The effect of this conceit on his painting has been a smothering artificiality. Dubuffet is still able to provide a kind of lowbrow satisfaction to an anxious highbrow audience, but he does so now as one of the high priests of French culture. His revolution proved to be a myth; what began as an assault on good taste has simply given rise to a new form of elegance. It is a bit nastier than the old elegance; it affects the slang of the streets and speaks at times with a menacing rhetoric, but it is really quite safe. Dubuffet's whole career reminds me of a man using four-letter words at a fashionable dinner party. At first one is a little shocked, and then one smiles; the talk is resumed—and the next course is served.

May 10, 1962

7. Hofmann in Perspective

The exhibition of paintings by the late Hans Hofmann, currently on view at the André Emmerich Gallery, is the first posthumous view of the artist's work we have been offered since his death nearly a year ago. Both as a painter and as a teacher—but especially as a teacher—Hofmann was immensely influential during the last quarter century of his long life. (He was eighty-five when he died.) He was a leader of the Abstract Expressionist movement and its most eminent pedagogue. There was a period in the 1950's when past or present enrollment in the Hofmann School seemed a virtual passport to the limelight, and certain university art departments dispensed his pictorial doctrines like a patent medicine guaranteed to cure every aesthetic ill. Though one noted a reluctance among some partisans of the Abstract Expressionist group to grant him full status—his work was omitted from the sizable exhibition of "The New American Painting" which the Museum of Modern Art sent abroad in 1958-9—he nonetheless loomed large on the American art scene. He was a force.

Yet, so swiftly does the history of art now devour its own protagonists, this force had ceased to count as a significant influence even before the artist's death. By the mid-1960's, the momentum of new art in New York—both the work itself and the thinking behind it—had moved, or appeared to have moved, completely outside the orbit of Hofmann's ideas and example. This has had two consequences relevant to the current exhibition of Hofmann's work. It means that for the first time Hofmann's work as a painter is going to be judged as something distinct and separate from his role as a teacher and prophet, and judged by a generation of artists and critics innocent of—if not actually hostile to—any attachment to his point of view. It also means that an older generation of artists and critics, whose attachment to Hofmann was all but inseparable from its attachment to art itself, has now been orphaned by history, deprived of its accustomed stance as defenders of the vanguard faith, and placed in the unfamiliar (and no doubt uncomfortable) role of defending "tradition."

We have not yet heard the verdict of the younger generation on Hofmann; it will be interesting to see if the show at the Emmerich Gallery—uncommonly well selected, by the way—will stir

any interest in that quarter at all. But a spokesman for the older generation has been heard from—namely, the critic Harold Rosenberg, writing a "Homage to Hans Hofmann" in the January number of *Art News*. Mr. Rosenberg denounces everyone and everything associated with the new styles of the sixties—Lawrence Alloway and Clement Greenberg, Kenneth Noland and Helen Frankenthaler are particular objects of wrath—and somehow manages to make of his human and aesthetic targets not only artistic delinquents but moral collaborators with—of all things—the Pentagon. This is indeed an odd and anguished performance in which there is not a single cogent remark about Hofmann's own painting.

Mr. Rosenberg's diatribe is, as it turns out, a more eloquent testimony to his own orphaned status than to the reality of Hofmann's art—or to the reality of anyone's art. For it is precisely by history, rather than by art, that he has been orphaned. Loyalty to a generation, to a historical moment now vanished, is what dominates the outlook of this critic, who succeeds in embracing the work of Barnett Newman and Ad Reinhardt (his own generational peers) while castigating all those artists and critics who have dared to take one or another of these artists' ideas as a basis for new pictorial developments. One need not be an apologist for these developments to see that such a feat of rhetorical flimflam could only be accomplished, or even attempted, by a writer totally indifferent to the pictorial actualities involved.

If one turns from this dispiriting polemic, in which ideology is made to serve the purposes of nostalgia, to the Hofmann paintings actually installed at Emmerich's, quite another view of the artist's relation to the current scene suggests itself. These paintings are, for Hofmann at least, relatively "cool" works in which the artist's characteristic hot color and Expressionist handling are kept more or less discreetly within the bounds of a classically oriented, quasi-geometrical design. An element of German bombast is still everywhere apparent, yet it is kept in check to an unusual degree. Evidently the pictures have been chosen to underscore this "classical" side of Hofmann's often wildly heterogeneous production.

But this emphasis only serves to underline something that is true of Hofmann's art as a whole. For Hofmann was, above all, a codifier of modernist pictorial procedures—in a sense, an academician of the modernist tradition—while remaining an exponent of romantic Expressionism. Conceptually, he availed himself of all the

modern conventions, and indeed—though of the same generation as Matisse and Picasso—could only realize his ambitions late in life, when these conventions proved to be susceptible to his own vigorous program of pedagogic distillation. Yet he handled this distillation—at times, a sheer pastiche—as if it were a personal invention, imparting to it all the bravura of the Expressionism that flourished in his youth. In the pictures at Emmerich's, one is given a particularly clear view of the codifier and the bravura romantic coming to terms.

What the younger generation has discarded in this amalgam is Hofmann's attachment to romantic handling, while greatly increasing its commitment to the codification of modernist form. In this sense, Hofmann is not really as distant from the interests of the sixties as he sometimes seems, or as his sectarian defenders might wish. The latter have simply mistaken the surface of his art for its substance.

January 29, 1967

8. Albers

Josef Albers is showing a large selection of recent paintings at the Sidney Janis Gallery. His is a career going back to the turn of the century; the current exhibition marks his seventieth birthday. It is a career which recalls us to the migration of European artists to this country in the years preceding the Second World War, and to contemplate once again the profound changes which their coming has made in American art and in American thinking about art.

Albers has been distinguished even among his coevals, so many of whom took up academic positions here, in retaining a cast of mind primarily pedagogic in its preoccupations. From the beginning he has been a teacher; he was already a licensed schoolteacher of twenty-five when he began his studies at the Royal Art School of Berlin in 1913, and ten years later he was an instructor at the Bau-

haus in Weimar. From 1933 to 1948, his influence governed the study of visual arts at Black Mountain College in North Carolina, and since 1950 his philosophy of art education has presided over the Department of Design at Yale University, from the chairmanship of which he retires this year. Now this history of Albers's teaching career is not merely an interesting biographical aside. It is of the essence; it is quite inseparable from the meaning of his work as an artist, for he remains, above all, even now—and I mean *in his art,* not only in the particulars of his career—a highly committed instructor whose individual works of art are in the nature of exalted but nonetheless pedagogic demonstrations.

In his exhibition at the Janis Gallery, Albers is showing two series of works: the "Homage to the Square" series and the "Variant" series. The paintings in both series are primarily statements of color brought to a climax of impersonal intensity. It is a chilly intensity which in the end numbs the sensibility instead of enlarging it; but it is an intensity nonetheless, and it commands an extraordinary optical power and a compelling intellectual clarity. The means by which this power is achieved—and to understand the means in this case is to understand almost everything—has been described by Albers himself as follows:

> As to the colors themselves, they are unmixed. They are applied with a palette knife directly from the tube to the panel [masonite], in one primary coat without under or over painting, without any correction. No painting medium is used. As exceptions, only pink and rose, not available in tubes, are mixtures of one color with white.
>
> Consequently I have deprived myself of great light contrasts, all colors remain on a medium level of light intensity. As there are no shaded or tinted colors, there is no modulation, all color areas are flat and of definite shapes joining along the contours tightly.
>
> All textures are the result of varying consistency only. The appearance of translucency or intermixture or film-like overlapping are achieved by the proper juxtaposition of pure color only.*

Albers's method is designed to remove the act of painting as far as possible from the hazards of personal touch and thus to place its whole expressive energy—or as much as can survive the astrin-

* Quoted from *Josef Albers: A Catalogue Prepared by George Heard Hamilton* (New Haven: Yale University Art Gallery, 1956).

gencies of the method—at the disposal of a pictorial conception already fully arrived at before a single application of pigment is made to the surface. The pictorial image is then "developed" in the act of painting in very much the same sense that a photograph is developed in the darkroom: it is not so much created as re-created. The execution is a form of reproduction. This accounts, I think, for the amazing—and slightly terrifying—clarity of everything which comes from Albers's hand, and it suggests, too, the cost at which clarity is won. The cost is nothing less than the elimination of all those notations of feeling which traditionally invest a painting with its pictorial meaning and make of it something more than a design.

To redeem such a radical dissociation of feeling from execution would seem to call for a conceptual content so compelling as to compensate for all that has been eliminated. In Albers's new work, this conceptual content dwells exclusively on color. The precise forms which function as containers for Albers's color differ in the two series, and sometimes they differ slightly from work to work within a series; but purely as formal inventions they do not command any special interest. (My own preference is for the "Variant" series because of the greater complexity of its elements, but both series of forms are purified to a severe minimum.) What interest Albers's forms do have derives entirely from their efficiency in imparting a given quantity of color to the spectator's eye and in their logistic placement within the artist's scheme of color dialectics. Normally the singularity of a work of art depends heavily, if not altogether, on its formal power; and at the highest reaches of achievement the formal invention of a painting is inseparable from its whole expressive intention, of which the creation of form is a coefficient but not an exclusive end. (This is as true of Mondrian as it is of Matisse.) Now the singularity of an Albers painting does not reside at all in its formal invention but exclusively in the particular confluence of colors which are brought together within their assigned forms in order to demonstrate their effective properties. Such a demonstration is, in fact, the *content* of each of Albers's new works. Having dissociated feeling from execution, Albers also dissociates content from form—or at least he goes very far in the attempt.

Within the given limits of this dialectic, Albers achieves some astonishing results. His color always generates a hard, cold light which is unlike anything else in modern art. Seen in a direct light,

the frigid luminosity of an Albers sears the vision, and even in a half-light it may stubbornly retain an elemental force. There is no question but that Albers fully achieves his demonstration of the affective power of color. If we remain very long in its presence, our eyes throb with the evidence of his success.

Yet, removed from the realm of inspired instructorship and placed squarely in the arena of art itself—that is, on the walls of the Janis Gallery, where they may now be seen—the effect of Albers's paintings is not altogether an artistic effect. We feel the force of their didacticism, and we respond to (or recoil from, as the case may be) their deeply pondered physics. But ultimately Albers's paintings lack something crucial to a really profound vision in art: what the narrator of Thomas Mann's *Doctor Faustus* means when he remarks about a certain character, "She lacked the primitive basis, that which in all art is the decisive thing . . ." Nothing could be more alien to the spirit of didacticism which governs Albers's painting than this sense of the "primitive basis." Yet in the work of the two men whose *oeuvres* may be properly compared to Albers's and who were not themselves without the didactic impulse—Klee and Mondrian—we still feel the presence of a raw artistic will which has no role whatever in Albers's art. In its stead we have only the temperament of a dialectician, refining his system and removing one by one the impediments to its own perfection.

April 1958

9. Louise Nevelson

The exhibition of sculpture by Louise Nevelson at the Pace Gallery is, except for her retrospective at the Whitney last year, the best exhibition of her work in some years. It is not a large exhibition, either in the size of the individual pieces or in number, but it marks

a new development in her work—a development that is going to have an influence on other sculptors and that already displays a remarkable authority and realization.

The new sculptures are constructions in Plexiglas. They are transparent, geometric, rather Miesian in their combination of a strict, unembellished syntax and a cool, detached glamour. They have distinct affinities with the current mode of Minimal sculpture; yet they stand apart from it, if only because Mrs. Nevelson's work offers the eye so much more in the way of visual incident. A maximum of visual incident—accretions of form that state and restate, that amplify and dramatize the basic structure of the work—was the principle on which Mrs. Nevelson designed her first sculptural "walls" some ten years ago. In the interim, though her work has passed through some notable changes, she has remained loyal to this principle, and it serves her well in these new constructions.

It is interesting to look back on the changes that have overtaken Mrs. Nevelson's work in the past decade or so. A great deal of art history—both the way art is conceived and executed and the emotions it can be expected to embody—is reflected in them. Those exhibitions at the Grand Central Moderns Gallery in the 1950's that won Mrs. Nevelson her first eminence were quite different from the present occasion. They were like no other exhibitions at the time. They were extremely theatrical. They were intended to overwhelm—and they did.

For those exhibitions were not mounted as discrete displays of separate objects; they were designed as spectacular sculptural environments. (The word—and the idea—had not yet suffered its current devaluation.) Mrs. Nevelson had begun by using a flat pedestal as a base upon which abstract wooden forms were arranged to resemble still-life and landscape motifs. These forms were painted a uniform mat black. Though each work embodied a distinct conception that was executed with great care, it lent itself to this sort of environmental-theatrical exhibition. And indeed, the method of exhibition, which made the whole more important than the parts (even where the parts consisted of splendid individual sculptures), led to a change in the sculptural conception. It led to the creation of those sculptural "walls" for which Mrs. Nevelson is now best known.

These walls absorbed the smaller pedestal sculptures into an infinitely expandable series of boxlike units that permitted a great variety of form within a fixed format. There was, at least at the start,

a recapitulation and anthologizing of all the forms that had formerly existed as separate conceptions. The scale became architectural, but the imagery remained romantic, subjective, mysterious. The attention to detail was painstaking and finical. There was a geometer's precison in the way forms were fitted together. But the feeling remained that of a romantic dream.

Mrs. Nevelson has, over the years, subjected the sculptural wall to a great many variations, but within these variations there has been one clear tendency—a tendency toward greater clarity, simplification, order. A certain helter-skelter quality was gradually abandoned; there was less emphasis on labyrinthine detail and more on the rigorous architecture of the overall structure. Found objects gave way to precision-made parts. Improvisation gave way to stricter design. The deeply subjective and romantic ambience of the earlier constructions gave way to an atmosphere of dispassionate analysis. Where the first sculptural walls suggested a Surrealist-*cum*-Expressionist taste, the later walls have moved steadily in the direction of an unadorned Constructivism.

This, of course, is the direction taken by a great deal of painting and sculpture in the sixties. David Smith, in the last years of his life, followed a similar course. Much of the most accomplished abstract painting of the sixties has done—and continues to do—likewise. The whole Minimal movement has been a celebration of this development. There are, no doubt, some interesting historical reasons for this, but there are also important aesthetic-syntactical reasons, and we see them with especial clarity in Mrs. Nevelson's work.

For Mrs. Nevelson is a romantic by temperament, and in following what is, essentially, an antiromantic course, she has submitted her work to something stronger and more persuasive than the subjective taste to which it first gave expression—she has submitted it to the logical imperatives of its own form. In her work of the fifties, the Constructivist element was a means; in her work of the sixties, it has become both means and end, but more end than means. Structure is no longer designed to "contain" the image; increasingly, it *is* the image, and the materials and technique invested in the structure are thus employed to articulate that image.

The ideal of a transparent structure, in which space, mass, and light are identical and indistinguishable, in which the very syntax of the structure gives voice to the unity and inseparability of these

elements—this ideal has haunted the Constructivist aesthetic from its beginnings. Indeed, from before its beginnings: we find it stated as an aspiration in those crystal palaces of the nineteenth century that anticipated so much of the Constructivist idea.

I doubt if any sculptor has carried this old ideal to a more vivid realization than Mrs. Nevelson has in her new work. These transparent structures—prototypes for larger works to come—effect the final transformation of the romantic architecture of the fifties, with its Expressionist chiaroscuro, into a stunning Constructivist clarity. Everything here is open, visible, luminous. Planes dissolve into mass and mass into light. Space is rigorously defined—for even the screws and bolts that join these Plexiglas panels provide a kind of pointillist three-dimensional drawing in space—yet it remains elusive and volatile. Ten years ago Mrs. Nevelson would have been one's last candidate for the office of redeeming the promise of Constructivist purity, yet that is precisely what her new work triumphantly accomplishes.

January 28, 1968

10. Joseph Cornell's Baudelairean "Voyage"

There is a passage in Baudelaire's prose poem called *"L'Invitation au Voyage,"* written in 1857–60—not to be confused with the more familiar poem of the same title, written in verse a few years earlier—which, it has sometimes occurred to me, sums up the peculiar poignancy, lyricism, and yearning we find in certain forms of modern art. This is the passage as it has been translated by Francis Scarfe:

> Do you know that fever which grips us in moments of chill distress, that nostalgia for some land we have never seen, that anguish of curiosity? There is a land that resembles you,

where everything is beautiful, sumptuous, quiet, and authentic, where Fancy has built and adorned a Cathay of the West, where life is sweet to breathe, where happiness is wedded to silence. There we must go to live; there we must go to die.

Further on in the same poem, the poet speaks of "A unique land, superior to other lands, as art is superior to Nature, where nature is reshaped by reverie, where it is corrected, beautified, remolded." I thought of this poem again the other day going around the new exhibition of collages by Joseph Cornell, which Henry Geldzahler has organized at the Metropolitan Museum of Art. And the more I thought about it, the more I wondered if Mr. Cornell was not, among the American artists of his generation, our most authentic French poet.

In terms of the art history of his career, of course, Mr. Cornell comes out of a later development in the line of French poetry that begins with Baudelaire. He comes out of Surrealism, which transformed the collage and the collage-like construction into a species of visual poetry. Surrealism provides the syntax of Mr. Cornell's style—that structure of juxtaposition, repetition, and unexpected personal conjunction which the Surrealists effected in wedding the methods of Cubist collage to the metaphors of Symbolist poetry. This creation—the Surrealist visual poem—was, perhaps, a more fateful event in the history of modern art than anyone has yet acknowledged.

It created a viable visual form for the intricate and often hermetic metaphorical flight of the Symbolist imagination, the means whereby the subjective materials of the mind—memory, reverie, and involuntary association—might be given an objective visual existence without recourse to the outworn conventions of academic aesthetics.

Yet if Mr. Cornell's art comes out of this Surrealist background, there is no mistaking it for an orthodox Surrealist performance. True, he shares with the Surrealists their interest in a dreamlike fantasy world in which the laws of reason are under permanent suspension. But beyond that, he has followed a path all his own, and in so doing has revealed an affinity for a realm of feeling closer to the Baudelairean "voyage" to a paradise of the imagination than to the vatic ambitions of the Surrealists themselves. From the two impulses that combined to ignite the Surrealist movement and give it its special energy—political revolution and

erotic transcendence—Mr. Cornell's art stands very far removed. He has helped himself to Surrealist methods in order to garner the fruits of his own imagination.

For the materials of Mr. Cornell's dreamworld are derived, above all, from the realm of aesthetic sensation, from aesthetic memory and association. His collages, no less than his celebrated "boxes," are pure distillations of aesthetic reverie, ruminations on aesthetic experience miraculously endowed with a flawless pictorial structure. They are a highly personal, autobiographical form of discourse about art as well as works of art in their own right. And it is a very particular view of art that we find delineated in Mr. Cornell's art—art exempted from the normal pressures of experience, art quintessentialized into a mythology of its own. This takes us very far from the ethos of Surrealism, with its programatic anti-art prejudices—takes us, in fact, not only into a private version of the Baudelairean voyage "where nature is reshaped by reverie, where it is corrected, beautified, remolded," but also into one of the purest creations to come out of this Baudelairean quest, the unblemished aestheticism of Mallarmé.

The exhibition that Mr. Geldzahler has mounted at the Metropolitan Museum consists of forty-five collages from Mr. Cornell's copious production during the last eight years. The work here is mainly untitled, but those familiar with the Cornellian *mise en scène* will recognize some familiar motifs—children and beautiful women out of Old Master paintings, balletic constellations of heavenly bodies, flowers, angels, birds, coins, and common objects as well as passages of pure color (especially the ubiquitous blue and white that have so often functioned as Mr. Cornell's Mallarméan signature) and certain lines and shapes that have acquired an extraordinary poetic resonance through their repeated appearances in his *oeuvre*. I see little difference, myself, between the boxes and the collages. The former may sometimes—but not invariably—be more complex, a shade more mysterious (since three dimensions are nearly always more mysterious than two), but the latter are executed with the same finical fidelity to the precision of the artist's imagination.

Not enough, I think, has been said about the scale of Mr. Cornell's work. He works small. His boxes are rarely larger than 18-by-12 inches in size, and many are smaller. His collages conform to these general dimensions—the dimensions of intimacy. It is no more conceivable for Mr. Cornell to produce a work the size, say, of a

painting by Rothko or Newman than it would have been for Baudelaire or Mallarmé to write a poem the length of *Paradise Lost* or *The Prelude*. It was Edgar Allan Poe who first wrote: "I hold that a long poem does not exist. I maintain that the phrase, 'a long poem,' is simply a flat contradiction in terms," and the French Symbolist poets ratified this aesthetic philosophy both in theory and in practice. Not for them—or for Mr. Cornell—what Poe called "the epic mania."

Mr. Cornell's work rigorously observes the Symbolist notion of a work of art as something highly concentrated, distilled, and brief, something hermetic and enigmatic, an utterance at once deeply personal and yet infinitely mysterious. Poe said of poetry: "Its sole arbiter is Taste. With the Intellect or with the Conscience, it has only collateral relations. Unless incidentally, it has no concern whatever either with Duty or with Truth," and this—while surely not the last word on everything we might want to demand of a work of art, or of some works of art—is a perfectly accurate way of defining the kind of art Mr. Cornell has perfected. Yes, he is indeed our most authentic French poet, if we think of French poetry as consisting primarily of the Symbolist followers of Poe.

Three years ago the Guggenheim Museum gave us a sizable review of Mr. Cornell's accomplishment. (Diane Waldman's essay for the catalogue of that exhibition remains, incidentally, the single best account of this accomplishment I know.) And we have had other, briefer glimpses of Mr. Cornell's work in other exhibitions during the last decade. The current show at the Metropolitan adds to our pleasure and our knowledge of this very singular artist, but it also makes one impatient for a really large, definitive exhibition. The history of art in our time will not be complete without it.

December 20, 1970

11. Balthus

More than a decade has passed since the Museum of Modern Art mounted a sizable exhibition of the paintings of Balthus, an artist who was then—and who has remained—a singular figure in the history of postwar French art. At a time when the strengths of the French pictorial tradition had turned—irrevocably, it seemed—into weakness and worse, Balthus was one of the few painters of consequence who appeared to carry on a dialogue with his great nineteenth-century predecessors as if he were their natural heir. Courbet, in particular, loomed larger in his art than any element of style or sensibility specifically traceable to the postwar scene, and indeed Balthus's only connection with the hurly-burly of that scene seemed to be the distance that separated him from it.

What distinguished Balthus's attachment to the past was a total lack of defensiveness. There was no suggestion of *déjà vu*, but—on the contrary—the sense of a living artist pressing into service precisely the materials that were most appropriate to his vision. At the same time, ensuring the air of conviction that presided over Balthus's art was a quality almost more social than aesthetic—an unmistakable hauteur. One was made to feel that, however depleted the legacy of Courbet and his illustrious followers may have come to seem to the groundlings of the cafés and the galleries, for an aristocrat of taste and craft like Balthus, it remained a precious source of invention and inspiration.

There was, to be sure, a distinct personal note in Balthus's painting, but it was a note of feeling rather than of form. A refined but obsessive eroticism dominated his imagery—an eroticism that exalted the passive figures of nubile young girls and made them the center of a private universe. There was about many of Balthus's pictures an aura almost of voyeurism, of a passion that exceeded the purely pictorial and engaged the innermost recesses of fantasy and appetite.

Yet even this most personal note was handled by Balthus with a certain aristocratic detachment—as a prerogative of a certain cultural inheritance as well as a personal disposition. In some respects, Balthus's eroticism—or rather, the particular form he gave it—was only another aspect of his abiding debt to Courbet. Balthus often took over from his nineteenth-century master specific poses and

motifs; he seemed to want to evoke and engage the past at the very moment he was disclosing the specifications of his own obsessions.

An artist so adept—technically and conceptually—at assimilating the materials of tradition and aligning them with the mechanism of his own imagination is difficult to place. There are times when his whole stance as an artist seems a conscious denial of modernity; yet the effect of his art—the solidity that somehow escapes complacency —is to encourage a wider definition of what modernity consists of.

Among French painters of this century, Balthus is second only to André Derain in his ability to remind us that the excesses of modern painting have themselves prompted a strong antimodern impulse from within the ranks, so to speak. The polemicists of the modern movement were once vociferous in condemning this impulse, but the perspective of history now makes it look less like outright heresy and more like a symbiotic growth of, if not equal vigor, at least equal validity. The art of Balthus, at least, retains a distinctly modern cast, if only because he interiorizes so much of what, in his nineteenth-century prototypes. was firmly given as objective and beyond the personal.

But it is true that an artist pays a price for keeping his distance from his own time. In the past one felt a certain unreality about Balthus's work, and this feeling increases as one follows his recent development. Last summer one had the opportunity to see a generous sampling of Balthus's new paintings in an exhibition at the Musée des Arts Décoratifs in Paris, and now four of the major works from that show have been placed on view at the Matisse Gallery, together with a selection of drawings and watercolors.

There are many wonderful things about these paintings. Anyone with a serious interest in easel painting will want to pay them careful attention, for they are, if not the work of a master, certainly the work of an extraordinary painter who has schooled himself in the standards of the masters and whose ambition it is to produce an art on their level.

But that, alas, is the trouble. In the end Balthus is not Courbet. He is not even Derain. And yet everything about his art forces us to weigh his accomplishment on a scale with their more robust achievements. In Paris, as it happened, I had just been looking at the Derains in the Walter-Guillaume Collection, then on view at the Orangerie, and the next day I went to see a very beautiful show of Courbets in the rue de Seine. The result was a distinct diminution of

Balthus's standing and a growing conviction that he was investing more and more of his art in a realm of artifice—of exquisite design and refined pictorial relations—very much at odds with the strengths on which painting of this persuasion ultimately rests.

I must confess that two of these paintings—*"La Chambre Turque"* (1963–6) and *"Les Trois Soeurs II"* (1965)—look rather better to me in New York than they did in Paris. Yet I note again the tendency to schematization that was disturbing at a first encounter, a tendency that shifts the center of gravity away from the painter's fantasy and places it more and more irrevocably in the realm of sheer decoration. To accommodate this shift, Balthus has flattened his space, silhouetted his figures, and otherwise styled his vision to allow the decorative a larger role in the picture-making process.

One result of this development is that Balthus has drawn closer to the taste of his own time, but at the sacrifice of something personal. His sense of fantasy now seems unexpectedly benign and relaxed, and this is a clear loss. Balthus remains exceptional, and his quality is unmistakable, but his holiday from history seems to be approaching an end.

April 2, 1967

12. The Problem of Francis Bacon

Few contemporary painters give the impression of enjoying all—or even most—of the expressive prerogatives that once belonged to the art they practice. Distinction is nowadays achieved by narrowing, not enlarging, one's focus. Painting has become a highly restricted enterprise. Certain resources—particularly what is known as the "literary" element in painting—are rigorously eschewed. Others— all that is meant by the decorative and the abstract—are carried to the most astonishing extremes.

The English painter Francis Bacon seems to be the great exception. He is, to be sure, one of the most dazzling pictorial technicians on the current scene. The new paintings he is showing at the Marlborough-Gerson Gallery are virtuoso performances of a kind that are rare even in an age of extraordinary technique. They deliberately court comparison with the masters. Their sheer authority is—at first glance anyway—overwhelming.

That this authority derives in large measure from the painter's unashamed reliance on illustration is not, in this case, particularly damaging. This alone would make Mr. Bacon an unusual artist. Illustration is, for most of our painters, an original sin which they labor strenuously to be absolved of. Mr. Bacon is a master of this despised aesthetic atavism and does not hesitate to flaunt this mastery. He gets away with it, too. For he is also in possession of an unerring pictorial intelligence. He is one of those painters who appears to achieve exactly what he sets out to achieve.

Clearly he has a lot more on his mind than exercises in technical excellence, however. He is a visionary of a particular sort—a specialist in the grotesqueries of modern life. He is a connoisseur of extreme emotions, with a taste for the macabre and a gift for transmuting the psychopathology of everyday life into a compelling and very personal pictorial imagery. There is nothing of the commonplace in his work. Everything is pitched to the intensity of a scream. The pressure is unremitting, a little brutal, and more than a little calculated. Yet, despite the calculation, it has the force of an involuntary avowal.

Why, then, does it strike me as being clever rather than profound—brilliant rather than authentic? I know of few contemporary paintings that make as strong an impact on first viewing as Mr. Bacon's, yet it is not an impact that lasts. The scream fills one's ears, but then—unexpectedly—one discerns in it a curious musical resonance. It is not a cry of pain, after all, but a well-composed aria. What seemed at first like raw emotion turns out to be a form of artifice. The emotional temperature drops rather suddenly. A world of exacerbated feeling and desperate appetites, which only a moment ago seemed to press so hard on our consciousness, dissolves, and we are once again on the familiar terrain of the contemporary artist—back in the studio, where the decisions are cool, technical, and deliberated.

This, for me, is the problem—perhaps I should say the ob-

stacle—which Mr. Bacon's painting invariably presents. An inevitable depletion seems built into its style. His portraits and portrait studies, of which there are many in the current show, promise much in the way of psychological definition. But there is, alas, no individuation in them. The psychology turns out to be uniform—an intense neurasthenia which easily resolves itself into aesthetic composure.

One's interest in Mr. Bacon's painting shifts straightaway from the particularity of the subject to the distortions the artist indulges in the rendering. These distortions—the mouth endowed with a blurred animal madness, the limbs strained in some desperate but not quite readable gesture, entire bodies contorted in miserable missions of passion—make a large purchase on our attention, but then disappoint it. We are left, not with a penetrating insight into the agony of the species, but with a mannered and deftly turned style. It is only then that one grows a little queasy, finding that one admires the expertise—the incomparable cleverness and facility—of the way a nose or forehead or behind has been so handsomely modeled with a heavily loaded brush when a moment earlier it seemed as if one were going to be the unwilling witness to some unspeakable act.

Which is to say that Mr. Bacon is not above titillating our expectation of the violent and even the obscene. He is not, I hasten to add, an obscene painter—far from it. But he does have a way of placing his audience in the position of disappointed voyeurs. His preoccupation with private acts of sexual violence turns out to be amazingly sociable. His depiction of male nudes may aspire to a condition of existential candor, but it concludes in a kind of perverse parody of Rubensesque hedonism. Everything the artist touches—all these themes of anguish, all these evocations of the forbidden—turns to art, one is tempted to say "mere" art. In the end, one feels a kind of fraud has been perpetrated.

But mine is, apparently, a minority view of this particular achievement. Read Professor Lawrence Gowing's heated essay in the catalogue of the current exhibition, and you will have a better idea of the established judgment—established, at least, in London—of Mr. Bacon's work. This is the opening paragraph of Professor Gowing's text:

> In London this year I have felt a distracting reverberation in the air. It is generated by the knowledge that a mile down the

street, too close for comfort, Francis Bacon is in tremendous form, painting continuously and surely disturbing something that one would sooner leave settled . . . Waiting for a new group of pictures I tremble a little, lose track of my thoughts, wake in the night. Every time the image that emerges can be counted on to strike directly at a vital and vulnerable sense. One has no way of preparing or protecting oneself. There is an uncommon kind of painting which, when it really penetrates, alters everything. For some unknown reason, one's private view of oneself is at stake.

One would be hard-pressed to find a painter in the entire history of art who answered to this description—even Bosch somehow falls short. But that is not the point, I suppose. Professor Gowing expresses very eloquently what one assumes to be the "correct" response to Mr. Bacon's art. Later on he talks a good deal about "paint," and that, too, is part of the correct attitude. Yet, oddly enough, all these paintings—"an uncommon kind of painting which . . . alters everything"—somehow manage to get themselves sold and somehow manage to hang in both public and private salons without changing anything. For myself, I trust these collectors more than I trust Mr. Gowing's text. They recognize exactly how safe an artist Mr. Bacon really is.

November 17, 1968

13. The Comic Fantasies of Saul Steinberg

The art of Saul Steinberg is an oddity—a happy oddity, a marvelously comic oddity, an oddity of breathtaking intelligence and wit, but an oddity all the same. It fits into no convenient category or genre. It is at once visual and extravisual. It displays an uncanny grasp of the social surface of modern life, especially American life,

yet it draws its peculiar imaginative energies from the realm of art. It carries on a sardonic and often hilarious exploration of the world around us, but it does so at several removes. Between the world as it exists and the way Mr. Steinberg renders it, art—not only Mr. Steinberg's own, but the whole amalgam of styles he brings us in brilliant parodic form—intervenes with a comic vengeance.

Normally we encounter Mr. Steinberg's odd universe, in which life is always doing an amusing but curiously unsettling imitation of art, in the pages of *The New Yorker* magazine or else in the published collections of his work he issues from time to time. Rarely do we see the artist's actual drawings. But this week we have been treated to one of Mr. Steinberg's infrequent gallery exhibitions. This is a two-part affair, divided between the Betty Parsons Gallery and the Sidney Janis Gallery, and it is a real event.

For Mr. Steinberg is a draftsman of genius, and an exhibition like the present one reminds us that there is no substitute for seeing the work of his own hand. These drawings, with their watercolor and collage embellishments, exhibit his genius on a scale and with an immediacy that no mechanical publication can adequately simulate. As with drawings generally, the prevalence of well-printed reproductions lulls us into believing we are seeing the artist's own work on the printed page, but the fact is that we miss a great deal at this mechanical remove.

It is also a revelation, even to those of us who follow his work with devotion, to see it in this quantity. One's conviction is re-enforced that this art does indeed constitute a "world," that Mr. Steinberg is one of those rare artists who has a highly original view of life as it is now lived.

The segment of this life he has made especially his own is the realm of highfalutin' cultural pretension, and he has been unrivaled in creating a graphic style—more various and more flexible than one had thought—that renders this realm with devastating precision. But he does something more than satirize this material—and this is his great distinction. He confers upon it a vision of dazzling complexity in which the language of culture, the very idiom of the pretensions he is penetrating, is employed with remarkable ease and authority to reveal the deceptions and ambiguities that lie at its core. Mr. Steinberg takes hold of the whole range of the visual language that modern art has thrown over experience like a magic blanket and treats this language as if it were the vocabulary of the unconscious,

which, at certain levels of culture, it now is. He is a dealer in dreams, fantasies, and impossible, transcendent yearnings, and he has had the wit to render them as commonplaces of educated sensibility.

It takes a genuinely comic mind, not just a jokester's, to see the world precisely this way. And it takes something else, too—an inner grasp of the morphology of modern art, an informed understanding of what each of its forms signifies, and a sense of the subtle ways in which their diffusion in the public imagination has modified their efficacy and made them something stranger and more elusive than their creators ever envisioned. It takes this comprehensive insight to fashion such risky comic materials into a style that communicates so much so concisely, and yet manages to do so with a Mozartian lightness and verve.

What it also takes is a graphic gift of the first order. Mr. Steinberg has always been good, but in recent years he has developed into an extraordinary virtuoso—not only of line, which is still his principal strength and glory, and of comic calligraphy, but of those deft watercolor flourishes that now punctuate his drawings with such dramatic effect. Indeed, as a watercolorist Mr. Steinberg shows signs—as in the "post card" series as well as in the details of some of the larger drawings—of developing an entirely new mode.

This impressive gift now displays itself in a greater range of motifs than ever before, and to each of these motifs the artist is able to bring the transfiguring power of a total imagination. A Steinbergian still life, however much it may parody the great Cubist statements of this genre, is a conception apart—precisely because its incongruous mastery of Cubist drawing is only one term of a comic vision that sees Cubism itself as an element in the still life. (Note the way Mr. Steinberg substitutes his own oval phonograph records for the guitars and mandolins to be found in the classic Cubist still lifes.)

A Steinbergian interior is a more complicated and a more menacing place than the stage of an Ionesco play, because here objects and even words—or sometimes writing that is not even words—play out the game of appearance and reality, of the fantasies of art intervening in the affairs of men—in more dimensions than human actors can encompass. A Steinbergian landscape—and it is in landscapes on the order of "Biography" and "Niagara" that he is often most brilliant—is a universe in which the romantic art of the

last century, together with its Surrealist gloss in this century and all manner of Cubist and Dada and Pop paraphernalia, is transmuted into a fantasy in search of a landscape amid the residue of so many contending points of view. And then there are the Steinbergian figures—those creatures in which all our pretensions are choreographed in an endless dance of postures imitating postures which are themselves imitations of something out of the imagination.

It is all immensely funny, immensely accomplished, and immensely unsettling. For like all true comic artists, Mr. Steinberg offers us a view of the world that is finally—and surprisingly—bleak; a world in which nothing is real or certain except the unreal images we have created for ourselves.

December 4, 1966

14. Isamu Noguchi

The exhibition of sculpture by Isamu Noguchi at the Whitney Museum of American Art contains some eighty works dating from 1928 to the present. Yet it would be a mistake to regard this exhibition as a full retrospective survey of Mr. Noguchi's accomplishments. As an artist, he has not confined himself to enterprises that lend themselves to a gallery or museum presentation. His theatrical designs for Martha Graham, his architectural commissions for Skidmore, Owings, and Merrill; the lamps and furniture and gardens and public decorations that have occupied him during much of the period covered in this exhibition—all this side of Mr. Noguchi's work is given only token recognition at the Whitney.

Indeed, a case could be made for regarding all that is *not* included at the Whitney as Mr. Noguchi's major work. I shall not be concerned here to make that case, but I think it important for visitors to the Whitney show to be aware of how much has had to be

omitted. We are being offered, in effect, a selective and homogeneous anthology drawn from a much larger and more varied *oeuvre*.

This anthology brings us an artist of superlative craft—the craft of the carver—and a highly refined sensibility. After Brancusi, who remains in a class of his own, Mr. Noguchi must be considered one of the most important of those modern sculptors who have upheld the purity of carving as the essential task of their art.

Like Brancusi, Mr. Noguchi has found his inspiration more often than not in traditions remote from the mainstream of Western European sculpture. These alien traditions, whether Oriental or Pre-Columbian or African or Oceanic, afford the carver direct access to a vein of expression and to standards of craft and sensibility that circumvent discredited conventions of representation and decoration. They place him in a happier, because less descriptive, relation to nature than that afforded by the conventions of Western European sculpture since the Renaissance. They restore to the modern sculptor a sense of the organic and creative relations that obtain between the materials of his art and the images to be gleaned from those materials, between the process of creation and the culture in which that creation enjoys an optimum expressive fate.

In the case of Mr. Noguchi, who, by birth and upbringing and adult choice, has enjoyed the advantages of three quite disparate worlds—the American milieu into which he was born; the Oriental, which formed part of his family background and personal experience; and the environment of Parisian modernism, which, in some fundamental sense, placed all these elements in a meaningful and programmatic relation to each other—these alien traditions have constituted the basic materials governing the whole conception of his vocation. Aesthetically, he has been a citizen of the world, and this has been at once the great strength and the great weakness of his art. He has remained loyal to the obligation of artistic purification implied in the whole modernist adventure without being able to supply that adventure with an impetus and an achievement capable of extending it into the future.

This is, alas, the overriding impression that one carries away from the really beautiful sculptural objects—so lovingly and knowingly created, so deeply indebted to traditions and to sentiments that have outworn their relevance to contemporary experience—that Mr. Noguchi has assembled at the Whitney: of an artist at the end of a

certain historical development rather than at the flood tide of its creative force, of a mode of sensibility refining a heritage rather than providing it with a viable basis for new growth and proliferation. Moving from sculpture to sculpture in this dazzling anthology, one is overwhelmed with admiration at the grace and tact and infinite pains invested in the realization of such pure embodiments of the carver's difficult art. But in the end, one is depressed—one is finally let down and defeated—to find that so much aesthetic refinement, so much intricate and painstaking craft should generate so little power. One admires this work and despairs over it at the same time.

The work itself is not of a kind that prompts one's curiosity about the artist's personal development. Certain individual pieces— the extraordinary portrait of R. Buckminster Fuller in chrome-plated bronze, from 1929, the terra cotta "Queen" from 1931, and a few other works from these earlier years—are proof enough, if one needed proof, that Mr. Noguchi was endowed with extraordinary talents from the start. At the same time, the exhibition makes clear that he has produced his most accomplished carvings in the past decade. "Woman with Child" (1958), "Bird B" (1957–8), "Integral" (1959), "Tiger" (1959), "Black Sun" (1960–3), "Jomon" (1963–4), "White Sun" (1966)—these are the artist's purest statements. Each is characterized by amazing subtleties of emphasis and inflection, by virtuoso details and brilliant simplicities—simplicities that only a master attuned to the complexities of his medium could command with such total authority.

I cannot pretend to have kept track of everything Mr. Noguchi has produced over the years, but I do miss in the current survey the unforgettable ceramic constructions, strung on vertical lengths of rope, which the artist exhibited at the Stable Gallery sometime in the 1950's. But their omission only recalls us to the fact that we are not in the presence of a complete account of Mr. Noguchi's work on this occasion. No doubt there are even more significant lacunae.

When one has savored the pleasures to be found in this exhibition, one returns to the problem of exactly how fully they represent the artist's deepest commitments. There are ambitious works at the Whitney—in some respects, the most ambitious—that seem misplaced in a museum survey: "The Roar" (1966), for example, or the two-part "Euripides" (also 1966). These are sculptures that cry

out for those gardens and plazas—for the worldly social milieu—where Mr. Noguchi has been most relaxed and probably most creative in recent years. Though I do not think they are his best work, they nonetheless make us impatient with the museum and its limited ambience. Paradoxically, it is in such work, rather than in his more perfect pieces, that this interesting and complex artist may point a path to the future.

April 21, 1968

15. "Homage to Trajan"

An almost tragic case is laid open to our inspection at the moment in the exhibition called "Homage to Trajan," which opened this week at the New School Art Center. Here we are given a glimpse of one of the least known and most beautiful *oeuvres* in the art of our time—a selection of sculptures and drawings by Turku Trajan, who died in his studio on East Seventeenth Street in Manhattan on the evening of March 14, 1959, at the age of seventy-one.

Trajan, who was born in Hungary, had lived in New York since 1908. He was one of the most accomplished artists who ever lived among us, a sculptor at once heroic and subtle, a craftsman of infinite delicacy and a profound poet who essayed the themes of the masters and who attempted to achieve what they had achieved, without the usual modern alibis and historical subterfuges. To an almost incredible degree, he realized this outmoded aspiration, too, producing a painstaking profusion of works—not only the sculptures and drawings on view at the New School but a sizable quantity of paintings as well—that resemble nothing else in the history of American art in this century. He died—need one add?—in the direst poverty. His friend Louis Slobodkin, in a note for the New School catalogue, reports that Trajan "never sold a piece of his

fine sculpture in his lifetime." His funeral was paid for by the con-
tributions of a group of younger artists who honored his work and
revered his memory.

Trajan was, above all, a sculptor of the figure. He was a master
of the nude, yet there is something almost unearthly about his
figures—an enchantment that lifts them into the realm of allegory.
He was a superb modeler who worked in plaster and cement, yet the
modeling of the sculptural mass was, for Trajan, only the beginning
of his work. The completion of his sculpture, the full realization of
its special quality, lay in his painting of its surfaces, and it was
indeed in the painting of his sculpture that Trajan created a mode of
visual poetry entirely his own.

Trajan's sensibility dwelt in a realm in which the poetic, the
spiritual, and the sculptural were not separate and distinguishable
interests. As a modeler, he worked on a heroic scale, bringing to
bear great powers of observation and craft. Physically and plasti-
cally his sculpture has an emphatic material reality. But this mate-
rial reality mattered less to him than the "spiritual" presence
conferred on his work by the delicacy and tact of his painting. For
painting was an integral part of Trajan's sculptural conception, as
much the fulcrum of the form and feeling of his work as the actual
shaping of the mass itself.

The exhibition that Paul Mocsanyi, the director of the Art
Center, has arranged at the New School is a "Homage to Trajan" in
more than one sense. It is, first of all, an excellent selection of the
artist's major pieces, both the painted reliefs and the free-standing
sculptures that Trajan often labored over for years on end. These
are, for the most part, of two types: portraits, including a very
striking relief-portrait of the painter Abraham Walkowitz (dated
1943), and—by far the majority—the mythological and Biblical
figures that were his abiding interest. Of the latter, the central place
is rightly accorded to the "Birth of Isis," which, with its luminous
blue torso and incredibly sensitive modeling, is a triumph of all the
values Trajan aspired to.

But then, there is nothing here that is not heroically conceived
or beautifully executed. The enormous "Fallen Angel," eighty-four
inches high; the fantastic "Spiritual Door," a relief 122 inches
high; the heroic couple, entitled "Earth and Fire"; these and other
sculptures, together with the oversized drawings that are at once
studies for sculpture and complete works in themselves, place the

visitor to this exhibition in the realm of an epic cosmology. For in the presence of Trajan's work one is very far from the world of mere objects; one feels the force of a superior imagination and succumbs to it.

But there is another sense, too, in which this exhibition is a "Homage" to an unacknowledged master. For Trajan, though deeply embittered by his isolation from a cultural milieu that found it impossible to come to terms with art on the only level he considered worthwhile, was not unknown to a certain few artists who followed his work with intense respect. Mr. Mocsanyi has brought together some statements from several of these artists—Peter Agostini, Karl Knaths, Jacques Lipchitz, and Reuben Nakian—who testify alike to their admiration for his accomplishment and to the curious fate Trajan suffered in the making of it. Two statements, in particular, frame an indictment that must be laid at the door of all those critics, collectors, and museum directors who for years found it possible to regard this artist with an indifference bordering on contempt. There is Nakian's unequivocal declaration: "I have always considered him as one of the best artists in America," and there is Lipchitz's haunting question: "How does it come that an American sculptor, absolutely original, could die unknown?"

Trajan was not entirely unknown, of course. He was only unacknowledged. His last one-man show was, I believe, in 1944, at the Valentine Gallery, and Mr. Mocsanyi reprints part of an extraordinary letter of praise that the late Lyonel Feininger wrote to Trajan on that occasion. In later years, he was induced by some younger artists to show his work now and then in their group exhibitions. And out of a sense of irony about his own position, or non-position, in the uptown art world, he showed for a time in the Washington Square Art Show. But by that time he recognized that history, in the form of sensational publicity and bureaucratic taste, had passed him by.

Both spiritually and aesthetically, Trajan lived at a great distance from the scene where such history is written. More than any other artist of our time, he dwelt in an almost timeless realm, far removed from everything but the work of his own imagination. This was both a source of his creative power, and an emblem of his martyrdom—a martyrdom that has been perpetuated in the insufferable condescension shown his *oeuvre* by virtually every public art institution in New York in the years since his death. One wonders if

our official connoisseurs are any longer capable of discerning the value of a work of art that significantly departs from the canons of taste laid down by their own vast publicity organs. The gratitude one feels toward Mr. Moscanyi and the New School Art Center for restoring Trajan's art to our attention is enormous, but the exhibition also reminds us of the fugitive status that art of this quality still suffers in this age of cultural explosions.

November 20, 1966

16. José de Rivera

One way of looking at the history of abstract art is to view it as a series of audacious attempts to achieve the maximum aesthetic results from the smallest possible artistic means. The Miesian dictum of "Less is more" represents a powerful impulse which, in the half-century-long chronicle of abstract art, has sometimes been implemented with a terrifying fanaticism and success. Standards have changed, of course, on the question of what the "smallest possible" means may be, but the chimera of some ultimate reduction has been ardently pursued. In all the arts, but most conspicuously in painting, sculpture, and music, the quest for some "final" essentiality has been adamant and abiding. This is what is meant—most of the time anyway—when a work of art is spoken of as "advanced."

Each "advance" in the direction of a new standard of reductionist purity, however, seems to prompt a recoil, or at least a reconsideration. And not only from artist to artist and from generation to generation, but often in the career of a single artist. Mondrian's final pictures were not as "pure," in this sense, as his pictures of the twenties, nor are Kenneth Noland's new paintings as adamant in their reduction of pictorial incident as the work he was producing five years ago. The quest for an abstract nirvana rarely follows a direct, uninterrupted course. Its characteristic route tends

to be dialectical, and one term of the dialectic may be a "return" to an earlier stage of development.

It is important, I think, to bear this history in mind in approaching the exhibition of sculpture by José de Rivera at the Whitney Museum, for we are also dealing here with a history in changes of taste. Mr. de Rivera is sixty-seven years old, and the earliest pieces on exhibition date from 1930. Ten or fifteen years ago, a retrospective survey of his works would have looked decidedly—even shockingly—austere and "minimal." (One can scarcely avoid the word, even though it was not much in use ten or fifteen years ago.)

But the Minimal movement of the sixties has drastically changed our sense of what constitutes, in this particular realm of artistic expression, an extreme position. Like everything else, the absolute is now more expensive than it used to be—if only in terms of what we have to hand over to achieve it. Mr. de Rivera, it now transpires, was obliged to hand over a good deal less than we thought.

The effect of Minimal art has been, in any case, to make an artist of Mr. de Rivera's particular craft and sensibility look a good deal more—dare one say it?—*Gemütlich*. This sculpture of open-form arabesques in slender, highly polished steel masses is quite as dazzling in its technical finish and formal perfection as one remembered it. But its very flawlessness—its vaunted "impersonality"— has acquired with the passage of time some unexpected implications and associations. Whereas the work formerly gave the impression at times of shutting out the spectator entirely, it now seems positively to embrace him. What was hitherto deemed austere—"cold" was the word commonly applied—now strikes the eye (and the mind) as almost too cleverly seductive in its sensuous appeal. Once the work may have seemed totally in thrall to the intellectual will, but the intervening storms of art history, with their blizzards of "ideas" (from which we are still digging out), have had the effect of revealing in Mr. de Rivera's art an unabashed—if also unavowed— hedonist impulse.

The artist calls these polished metal forms "constructions," but they do not really belong to the Constructivist tradition. They are a good deal closer to Brancusi—the Brancusi of the polished bronze "Bird in Space"—than to either Gabo or Tatlin or Moholy-Nagy. Industrial tools and materials are employed in producing the sculp-

ture, but the final result is an art that has been firmly removed from an industrial ambience. We are instead in an aesthetic realm where sculpture is conceived as a form of drawing in space—a realm of pure optical pleasure.

One feels in this work that special pride in the mastery of materials that is distinctly Brancusian, and at the same time that special ambition to create an art object whose physical attributes are so perfect that they relieve us straightaway of the necessity of thinking about its physical existence at all. A great deal of hard physical labor has been invested in creating a delicate illusion of light, space, and movement. One is reminded here of the work of a great dancer who perfects his technique in order to be able to create the illusion that his body is no longer bound to the laws governing its workaday functions.

What separates Mr. de Rivera's work from that of the Minimalists is precisely this attitude toward the materiality of art. For him, this materiality is something to be redeemed, transmuted, elevated, and transcended; the materials of sculpture are looked upon as the physical coefficient of an ideal. For the Minimalists, the materiality of sculpture must, at all costs, remain firmly entrenched in our consciousness and in our vision as *itself*, however much the artist may arrange and manipulate it for an aesthetic purpose. The appeal of the ideal is firmly resisted. With the Minimalists, we are often reminded of some of the newer dance philosophies in which any attempt to distinguish the movements of the dancer from those of the man in the street is somehow regarded as elitist and dishonest.

This radical difference in attitude toward the materiality of art necessarily involves some radical differences in the attitude toward both craftsmanship and physical scale. Mr. de Rivera brings to his work the kind of painstaking workmanship that allows him to remain completely in control of every detail, every visual nuance, and the strength of his work is to be found, I think, in the kind of delicacy and refinement that his working method makes possible. This is a strength more easily sustained, at least in my experience of sculpture, in small works of an intimate scale than in large public works. For myself, something essential is lost when Mr. de Rivera moves into the realm of architectural sculpture.

The Minimalists, on the other hand, require an architectural scale for their work. Their attitude toward the refinements of craft may best be described as indifferent. It is the "idea" of the work that

is expected to animate it artistically, not the details invested in its realization, and the idea requires a large space.

The exhibition at the Whitney is a retrospective, but it does not have the interest of a retrospective—it does not offer much in the way of historical development once we have glimpsed the few earliest pieces. This is not a criticism but a characterization of Mr. de Rivera's aesthetic outlook. His is an art of repetitions or, more precisely, near-repetitions, and the pleasures it offers will be most evident to the public (rather small, I suspect) that savors the kind of variations and differences that can only be fully appreciated if we are prepared to be as painstaking in our attention as the artist has been in his creation. Even more than the elegance of his imagery, it is indeed the kind of attention Mr. de Rivera requires that places his work—spiritually at least—in an earlier era than our own.

May 21, 1972

17. Hélion: Returning from the Absolute

Considering the pre-eminent place long occupied by abstract art in our aesthetic economy, it is surprising that there exists such a meager literature on the subject. Art books abound, art criticism grows more fanciful and recondite, but the historiography of abstract art remains in its infancy. The latest volume pretending to comprehensiveness—Michel Seuphor's deplorable *Abstract Painting* (Abrams, 1961) is as useless as it is verbose, and yet nothing has come along to replace it in the six years since its publication.

You will not, for example, find any discussion of the abstract paintings of Jean Hélion in Mr. Seuphor's book. This is an astonishing omission when one recalls that both Hélion and Seuphor were active participants in the small band of devoted abstractionists functioning in Paris in the early 1930's. But then, abstraction was

not only a minority position in the Paris art world of that period; it was something like a religious calling, with all the divisions and contradictions that such callings engender. "Our need for the absolute was tremendous," Mr. Hélion recalls, and even in those days he and Seuphor found themselves in distinct, if adjacent, camps, with Hélion joining Van Doesburg in the short-lived Art Concret group (1930) and Seuphor organizing the larger Circle and Square group around the same time.

Subsequently, of course, Mr. Hélion did the really unforgivable thing. He abandoned abstraction and turned eventually to the idiosyncratic realism of his current style—reason enough, apparently, for Mr. Seuphor to consign even Hélion's earlier *oeuvre* to oblivion. Such is the sectarianism that still presides over the writing of modern art history.

The exhibition of nineteen of Mr. Hélion's paintings from the years 1929–39 at the Willard Gallery is, under the circumstances, a salutary reminder of just how good a painter he then was. Indeed, he was clearly one of the best. These are paintings of extraordinary conviction and purity—paintings that fully realize an ambition for a style "at once clear, transparent, legible, intelligible," and that are yet touched with an unmistakable quality of personal eloquence. The irony is that personal eloquence was the last quality an abstract painter of Mr. Hélion's persuasion was then seeking. The aspiration was for an "art to be founded on the spirit, to exist free from sentimental exaltation, free from references and from ornamental seductions," yet in practice something beyond this impersonal program—a compelling element of sensibility—managed to assert itself.

I have been quoting from Mr. Hélion's memoir, "Art Concret 1930: Four Painters and a Magazine," which appears in the current issue of the journal *Art and Literature* (No. 11), a document that does much to clarify the artistic atmosphere in which abstract painters worked in Paris in the thirties. For these painters, the dominant influences were non-French. Mondrian, Van Doesburg, and the principles of De Stijl; Kandinsky and the culture of the Bauhaus; Gabo, Pevsner, and the ideology of Constructivism: these were the sources with which groups like Art Concret and Circle and Square hoped to revitalize the Parisian avant-garde. It was a time when all of the above-named artists were domiciled in Paris, but the French were notoriously resistant to the movement they represented

—a movement that threatened (or so it seemed) to undermine the traditional values of French painting.

What Mr. Hélion says apropos his first visit to Antoine Pevsner in 1930—"On seeing him I realized for the first time that a man of a certain age, having accomplished a lot and produced important work, could be almost unknown in the country where he lived"—applied equally to the other protagonists of the abstract movement in France. Anyone charting the downward course of the School of Paris might well take this historic resistance as a pivotal date.

Mr. Hélion himself proved to be one of the very few native Frenchmen who grasped what was involved, artistically, in the theory and practice of these revolutionary foreign talents, and he responded not only with enthusiasm but with an exemplary intelligence and tact. No doubt his training as an architect and engineer disposed him to favor their innovations, but it was above all as a painter that he was able to translate this disposition into a viable artistic statement.

Working close to the geometric Neo-Plastic purities of Mondrian and Van Doesburg, but at the same time jettisoning what was most doctrinaire of their respective theories of abstraction, Mr. Hélion attached his art to one of the strongest links in the chain of modern French sensibility—the Cubism of Léger, himself one of the original sources of Mondrian's innovations. Indeed, from Léger to Mondrian to the Hélion of the thirties, one can trace a line of development in which the Cubist aesthetic is elevated from its earthly origins, raised to an almost utopian altitude of syntactical refinement, and then restored to the workaday world of common pictorial discourse.

For compared to the austerities of Neo-Plasticism, with its straight lines and primary colors, the characteristic Hélion pictures of the thirties—with their gently orchestrated forms, their elegant and almost organic construction, and their easy, luminous color— restore abstract painting to the mainstream of French sensibility. Pictures such as the "Composition" of 1937 and the *"Figure Complexe"* of 1938 are a good deal closer in feeling to Poussin than to the original program of Art Concret.

The need for the absolute may have been tremendous, but in Mr. Hélion's case it was tempered by a sensibility that transformed the absolute into a more sociable and manageable utterance. Per-

haps we can see in this tendency the roots of Mr. Hélion's later disavowal of the whole abstract adventure, but the fact remains—and the Willard show is ample testimony—that his work of the thirties constitutes a solid accomplishment that sectarian historiography can no longer wish away.

March 25, 1967

18. Helen Frankenthaler: "The Landscape Paradigm"

The large exhibition of paintings by Helen Frankenthaler which has come to the Whitney Museum of American Art will be a surprise, I think, even to many people who had reason to feel that they were well acquainted with her work. Organized by E. C. Goossen, the chairman of the Art Department at Hunter College, the exhibition consists of forty-five paintings dating from 1952 to 1968. Not only does the work fully support the retrospective scale of the exhibition but—what is more surprising perhaps—the scale of the exhibition is genuinely illuminating. For myself, certainly, this exhibition establishes Miss Frankenthaler as one of our best painters.

As a painter, she derives, of course, from the Abstract Expressionist movement and in some respects has remained more faithful to the basic tenets of the movement—especially as they were exemplified in the work of Jackson Pollock—than any other painter of her generation. At the same time, her work forms a decisive link between the art of the Abstract Expressionists and that of the color abstractionists of the sixties. She gave to the latter the technique of staining or soaking color into the canvas as an alternative to applying pigment with a brush. This technique, itself a refinement of Pollock's "drip" method, proved to be of great stylistic consequence, eliminating the bravura rhetoric of Expressionism while maintaining its sense of physical immediacy. This technique has

undoubtedly influenced a great deal of the most accomplished abstract painting over the past decade.

But Miss Frankenthaler is not the kind of artist who is interesting primarily because of her influence. The influence has been, in any case, an oblique one. It was Morris Louis and Kenneth Noland who, in taking up Miss Frankenthaler's example, set the terms by which the influence of this method of applying color to the canvas made itself felt, and they were not quite her terms. Indeed, it would be a mistake to think the importance of her work is to be found in her having authored a technical "breakthrough." The real interest of her work lies elsewhere, in the quality of its expression rather than in the technical means by which that expression is realized.

Nor can the exact nature of this quality be deduced from Miss Frankenthaler's historical credentials. There is, to be sure, a great deal of Pollock and Gorky in all the early pictures. There is a hint of Gottlieb's pictographic style in "Ed Winston's Tropical Gardens" (1951-2), and more than a hint of Rothko's color in "Open Wall" (1953). While these and other elements of the Abstract Expressionist vocabulary are handled with a remarkable assurance, they do not quite define Miss Frankenthaler's particular universe of discourse. Her real affinities are, I think, with certain earlier artists. Mr. Goossen, in his essay for the Whitney catalogue, suggests that "the landscape paradigm lies behind all of the artist's painting from the beginning." He also refers, earlier on, to traces of Arthur Dove and John Marin. If one adds to this the name of Georgia O'Keeffe and adds further that it is their lyric landscape watercolors that one has in mind, then I think we are a good deal closer to the kind of sensibility and vision that inform Miss Frankenthaler's mature work.

For she is, really, a lyric landscapist who has profited—hugely—from the increased scale and confidence that came into American painting with the Abstract Expressionists. Without committing her art to the descriptive conventions of traditional landscape painting, Miss Frankenthaler has nonetheless remained within its general orbit of feeling. The kind of synthesis of landscape and abstraction that she has so successfully effected—a style at once very personal, very responsive to the articulation of an individual temperament, and yet owing much to the historical imperatives that have overtaken the methodology of painting—this sort of synthesis is only possible, perhaps, when the syntax of painting has been decisively

redefined beforehand. For Dove, Marin, and O'Keeffe, this redefinition has taken place in Paris in the work of the Fauvists and the Cubists. For Miss Frankenthaler, it was carried out on native ground, in the work of the New York School, and the assurance her art exhibits from the very beginning is certainly traceable—in some measure at least—to this change in the cultural distance that once separated our artists from the ideas that nourished them.

In refining the style of her abstract landscapes, Miss Frankenthaler has narrowed her expressive materials to a very few essentials, mainly color—vibrant, limpid, often elegantly transparent—in the service of a highly simplified design. Color is used, almost invariably, as if it were watercolor, with all that this implies in the way of lyric immediacy. The design itself has grown very spare, focusing on fewer and fewer elements, but endowing these elements with a more concentrated power and intensity. The color itself has been raised in intensity; it is something of a shock to revisit the early pictures after seeing the later ones, for the former look almost blurred and certainly muted in the light of what succeeded them. In the big pictures of the later sixties, the last traces of the Expressionist impulse have been discreetly transmuted into something more equable and controlled.

Beside an artist like Kenneth Noland, say, or Frank Stella, Miss Frankenthaler is indeed a more traditional composer. Pictures such as "Three Moons" (1961), "Sea Scape and Dunes" (1962), "Island Weather II" (1963), or even the more recent "Noon" (1966) and "Flood" (1967), do not require the kind of radical adjustment in our expectation of the pictorial experience that, for better or worse, is essential to an appreciation of Noland's or Stella's recent work. There is, in her work, no suggestion of a system or a formula or a doctrine that must be satisfied before the sensibility of the painter can be allowed to enact its expressive tasks. There is, on the contrary, a very evident amplitude of feeling that has found a style perfectly attuned to its freedom and intelligence.

March 2, 1969

19. Mark di Suvero

Among the sculptors of the younger generation who may be said not only to be practicing their art with some distinction but to be transforming it in quite far-reaching ways, the single most interesting figure is Mark di Suvero. He seems to me the most significant new American sculptor to have emerged since the generation of Alexander Calder, David Smith, and Isamu Noguchi, and, with his English contemporary Anthony Caro, to be producing work that will have the greatest consequence for the future of this art.

The new pieces which he is showing at the Park Place Gallery, as part of a two-man exhibition with the painter David Navros, confirm Mr. di Suvero's pre-eminent place in current sculpture. It also gives us a clear view of why this work has been slow to win a wider appreciation of its true significance. For while Mr. di Suvero's work has been properly admired by a small group of critics and collectors, and has been shown now and again in museum surveys, it has nonetheless remained a special taste, almost an underground enthusiasm, in a period that has seen the superficial novelty of far easier styles attain a nearly unlimited prosperity.

There is no mystery, however, as to why this situation should obtain. Mr. di Suvero's sculpture makes few concessions to our normal expectations about the scale and polish that are appropriate to sculptural craft. At first glance, anyway, there is something not only staggering, even offensive, in the size of the individual pieces, but something emphatically impolite in the way the artist persists in constructing a really monumental image out of materials so little adorned with the conventional felicities of sculptural ornament. The rough wooden beams, iron chains, and painted steel sections of Mr. di Suvero's giant constructions lie well beyond the perimeter of taste established by the more sedate open-form metal sculpture of the 1950's. In relation to the glittering surfaces of the latter, so suitable to expensive interiors and self-satisfied feeling, Mr. di Suvero has seemed to be leading a kind of peasant revolt in the aesthetics of his medium.

The roughhewn look of Mr. di Suvero's work is not irrelevant to the quality of feeling it seeks to preserve, but it would be a mistake to judge its accomplishment solely on that basis. While the uninhibited rhetoric of his sculpture may suggest to the untutored

eye an expression of unbridled feeling, what is most impressive about this sculptor's work is the tough-minded intelligence with which he has pursued a difficult course. There is something Whitmanesque in the gesture and sweep of Mr. di Suvero's sculptural imagination, and like Whitman, the results are easily misunderstood if the artist's abiding intelligence is not seen as the coefficient of his ambitious rhetorical devices.

In the current Park Place exhibition, there are two recent constructions that represent Mr. di Suvero at his best. Both are mobiles. The larger of them, called "The A Train," would easily fill a normal-size gallery, though it is accommodated without difficulty in the ample space of its present installation. One of its two sections hangs from the ceiling; the other rests on the floor; and together they totally transform the space they occupy with an undulating rhythm of masses and voids that is completely and beautifully controlled. The smaller work, called "The New York Dawn" (after the poem of Lorca), moves with a much gentler rhythm that gives its wood and steel masses a surprising and lyric lightness.

What Mr. di Suvero has done in these pieces is bring together the formal rigor of the Constructivist tradition with the more poetic inflection of the mobile to produce, under the pressure of a radically increased scale, a style that no longer owes its expressive integrity to the historical precedents from which it stems. Without Cubism, and the Constructivist sculpture that derives from Cubism, Mr. di Suvero's three-dimensional syntax would surely be unthinkable, just as the movement of these sculptures would be inconceivable without Calder's pioneering work in kinetic construction. But the range of Mr. di Suvero's sculptural imagery defines a mode of feeling quite different from either of these sources. There is an urban, bustling momentum evident in the work—particularly in "The A Train"— that separates it from the laboratory atmosphere of a Constructivist like Naum Gabo, a vernacular energy that could never be confused with the punning wit and elegance of Calder. It does not refine so much as absorb the feelings it focuses on and projects forms that enlarge these feelings on a monumental scale.

In Mr. di Suvero's work, as in Caro's, sculpture is no longer confined to a tidy base or a discreet pedestal, no longer content to rise, figurelike, on a mass that leaves the surrounding space expressively uninvolved. Both these artists have given sculpture an almost architectural range, reaching out to dominate the floor space in a

manner reminiscent of the way the Abstract Expressionists broke loose from the confinement of easel painting to occupy entire walls. There is the attempt—successful, I think—to give the floor beneath our feet as large a role in the sculptural imagination as the isolated object in space.

Though the sculpture so far produced by Messrs. Caro and di Suvero mark the outermost limits of the sculpture of the 1960's, we are, I think, only at the beginning of the development they represent. It is a development bound to disturb—indeed, intended to disturb—for it robs us of our traditional notions of what sculpture is. It is bound to make certain celebrated reputations of the recent past—reputations mistakenly celebrated for their audacity and originality—seem timid by comparison. It is bound, ultimately, to compromise pious feelings about sculpture as an art of small, precious objects produced for the private delectation of connoisseurs. For behind this work—especially in case of Mark di Suvero—one can discern a social imagination intent upon making sculpture what it once was: a glorious public art, capable of sustaining the scrutiny of the crowd, robust enough to stand its ground amid the tumult of modern life. This, too, is a Whitmanesque ambition and reminds us of the native roots from which this sculpture springs.

January 30, 1966

20. Anthony Caro

It is now exactly ten years since the English sculptor Anthony Caro embarked upon the series of large, open-form, painted steel constructions that have earned him a worldwide renown. At the age of forty-six, Mr. Caro stands today all but unrivaled as the most accomplished sculptor of his generation. He is unquestionably the most important sculptor to have come out of England since Henry Moore. As both an artist and a teacher, he has wielded a consider-

able influence in a very short time—not only in England but in this country as well. If he continues on his present course, adding distinction and eloquence to an already powerful *oeuvre*, he must certainly be counted among the great artists of his time.

Mr. Caro is showing four new sculptures at the André Emmerich Gallery. Three of them—"Orangerie," "Deep North," and "Sun Feast"—are among the best works he has ever produced. In imagery they introduce a note of Matissean splendor—I am thinking particularly of the larger paper cutout collages of Matisse's old age—into what has, until recently, remained a more or less closed system of Cubist design. One has the impression of an artist who, having totally mastered a new and difficult area of sculptural syntax, is now permitting himself a freer margin of lyric improvisation.

There are, I think, only three sculptors with whom Mr. Caro's work may be profitably compared—David Smith, Alexander Calder, and Moore. Of these, Smith is undoubtedly the most important, for it was Smith's work that set Mr. Caro on his present course.

It was on a visit to the United States in the fall of 1959 that an encounter with Smith's sculpture prompted Mr. Caro to abandon the unpromising monolithic figure style he had been pursuing, a style which had already won him a certain reputation on the London scene. As Sheila Caro put it in a biographical note for the catalogue of the 1963 Whitechapel exhibition in London: "Effect of visit was to call into question dependence on the conventions of traditional culture, and open the way to a more direct and free sculpture."

Specifically, Mr. Caro adopted Smith's basic method of direct-metal construction. He also followed Smith's abiding practice—which Smith had derived, some thirty years earlier, from Picasso—of conceiving his sculptural constructions in fundamentally pictorial terms. (Nothing—neither the use of welding for sculptural construction nor the conversion to an open-form style—so decisively marked a break with the artist's own past and with the Moore-oriented English sculptural ethos as this radical adherence to a pictorial aesthetic for sculptural purposes.) Smith drew a constant and highly creative inspiration from what he regarded as the challenge which painting—first Abstract Expressionism and then the color abstractionists—offered the sculptural imagination. Mr. Caro, to his great aesthetic profit, has followed suit and has taken a whole generation of English sculptors with him.

Mr. Caro's first sculptures in the new mode were exceedingly "tough." He seemed intent on placing the greatest possible distance between his new work and the genteel styles which were then prevalent even among the most advanced artists in London. This, too, was in keeping with the Smithian stance, which was always to appear tough and uncompromising even when, as sometimes happened, the work was not all that difficult to take. Like most intransigent aesthetic postures, Mr. Caro's proved to be a temporary tactic —with the passage of time, his work seems naturally to have grown gentler and more delicate—but it succeeded in creating an ampler cultural space in which he and his contemporaries could develop their talents.

Where Mr. Caro's work differs from Smith's—and where his true originality may be found—is in the nature of what might be called his spatial choreography. Smith's sculptural sensibility inclined for the most part toward forms of a figurelike verticality. Even his "landscapes" were usually mounted on pedestal "feet." Mr. Caro's sensibility is very different, generally expressing itself in a landscapelike horizontality. Into this characteristic horizontal landscape space he projects a similar species of Cubist drawing—what used to be called drawing-in-space—which effectively eliminates the pedestal (real or imagined) in order to root his forms in the ground itself.

It is this use of a landscapelike horizontal space that invites comparison with Moore, whose assistant Mr. Caro was for several years in the early 1950's. Commenting on Moore's reclining figures, David Sylvester once observed: "Moore thinks from the ground up." Nothing could better summarize the characteristic sculptural gesture to be found in Mr. Caro's constructions. Ten years ago his work seemed to mark an unequivocal break with everything Moore represented, but now I think this underlying affinity with his former master is becoming more evident with every new piece that comes from his hand.

The relation of Mr. Caro's sculpture to Calder's—specifically, the large painted metal stabiles—is, frankly, more conjectural. I know of no direct or indirect influence. Yet Calder's outsize stabile sculptures are the only works I do know of that occupy the ground the way Mr. Caro's do—and do so with a similar technology and sweep. Their imagery is very different, of course, though the difference is less marked in Mr. Caro's current exhibition. Yet certain

structural similarities suggest themselves. It would be interesting to see their work brought together in a single exhibition.

In any event, Mr. Caro has now given us several new works which are equal to the comparisons I have invoked here. "Orangerie"—painted a brownish earthy red that one recalls from some of Monet's late paintings—is a lyric masterpiece of sculptural drawing. "Deep North," painted a deep mossy green, is a more difficult, problematic work. Divided into two almost—but not quite—separate units, one tall, formal, architectural, the other relaxed in a free-form sensual disarray, this work is one of the most interesting Mr. Caro has made. It lacks the immediate pleasurable impact of "Orangerie," but it offers the mind more to contemplate. "Sun Feast," in dazzling yellow, is perhaps closest to both Smith *and* Moore—itself a feat of sorts. Time may modify one's perception of this work, but at the moment it seems more like a handsome summation than a genuine departure into new terrain.

In the current issue of *Art News*, John Russell reports that "for several years now Caro has been working with a cache of 37 tons of steel which was shipped to London . . . from the late David Smith's studio at Bolton Landing." There is something eminently appropriate about the aesthetic and spiritual continuity which this logistical detail signifies. For Mr. Caro has kept faith with the vision he gleaned in Smith's large achievement a decade ago. It was not only Smith's method and his aesthetic that he took for his own. He also took on the burden of Smith's ambition, which was nothing less than to create a body of work that could sustain comparison with the masters of modern European art. On the basis of his accomplishment to date, it looks very much as if Mr. Caro is going to fulfill that ambition.

May 17, 1970

DAVID SMITH: *Artist with "Australia"* (1951)
Painted steel, 8' 1½" × 8' 11⅞" × 16⅛"
COLLECTION, THE MUSEUM OF MODERN ART, NEW YORK. GIFT OF
WILLIAM S. RUBIN. PHOTOGRAPH BY DAVID SMITH

JEAN DUBUFFET: *"Joë Bousquet in Bed"* (*1947*)
Oil on canvas, 57⅝ × 44⅞″

HANS HOFMANN: *"Joy Sparks of the Gods II"* (1965)
Oil on canvas, 72 × 60″

PHOTOGRAPH BY GEOFFREY CLEMENTS, COURTESY ANDRÉ EMMERICH GALLERY, NEW YORK

Louise Nevelson: *"Model for Atmosphere and Environment, Ice Palace I"* (1967)

Plexiglas, 24 × 26 × 12″

PHOTOGRAPH BY FERDINAND BOESCH, COURTESY PACE GALLERY, NEW YORK

JOSEPH CORNELL: "Pays-bas et Sardaigne" (*undated*)
Collage with coins on masonite

HELEN FRANKENTHALER: *"Eden"* (1957)
PHOTOGRAPH BY RUDOLPH BURCKHARDT, COURTESY ANDRÉ EMMERICH GALLERY,
NEW YORK

MARK DI SUVERO: *"Poland"* (1966–7)
Steel

COLLECTION, MARK PASTREICH. PHOTOGRAPH BY JOHN D. SCHIFF, COURTESY
PARK PLACE, THE GALLERY OF ART RESEARCH INC.

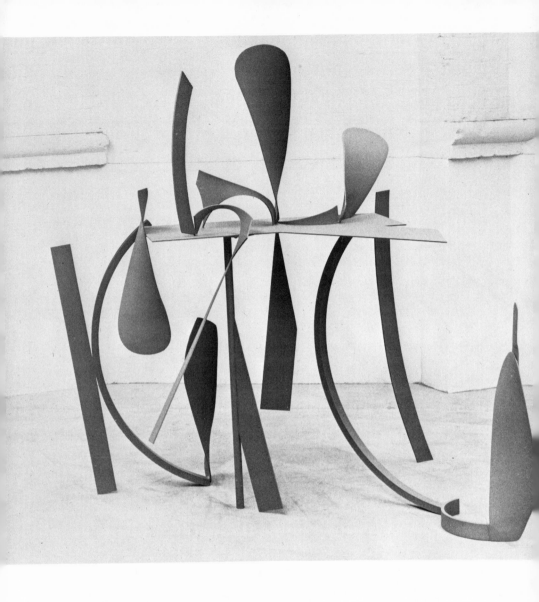

ANTHONY CARO: *"Orangerie"* (*1970*)
Painted steel
PHOTOGRAPH BY GUY MARTIN, COURTESY ANDRÉ EMMERICH GALLERY,
 NEW YORK

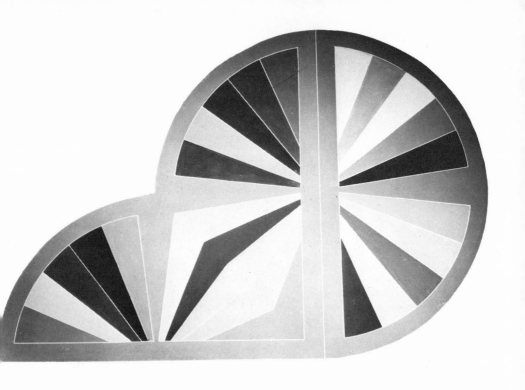

FRANK STELLA: *"Darabjerd III"* (*1967*)
Acrylic on shaped canvas, 10 × 15′
THE HIRSHHORN MUSEUM AND SCULPTURE GARDEN, SMITHSONIAN INSTITUTION,
WASHINGTON, D.C.

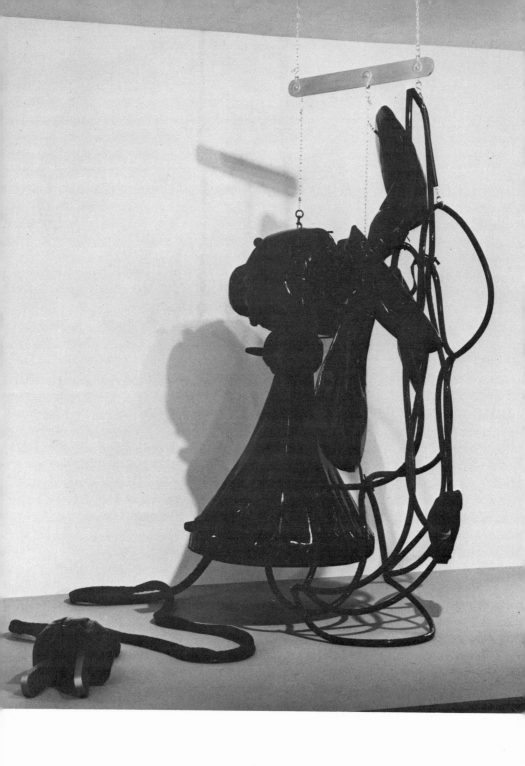

CLAES OLDENBURG: *"Giant Soft Fan"* (*1966–7*)
Vinyl, wood, and foam rubber, 10′ × 10′ × 6′ 4″
THE SIDNEY AND HARRIET JANIS COLLECTION, GIFT TO THE MUSEUM OF
MODERN ART, NEW YORK

STANISLAV KOLIBAL: "One's Missing" (*1969*)
Plaster and wood
PHOTOGRAPH BY JAN SVOBODA, COURTESY STANISLAV KOLIBAL

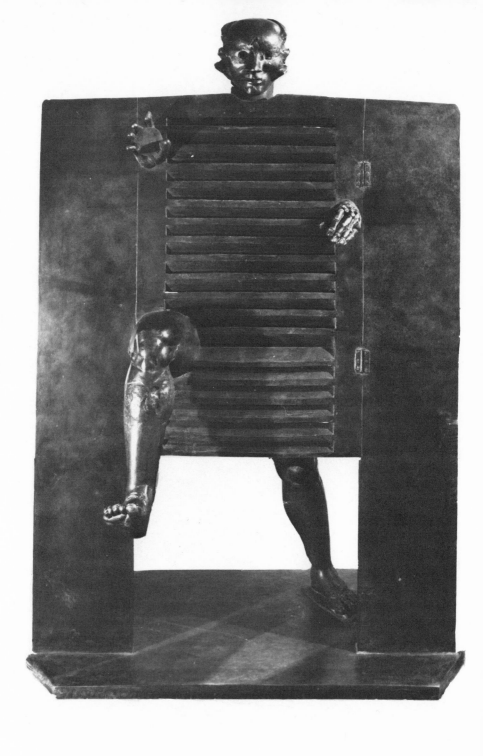

JEAN IPOUSTEGUY: *"Man Pushing Door"* (1966)
Bronze
PHOTOGRAPH BY ERIC POLLITZER, COURTESY PIERRE MATISSE GALLERY,
NEW YORK

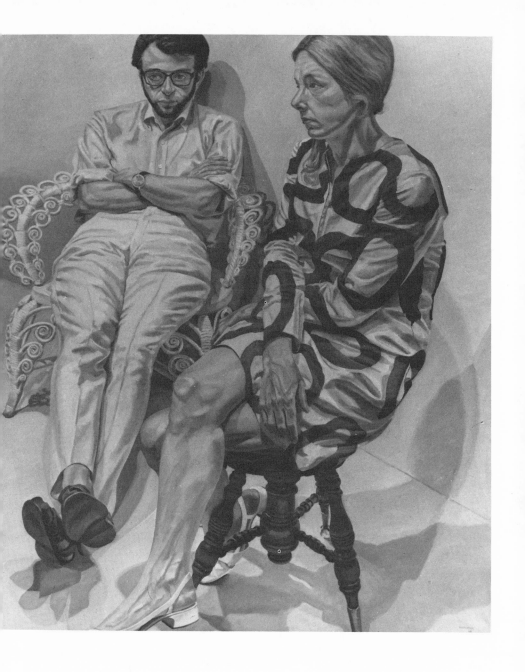

PHILIP PEARLSTEIN: *"Portrait of Mr. and Mrs. Pommer"* (1968)
Oil on canvas, 72 × 60″

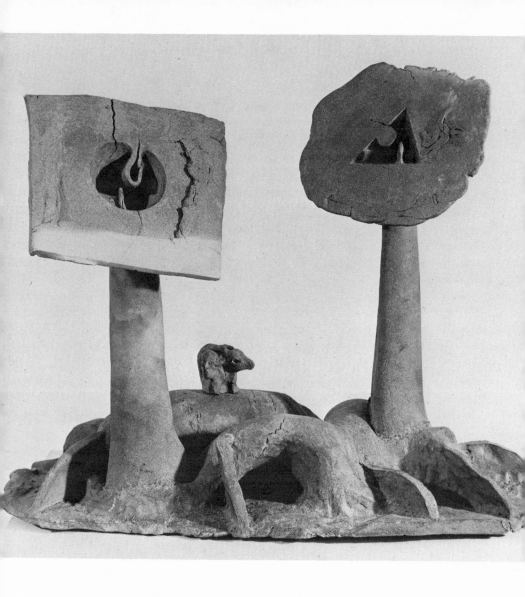

MARY FRANK: *"Resonance of Stars"* (1969)
Ceramic, 24″

PHOTOGRAPH BY RICHARD DI LIBERTO, COURTESY ZABRISKIE GALLERY,
 NEW YORK

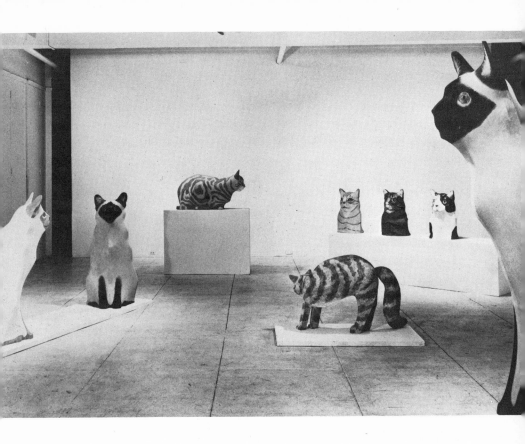

ANNE ARNOLD: *Installation view of 1969 exhibition*
Sculptures of wood and painted canvas
COURTESY FISCHBACH GALLERY, NEW YORK

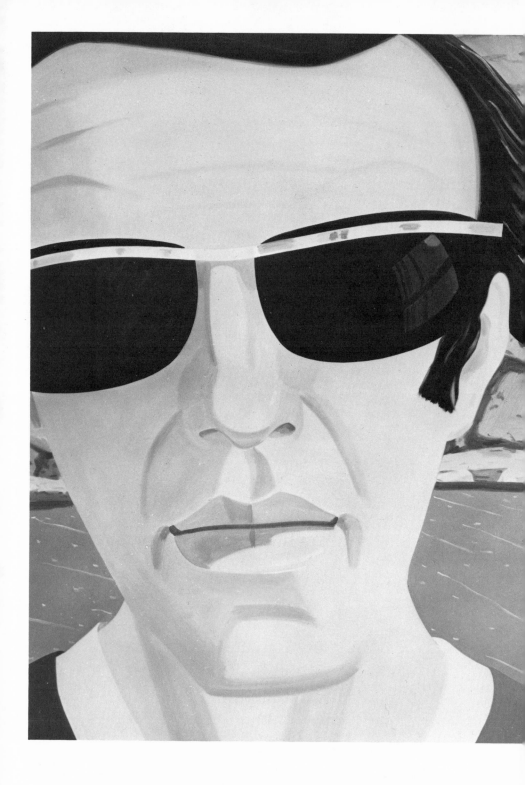

ALEX KATZ: *"Self-Portrait with Sunglasses"* (1969)

PHOTOGRAPH BY ROBERT E. MATES AND PAUL KATZ, COURTESY MARLBOROUGH
GALLERY, INC., NEW YORK

21. Frank Stella

I

The career of Frank Stella, whose new paintings are on view at the Castelli Gallery, is in many respects a representative one of the 1960's. Mr. Stella was born in 1936. While he can no longer be said to be a member of the youngest generation on the New York art scene—nowadays a new generation emerges with each new season—his work nonetheless embodies a good many of the qualities especially prized by artists who have come of age in the present decade. Moreover, his success, which was virtually instantaneous, is a measure of the degree to which the art world generally—museums, collectors, critics, the art journals, and other artists—has embraced Mr. Stella's work as an *oeuvre* of historic importance. Even the resistance that Mr. Stella's work occasionally encounters is taken as a confirmation of his accomplishment, lending it the cachet of Philistine disapproval without which no contemporary vanguard artist can hope to keep his reputation intact.

Mr. Stella's paintings first came to wide public notice when they were included in the Museum of Modern Art's "Sixteen Americans" show in the winter of 1959–60, about a year and a half after the artist was graduated from Princeton. Between that auspicious debut and his present exhibition, Mr. Stella has been represented in nearly every major national and international show of contemporary abstract painting, including those surveys—like the 1963 "Toward a New Abstraction" show at the Jewish Museum and the 1964 "Post-Painterly Abstraction" exhibition at the Los Angeles County Museum—which were organized specifically to underscore the change that has been taking place in current pictorial values. He has been shown at both the Venice (1964) and São Paulo (1965) biennial exhibitions, and last year was honored in a show called "Three American Painters" (the other two being Kenneth Noland and Jules Olitski), organized for the Fogg Art Museum at Harvard by Michael Fried, a critic, poet, and former Rhodes Scholar who has been a close personal friend of Mr. Stella's since their undergraduate years at Princeton.

For the "Three American Painters" exhibition, Mr. Fried produced a long catalogue essay that has become one of the essential

documents in any discussion of the aesthetics of painting in the present decade. Elucidating what he calls "deductive structure"—that is, the practice of "deriving or deducing pictorial structure from the literal character of the picture-support" (or, in other words, from the shape of the canvas)—Mr. Fried found in Mr. Stella's paintings an "exaltation of deductive structure as sufficient in itself to provide the substance, and not just the scaffolding or syntax, of major art." It would not be exaggerating, I think, to suggest that Mr. Fried takes Mr. Stella's paintings, which, as he says, are "nothing but structure," as a touchstone of contemporary achievement. His whole essay is a brilliant and elaborate celebration of the pictorial practices so single-mindedly pursued by Mr. Stella.

The paintings that Mr. Stella showed at the Museum of Modern Art in 1959–60 were works in which, in Mr. Fried's words, "parallel stripes of black paint, each roughly 2½ inches wide, echo and re-echo the rectangular shape of the picture-support until the entire canvas is filled." Following these black paintings, which looked rather like enlarged, formalized details of pin-stripe suiting materials, Mr. Stella executed similar pictures in aluminum, copper, and magenta metallic paint. More recently, for the pictures he showed at São Paulo—they were exhibited this winter at the National Collection of Fine Arts in Washington—Mr. Stella designed a number of oddly shaped canvases which he continued to fill with the same stripe-module, varying his color but keeping to the same monotonous unit of composition.

For his current exhibition at Castelli's, Mr. Stella has designed still more oddly shaped canvases, only he has now abandoned his monotonous stripe for startling units of brilliant color that—as his original stripe-compositions did—echo the canvas shapes. He has thus moved more directly into the arena of color painting, and these new pictures look like a self-conscious attempt to synthesize his own preoccupations with those of Kenneth Noland, the most interesting of the color painters, who has also come more and more to rely upon unorthodox canvas shapes to keep the formal inventiveness of his work from mere repetition or atrophy.

Like a good deal of current color painting, Mr. Stella's new work delivers a quick visual assault to one's optical sensibilities—an assault abetted, in this case, by a method of lighting so overpowering that the bare walls would be enough to induce a kind of retinal vertigo. But this overlighting, like the vibrant color and

irregular canvas shapes adopted by Mr. Stella, is part of the revolu-
tion in sensibility we are witnessing at the present moment—a
revolution characterized by its happy preference for blunt and
impersonal physical sensation and its indifference, if not its outright
hostility, to interior experience. In painting of this persuasion, the
metaphorical element in art, or indeed all reference to anything that
suggests the interpretation or transmutation of experience, is totally
and cheerfully rejected, and a complete divorce is effected between
the work of art and its commerce with the world of extra-artistic
meaning. What results is an art that strictly confines itself to meditat-
ing on its own artistic strategies—an art that is, in essence, a
specialized form of problem-solving.

As may be inferred, I do not myself find this development a
very inspiring one. It leaves one with too great a sense of all that
has been lost from the universe of artistic discourse. Yet it would be
a mistake to regard an *oeuvre* like Mr. Stella's as an aesthetic or
historical sport. No doubt his work is currently overrated, but it
nonetheless says something authentic—unhappily authentic—about
the life of feeling among the cultivated classes in our society. And it
embodies an aesthetic attitude that is by no means confined to
pictorial art.

Looking back on the last decade, the event that stands out as
the most memorable prophecy of this aesthetic attitude—an event
that brought the past and the future into an unforgettable colli-
sion—does not come from the visual arts at all but from the dance.
When, in 1959, Martha Graham and George Balanchine collabo-
rated on a work called "Episodes," one had the rare experience of
seeing the aesthetic assumptions of one era confronting and, before
one's very eyes, displacing those of another.

Miss Graham's contribution, it will be recalled, consisted of a
highly poetic, elaborately costumed dance-drama on the life of
Mary, Queen of Scots. Like all her work, it explored a difficult,
deeply subjective terrain, reminding us that Miss Graham belonged
to a generation of modernists that looked upon art as a metaphorical
medium, which, if pressed hard enough, would illuminate and exalt
the mysteries of experience. Mr. Balanchine's contribution, on the
other hand, was utterly cheerful, extrovert, geometrical; his dancers
very bright and young and athletic in their practice clothes; the very
point of his inspired choreography apparently intended to close the
door on the subjectivity of the old art and make of the objective

mechanics of dance a sufficient, even a transcendent, subject matter.

In Mr. Balanchine's "Episodes," one had a benevolent preview—in this case, tempered by a sensibility of the utmost refinement and grace—of the aesthetics of the 1960's, an aesthetic of impersonal surface and shape that is content—no, actually eager— to avoid the contours of personal emotion. In Mr. Stella's new pictures, we are given an interim report on what this aesthetic has come to. And we have seen only the beginning.

March 20, 1966

II

"I hold," André Gide once wrote, "that the best explanation of a work must be its sequel." Whether or not this rule invariably obtains in the study of an artist's work, there are certainly some artists whose work seems to defy almost any other mode of analysis. Such *oeuvres* are so completely self-enclosed, so fixed in the orbit of their own internal logic, that the usual "explanations" seem almost supererogatory. All that matters is the sequential progression from work to work, from idea to idea. In the presence of work of this sort, the critic is tempted into—well, not silence exactly (never that!), but a form of apology and advocacy which lavishes all its intellectual resources on expounding the artist's rationale, passing over the larger questions of value and significance with silent contempt.

The art of Frank Stella, which is now the subject of a large retrospective exhibition at the Museum of Modern Art, is work of this sort. It offers us a sequence of pictorial forms that are so highly rationalized, that are themselves so close to being a species of critical discourse, that they seem to leave criticism no function but to ratify the scenario of analytical decision-making which they embody. The art of painting has been transformed here into an act of cold and audacious ratiocination, and the critical intelligence responds by placing its own analytical and rhetorical powers at the service of what is already a series of critical deductions in painted form. This, in any event, is what has usually been the case with Stella's work.

There is certainly some reason for it. On one level, at least, every Stella exhibition is more like a seminar on aesthetics than an

exhibition of paintings. It seems to call for explanation, or explication, rather than for an unmediated response. There is always something grimly academic in the way this art doggedly pursues its narrow range of problems. The atmosphere is cerebral, even clinical. Pictorial conception seems almost out of reach of the normal vicissitudes of feeling. The techniques of realization are as impersonal—as "objective"—as the fallible human hand can make them. One has the sense of an art reduced to a series of diagrams illustrating ideas for paintings rather than a sense of painting itself.

On another level, however, the spectator is offered a very rich and complicated optical experience. In the earlier years of Stella's development—in the period of his "black" and "aluminum" paintings—the materials of this experience were extremely austere, but their deployment was very canny, ingenious, and intriguing. In recent years—especially in the series of paintings based on the form of the protractor—the materials have become more luxuriant and ornamental. A lush, fluorescent chromaticism, abetted by an almost baroque elaboration of form, now seduces the eye with a delicious bath of visual sensation and exotic shapes. The result remains cold, calculated, and cerebral, but this cold-blooded rationality is now wedded to an extravagant decorative taste.

The immense critical edifice that has been constructed on behalf of Stella's paintings—probably the largest and most ambitious body of criticism ever devoted to an American painter in the first decade of his career—addresses itself almost entirely to what I have called the academic side of his work. It is concerned with the process of critical deduction which led the artist to his characteristic forms. It traces the morphology of these forms and confers on this morphology a high philosophical importance. It remains curiously silent, however, about the way Stella's paintings actually function in the visual arena. It carefully avoids any mention of the artist's dependence on a very slick decorative formula for his visual effects. Reading this criticism, one often has the feeling that Stella's paintings are being examined under some sort of microscope rather than with the naked eye. For to the naked eye their appeal is rather simple—the appeal of a handsome, well-ordered design that can be taken in at a glance, an appeal that requires no second thoughts, no sustained attention, and no very complicated emotions.

I have now seen this exhibition, which consists of some sixty paintings and drawings from the years 1958–69, twice—once before

the opening, when the galleries were entirely deserted, and once after, with the usual museum crowd milling around. I have seen some of the pictures in the show many times before, and most of them at least once before. I have written about some of them on earlier occasions when they were first shown in the galleries. I find looking at them in an empty gallery is a rather desolate experience. These pictures need a certain number of people moving around in front of them. This is a very sociable, highly decorative art, and it requires at least a minimum of human activity to provide a context—an ambience—which the pictures on their own are unable to supply.

The more I see of these paintings, the less convinced I am that they have much to do with the artistic profundities which are so regularly attributed to them by Stella's critical apologists. What is most interesting to me about Stella is something which his partisans can never bring themselves to acknowledge—namely, the discrepancy between the very sophisticated intellectual origins of his art and its rather lightweight results.

Here is an art derived from a very shrewd, well-informed critical "reading" of modernist painting, yet it issues in a series of images that make very little demand on one's sensibilities. The regular patterns of stripes and arcs, echoing and re-echoing the shapes of the surfaces they adorn, yield a surprising range of formal variations. They are, for the most part, delightful to look at. But they are without emotional resonance. They lack the minimum expressive pressure. Beyond their superficial effects, they are without impact. Between the "idea" and its gorgeous visual statement, there is a large void that remains utterly empty—empty, above all, of feeling. Ideas cannot fill it. The most beguiling decorative surfaces cannot disguise it. It remains a void.

If you want to read a cogent account of the more orthodox view of Stella's achievement, you will find one in the ambitious text which William S. Rubin, the Chief Curator of the Painting and Sculpture Collection at the Museum of Modern Art, has written for the catalogue of the show. Mr. Rubin, who organized the Stella show, writes as an art historian as well as a critic. He gives us a detailed history of the artist's short, amazing career—Stella is only thirty-three—as well as a résumé of the critical response it has inspired. Mr. Rubin is himself a true believer in Stella's genius, and he enters into aggressive but sympathetic dispute with that other

true believer, Michael Fried, who, until now at least, has pretty much set the terms of Stella criticism. Cognoscenti of the Stella literature will find much here to occupy them.

Most interesting to me, I must confess, are the purely biographical portions of Mr. Rubin's monograph. Here we are given an account of the artist's education (Phillips Academy and Princeton University), his attitude toward the New York School, the inspiration he drew from Jasper Johns—a point which has hitherto eluded Stella's devoted commentators—and the step-by-step calculations that led to his first "black" paintings. This is a portrait of the artist as an Ivy League intellectual, and it does much to explain both the strengths and the peculiar weaknesses of Stella's art.

April 5, 1970

22. Robert Morris: The Triumph of Ideas over Art

Among the new artists who came to enjoy a special prominence in the 1960's, none currently wields so much influence or commands such conspicuous patronage and critical genuflection as Robert Morris. At the age of thirty-eight, Mr. Morris is an established *chef d'école*. His theoretical pronouncements are avidly studied in the universities. Museums vie for the privilege of showing his work. Collectors are eager to honor his every whim, even when—as is now sometimes the case—the results are not exactly collectible, and critics hasten to confer on his endeavors those massive philosophical justifications, which, though they often tell us remarkably little about the work in question, are always a sure sign that some new aesthetic disturbance has made itself felt.

In Detroit at the moment, one can see the second installment of a two-part retrospective survey of Mr. Morris's work that has been jointly organized by the Detroit Institute of Arts and the Corcoran

Gallery of Art in Washington. The first installment was shown last month in Washington. At the Museum of Modern Art in New York, Mr. Morris is currently represented in the "Spaces" exhibition—his is the refrigerated room containing all those tiny spruce trees. He is also represented in the big American show at the Met. And another ambitious one-man show of his work is said to be forthcoming at the Whitney Museum later this year. Clearly, Mr. Morris is regarded as a figure of some importance.

The Detroit exhibition, directed by Samuel Wagstaff, the Institute's Curator of Contemporary Art, offers us the clearest and most comprehensive account of Mr. Morris's work we have had. For this exhibition traces Mr. Morris's development from an initial preoccupation with Neo-Dada objects, more or less in the manner of Jasper Johns, through the various stages of Minimal sculpture—a movement that Mr. Morris helped to pioneer—to his current concern with large, open-air constructions and so-called "earth works" and environmental designs on a vast architectural scale. Along the way, of course, Mr. Morris has also involved himself in various dance and theater enterprises as dancer, choreographer, and designer, but these are not represented in the current exhibition.

The gallery devoted to Mr. Morris's Neo-Dada objects, though entertaining as well as interesting, might best be described as constituting the prehistory of his principal aesthetic ideas. The "Box with Sound of Its Own Making" (1961); the "Fountain" (1963), a metal bucket hanging from a hook on a wooden scaffolding; the "Card File" (1963); "Brain" (1963–4), whose surface is covered with dollar bills; and the various lead objects and rope pieces—all of these are amusing, well-executed examples of the kind of Duchampian game that Mr. Johns restored to currency in the late fifties. They differ from Mr. Johns's work, however, insofar as they repudiate those traces of personal touch and process-made-evident which Mr. Johns carried over into his work—even his sculptural objects—from Abstract Expressionism. Mr. Morris, even in this Neo-Dada phase, preferred impersonal surfaces, workaday materials, and an austere taste that insisted on the removal of easy optical appeals. Indeed, this taste—or antitaste—is, perhaps, the only important clue to Mr. Morris's Minimal sculpture which these early objects disclose.

As for the sculpture itself, Mr. Morris has been admirably lucid about what he regards as expendable. In his "Notes on Sculp-

ture" (1966), he wrote: "The sensuous object, resplendent with compressed internal relations, has had to be rejected." Still, he argued, "The object itself [that is, the sculpture-as-object] has not become less important. It has merely become less *self*-important." Eliminating both sensuous effects and those despised "internal relations" does not mean, however, that we are left with no purchase on the work's quality. "The particular shaping, proportions, size, surface of the specific object," Mr. Morris continued, "are still critical sources for the particular quality the work generates."

The sculptor's taste for sensuous effects is, then, to be sublimated in the general conception and design of the work as a whole. And what of the work's "internal relations"? Here, too, a kind of sublimation or transference takes place: "The better new work [that is, Minimal sculpture itself] takes relationships out of the work and makes them a function of space, light, and the viewer's field of vision." The viewer is to be made more conscious—indeed, more *self*-conscious—of himself vis-à-vis the sculptural object and not be allowed to lose himself in the artist's own imaginary world. "One is more aware than before that he himself is establishing relationships as he apprehends the object from various positions and under varying conditions of light and spatial context. Every internal relationship, whether it be set up by a structural division, a rich surface, or what have you, reduces the public, external quality of the object and tends to eliminate the viewer to the degree that these details pull him into an intimate relation with the work and out of the space in which the object exists." Hence the Minimalist's concern with size: "Much of the new sculpture makes a positive value of large size. It is one of the necessary conditions of avoiding intimacy."

What we are being offered in this new sculpture is not so much a sculptural object, in the traditional sense anyway, as a sculptural *mise en scène* in which the spectator is obliged to become an actor in a playlet of spatial perception and self-awareness. We are not to look for revelatory relationships among the parts of the work which the sculptor has made—or, as is now the case, has had made for him. Revelations, to the extent that they exist, are dependent on the will, if not indeed the fantasy, of the spectator.

Having spent a good deal of time with Mr. Morris's sculptural constructions, not only in Washington and Detroit but in other galleries and museums over the years, I see no point in "reviewing" their individual merits. The "critical sources" of their differing

qualities I find embarrassingly insignificant. In any case, the critic confronting such work ought properly (I gather) to offer the reader a memoir of his experience as a participant in the artist's particular *mise en scène* rather than an analysis of its concrete sculptural constituents, but here again I must confess to an embarrassment of poverty. The experience is simply too thin, too commonplace, too utterly sterile to permit either a recapitulation *or* an analysis. In the repertory of playlets dealing with the drama of spatial perception and self-awareness, I find more to engage my faculties in any number of workaday experiences—sitting at my desk, for example, or riding in an automobile, or simply entering a room. I cannot see that Mr. Morris's essentialization of such experience adds anything but the *idea* of essentialization to what one already knows, feels, and *sees* in the ordinary course of one's experience of the world.

This is, of course, the standard criticism that has been made of Minimal sculpture from the outset, but I think it is a criticism that bears repeating. Writing in 1967, Clement Greenberg remarked: "Minimal art remains too much a feat of ideation, and not enough anything else. Its idea remains an idea, something deduced instead of felt and discovered." But those for whom ideas are more compelling than the achieved experience of a work of art find this "feat of ideation" more than sufficient for their needs. Indeed, their evident satisfaction in this triumph of ideas over art is one of the most interesting and most alarming aspects of the Minimal movement as a cultural phenomenon.

January 25, 1970

23. An Art of Boredom?

No doubt the most striking development of the 1965–6 art season, now drawing to a close, has been the proliferation of exhibitions devoted to the new sculpture, three-dimensional painting, and/or

miscellaneous construction generally referred to as "Minimal" or "ABC" art. Two major surveys of this work—the "Primary Structures" exhibition at the Jewish Museum and "Art in Process" at the Finch College Museum of Art—remain on view at the present moment. An earlier presentation called "Sculpture from All Directions" was shown at the World House Galleries in November, and works by certain of the same artists have been included in the recent new-acquisitions shows at the Museum of Modern Art and the Whitney Museum. The Lipman Collection, shown at the Whitney in April, also included a sizable portion of this work, and, as always happens with an idea that catches on, the galleries have been vying with each other in mounting a succession of one-man shows of artists represented in these general surveys.

If rumor is to be believed—and I think it is—we shall be seeing and hearing about even more of this Minimal art next season. Not only are numerous exhibitions in the offing but—a sure sign of success—the college and university art departments, which follow developments in the New York art market the way Kremlinologists count noses at the May Day parade, are reportedly preparing to welcome the new style, or congeries of styles, with enthusiasm. Already the invitations to serve as artist-in-residence are out, and in anticipation of the new wave some departments are said to be enlarging their workshop facilities to permit the kind of large-scale carpentry and metalwork that this art requires for its realization.

In the offing, too, one may be sure, are the critical and theoretical disquisitions without which Minimal art, even more than its predecessors, would scarcely be given the kind of concentrated attention it now enjoys. For it is a fact that art has become increasingly dependent upon criticism and aesthetic theory, not only for its audience but for the whole conceptual framework on which it is based. In this respect the exponents of Minimal art may only have carried to a further extreme the critical self-consciousness that characterizes nearly all of modern art, but the nature of the art in question—its surpassing visual simplicity and utter lack of expressive or symbolic elaboration—gives to its theoretical rationale an importance never before equaled in even the most theory-oriented styles of the past.

The artists themselves have been more than ready to offer ambitious explanations for the simplest of their creations—to such an extent, indeed, that one wonders if there may not be a "law"

operating here to the effect that, the more minimal the art, the more maximum the explanation. But for all their garrulous and ingenious theorizing, the artists are still outdistanced by the critics in conferring on this art its aura of intellectual complexity and profound philosophic involvement. Overnight, as it were, one has learned to anticipate from any intellectually respectable analysis of a white formica box, say, or a galvanized iron shelf those knowing references to Wittgenstein and McLuhan and Merleau-Ponty, Panofsky and Robbe-Grillet and Buckminster Fuller, that are now deemed absolutely necessary for an understanding of the new art.

Anyone suffering from an incontinent sense of humor may be excused, perhaps, for finding something ludicrous in the discrepancies that obtain between the complexity of the discussion and the simplicity of the objects that prompt it. But it will not do to dismiss the discussion as a joke; it may be preposterous at times, but it is dead serious and has already effected a certain change in the way one thinks about art and even in the way one responds to it.

The most comprehensive discussion to date has been Barbara Rose's essay, "ABC Art," a virtual collage of theory, history, shrewd quotation, and critical generalization, published in *Art in America* last fall. There is much to be said of this essay, which is a sort of Baedeker to the new art and the sensibility embodied in it, but I want here to mention only one point—the extraordinary paragraph Miss Rose devotes to the subject of boredom. She writes:

> If, on seeing some of the new paintings, sculptures, dances or films, you are bored, probably you were intended to be. Boring the public is one way of testing its commitment. The new artists seem to be extremely chary; approval, they know, is easy to come by in this seller's market for culture, but commitment is nearly impossible to elicit. So they make their art as difficult, remote, aloof and indigestible as possible. One way to achieve this is to make art boring. Some artists, often the most gifted, finally end by finding art a bore. It is no coincidence that the last painting Duchamp made, in 1918, was called *Tu m'*. The title is short for *tu m'ennuie*—you bore me.

Now it is true that much of this art is boring, and one is at first relieved to hear that one's own boredom in confronting it is, after all, the correct response. But then one wonders. Clearly Miss Rose herself does not find this art really boring, and in reading her essay one's own boredom is quickly dissipated, one's interests are aroused.

For her, boredom is simply one of the interesting theoretical elements that may or may not enter into the creation and experience of this art—which is quite a different matter from being really bored. The discussion of boredom turns out to be another ploy for soliciting our interest in the art itself—in fact, a strategy for dealing with charges of authentic, brute boredom by transforming it into a creative principle. Even the reference to Duchamp is a ploy, conferring on Minimal art the cachet of his legendary abstention.

I am reminded of the remarks Susan Sontag devotes to the subject in the last pages of her book, *Against Interpretation:* "The commonest complaint about the films of Antonioni or the narratives of Beckett or Burroughs is that they are hard to look at or to read, that they are 'boring.' But the charge of boredom is really hypocritical. There is, in a sense, no such thing as boredom. Boredom is only another name for a certain species of frustration. And the new languages which the interesting art of our time speaks are frustrating to the sensibilities of most educated people." Of course, in another sense, there *is* such a thing as boredom, but for writers like the Misses Rose and Sontag it apparently does not exist.

Miss Sontag is at least correct in referring to boredom as a "species of frustration." And this is where criticism plays its crucial role, for it has assumed—to a degree no one has yet measured— some of the functions art itself has forfeited. It is criticism rather than art which now relieves that frustration and adjusts our sensibilities to the object at hand. Like nature, art abhors a vacuum, and in that vast imaginative vacuum created by the new Minimal art the critics and theorists are in the process of building a new intellectual empire.

June 5, 1966

24. Claes Oldenburg

Claes Oldenburg is, in several important respects, the most appeal-
ing artist to have appeared on the New York scene in the last
decade. Beside the increasingly constricted concerns of the abstrac-
tionists, his zany sculptures and offbeat designs for monuments offer
a robust engagement with the world we actually encounter beyond
the perimeter of the art gallery, the museum, and the millionaire's
fancy pad. There is a comic energy in the work that suggests that
art, contrary to what we had been led to believe, has not lost its
capacity to intervene in the affairs of life—to criticize, make jokes,
sentimentalize, exalt, and deplore. In Oldenburg's art, the emotions
of the *homme moyen sensual* rarely, if ever, defer to the interests of
the detached visual technician intent upon distilling from the
plethora of workaday sensation some parsimonious aesthetic es-
sence. There is an openness to experience, to the social environment,
and to the mind's freewheeling tendency to proliferate fantasy in the
face of these that, in the context of so much bloodless formalism,
would be liberating even if the results were not so amusing.

But amusing Oldenburg certainly is, and it is essential to his
art that it be amusing. (Whether it *remains* amusing is another
question.) Modern art has been, more often than not, a solemn
enterprise, and among the self-appointed guardians of modernist
purity in the 1960's, this tradition of solemnity has been carried to
almost unimaginable extremes of aridity, humorlessness, and farci-
cal self-importance. Oldenburg's art amuses precisely because it
mocks this solemnity with such devastating and insouciant au-
thority.

Not only has Oldenburg upset conventional expectations (in-
cluding those of "advanced" taste) about the way objects and the
environment are to be treated in a work of art, but he effectively
alters the tone in which the artist speaks to the public. He plays the
clown. At the Museum of Modern Art's large retrospective exhibi-
tion of Oldenburg's work this fall, the faces in the crowds of spec-
tators were happy faces—smiling, relaxed, often actually laughing.
At the very altar of high artistic seriousness, Oldenburg invited the
crowd to abandon its pieties and have a good time, and the crowd
responded with enthusiasm.

All of this—the openness, the clowning, the energy, and the

cheerful embrace of the mundane—is, as I say, very appealing. Yet the exhibition itself was a lightweight affair. Oldenburg's comic talents were abundantly in evidence wherever one turned, and the jokes had not noticeably staled. But as soon as one got past the early work and really examined the "major" pieces of the last seven years, the jokes tended to reduce themselves to a single joke—indeed, to something uncomfortably resembling a formula. The small made large, the hard made soft, the trivial transformed into the monumental: the virtuoso changes wrung on these basic strategies could not conceal a certain poverty of conception. Between the amusing giant hamburger (seven feet in diameter) and giant piece of cake (nine feet long), both made of foam-rubber-filled canvas in 1962, and the soft bathroom fixtures of 1966, made of vinyl, wood, etc., there are changes of material and scale, but conceptually the work rehearses the same comic scenario over and over again. The effect of this repetition was to make the exhibition as a whole seem a good deal smaller than the actual space it occupied. Despite the extravagant and infectious display of high spirits, Oldenburg's art showed itself to have a fatally limited range.

It is true, of course, that most large exhibitions devoted to the work of a single artist over a short period of time tend to diminish rather than enlarge our sense of the artist's possibilities. Only the most fecund genius can withstand the kind of exhaustive inventories that museums now lavish on talents of every size, and in this respect Oldenburg—whose exhibition contained over two hundred items from scarcely more than a decade—was only paying the price of his current celebrity. What this exhaustive exhibition did make unmistakably clear, however, was the extent to which the nature of Oldenburg's ambition had significantly changed over the past decade. From an art founded originally on alienation—on a profound moral disgust with the established values of bourgeois culture and with a deeply critical attitude toward the way advanced art functioned as a coefficient of those values—Oldenburg has moved in a very short time to an art that accommodates itself with remarkable ease to a form of bourgeois entertainment.

As a measure of the change that has overtaken Oldenburg's work, consider this passage (written in 1961) from *Store Days:*

> If I could only forget the notion of art entirely. I really don't think you can win. Duchamp is ultimately labeled art too. The bourgeois scheme is that they wish to be disturbed from time

to time, they like that, but then they envelop you, and that little bit is over, and they are ready for the next. There even exists within the b. values a code of possibilities for disturbance, certain "crimes" which it requires some courage to do but which will eventually be rewarded within the b. scheme. B. values are human weakness, a civilization built on human weakness, non-resistance. They are disgusting. There are many difficult things to do within the b. values, but I would like to find some way to take a totally outside position. Bohemia is bourgeois. The beat is bourgeois—their values are pure sentimentality—the country, the good heart, the fallen man, the honest man, the gold-hearted whore, etc. They would never think f. ex. of making the city a value of good.

Possibly art is doomed to be bourgeois. Two possible escapes from the bourgeois are 1. aristocracy and 2. intellect, where art never thrives too well. There again I am talking as if I want to create art outside b. values. Perhaps this can't be done, but why should I ever want to create "art"—that's the notion I've got to get rid of.

Oldenburg was never, of course, rid of the "art" notion either then, when he was working on his "Store"—an actual store he opened on the Lower East Side in which to exhibit and sell his painted plaster sculptures of cheap pastries and other mundane food items—or later, when he was more than pleased to show his work in the most stylish galleries and museums. No "totally outside position" was possible, after all. But the passage itself is indicative of the kind of aspiration that governed his work at the beginning of his career—an aesthetic aspiration for an art whose purity and innocence and sharp cutting edge would be safeguarded by a taste too vulgar and too perishable, too low-class and common, to permit any quick or easy absorption into the bourgeois "scheme."

The aspiration itself proved wholly illusory—scarcely a year after it was voiced, Oldenburg found himself amply "rewarded within the b. scheme" as part of the new craze for Pop art—but it defined an interesting position. Prior to "The Store," which actually launched Oldenburg as an uptown eminence, he had taken the *art brut* of Dubuffet and the ferociously antiliterary style of Céline's *Mort à Crédit* as his models. This, in itself, betrayed a certain naïveté, for the styles of Dubuffet and Céline can scarcely be regarded as even near equivalents. Whereas Dubuffet is a very canny Parisian intellectual who long ago mastered the art of playing the primitive

for a mandarin bourgeois public, knowing exactly how far he could go at every turn, Céline was a genuine reprobate whose gut hatred of bourgeois values placed him permanently beyond the reach of respectability. If there is such a thing in modern culture as a "totally outside position," then Céline occupied it, and it is a sign of Oldenburg's intelligence to have glimpsed this fact.

But his identification with Céline was, at best, an act of self-deception. Oldenburg's sensibility is actually very cheerful, optimistic, and accommodating; he has never been possessed of the kind of spleen and violence that animated Céline's whole outlook on life. In the so-called "Street" works (1959–60), when all the themes were drawn from unlovely images of life on the Lower East Side, there is a touching throwaway quality, at times even attaining a homely sidewalk lyricism, but the work remained securely locked within a vein of taste that Dubuffet had long established as completely permissible.

Still, one does not feel in the "Street" works or even in the items from "The Store" that the artist has set out deliberately to amuse or beguile. He is still acting under some illusion of resistance and rebellion. But from the moment Oldenburg made his uptown debut—at the Green Gallery, in 1962, where the first giant sewn-canvas works were shown—it was difficult to credit the rebel stance as anything but a useful charade. The public was "ready for the next," and Oldenburg was delivering it in abundance. The possibility that art might be "doomed to be bourgeois" was, to all appearances anyway, faced with remarkable equanimity.

For the next few years Oldenburg was in the mainstream of the Pop movement, producing entertaining parodies of the very objects so beloved by the once despised bourgeois public. He had entered art history and—what nowadays amounts to the same thing—began to enjoy considerable prosperity and fame. The strategy of Dubuffet proved to be far more congenial to his talents than that of Céline.

In 1965, Oldenburg embarked upon still another enterprise—his comic designs for colossal architectural monuments. Many of these have already become legendary: a monument in the shape of a baked potato for the Grand Army Plaza in Brooklyn, a giant teddy bear for Central Park, a Good Humor bar for Park Avenue, a drainpipe for Toronto, a windshield wiper for Grant Park in Chicago, a fan to replace the Statue of Liberty. In their put-on iconography, these designs are only a logical, if more grandiose,

extension of Pop's facetious attitude toward any kind of exalted public symbolism. They are not so much a criticism of what public visual discourse has degenerated into in our culture as a comic elaboration of what, given the infantile-mercantile sensibility that dominates public space in our cities, such discourse might ideally be.

Oldenburg's own attitude in these designs is extremely equivocal; the satirist is clearly prepared to go "straight" at the first nod from the city fathers, but meanwhile he goes through his comic turns with gusto. What is remarkable about these designs, however, is not their facetiousness—a commonplace among Pop artists of every sort—but the style in which they are rendered: a delicate, romantic, Old Master pastiche, with washes, shadings, and perspective as deft and correct as anything you could expect to find in the old academies.

In another passage in *Store Days* Oldenburg had written: "I want these pieces to have an unbridled intense satanic vulgarity unsurpassable, and yet be art," but in these later drawings, which were mounted in the drawing galleries of the Museum of Modern Art with the kind of solemnity usually accorded a revered master, he adopts a style unsurpassable in sweet respectability. They are indeed the drawings of an academician *manqué*, and they recall us to an essential feature not only of Oldenburg's art but of the Pop movement itself—its fundamental conventionality, its yearning to assume the duties of the old and now discredited academic tradition, with its busy civic commissions and public decorations.

Needless to say, none of the books under review* regards Oldenburg as anything but the genius of our day. The large volume devoted to his *Drawings and Prints* is a very handsome production, and as Oldenburg is always seen at his best in his drawings, this book is, I suppose, an essential document for the study of his work. *Proposals for Monuments and Buildings 1965–69* is also devoted to his drawings, but only those concerned with this special enterprise, whereas the *Drawings and Prints* volume covers the entire course of the artist's career. The latter suffers from an excessively pious text by Mr. Baro, who has a mind so fine that no comic idea of Oldenburg's will ever violate it.

The *Proposals* volume has the advantage of containing an

* Gene Baro, *Claes Oldenburg: Drawings and Prints* (Chelsea House) and Claes Oldenburg, *Proposals for Monuments and Buildings 1965–69* (Big Table).
Claes Oldenburg and Emmett Williams, *Store Days: Documents from The Store (1961) and Ray Gun Theater (1962)* (Something Else Press).

interview with Oldenburg himself, who remains—so far—the best commentator on his own work. At least he makes it sound as if a human being has produced it, which is not always the case with uptight admirers like Mr. Baro. For this reason, too, the best of these books is *Store Days,* which, although only concerned with a brief phase of Oldenburg's work (1961–2), conveys very accurately the character of his early endeavors, with many of the artist's texts as well as pictures. When one considers the course Oldenburg's art has followed since those days, the book makes rather sad reading, but that, too, is part of its importance.

December 4, 1969

25. Matta: Style vs. Ideology

Matta, the Chilean-born Surrealist painter long resident in Paris, is currently showing six new mural-size canvases at the Alexander Iolas Gallery. Except in one important respect—their political topicality—these paintings differ very little from the large body of Matta's work with which one is more or less familiar. Their chief interest at the present time is not, therefore, to be found in any disclosure of an aesthetic "breakthrough"—aesthetically, Matta does not seem to have budged for a couple of decades—but in another realm altogether. For these paintings—and most particularly, the three given over to the most explicit political subjects—raise an important question about the relation of an artist's style to the ideological energies that animate it.

As a Surrealist, of course, Matta has been involved from the beginning of his career—in the late 1930's—in an artistic attitude that deliberately set out to accommodate a wide range of extra-artistic concerns. As Professor J. H. Matthews notes in his recent critical study, *An Introduction to Surrealism:* "If one fact finds repeated stress in Surrealists' writings on literature and painting, it is that

these are to be regarded as means, and not as ends in themselves."
And Professor Matthews adds: "Surrealism has never aimed at the
enrichment of a given artistic form . . . Surrealism has not devi-
ated from its primary, extra-literary and extra-artistic aims."

Whether art—and especially the art of painting—permits
such an easy separation of ends and means is doubtful, to say the
least, and no less so in Surrealist painting than in any other mode.
In the Surrealist order of priorities, radical political aspirations
together with equally radical sexual ambitions have held a high
place. No word in the Surrealist lexicon is more honored than the
work "revolution." But at this distance in time, it looks as if the idea
of revolution was, if anything, more a means to an aesthetic end
than the other way around.

Thus, while it may be true, as Professor Matthews observes,
that in Surrealism we "encounter the same lack of concern for Art
with a capital letter which Dada had taught," it is only in its works
of art, capitalized in more than one sense, not in its vaunted
revolutions, that Surrealism still lives. Like other art movements that
upheld ideal standards of conduct and consciousness, the impor-
tance of Surrealism is not be be found in those transcendent
revisions of ethics or politics or sexual morality upon which Sur-
realist visionaries lavished so much beautiful rhetoric, but in the
perfection of certain styles that vividly expressed a yearning for
such transcendent states.

While not (I believe) a major painter, Matta is nonetheless the
author of one of these styles—a distinct pictorial manner that
already has a place in history. Into a deep luminous space he
projects an imaginary and highly metaphorical spectacle of bizarre
objects and structures. Everything contained in this pictorial space
seems to be in motion—indeed, at the point of violent collision or
collapse—and the space itself is imbued with an eerie liquid color
that confers a further element of menace to the objects it illuminates.
These objects—rarely, if ever, realistic, yet rarely far removed from
the real objects that have prompted their metaphorical transforma-
tion—are rendered with a brilliant, painstaking draftsmanship.

Trained as an architect—he was once a student of Le Cor-
busier—Matta is a consummate constructor of imaginary worlds,
meticulously designed cosmologies that combine the atmosphere of a
science-fiction fable with some of the lurid feeling of an erotic

nightmare. But his very strengths only underscore his principal weakness: the tendency to sacrifice the expressive features of a painting to its illustrational elements. There is never, in Matta, any necessary relation between form and color, between the complexities of the draftsmanship and the extreme artifice of the chromatic effects that adorn them. For all their imaginative sweep, Matta's paintings are often oversize illustrations rather than genuine pictorial realizations.

It is for this reason that Matta's inventiveness—the particular way he draws his forms and tints the space they occupy—has proven more congenial to us at secondhand, in the work of the late Arshile Gorky, who, in responding to Matta's imagery and technique, placed them at the service of a much finer painterly sensibility.

In his new work, Matta seems to have seized upon the illustrational side of his talents and given them an even more emphatic role than they enjoyed in the past. The guns, helmets, and eviscerated bodies that dominate the three political paintings at the Iolas Gallery—"Vietnam," "Santo Domingo," and "Alabama," all from 1965—have an explicitness that tends to dissipate the special aura of mystery that is one of Matta's greatest strengths. Nor is there anything about the pictorial design of these paintings that compensates for this increased graphic explicitness. The violence usually prophesied in his pictures has here come to pass, but the prophecy proves to have been a more expressively potent theme than its realization in a concrete political example.

Still, Matta's style exercises so complete an authority over whatever details he undertakes to include in his pictures that the results remain firmly in the realm of the artist's characteristic vision. The polemical thrust of these paintings is all but lost in their stylistic expertise.

Is it morally or politically callous to deal with paintings on such urgent themes in terms of pictorial aesthetics? Matta himself apparently thinks so. In a statement last year at the time of his exhibition at the Musée des Beaux-Arts in Lucerne, he declared: "In our day two attitudes are possible: either one feels the drama of the class struggle, of man's struggle against oppression and exposes the cruel constant of daily life, thus becoming the poet of this drama, or one remains unaware of the class struggle and falls into the expression of a style or taste."

Clearly, Matta now sees himself as "the poet of this drama," but I daresay he is mistaken. If one is moved to discuss his work, including his new political paintings, in aesthetic rather than political terms, it is because their political details alter nothing really important in his style—because, finally, the artist's political devotions only serve him in "the expression of a style or taste."

What we see in Matta is another example of the victory of style over ideology—the trick that history has played on many of the most radical movements in modern art. And the style itself has not been visibly strengthened by this excursion into the "class struggle"; it seems scarcely to have been touched by it.

May 15, 1966

26. Prague: 1969

When André Breton, the French poet and founder of Surrealism, came to Prague in 1935, he spoke of it as "the magical capital of old Europe," a city that "carefully incubates all the delights of the past." It was the last moment in modern history when Prague could be described in such rosy terms. The visitor nowadays, certainly, sees something very different. The "delights of the past" still abound, but one cannot help but be aware of the extent to which this "magical capital" has become the scene of an immense political tragedy.

Going the rounds of galleries, museums, and studios in Prague earlier this summer, one could see easily enough what this tragedy has meant in terms of the cultural life of Czechoslovakia—and what, because of an extraordinary courage and commitment, the Czechs have refused to allow it to mean. One met artists and intellectuals who had been jailed by the Nazis as "Communists," others who had been jailed by the Communists as "Fascists," and still others who

had the unhappy distinction of serving jail terms under both regimes. More often than not, their "crime" was simply their steadfast loyalty to the liberal cultural ideals that prevailed in Czechoslovakia when the country was still a democratic republic.

So far as the art world of Prague is concerned, these ideals—which, in aesthetic terms, mean an unswerving adherence to modernism—still persist even in the face of the political crackdown that followed the Soviet invasion of 1968. Thus, if one comes to Prague expecting to find an interest in modernist art being pursued in the kind of covert, semi-clandestine manner that necessarily obtains in the Soviet Union, one is pleasantly surprised to find that this is very far from being the case.

Whereas the Kandinskys and Maleviches in the Soviet state collections are still relegated (for political reasons) to the storerooms, the equally radical paintings of Frank Kupka—the Czech pioneer abstractionist—are proudly installed in the modern rooms of the National Gallery. And the policy that has put them there is not confined to isolated historical figures. These same rooms contain abstract paintings by many younger artists from the 1960's.

Moreover, the principal artistic event in Prague this summer was a large exhibition of American painting since 1945—a loan show organized by the Smithsonian Institution in Washington. A survey of this kind, with ample selections of Abstract Expressionism, color-field abstraction, and Pop art, is even now unthinkable in Moscow (where it would be an almost unimaginable sensation), but in Prague it seemed to be taken very much in stride.

For the Czechs do not give the impression of being cut off. They seem entirely at home in the language of modernist art. Travel to Western Europe may be difficult (and growing more difficult day by day), but it is not yet impossible. Czech artists show their work in West Germany, Italy, France, and elsewhere in the West. They know what is going on and are not by any means uncritical about what they see. Often their gravest problem (apart, of course, from the pressure of political circumstance) is a purely material one: the problem of finding proper materials for their work. The problem is particularly acute for printmakers, who find it difficult to procure suitable paper for their prints, and for sculptors attempting to work in the newer synthetic materials.

The obstacles, then, while nothing like as enormous as those

confronting modernist artists in the Soviet Union, are still formidable. And yet some very interesting work is being produced—and some that is more than just interesting.

The best work I saw on what was a very short visit was that of Jirí Kolár, who works entirely in the collage medium (and whose name is pronounced as if it were spelled like "collage"), and the sculptor Stanislav Kolibal. Mr. Kolár already enjoys a certain reputation in Europe; his work was shown in the Documenta exhibition last year, and the Willard Gallery in New York is planning an exhibition for the coming season. Mr. Kolibal, though he was represented in the last Guggenheim International exhibition, is still pretty much unknown outside of Prague.

Mr. Kolár began his career as a modernist poet and turned to the collage medium after his ideological troubles with the Prague regime made it all but impossible for him to continue his work as a writer. He is still very much the poet. In fact, much of his work employs cutout forms of printed type-matter that is used in a manner similar to that of concrete poetry. What removes this aspect of his work from purely "literary" associations, however, is the artist's almost dizzying gift for pictorial invention. Lately Mr. Kolár has also begun a new series of collages, using color reproductions of famous paintings which are cut up and recomposed in an astonishing repertory of new forms. These are, in effect, commentaries— *hommages* in the form of parodies—on the art of the past. But whatever the materials he employs, Mr. Kolár is a virtuoso of the collage medium—a copious and painstaking craftsman whose work creates a world of its own.

Mr. Kolibal works in a very different spirit. He might best be described as a purist with an acute sense of the absurd. Using plaster and stark-white polyester, he adheres to the basic vocabulary of geometric form—but it is geometry afflicted with a sense of the irrational. A strict cubic form will be found to "melt" at one of its corners; a pattern of immaculate rectangles will have one of its elements slightly fragmented. The language of reason is transformed into a language of anxiety. In a very quiet, sensitive, and understated way, this is sculpture of real eloquence and power.

Apart from the quality of work of this sort, what is so impressive about the Prague art scene is the determination to pursue the artistic vocation—and to pursue it in the most disinterested terms— in the face of such overwhelming political adversity. Many of the

artists one meets in Prague could probably enjoy more prosperous careers outside their own country. Yet, though these artists yearn to be free of political constraint, free to reach as far as their talents may take them in the larger world of liberal modern culture, there appears to be little wish to be free of Czechoslovakia itself. Their attachment to their native ground is profound, and the Soviet occupation has, if anything, only strengthened an already intense emotion.

In circumstances of this sort, art—no matter how disinterested—inevitably acquires a political character. And this is the paradox in which the best Czech artists now find themselves: that in attempting to free the culture of their country from political constrictions, they are, perforce, involved in a political act. Whatever it may have become elsewhere, modernism in a situation of this sort is still a matter of great risk, uncertainty, and spiritual regeneration.

September 7, 1969

27. Jean Ipousteguy

The rhetoric of power—even aesthetic power—dies hard. In Paris, for so long the seat of an unrivaled artistic imperium, it lives on—risking fatuity in the interest of sustaining grandeur—in certain isolated styles of which the purest, because the least self-conscious, is to be found in the writings of General de Gaulle. In the world of the arts, where a sense of irony combines with a sense of history to make such rhetoric an object of ridicule, the vocabulary of grandeur has long ago passed into disrepute. Only in the funeral orations of André Malraux, pronounced at burial ceremonies honoring such luminaries as Le Corbusier and Braque, does this rhetoric of power still impinge upon the realm of art, and these occasions are, after all, by their nature retrospective, looking to past glories rather than to current realities.

Nothing would seem less profitable for a contemporary artist than to attempt to build a style, whether in painting or in sculpture, on the visual equivalent of this rhetoric, and yet one of the most interesting sculptors to have emerged in Paris during the past decade—Jean Ipousteguy—appears to have attempted precisely this enterprise. With an audacity akin to de Gaulle's, Mr. Ipousteguy turns his back on the vernacular of the moment and places his work in a universe of discourse remote from its concerns. He acknowledges no obstacles to the realization of a style that looks to tradition for its sanctions, to heroic ideals for its ethos, to an inflated and discredited idiom for its eloquence.

None of this would be worth remarking if Mr. Ipousteguy had not achieved something surprising—surprising in its power to sustain our interest at the present moment—out of his involvement with such retrograde materials. Like all modern attempts at traditional high style, Mr. Ipousteguy's looks down on contemporary experience as if from a great height—from the elevated altitude of a mind absorbed in history, tradition, and mythology. With true Gaullist hauteur, the work of this sculptor addresses the present as if the authority of the past had not been irrevocably shattered. The result is a kind of sculptural fiction. One recognizes its inauthentic elements easily enough, and yet the total conviction of the work persuades one to take it completely seriously.

Certain examples of this work have been shown in New York—and elsewhere in the United States—in recent years, but the exhibition that has now come to the Pierre Matisse Gallery affords the amplest view we have had. There are four major bronzes here—the separate figures of "Man" and "Woman" of 1963, "Alexander in View of Ecbatane" (1965), and "Man Pushing a Door" (1966)—in addition to several smaller pieces and some studies for the large ones. Conspicuously missing is the large "Woman in a Bath" (1966), which the Frumkin Gallery exhibited last year.

What these sculptures reveal, first of all, is a virtuoso mastery of the conventions of heroic sculpture as they existed at the turn of the century. Bourdelle, apparently, is the model, or so one surmises. But Mr. Ipousteguy is no mere *pasticheur* of period styles. Upon the scaffolding of these conventions he has lavished not only his immense technical gifts—among which his astonishing powers as a modeler of the human anatomy rank especially high—but something more interesting: a kind of fragmentation and articulation of the

figure that pays homage to a certain vein of modern sensibility at the same time that it triumphs over it.

Clearly Mr. Ipousteguy has learned a great deal from Cubism about the analysis and synthesis of monolithic form. In the "Ecbatane" piece especially, the articulation of the musculature reflects this distinctive modern intelligence; and indeed, the entire handling of fragmented masses in this complex work betrays a real mastery of modern sculptural syntax. But the spirit of this work is anything but Cubist. It places itself at a great distance from the preoccupations of modernism in order to dwell in a realm of timeless mythical utterance. We are closer to Bourdelle than to Picasso, and closer perhaps to the Etruscans than to Bourdelle. We are, above all, in the presence of a vision that moves in and out of history with an ease and an authority that are utterly astonishing—astonishing because the sculptor in question obviously regards himself as equal to this contest with the most exalted of his predecessors.

The themes that occupy Mr. Ipousteguy in these sculptures are the themes of the ancients—power, action, the sheer pressure of human will, the high drama of human conflict and vital force. These themes are invested in the human body—are, indeed, celebrated in the elaborate and magnificent depiction of the body. No sculptor since Lachaise has conferred upon the anatomy of the human figure such dramatic and profound emotions. But whereas in Lachaise's case, the emotions were those of a highly personal and obsessive eroticism, in the art of Mr. Ipousteguy they are generalized and mythicized into a more universal scenario of human actions. One feels in Lachaise's sculpture the pressure of a private exultation, but in Mr. Ipousteguy's sculpture the pressures seem to derive from the artist's exalted sense of a cultural heritage.

In the end, it is the rhetorician rather than the poet who speaks to us in this work. Though we cannot help being aware that the artist has undertaken a profound task—or, to be precise, a task meant to be profound—the work itself lacks the very profundity that its rhetoric promises us. The distance at which it places itself from both modern experience and modernist form—contemptuous of one and cleverly exploiting the other—turns out, paradoxically, to be the distance at which it remains from its own goals. The price of remaining at so elevated an altitude turns out to be a high one.

What we have in this *oeuvre*, then, is a kind of fiction, an art of the "as if," an art that requires a certain suspension of our own

experience of both art and life. Enormous gifts are invested in this fiction, and we inevitably respond to the display of such gifts and such power—but only as a fiction. For in this case, the rhetoric of power turns art into a romance.

May 12, 1968

28. Nicolas de Staël

Ten years ago the name of Nicolas de Staël (1914–55) signified a legend. People spoke of this Russian-born Parisian painter, who had risen to fame and fortune—seemingly overnight—and then taken his own life, as an artist suicided by success. Critical controversy surrounded his work. His figurative paintings of the 1950's were said to represent a moral compromise, a failure of nerve, an irreparable breach of faith with the spirit of his earlier, more somber abstract work of the 1940's. Yet his influence persisted, and was widespread. In England, for a short period in the 1950's, this influence amounted to a virtual cult, and was finally dimmed only by the rising prestige of the New York School.

Indeed, part of the controversy attaching to de Staël's work on this side of the Atlantic stemmed from the fact that his pictures were fetching high prices and entering important collections at a time when the paintings of the New York School were still begging for public attention. De Staël's success was much resented. It was looked upon as a vestige of the glamour that had remained an untarnished possession of the School of Paris even after the center of aesthetic gravity had shifted to New York.

But there was more to de Staël's legend than art-market politics or his influence on other artists. The man himself had lived a life of tragic dimensions. Born into the St. Petersburg nobility in 1914, just three years before the Bolshevik Revolution, he was the son of a

Russian general and found himself a wanderer and an orphan at the age of eight. He passed his childhood in Brussels and as a young man traveled throughout Europe and North Africa, settling in Paris in 1938 and then serving with the French Foreign Legion in Tunisia in the early stages of the war. All in all, the kind of odyssey of which myths are made.

Physically, too, de Staël seemed cast for a heroic role. His gaunt, handsome features suggested at once a melancholy outlook and an aristocratic detachment. The abstract paintings he first produced in the 1940's—tenebrous structures of earth colors in which all the felicities of Parisian art were invested with the brooding emotions of the Occupation and the difficult period of the Liberation—reflected both the melancholy and the detachment, being at the same time a statement of the artist's dilemmas at that unpromising moment in history and of art's ability to confront them with dignity.

When, early in the 1950's, de Staël abandoned his restricted palette of close-valued earth colors and the tightly wrought pictorial architecture that distantly recalled the Cubist rationale of Braque (his friend and mentor), he turned to vibrant color and highly simplified design. Retaining his preference for the palette knife over the brush, he spread the pigment across the surface of his pictures with increasing extravagance, loading his forms—those lozenge-shaped rectangles that became a de Staël trademark—until they glowed like jewels set in an expensive, oversize brooch.

The spirit of these pictures, with their air of physical luxury and aesthetic opulence, already marked a break with the austere vision of de Staël's earlier work. The fact that they also incorporated a more explicit and traditional imagery—landscapes, figures, and still life—increased the suspicion that de Staël was merely trading on the tastes of an affluent public no longer susceptible to the tragic emotions of earlier days.

The campaign against de Staël, reaching at times some vicious extremes, obscured, I think, the genuine problems he was attempting to explore, for de Staël had been, from the beginning, an artist of conservative temperament and was only pursuing in these late works the same goal that had occupied him in the 1940's: the revivification of the traditional values of French painting in forms that a new generation could still respect and find appropriate to its experience.

He did not, to be sure, escape the traps of facility, of mere elegance and practiced rhetoric, that the adversaries of the French school—now moving in for the kill—especially despised. But at their best, it seems to me that his later pictures of the 1950's were no less compelling than the earlier works of the immediate postwar years, though it is true that his best efforts finally came to occupy a smaller proportion of his output in the later years.

The exhibition of de Staël's work which opened this week at the Guggenheim Museum makes it peculiarly difficult to evaluate his later pictures with any justice. The exhibition includes 118 works, both paintings and drawings, and represents just about every kind of picture he produced. But the selections of the later years are, in terms of aesthetic quality, very spotty. The choices seem to have been arrived at by committee agreement—always a disadvantage. Museums in Rotterdam and Zurich were undertaking a de Staël retrospective at the very moment that three American institutions— the Museum of Fine Arts in Boston and the Art Institute of Chicago, along with the Guggenheim—were planning a similar survey. In the end, all five museums, aided by the artist's widow and his principal French dealer, joined in the selection—a guarantee that the show could not possibly represent the disinterested judgment of a single critical intelligence.

As it is, there are a few late pictures at the Guggenheim that display de Staël's quality at its best—the finest of these is "The Fort at Antibes" (1955)—but they have only a kind of fugitive status among too many paintings of indifferent accomplishment. To preserve the exalted purity of French painting against the aesthetic dissolution that was threatening on every side was not a task that even an artist of de Staël's powers could consistently sustain. On this showing, the artist does look calmer and more resolute in his earlier work, and in the drawings that are a particular pleasure of the present exhibition. He was one of the last serious painters to uphold the verities of Parisian taste and to attempt to derive from them a major expression. He was more nearly successful than one might suspect from some of the evidence on view at the Guggenheim, but there is no mistaking the fact that he represents the end, rather than the beginning, of a glorious pictorial lineage.

French painting, in the terms de Staël still found viable, has never regained its former glory. The art coming out of Paris that commands our attention today derives from quite different assump-

tions. Thus, de Staël's suicide, if we still feel inclined to regard it as symbolic, is more likely now to be read as closing a chapter of art history than as an episode in the life of a tragic hero.

February 27, 1966

29. Fairfield Porter: Against the Historical Grain

Styles that cast a glance backward in time, drawing their inspiration from settled modes of perception as much as from immediate experience, pose awkward problems for criticism. The *frisson* of confronting what is unfamiliar and unexpected—the startled emotion we have come to rely on as a measure of our involvement with a new work of art—is drastically reduced. In its place is a feeling suspiciously akin to nostalgia—an emotion that modern art has taught us to distrust. The spontaneous pleasure we may take in such work is not always enough to quiet our doubts about its ultimate worth and justification. The lessons usually drawn from the art history of the past hundred years—the history that has formed our sensibilities more than any other—offer us few persuasive arguments for believing that an accommodation of the tastes and practices of the past can yield anything but an obstacle to authentic expression.

Yet, if we search our experience, we know there are works of art that quite transcend—not only in our affections, but in sheer aesthetic quality—the stringencies that modern art history has taught us to live by. The pleasures afforded by, say, a Morandi still life or a modest landscape of Marquet are not really susceptible to explanations on a historical scale. If we really value such works, we must always be a little skeptical about historical categories that seem to exclude them.

But then, our sense of the historical scale changes, too. Only a few years ago it seemed "unhistorical" to regard Bonnard as a

major painter. No one seriously denied his quality; everyone, in fact, seemed to lavish affectionate attention on it. But he was nonetheless put down as a latter-day Impressionist, a painter who had somehow not kept abreast of the most important new developments. This judgment now strikes us as ludicrous, as "historical" in the worst sense—that is, merely dated—for with every new exhibition of his work Bonnard ascends to the heights of our esteem. The painter who never quite fitted the avant-garde mold has triumphed over many of the artists who fitted all too cosily.

Without wanting to suggest that the paintings of Fairfield Porter are of a magnitude equal to Bonnard's—for they surely are not—it nonetheless seems to me that this American painter's work presents us with a similar problem. Where is one to place it in the historical scale? The pictures in Mr. Porter's latest exhibition, which opened this week at the Tibor de Nagy Gallery, include some of the best work the artist has ever produced. They are pictures that could only have been painted by an artist who had remained especially alert to the central artistic issues of his time, yet the pictures themselves exist at a considerable distance from those issues. Inevitably, then, our response to Mr. Porter's work will have much to do with our feelings about that distance.

For here is an artist with an abiding loyalty to certain figures out of the painting of the last century and the early decades of this century, an artist in whose consciousness the felicitous precedents of Manet and Vuillard, of Monet and Sargent and Hopper, still act as a spur and a guide. Mr. Porter is an artist unembarrassed by good painterly manners; yet he is very far from being merely genteel. The visual world one encounters in his work—those commodious interiors in which lovely young girls (the artist's daughters) sit comfortably reading, the landscapes of Maine and Long Island, the affectionate portraits of family and friends, the flower paintings in which each stroke is set down with unabashed delight—all seems at first glance so familiar, so given, so easy. One is immediately on guard against the graciousness and attractiveness, the sheer comfort of this world. Yet nothing is really taken for granted here.

For underlying the correctness of Mr. Porter's style, with its well-bred synthesis of French elegance and American dryness, one discerns a pictorial mind of unusual intelligence. This quality of intelligence is abetted by a fine sensitivity to the nuances of direct observation, and both the intelligence and the sensitivity act as a

brake against the painter's extraordinary facility. The existence of this facility allows Mr. Porter—and his public—some old-fashioned painterly pleasures: passages of bravura brushwork, exquisite glimpses of the effects of light, and so on. But these are only means—and very beautiful means—to an end; they are never the main issue.

What this issue is may best be appreciated, perhaps, if one compares Mr. Porter's approach to that of his counterparts on the West Coast. I refer to the Bay Area figure painters whose doyen is Richard Diebenkorn. For them, too, the examples of Vuillard and Hopper seem to exercise a certain authority, and Mr. Diebenkorn has produced some small still lifes that are even closer to Manet than Mr. Porter's flower paintings in the current show. But where in Mr. Diebenkorn and his California confreres these influences are all subjected to the transfiguring effects of the Abstract Expressionist manner, so that we are given in the end a painting that is essentially abstract in realization and only superficially concerned with actual observation and representation, Mr. Porter preserves the integrity of his observed world. All his intelligence and sensitivity are made to serve that world, and there is thus a more affecting equilibrium struck between the dictates of style and the experience that style serves.

It is precisely this equilibrium that painters in Mr. Porter's position, knowledgeable about every innovation in modern pictorial syntax—Mr. Porter himself was for years a critic of some note—and yet reluctant to overwhelm their response to the world around them with that critical knowledge, find difficult to sustain with any aesthetic poise. The tendency is to come down too hard on one or the other side of a subtle equation.

Two pictures in the current show bring us Mr. Porter at his best—pictures in which this carefully deliberated equation of ends and means are given the most complete realization. The first is "Interior in Sunlight," one of those domestic scenes that may seem all gracious atmosphere and lovely effects but that is actually constructed with the probity of a Cubist still life. The other is "Flowers by the Sea," a still-life composition that mingles the disparate disciplines of a Manet and a Mondrian with an authority few other living painters could equal.

Indeed, in pictures like these two, we can see Mr. Porter turning the formal pressures of twentieth-century painting on the mate-

rials of the nineteenth century and producing something very personal in the process. They are accomplishments of mind and craft that only a very independent, very confident, and very capable artist could envision, and then bring to realization in the face of all the countervailing movements of the current scene. If they seem for the moment to exist outside the boundaries of contemporary art history, they are not diminished by the fact. They merely await the revision of history that the future is bound to bring us. In this sense, as in others, the example of Bonnard cautions us against the hard and fast certainties of current dogma.

February 20, 1966

30. Expressionism plus Objects: The Art of Jim Dine

There are artists whose work seems permanently "frozen" in a particular moment of art history—a particular moment of taste, style, and aspiration. No matter what their subsequent development may be, their work remains anchored in that moment, especially for anyone who saw the work on its initial appearance when the issues were still raw and the implications of it unclear. The passage of time seems only to entrench the work more deeply in its original moment of conception. The modifications of history serve only to reflect back on the starting point.

For myself, Jim Dine is an artist in this position. The large retrospective exhibition of his work, currently installed at the Whitney Museum of American Art, covers a ten-year period, 1959–69. There are 127 items listed in the catalogue, some of them very large and some multiple-work series. In addition, the Sonnabend Gallery is showing a selection of the artist's latest works. Certainly there have been some changes in the work over the years, and Mr. Dine himself, at thirty-five, has now removed himself from the hurly-burly

of the New York scene. He has expatriated himself to London. But his art remains, for this observer at least, firmly anchored in the moment of its beginnings in New York a decade ago.

For certain young artists at that moment (1959–60), two considerations were uppermost in all their thinking about their own work. The first was the immense and accelerating success of the Abstract Expressionist movement. The second was a desire to go "beyond" abstract art—a desire for a looser, less restrictive style that would allow the admission of certain symbols of "reality," either in the form of representational images, found objects, or actual space, yet not entail any wholesale repudiation of the Abstract Expressionist manner.

It was a desire for Expressionism plus objects, or—to put the matter another way—de Kooning plus Duchamp. Two influential artists—Robert Rauschenberg and Jasper Johns—were already demonstrating that, far from representing an incompatible alliance of attitudes, the de Kooning–Duchamp synthesis was a winning combination. Its large debt to Abstract Expressionism offered just the right obeisance to established taste, and its debt to Dada—a Dada now cleansed of any political overtones—just the right degree of innovation and surprise. At the same time, this stylish synthesis of the pure and the impure opened up a large new territory for colonization and exploitation. The freedom to eschew the strict pictorial purities of abstraction released an extraordinary energy and optimism, and once the impure was established as an agreeable and permissible artistic component, every artist was free to interpret it in his own way. Thus, there followed not only new styles in painting, sculpture, and construction but the first happenings and the new styles in dance, theater, and poetry that were directly influenced by the visual arts.

Mr. Dine staked his claim in this territory very early on. If he was not one of the original pathfinders, he was certainly one of the first settlers. His "Green Suit," the first of the large collage-paintings that incorporates an actual object as part of its design, is dated 1959—the year Mr. Dine came to New York from Ohio (but four years after Mr. Rauschenberg's "Bed"). The terms of this art were all established at the outset—the painting sensibility totally circumscribed by Abstract Expressionist taste (more specifically, the "tough guy," version of this taste that prevailed on Tenth Street at the end of the fifties), combined with the found-object iconography

sanctioned by the spread of Neo-Dadaism. Thereafter, the objects (and therefore the iconography) might change because of heavier objects purchased at the hardware store. The scale might be enlarged to the dimensions of an environmental tableau. But the conception remained fixed in its original mold. The new series of large paintings-with-objects that Mr. Dine is now showing at Sonnabend's are, perhaps, a little handsomer than his earlier work—for he has now effectively dropped all the old "tough guy" affectations—but they do not modify this conception in the least.

There is, however, another side to Mr. Dine's talent which is equally apparent in the early work and which not only persists but now seems freer and more productive than ever—the side given over to "straight" expression. Mr. Dine has a sweet gift for the engaging graphic image. His drawings are often wonderful in a rather old-fashioned way. Despite the Pop imagery, the style is often academician *manqué*—and very nice, too. Even nicer are the recent watercolors—the so-called "Heart Drawings." There are sixteen of these at the Whitney, collectively titled "March without You" (1969), and many more at Sonnabend's. They are all very fresh, inventive, and delightful—and surprising, too. Who, ten years ago, would have expected the "tough guy" stance to be buried so quickly under this avalanche of valentines to marital bliss? (How odd it is, too, that the most conventional symbol of sentimental passion—the image of the heart—should yield the artist so much in the way of visual high spirits, while his watercolor renderings of male and female sexual organs reduce him to a kind of tongue-tied silence.)

All of Mr. Dine's most ambitious work eschews the "straight" side of his talent in favor of the object gimmickry, which, unfortunately, has become his international trademark. It thus remains frozen in an attitude that is not only out-of-date but that seems, on the evidence, to constitute a real obstacle to his future development as an artist. But Mr. Dine is still young. Who knows? In the more benign atmosphere of the London art world, perhaps even this obstacle will be overcome. It would certainly be interesting to see what might happen if he turned his back on all that hardware and settled down to the problems of serious painting.

March 8, 1970

31. Lindner's Dream

The character of an artist's fantasy cannot, in itself, guarantee the quality of his art, yet there are cases where the power of a highly personal fantasy so completely asserts itself as the dominant element in an artist's work that all other considerations are relegated to second place. In the context of the current art scene, where many young and aggressive talents scorn personal fantasy as a vestigial obstruction barring the way to a cherished impersonal perfection, an artist heavily indebted to the fantastic element enjoys, at best, an ambiguous eminence. The tendency is to savor the revelations of his private dreamworld while withholding aesthetic assent.

Still, in a cool climate, the brilliant display of a heated imagination is not something that can be ignored. This is especially so when the nature of the display is as assured, as manifestly professional and knowing, as it is in the work of Richard Lindner, who is showing a new group of his pictures at the Cordier & Ekstrom Gallery. For Mr. Lindner does not stand entirely apart from this cool climate. In at least one respect—its sheer glassy surface, amounting at times to an outright slickness—his work partakes of the climate in large measure. As a designer, too, he helps himself to a good deal of its basic invention, and his "handwriting" as a painter applying pigments to a canvas is no more "personal" than Albers's. Yet none of this matters much, or matters only to the extent of reminding us that Mr. Lindner is a very detached and sure-handed pictorial craftsman who knows what is going on and who insists all the same on placing his considerable abilities completely at the disposal of his own obsessions.

These obsessions are mainly in the realm of erotic fantasy, and it is as a pictorial fantasist that Mr. Lindner makes his claim on our attention. The imagery of his art is dominated by female figures of an icy voluptuousness—figures whose exaggerated physical endowments answer to the needs of the most commonplace sexual wish fulfillment at the same time that the peculiarities of their various costumes hint at more specialized appetites. The various helmets, masks, goggles, belts, gloves, stockings, and other weird items of attire that adorn these robust dream figures make ample reference to a vein of fetishist satisfaction that any amateur of deviant psychology will recognize as an abiding feature of the artist's imagery. And over

the whole of Mr. Lindner's work there hovers an atmosphere of sado-masochist pleasure that re-enforces one's sense of a particular and compulsive fantasy being given every priority in the realization of the artist's aims.

It would be a mistake, however, to attribute this fantasy—and the place it occupies in his art—solely to the artist's personal psychology. For what we have in Mr. Lindner's art is another extremely vivid version of a more general phenomenon, namely, the odd poetic fantasy that America itself came to represent for an entire generation of German-speaking Central European artists and writers. In its various manifestations, one finds this fantasy playing an important role in certain works of Brecht and in Kafka's *Amerika*. From all that one knows of George Grosz's early life in Berlin, this same vein of compulsive illusion seems to have taken a firm hold on his sensibilities and contributed substantially to his subsequent disillusion when he actually came to live in America. What it amounts to is a dream of decadent vitality, of an impossible liberation and release accompanied by salutary punishments and exquisite denials—the oxymoronic ideal fashioned by European intellectuals to cope with the crises in their own midst and as a more sophisticated and equivocal counterpart to the traditional immigrants' hopes for American freedom.

As a European, Mr. Lindner is still very much under the spell of this curious dream, and it is this which gives his art even now a distinct European accent and sets it apart from similar work by native sensibilities. At the same time, his long residence in America has made him witness to the transformation of certain aspects of American life into the very terms of the dream itself. It is not a case of art becoming more realistic but of life becoming more fantastic, conforming in so many of its quotidian details to the specifications of a fantasy once harbored by a tiny minority of gifted and agitated spirits.

Out of this fantasy, now given the added authority of the palpable living reality, Mr. Lindner has created a very powerful art. But it is an art that speaks to our fantasies more than to our sense of aesthetic delectation. Mr. Lindner is a very expert handler of pictorial form and a draftsman of distinction, yet he holds our interest principally as an image-maker, and his images are not the sort that invite one to linger over whatever formal strategies have been

invested in their realization. Even his use of color, which is dazzling, seems only instrumental to his larger purposes.

From early Léger and the *Neue Sachlichkeit* to the latest developments in Pop art, not to mention even earlier German folk sources, Mr. Lindner has drawn whatever he needs. Nor have the lessons of recent abstract painting been lost on him. But there is no suggestion of pastiche in this work. Quite the contrary. One feels the electric charge of a totally contained sensibility that knows what its interests are. It takes an artist of a certain experience, as well as a certain talent, to arrive at such a point of complete conviction, and it requires, too, an absolute determination to remain faithful to that experience in the face of other temptations. There was a time not so long ago when Mr. Lindner's art seemed merely eccentric and willful, but the vicissitudes of life as well as his own growth as an artist have changed all that.

January 22, 1967

32. The Futurism of Ernest Trova

Ernest Trova is exhibiting his new sculpture at the Pace Gallery. As befits an artist currently enjoying a huge success, the exhibition is a large one. It is, moreover, the kind of exhibition that offers the eye a great deal to look at. Most of the individual works are intricate in image, complex in design, and flawlessly produced. There is—as always with Mr. Trova—a consistent theme: the figure of the "Falling Man," which recurs in all the artist's work as his special symbol.

All artists have a tendency to fall in love with their own symbols, and this is certainly the case with Mr. Trova. He submits his symbolic figure—faceless, armless, polished, unsexed, and apothesized into an inhuman mechanical purity—to almost as many varia-

tions as the *Kama-sutra* describes for the act of love. The materials he employs also vary: nickel and chrome-plated bronze, enamel on aluminum, with some works encased in Plexiglas, and now—in this new exhibition—marble carved with virtuoso finesse and polish. All of these materials are, in fact, extremely and deliberately slick, with an industrial finish that effectively removes the art object from any association with the artist's hand.

The figure that serves as Mr. Trova's all-purpose symbol is generally observed in some relation to machinery. The relation is ambiguous, however; perhaps deliberately so. Are these figures victims of the machines into which they have been absorbed and in relation to which they often seem little more than minor appendages? Or are they exalted by the superior power and energy—the transcendent dynamism—to which the machines give unique access? The titles, if we take "Falling Man" to be a reference to the Fall of Man, suggest some radical victimization, and this interpretation is borne out by the iconography of the figures—reductions of the human form to robotlike mannequins. Yet the feeling of the work, far from supporting this interpretation, runs distinctly counter to it. There is a very evident note of exaltation in Mr. Trova's designs—an air of celebration rather than of lament. In the contest between man and the machine, Mr. Trova's sympathies—the overwhelming commitment of his emotions—are with the machine.

There is, then, a large element of the Futurist in Mr. Trova's sensibility. Indeed, his work stands in relation to de Kooning, Dubuffet, and Bacon very much as Futurism stands in relation to German Expressionism. The whole realm of interior emotion, anguish, and critical self-doubt is banished; all resistance to the mechanization of life is abandoned. Mechanization is now raised to a mode of salvation, and the human agent becomes merely a coefficient of a technological destiny.

The visual arts have come a long way since the Futurists declared their allegiance to the machine as both a style and a destiny more than half a century ago. The Futurists could only dream of an alliance between art and the machine. They remained, however reluctantly, artists of the studio, easel painters, and sculptors who followed the venerable methods of the classical tradition. Their iconography aspired to a vision which, in varying degrees, could only be subverted by the traditions and techniques to which their own training and talents condemned them.

Artists like Mr. Trova no longer suffer such handicaps. Though he began, in the fifties, as an Expressionist painter, there is no longer any trace of the atelier tradition in his art. (Or, to be precise, there wasn't until he produced the two marble figures that dominate the current exhibition.) The methods and materials of industry, which the Futurists could only dream about, are now a commonplace in the production of works of art. Mr. Trova places his art almost wholly within the boundaries of this industrial ambience and does so with a dazzling authority and assurance. One can imagine how Boccioni would have envied his access to the methods of industry! All those polished chrome surfaces! All those machinelike figures and figurelike machines! All that paraphernalia of technological power and menace! One sometimes feels that in Mr. Trova's *oeuvre* all of the Futurists' most extreme fantasies have come to fruition.

Yet it is odd to see how, in turning now to stone-carving, Mr. Trova recapitulates the paradox of Boccioni's career. Here are two marble figures of heroic stance, even if antiheroic in spiritual substance—sexless, mummylike automatons, carved in stone like the gods of the ancients. The votary of the machine betrays an unmistakable nostalgia for the lineaments of the old heroism. The ambiguous symbol of the dynamism that is stripped of nearly all human attributes—a dynamism in which the machine has displaced the human heart—is elevated to the status of a monument. If Mr. Trova were the kind of artist who showed himself capable of perpetrating an irony, one could indeed take these marble "Manscape" figures, as they are called, as his most ironic utterance. But Mr. Trova is not an ironist. His art is entirely "straight," solemn, even pontifical. He has only succeeded in monumentalizing his own fantasy, and in so doing, the confident visionary of the machine has revealed a remarkable resemblance to a macabre sentimentalist like Leonard Baskin. The Futurist, abandoning for the moment his chrome surfaces and horrific weaponry, shows himself to have a sneaking envy of the old glories.

When Boccioni traced a similar course in creating his great sculpture, "Forms of Continuity in Space"—a work that assimilated the Futurist imagery and ideology into a conception of the purest classicism—the paradox had a certain tragic grandeur. The sculptural leader of Italian Futurism—a movement predicated on the destruction of the great Italian traditions in art and dedicated to

their final overthrow—turned out to have a deeper affinity with those traditions than he knew. Mr. Trova's affinities are, alas, with sentiments of a more meretricious order. Whereas Boccioni's dilemma was tragic, edifying, and somehow heroic, Mr. Trova's is only pathetic. It betrays a woeful lack not only of self-knowledge but of knowledge of the world in which he functions.

For it is too late to be a Futurist. The "future" has arrived, with all its horror, complexity, and debilitations. Mr. Trova creates icons to an imaginary future that exists only as a sentiment—a curiously comfortable sentiment. Is this perhaps why his large adoring public finds his art so easy to take?

January 19, 1969

33. Plebeian Figures, Banal Anecdotes: The Tableaux of George Segal

The exhibition of new sculpture by George Segal, at the Sidney Janis Gallery, is, like so many exhibitions of new art these days, almost as much a sociological as an artistic occasion. Mr. Segal is, to be sure, an artist. The creations he exhibits for our edification—and possibly even our delight—are, certainly, works of art. Moreover, they address themselves to the kind of artistic problems—problems of illusion and reality, of the relation of "meaning" to the materials out of which art is constructed—which are very much in the foreground of the current scene, not only in the visual arts but in films, the theater, and the novel. In short, Mr. Segal's work embodies a taste that is instantly recognizable as up-to-date.

Yet there is something about these works that is old-fashioned, familiar, even cosy. They bring us an echo of other times and other styles. Once we catch that echo and connect it with the appeal that Mr. Segal's art enjoys at the present moment, our interest tends to shift. We are no longer in the realm of pure artistic expression but

at a crossroads where public taste illuminates its own follies and deceptions.

Mr. Segal works in a medium that might best be described as three-dimensional tableau. His white plaster figures are, I believe, cast from life, but they are scarcely portraits in any meaningful sense. They are types. These figures are placed in a "real" setting. Which is to say, the setting is reconstructed out of actual materials—the interior components of a subway car, an old double bed, a metal shower stall, etc.—to approximate the look of an actual locale. We are thus invited to contemplate a contrast of divergent realities—the fabricated plaster figures set in an environment of commonplace objects.

As a visual metaphor, this conjunction of the "real" and the "unreal" is, of course, in a venerable modern tradition. Mr. Segal takes hold of this tradition with a certain rude force, removing whatever traces of subtlety may have accrued to it and placing it firmly in the arena of Pop sensibility. He reduces the metaphor to an anecdote.

The subjects, if not entirely drawn from low life, are generally limited to the most workaday environments of modern life: "The Parking Garage," "The Subway," "Motel Room," "The Laundromat," and so on. There is, in Mr. Segal's work, an unremitting insistence on this sort of banality. The assumption is, I suppose, that Mr. Segal redeems the banality of his subjects through the eloquence of his style. But the style itself is anti-eloquent. It is, in a quite deliberate way, extremely dumb. We are meant to find it abrasive, perhaps even a little shocking, and then perhaps to experience another kind of shock—the shock of recognition that reminds us of the eloquence inherent in these commonplace materials.

All of this is part of the standard—and rather crude—psychology of response that has been an essential ingredient of Pop art from its inception. Mr. Segal has quite mastered the stylistic formula—the reduction of style *to* a formula—which the Pop aesthetic entails. Indeed, his own version of the formula is now sufficiently established—and his own position as an artist sufficiently historical—for him to come forward with a kind of monument to himself. "The Artist in His Studio" is the most ambitious work in the current exhibition—a work of autobiography that employs among its props not only a plaster cast of Mr. Segal himself ("the artist") but a selection of his drawings from the model. Thus, we are

given "real" drawings from the model, but plaster models and a plaster artist frozen in the gesture of drawing his models.

One could, I suppose, make much of this apotheosis of the artist at work. All the materials for a grandiloquent Pirandelloesque analysis are here: the references to Mr. Segal's earlier Expressionist style in the drawings, the contrast of the plaster models and the drawn models, the plaster artist at work on a "real" drawing board, and so on. Mr. Segal may seem, at forty-four, a bit young to be indulging in this sort of retrospective charade, but fame is a great inducement to the practice of autobiography and he is certainly not the first of his generation to succumb to the temptation. No doubt some eager museum director will take the hint and be anxious to acquire such a "historic" statement.

For myself, I find it impossible to take Mr. Segal's rather innocuous tableaux completely seriously in these terms. As statements about the workings of the artistic imagination, about the relation of art to reality, about the role of mundane objects in the rhetoric of feeling—about all such matters, I find Mr. Segal's work simply inadequate. In this particular universe of discourse, he is beyond his depth. He reiterates a commonplace and mistakes it for a profundity.

What interests me in Mr. Segal's tableaux, with their plebeian figures and banal anecdotes, with their glorification of vulgar details and fidelity to low-life atmosphere, is that echo of other times and other styles. For the conception of his anecdotal material, the particular muteness that characterizes the actors in this silent drama, the source is undoubtedly Edward Hopper. But Mr. Segal lacks Hopper's poetry, his modesty, and the puritan rigor of his dry, understated tension. This is the world of Hopper's imagination vulgarized for a public unequipped to appreciate Hopper's silences and unable to feel anything but an amused condescension toward the contemporary equivalent of his subject matter.

Still, it is this world of the old American realists that Mr. Segal's tableaux evoke—the world not only of Hopper but, to name a figure who more nearly approximates the level of Mr. Segal's own accomplishment, of someone like Kenneth Hayes Miller. But what is most interesting about this resurgence of realist devices—realism with a Pop discount—is not so much what Mr. Segal does with them as what his audience makes of them, and specifically, the way they have become the expensive toys of an affluent and rather jaded

public. To place a laundromat in a gallery, a seedy motel room in a museum, a parking garage in a smart Park Avenue apartment—such a strategy, for all its pretensions to high artistic meanings, only reduces the materials of realism to the level of frivolity. This has been the special business of Pop as a style, and it is Mr. Segal's distinction—precisely because he burdens his work with these materials in such an essential way—to carry this business even further than his contemporaries.

Mr. Segal has made no contribution to the art of sculpture. He has done nothing to advance our understanding of the relation of the artistic process to the world of objects we inhabit. But the success of his work, the taste that it flatters, and the influence it wields tell us a great deal about what has happened to our capacity to discriminate an authentic artistic vision from a vulgar counterfeit.

December 15, 1968

34. Philip Pearlstein

The new Philip Pearlstein exhibition, currently on view at the Allan Frumkin Gallery, is a remarkable event. It is remarkable, first of all, for its high quality, but it is remarkable also for the particularities of style on which that quality is based. Against all the odds of fashion, history, and critical prejudice, Mr. Pearlstein has wrested from a very unpromising source—namely, realism, with all its attendant fallacies, pitfalls, and banalities—an art of extraordinary lucidity and power. He has done what most of the "advanced" critical opinion of the last two decades had declared impossible: he has created a major pictorial style based on an accurate and painstaking depiction of the figure.

The two double portraits and eleven paintings of nude models that make up this exhibition offer very little solace, however, to those who have been looking—probably since the advent of Cubism

—for a return to the old verities. Mr. Pearlstein has, to be sure, the kind of technical mastery of his medium that such a "return" would ideally require—if, that is, it existed as a real artistic possibility (which it doesn't) rather than a form of nostalgia for a lost world (which is what it mainly is). But this technical mastery has, in Mr. Pearlstein's case, been firmly placed at the service of a sensibility that is completely up-to-date—a sensibility that is cool and analytical in its emotions, ruthless in its rejection of the old painterly rhetoric, utterly positivist in its attitude toward both the painter's medium and his subject matter. The result is a difficult and tough-minded style that makes no concessions to either a decorative or a sentimental appeal.

Behind the development of this style lies an interesting history. Mr. Pearlstein made his New York debut some fifteen years ago. (The occasion was an exhibition called "Emerging Talent," selected by the critic Clement Greenberg, at the Kootz Gallery.) Like so many other young painters of the period, Mr. Pearlstein was then very much in thrall to the mannerisms of Expressionism. From a kind of Soutinesque abstraction he moved into a style of Soutinesque landscape painting—all rocks, trees, and roots, and rendered with the drips and smudges and viscous occlusions of pigment that constituted the accepted pictorial vernacular of the time.

What was distinctive about Mr. Pearlstein even then, however, was his drawing, which gave promise of what his voluminous performance has since confirmed: that he is one of our finest draftsmen, with few peers among the artists of his own generation. The development of his painting into something equally distinctive was inevitably slower in coming. The task took Mr. Pearlstein into realms that astonished even the small public (mostly other artists) who paid his work any attention. He not only unburdened his painting of its heavy Expressionist rhetoric, but a period of travel in Italy prompted an ambitious and highly romantic series of landscapes devoted to ancient ruins—pictures that were vivid and even garish in color (they harbor, I think, Mr. Pearlstein's only real audacities as a colorist) and yet impeccable in their drawing. These pictures constitute an odd and eloquent achievement and will one day enjoy greater recognition than they have yet received.

By the early sixties, then, Mr. Pearlstein's art was firmly established on a venerable but not very popular principle—the principle

of working directly from nature—but he had not yet found a style. It was when he turned his attention to the nude model that this style, with its strict excisions of all romantic and psychological associations, began to assume its present form. The great strength so evident in his drawings—the authority with which Mr. Pearlstein was able to render the concrete mass of the figure while sacrificing nothing in the observation of detail, gesture, or attitude—began to find its way into the paintings.

There was still, in the early stages of this development a certain disparity between the drawings and the paintings, with the account of the space occupied by the figures in the paintings being too inexpressive to support the virtuosic rendering of the figure itself. But it was clear to those who paid attention that Mr. Pearlstein was working his way toward a powerful realization. And by the mid-sixties, those paying attention included a number of other painters who were, almost surreptitiously, helping themselves to certain elements of his style. (As usual, the big-time collectors and museums had eyes only for the stars.)

The paintings of nude models that Mr. Pearlstein is currently exhibiting are his most successful to date. They are difficult pictures—complex in form, rather icy in their attitude toward the spectator, extremely intellectual in conception, and yet painted with a deliberateness and pressure that gives them an unexpected air of vehemence. They are certainly like nothing else in the painting of our time. One hears a great deal about the independence, the courage, the individuality of artists. Mr. Pearlstein is one of the very few to whom these words actually apply.

Out of his involvement with the figure, he has in recent years turned part of his attention to another "unpromising" genre (unpromising, anyway, so far as current critical theory is concerned): the portrait. And in this realm his accomplishment has been, if anything, even less equivocal than in his paintings of the nude. On the basis of the two double portraits in the current show, I do not hesitate to pronounce Mr. Pearlstein the best painter of portraits in the country—indeed, one of a very small number of artists who has restored portraiture to a level of artistic utterance that needs no apology and brooks no compromise. These pictures are triumphs of style, candor, and technical mastery. If they are not (shall we say?) exactly lovable, they are nonetheless extremely powerful. They

achieve what the portrait at its best must always achieve: they give individual character a highly individual form. In this genre, Mr. Pearlstein is in a (lonely) class of his own. But this entire exhibition establishes Mr. Pearlstein as an artist who has ceased to be a follower of history and has become instead an artist who is making history.

April 13, 1969

35. Ellsworth Kelly

Ellsworth Kelly, who will be fifty next year, is one of the most accomplished, and at times one of the most baffling, abstract painters of his generation. He is also one of the most audacious.

His work brings together two of the central concerns of modernist painting—an interest in pure color and an interest in geometrical, or Constructivist, form—and it carries their synthesis to a point of extreme economy and compression. It thus subsumes an established pictorial tradition and takes it a significant step further in its headlong course toward a radical simplification.

His latest pictures, now on exhibition at the Albright-Knox Art Gallery, are called "The Chatham Series," after the area of New York State where the artist has lately gone to live. They are, I think, among the very best pictures Mr. Kelly has produced.

They do, indeed, constitute a coherent series, with the serial theme deriving from the repetition of a single formal idea—the placing of two rectangles, each painted a single color, at right angles to form a straight left-hand edge. The fourteen variations Mr. Kelly manages to obtain from this basic theme of an inverted L-shaped form owe their interest as much to subtle differences in the size and scale of the separate rectangles as they do to more obvious differences in color.

It is color, of course, that at first fills the eye in this exhibition—vivid blocks of red, yellow, blue, and green and, what is more surprising, equally vivid blocks of black and white. This is color without inflection or "personality," color laid on without the least trace of the artist's "handwriting." It is color designed to effect the shortest possible course to the eye of the observer, which it dazzles and bemuses with an extraordinary immediacy.

Yet once the shock of this vividness has been encompassed, it is the subtle variations in pictorial construction—the variations in visual weight and density—that become the principal focus of interest. There is a strong architectural element at work in this pictorial style—an impulse to modify and transform, if only in the eye of the beholder, the actual space the spectator traverses in the presence of these pictures.

Thus, the variations in the size of the rectangles that compose the "Chatham" paintings, as well as the differences in the colors they contain, are not designed simply to please the eye—though please the eye they certainly do—but to induce a certain kind of consciousness about enclosed space and its inherent poetic properties.

It is this larger architectural ambition that joins Mr. Kelly's work to the Constructivist tradition, which has always conceived of the art of painting not as the means of conveying a private emotion but as an instrument for revising and exalting our sense of the environment we inhabit.

Still, it is painting that Mr. Kelly produces, not architecture, and even within the radically reduced means he has chosen to employ in the "Chatham" paintings, certain traditional pictorial elements persist. Sooner or later one cannot help noting that the division of rectangles in these paintings is, essentially, a division of light and shadow. This is most evident in the black and white paintings, of course, but even where the colors are hottest, in the red and yellow pictures, the basic division of light and shadow makes itself felt.

What we have in "The Chatham Series," then, is a pictorial environment constructed of blocks of light and shadow. Oddly enough, a style that at first glance looks totally removed from any attachment to nature is nonetheless deeply evocative of a certain naturalistic poetry.

In the recent past Mr. Kelly has sometimes carried his work

into a realm so hermetic, so resistant to the normal course of aesthetic response, that some of us simply could not follow it. But in the new "Chatham" paintings he has produced a series that is not only accessible and engaging to the eye but very eloquent in its purity of feeling.

July 26, 1972

36. Mary Frank

In the current climate of art, aesthetics, and critical opinion, the sculpture of Mary Frank is difficult to place. It seems, by most of the prevailing standards, to exist outside of contemporary art history altogether. It derives from no clearly defined intellectual position. It invokes no sweeping historical imperatives. Theories of any sort seem alien to its purposes. Kant, Wittgenstein, Merleau-Ponty— none of the glittering names can usefully be quoted on its behalf. Historically and intellectually, it is utterly defenseless—an orphan in the storm of theory and countertheory that now consumes so vast a proportion of the attention, energy, and talent of the art world. It is a throwback to other times—even its technique is ancient.

This sculpture is shamelessly small in scale. It is openly searching for a realization that is, by its very nature, uncertain and elusive. It is stubbornly poetical, metaphorical, interior. It is an art outrageously in love with images—with metamorphoses of perception, and the interplay of perception, materials, and imagination. Modest it is, yet it offers us—on however small a scale—some of the satisfactions we derive from the art of early civilizations and from certain aspects of Picasso. The hand of the artist is everywhere evident, emotions are undisguised, the sheer pleasure of the artistic process is communicated with the directness of a song.

A new exhibition of Mrs. Frank's sculpture is on view at the

Zabriskie Gallery. In the past, she has worked in wood, plaster, and bronze. The plasters were the most successful, I think. Something got lost—some personal nuance, something having to do with the play of light and shadow on the white plaster forms—in the transfer to bronze. To go from the plasters to the bronzes was a little like going from a poem in its original language to an accomplished, correct translation. It wasn't quite the same experience.

Now Mrs. Frank is showing ceramic sculptures for the first time—eighteen tabletop pieces and seventeen small wall reliefs. This medium—as direct as plaster but far less fragile—is perfect for her particular purposes, and the wonder is that she had not got around to using it until now. These ceramic sculptures are, in any event, her best work to date. They are marvels of poetic invention.

Mrs. Frank has long been known for the quality of her drafts-manship. Indeed, her drawings, with their wonderful delicacy of observation, have in the past tended to overshadow her sculpture. She has been extremely copious in producing these drawings, and they already constitute a significant *oeuvre* in themselves.

In the past, one sometimes felt a certain discrepancy between the richness of these drawings—so remarkable for their complete-ness of statement—and the tentative quality of the sculpture. This was especially the case with Mrs. Frank's early wood carvings. But over the years she has narrowed this difference between her draw-ings and her sculpture, and in the new ceramic sculptures she has virtually eliminated it. These sculptures have the directness of a drawing and, if anything, have more the character of "sketches" than many of Mrs. Frank's large formal drawings. In the reliefs, of course, there is a good deal of actual drawing to be seen on the ceramic surface—figures, faces, the usual iconography of the lyric imagination. But in all these sculptures there is the sense of improvi-sation, response, quickness of observation, and sureness of execution that one had always admired in her best drawings. The very process of the ceramic medium seems to have released the requisite spon-taneity.

It is, of course, all utterly removed from what "advanced" critical thought now defines as the sculptural frontier. An art like Mrs. Frank's takes us back to the realm of an artist's personal fantasy and allows us to follow its course in an actual physical medium. Nor is the nature of this fantasy exactly up-to-date—it is

completely lacking in violence, aggression, or perversity. It is, alas, extremely gentle, delicate, and—dare one say it?—beautiful in a rather traditional way.

February 22, 1970

37. Richard Hunt

Richard Hunt, the young Chicago sculptor, is something of a phenomenon on the current art scene. His latest exhibition at the Alan Gallery—his third in New York—consists of twenty-one works in steel and copper, half a dozen of them six feet tall. Anyone seeing this very rich and crowded exhibition will recognize, I think, that Hunt is one of the most gifted and assured artists working in the direct-metal, open-form medium—and I mean not only in his own country and generation but anywhere in the world. What may not be so immediately apparent is the speed and the aesthetic ease with which he has achieved so remarkable a position.

Born in 1935, Hunt has been exhibiting his work for the better part of a decade. From the start, there was nothing of the student or the arrivist in his work. Hunt took to welded-metal sculpture as if born to the medium, mastering its difficult technology with amazing swiftness and proliferating an imagery entirely his own; and he achieved this without recourse to the gimmickry and extrasculptural high jinks that in recent years have so often degraded the work of young artists in this sphere. At its best, it is an imagery of sustained linear power, deploying slender masses of steel tubing in very precise and elegant traceries that are none the less very strong and forthright in their sculptural stance.

Sculpture of this genre is often described as drawing-in-space. The sculptor-constructor undertakes to build his three-dimensional image in a way that will render its overall unity and intricacy to the eye with a conviction and economy akin to what one feels in the

calligraphy of an accomplished draftsman. There are works by Gonzalez and David Smith, the two principal masters of this genre, that are indeed "drawings" of a very high order—but drawings which utilize and inflect the three-dimensional space they occupy as effectively as a draftsman uses a flat sheet of paper. The technical feat by which such drawing-in-space is accomplished—construction by means of welding together discrete metal forms—introduces, of course, a whole range of expressive possibilities new to both sculpture and calligraphy, and some of the most impressive works in the direct-metal canon derive from the audacity with which these possibilities have been perceived and exploited. Smith, for example, has created a new and widely influential style—a sculptural dialectic, as it were—out of his habit of seizing upon the technical and material procedures by which a piece is put together, the ways in which forms are cut and joined and related to one another, and making of *them* an additional resource for realizing the overall calligraphic gesture of the work as a whole. Every work becomes, at least in part, a clear exposition of the way it has been made. Structure and image are reciprocal and indissoluble, the sculptor's fantasy being completely assimilated to the technology of his method.

Work of this genre is a sculptural counterpart to the kind of modern architecture in which, as Reyner Banham recently put it, "structure must not only be done, it must manifestly be seen to be done." Hunt's sculpture derives directly from the precedents of this genre, which by now form a varied and robust tradition, and subjects them to the pressure of a different imaginative ambience. Whereas in Smith's work one feels the force of a sensibility that has transmuted a voracious appetite for all the conflicting schools of modern painting—and especially the countervailing claims of Cubism and Surrealism—into a sculptural style ample enough to satisfy so wide-ranging a synthesis, Hunt takes off from the very ground Smith has won. If the latter's style became a kind of funnel through which the most radical innovations of modern European painting were made available to direct-metal sculpture, to Hunt (who is Smith's junior by three decades) this feat of imaginative synthesis is as historical as Cubism itself. It forms the point of departure for his own imaginative universe, but contributes remarkably little to the basic contours of that universe.

For Hunt, unlike the majority of sculptors who work in this medium, has liberated his imagery entirely from the atmosphere of

Cubism. He has moved his sculpture entirely beyond the reach of those fixed structures of pictorial planes, either real or imagined, by which the Cubist idea has continued to hold abstract sculpture in thrall and make of it a satellite of painting. The result is a sculptural style whose calligraphic traceries are free of pictorial illusionism, free of painterly precedents in structure as well as technique, and thus all the more forthright in its particular combination of linear invention and lyric finesse.

Hunt's use of "line" in sculpture—and by "line," of course, one means those slender masses of steel rod or tubing which are Hunt's customary materials—is probably the subtlest and most elegant in current art. In a huge and ambitious work like the "Linear Spatial Form" (1962), 85½ inches high, the control he has been able to exercise not only over the concept of the whole but in the execution of each separate linear element is truly remarkable. The work virtually floats before one's eye, looking as if it had only moments before been quickly and perfectly sketched in light out of the very air. It sustains its curiously weightless buoyancy by means of virtuosic handling of masses which vary from sudden thicknesses that dissolve into light to the thin incisive lines and fat "strokes" that inflect the overall image at all its crucial points of juncture and extension. The exhibition at Alan's abounds in a copious and restless inventiveness of this kind. Hunt can also produce works that are austere and economic, such as the two "Standing Forms," and then with a simple, emphatic elegance create in the "Branching Construction" (1962) one of the most nearly perfect works of its kind I know. He calls some of his recent works "Peregrinations," and one does have the sense throughout this exhibition of the sculptor's fantasy pouring forth in many directions at once, seeking not one but a multitude of destinations for each concept that his fecund imagination poses for itself.

So lyrical and spontaneous a vision places great demands on the welder's craft as well as the sculptor's art, and Hunt shows himself entirely equal to the task. His present achievement would be remarkable for an artist twice his age; as it is, still under thirty, he produces art that is an astonishment and a delight.

March 23, 1963

38. Leland Bell: Painting in the Shadow of the Museum

Certain artists sustain our interest even when their work no longer affords a new revelation. Their seriousness is such that it compels us to regard even their failures as meaningful. The pleasures they offer us may not define new aesthetic terrain—indeed, it may be their explicit intention not to, but, on the contrary, to re-explore old terrain that has fallen into neglect, misuse, or corruption. Artists of this persuasion, even at their best, prompt us to reflect on the past glories of the medium as much as on present accomplishments. They not only run the risk of invoking certain masters—and thus, certain aesthetic standards which their own work is not likely to meet at the same level; they revel in such invocations, and derive the logic of their enterprise from the comparisons that inevitably follow from them.

In the case of Leland Bell, one of the most determined and energetic of these painters, we are in the presence of an artist who has been at some pains to make his allegiances clear. It is from the work of André Derain, above all, that Mr. Bell has drawn sustenance, and not from the easy, widely admired Fauve pictures of Derain but from the later work that is commonly regarded as academic, anemic, and irredeemably decadent. While Mr. Bell may not be entirely right about the later Derain, it seems to me that he is probably closer to being right than the view that dismisses this phase of Derain.

Being right or wrong about Derain is not quite the point, however. The point is, Mr. Bell is the kind of artist who is committed to a concept of painting—one might better call it a culture of painting—that requires for its realization a sense of intimacy with, and emulation of, the great tradition, and this was the tradition Derain was seeking to recover in the last decades of his career, when he recoiled against the whole modernist adventure.

Like Derain, then, Mr. Bell places his painting at a considerable distance from the fashions of the moment—fashions that have no use for easel painting as he understands it. In the new exhibition of Mr. Bell's work at the Schoelkopf Gallery, the pictures are small; their subjects are mainly figures, portraits, and still life; the color is not vivid; the brushwork is at once studied, sketchy, and impulsive,

intent upon depicting certain observed motifs and yet observedly uncertain and anxious in its realization. Several of these paintings—most notably, the self-portraits—are powerful pictorial statements. But it is not, curiously enough, their power that makes them interesting so much as their desperate ambition—ambition that communicates itself as an intense and palpable emotion.

This may only be another way of saying that Mr. Bell paints in the shadow of the museum—a position that seems, to judge from the evidence at hand, to guarantee fragmentary results in the very talents that look to the museum for a sense of wholeness. Almost everything Mr. Bell produces assures the observer that he is a real connoisseur of great painting, for only a sensibility nurtured on a fundamental comprehension of great painting would lay bare so nakedly its own distance from it. An artist less acutely conscious of great pictorial quality would find it easier to be facile and slick; you need only look around at most of the exhibitions currently available.

History has not been kind to painters who work under the burden of such imperatives—Derain has not been the only casualty —and the present moment is particularly unreceptive to their aspirations. Only Balthus perhaps—and Balthus is another of Mr. Bell's enthusiasms—has been able to bring off such a museum-oriented pictorial style and have it accepted as a statement of contemporary feeling. And there is a connection, I think, between Balthus's success and the best of Mr. Bell's pictures at the Schoelkopf Gallery. For just as in Balthus one is made to feel the pressure of a very personal and slightly perverse mode of feeling animating and transforming what would otherwise be merely a very brilliant academic technique, so in Mr. Bell's self-portraits one feels the almost disruptive force of something beyond the painting itself.

What this means, I think, is that the artist who, like Mr. Bell, paints in the shadow of the museum, who carries—as part of the load on his brush, so to speak—the burden of what he most admires in the art of the past, places himself under a peculiar obligation to bring to his art a sense of his own experience equal in intensity to his experience of the museum. The artist who seeks refuge in the museum at the expense of his sense of life condemns his art to academic infertility no matter what the fashions of the moment may be.

Mr. Bell is very far from being academic in this sense; yet in certain of his pictures—particularly in the copious series of family

groups (three figures chasing a butterfly)—one does have the sense of an artist conducting a closed dialogue with the painting of the past rather than a dialogue with life. There are fine passages in many of the pictures in this series. Only a very gifted and very serious painter could have produced them. But they are closed— closed to life—in a way his self-portraits are not. We are reminded that Mr. Bell finds—perhaps despite himself—an impetus in the mirror that he does not always find in the pictures he admires and aspires to emulate. It is no doubt a paradox to suggest that the great tradition of easel painting so much admired by Mr. Bell may be redeemable only through the agency of a certain subjectivism, but— such is our distance from that tradition—this may be the case.

April 28, 1968

39. Dude-Ranch Dada

The art scene in San Francisco (meaning the entire Bay Area) has rarely, if ever, been characterized by a sense of aesthetic abundance. There is certainly no shortage of artists here, and the museums are impressive in their number, if not always in their quality. Indeed, the Bay Area now boasts two new museum structures—at Berkeley and at Oakland—which are among the handsomest and most original anywhere in the world. But the gallery scene is meager, and this, I think, is a reflection of something significant in the art life of the place—not only the absence of a lively market for new art but the absence of a certain energy and curiosity, a certain indispensable complexity and élan, of which the dynamics of the art market are more a symptom than a cause. Such energy and complexity no doubt exist, but they remain isolated and embattled, almost a private moral code suspicious of social connection and thus without the power to effect a vital, ongoing cultural enterprise.

Given this circumstance, any new artistic effort that shows a marked originality, that comes before the art community here with a

robust display of high spirits and audacious ideas is bound to cause some excitement—as well as some envy, suspicion, and resentment. In this respect, the man of the hour is unquestionably William T. Wiley. His current exhibition at the Hansen Fuller Gallery is not significantly different from work he has shown in New York and elsewhere, but one somehow feels the reverberations of it more keenly here. Its sources and motives and general impulse are, at least to this observer, a good deal clearer in the San Francisco context, and its implications are more readily seen in the kind of enthusiasm the work has generated among many of the younger artists here.

Wiley's style might best be described as Dude-Ranch Dada. His work consists of elaborate mixed-media construction combining painting, drawing, writing (lots of writing), objects (both real and depicted), and miscellaneous materials, all incorporated into a kind of tableau that is intended to be "read" as well as looked at the way you would look at a painting or a sculpture. The more ambitious works, such as "How to Chart a Course" and "Random Remarks and Digs," include, in addition to the central tableau, suites of color drawings that are designed to explicate the basic scenario, and "How to Chart a Course" even contains as part of the tableau construction a large hard-cover ledger filled with the artist's writings. It is not uncommon to see some of Wiley's younger admirers sitting on the floor of the gallery reading this ledger (as well as other writing in other works) with rapt attention.

The scenarios that are secreted in Wiley's work interest me, I must confess, a good deal less than its general feeling and ethos, which are those of a mock epic. There is a good deal of punning and joking in this work, and the jokes are all about art in relation to life and culture. In short, there is a good deal of Marcel Duchamp in the work—or, to be more precise, those aspects of Duchamp that have been domesticated and elaborated for us in the work of Jasper Johns. But the Duchamp–Johns component in Wiley's art is joined to an imagery that transforms it, an imagery that is distinctly "Western"—movie Western, the "frontier" imagery of tourist souvenirs and dude-ranch charades. In other words, Pop Western. Much of the appeal and much of the real humor of Wiley's work is to be found in the way he has applied these now so familiar and even overworked Neo-Dada strategies to cultural material that has never been exploited in quite this manner. He has turned the comic

Western, with its parodies of heroism, into a series of aesthetic jokes on the relation of art to life and has done so in a vocabulary that effectively removes the subject from its Eastern "intellectual" associations.

Nothing could be further removed from what used to pass for high artistic seriousness in this area than the comic visions that animate Wiley's new work. And Wiley, who was formerly a painter in the well-known Bay Area figurative style, is in fact a renegade from the more solemn notions of seriousness that used to prevail here and which still command the loyalty of some of the best artists around. Two exhibitions—Alvin Light's at the San Francisco Art Institute and Frank Lobdell's at nearby St. Mary's College—defined the quality and character of that seriousness for us with particular vigor.

Lobdell is one of the senior painters on the Bay Area scene, an influential artist whose sense of vocation—a sense of art conceived primarily as a moral enterprise—still reflects the atmosphere and ambition of the period when Clyfford Still was the reigning deity of the California School. There has always been in Lobdell's work a feeling of struggle against impossible odds—a feeling that the artist was a man who assumed burdens so great that he could not be expected to carry them to any easy success. Indeed, it was the essence of this position that anything easy, flippant, or even spontaneous, was to be regarded with deep suspicion if not outright hostility. Art was—almost by definition—something that had to come hard.

His new paintings, all devoted to a "Dance" motif, are a good deal more lyrical and relaxed than Lobdell's past work. There is a kind of Picassoesque movement in them that looks new to me, and the pressure to achieve the absolute is somewhat diminished. I think they are beautiful paintings, and they appear to have opened a new vein for Lobdell himself. But I can easily see why the kids who look to Wiley for inspiration could not be expected to find in Lobdell's work any easy access to their own emotions. Lobdell's art speaks with a kind of parental certainty, not only about itself but about the nature of art, and the moment is not exactly propitious for parental certainties of any sort, least of all those about art.

Alvin Light's sculpture is closely related to Lobdell's painting, and in fact his carved wood-constructions achieve a kind of massive painterly grandeur. They share something of the moral atmosphere

that Lobdell's work defines for us, but their imagery is quite different from Lobdell's new work. This is a beautifully realized abstract style that nonetheless remains close to the dynamics of nature in its rhythms—a style that, without being in any way realistic, makes its own affinities with the observable world of nature emphatic.

To turn to Wiley's work in this context is to enter a different moral and aesthetic universe, where art has ceased to be a moral problem and has become instead a beguiling game of appearance and reality—a game of culture and anticulture. And to judge by the response that Wiley's show has excited here—the University Museum in Berkeley is already planning a Wiley retrospective for the fall—it looks as if this particular game has touched a nerve.

May 16, 1971

40. Anne Arnold's Peaceable Kingdom

The new exhibition of sculpture by Anne Arnold at the Fischbach Gallery is quite unlike any other exhibition of sculpture you are likely to see at the present time. The visitor who wanders in, fully expecting to experience the latest aesthetic *frisson*—an expectation that the Fischbach Gallery is usually in a position to service—may very well feel a little cheated. For here is an artist whose work is closer in feeling to Beatrix Potter than to L. Wittgenstein. We are suddenly delivered from the storms of history and the seminar room into something that resembles the peaceable kingdom—an odd turn, to say the least, in our experience of contemporary art.

Yet make no mistake about it: Miss Arnold is one of our most original sculptors. She is certainly too original for our museums, who consistently ignore her work when they organize their blockbuster surveys of new sculpture, and criticism—"serious" criticism, as we say—has proved helpless in accounting for her special quality.

Despite this lack of critical and museological attention, however, her work enjoys a devoted following among artists and collectors who are sufficiently free of the pieties of the moment to appreciate what she is up to. And as we all know by now, freedom from the pieties of the moment is the last thing we can expect from the most active and articulate members of the art establishment.

Miss Arnold specializes in the making of animal sculpture, and just now she has this venerable field of creative endeavor—which has occupied some of the most exalted talents in the history of art—pretty much to herself. Contrary to received opinion, which can hardly ever acknowledge what an artist is doing if he is not doing what everyone else is doing, this is an enviable position for an artist who is equal to it—and Miss Arnold has proved more than equal to the task at hand. She has taken up a folk tradition that had been allowed to languish under the pressures of modern sophistication, and she has given it a new aesthetic life by skillfully joining folkish and modernist elements into a sculptural style all her own. Her work miraculously retains what is most appealing to us in the artifacts of certain folk artists—especially the affectionate observation of and empathy with a familiar subject, and the direct expression of this observation and empathy in a medium that preserves their integrity and immediacy.

But this folk element, with its beguiling quotient of "innocent" observation, is only one aspect of the appeal that Miss Arnold's work holds out to the modern eye. The other is precisely its modern, tough-minded attitude toward form. There is a great deal of tender feeling in Miss Arnold's work, but there is nothing sentimental, nothing mawkish, in its conception. As sculptural "ideas," her animals have an authority that owes little or nothing to extra-artistic associations and almost everything to the way they are made. At first glance, they charm and delight us, but the charm is sustained in sculptural terms that are very fresh and very personal.

Much of the work Miss Arnold showed in the sixties consisted of wood carvings that were painted. Sometimes the parts were carved and then joined together. But two years ago, in an exhibition devoted entirely to cats, she turned to a more complicated medium: canvas stretched over a wooden armature to form a "modeled" mass. The surfaces were painted, and the work became, in effect, an amalgam of painting and sculpture. In her new exhibition, she con-

tinues to work in this medium, only now the subjects are rabbits, an elephant head, and a hippopotamus head, the latter with its mouth wide open.

The observation, as always, is highly realistic. But where Miss Arnold's work really triumphs is in the way the gesture—the specific animal tension in her given subject—is translated into sculptural terms. Whether the subject is "cropped" or given complete, she is a master at sustaining this biological gesture—a kind of animal choreography—in a large, decorative sculptural mass. Every detail contributes to sustaining this gesture—the way the eyes are painted no less than the complicated structure of ears or mouth. The hippo's tongue is a masterful detail in itself, as are the elephant's ears and the ears of the wonderful rabbit called "Pee Wee." There is a feeling, not so much of life as of sculpture in touch with life.

A style of this sort, which never traffics in irony as a means of placing the subject at a distance and which never condescends to its subject, does not fit comfortably into the scenario of modern taste. It requires the most complete command of craftsmanship and the kind of aesthetic conviction that only those artists who have worked out their values for themselves are ever able to muster. Miss Arnold has, in other words, performed a miracle of sorts.

April 18, 1971

41. Alex Katz

The Alex Katz retrospective that has now come to the Wadsworth Atheneum in Hartford is a large show. It consists of nearly eighty works representing a period of fifteen years (1956–71). Many are big pictures. The "Self-Portrait with Sunglasses" (1969) measures 8-by-6 feet, and the painting of the Paul Taylor Dance Company, called "Private Domain" (1969), is 19½ feet long. Many of the

pictures are portraits, and a good many of these are multiple portraits. The show abounds in visual incident and good humor.

It also contains a good deal of art-world social history. The portraits of Frank O'Hara, Al Held, Edwin Denby, Red Grooms, Joe Brainard, Elaine de Kooning, Richard Bellamy, Irving Sandler, and all the folks in "One Flight Up" and "Lawn Party" have an interest quite apart from their quality as works of art. They tell us what certain people looked like in the 1960's—already a historical period quickly receding under an accretion of myths and outright distortions. The visitor to the show could, if he wished, occupy himself with nothing but its documentary aspect and he would not leave unrewarded. Indeed, he would be instructed and amused—especially, of course, if he knows something about the subjects and the milieu portrayed.

There is, then, quite a lot to look at. Yet there is something more here than a social comedy of manners. There is a sizable and utterly serious artistic aspiration at work. It is not, however, the kind of aspiration we are used to thinking of as utterly serious. For one thing, it is so unremittingly cheerful. It lives on such easy terms with the taste of its time. It is canny to a fault. The desire to please is so great that it amounts to a principle. There is, too, a studied refusal of anything mysterious, portentous, or profound. This is an art singularly devoid of angst, uncertainty, or inwardness. It is an art in love with surfaces, which the artist deems wholly sufficient for his purposes. Which, of course, is why there is so much to look at. Compared to the surfaces of life, the depths of the spirit—at least as they are nowadays translated into pictorial form—are often monotonous indeed.

With pictures like "Impala" or "Ada with Superb Lily" (both 1968), we are a long way from the fifties, when (in some circles) it was considered indecent to mention de Kooning without invoking the spirit of Melville or Rimbaud. With Alex Katz we are out of the Existentialist woods, basking in the clear, bright light of an easy sociability. Yet Mr. Katz belonged—he still belongs—to the milieu in which de Kooning is venerated. He is, in this respect, a "second-generation" artist, a spiritual denizen of Tenth Street, a true believer in the New York School. Yet he managed, without rocking any boats, to come out untouched by any of the grosser orthodoxies of the Tenth Street milieu. The question is, how did he do it?

First, there was the affinity for Matisse and Milton Avery. (See the still very lovely "Yellow Interior" of 1959.) They were the perfect antidote to the kind of incontinent Expressionism that debauched so many Tenth Street talents. The artist's focus was shifted from the labyrinth of the self to a world that could be observed. Then, too, there were the New York poets, who, though disciples one and all of the Abstract Expressionist painters, were nonetheless busy in their own work, producing something lighter, more conversable, and diaristic—a poetry of anecdote and reminiscence in which parties, movies, love affairs, art shows, weekends in the country, indeed almost anything observable in the street or of interest to the poet's friends became the favored literary materials. In the relaxed, often facetious style of the New York poets, or at least in the attitude which animated that style, Mr. Katz found an impetus and an inspiration. The art historians who are beginning to sniff out the Tenth Street archives should be warned that not everybody took the references to Melville seriously. There were those who preferred Satie.

This, at least, was the situation in the later half of the 1950's. What characterizes the work of the fifties in the Hartford show is an absolute refusal to engage in high-flown rhetoric. The figures are all painted with an air of affectionate innocence. They are highly simplified in their contours, set into flat fields of color, uninvolved in any environment but the painted surface, which is neat and clean and without complication. Even better than the paintings, though, are the small collages of the fifties—landscapes, still lifes, and interiors that are tiny pictorial constructions of flat, pure color. Every one of them is a beauty.

It was in the sixties that Mr. Katz began painting his big pictures of oversized heads. The scale is that of the movie close-up or the commercial billboard. The color is no longer soft or delicate or intimate, but hard, bright, and extrovert. The contours of every shape—even a shadow or an eyebrow—harden, and the modeling is reduced to a minimum number of large, simplified forms that can be easily read at a considerable distance. There is a great deal of audacious cropping. Everything looks somehow quicker and bigger and brighter, and yet more abstract and decorative.

What had happened, of course, was Pop. Mr. Katz moved into the orbit of Pop taste, helping himself to the sense of scale that Pop derived from advertising art, and to the slick color and hard light

and cartoonlike modeling that went with it. When I first saw these pictures, I was frankly appalled by them. I still feel the artist paid a steep price for what he got out of Pop art, but I no longer doubt that he got something useful. Pop gave him the means to develop a "big" style out of personal anecdotage and affectionate portraiture—to make something physically and visually large out of something emotionally small. Pop gave him the means to be monumental while remaining superficial. The physical reach of the painting kept faith with the ambitions of the New York School, while the emotional tenor of its imagery remained faithful to the aesthetics of the New York poets. And the artist came out of it a far better painter than any of the Pop artists themselves. The debacle of the Pop movement has left his work untouched.

Also in the sixties, Mr. Katz developed the "cutout," free-standing flat paintings, usually portraits, painted front and back, often cropped in unexpected ways. They are enormously engaging, very accurate, and quite perfect as far as they go. They contain a good deal of what had to be expunged from the big pictures. They have to be read close up to be appreciated. They amuse, and then they do something more.

All in all, an interesting career, a career conducted with enormous energy, intelligence, and wit. And still, of course, in mid-course. Mr. Katz is forty-four and may be expected to produce bigger and better things in the years to come. But we know now what to expect—not in what turns his work may take (he is too inventive for that), but in the area of discourse where the turns will be made. We know now that he is an artist in love with his life and is therefore unlikely to make his art a spiritual escape from it. This is still a shocking notion—an artist in love with surfaces, in love with what is, and eager to stake his work on his affectionate attachment to the here and now. So little that we value in modern art has prepared us for such inspired insouciance.

November 28, 1971

42. Comedies of Manners:
Cecil Beaton and David Hockney

All forms of art are sociable enterprises, but some forms are more sociable than others. Indeed, some forms of art make of their sociability a distinct element of style—an element as indispensable to their artistic realization as the hermetic metaphors of Mallarmé were to his. Modernist art, having enlisted its energies in the pursuit of the absolute, has tended to denigrate—by implication, if not by direct attack—the sociability quotient in art, and for that reason it is rarely, if ever, discussed at the higher altitudes of modern criticism. This is an understandable—but no longer, I think, a completely defensible—prejudice, for a good deal of current abstract painting tends to turn the absolute itself into a highly sociable form of discourse. But it requires a certain sense of irony to perceive this, and a sense of irony is the last thing one expects nowadays from the higher criticism.

Still, it must be admitted that the kind of art I have in mind here—art that is eminently conversable and evidently addicted to the things of this world, even if mildly scornful of the shape they sometimes assume—has traditionally existed on the margins of modern art rather than at its center. As a result of this marginal status in the world of painting, art of this persuasion has usually taken refuge in the less stringent purlieus of photography, where it is free to exercise its right to be superficial without a qualm of aesthetic conscience. This is not to say that superficiality is the *sine qua non* of this art but that the nature of truly sociable art requires that it carry on a cheerful commerce with the superficial—with the surfaces of life, with manners, with "personalities," with all that is most decorative, amusing, stylish, and temporary. At the more sophisticated levels of sociable art, it may even engage the satiric impulse, but its satire must be gentle and affectionate, inclining to flattery and never really wounding—the satire of a Beerbohm or a Nancy Mitford rather than of a Swift or a Ben Jonson.

It was inevitable that such an art would find a congenial home in the world of photojournalism, which is itself a massive form of sociability. The museum, on the other hand, is less susceptible to its charms. Museums require in their objects a kind of absoluteness of

statement that is foreign to the very idea of sociability, which is why museum exhibitions that seek to emulate the effects of journalism always have an air of intellectual condescension and inverted snobbery.

The exhibition of photographs by Cecil Beaton, entitled "600 Faces by Beaton: 1928–69," at the Museum of the City of New York, can scarcely be said to escape such hazards. In fact, the exhibition seems almost designed to encourage our sense of its superficialities, to underscore the photographer's attachment to the vicissitudes of fashion, celebrity, and the vagaries of publicity. Certainly no photographer who cared deeply about the aesthetic integrity of his medium would have permitted the inclusion of so many indifferent prints or sanctioned an installation—complete with campy musical sound tracks—that invites the blurred vision of nostalgia to take such overwhelming precedence over the appreciation of individual images.

But in all this Mr. Beaton has only been true to his own sense of vocation—a vocation that has always ministered to the well-lighted stage on which established figures in the arts, mannequins from the world of high fashion, and the elegant human detritus of the *beau monde* cross each other's paths and engage temporarily in mutual promotion. In his role as photographic courtier to this milieu, Mr. Beaton has occasionally displayed a kind of genius—a genius for precisely the form of sociability I have been speaking of. His entire vision is circumscribed by the values of the clients he has so shamelessly flattered over a long stretch of years. There is never a critical note, though there is occasionally some very gentle humor. There are even some very arresting moments—the photograph of Gertrude Stein and Alice B. Toklas is one of them—when he takes a holiday from the world of chic feeling and gives us a glimpse of something infinitely more fundamental. But such moments are rare. He is, in the main, a prisoner of the superficial, making the most of the freedom he enjoys in that realm.

As sheer documentary, of course, the exhibition is very entertaining, and it provides an index not only to the history of celebrity over the past forty years but to the changes in public image which celebrity has permitted itself. Compare the lush romantic lighting of the twenties and thirties with the frankness of, say, the recent picture of Patrick Proktor—the young English painter surrounded by

nude male models in his studio—and you have a concise history of genteel taste. Mr. Beaton is not a great photographer, but his career is an essential datum in the history of an era.

As it happens, one of the pictures in David Hockney's exhibition at the Emmerich Gallery—his large double portrait of Henry Geldzahler and Christopher Scott—also figures in the Beaton exhibition, where the subjects are seen posed in front of their own portrait. The comparison is, I think, much to Mr. Hockney's advantage, for whereas Mr. Beaton merely provides the materials for a comedy of manners, Mr. Hockney creates such a comedy. Indeed, in this painting and in two others—the double portraits of Christopher Isherwood and Don Bachardy, and of Fred and Marcia Weisman—Mr. Hockney offers us pictorial sociabilities of a high order, at once amused and disabused, very much a part of the milieu they depict and yet detached enough to be witty, precise, and even, on occasion, a little cruel.

Mr. Hockney is not, to be sure, a very distinguished painter. The landscapes that fill out his exhibition are little more than facile illustrations, and even the pictorial construction of the portraits, though adequate to his purposes, is simply a neat pastiche of well-worn devices. But sociable art of this sort does not ask to be judged primarily on the basis of its formal rigor. It undertakes to illuminate a world, to be conversable about familiar things, to make a point—if possible, a comic point—and this Mr. Hockney does very well indeed. There is nothing as witty in all six hundred of Mr. Beaton's photographs as the painting of the fruit bowl in Mr. Hockney's portrait of Messrs. Isherwood and Bachardy, nor is there anything quite as devastating as the faces and posture of the "American Collectors"—as the Weisman portrait is called—in their California sculpture garden.

No doubt the art of painting has higher tasks to perform than those Mr. Hockney has undertaken in these three large pictures. Yet they remind us of certain resources that painting may still avail itself of, certain powers that it has long surrendered to photography, literature, and the movies that it may now want to recover, or at least reconsider. Perhaps the comedy of manners, insofar as it enters into pictorial art, will always be a form of illustration, and thus always dependent upon a realm of association that the painter can rely on without reconstituting in his own terms. But this is the risk of sociable art and one of its pleasures.

Certainly in the case of Mr. Hockney, this is a vein of pictorial art that shows him at his best. He is the kind of artist who needs a face and a body to look at and a situation to grasp before his talents can be fully engaged. What he has done on the present occasion is to carry a certain aspect of Pop art in the direction of Evelyn Waugh —a development both unexpected and often very funny.

May 11, 1969

43. The Sculpture of William King

The great part of our knowledge of life and of nature— perhaps all our knowledge of their play and interplay —comes to us as gesture. . . . Let us say that good sculpture has a heaviness or lightness which has nothing to do with stone or wood or the carver's trade, but which has everything to do with the gesture which illumines the medium.
—R. P. Blackmur

The sculpture of William King is a sculpture of comic gesture. It is sculpture that choreographs a scenario of sociability, of conscious affections and unavowed pretensions, transforming the world of observed manners and unacknowledged motives into mimelike structures of comic revelation. Often very funny, sometimes acerbic, frequently satiric and touching at the same time, it is sculpture that draws from the vast repertory of socialized human gesture a very personal vocabulary of contemporary sculptural forms.

This preoccupation with gesture is the locus of King's sculptural imagination. Everything else that one admires in his work— the virtuoso carving, the deft handling of a wide variety of materials, the shrewd observation and resourceful invention—all this is secondary to the concentration on gesture. The physical stance of the human animal as it negotiates the social arena, the unconscious gait that the body assumes in making its way in the social medium, the emotion traced by the course of a limb, a torso, a head, the

features of a face, a coiffure, or a costume—from a keen observation of these materials King has garnered a large stock of sculptural images notable for their wit, empathy, simplicity, and psychological precision.

King is, then, among other things, an amusing artist, and nowadays this can at times be almost as much a liability as an asset. Modern art, particularly in its later phases of development, has tended to favor a certain solemnity. Works of art that amuse, that tickle our fancy with unexpected conjunctions of images and materials, that actually afford some risible and irresistible insight into the human comedy run the risk of not being taken seriously for their intrinsic aesthetic qualities. This is especially true of the art of sculpture. Although the history of modern art can boast some first-rate comic sculpture—by, among others, Picasso, Nadelman, Calder, David Smith, and Richard Stankiewicz—a suspicion of frivolity nonetheless persists wherever wit, satire, or humor plays a central role in the sculptural conception.

Thus, any sculptor aspiring to the comic mode has had to prove himself on purely formal grounds as well as on the basis of his particular vein of comic invention. Amuse us he may—but the comic sculptor had also better do something more than amuse if he hopes to have his work taken as a viable artistic statement. The comic sculptor assumes, by the very nature of his task, a burden that his contemporaries in the more solemn abstract modes of the sculptural art need never be concerned with: the burden of aligning his observation of the particulars of experience with the strictest requirements of form. He must be a connoisseur of two worlds—the world in which he moves as a man and the world of forms to which his vocation as an artist has ineluctably committed him—and he must remain true to both while allowing neither to swamp his attention or dictate his priorities.

In King's case, he has naturally looked to a world of forms that would best accommodate his basic instinct and empathy for the comic gesture, and in doing so has found hints and inspiration, precedents and useful procedures in a variety of sources. His deepest affinity is with the sculpture of Elie Nadelman, whose painted wood carvings and papier-mâché figures—at once so lighthearted, so elegant, so original, and so fully articulated—have provided King with a vision and an ideal of craftsmanship against which to measure his own accomplishment and aspiration. It is indeed a sign

of King's own originality that he recognized in Nadelman's *oeuvre*, and did so at a time when this great sculptor was generally neglected, a decisive connection with the nature of his own sculptural ambitions.

In King's work, as in Nadelman's, there is an echo of American folk art, with its air of artisan innocence and its indifference to high-flown rhetoric. And there is also a comparable sophistication, which takes the form of a lively curiosity about the sculpture of the past and an alert attention to new developments that have no very immediate relation to the sculptor's own program. King has lived for extended periods in Italy and Greece, and there are in his work distinct traces of ancient and even Renaissance influences. One sees an Etruscan vision at work in the "Self as Bacchus" (1963) and the ambience of della Robbia in the wonderful series of terra-cotta heads from 1959–60. And those spindly legs on which so many King figures are precariously perched—are these slender masses conceivable without a keen appreciation of Giacometti? Yet the classical influences in King's sculpture enter his work as materials for parody as well as emulation, and if Giacometti is a factor in his conception of the human form, it is because King—who is the most autobiographical of all living sculptors, at times making his sculpture almost a diaristic record of his love life, his family life, and his social milieu—has recognized in his own tall, lanky physique a kind of comic counterpart to the anguished slender figures of the Giacomettian world.

King's own sculptural world is not without its moments of anguish and even misanthropy. The series of cadaverous figures and groups he first showed in 1967—"Greek Restaurant," "The Little Dinner," "Jimmy," etc.—were ferocious in laying bare the antics of a dramatis personae who were no longer amusing or absurd but denizens of a world already consigned to hell. Without altering the syntax of his figures, King suddenly revealed a new taste for an expressionism of extreme emotions.

But this series has—so far—remained an exception to the general climate of feeling that one finds in King's work. The characteristic King figure may be awkward and even ridiculous, caught unaware in the unlikely contraption of his own physique and decked out with accoutrements that only succeed in amplifying an innate absurdity. His actions may be ungainly, his emotions confused and unacknowledged, his relation to the world at large a farrago of

misconceived ideas. But by and large, the world in which this figure exists is very gently envisioned. King is a sharp observer, but also a sympathetic one. There is a marvelous delicacy even in his most satiric images. This is not the kind of comic vision that seeks to humiliate the species.

Nowhere is King's fundamental sociability more evident than in the new series of constructed aluminum structures which he has just completed. These are, in conception at least, open-air sculptures. They have a large, robust, outdoor reach. And they must be just about the friendliest, least daunting, least impersonal open-air sculptures of real quality since Calder designed his first outdoor stabiles.

Not the least interesting thing about this new series is the perspective it affords on King's work as a whole. He is working here in a new material—aluminum plate that is sawed into silhouettes and slotted to allow for easy assemblage. The method is thus a synthesis of carving and construction. The use of this new material—and the scale on which it is used—mark a notable advance in King's development. Gone are the associations that inevitably attach to bronze casts and the carved block of wood. There is a freshness, a leanness, a suggestion of expression unencumbered by associations with other times and other places that King's work has not always enjoyed in the past. The essential gesture embodied in each form is realized with a greater economy, the governing emotion is distilled in a tighter, simpler image.

One is reminded, seeing this new material used with such effortless authority, of the audacity King has shown in his use of materials in recent years. Though fundamentally a carver, he has used burlap and vinyl with a grace and elegance unsurpassed by any other sculptor of his time. Indeed, no other sculptor has moved from the traditional uses of bronze and wood to the new "soft" materials with so little change in the spirit of his work. The very character of his sociable imagery has permitted radical transitions in material and scale without any violence to the spirit of his enterprise.

This imagery persists in the new aluminum sculptures. Figures point, kiss, ponder, reach, sit, crawl, or lie about, their emotions very gently defined. There remains a strong element of the autobiographical; there is no mistaking the fact that the artist is disclosing some personal item of experience. There is a fine intimacy of feeling in these works. But there is also something else—a kind of abstrac-

tion or concentration of the gesture that informs them. They are starker, more direct, less obviously ingratiating. The distance between ends and means is now shorter than it was. There is a succinctness in this new work that elevates it above its thematic materials, endowing each image with the suggestion of a good-humored archetype. The last traces of caricature have been transformed into gestures that signify the stages of human experience. There is a concision that seems itself a distillation of experience.

King's talents have always drawn their strength and energy from a sympathetic, if disabused, perception of the world around him. Among the sculptors of his generation, he has been remarkable in his fidelity to such perceptions—and his ability to create out of his encounter with worldly experiences sculptural images of such economy and probity. There is a quality that is almost Chaplinesque in King's work—a mockery that remains sweet to the taste, a satirical vision that does not exempt the artist himself from the reach of its criticism. He is an artist of uncommon intelligence and originality who has kept sculpture alive—kept it vital and inventive as well as amusing and telling—as a medium of humanistic discourse. At the present moment there is—quite literally—no one else like him.

December 1969

V. The Art of Photography

1. The Classicism of Henri Cartier-Bresson

There are some forms of art that need to be protected from their own popularity. The pleasure they offer is so immediate and the obstacles we encounter so few that we are in some danger of underrating the scope and the profundity of the art itself. A sense of the familiar tends to dissipate our sense of what is truly special; we feel that we are already in possession of the materials of such art even before we have taken hold of its true aesthetic character.

Such, at least, seems to be the case with the art of photography. No other form of visual art seems more accessible to our sensibilities, none is more eagerly or more quickly consumed, none invites such an easy and unconscious blurring of the excellent and the indifferent. To appreciate the art of the photograph, it often seems that one need only have an appreciation of life itself. The intercession of the aesthetic and critical faculties seems—almost—a form of supererogation.

Yet one has only to confront the work of a master to realize that in this art, as in others, an immense—and an immensely refined—capacity for discrimination is essential, that an uncommon intelligence is indispensable and a certain passion—passion informed by intelligence—is central to the whole enterprise. And to realize this is already to be aware of the aesthetic faculty that distinguishes, first in the mind of the artist and then in the mind of his audience, the significant from the insignificant, the true work of art from the raw, unformed materials of art.

Among the living masters of photography, Henri Cartier-Bresson is perhaps the most famous. He has often functioned as a photo-journalist for some of the best of the mass-circulation picture magazines in this country and abroad, and photo-journalism is surely the medium that has been pre-eminent in bringing us into a close and steady contact with a certain kind of photograph—the quick, head-on glimpse of a historical moment or (what Mr. Cartier-Bresson has virtually made a genre all his own) the oblique view that distills the emotional essence of an event in an ironic concentration on its least "significant" details. Mr. Cartier-Bresson has worked in this realm long enough—well over three decades now—and with sufficient influence to have won for himself both a world-wide renown and an enormous corps of imitators, yet he remains a

rarity. He is at once the Balzac and the Poussin of the modern camera, displaying both an extraordinary appetite for experience and a sublime sense of form in rendering it.

The exhibition of Mr. Cartier-Bresson's work which John Szarkowski, the Director of the Department of Photography at the Museum of Modern Art, has now installed in the museum's first-floor galleries is called "Recent Photographs" and dwells for the most part on pictures from the last decade. But Mr. Szarkowski has also included a small retrospective survey of photographs from the years 1929–50. The subject matter ranges from landscape to portraits, from moments of tragedy to vignettes of utter hilarity, from mob scenes to delicate glimpses of loneliness, isolation, and meditation. A dozen or more countries provide the settings, and almost every social class on the face of the globe is represented. All in all, about 150 pictures are on view—a small sampling considering Mr. Cartier-Bresson's tireless production, but more than enough to confirm his genius and to give us a renewed sense of the elements of which it is composed.

Foremost among these elements are the two I have already mentioned—the photographer's appetite and sympathy for experience and the sense of form that, without exactly dominating that sympathy, is clearly in control of its response to every detail of the subject at hand. Mr. Cartier-Bresson has himself observed: "The chief requirement is to be fully involved in this reality which we delineate in the viewfinder," and his own work does convey a terrific sense of devotion—at once humane and analytical—to precisely those observable surfaces of life that may, in a work of art, be made to signify so much of what lies beyond the observable—so much in the way of meaning and value and emotional import.

But it is probably a mistake to try to distinguish this quality of empathy—which is a form of moral delicacy—from the formal intelligence so evident in this work. The analytical detachment which Mr. Cartier-Bresson achieves in the face of his subjects and which is very much a part of that empathy is itself indicative of a certain disposition to form—specifically, to a kind of classicism that is essentially French. Mr. Cartier-Bresson, who once aspired to be a painter, studied in his early years with André Lhote, and he brings to his photographic work a sensibility imbued with the Cubist aesthetic. There are no abstract images in this work; it abounds in vivid representations of particulars, in anecdote and reportage and minute

attention to concrete detail. Yet the work belongs to Cubism, and to the larger tradition of French classicism of which Cubism is but the most recent chapter, by virtue of its compositional rigor, its clear and highly rational placement of forms, and its impeccable pictorial logic.

Someday a study will have to be written of the aesthetic commerce that has obtained between the inventions of modern pictorial art and the photographic styles that have followed in their wake. The subject is by no means a simple one. Nor are the explanations to be found entirely in the realm of technique or its cultural employment, though this undoubtedly plays a part. The classical or Poussinesque element in the art of Mr. Cartier-Bresson has a great many analogues in the painting of our time and, as I have suggested, is to some degree derived from them, but there are virtually no analogues to the Balzacian element that is equally a claim to glory. In this respect, one is made almost painfully conscious, on seeing an art as powerful and accomplished as Mr. Cartier-Bresson's, of the enormous expressive freedom that has passed from the hands of the painter to the hand and the eye of the photographer.

The camera is still a relatively new artistic vehicle—new, indeed, when one measures its short history against the entire history of pictorial art—and the photographer has, in a sense, become the heir to a great artistic fortune. He has been freer to negotiate the resources of this fortune than the painters themselves, who have grown increasingly more conscious of their limitations than of their freedom. In many ways, the photographer in the twentieth century tends, in his relation to the painter, to resemble the novelist in the nineteenth century in his relation to the poet: the epic and dramatic materials have passed into the hands of the photographers in our time, just as they passed into the hands of the novelists a century or more ago. The poets remained the custodians of the lyrical impulse, but the larger forms proved unworkable, and this is pretty much the case with painters today.

July 7, 1968

2. Edward Weston's Privy and the Mexican Revolution

The relation in which artistic ideas stand to the pressures of revolutionary politics is too often assumed—almost always for political rather than artistic reasons—to be a simple one. Despite a mountain of evidence to the contrary, the belief persists that art, if it is sufficiently "advanced" aesthetically, will naturally ally itself with the ideology of revolution. What this usually means in practice is that art is expected to subordinate its interests—assuming that art has genuine interests of its own, which the ideologues of revolution are not in the habit of admitting—to immediate political goals. It all comes down to the notion that art will somehow provide a service, a store of aesthetic hygiene, helping to cure the social and cultural diseases that linger in the aftermath of every revolutionary situation.

This is, to say the least, a naïve belief. It is naïve, above all, about the way the artistic impulse—especially the modernist impulse—responds to experience. It is mistaken, when it is not openly cynical, in its easy assumption that the artistic imagination has no more serious function than to deliver a message. The actualities of art are otherwise, however. They are often characterized by the kind of paradox that drives revolutionary ideologues to despair—which is to say, to censorship and repression.

Take the case of Edward Weston. In 1923, at the age of thirty-seven, Weston went to Mexico. He was already a photographer of considerable distinction. He had begun his career by producing delicate, soft-focus portraits in the established romantic mode and had then turned his attention to the urban scene. What interested him in the latter, however, was not its human pathos but the abstract beauty of its newly created forms. It was in the care he lavished on pictures of factories, machinery, and smokestacks that he began to develop the extraordinary clarity and precision for which his photographic style has ever since been celebrated.

In Mexico, Weston was accompanied by Tina Modotti, a remarkable woman who was something of a personality in the left-wing parties of Mexico, Cuba, and Spain. (Tina Modotti developed into a first-rate photographer herself. Her uncommonly dramatic life cries out for a biography, and an exhibition of her work is surely overdue.) The household and studio that Weston and Modotti estab-

lished in Mexico very quickly became an important part of the cultural life that was beginning to dominate Mexico in the wake of the revolution. Diego Rivera, who functioned as something of a cultural commissar as well as his own chief client in this period, was a close friend and supporter. Siqueiros and Orozco, too, hailed Weston as a master, and he seemed for a while to belong—mainly on the basis of his vivid interest in the folk art and archaeological objects which were then beginning to be upheld as symbols of an indigenous aesthetic tradition—to that "renaissance" in Mexican art in which political and aesthetic interests appeared to be united.

Weston's experience in Mexico was relatively brief—by 1926 he had permanently returned to California—but it was nonetheless profound. It was in Mexico that he fully matured as an artist—in my view, one of the greatest American artists of the century. But the very nature of his artistic development during this period confounds all the conventional assumptions about the relation of art to life, especially political life. Weston clearly responded to the ethos of the Mexican revolution with enormous enthusiasm, yet the effect of his Mexican experience was to deepen the purely formal aesthetic interest he brought to his photographic work. The truth is, he had no real political interests at all. The atmosphere and momentum of revolution served, in his case, to abet a very personal vision that located itself, ideologically, at a very great distance from the characteristic obsessions of the Mexican "renaissance." In the face of revolution, Weston becomes the complete aesthete.

In the exhibition of thirty-five Weston photographs which Phyllis D. Massar has now organized at the Metropolitan Museum of Art there is one—a famous one—that dramatically illuminates the paradox I am speaking of. It is the great platinum print of 1925 called *"Excusado"*—one of the series Weston devoted to the white toilet bowl in his house in Mexico. This picture is neither an antiart statement in the Dada manner nor a documentary effort of the social-realist type. It is an essay in pure form, and it was as such that Weston saw it. He was fully conscious of what he set out to achieve in photographing so unorthodox a subject.

Indeed, Weston himself did not hesitate to compare this "portrait of our privy," as he called it in his *Daybooks,* to the Victory of Samothrace. Here are the passages from his journal in which he speaks of this project:

I have been photographing our toilet, that glossy enameled

receptacle of extraordinary beauty. It might be suspicioned that I am in a cynical mood to approach such subject matter when I might be doing beautiful women or "God's out-of-doors"— or even considered that my mind holds lecherous images arising from restraint of appetite.

But no! My excitement was absolute aesthetic response to form. For long I have considered photographing this useful and elegant accessory to modern hygienic life, but not until I actually contemplated its image on my ground glass did I realize the possibility before me. I was thrilled— Here was every sensuous curve of the "human figure divine" but minus imperfections.

Never did the Greeks reach a more significant consummation to their culture, and it somehow reminded me, forward movement of finely progressing contours, of the Victory of Samothrace.

We may still smile at the attitude expressed in this passage— Weston's own household thought him quite crazy ("Brett offering to sit upon it during exposure, Mercedes suggesting red roses in the bowl," etc.)—but we would be mistaken if we allowed this smile to divert us from an understanding of what Weston's effort here signifies. For this picture marks one of those turning points in the history of a medium—and all the more so in this case because the medium was one, and remains one, in which "the subject" counts for so much. In exalting so humble and so unexpected a subject, Weston was asserting the primacy of the medium over the materials it recorded, and yet doing so without denying or denigrating the necessity for a "subject." He was, in short, doing for photography what his peers among the painters—though not in Mexico!—had already done for painting.

The other pictures in the Met show speak for the great variety of subjects that continued to interest Weston. The show ranges in date from 1921 to 1944, and virtually every one of his characteristic motifs is represented. But *"Excusado"*—together with the comments he made on it—has lost nothing of its special aesthetic and historical significance. Weston was an artist in love with the perfection of form. In the passage I have quoted, his reference to the lack of "imperfections" in the object under scrutiny sums up the very essence of his vision and the nature of his artistic ambitions. It is

not the sort of vision we have been led to expect from the ferment of revolution, but there it is—an object lesson in the illusions that a "committed" view of art has all too often generated in the endless discussion of culture and revolution.

May 7, 1972

3. Paul Strand

In the visual arts, the field containing the greatest number of masterpieces yet to be "discovered"—which is to say, given serious attention, appropriate commentary, and adequate exhibition, preservation, and publication—is that of still photography. The situation is changing, to be sure. A keener appreciation of the photographic medium is beginning to make itself felt in the higher academic altitudes. The Fogg Art Museum at Harvard has recently established "a new category of acquisitions" for photography, and the Yale University Art Gallery is about to open its first important photographic show. (It is devoted to the work of Walker Evans and includes examples not represented in the Museum of Modern Art's recent retrospective.) One hears rumors of similar moves elsewhere, and the number of serious exhibitions and publications is certainly on the increase.

Yet a curious prejudice persists in relegating this medium to a sort of intellectual limbo, where its achievements are neither affirmed nor denied but simply left to survive as best they can in the hurly-burly of the cultural marketplace. Photography, of all the arts that now claim our attention, remains the one with the smallest intellectual constituency. To think about photographs the way one thinks about paintings or poems or (especially nowadays) movies is a habit that remains alien to a great many people who are otherwise very intelligent about the arts.

Thus, the large retrospective exhibition devoted to the work of

Paul Strand that is now installed at the Philadelphia Museum of Art will be an event of capital importance to connoisseurs of photographic art, but it is difficult to know what the larger art public will make of it. Here are nearly five hundred prints, from the years 1915 to 1968, by one of the living masters of the medium. Mr. Strand is both a historic figure and a great artist, one of our last links with the legendary Stieglitz circle. In what other field could we have sprung upon us at this late date so vast an achievement so much of which is unfamiliar to us? How many of the people for whom Andy Warhol has become a household name are even dimly aware of who Paul Strand is or know that he remains, at the age of eighty-one, one of our most vital and productive artists? Such is the crazy manner in which our cultural affairs are conducted.

As it happens, the Philadelphia show will be something of a revelation even to many who feel they know a good deal about Mr. Strand's accomplishments. Between the earlier pictures and the later ones, there is the kind of development that only an artist of large creative resources and an uncommon consistency of purpose could have sustained. With an achievement of this size, it is not enough to know a great many individual prints. One needs to know something of the relations that obtain between them. As with any large *oeuvre*, each successive work tells us something of importance about what has preceded it. The work of one period serves to illuminate that of another. There is nothing like a large retrospective for establishing not only the scope of an achievement but also its internal dynamics and its essential character.

Mr. Strand's early pictures return us to the Alfred Stieglitz period, when serious photography took its aesthetic cues from the great modern painters. This was less a matter of attempting to achieve the look of painting than of exploring the fundamental nature of the photographic medium itself and of conceiving each picture strictly within the expressive terms of the medium. The aim was to entrench the photographic image as deeply as possible in the very process of its production. A highly self-conscious aestheticism was combined with an attitude of technical rigor, and technique acquired a moral as well as an aesthetic dimension.

In the later pictures—some of the most recent were taken in Egypt, Ghana, and Rumania—we are a long way indeed from the Stieglitz atmosphere. The vision is flawless, the technique impec-

cable, the command of the medium total, but there is no suggestion of an aesthetic battle being waged. What persists is a certain attitude, a certain gravity, a certain quality in the attention that is lavished on each subject. But something has changed. An aesthetic program has been subsumed in a more concentrated fidelity to the subject. Now it is the subject that has acquired for the artist a moral dimension as well as an aesthetic one. The formal rigor now serves the subject; the subject is no longer an excuse for an effective image. The subject is the image.

A great deal of history—and not only photographic history—is concentrated in this change. It would be interesting to know how large a role politics played in this fateful revision of the photographer's objectives. The change I speak of is apparent from the early thirties onward, and political considerations do seem to have figured in the scenario—both then and later. It would not be a mistake, I think, to speak of Mr. Strand as a man of the Left. But what makes the question interesting is not the political character of his art but the fact that his art is devoid of ideological corruption. If indeed politics played a part in his artistic development, the effect was altogether salutary. It tells us something about the intellectual poverty of the literature on photography that such questions, which are commonplace in discussions of literature or the theater, are rarely broached.

In terms of photographic history, the significance of Mr. Strand's development is great indeed. Writing about Alfred Stieglitz recently, Walker Evans remarked that "Stieglitz was important enough and strong enough to engender a whole field of reaction against himself, as well as a school inspired by and following him. As example of the former, Stieglitz's veritably screaming aestheticism, his personal artiness, veered many younger camera artists to the straight documentary style; to the documentary approach for itself alone, not for journalism."

Now the extraordinary thing about Mr. Strand's work is that it embraces both terms of this split in Stieglitz's influence without succumbing to the facile orthodoxy of either. To have negotiated this difficult course, to have retained the high-minded aesthetic probity that prevailed at "291" and in the pages of *Camera Work* while functioning in a world far beyond the boundaries of Stieglitz's art-centered imagination, a world in which life has an imperative

priority over art—this has been Paul Strand's great triumph. Its accomplishment makes him an exemplary figure in the history of his medium.

December 5, 1971

4. Bill Brandt

The exhibition of photography by the British photographer Bill Brandt, currently on view at the Museum of Modern Art, consists of 123 prints and covers a period of over three decades. It focuses on a wide variety of subjects and exhibits a wide range of attitudes toward the photographic medium itself. Yet in every sphere that Mr. Brandt has chosen to explore—from the documentary style he adopted in the thirties to the poetic fantasy of the nudes he concentrated on in the fifties—he establishes a quality of his own.

This quality is primarily visual. Throughout the shifts in subject and attitude over the years, there are in Mr. Brandt's photographs the same inky, velvety blacks, the same range of delicately articulated gray textures, the whites and near-whites that are nearly always, when given a prominent visual role in a picture, something of a shock—an almost violent focus of attention. In what might be called Mr. Brandt's "black" style, we are given a glimpse of a very romantic temperament. His vision seems most at home in a world of darkness and semidarkness, a world in which light seems an almost unnatural element—an element to be valued, captured, preserved, but not to be counted on.

This visual quality is seen at its best, I think, in those pictures that have the most compelling subjects. These are, for the most part, the photographs of high life and working-class life in England in the thirties, those of life in London during the blitz, and the portraits. It requires, apparently, the *frisson* of a subject just beyond the reach of the photographer's expectation—the unexpected conjunction of

an image, an emotion, and an inspired response—for a certain kind of "life" to find its way into a powerful photograph. The photographer may come to his subject, as Mr. Brandt certainly has, with an immensely sophisticated grasp of the medium, but he is still dependent on those moments of discovery when he suddenly "sees" his subject for the first time through the "eye" of his camera.

Indeed, it is even possible for this sophisticated grasp of the medium to be, if not a liability, at least a hazard. In Mr. Brandt's case, this sophistication tempts him into using the camera to imitate art itself. As a photographer of nature, he is almost too much the romantic poet. We may be pleased by what his camera finds in the landscape—these photographs are often indeed very beautiful—but we are rarely surprised by it. We have been there before. And his photographs of the female nude, with their Surrealist distortions and highly pictorial landscape settings, belong to this class of "natural" subjects. Both the landscape and the nude, either separately or together, are, perhaps, too accessible to the photographer's sensibility. They offer no resistance to romantic indulgence. They may yield his purest aesthetic statements, but their sheer aestheticism, with its evocation of and deep dependence on other art, attenuates their power. The intensity and concentration of the so-called documentary pictures (in which I include the portraits) gives way to something softer and more familiar—the vast terrain of Surrealist cliché.

Where the subject lies beyond this terrain and cannot be so totally controlled and manipulated by the photographer himself, Mr. Brandt shows his greatest strength—and (what may be the same thing) his greatest inspiration. The "Parlourmaid" series from the thirties, must be among the greatest pictures of their kind. So, too, the pictures of coalminers from the same period, and the pub scenes and the air-raid shelter series from the forties. They share in the English literary gift for anecdote, social detail, and appreciation of character, yet everything is given in visual terms. The world of these pictures is, in more than one sense, a dark place, and Mr. Brandt's achievement is to have found for the social and psychological malaise he sees in the subject its precise visual analogue. The materials of a thousand novels have been perfectly transmuted into the inky blacks and startling whites of a strict visual statement.

Mr. Brandt's portraits are also characterized by this same sense of malaise. The best of them—photographs of Robert Graves,

Francis Bacon, Dylan Thomas, Malcolm Muggeridge, Edith and Osbert Sitwell, Ivy Compton-Burnett—show us figures and faces almost unbearably vulnerable. No one is held up to ridicule in these pictures; there is no aura of gossip or scandal, or any easy comedy either. The world these figures inhabit is shown to be a harsh place; an unbenevolent fate seems ready to close in the moment the shutter has closed. John Szarkowski, the director of the museum's Department of Photography who organized the current show, says of Mr. Brandt's work: "We feel in his pictures a dislocation of the rational structures of experience, a recasting of the familiar into forms which show its meanings to be unfamiliar and threatening." This is a very accurate description of these portraits especially.

There are photographers—Henri Cartier-Bresson is the outstanding example—who seem to cast their subjects into an eternal present, preserving and exalting their immediacy and, in effect, removing them from time. The strategy of Mr. Brandt's style seems to require something very like the exact opposite of this approach. The nature of his vision seems to place his subjects at a certain distance from the present. This sense of distance is untouched by nostalgia or regret. It is almost impersonal. It is a metaphor of fate.

This exhibition is the first major show of Mr. Brandt's that has been mounted in this country, and it certainly establishes him as one of the classics of the medium.

September 28, 1969

5. Walker Evans and Henri Cartier-Bresson

Walker Evans and Henri Cartier-Bresson: the mind reels slightly at the thought of these two great names and the achievements they signify. The one, an American, quintessentially American, Ameri-

can not only in subject matter but in style, a style that is proud, lonely, reticent, original, even a little vain in its originality; the other, a Frenchman, quintessentially French, French in the grand manner, or what used to be the grand manner, now somewhat chastened, more economical perhaps, with a hint of modesty, yet with its large appetite for experience and its fine analytical intelligence undiminished, completely in touch with each other, and flourishing. Different as they are from each other, different in style and in the ethos that informs and determines style, these two great photographers are alike in one respect: they are not only the best in their line but each virtually invented the line for himself.

In the case of Walker Evans, we can now follow the course of his extraordinary accomplishment in the large retrospective exhibition of his work organized by John Szarkowski at the Museum of Modern Art. The current Cartier-Bresson exhibition at the Hallmark Gallery is a more narrowly focused survey. It consists entirely of the photographs in *Cartier-Bresson's France* (Viking), a new book that brings us the photographer's first concentrated view of his native country.

These are, then, unequal events—the Walker Evans show encompassing an entire *oeuvre*, the Cartier-Bresson exhibition and book bringing us only an episode in a long and distinguished career. But they are nonetheless extremely interesting in the comparisons they afford, for each man's work illuminates the special qualities of the other.

The first, and in some respects most important, comparison to be observed is this: whereas Cartier-Bresson's photographic eye is at home in society, always on the alert, to be sure, for a particular nuance, but essentially (one might say organically) social in its affinities, Evans's functions at a certain spiritual distance from social attachment. Cartier-Bresson's pictures come to us from inside society, Evans's from outside, far outside. Evans isolates his theme, and the very rigor of his design is a coefficient of the distance he places between his own photographic image of the motif and its conventional associations. Cartier-Bresson offers us a glimpse of the human comedy—and never more so than in the new pictures of France. Evans, even when he is photographing particular people, which he does remarkably seldom, separates them from their common social alignments.

Thus, the banal or commonplace—so important for both these

photographers—signifies something quite different for them. For Cartier-Bresson, it is most often humorous, touching, sweet, a revelation of something universally shared and appreciated. For Evans, it is something to be seen anew, something to be detached and savored, radically set apart. There is a concreteness in Evans's photographs—a concentration—that is almost mordant, almost ferocious in its necessity and single-mindedness, and it shows up most dramatically where the motif is "discovered" in the commonplace débris of the observed social scene. Cartier-Bresson is, above all, a comic artist, at home in the universe, whereas Walker Evans looks more and more like an American solitary, metaphysically isolated. Everything in his work is cast in the elegiac mode.

Evans's characteristic motif is a building or a group of buildings or an interior or something in a landscape—an object, or objects, in space. He is a still-life artist, even when he is working outdoors. Cartier-Bresson is a virtuoso of the social transaction, a social voyeur, if you will; an affectionate chronicler. Lincoln Kirstein, who has written superlative accounts of both photographers (we should really have a book of Kirstein's essays on photography—they are invariably superb), observes that Cartier-Bresson "is a moralist," and reminds us that the photographer's favorite writers are Saint-Simon and Stendhal. His interest, Kirstein notes, is "in *les moeurs*, the actual, essential behavior of men." To wrest from the flux of the human comedy its quintessential gestures and epiphanies is indeed this artist's forte.

My own impression is that the analytical side of Cartier-Bresson's talent is somewhat relaxed in these new photographs of French life; I miss a certain rigor in all this engaging felicity, but that may very well be because of the extreme contrast with Walker Evans. In Evans's photographs, no matter what the subject, there is an austerity, an aesthetic concision, a deliberateness of design, a will to form that is never relaxed, never merely sociable or amusing. At times this deliberateness is almost chilling, which Cartier-Bresson never is. An Evans photograph always compels attention to its design, whereas Cartier-Bresson—more than ever before, I think, in these new pictures of France—compels attention first of all to the anecdote.

Looking at Evans's photographs at the Museum of Modern Art, another comparison comes to mind. Because of his famous collaboration with James Agee on the book, *Let Us Now Praise*

Famous Men, it has sometimes been assumed that their styles were somehow alike. But this, I think, is to misunderstand both their individual achievements and the reason their collaboration proved so effective. For, as a stylist, Agee was essentially a modeler, in the sculptural sense of that term, building up each image by adding detail upon detail until he had achieved an almost baroque, many-faceted surface of multiple nuances. Evans, on the other hand, is essentially a carver, clearing away all excess, clarifying, penetrating, revealing some fundamental precision of focus. It is the essence of Evans's pictorial style that it does not leave the viewer free to improvise his own "interpretation" of what he sees, for he sees exactly and only what Evans intends him to see, and sees it all.

Walker Evans and Henri Cartier-Bresson are both great artists. If you are still startled or discomforted in hearing photographers spoken of in such terms, you are simply late—historically, aesthetically late—in recognizing one of the artistic glories of our own epoch. Seeing work of this quality, I think of Henry James's comment on a visitor's (obviously his own) first experience of the Théâtre Français: "He has heard all his life of attention to detail, and now, for the first time, he sees something that deserves that name."

February 7, 1971

6. From Fashion to Freaks: Diane Arbus

The photograph allows us . . . to admire in reproduction something that our eyes alone could not have taught us to love.
 —André Bazin

From fashion to freaks: this, briefly stated, is the course traced in the short, meteoric career of one of the most remarkable photo-

graphic artists of the last decade. The late Diane Arbus, who died a suicide in 1971 at the age of forty-eight, was one of those figures— as rare in the annals of photography as in the history of any other medium—who suddenly, by a daring leap into a territory formerly regarded as forbidden, altered the terms of the art she practiced. Already a legend and an influence at the time of her death, she has swiftly become a classic without ceasing to be either controversial or difficult. Whatever else may be said of her retrospective exhibition at the Museum of Modern Art, one thing is certain: a great many people are going to be shocked by it, appalled by the audacity of her subject matter, and stunned by the photographer's studied refusal to soften its effect with the usual artistic embellishments.

For what Diane Arbus brought to photography was an ambition to deal with the kind of experience that had long been the province of the fictional arts—the novel, painting, poetry, and films—but had traditionally been "off limits" to the nonfictional documentary art of the still camera. Except for the purposes of pornography, photography has been, by and large, a distinctly public art, focusing its attention on the socially observable. It might isolate eccentric or violent behavior, occupy itself with unfamiliar sects or marginal styles of life, but it nonetheless remained overwhelmingly committed to a public imagery—to visual materials that could be glimpsed without any sense that the camera was taking us into a hidden terrain in which we would not, in one degree or another, recognize something of ourselves and our world.

What we admire in the great modern photographers is, more often than not, the quick pictorial eye that wrests from this heterogeneous public scene an arresting conjunction of detail. What the camera records in the "decisive moment" (as Henri Cartier-Bresson has called it) of contact may be amusing or grave, preposterous or poignant, but it is essential that the subject be "caught" from the outside—trapped, so to speak, in a given instant that can never be repeated. In that unrepeatable point in time, the photographer composes his picture, the quickness of his eye and the lightning sensitivity of his emotions joined in the flash of the shutter, and from that moment the reality of the subject inheres in the composition, for it can no longer be said to exist "out there."

Part of the shock of Arbus's photographs is to be found, I think, in the fact that, in her work, there is no "out there." She takes us "inside" in a way that photography rarely attempted in the past.

The dwarfs, the transvestites, the identical twins and triplets, the retarded women and nudists, and other "freaks" in her photographs are not observed—are not "caught"—in the usual photographic sense. The photographer is not, in this case, a visual eavesdropper on the lookout for the pictorial equivalent of the revelatory phrase. The customary distance separating the photographer from his subject has disappeared. There is, as a consequence, none of that quickness—that split-second "take"—which this distance necessitates and celebrates. Nor is there, in the traditional sense, any attempt at "composition." What we are offered instead is something posed and intimate, an insider's patient record of what it feels like to inhabit the mind and body and the milieu of certain people society has judged to be abnormal or unusual.

The woman who produced this extraordinary body of work, thereby effecting a historic change in the way a new generation of photographers came to regard the very character of their medium, was not herself born into the world of social oddities she came to celebrate in her pictures. Far from it. She belonged to the comfortable world of the upper Jewish bourgeoisie in New York. Her father was David Nemerov, then the owner of the once prosperous and now defunct Fifth Avenue store called Russeks, which his wife's family had founded. Diane's brother is the well-known poet and critic Howard Nemerov.

At the age of eighteen, Diane Nemerov married Allan Arbus, and they both went to work for Russeks's advertising department, eventually establishing themselves as successful fashion photographers. And fashion photographers they remained for nearly two decades. As Doon Arbus, their daughter, recently wrote in a memoir of her mother: "He would take the pictures. She would get ideas for them. She was the first to quit."

In the late fifties she enrolled in Lisette Model's class in photography and was clearly determined to strike out on her own. "What I want to photograph, I can't photograph," she complained to her teacher. It turned out that what she wanted to photograph, as she said to Lisette Model, was "what is evil."

It is a word that easily lends itself to misunderstanding, for in my reading of Diane Arbus's photographs I find no suggestion that she regarded her subjects as being "evil" in any ordinary sense. I think Doon Arbus is correct when she remarks that "what she meant was not that [her subject] was evil, but that it was forbidden, that it

had always been too dangerous, too frightening, or too ugly for anyone else to look on. She was determined to reveal what others had been taught to turn their backs on."

The change of focus from the world of fashion to the world of freaks is a vast one, of course, by any obvious standard of social acceptability. The one is the very quintessence of what we mean by good taste—that which is to be preferred. The other is the embodiment of what, in its root sense, we mean by obscene—that which is too repulsive or offensive to be shown. Yet beyond this obvious difference there is a common ground, which I doubt even Diane Arbus was fully aware of. For both the world of fashion and the world of freaks exist at a great distance from the world of workaday experience, where most of us live out our daily lives—and where, incidentally, photographers have generally been content to take their pictures.

The world of fashion, especially fashion photography, is a world of self-conscious artifice, of cosmetic and sartorial invention, a world untouched by the common flaws of existence, where standards of normality are under continuous revision and embellishment. In its own way, it too is a world of freaks: Baudelaire spoke of fashion as "a sublime deformity of nature," and who, observing the gyrations of our own fashions, would disagree? Is it, then, such an enormous step from this "sublime deformity of nature" to those other deformities, which, whether self-imposed or the product of a malevolent fate, we think of as freakish? On the contrary, I can think of no better "school" for the study of human oddities than the world in which fashion rules.

But it is one thing to map out a territory you want to make your own; it is quite another to be able to conquer it. The world of fashion is easily entered, especially from Russeks's front office; the world of freaks is not. To breach that world—and to remain in it long enough, first as a visitor, then as something of a participant, to produce the kind of painstaking pictures Arbus's work consists of—requires courage, imagination, and most important, because it forms the very essence of her photographic vision, an exceptional empathy. And it was this that Arbus had in such abundance—that inner comprehension of, and sensitivity for, the hidden mental terrain in which her unusual subjects lived out their "normal" lives. It was a terrain she accepted with remarkable ease, and it is that total accep-

tance that removes her pictures from any suggestion of condescension or voyeuristic indulgence.

There is, if anything, a partisanship with her subjects which, once the shock of the strange and the unfamiliar has abated, is quickly transmitted to the spectator as well. Sooner or later—and some of her pictures, like those of retarded women playing games, take longer than others—she completely wins us over, not only to her pictures but to her people, because she has clearly come to feel something like love for them herself. "For me," she once remarked, "the subject of the picture is always more important than the picture," and this too is part of the secret of her power.

In the end, she achieved what she set out to achieve—she photographed what "can't" be photographed. She ventured into nudist colonies, hung out with prostitutes, attended gatherings of transvestites, stopped people in the street and managed to enter their homes and their lives. She invited them to collaborate in the picture-making process, and they agreed. Her subjects are thus participants who face the camera with patience and interest and dignity, they are never merely "objects." She said of them: "They've passed their test in life. Most people go through life dreading they'll have a traumatic experience. Freaks were born with their trauma. They're aristocrats."

She made us *see* these "aristocrats" in a way they had never been seen before. It was at once an artistic and a human triumph.

November 5, 1972

VI. Critics

1. A Critic on the Side of History: Notes on Clement Greenberg

A criterion of taste is . . . nothing but taste itself in its
more deliberate and circumspect form. Reflection refines
particular sentiments by bringing them into sympathy
with all rational life.
 —*Santayana, "Reason in Art"*

One joins the movement in a valueless world
Choosing it, till, both hurler and the hurled,
One moves as well, always toward, toward.
 —*Thom Gunn, "The Sense of Movement"*

Mr. Clement Greenberg's *Art and Culture,** although published more than a year ago, has not elicited the kind of discussion one had expected of so important a work. The odd silence that has greeted this book, a silence interrupted only once or twice by reviews that recognized its stature without attempting to assess its implications, may be traceable in part to the author's withdrawal from the regular practice of criticism. There was a time when Mr. Greenberg's articles on the current art scene appeared at weekly or monthly intervals and thus played an active role in forming the tastes and ideas that lay behind a good deal of contemporary painting and sculpture. He has gradually discontinued such an active critical program. His articles appear now at infrequent intervals and seem, as the result of their scarcity perhaps, to be unduly concerned to summarize rather than to elucidate a point of view. Mr. Greenberg is still avidly read by everyone concerned with contemporary art, but one suspects that he is read now with more avidity than intellectual curiosity and that the scarcity of his articles has encouraged certain readers to look to his utterances, rather as people read reviews of Broadway shows, to see if they contain news of a "hit." This is an unlucky fate for a writer who has certainly brought the finest mind to the regular practice of art criticism in our time, but it is not, perhaps, a difficult one to understand. It seems to be a law of our

* Clement Greenberg, *Art and Culture: Critical Essays* (Boston: Beacon Press, 1961).

culture that if a writer does not press his claim upon us with persis-
tent and single-minded advocacy, we shall not ourselves be inclined
to recognize its true value, and Mr. Greenberg's distance from the
hurly-burly of current critical writing has undoubtedly contributed
to the silence with which his book has been received.

But surely another reason why *Art and Culture* has failed to
provoke more widespread notice is its author's stern commitment to
ideas and his refusal to corrupt his style with that literary fancywork
which has so degraded the practice of art criticism in this country
and has yet, paradoxically, contributed to some extravagant reputa-
tions. Unlike Mr. Harold Rosenberg, for example, Mr. Greenberg
has never been tempted to make rhetoric do the work of analysis.
Unlike some of the windier contributors to *Art News*, he has never
mistaken himself for a poet. His writing may not always be the most
gracious instrument one could conceive for its purposes, but it has
the indispensable characteristics of clarity, coherence, and logical
argument, and it is not lacking in the power to engage our minds at
the most serious level. Its elegance is intellectual rather than verbal,
a matter of ideas rather than of music. If it lacks a certain felicity
over and above the discharge of its critical functions, it is at least
true, in this respect, to the aesthetic position it advocates. For Mr.
Greenberg has been a relentless partisan of a point of view which
condemns the use of the inessential in art, of all those felicities and
complications no longer deemed necessary to artistic realization, and
he has not asked any less of his own style than he has of the works of
art it is employed to discuss.

In bringing together his first collection of essays, Mr. Green-
berg has not given us, as many people expected he would, a chron-
icle of the forties and fifties in the manner of Edmund Wilson. "This
book," he writes, "is not intended as a completely faithful record of
my activity as a critic." *Art and Culture* contains thirty-seven
essays, many of them generously revised, and is less a history of its
author's opinions than a catalogue of his present views. One must
respect Mr. Greenberg's decision to cast this work in the present
tense, as it were, but it does nothing to alter the fact that the history
of art in New York during the last two decades will not be complete
until a full chronicle of his essays and reviews has been collected.
Even as a volume of major essays, the book has some unaccountable
omissions; I think particularly of his pieces on Surrealism and on

Paul Klee. But there is, nonetheless, a great deal here. Beginning with the essay on "Avant-Garde and Kitsch," first published in 1939 and now virtually a classic, the book includes important studies of Monet, Cézanne, Picasso, Braque, Léger, Lipchitz, Soutine, Milton Avery, David Smith, and Hans Hofmann. There are pieces—less interesting, in my opinion—on Renoir, Eakins, and Winslow Homer. There is the well-known essay on the New York School, called " 'American-Type' Painting," and a number of ruminations on sculpture, easel painting, and related subjects. The volume concludes with four literary studies, of which one—the piece on T. S. Eliot's criticism—tells us a good deal about Mr. Greenberg's own procedures as a critic.

However one may want to disagree with particular judgments, however one may object at times to the assumptions that lie behind them and the tone in which they are announced, there can be no doubt that *Art and Culture* is art criticism of a very high order—the highest, I should say, in our time. It is the only book in its field that could be seriously compared to the celebrated works of literary criticism produced in this country in the thirties and forties. *Art and Culture* is, moreover, the most important book of its kind since the death of Roger Fry, and it is for that reason that it must be approached with a certain caution and skepticism as well as with respect. Like Fry's work, it represents a period—in this case, the twenty years following the start of the Second World War—and its publication may very well mark the end of that period. To understand *Art and Culture* is to understand a great deal about the artistic values that came out of the war and the Cold War years; to question it is to question some of the salient achievements and aesthetic beliefs of those years.

At the time he first started writing art criticism, in the late thirties, Mr. Greenberg was, I believe, a Marxist of the Trotskyite persuasion. In the early forties he was for a time an editor of *Partisan Review*, when that journal still inclined to a Trotskyite position in political matters along with its liberal interest in modern art and literature. In the late forties and fifties he was an editor of *Commentary*, a journal that wielded considerable influence in dispelling Marxist illusions about Russia's role in the Cold War and in revising the aims of American liberalism. During the forties the bulk of Mr. Greenberg's criticism appeared in *The Nation*, a magazine he served

as a regular art critic and with which he broke, eventually, for political reasons. In the fifties his articles continued to appear in *Partisan Review* and in the art journals.

Now this highly telescoped résumé of his past professional involvements is no idle biographical footnote to his development as a writer. To grasp Mr. Greenberg's particular stance as a critic and an intellectual, it is of the essence to understand the ideological context in which his aesthetic position was formed. In approaching *Art and Culture*, it is no more irrelevant to mention its author's early Trotskyism and his later connection with *Commentary* than it is to examine Roger Fry's connections with Bloomsbury for an understanding of *Vision and Design*. Mr. Greenberg's critical intelligence was formed in the crucible of Marxian dialectics, and long after he eschewed the illusions and commitments of Marxist ideology, his criticism continued to draw upon the dialectical practices which had already determined his attitude toward culture and his habits as a writer.

Foremost among these was the assumption that critical judgments, if they are to carry the authority and force of something more than a merely personal taste, must be made in the name of history. Every critic faces the responsibility of having to discriminate between his own irrational preferences and the application of meaningful principles. Criticism may indeed properly be said to begin at a point where one recognizes the germ of a general principle amid the claims of one's own sensibility, and it is unlikely that criticism will mean very much if it does not, sooner or later, derive from some harmonious *rapprochement* between personal experience and general ideas. "Mere" taste, on the one hand, and abstract dogma on the other, must both be faced, and allowed to educate each other and mediate our judgment, for it is doubtful if criticism can function without them. Mr. Greenberg's habit of pronouncing all judgments as if they were objective readings of history—in this case, art history—is a device carried over from Marxian dialectics, in which taste and personal experience carry very little ontological weight beside the imperious claims of the historical process. If there is something impossibly arrogant in this habit, there is also something modest: a refusal to allow one's personal experience of a work of art to affect one's final judgment of it until that experience can be completely assimilated to historical principles. History is thus invoked as a brake against the vagaries of private enthusiasms. The

question, of course, is whether this deference to the claims of history is anything more than a rhetorical device; whether it may not be, in fact, as personal and subjective a basis of judgment as any other.

It seems to me that behind Mr. Greenberg's deference to history there lies an unacknowledged belief, Marxist in origin if not in its present form, in a doctrine of historical inevitability which he has been at no pains to elucidate, but which provides him nonetheless with the governing "myth" upon which his whole critical position has been constructed. (If I use the word "myth" here in quotation marks, it is because of the difficulty one encounters in estimating how deeply Mr. Greenberg is committed to this belief as an actuality.) The precise degree to which Mr. Greenberg believes in such a doctrine is important, and his refusal to spell it out all the more to be lamented, for as the utterances of a true believer, Mr. Greenberg's judgments may be regarded as modest discriminations emanating from a coherent body of fixed principles, but if, as one suspects, he is at heart as skeptical of teleological doctrines as the rest of us, then his judgments are indeed arrogant, for they derive from purely rhetorical criteria which are merely assumed to be operative for the sake of critical distinctions.

In Mr. Greenberg's criticism, the impersonal process of history appears in the guise of an inner artistic logic, which has its own immutable laws of development and to which works of art must conform if they are not to end up on the historical ash heap. This inner artistic logic is purely a matter of the relations that obtain among abstract forms arranged in a decorative pattern. It has nothing to do with the representational, the expressive, or the symbolical functions of art which, in Mr. Greenberg's aesthetic, have at best an epiphenomenal status; they are all part of the superstructure, as it were, and his criticism never condescends to discuss what he can only regard as mere accidents of time, place, and personality. Artists appear, rather, as anonymous inventors and manipulators of form-machines on the stage of history; they exist as impersonal exponents of aesthetic laws—or they would if Mr. Greenberg's sensibility did not intervene from time to time to save him from the logic of his own doctrine. There is in Mr. Greenberg's writing a fear of the personal element in art, an embarrassment in the face of anything but the formal and the historical, which I find chilling and unreal; but then, an extra-artistic empathy will sometimes act as a leaven when one least expects it. This is particularly

true of his essay on Chagall, whose work he wildly overpraises without once touching on that vein of fantasy which lies at the center of Chagall's early and best painting. Mr. Greenberg responds to something in Chagall's art that his principles cannot explain. I respect his response, but as a critic he has left it unarticulated. It will not do in this case to invoke Cubism, which Mr. Greenberg does sooner or later in most of these essays, when something closer to the artist's experience has so obviously been overlooked.

What one sees in Mr. Greenberg's criticism is the aestheticism of Roger Fry, itself derived from a synthesis of the aesthetic doctrines of Wölfflin and Mallarmé, fitted out with a principle of historical development drawn from Marx and employed with great skill in the defense of a point of view which is completely hostage to the New York School. This is the great strength and the appalling weakness of his criticism: that its intellectual rigor is supported by—is, indeed, derived from—a living body of art which provides the values by which all prior accomplishments may be judged; and that it is so radically incapable of accommodating anything in the art of the past (or the present) which has not been sanctioned by the practice of those few artists whose work is regarded by Mr. Greenberg as occupying the historical center of our time. His essay "The Later Monet" is superb precisely because it is so obviously, so eloquently, a case of special pleading. Here Monet is defined as precursor and mentor of the New York School, and something that had been lost from view in Monet's paintings is thereby recovered. But as Braque once remarked, "Any acquisition is accompanied by an equivalent loss," and the question here, as in all Mr. Greenberg's writings, is whether the loss is too great to justify the acquisition. It is not only that Monet's abiding naturalism is virtually canceled but his weakness for the decorative is raised to a lofty principle. When we come to the last paragraph of this essay on Monet and find Mr. Greenberg judging Van Gogh as inferior to Monet, as lacking a "largeness of view" that seems to refer to nothing more than the decorative element in which Monet, like certain members of the New York School, triumphed to the exclusion of much else of importance in painting, only then perhaps do we fully grasp the extent to which Monet has been enlisted in the service of a particular taste.

This taste asserts itself again and again—a taste for the decorative elevated to a historical principle and virtually identified as the inner logic around which all modern painting develops. One

sees it in the short essay on Renoir, in which "Simplification, broadness, directness"—in short, the characteristics of the New York School—are invoked at Renoir's expense. It comes through with particular force in the following comment on Soutine: "Certainly, he discounted to an excess the obligation to organize a picture decoratively . . . the decorative ordering of a picture remained something he submitted to rather than embraced. What he wanted of the art of painting seems to have belonged for a long while to something more like life itself than like visual art." This last sentence strikes one as absolutely right; the same comment would apply to Van Gogh and the whole development of figurative Expressionism—to Munch and Corinth and Beckmann, as well as Soutine—and it is for that reason that Mr. Greenberg (like Fry in this respect) is fairly helpless in dealing with such art. Wherever art threatens to abandon the decorative for a more direct contact with life, Mr. Greenberg shudders; the historical mode is disrupted, individual experience obtrudes, and a world of feeling not totally assimilated to the needs of style is indecorously exposed. In formalist criticism, as in formalist art, emotion must never be allowed to transcend decoration.

Mr. Greenberg has, of course, the strengths of his weakness. About Cubism, which is really the only major style of the twentieth century that has not functioned as a criticism of life, he writes supremely well. The fine essay "Collage" is actually a study of the Cubist works of Picasso, Braque, and Gris—Mr. Greenberg had already demonstrated, in his book *Miró*, his inability to understand the post-Cubist uses of collage—and is the best analysis of Cubist aesthetics I know. The essay on Cézanne, too, is magnificent, but in a radically limited way. It is as question-begging as the essay on Monet—and as eloquent. This is the Cézanne of the Cubists, Cézanne as he has been transmitted from Cubism to the New York School—Cézanne as a modernist, decorative master. For myself, this is Cézanne reduced to something less than his real size—it is Cézanne seen through the wrong end of the historical telescope—and Mr. Greenberg does not make the mistake of trying to include the artist's portraits in his lean and pointed commentary. Mr. Greenberg remarks in this essay that "The Cubism of Picasso, Braque and Léger completed what Cézanne had begun," and one can say that his own essay completes the discussion of Cézanne initiated by Roger Fry.

Robert Goldwater has already pointed out that Cubism is "the obsessive theme" of *Art and Culture*. The reason for this is clear. Cubism submits more completely to the historical-formalist view of art than any other modern development. Its morphology is the one most susceptible to being turned into a historical system. Like the Marxist view of history, it has internal "laws" which can be taken as moral imperatives. And Cubism, like Marxism, places the greatest possible distance between individual experience and the functioning of its own inner logic. In his essay "The Late Thirties in New York," Mr. Greenberg writes: ". . . some day it will have to be told how 'anti-Stalinism,' which started out more or less as 'Trotskyism,' turned into art for art's sake, and thereby cleared the way heroically, for what was to come." One swallows hard on this curious reference to heroism, but all the same, *Art and Culture* is certainly one of the principal documents of this transition from purist ideology in politics to pure aestheticism in art.

October 1962

2. The Contradictions of Herbert Read

The passing of Sir Herbert Read, who died on June 12 at the age of seventy-four, brought to a close one of the most remarkable careers in modern times. Herbert Read was probably the most famous art critic of his day, at least in the English-speaking world, and, besides being an active polemicist on a wide range of social and political questions and a poet, he was also prolific as a literary critic. He made sizable contributions to the literature of anarchism, and to educational theory—particularly the theory of art education. A complete bibliography of his writings would itself constitute a thick volume.

He was one of the last survivors of a legendary era. He belonged to the generation of Brecht and Hemingway and Robert

Graves—the generation of writers and artists whose outlook on life was permanently altered by their experience of the First World War. In the aftermath of the war, Read embarked on the career that brought him first—in the 1920's—into the circle of T. S. Eliot and *The Criterion* and later—in the thirties—into contact with Henry Moore, Barbara Hepworth, and Ben Nicholson. Thus, in the period between the wars, he was at the center of the most important literary and artistic activity in England. Like Eliot, he was a man of letters in the grand manner, taking all culture as his province and conceiving of his critical function in the widest terms.

His role as an art critic was quite different, however, from the role he assumed in the literary battles of the twenties. In the latter, he became the unashamed defender of the Romantics at a time when Eliot was leading advanced literary opinion against them. He was probably Eliot's most affectionate, if not his most powerful or persuasive, antagonist.

But Read was not, I think, either a great enough critic or a good enough poet to alter the course of Eliot's influence on literary values. When that influence ultimately abated, it was because a new generation of poets brought a quite different perspective to the practice of literature—a perspective glimpsed, perhaps, in Read's criticism, but not articulated with sufficient force to make the crucial difference.

Whatever Read may have lacked in force, however, he apparently made up in intellectual and personal generosity. Concerning this phase of his work, the English poet Kathleen Raine has drawn a vivid contrast between Read and Eliot. In a *hommage* published on the occasion of Read's death, Miss Raine wrote: "Herbert Read and T. S. Eliot each represented an aspect of the thought of their generation: Eliot, Anglican, Royalist, and classicist; Herbert Read, anarchist, romantic, resolutely resisting conversion because for him the human spirit was the thing itself; Eliot, discouraging all weak enough to be discouraged, Read encouraging all who had the desire to create."

Encouragement, the championship of the new and the unfamiliar, the defense of the modernist faith—these were the prevailing motives in Read's art criticism in the thirties, when he took up the cause of modern art and gave it an eloquent and high-minded advocacy. In this sphere, he was not confronting a mind and an imagination of Eliot's quality and refinement. He faced an easier, if

also a more amorphous and insidious, opponent: the Philistine public, which in England especially had a closed mind and a closed pocketbook to artistic innovation of any sort. Read devoted his polemical skills, his wide knowledge of art and artists, and his philosophic erudition to establishing, in the mind of this public, both the English modernists and the whole tradition of modern art as one of the central forces of the culture of our time.

Moreover, as a writer who conceived of art as an essential—perhaps the most essential—constituent of an enlightened social fabric, Read carried his defense of modern art beyond the realm of pure aesthetics. He made it a cornerstone of his attempt to effect a wholesale revision of social values. In that attempt, education was to play a major role, and his influential writings on education were, in effect, a synthesis of his social and aesthetic preoccupations. The critic of poetry and painting became the critic of society and of the social morphology of the imagination itself.

Read's career recalls us, then, not only to the critical debates of the twenties and thirties—to the spacious intellectual atmosphere in which the new literature and the new art were first elucidated and argued and tested against the social and political exigencies of the modern epoch—but to another, more specifically English tradition. This is the tradition of Godwin and Ruskin and William Morris which subjected the cultural consequences of industrialism to an unremitting moral criticism. Read's writings are witness to a period when the notion of the avant-garde—both in art and in social thought—signified an aesthetic aspiration and a spiritual vocation and not merely a temporary place on the map of fashion.

Yet Read was not immune to the temptations of what, in this context, we mean by fashion. The early champion of modern art became an undiscriminating apologist for much that was meretricious. The critic upholding an enlightened minority position became one of the most celebrated panjandrums of the international cultural bureaucracy. Wherever juries met, boards convened, exhibitions opened, symposia took place, or prizes were doled out, Read was a familiar presence. He could be counted on to lavish his prestige and his solemnity on these occasions, and he wielded real power. The critic of established institutions and received values proved to be a master at winning a place—and a high place—in the complex apparatus that administered these institutions and values. He apparently found little contradiction in being, at one and the same time,

both a pillar of the establishment and a philosophical partisan of the forces that hoped to bring it down.

To someone following his career from a distance, Read seemed indeed to dwell in two worlds—to function with extraordinary efficiency, influence, and success in the world of committees, boards, and juries—in other words, the world of power—and yet to harbor a profound nostalgia for that other world where power is questioned and attacked, where the dream of uprooting power persists as a romantic aspiration.

Nor were these divisions—I have no way of knowing whether they were also conflicts—a late development in his life. It was only that his later celebrity amplified the contradictions that had been evident from the beginning. The pacifist who accepted a military commission to fight in the First World War, the anarchist who accepted a knighthood, the intellectual—with an exalted sense of that vocation—who produced so many potboilers clearly had a gift for adjusting to the realities of life while sustaining the illusion that his ideals had transcended them.

In England, where Read's generosity to several generations of artists and writers was itself a legend, these contradictions were not much explored. His prestige remained immense, but I doubt if his influence was any longer very deep. In the end he belonged to the Philistine public, which he had wooed and won. His *Concise History of Modern Painting*—a lamentable late work of no discernible intellectual substance—was said to have sold over half a million copies throughout the world.

Certainly a remarkable career, and not one likely to be repeated. There was something admirable in Herbert Read—not only his gifts and his generosity but the social passion that animated them. But he leaves curiously little to the future, and from the perspective of the sixties, his work seems more and more to belong to the illusions—some of them wonderful illusions—than to the hard accomplishments of a great era.

June 30, 1968

3. The Strange Case of Harold Rosenberg

Men have generally more vivacity than judgment; or, to speak more accurately, few men exist whose intelligence is combined with sure taste and a judicious criticism.
—La Bruyère

The case of Harold Rosenberg is an exceedingly strange one. Here is a writer of extraordinary intelligence, with an uncommon gift for rhetoric and a wide acquaintance with the materials that form his ostensible subject matter. Few other commentators on the current art scene can equal his abilities as a phrasemaker, and none perhaps has been so successful in inducing in his readers the sensation of being admitted to the mysteries of an experience—the experience of contemporary painting and sculpture—which baffles almost as much as it attracts. Of all the resources needed by a successful writer on a difficult subject, Mr. Rosenberg has proved himself to be the master of what, in some quarters, seems the most essential: the ability to fabricate a style that does not so much elucidate its chosen themes, let alone judge them, as offer itself as a compelling substitute. Gags, epigrams, stunning figures of speech—all abound in his writing with an astonishing richness and quickness of wit.

Yet between this vivacity and the aesthetic experience that calls it forth there is a void which only a more workaday mode of criticism can fill—criticism which focuses not only on motives, intentions, and the interplay of the artist and his audience but, above all, on the actuality of the given work of art. It is this void which remains open in all Mr. Rosenberg's extensive commentaries on the art of our time. Certainly in the essays he has brought together in *The Anxious Object* (New York: Horizon Press, 1964), one feels a persistent disjunction between the author's intelligence— between everything that is represented by the wit and energy of his style—and the works of art it is meant to illuminate. The reader who is also an attentive observer of current painting and sculpture is thus left with the discomforting sensation of confronting a procession of brilliant *aperçus* which do not quite fit the objects of his experience but which, purporting to account for them, are not quite irrelevant either. The result is a kind of intellectual blur in which the general

shape of things is vaguely discernible but in an altered and unclear form—surely an unhappy fate for a body of criticism that seeks to dispel misconceptions and establish a clear picture of present achievement. An unhappy fate—but not, apparently, an unwelcome one, for my impression is that Mr. Rosenberg's criticism is widely valued more for the extravagance of its rhetoric than for the cogency of its ideas. Moreover, the public that now looks to this criticism for a clue to its own apprehensions over all the dizzying gyrations of current art is right, I think, to respond more eagerly to the glittering verbal surface of essays like those collected in *The Anxious Object* than to their intellectual substance, which is apocalyptic and facetious by turn. Stylistically these essays boast a coherence and consistency which their critical content frequently belies.

To account for the disjunction I speak of, it is essential that one understand the place which Mr. Rosenberg's criticism occupies in the development of recent American painting, for his writings on art belong to a distinct phase in the history of the New York School. They first made their appearance in the most fashionable journals at the very moment when the art itself was moving into the most fashionable galleries; and their ideas—or at least certain coinages that passed for ideas—have gained currency at a rate of speed more or less paralleling that at which prices have risen on the art market. This criticism is a product, then, not of the forties, when the basic ideology of the New York School was being formulated and acted upon in the studios, but of the fifties, when the results of this action began to enjoy a far greater public esteem. *The Anxious Object*, consisting of essays written in the sixties and subtitled "Art Today and Its Audience," is in the main an attempt to sustain the values of the fifties in the face of the radically altered situation at the present time—a situation in which the hegemony of Abstract Expressionist painting has been breached, at least in the mind of its audience, by a variety of countervailing styles. It is this loyalty to the fifties, to a time when the paintings of Willem de Kooning—for Mr. Rosenberg, always the touchstone of the age—were immensely influential, which gives to all of Mr. Rosenberg's recent writings on art that air of defensive combat which lies just below the surface of their confident rhetoric.

The task which Mr. Rosenberg set himself in the fifties was an interesting one, but it was compromised from the start by a refusal to make those necessary connections between the specification of

form on one hand, and the exposition of general ideas on the other, without which his critical objective could not be achieved. For the apparent aim of his writing in the fifties was to identify, and thus to amplify and preserve, the existential content of Abstract Expressionist painting and thereby assign to this content a radical priority over the "merely" formal means which seemed to many spectators the most striking feature of the style. Coming at a time when its first enormous success threatened to reduce the Abstract Expressionist aesthetic, in the eyes of its new public at least, to the purely decorative visual constituents of which it was to a large extent composed, Mr. Rosenberg's critical strategy might have scored a significant intellectual *coup* had he been able to establish some direct link between the existential motives of the painters in question and their characteristic pictorial forms. But it was, of course, precisely on the question of form that Mr. Rosenberg had nothing to say. Dwelling exclusively on the artist's status as a cultural insurgent, on the putative "action" of his psyche during the creative process, and on all manner of motives and intentions, he eschewed the analysis of form as an inferior, if not an altogether irrelevant, interest. This shift of critical focus away from the artist's completed work—which is to say, away from his objective accomplishment and its aesthetic commerce with historical precedent—and onto the psychodynamics of his spiritual life had an effect quite the opposite of what was intended. It alienated the visual realities of painting from the crux of the discussion, leaving the audience free to regard the creation as being little more than the psychological residue of the artist's personal crisis. In making the existential component not only dominant but all-encompassing, Mr. Rosenberg succeeded in reducing Abstract Expressionist painting to a cultural datum utterly discontinuous with the art history that actually produced it.

The refusal to traffic in questions of form is now writ large—even, indeed, celebrated—in *The Anxious Object*. A good deal of scorn is lavished upon what Mr. Rosenberg describes, in his essay on Barnett Newman, as the "present state of art criticism, with its numbing counterfeit of the shop-talk of artists about painting 'elements'—color values, light values, deep space, flat space . . ." Such criticism is even held responsible for the difficulty Newman experienced in "isolating his 'thought-complex' "—though exactly why this alleged "counterfeit" of artists' shoptalk should have impeded an artist to whom Mr. Rosenberg attributes such prodigies of

dialectical finesse is not altogether clear. What *is* clear is Mr. Rosenberg's unshakable conviction that formalist criticism, or in fact any criticism which seeks to establish a grammar of style independent of the artist's psychological predicament, robs painting of its true meaning. Castigating earlier writers on Abstract Expressionism who had been impious enough to assume that this painting was, after all, a form of art and therefore, in its essentials, susceptible to analysis, comparison, and evaluation like any other, Mr. Rosenberg writes: "The tension of the painter's lonely and perilous balance on the rim of absurdity is absorbed into the popular melodrama of technical breakthrough, comparable to the invention of the transistor. Sophistries of stylistic comparison establish shallow amalgams which incorporate contemporary art into the sum total of the art of the centuries. By transferring attention from the meaning of the artist's statement to the inherited vocabulary, modern works are legitimized as art to the degree that they are robbed of sense." Evidently for Mr. Rosenberg the "artist's statement," his "sense," has no very profound connection with his "inherited vocabulary." For him, the great benefaction which Abstract Expressionism bestowed upon modern art was in bringing it to the point where "The content of paintings became more important than ever before." And since this content consists of "the artist's drama of creation within the blind alley of an epoch that has identified its issues but allowed them to grow unmanageable," it clearly lies beyond the reach of mundane critical analysis. Only a seismograph, perhaps, could accurately register such tremors.

Now if there is anything "unmanageable" here, it is the adoption of a critical method so patently designed to locate an artist's "statement" in some philosophic empyrean having little or no relation to his particular use of an "inherited vocabulary." The logic of this method is not to be found either in the "content" or in the form of Abstract Expressionist painting but rather in Mr. Rosenberg's abiding loyalty to the fifties and—what comes to the same thing—his initial misreading of this painting as a vehicle of some far-reaching cultural rebellion. This misinterpretation of what was essentially an art-centered style—a style whose principal dialectical commerce was not with grand revolutionary strategies but with other painting, and perhaps especially with the painter's "inherited vocabulary"—derived from the emphasis Mr. Rosenberg placed on conditions and criteria wholly extrinsic to the fundamental aesthetic reality of the art he

was discussing. These conditions, basically no different from those which have attended every stylistic innovation from the time of Courbet onward, were actually of shorter duration in the case of Abstract Expressionism than with many an earlier episode in the unlovely history of bourgeois resistance to aesthetic change. Placed in the context of that history, moreover, Abstract Expressionism constitutes the last chapter of such resistance; thenceforth the affirmation of change became the hallmark of bourgeois interest in the arts and remains so today. The social factor, even with Mr. Rosenberg's existential embellishments, proved in any case to be very shaky ground on which to base a theory of art: conditions thought to be central to the Abstract Expressionist enterprise had already undergone drastic alteration by the time the theory could be published in book form in *The Tradition of the New* (1959). An art upheld as *maudit* had shortly become *à la mode*; and a criticism so heavily indebted to the sociology of taste—a sociology beautifully embroidered with philosophic and psychoanalytic ornamentation— was revealed as having touched on nothing essential to the *art* in question.

Writing in the sixties, it is of course impossible—even for Mr. Rosenberg—to ignore the altered relation that now obtains between the artist and the public. He does indeed have many wise observa- tions to make about this public, which, as he correctly notes, "is the major phenomenon that art will have to deal with in the decades before us." And he scores some telling points against the Pop artists, whose work he identifies as part of the trend "toward an art that accommodates itself to a prepared taste . . ." As an analyst of the social scene in which artistic values are now being manipulated as counters in a game of culture, Mr. Rosenberg is usually a good deal more persuasive than as a critic of the authentic art which is being degraded in the process.

In the end, though, Mr. Rosenberg's case against the accom- modations and manipulations of the current scene is based, not on any clear recognition of what is genuinely new and serious in the art of the present moment but on his all-consuming nostalgia for the fifties. In a delicious flight of semantic flimflam, he even confers a kind of timeless historical priority on that decade: "Speaking of the current situation in American art, all that can be said definitely is that Abstract Expressionism is no longer the latest mode, though it may well be the newest in terms of potential originality and depth."

Thus, the much-vaunted Tradition of the New turns out to be only the Tradition of Abstract Expressionism; the very idea of the "New" is revealed to be the exclusive prerogative of a style that already belongs to the past.

Foremost among the practitioners of this style, in Mr. Rosenberg's canon, is de Kooning; *The Anxious Object* is, in some respects, only an elaborate setting for the author's panegyric of this artist. The two essays devoted to de Kooning are heavy with the atmosphere of worship; here irony is reserved only for the painter's critics, while a kind of hushed solemnity imparts to the reader the distinct feeling that something more than "mere" art is being discussed. True, at one point in his account of de Kooning's paintings of the late forties—still, I believe, the high point in this artist's *oeuvre* to date—Mr. Rosenberg falters in his resolve and indulges in the despised "counterfeit of the shop-talk of artists about painting 'elements,'" and thus refers to the painter's effort to "resolve the conflict between 'deep' and 'flat' space . . ." But this glimpse into the actual morphology of de Kooning's style is brief, to say the least, and is pretty much swamped by an overambitious attempt to turn the artist into a Symbolist poet—the Rimbaud of American painting. (Melville, too, is invoked at the last minute.) Except for some portentous references to "hurricanes of paint" and the like, that is the last we hear of painting "elements" in this account of an artist in whose work the "inherited vocabulary" has probably played a more crucial—and, in his pictures of the fifties and sixties, a more defeating—role than in that of any other member of the New York School.

Underlying this overinflated defense of de Kooning—a serious artist in serious trouble who is ill-served by praise so obviously divorced from the real problems of his art—is the unacknowledged critical war that is being waged in *The Anxious Object* against the ideas of Clement Greenberg and their influence in establishing, in some quarters, the work of Kenneth Noland and the late Morris Louis in the direct line of succession to the New York School of the fifties. This war also entails a gentle but firm downgrading of the role of the late Jackson Pollock in creating the New York School. (About de Kooning's own remark, that "Jackson broke the ice for us," Mr. Rosenberg writes: "It is possible, to paraphrase Lady Macbeth, to stand not on this order of the breaking.") De Kooning is thus made the principal repository of all that is authentic in the

New York School; his vast army of imitators is looked upon as constituting the "little masters" of this school; and nearly everything lying outside the de Kooning shadow—which, so far as abstract painting in the sixties goes, means nearly everything that remains interesting—is rejected in a language of ridicule not very different, really, from that employed by the celebrated Philistines of yesteryear.

The outstanding exception to this rule is the work of Barnett Newman. Nowhere in *The Anxious Object* is Mr. Rosenberg's reliance on non-visual, non-formal, extra-artistic criteria more flagrant than in his essay on this artist. But this evasion of pictorial analysis clearly has its uses: it enables the critic to accept Newman—he belongs, after all, to the beloved fifties—and reject the artists favored by Mr. Greenberg without confronting a single one of the concrete artistic issues that unite them. For myself, Messrs. Greenberg and Rosenberg both leave out rather too much of what is valuable in current art to be taken as wholly reliable guides, and Mr. Greenberg is certainly at times excessively gnomic in his pronouncements. But it can be said of Mr. Greenberg's criticism, as it cannot of Mr. Rosenberg's, that it remains focused on the artist's actual pictorial accomplishments and is not given to confusing them with "ideas" that, whatever their intrinsic interest, have only the most extrinsic relation to the making of paintings. The ease with which Mr. Rosenberg accommodates Newman's art to his existential outlook, and the vehemence with which he bans younger artists pursuing similar—and, in my view, more interesting—objectives, betrays his criticism as being, essentially, the performance of a theoretician. In this sense, it belongs less to "Art Today" than to "its Audience."

1965

VII. Into the Seventies

1. "Information"

The other day I went over to the Museum of Modern Art for the press preview of the new "Information" show. As it happened, the show was not yet fully installed. Much of the machinery wasn't working. Some of the—what shall we call it?—visual data was not yet in place. There were few wall labels identifying the—what shall we call *them?*—contributors to the exhibition. None of this was unusual. Museum staffs work on very tight schedules. Even the most conventional exhibitions involve head-cracking logistical problems, and "Information" is no conventional exhibition. In any case, the absolute deadline for getting everything into place is not the press preview, which takes place during the day, but the poshier preview, complete with free drinks and "beautiful people," which takes place in the early evening.

I've never acquired a taste for "beautiful people," and I prefer, as a general rule, to do my drinking sitting down. So I decided to wait until the next day before having another look at "Information" in its completed state. Before I could get to the museum the next day, however, something interesting happened to me on the way to the office. I picked up a copy of the July 6 issue of *New York* magazine, fresh on the stands that morning. Imagine my surprise when I found the magazine's art critic and versatile *homme des arts*—John Gruen—pronouncing the "Information" exhibition "a show that is altogether fascinating and illuminating."

How amazing, I thought. My mind was suddenly aglow and agog with admiration for the miracle of modern communications. Writing about "Information," Mr. Gruen remarked: "These new young artists have observed how newspapers, films and periodicals disseminate information in a matter of days, hours, or minutes," and instantly I knew what he meant. Wasn't he, after all, giving us a marvelous demonstration, right here in *New York* magazine, of the unprecedented speed with which "information" is disseminated in the media these days? This was the purest case of the medium being the message I had ever personally observed.

There was, for me, a further thrill to be had from Mr. Gruen's remarks. They suddenly reminded me that I, too, am in the "information" business, even as Mr. Gruen and a few million other people

are. And—just imagine!—here are "new young artists" drawing their inspiration from, as the saying goes, *our thing! Wow!*

But then, just as suddenly, an ugly thought began to take shape in my mind—a really distressing and disillusioning thought. For it occurred to me that, despite the miracle of modern communications, magazines had still somehow to be printed. They had somehow to be bound. They had somehow to be delivered. I thought of all those clogged crosstown streets in Manhattan which trucks delivering this latest number of *New York* magazine had somehow to traverse in order to bring me Mr. Gruen's—what shall we call it?—"review." Speed is certainly one of the essential ingredients in the miracle of modern communications, but it remains utterly foreign to Manhattan's crosstown traffic. I began to brood about deadlines. In the "information" business, you brood a great deal about deadlines. I have no idea what the deadline for late copy is at *New York* magazine, but I was reasonably certain it had to be more like "days" than like "hours" or "minutes" before the magazine had come to hand. I could hardly bring myself to face the awful truth, but there was no resisting it. Mr. Gruen could not have seen the "Information" exhibition before disseminating his own bit of "information" on it. Alas for the miracle of modern communications.

A few hours later, my faith in this vaunted miracle rudely shaken, I returned to the "Information" show. Kynaston McShine, the museum's Associate Curator of Painting and Sculpture, who organized the show, was good enough to take me on a lengthy guided tour of the exhibition, explaining the rationale—or should I say the irrationale?—of each item in it. I must confess I found it difficult at times to follow his discourse. The night before I had spent some time examining the—what can one call it?—souvenir album which Mr. McShine had put together in lieu of a catalogue of the exhibition. I was particularly struck by the list of "Recommended Reading." Had Mr. McShine himself read the "Recommended Reading"? Did it have any relation to the exhibition? I was too embarrassed to ask. After all, Mr. McShine has been very busy assembling this exhibition, which brings together more than 150 "artists"—amazing, isn't it, how people will cling to these outmoded expressions?—from fifteen countries. When could he have found the time to read Jurgen Ruesch and Gregory Bateson's *Communication: The Social Matrix of Psychiatry* or Mao Tse-tung's *Problems of Art*

and Literature or Manuel Villegas Lopez's *El Cine en la Sociedad de Masas: Arte y Comunicación?*

Mr. McShine's "Essay" for the souvenir album was, on this question, no help at all. But it did raise another interesting question: "If you are an artist in Brazil, you know of at least one friend who is being tortured; if you are one in Argentina, you probably have had a neighbor who has been in jail for having long hair, or for not being 'dressed' properly; and if you are living in the United States, you may fear that you will be shot at, either in the universities, in your bed, or more formally in Indochina. It may seem too inappropriate, if not absurd, to get up in the morning, walk into a room, and apply dabs of paint from a little tube to a square of canvas. What can you as a young artist do that seems relevant and meaningful?"

The "Information" exhibition is Mr. McShine's answer to this question. The "relevant and meaningful" thing to do in the face of this grave political crisis is, apparently, to look at inane films through an Olivetti "visual jukebox," ask spectators questions on closed-circuit, delayed-tape television, scrawl circles and other graffiti on the walls, go to town with the Xerox machine, collect a lot of pointless photographic junk, listen to a poem on the telephone, or simply go to sleep. Never mind what any of this has to do with Claude Lévi-Strauss's *Structural Anthropology* or Herbert Marcuse's *Eros and Civilization* or George Steiner's *Language and Silence*— more of the "Recommended Reading." Such questions are, I guess, irrelevant and impertinent. For Mr. McShine and his "artists," they don't qualify as "information."

July 12, 1970

2. Art and Politics: Incursions and Conversions

The cultural landscape here has lately been the scene of some re-markable incursions and conversions. Politics—or at least some ideological simulacrum of politics—has finally penetrated the New York art world where the word "revolution" has heretofore signified nothing more violent than the decision to paint a picture in a single color or attach a hot-water bottle to its surface. Artists, critics, and museum personnel who, until just the other day, were pleased to pretend that even the barest awareness of the social implications of their professional pursuits constituted an intolerable violation of the purity of their tasks, have suddenly come forward as—well, as what? Revolutionaries? Hardly. Fellow-travelers of revolution? Not exactly. The problem, alas, is to discover precisely what the real scenario is behind the noisy chorus of radical affirmation which is now being heard in all the most fashionable purlieus of the art establishment. The air crackles with revolutionary rhetoric. Yet it is very difficult to make out the exact political or cultural content of so many words, so many slogans, so many gestures and threats de-signed to suggest that some momentous change has already over-taken us. The actors in the drama are, to be sure, political amateurs. Their own realm of competence—such as it is—is drastically limited to the narrow and highly specialized world of aesthetic innovation— a world that, for decades now, has been deliberately sealed off from the kind of social oxygen that animates politics of the common, vulgar sort. It is no wonder, perhaps, that those suddenly emerging from a long hibernation in this rarified atmosphere should suffer the ideological equivalent of a severe case of the bends.

Thus, Barbara Rose, the art critic for *Vogue* magazine and author of a stylish history, *American Art Since 1900*, stood up before a conference at the Guggenheim Museum a few months ago and announced that henceforth modernist art together with all the picayune critical discriminations that have followed in its wake must be consigned, as it were, to the trash heap of history. What the future needs, Miss Rose averred, is an art that will appeal—without difficulty, complexity, or snobbery—to the masses: the visual equivalent of Rock. High art was condemned as elitist, divisive, and undemocratic. Our speaker, who for the better part of a decade had

been at the nerve center of the art establishment, writing articles and organizing exhibitions eloquently promoting every new artistic innovation as a miracle of artistic accomplishment, had suddenly discovered to her horror that art existed as a commodity, that it enjoyed a certain relation to money, class, publicity, the market, and all the other ills that capitalist culture is heir to. Her indignation was impressive. The pseudo-Leninist phrases poured forth with evident emotion. One had the impression of a speaker suffering the agony of her first contact with the real world—not the best position, perhaps, from which to frame ultimate pronouncements on the future of culture, but one which clearly lent a certain urgency to her appeal. Precisely what changes she contemplated in her own career were a little less clear, however. Also unclear was whether her new monograph on the art of Claes Oldenburg, then in the press and now published (complete with glossy vinyl cover) by the Museum of Modern Art, represented her new political militancy or the old critical allegiances she was then in the very process of repudiating. Who could tell for certain without a score card?

Then there is the bizarre case of Robert Morris, the doyen of the Minimal sculpture movement who, such a short time ago, so excited Miss Rose's enthusiasm because the new style he had done so much to create, to explain, and to spread far and wide promised us the ultimate in aesthetic experience—the "equilibrium of a passionless nirvana," as Miss Rose herself once described it. In that all but forgotten, faraway epoch—1965—when such phrases were much on the lips, or at least in the catalogue introductions, of "advanced" spokesmen for the arts, Minimal sculpture was said to be "uncollectable," and thus truly radical and subversive, a crushing blow to bourgeois tastes and values, resistant even to the capacity of the museums to assimilate (and therefore compromise) its unique disruptive force. Somehow, though, the "uncollectable" managed to pass into collections—and at nice prices, too—after all. There is nothing that the art establishment likes so much, of course, as a powerful assault on its sensibilities—such "blows" to bourgeois self-esteem have long been the special pleasure of collectors (both in and out of the museums) whose purchases do so much to determine the new canons of taste. Mr. Morris's own brand of this "subversive" art was thus treated to three major museum exhibitions—in Washington, Detroit, and New York—in the past year alone.

But last spring Mr. Morris emerged in a new role—one might

almost say, *the* new role. He closed down his exhibition at the Whitney Museum as a gesture of protest against the invasion of Cambodia, the condition of the blacks, and the repressive policies of the government. (It would be interesting to know, incidentally, exactly how Mr. Morris felt about war, racism, and repression last fall when he agreed to install a major retrospective exhibition of his work at the Corcoran Gallery in Washington, practically on the doorstep of the White House). In his capacity as a leader of the newly formed New York Art Strike, Mr. Morris then attempted to close down all the other museums in the city. The notion that this country's ruinous foreign policy or the Nixon administration's attitudes toward racial justice and law enforcement might be modified in the smallest degree by a campaign to prevent people from, say, looking at the Rembrandts in the Metropolitan Museum—not, so far as I know, a favorite haunt of the President, the Secretary of State, or the Attorney General—is a fair measure of the kind of political intelligence that has now, overnight, come to engage the energies of a small but highly vocal band of artist-militants who have demonstrated their capacity to disrupt the normal operations of our institutions, capture the attention of the mass media (whose values they decry but whose dynamics they are expert in manipulating), and generally cause havoc in one of the few sectors of our culture to have remained more or less free of political interference.

Other demands have also been heard. The museums have been denounced for their undemocratic policies. More space, money, attention, and—alas—praise have been insisted upon for the work of black artists. Above all, the demand has been made to give "artists" (meaning, of course, only certain artists) more of a "voice" (meaning, of course, the dominant voice) in making policy wherever and whenever contemporary art—or indeed, the showing of art of any period—comes under institutional sponsorship. It is assumed as a matter of course that museums refusing to make official policy statements denouncing the government are mere stooges for the Nixon administration. There have also been some suggestions for "taxing" the sale of art works in the galleries as forced contributions to radical causes, and so private dealers, too, may find themselves in the political cross-fire when they reopen their galleries in the fall.

The intellectual strategy of this political assault is a familiar one, of course—the strategy of a pampered elite making claim to the

political status and the moral imperatives of a woefully exploited underclass. What is most interesting, however, is not the extent to which the efforts of Mr. Morris and his comrades—many of whom have, like Miss Rose, succeeded in riding every wave of avant-garde fashion for much of the past decade—have adopted the strategies of the student movement in presenting themselves as the injured "niggers" of an oppressive system. In this respect, they are merely following the current style of political double talk. No, what is most interesting—and most alarming—is the unacknowledged contempt for art itself which is so clearly implied in this campaign to impose political criteria on every decision affecting the creation and exhibition and judgment of works of art. For in this new political scenario, art is assumed to have no defensible social functions apart from its alliance with specified political objectives.

What has happened, of course, is that the sacred pretensions of the so-called avant-garde have been overtaken by the actual events of history. All those vaunted "revolutions" in sensibility, announced with such regularity every time an artist decided to make an oversize object or adopt some new material, have now been exposed by the cruel realities of the political process to be nothing but *aesthetic* events, and aesthetic events of a rather small compass. Suddenly deprived of the cherished fiction that they represented some sort of "revolutionary" vanguard in making a fetish of artistic novelty, the spokesmen for everything "far out" on the art scene are experiencing a profound demoralization with the very concept of art as a disinterested creative enterprise, and they are hastening to fill the moral vacuum left by this disenchantment with their self-proclaimed historical mission by latching on to some of the debased notions of populist culture currently emanating from the New Left. Their new posture cannot, I suppose, be a very comfortable one, for it has obliged them—especially in their support of black demands for greater representation in the museums regardless of the aesthetic quality of the work in question—to uphold certain critical positions which contradict everything they stand for in the aesthetic arena. But their need is great, and consistency—which is to say, intellectual integrity—is, apparently, easily sacrificed in its behalf.

It has been left to John B. Hightower, the new Director of the Museum of Modern Art, to carry this development to its logical absurdity. Mr. Hightower is a political protégé of Governor Rockefeller and is totally lacking in either the training or the experience

that would normally be required in a candidate for the position he has now assumed. But the good opinion of Mr. Rockefeller counts for a great deal at the Museum of Modern Art (where the Governor and his brother David, both eminent collectors and lavish bene-factors, more or less call the shots), and Mr. Hightower lost no time in proving that when it comes to being "with it," he could compete with the best of them. Immediately upon assuming his new position, he announced that, "I happen to think that everybody is an artist." This sobering revision in traditional estimates of the artistic enter-prise may or may not have come as a shock to the Governor and his brother, who have invested some rather large sums of money on the quite different assumption that certain talents—say, Picasso's or Cézanne's—do, after all, differ from the common run. As for the museum's large curatorial staff, who are paid to make precisely the kind of discriminations their new director had declared obsolete, one can only guess at their feelings.

Despite strong temptations to the contrary, we must assume—if only as an hypothesis—that Mr. Hightower is no fool, however. As a political functionary, he had learned long ago to make the kind of noises that would placate the plebes, and the plebes in this case were the various radical groups that were already pressing the museum (in the form of meetings and demonstrations) to accede to their demands. A wholesale affirmation of the populist notion that there are no essential differences between the work of artists and non-artists (not to say, between some artists and others) must have seemed a small enough price to pay for a little peace at the front entrance. Mr. Hightower showed himself straightaway to be a master at winning such short-term reprieves. It seems never to have oc-curred to him that he might someday have to deliver on his implied promises, or what the cost of that delivery might be in terms of the integrity of the institution he was now presiding over.

Thus, on the most highly charged of all the issues confronting the museum—the question of establishing a special wing or center exclusively for black artists—Mr. Hightower offered us still another of his rhetorical pirouettes. For some months preceding Mr. High-tower's appointment, the Art Workers Coalition had been campaign-ing for the establishment of a Martin Luther King Study Center, to be devoted, of course, to black art, at the museum. (The original demand was for a special wing, but the idea was later transformed

into a demand for a "study center.") The most vocal and energetic leader of this campaign was a black artist named Tom Lloyd, and when Mr. Hightower was asked for his opinion of this proposal in the course of an interview in the May issue of *Arts Magazine*, he replied: "Gee, if Tom wants to force this demand on the Museum of Modern Art to have a Martin Luther King Study Center I wish him well—I think it is a great idea!"

Later on he hedged a bit—hedging, you might say, is Mr. Hightower's favorite choreographic gesture—and suggested that it might be a better idea to name the study center after Langston Hughes. Now this was an interesting development. Why, one wondered, Langston Hughes, who was a poet but not, so far as I know, a practitioner of the visual arts? Was it—just conceivably—because even Mr. Hightower, with the best will in the world, could not think of a single modern black painter or sculptor whose achievement was sufficient to merit having this new institution named in his honor? This is not the kind of question that you will hear much discussed among members of the Art Workers Coalition, the New York Art Strike, or other radical artists' groups, but it happens to be central to the issue. However painful the truth may be and no matter how profound our political indignation may be over the historical conditions that have produced this unfortunate truth, the fact is that black artists in this country have not yet produced a body of work which has earned, by virtue either of its quality or of its special, identifiable artistic characteristics, a separate museological status. Mr. Hightower could scarcely bring himself to make such an ideologically unpopular admission, but his spontaneous suggestion about Langston Hughes was an eloquent, if unconscious, affirmation of it.

Still, he was not done hedging the issue. In July, when he was interviewed on the "Today" show and asked how he felt about establishing a separate black wing at the museum, Mr. Hightower now replied: "I would much rather show, on perfectly equal terms, the works of good artists, black, Puerto Rican, white, whatever they are." What in May had been a "great idea" had, apparently, lost something of its greatness two months later.

You might suppose that Mr. Hightower had learned something—if not about art, then at least about the way in which a man in his position might want to consider the exact meaning of the

words he uses in public utterances. But this, unfortunately, was not the case. Here he was again, writing in the July 18 number of the *Saturday Review:*

> We hear much about "quality" and "standards" when suggestions are made for altering accepted credentials for academic acceptance or artistic excellence. We also hear much about "cultural deprivation," which means, of course, that people in black and Puerto Rican neighborhoods do not hear white symphonies or see white plays; and it implies that the culture of the ghetto is primitive compared to white culture. Yet, the black and ethnic sections of cities are, quite to the contrary, where the arts are most immediate and full of life. If there are any culturally disadvantaged ghettos, they are probably to be found in white suburbs.

Was this, then, a plea for special subsidies and preferential treatment for the "culturally disadvantaged" white suburbs? Hardly. And if the artistic vitality of the urban ghettos could boast such optimum accomplishments, what was there left to do? One had to remind oneself that this was no "black power" militant speaking but the Director of the Museum of Modern Art, a man for whom the words "quality" and "standards" had clearly become politically distasteful, even hateful.

There is, I think, a tiny bright spot in this dismal picture, though it hardly compensates for all the harmful nonsense and the really egregious dishonesties it has brought in its wake. The politicization of the art scene has washed up, at least for the foreseeable future, all those fantastic "revolutionary" claims which for years have dominated the discussion and promotion of new art. Henceforth it will be impossible for publicists of the new to lavish upon every technical innovation in the arts a language borrowed with impunity from the real revolutions of the past, for now they run the risk of being laughed at—or worse. This is admittedly a very small victory for intelligence, but it is the only one I can discern on the cultural landscape at the moment.

Fall 1970

3. Avant-Gardism

For the casual visitor to exhibitions of new art, for the innocent reader of the art columns of the weekly news magazines, and, in general, for the large public that eavesdrops on the current art scene without actually following it with any serious concern—for all such innocents, it must often seem that the art world, or at least that part of it engaged in the production of new and far-out styles, is a virtual monolith of publicists, ideologues, bureaucrats, and tastemakers laying down this or that "line" for any given season. The reality, of course, is something quite different. It is much more a crossfire of competing orthodoxies than anything resembling even a temporary unanimity of opinion or pressure. The true scenario is, more often than not, a scenario of intellectual conflict, frequently expressed with a fierce contempt for rival points of view.

Everyone who belongs to the art scene is keenly aware of this conflict; it is only the outsiders—the intellectual provinces, as it were—who miss its significance in their effort to embrace the newest reputations. In this sense, at least, the art columns of *Time* and *Newsweek,* with their breathless celebrations of the latest thing, belong to the provinces, where it is usually deemed more important to "keep up" than to exercise any sort of serious discrimination.

From time to time, however, the conflict within the art world is articulated with a force that makes itself felt even on the anesthetized periphery. In the music world, we had a notable example of what I mean when, earlier this season, no less a figure than Virgil Thomson pronounced the work of John Cage "emotionally shallow." In his essay on "Cage and the Collage of Noises," which forms a chapter of Mr. Thomson's book, *American Music Since 1910* (Holt, Rinehart and Winston), we were treated to the following verdict on Cage's aesthetic philosophy: "He prizes innovation above all other qualities—a weighting of the values which gives to all of his judgments an authoritarian, almost a commercial aspect, as of a one-way tunnel leading only to the gadget-fair." Such pronouncements, you may be sure, have consequences.

And now, if I'm not mistaken, we have been given another such utterance, also dealing with the question of "innovation," in an important essay by Clement Greenberg called "Counter-Avant-Garde." It appears in the latest number of *Art International* (dated

May 20), which is published in Lugano, Switzerland. Mr. Greenberg is here concerned to distinguish between genuine "advanced art of superior quality" and what he calls "advanced-advanced art"—between the authentic avant-garde and art that is merely "avant-gardist." His essay is thus an analysis of "avant-gardism" as an art-historical phenomenon, especially as it has manifested itself in the art of the past decade. It traces the degeneration of the avant-garde into its more spectacular "avant-gardist" simulacrum, which he regards as a new form of academicism.

The key figure in this history is, of course, Marcel Duchamp. "The Futurists discovered avant-gardeness," he writes, "but it was left to Duchamp to create what I call avant-gardism. In a few short years after 1912 he laid down the precedents for everything that advanced-advanced art has done in the fifty-odd years since. Avant-gardism owes a lot to the Futurist vision, but it was Duchamp alone who worked out, as it now looks, every implication of that vision and locked advanced-advanced art into what has amounted to hardly more than elaborations, variations on, and recapitulations of his original ideas."

With Duchamp, according to Mr. Greenberg, the whole notion of "originality" in art was altered—indeed, perverted, into an act of will. "All along the avant-garde had been accused of seeking originality for its own sake," he writes. "And all along this had been a meaningless charge. As if genuine originality in art could be envisaged in advance, and could ever be attained by mere dint of willing. As if originality had not always surprised the original artist himself by exceeding his conscious intentions."

Mr. Greenberg continues: "It's as though Duchamp and avant-gardism set out, however, deliberately to confirm this accusation. Conscious volition, deliberateness, plays a principal part in avant-gardist art: that is, resorting to ingenuity instead of inspiration, contrivance instead of creation, 'fancy' instead of 'imagination'; in effect, to the known rather than the unknown. The 'new' as known beforehand—the general look of the 'new' as made recognizable by the avant-garde past—is what is aimed at, and because known and recognizable, it can be willed."

Mr. Greenberg then establishes an illuminating parallel between Duchamp's relation to Cubism and the relation of the avant-gardists of the 1960's to Abstract Expressionism (and particularly to Jackson Pollock). Duchamp, he writes, "would seem to have

attributed the impact of Cubism—and particularly of Picasso's first collage-constructions—to what he saw as its startling difficulty; and it's as though the bicycle wheel mounted upside down on a stool and the store-bought bottle rack he produced in 1913 were designed to go Picasso one better in this direction. Young artists of the 1960's, reasoning in a similar way from this misconception of Pollock's art, likewise concluded that the main thing was to look difficult, and that the startlingly difficult was sure to look new, and that by looking newer and newer you were sure to make art history."

The burden of Mr. Greenberg's essay is to chart the exact route by which this false quest for the "newer and newer" leads only to academicism in avant-gardist disguise. His essay abounds in complex discriminations which cannot be easily restated here. Suffice to say that anyone who has pondered the relation between "raw" art— "art at large, art that is realized or realizable everywhere, even if for the most part inadvertently, momentarily, and solipsistically"—and what Mr. Greenberg calls "art proper, public art," will find the issue brilliantly clarified. And on the role of taste, tradition, and expectation, on the phenomenon of "avant-gardist medium-scrambling," even on the issue of art's capacity "to move and elate you," Mr. Greenberg has much to say that illuminates both the public success and the aesthetic failures of the far-out art of the past decade.

In a final reference to "conceptualist art," Mr. Greenberg remarks: "as though boredom did not constitute an esthetic judgment." Which reminds one of Mr. Thomson's comment on Cage's musical compositions: "They do not seem to have been designed for holding attention, and generally speaking they do not hold it." It begins to look as if the 1970's are going to be an interesting decade.

June 13, 1971

4. And Now . . . Pop Art: Phase II

Ten years ago the Sidney Janis Gallery mounted an exhibition called "New Realists," which effectively launched the Pop art movement on the New York art market. Now the same gallery has organized another large show, this one called "Sharp-Focus Realism," in yet another attempt to blitz the art market and make history. The first of these events was, as all the world knows, a howling success. It was also, as so many successes are nowadays, a very great disaster. Not since the Pyrrhic victories of the Pre-Raphaelites in Victorian England had the taste and standards of the professional art world been so radically debased. For a sizable portion of the art public, the whole notion of artistic seriousness was altered—altered downward, it must be said, to a level where an insidious facetiousness and frivolity could pass muster as an attitude of high endeavor.

Although the Pop movement itself is moribund, it is worth recalling its enormous negative influence on the art scene. For one thing, we are still living with the consequences of that influence, which transformed a large part of the art scene into a branch of show business, with all of its attendant ballyhoo and baloney and ersatz art. For another, we are not done with attempts to revive this movement, which proved to be such a gold mine to its original promoters. That, indeed, is what the "Sharp-Focus Realism" exhibition essentially is: an attempt to revive Pop on a somewhat revised, academic basis. Mr. Janis refers to the artists in the current exhibition as "Post-Pop Realists," but the show itself could more accurately be called "Pop Art: Phase II."

Between the "New Realists" of 1962 and the "Sharp-Focus Realism" of 1972 there are, to be sure, certain differences. Ten years ago, the rage was for the use of actual objects. (Remember the small refrigerator whose door opened to the sound of a fire siren? In what Park Avenue salon, one wonders, does that odious little memento of the New Realism currently reside?) Now the emphasis is on fool-the-eye illusionism and outright illustration. This shift of emphasis has brought with it a significant change in attitude about technique. Whereas formerly the attitude toward any sort of high technical finish was either ironic or openly hostile, a legacy perhaps of both Abstract Expressionism and the Dada philosophy that played so large a role in the first phase of the Pop movement, now

the most painstaking technical means are employed with an unrelieved earnestness and solemnity. The aim is for a look that is flawless, impersonal, "photographic," and indeed the work is often derived from photographic materials.

Direct links with earlier Pop practices nonetheless persist. Jan Haworth's "Maid," a three-dimensional figure seated on a real chair, was included in the big Pop show which John Russell and Suzi Gablik organized in London in 1969. Marilyn Levine's stoneware "Brown Suitcase" could easily have appeared in the "New Realists" show, only then it would probably have been decorated with a few smears or drips of paint, and the suitcase itself would have been open just enough to reveal a few bits of soiled underwear. The new artists eschew all such Dadaist conceits. All that is scruffy is now out, and all that is immaculate is in.

Sharp-Focus Realism, as the Janis show defines it, is, in any case, primarily a picture-making art. (One can hardly call it a painter's art; there is so little real painting to be seen.) What we have in the work of Tom Blackwell, Don Eddy, Richard Estes, Ralph Goings, Ron Kleeman, Richard McLean, Malcolm Morley, and David Parrish is a style of picture-making based on glossy, full-color photographs of the kind usually seen in magazine ads or picture postcards. The cropping here and there may be a touch more audacious, and the craftsmanship is certainly arduous, not to say boring and mechanical in the extreme. But the taste, the subject matter, and the attitude toward the subject are all there in the original materials, no matter how the artist may alter the image. Originality—I suppose we have to call it that—consists in transferring these "found" materials to the canvas without sacrificing anything in the way of visual gloss. This, I can report, these picture-makers do succeed in doing. They are nothing if not proficient.

For the observer, however, there is an awful sense of futility in this enterprise. Someone once said that research consisted of writing out in longhand what already exists in print. Similarly, this Sharp-Focus Realism seems to be an art that consists of doing over again by hand—and larger, of course—what is already widely available in printed form. This is not an art that transforms visual clichés; it simply exalts them by means of a carefully applied technique.

But "Sharp-Focus Realism" is not itself a sharply focused exhibition. In addition to the leftovers from Pop: Phase I and what we may regard as the mainstream of Phase II, we are also offered

a number of tangential efforts—varieties of picture-making (and even some real paintings!) which bear little relation to the work that occasioned the show in the first place.

Take Guy Johnson's pictures, painted in oils on photographic paper. Brimming with charm and all sorts of amusing details, they are pure exercises in nostalgia—of interest, I have no doubt, to fanciers of antique automobiles, old postcards, and family photo albums, but having about as much relation to realism, sharp-focus or otherwise, as Queen Victoria's memoirs. Then, too, there is Paul Sarkisian's gigantic monochrome picture of the front of a ramshackle old house. It is pure illustration of a kind that went out with the Model T Ford. I first saw this picture in Berkeley last spring. I attributed the enthusiasm of the man who showed it to me to the sort of academic provincialism one frequently encounters in even the most "advanced" university art centers. Little did I know that this tired compendium of illustrators' clichés would so quickly turn up on Fifty-seventh Street as an example of—you should excuse the expression—the latest thing.

Also included in the "Sharp-Focus Realism" show are several paintings by Philip Pearlstein. They don't belong here. They are, after all, real paintings. They are painted from models, not photographs, and their whole aesthetic purpose runs counter to the values that are being celebrated in this exhibition. There is an interesting realist movement at work on the art scene just now, and Mr. Pearlstein belongs to it—indeed, he is one of its heroes—but he is the only artist in this exhibition who does.

January 16, 1972

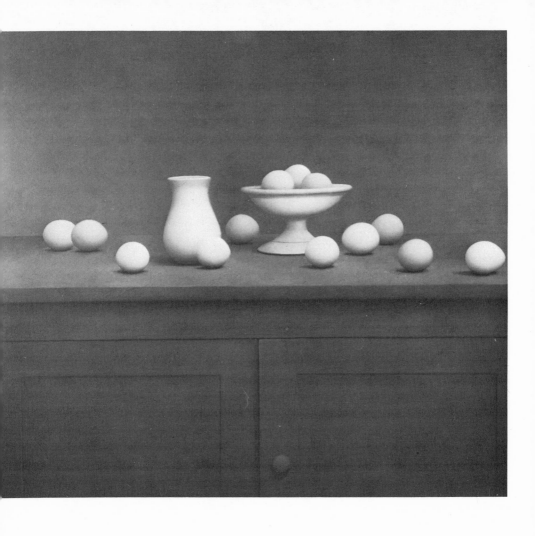

WILLIAM BAILEY: *"Still Life with Eggs, Bowl and Vase"* (*1971*)
Oil on canvas, 40 × 44″

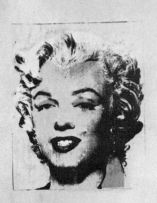

ANDY WARHOL: *"Gold Marilyn Monroe"* (*1962*)
Synthetic polymer paint, silk-screened, and oil on canvas, $83\frac{1}{4} \times 57''$
COLLECTION, THE MUSEUM OF MODERN ART, NEW YORK. GIFT OF
 PHILIP JOHNSON

5. William Bailey and the Artifice of Realism

One hears a good deal of talk these days—not in what we might call the corridors of power but elsewhere, behind the "scene," so to speak—about a "return" to realism. Certainly the galleries and the art journals seem to be a shade more hospitable to painting of a realist persuasion than they were a few years back. At least they are not quite so automatically hostile. Even the big university art departments, where realism of some sort was never entirely out of favor, now seem to accord it a new respect. At least the latest far-out inanity is not so often immediately assumed to have a greater artistic importance than a painter working directly from "life," a word that for the moment had better be left in quotation marks if we want to avoid some of the ambiguities that discussions of realism inevitably trade in.

One has heard it all before, of course. Virtually every stage in the development of modernist art has been accompanied by some pronouncement heralding a "return" to "nature" or "the figure" or some such haven from the storms of radical innovation. I remember very well indeed a panel discussion at the old Artists Club—I think the year was 1954—in which a prominent and enormously influential museum director disclosed to us his happy contemplation of a vaunted "return" to historical painting. A year before, Larry Rivers had produced his "Washington Crossing the Delaware," you see, and we were invited to judge this rather pathetic attempt at a "major" pictorial statement as the real thing. Somehow the swing to historical painting never materialized, though one still hears rumors from time to time about this or that painter secretly hoping to take the public by storm as the Emanuel Gottlieb Leutze of his time.

But all this talk about a "return" to something or other is misleading. In art, much can be renewed or revived, but we can never seriously "return" to anything in the past. We can only hope to create a new synthesis of our emotions, which, whether we like it or not, are completely hostage to the era in which we live, and what we respond to most deeply in the art of the past, whether the "past" in question is the day before yesterday or 1855 or the Age of Pericles. And there is absolutely nothing new in this. The truth is, the history of modern art has always been a good deal more plural-

istic than avant-garde doctrine has ever permitted us to believe. Edward Hopper was Paul Klee's contemporary; Fairfield Porter was Jackson Pollock's; Marsden Hartley was Marcel Duchamp's. And Philip Pearlstein is no less Kenneth Noland's contemporary than either Frank Stella or Jasper Johns.

What is new, perhaps, is our willingness now to grasp the implications of this pluralism. The old modernist orthodoxies, without being exactly discredited, have somehow loosened their hold. We have lived with the claims of the avant-garde long enough to recognize how swiftly the innovations of one season become the safe, academic formulas of the next. We are, as a consequence, a little more open to the real aesthetic diversity of contemporary art than we used to be, and a lot less certain that history decrees one style, one method, one doctrine, as the only permissible approach to art at a given moment in time.

The partisans of realism are certainly among the beneficiaries of this more relaxed attitude toward contemporary art history. It is allowing them to gain a greater visibility on the current art scene, and in the dynamics of the current scene, sheer visibility counts for a great deal. No doubt this development is going to bring us a good deal of rubbish, but no more, I am sure, than we have had to endure in the name of more "avant-garde" developments. When it comes to producing large quantities of meretricious art, no style has yet been able to establish a secure monopoly.

It is important, then, to focus attention on the few artists of real quality who may be expected to emerge from the current free-for-all. One of them, in my opinion, is William Bailey, who is currently showing thirteen paintings and a group of drawings at the Robert Schoelkopf Gallery. Mr. Bailey is, first of all, a draftsman of really breathtaking powers. His drawings of the figure, which line the wall of the corridor at Schoelkopf's, display the kind of easy mastery that tempts us for a moment to consign a great deal of the modernist canon—even the things we most value—to oblivion. Here (we are likely to feel) is the real thing—which is to say, the realist thing—with no dodges or apologies, and with that unflagging abundance of talent that promises to deliver on all of its commitments.

It isn't anything outside the gallery that prompts some serious second thoughts on the matter; it is Mr. Bailey's own paintings, which are so mysterious and so personal, so poetic and yet so

abstract, that we find ourselves obliged to invoke the burden of modernist aesthetics in the very process of coming to terms with them. Between Mr. Bailey's meticulously observed realism and the modernist abstract painting it seems to repudiate, there are, after all, continuities as well as discontinuities, affinities as well as disavowals, and the critic is brought up short with the realization that his standard vocabulary, his customary ways of approaching such matters, have not really prepared him for an art that is so intent upon establishing itself in the aesthetic space that usually separates one pictorial style from its polar opposite. The paintings put us back in touch with all the vexing problems of pictorial expression that the drawings seemed to relieve us of.

The paintings are mostly still life—traditionally, among modern painters at least, the most "abstract" of subjects, the one that lends itself to the strictest control of pictorial space and admits the smallest margin of psychological or literary association. Turning from Mr. Bailey's figure paintings, of which there are three in the current show, to his still lifes, one immediately senses a greater mastery over the formal constituents of the picture—a greater confidence in the overall design as well as in the realization of its details. By contrast, there is always in the figure paintings a literary or psychological residue that has not been completely assimilated into the form—a margin of uncertainty, perhaps, about exactly how one may turn the figure into a pictorial object without at the same time depriving it of its uniquely affective properties.

Mr. Bailey is clearly a painter who wishes to avail himself of all the resources painting can command, and he brings extraordinary reserves of intelligence as well as sensitivity to the task. It is not the least of his merits that he forces us to reconsider the nature of realism and its relation to modernist art. He forces us, indeed, to come to terms with the large element of aesthetic artifice upon which realist art is based. He is certainly one of the most interesting and one of the most accomplished painters of his generation, and one that we shall be obliged to keep track of in the hurly-burly of styles and counterstyles that is now upon us.

October 31, 1971

6. Andy's "Mao" and Other Entertainments

Looked at from the vantage point of the early 1970's, the career of Andy Warhol already seems to belong to a distant historical era. The antics of the Exploding Plastic Inevitable, the mixed-media light show Warhol produced for a New York discotheque—the Velvet Underground—in 1965–6, seem as remote from current standards of chic as the pointed-toe shoes the artist once made a handsome living illustrating, and the giddy crowd that once flocked to *The Chelsea Girls* and *Lonesome Cowboys* has since turned to the hard-core pornography of *Deep Throat* for the requisite combination of kicks, giggles, and aesthetic transport. The deadpan paintings of Coke bottles and Campbell Soup cans have now passed into the hands of the museums and the art historians, objects of solemn study on which students take exams and professors promulgate theories. The put-ons of the sixties are now established classics (and valuable investments), the once ubiquitous celebrity of "the scene" now installed in the modern pantheon as a master.

By the time the Pasadena Art Museum came to organize a Warhol retrospective in 1970—a show that toured the European museums and came to the Whitney in New York a year later—even his fondest admirers had reason to wonder if this phenomenal career had come to an end. "Warhol's career as a painter and even a movie-maker may or may not be over," John Coplans wrote in 1970. "Only the future will answer this. . . . like Duchamp, whom he so ardently admired, here is a man who now only speaks when he has something to say."*

This concern about a protracted Duchampian silence was, it turned out, premature. In the fall of 1972, precisely ten years after his debut as the coolest of the Pop iconographers, Warhol exhibited a new series of silk-screen portraits of Mao Tse-tung. His timing was, as usual, perfect. President Nixon, it will be recalled, had just succeeded in rendering the benign countenance of the venerable Chairman as familiar and acceptable to the American public as that of Marilyn Monroe or Jackie Kennedy—two earlier favorite subjects of the artist, whose work, as Mr. Coplans put it in a characteristic statement, "almost by choice of imagery alone it seems, forces us to

* *Andy Warhol* (Greenwich, Conn.: New York Graphic Society, 1970), p. 52.

squarely face the existential edge of our existence." Chairman Mao had indeed—thanks to the combined efforts of the White House and the mass media—become something of a Pop icon in 1972, and Warhol was quick to see that such an image was now as ripe for aesthetic conversion as Elvis Presley had been a decade before.

At the same time, for the opening of the new Art Museum of South Texas in Corpus Christi, Warhol came up with several other new portraits, one of these of Philip Johnson, who designed the new museum. For this occasion, Warhol also appeared in a short documentary movie, filmed in the architect's offices, doing his now-familiar turn as the art world's lovable idiot-ingénue, speaking in facetious non sequiturs and uninterruptedly snapping Polaroid pictures of all those present—the *données*, no doubt, of still more portraits to come. Whether or not he now had "something to say"—whether, alas, he had ever had anything to say—might be argued, but there seemed little danger that Warhol would not continue to be heard from.

Still, if Mr. Coplans was wrong about the Duchampian silence, he was right in suspecting that a significant change had occurred. As an art movement, of course, Pop art had already been in eclipse for several years. Even before the sixties had run its course, the spokesmen most closely identified with Pop's sensational success had begun to adopt a more studied, "historical" view of its accomplishments. Thus, when Henry Geldzahler, the Curator of Contemporary Arts at the Metropolitan Museum who had been the movement's most visible and energetic booster, even becoming a Pop celebrity himself in the process, mounted his mammoth historical show of "New York Painting and Sculpture: 1940–1970" in 1969, he used the occasion to place a certain distance between himself and his once favorite artists. "It seems today that Pop Art was an episode, an interesting one that has left its mark on the decade, and will continue to affect the future, but not a major modern movement which continues to spawn new artists," he wrote. "In fact, just about everything new and original in Pop Art was stated by a few artists in the first years of its existence."*

But Pop art, insofar as there was anything "new and original" about it, was, from its very beginnings, always something more than—something a little different from—an art movement. Its prin-

* *New York Painting and Sculpture: 1940–1970* (New York: E. P. Dutton, 1969), p. 37.

cipal appeal was never primarily aesthetic, though it succeeded for a while in effecting a considerable alteration in aesthetic values. Its appeal was social, and its profoundest effect was not on serious art, which it exploited and for a time demoralized, yet left fundamentally unchanged, but on the art public. This it changed to an extraordinary degree. Under the guise of representing the latest "advance" in avant-garde innovation, Pop art actually addressed itself to the largest possible audience—an audience that was suddenly and gratefully relieved of having to deal with all the legendary difficulties that modernist art had always been said to interpose between the public and its ability to accept new artistic vocabularies. In place of complex ideas and hermetic images, of forms that had somehow to be parsed before they could be fully experienced, Pop offered a familiar iconography and a flip, easy irony. Everything in the new art was instantly recognizable, instantly assimilable, and if this were not sufficient to guarantee its immediate success, Pop also enjoyed the advantage of offering this public a kind of revenge on the past, on all that obnoxious seriousness to which it had been obliged to pay lip service in the name of high culture. Now high culture was shown to be just another gag, another put-on, its despised scruples and distinctions an easily penetrated tissue of pretenses, and to qualify as a communicant, one now needed little more than a liberated sense of humor and a knowledge (painlessly acquired from the media) of where "it"—the latest thing, the thing that would up the ante in facetiousness and "going too far"—was at.

Pop art was never a mass art, but it nonetheless enlarged the art public as nothing else ever had, bringing to its altered confines larger numbers of the young, the hip, the chic, the newly rich, and the intellectually curious than had ever before been attracted to an art movement. This new audience was not only without serious aesthetic standards but, so far as painting and sculpture were concerned, very largely without any real aesthetic experience. It looked to Pop music, the movies, the world of fashion, and the gossip column—and to the fantasies of fame and sexual privilege spawned in their public legends—for its touchstones of quality and success. It was, in short, an audience thoroughly bemused by the myths of popular culture but differentiated from the mass audience by virtue of its consciousness of its own taste—a taste prepared to embrace whatever trash the juggernaut of cultural fashion might turn up, so long as it could be experienced in a mode of irony.

This was the public that Warhol understood so well and served so efficiently—the public that he actually helped to create, to the extent that he was the boldest in openly exalting its meretricious tastes, and was, at the same time, created by. He had mastered the intricacies of its peculiar affinities and fetishes in the best training school available—the world of high-fashion publicity, with its corps of professional faddists, its canny retailers, its worship of fame, money, and scandal, and its indispensable alliances with homosexual bohemia. Warhol served a meteoric apprenticeship in this world, becoming the darling of *Vogue* and *Harper's Bazaar*, famous for his irresistible shoe drawings and his Peter Pan personality, before he ever had occasion to apply the valuable experience garnered in its precincts to the more prestigious market for high art.

Many serious artists have resorted to commercial work as a means of supporting their careers, but Warhol's case is different: his art remained essentially the same whether its intentions were explicitly commercial or ostensibly "aesthetic." What changed was the context—the social environment in which the art was judged and "consumed." And just as Warhol had proved to be a virtuoso in pleasing his commercial patrons, he now demonstrated an uncanny ability to titillate the art audience with his "artless" images of the banal. But he remained throughout this shift from one context to another an illustrator shrewdly exploiting the spectator's expectations. Whereas his subjects had formerly been supplied by clients with products to sell, they were now selected from the commonplaces of popular culture—an art source already certified by the success of the Neo-Dadaists, yet still sufficiently novel to qualify as something new.

There was, if anything, a more personal style at work in the commercial art. As Calvin Tomkins observed in his profile of Warhol, "He could kid the product so subtly that he made the client feel witty."* If there was no longer room for the marks of a personal style in the art that launched Warhol as the Prince of Pop—for serious art had already turned away from such emblems of "painterly" sensibility—the strategy was more or less the same. Only, in the latter case, the "product" being kidded—and this time not so subtly—was not Campbell Soup or Coca-Cola but *art* itself, and the

* "Raggedy Andy," in *Andy Warhol, op. cit.,* p. 9.

client (now the art audience) was made to feel even wittier in recognizing the put-on.

Warhol's movies likewise kidded the product—first, movies as such; then, upping the ante, the mythical sex life of the "stars"— and, as before, the timing was shrewd. The surfacing of the counter- culture had already rendered perverse sexuality, drug taking, *et al.*, familiar topics of the daily press and the nightly television show. Warhol's "dumb" but explicit treatment of such subjects gave the new audience a comfortable way of observing them at a safe "aes- thetic" distance and, at the same time, of feeling superior to their trashy inanity. As with his Pop paintings, he was under no obliga- tion to spell out the "significance" of his subject; he had only to identify it. Significance, such as it was, inhered in the mere act of transferring the subject from "life"—which is to say, the media—to "art," and any suggestion of the didactic was, in any case, incom- patible with the strategy of kidding the product.

Warhol has never been political, but his art nonetheless stands in relation to museum art, especially the museum art of the avant- garde, more or less as the counterculture once stood in relation to traditional liberalism. It capitalizes on its weaknesses, while ruth- lessly calling its bluff, and offers its own bluffs as an alternative—the bluffs of immediate gratification. Yet Warhol, unlike the more radical fringes of the counterculture, has always remained securely within the perimeters of liberal culture, never going beyond the permissible limits of "going too far." He has succeeded in his remarkable enterprise by turning everything he touches, no matter how banal or vulgar or outrageous it may be "in the original," into a form of light entertainment. His "Mao" is, in this respect, no different from his "Marilyn Monroes" and his "Jackies." Only the changed context of the seventies locates such visual entertainment more readily as a coefficient of what is acceptable to our official culture—the culture that is sanctified by institutions. For it was not, after all, the "existential edge of our existence"—whatever that may be—that Warhol's "choice of imagery" forced us to face but only the superficies of the fashions of the day.

7. The Return of "Handmade" Painting

One often hears it said nowadays that abstract art is in decline. One can even detect a sly satisfaction among those who say it, an unmistakable air of "I told you so," as if an old score were being settled or an uneasy conscience laid to rest. But the assumption of a decline is, I believe, a false one. It does not accord with the facts.

Abstraction, in one form or another, still commands the artistic allegiance of a large portion of the best talents. With few exceptions, it continues to inspire the largest ambitions. The energy and imagination invested in it show no abatement, and the public loyal to the special gratifications it offers is probably larger than ever—if only because the public for everything is larger than ever. Despite the many strong and interesting challenges to its aesthetic hegemony, abstract art remains at the moment the mainstream of contemporary visual expression.

Even false assumptions, however, may contain their element of truth. The mainstream, if one can call it that, no longer runs as wide and free and rapid as it once did. It no longer poses the threat of a flood engulfing the entire terrain. The challenges *are* stronger and more interesting. Even more important, perhaps, they are more confident. The sense of historical necessity that attended so many new developments in abstract art has unquestionably loosened its grip. Artists are no longer the pushovers they once were for the pretty face of an absolute, and the art public—a little weary, perhaps, from being told so often that it must take sides in some internecine warfare it neither understands nor condones—is more and more content to pick and choose its pleasures wherever it finds them.

It is in this context of a freer, more open-ended field of contending aesthetic ideologies that the exhibition called "Abstract Painting in the Seventies," which Kenworth Moffett has organized at the Museum of Fine Arts in Boston, proves to be at once so refreshing and so revealing. This is a strong show. Mr. Moffett has brought together the work of twelve artists who, in his judgment, "are the best practitioners of abstract painting right now." (He notes that Clyfford Still "does not consent to exhibit in group shows.") Each painter is represented by four or more pictures, most of them quite large, all dating from the seventies and many of them exhibited here for the first time. The artists are Walter Darby Bannard, Jack Bush,

Dan Christensen, Richard Diebenkorn, Friedel Dzubas, Helen Frankenthaler, Robert Goodnough, Adolph Gottlieb, Robert Motherwell, Kenneth Noland, Jules Olitski, and Larry Poons.

Certain omissions—notably Josef Albers, Frank Stella, and Ellsworth Kelly—are almost as interesting to think about as some of the inclusions. I think it is fair to say that no doctrinaire "line" is being laid down in this exhibition, but some important judgments are certainly made manifest. Mr. Moffett himself notes "a shift away from the hard-edged, geometric look that characterized so much of the art of the 60's and a return to the open, looser, painterly handling of the 40's and 50's." There are no shaped canvases here, no monochrome panels, virtually nothing that reflects the imperatives of the "minimal" aesthetic, and a notable diminution of the masking-tape edge. There are no pictures that suggest that every detail of their design was worked out on graph paper before a single drop of pigment was applied to the canvas surface. There is a greater emphasis on that element of unexpectedness that, in the right hands, is one of the surest sources of eloquence in the picture-making process.

One is tempted to say that the exhibition marks a return to "handmade" painting—to painting in which the artist's hand plays a role equal to that of the artist's eye. The sense of painting held in the grip of a cold-blooded ratiocination gives way to a sense of painting in which a freer play of mind and emotion makes itself felt at every stage in the realization of the work. Sheer feeling, if not actually deeper, is certainly less concerned to disguise its presence in the physical execution of the painting.

Having noted this shift, however, I feel obliged to warn against the fiction of a "trend" in which every painter and his brother (and sister) have been swept up overnight. In this sense, there is no significant change to be discerned in the work exhibited here by Diebenkorn, Dzubas, Frankenthaler, Gottlieb, Motherwell, or Olitski. Mr. Bannard has been moving in the direction of this "looser" style for several years, and Messrs. Bush, Christensen, and Goodnough are each involved in an individual synthesis that cannot be easily placed in either a "tight" or a "loose" category.

Only Kenneth Noland and Larry Poons can be regarded as having effected an important revision in the styles associated with their names. Mr. Noland has lately moved more and more rapidly in the direction of a kind of Whistlerian light and atmosphere. (In the

case of one painting in the Boston show—"Imbros"—he seems even closer to Sickert than to Whistler.) Mr. Poons has now divorced his color interests from precisely designed patterns of discrete color shapes and gone over entirely to a free-swinging Expressionist surface that fairly groans under the weight of clotted pigment it is obliged to bear.

For Mr. Moffett, the unity of this exhibition lies in the degree to which these painters are concerned, as he says, to give "primacy to color." I wonder. "Color in its purity is flat," he writes, "and to be visually effective it must spread out. Thus the color painter seeks literally the space he needs to develop chromatic ideas. Complications of drawing and design can divert the viewer's attention from the color relationships." There is no denying that color is a dominant interest here, but do "complications of drawing and design" actually play the negligible role Mr. Moffett suggests? This is not my reading of Motherwell's work, or of Diebenkorn's or Gottlieb's or Dzubas's or Bush's new pictures. On the contrary, I find the "complications of drawing and design" to be absolutely essential to what they are doing, and these complications articulate—as nothing else can—the viewer's grasp of the color relationships instead of diverting it.

The dream of an art of pure color from which drawing has been permanently expelled has haunted modern painting at least since the age of the Impressionists. Matisse lavished some of his most inspired energies on its realization, and lesser talents have taken up the cause with even greater fanaticism. But the exhibition Mr. Moffett has put together with so much sympathy and intelligence leaves one wondering if this dream hasn't become something of a pipe-dream. After all the talk about painting becoming more deeply entrenched in its own medium, I cannot help wondering if it is really in the nature of the pictorial medium to eliminate drawing as a pictorial function. Whatever lip-service they may give to the current orthodoxy, most of the painters in the Boston show clearly believe otherwise when they are actually at work on their pictures.

April 30, 1972

8. Documenta 5: The Bayreuth of the Neo-Dadaists

Dada, as we all know, was a revolt against established culture, a repudiation of "fine art" and the learned art historians who presided over its elucidation and veneration. Dada—so the myth goes—wrote "Finis" to all those scholarly disquisitions and abstract categories which, in the name of high culture, only serve to mask the naked realities of both art and experience. Dada affirmed what culture denied: that a gratuitous gesture, a vulgar expression, an obscene act, even an act of violence might be more creative in liberating man's poetic energies than the entire stock of works of art incarcerated in those cemeteries known as museums.

So the myth goes, and a very powerful and appealing myth it has been, enlisting extraordinary talent in a war against the very concept of talent. In ways that are all too familiar to anyone who follows events in the art world—and not only in the visual arts but in literature, music, films, theater, and dance as well—Dada has clearly triumphed. Its ranks have swelled into multitudes. Its influence abounds; and its financial resources are apparently without limit.

But the victory of Dada over established culture, over "fine art" and its learned representatives, has proved to be ambiguous. For such victories—in the arena of culture no less than in politics—produce regimes. Regimes require institutions to implement their aims. An official literature is needed to explain and enforce the new doctrine. A new batch of learned representatives is needed to sustain the faith. The blow for total freedom ends up in stupefying bibliographical research and the mounting of stupendous exhibitions. Which is to say: in established culture.

This is the historical scenario we see writ large—larger, indeed, than ever before—in the fifth Documenta exhibition, which opened in Kassel on June 30 for its long summer run, and in the mammoth catalogue that has been published to mark and celebrate the event. With Documenta 5 installed in two immense museum buildings—the Fridericanum Museum and the Neue Galerie—and even spilling over into additional facilities around town, Kassel has this year become the Bayreuth of the Neo-Dadaists and their myriad

groupuscules. One may be elated or depressed by what one discovers to be the constituents of this giant shrine consecrated to the spirit of Dada, but one cannot help being impressed—impressed, above all, at the size of the budget that the higher councils of an advanced industrial state are willing to lavish on a mockery of their own values.

The theme of Documenta 5 is itself of Wagnerian proportions, for it is nothing less than an "Inquiry into Reality—Today's Imagery." The aim is to embrace "the sum of all the images" that currently determine our sense of reality. What this means, at least as the theme has been interpreted in Kassel, is that "life" (albeit in some radically abridged form) must be given a role equal to or even greater than "art" (the conception of which is also drastically abridged). The result is a mélange of horrors and hilarities, of numbing inanities and real shocks, that succeeds in deepening not our sense of "reality" but of the ideology governing this highly selective anthology of "Today's Imagery."

It is an ideology designed above all to discredit the notion of artistic quality, to break down all distinctions between the artistic vocation—as that enterprise has been traditionally conceived—and the adventitious workings of the "non-artistic" Zeitgeist.

Art may be employed in this ideological task, but it had best be the sort of art that is itself diffident or ambiguous in its relation to "non-artistic" sources and materials, whether these are drawn from nature, the hardware store, the movies, or the world of kitsch.

But of course it is kitsch itself and the art explicitly based on it that are the most useful means for illustrating the dominant "non-artistic" component of "Today's Imagery." Thus, at Documenta 5, artists share the scene with non-artists. We are offered large displays of advertising art, political propaganda, science fiction, comics, popular religious art, and other forms of kitsch, together with surveys of Sharp-Focus Realism, Pop art, Video art, Conceptual art, Process art, and all their various hybrids and amalgams. There are large tableaus (some with live performers), films, environments, "information" booths, and an unending stream of words and more words, spoken and printed, recorded and live—words that hang on the wall like political slogans and are shouted in one's ear like a threat.

It is absorbing, exhausting, amusing, illuminating, and finally

depressing and a little frightening—this unending and well-orchestrated effort to destroy our sense of art as a disinterested and high-minded calling and to substitute for it a carnival of rubbish in which artistic merit is no more important than its most cynical and grotesque simulacrum.

Sifting through the rubbish, to be sure, examples of artistic merit are not hard to find. Foremost among them, certainly, is Claes Oldenburg's "Maus Museum," in which the artist's own miniature kitsch inventions and collections perform a reverse parody on the general theme of Documenta 5. Oldenburg once again demonstrates his gifts as a kind of Midas who can turn any bit of rubbish into art, and his "Maus Museum" is therefore a kind of counterpoint to the general thrust of the exhibition as a whole.

Somehow, too, a place has been found for the work of Joseph Cornell, Jasper Johns, George Brecht, William T. Wiley, Agnes Martin, Richard Serra, and even Auguste Herbin. But it is not artists like these who give Documenta 5 its special and rather sinister atmosphere. ("In this atmosphere," an American critic remarked at the opening, "Agnes Martin looks like Poussin.") The Sharp-Focus Realists are here in abundance, bringing with them a slight increase in pornographic content, although it is an Austrian cartoonist—Rudolf Schwarzkogler—who carries the pornographic element to its most vicious sado-masochist extremes. The latter's "Panorama" on the male genitals makes even Lucas Samaras's "Autopolaroids," which are also here in abundance, look almost innocent and benign by comparison.

Much of the show is alternately nasty and boring. The range is from large, gallery-size spaces in which there are nothing but words on the walls to a tableau—Vettor Pisani's *"L'Eroe da Camera"*—in which a naked young girl, chained by the neck, is under threat of violence from a fully clothed, grimacing young man with a knife. Anti-Semitic posters from the Hitler period make their appearance in the political propaganda section, and there is a large open-air antiwar environment complete with a black soldier in residence. Naturally, the Peking Opera's movie version of *The Brigade of Red Women* is included in the film program.

The official poster of the Documenta 5 exhibition depicts a colony of ants against a vivid orange background. The same motif adorns the cover of the massive catalogue, with its long theoretical introduction sporting dozens of learned references to Kant,

Nietzsche, Husserl, and Lenin, and, of course, enough bibliographical data to keep the graduate schools humming for years. The ant hill and the bibliography—the symbolism is perfect. This is what the victory of Dada has come to—established culture employing its resources in a vigorous effort to destroy itself.

July 9, 1972

Index